JAPONISME

The Japanese Influence on Western Art in the 19th and 20th Centuries

by Siegfried Wichmann

Harmony Books/New York

Translated from the German
*Japonismus: Ostasien und Europa, Begegnungen in
der Kunst des 19. und 20. Jahrhunderts,*
by Mary Whittall (pp. 6–105), James Ramsay (pp. 106–241),
Helen Watanabe (pp. 242–323), Cornelius Cardew (pp. 324–406),
and Susan Bruni (pp. 407–13)

Inquiries should be addressed to Harmony Books, a division of
Crown Publishers, Inc., One Park Avenue, New York, New York
10016. Harmony Books is a registered trademark of Crown
Publishers, Inc.

Library of Congress Cataloging in Publication Data

Wichmann, Siegfried, 1921–
 Japonisme: the Japanese influence on western
art in the 19th and 20th centuries.

 Translation of: Japonismus.
 Bibliography: p. 417
 Includes index.
 1. Art, Modern—19th century—Japanese
influences. 2. Art, Modern—20th century—Japanese
influences. I. Title.
N6447.W5313 709'.03'4 81–8128
ISBN 0–517–54507–1 AACR2

10 9 8 7 6 5 4 3 2 1
First edition

Text filmset in Great Britain by Keyspools Ltd, Golborne, Lancs
Printed and bound in Italy

Contents

Introduction

Japan and Western art

The most convincing method of presenting a case in the study of the fine arts is through a series of pictorial examples, constructed according to a genetic principle. Such a series can illustrate the way in which any number of variants can branch off from a basic primary type, as the examples in the present volume will show. It is an adaptable system, and can be used for comparing thematic as well as technical matters, such as colour, form, line, depth, light and shade. Analysis of pictorial material can lead to an understanding of the processes and the motivation that went into the creation of the works concerned, and it can suggest further exploration along a wide variety of interdisciplinary lines. How the encounter of European artists with Japanese art created specific analogies and adoptions – the manifestation known as Japonisme – becomes much clearer when as many items of visual evidence as possible can be seen together.

The series of comparisons selected for inclusion here are only a small proportion of the examples that exist. Every chapter could have been longer than it is, for in none of the examples selected is it a question of random borrowings or a passing trend: interest, admiration, understanding, eagerness to learn and conscious acknowledgment can be seen at work, stimulating emulation and original creative endeavour. The study of Japonisme has led to some highly varied and surprising conclusions, and it continues to be a fruitful subject to the present day.

This book follows essentially the same system of thematic organization as the exhibition 'Weltkulturen und moderne Kunst', mounted to mark the Olympic Games in Munich in 1972 (and incorporates extensive extracts from its catalogue). Some adjustments and additions have been made to the system as a result of further research carried out in the Far East in 1973, 1974 and 1976–77. European artists learned a variety of artistic methods from Japan, from compositional ones – such as silhouette, the diagonal principle, the imposition of a grille pattern or of cut-off objects placed in the foreground – to formats such as the fan leaf, the tall vertical format or the folding screen.

Subject matter is one of the central features differentiating groups of European artists in their choice of Japanese exemplars: the selection of such themes as the wave and its ornamental form, new types of posture and movement, the abstraction of nature, the rock in the sea, therefore has a scholarly justification beyond the incidental purpose of conveying historical information. Selection of this kind is a common practice in the fields of architecture and the crafts, encouraged by the scope for comparing materials and methods. The analysis of architectural works is – as it has always been – concerned with interior and exterior, with sight-lines, proportions and modular systems.

The presentation of the material in this book benefits greatly from its format, which allows a generous spread of illustrations for comparison and for tracing the course of an idea. The art of the Far East makes a virtue of the detail, of seeming to pick out the significant part of some hypothetical larger composition, and this was a feature that in Europe had a particularly enduring effect, in the work of the Impressionists, the Symbolists and even the Expressionists after them.

Besides the chapter divisions, the illustrations were chosen to establish chains of connection starting from little known, or unknown, Japanese exemplars such as the botanical manuals of the nineteenth century. Other important subjects are signature seals and the *mon* (or crest), the ornamental sword guard and its influence on Western jewellery design, the paper stencils used by Japanese textile dyers and their relation to European monochrome prints.

Vincent van Gogh evolved a technique of drawing with dots and lines, using a reed pen, which he based on Far Eastern techniques, with Hokusai as his preferred model; and the adoption of Oriental models can be seen in areas that have hitherto received little attention: Toulouse-Lautrec and the *mie* grimace of the Kabuki theatre, Gauguin and *ishizuri* technique, Vallotton and Chinese stone-rubbings.

This book does not trespass on the territory of Sinology or Japanology. The intention is not to offer any interpretation or ethnological analysis of Far Eastern art, but solely to illustrate the effects of the encounter between Far Eastern and European art; to take, as it were, an optical grasp of the stimuli, the analogies and the continuing impulses that resulted from that encounter, and to comment on them within the context of the period (the late nineteenth century and early twentieth) in which it occurred.

The connection between the influence of Japonisme and the *chinoiserie* (the fashion for Chinese art) of the eighteenth and nineteenth centuries is closer than art historians have hitherto recognized. The concept of Japonisme is not restricted to painting alone, but has even stronger ties with the applied arts. As a result, this book covers a wide range of subjects which are only now coming within the range of scholarship.

Some areas of Japonisme have not been touched on at all: the iconographic connotations of trees and plants, or the representation in European art of exotic fauna

originating in Japan or in Japanese mythology. The design of Chinese vases made of semi-precious stone and standing on metal bases had mythological and symbolic associations which greatly interested the Symbolists in Europe.

Beyond that, the purpose that I have kept constantly in view is to demonstrate the role played by Japonisme as a force that stimulated the development of modern art. Japonisme is not a style: it does not lend itself to being used as a concept in place of a style; and it cannot be pinned down to a specific period.

Designing the layout of this book was itself a task for a scholar, if justice was to be done to its content. In collaboration with the author, Professor Fritz Lüdtke was able to call upon his own Japanese experience and his understanding of the spirit of Zen and of artistic proportion in fulfilling that task.

My thanks are due to the publisher of the original German edition, Anton Graf Bolza, for the care, the understanding, the sympathy and the energy which made it possible for the book to be produced in the form in which we now see it.

Historical survey

A taste for the art of the Far East, with its combination of artistic quality and traditions of craftsmanship, became increasingly prevalent in Europe from the late Baroque period onwards. As early as the sixteenth century objects of Far Eastern origin, made of jade and semi-precious stones, were already in demand among European collectors. By the end of the seventeenth and throughout the eighteenth century, the limitation of Asian lacquer-ware, often to high technical standards, was common in Europe. In Holland and England the passion of the middle classes for collecting centred on Chinese porcelain and ceramics, and royalty and the nobility boasted sumptuous porcelain cabinets.

One can perhaps accuse these European collectors of mere exoticism, but the evidence makes it clear that the delight in all things Chinese was not only long lasting but also – if literature and the theatre are taken into account – capable of assimilating traits which were thoroughly authentic, for all their fairy-tale, never-never-land aura, and conveyed positive information about the Far East.[1] It was the international exhibitions of the later nineteenth century that were to do most to foster a more realistic understanding of China and Japan alike. However, considering that in the seventeenth and eighteenth centuries information was available only at second hand, and that channels of communication were still un-developed, European knowledge of Chinese art was already remarkably extensive.[2]

It has been asserted that *chinoiserie* – the fashion for Chinese art – merely exploited the charms of the exotic, and that there was no real progress in the understanding of China during that period; this claim also casts its shadow over the study of Japonisme. There has not yet been enough research into the similarities and differences between the crazes for Chinese and Japanese culture to draw many positive conclusions, but it is safe to say that in many areas *chinoiserie* had paved the way before people's interest shifted to Japan. This event can be dated: to 31 March 1854, the day on which the ports of Japan were opened to the world by Commodore Perry of the United States Navy. A year later Japan concluded trade agreements with Russia, Great Britain, the United States and France, and in 1856 with the Netherlands. After two centuries of isolation, economic and cultural exchanges could begin. China had already displayed its artistic strength at the Great Exhibition in London in 1851; thereafter China and Japan were both represented at the international exhibitions of the following decades.

The artist Walter Crane, one of the leading students of Japanese art in England, and a devotee of the Middle Ages, wrote:

There is no doubt that the opening of Japanese ports to Western commerce, whatever its after-effects – including its effect upon the arts of Japan itself – has had an enormous influence on European and American art. Japan is, or was, a country very much, as regards its arts and handicrafts with the exception of architecture, in the condition of a European country in the Middle Ages, with wonderfully skilled artists and craftsmen in all manner of work of the decorative kind, who were under the influence of a free and informal naturalism. Here at least was a living art, an art of the people, in which traditions and craftsmanship were unbroken, and the results full of attractive variety, quickness, and naturalistic force. What wonder that it took Western artists by storm, and that its effects have become so patent.[3]

William Michael Rossetti recorded:

It was through [James McNeill] Whistler that my brother and I became acquainted with Japanese woodcuts and colour-prints. This may have been early in 1863. He had seen and purchased some specimens of those works in Paris, and he heartily delighted in them, and showed them to us; and we then set about procuring other works of the same class. I hardly know that anyone in London had paid any attention to Japanese designs prior to this.[4]

Japan's triumphs at the international exhibitions held in London in 1862 and in Paris in 1876, 1878 and 1889 were equalled by those of China. Chinese painting, porcelain, lacquers and textiles appealed as strongly as ever to European taste. In their choice of models or analogies to develop, artists hardly bothered to distinguish between Japan and China, least of all when it came to the applied arts. An old tea bowl from Japan was as likely to be of Chinese origin as a painting on silk.[5] In the journal *Le Japon artistique* which he founded in 1888, the Parisian dealer Samuel Bing gave generous coverage to Chinese, as well as Japanese, art and artefacts.[6] His collector friends, with their enthusiasm for Japanese art, built up substantial Chinese collections at the same time.

The serious student of Japonisme has to decide whether to look upon the colour woodcut as the sole inspiration for it, or to include the applied arts as well, which in the Far East were not distinguished from fine art as they were in Europe. Bing's intention in founding *Le Japon artistique* was to raise 'crafts' from the lowly position they occupied in European estimation at that date by offering the best examples of a different tradition.[7] The collecting of, for example, Japanese lacquers, ivories, ceramics, textiles, medicine boxes and ornamental sword guards should be looked at sep-arately. It was essential for artists and craftsmen to be able to study Chinese and Japanese examples at first hand if they were to learn the techniques. The statement that the fashion for Japanese art in the nineteenth century was 'in the beginning a kind of exoticism'[8] is incorrect. By then the fashion for Chinese art had already been assimilated by European artists, and their under-standing and appreciation of Chinese civilization thereby enlarged, to the extent that the results can in no way be dismissed as superficial copies. The best demonstration of this is the case of the ceramic artist Théodore Deck. After making a study of the techniques of Islamic art, from 1862 onwards he turned his attention to Chinese exemplars of the difficult technique of *émail*

cloisonné, which he himself began to use in the 1870s. He was rewarded for his efforts at the international exhibition of 1878 in Paris by the Grand Prix, the highest award, and by appointment to the Légion d'honneur.[9]

In 1856 Félix Bracquemond discovered a volume of Hokusai's woodcut 'sketchbook' series, *Manga*, though it was another year before he was able to acquire one for himself. It is difficult to calculate the importance of this event in the development of Japonisme: it has recently been revealed that Japanese block books were already known in large numbers in Europe,[10] but the study of Japonisme usually starts with Bracquemond, even among those scholars who regard the colour woodcut as the sole germinal influence. Bracquemond was a graphic artist and designer, who also worked in the field of ceramics. He was introduced to Far Eastern techniques by Deck when he was appointed to the staff of the Manufacture Nationale de Sèvres in 1866. Weekly sessions at Deck's house led to a direct artistic exchange which fostered the growth of Japonisme.[11] The stoneware service of 1867, commissioned by François Eugène Rousseau, which Bracquemond decorated with motifs from Hokusai's *Manga*, is probably the reason for the familiar version of the story.[12] But Rousseau, a dealer in ceramics in Paris, was already a connoisseur of Far Eastern models and techniques, and went on to produce glass modelled on Japanese jades.[13] There is no reason why it should not have been Rousseau who conveyed his own wishes and suggestions to Bracquemond.

Naturally, Japonisme was first and foremost a fusion of themes that were in the air. Edouard Manet's portrait of Emile Zola, of 1867–68 (22), is almost a manifesto of an interest on Zola's part which was already finding expression in his commentaries on Japanese art.[14]

The numerous portraits of beautiful Western women in kimonos represented a kind of Japan cult which found a comparable expression in novels, operas and plays, Japanese ballets, and again and again in the influential international exhibitions and in people's reactions to them.[15] The descriptions of the Chinese and Japanese sections of the exhibitions in France alone fill a thick volume, and reports published in other countries in Europe were similarly exhaustive.[16]

The establishment of tea shops, such as La Porte Chinoise at 36 rue Vivienne in Paris,[17] contributed to public knowledge of Far Eastern ways and was yet another manifestation of the general trend of the times. It became *de rigueur* for every Parisian store to have Chinese and Japanese departments.

Toulouse-Lautrec valued Chinese hanging scrolls (*kakemono*) as highly as he did Japanese *netsuke* (small carved figures used as stoppers). Maurice Joyant describes his studio at 7 rue Tourlaque as containing 'an extraordinary number of Japanese *objets d'art, kakemono* and *netsuki*'.[18] And the Dutch Art Nouveau artist Jan Toorop wrote: 'The East is the foundation of my work! This wonderful, half-Chinese décor . . . [was] my first contact with beauty.'[19]

One of the most important figures in the history of Japonisme is Samuel Bing. Originally from Hamburg, he opened a shop in Paris at 22 rue de Provence; with the founding in 1888 of the periodical *Le Japon artistique* (simultaneous editions appeared in German and English) he effectively created Japonisme. Bing always had several thousand Japanese woodcuts in his salerooms, of every standard of quality. Vincent van Gogh wrote to his brother Theo:

But please keep the Bing stock, it is too much of an advantage. I have rather lost than gained on it as far as money goes, but for all that, it gave me a chance to look at a lot of Japanese stuff long and composedly. Your rooms would not be what they are without the Japanese things always there. . . .

But on no account cancel the deposit. In a way all my work is founded on Japanese art, and if I have held my tongue about Bing, it is because I think that after my visit to the South, I may be able to take up the business more seriously.

Japanese art, decadent in its own country, takes root again among the French impressionist artists. It is its practical value for artists that naturally interests me more than the *trade* in Japanese things. All the same the trade is interesting, all the more so because of the direction French art tends to take.[20]

Bing's interest did not stop at woodcuts: he also dealt in objects such as lacquers, sword guards (*tsuba*), dyers' paper stencils (*katagami*) and Chinese stone-rubbings.[21] He also used to mount special exhibitions in his galleries: for instance, in 1888 he showed some rare prints by Utamaro, most of which he kept for his own collection.[22]

The exhibition organized by Louis Gonse in 1883, in the Musée Japonais Temporaire in the rue de Sèze, stimulated the interest of many collectors, and Bing became their adviser as well as their supplier in the years that followed. The exhibition of Japanese woodcuts that Vincent and Theo van Gogh put on in a café (Le Tambourin) in 1887 consisted largely of prints they had bought from Bing. Vincent remarked in a letter to Theo:

The exhibition of prints that I had at the Tambourin influenced [Louis] Anquetin and [Emile] Bernard a good deal, but what a disaster that was! As for the trouble we took over the second exhibition in the room on the Boulevard de Clichy, I regret it even less: Bernard sold his first picture there, and Anquetin sold a study, and I made an exchange with [Paul] Gauguin; we all got something out of it.[23]

In 1890 Samuel Bing organized another exhibition, held in the Ecole des Beaux-Arts, at which were displayed 763 woodcuts from the collections of his friends in Paris and the environs. It was an immense success.[24]

In the 1890s the trade, which had hitherto been conducted in private, moved into the open market. The leading galleries turned out in force at the Hôtel Drouot when the collections of the great pioneers of Japonisme were put up for auction: those of Burty (1891), Goncourt (1897) and Hayashi (1902).[25] The legendary Galerie Durand-Ruel, with its long-standing association with the Impressionists, showed a selection of prints by Kitagawa Utamaro and Andō Hiroshige, compiled by Bing, in 1893.[26]

The quality of Japanese contributions to the international exhibitions rose steadily from year to year. In Paris in 1900, the display in the Japanese pavilion included india ink drawings, calligraphy, and early sculptures from the imperial collection and temples in Japan. This temple and court art was already known to

connoisseurs, and was singled out for mention in the catalogues and press reports.[27] But Japanese applied art and woodcuts had already become so popular in Europe that the court art was regarded as merely an exclusive extension of it. There appears to have been no comment on the colour woodcuts. The expression 'late flowering',[28] applied to the Japanese colour woodcut, originated with the Japanese critic Akiyama Terukaza in 1961.[29]

The outcome of detailed study of Japanese woodcuts and applied arts now became visible in Art Nouveau. The Symbolist movement, too, owed some important inspirations to the art of the Far East, which contained much that corresponded in outlook and content with its own aims. Imitative realism was transformed into symbolic realism. The religious inspiration which was at the heart of representation in the Far Eastern models was replaced in Europe by a stylized, remote reality, as in Belgian Symbolism for instance. Its basis was not objective reality, but a reality that transcended the everyday, a fantasy world that transcended empiricism – all these were stimulated by the encounter with Far Eastern art. The result was the establishment of an association with abstraction, which in turn pointed the way towards modernism. From henceforth the symbols of Far Eastern art were comprehended by European artists. The great French glass makers, Emile Gallé and the Daum brothers, used the Far Eastern symbols of nature, plants and animals in the decoration of their exotic vases, transmitting an abundance of such symbols to a wider public.[30]

To the Impressionists and their second-generation successors, Japonisme spelt liberation, the revelation of techniques which released them from the old traditional concepts of classical modelling taught at the academies.[31] The dictatorship of naturalistic illusionism was now to be overthrown by an art which understood painting primarily as the disposition of brilliant colour on flat surfaces.[32] Instead of the single perspective obtained from the fixed viewpoint of the European tradition, depth in Japanese prints and painting is represented by a systematic fragmentation. The eye is directed towards distant or middle ground by the arrangement of foreground objects which are so close that they are cut off short and serve as a frame within the actual edges of the picture. Chinese models[33] were the pattern above all for the transformation of the fragment into an overwhelming totality. The partial view, the view as from a very great height, the suspension of figures in space without a background, ushered in an artistic revolution. Instantaneousness, mobility, the recognition of the positive artistic value of a natural, transient posture, were set up in opposition to the ceremonial, held poses of formal portraiture.[34]

The enormous swing away from the imitative and photographic and towards the decorative as a valid artistic means, was probably the greatest gain attributable to the impact of Far Eastern art. The abandonment of the dark modelling and sombre tonal values of academic painting in favour of a light with no shadows gave European artists a new relationship to reality.[35] The acceptance in the West, from the Renaissance onwards, of central perspective with a fixed viewpoint and a vanishing point had created a gulf between Western and Eastern concepts of space, but this now began to close again, as the example of Eastern art showed that the Western illusion of perspectival depth need play no part in pictorial composition.[36] Japonisme provided some of the central concepts of twentieth-century modernism, for it introduced new and astonishing angles of vision – from below, from above – and the separation of planes by a strong diagonal, combined with the framing function of truncated foreground shapes.[37] The tall, narrow formats of Japanese hanging scrolls and 'pillar pictures' suggested new ways of organizing the picture plane with objects cutting across the field of vision, apparently quite arbitrarily, yet subject to a scrupulous compositional order. This crossing of the boundaries of pictorial perception revolutionized the Impressionists' composition and made it boundless.[38]

The French Impressionists experimented with the tall narrow format; but it was in certain areas of Art Nouveau that it came to constitute the very nature of the painting.[39] Instead of the Impressionist illusion of depth the composition is stacked in a series of layers and levels, towards the top edge of the picture.[40] Height signifies space as well, and space – perspectival space at least – is an illusion. By stacking objects upwards in tall compositions under the influence of Far Eastern models, European painters introduced a clarifying element which either brings all the forms forwards to the surface of the picture plane or momentarily allows them to float in an 'unspatial space', a foil which can be sensed as extending in all directions (floating space).[41]

These new concepts had an important effect on poster art at the turn of the century and, in conjunction with the newly discovered value of colour for its own sake, hastened the demise of the copy made from nature and the birth of abstraction.[42] The Modern Movement in Europe was in the position to generate stimuli through formal rhythms; the stimuli are of an aesthetic nature and can affect the viewer as effectively as Japanese symbols, which in any case were already widespread and familiar by 1900.

The inclusion of architecture, pottery and calligraphy in a study of Japonisme is subject to certain historical conditions. Not all the historical events have yet been placed in their proper context, and certain areas have been excluded from consideration by art historians. Even so, it can be said that Far Eastern models provided analogies which were still being utilized by the early Expressionists, and even by artists in the 1920s. To take only one example, posters produced in the first two decades of this century in Europe and the United States provide some amazing instances of the persistence of the influence of Japonisme. The posters for *Harper's Bazaar* between 1919 and 1928 can be traced directly back to Japanese woodcuts of the school of Yoshitoshi.

The European encounter with the art of the Far East, and in particular with that of Japan, gave rise to a whole new range of subject matter, new techniques and new artistic devices – this last to be understood as including the representation of depth and surfaces, the treatment of light and shade, the format and division of the picture

plane, the principle of ornamentation and the treatment of glazes in ceramics, the symbolic role of real objects, architectural proportions, the reduction of the object to the simplest terms, new poses captured through new means of representation, and much else besides.[43]

Of course it was as individuals that European artists made their choice of these methods under the impact of Japanese art, yet there was an element of group choice too. The discovery of certain of the methods of Far Eastern art, in particular such as were employed in the Japanese colour woodcut, was made jointly.[44] Groups then formed, their members united by a common use of specific Japanese techniques and artistic devices. The close relationship in these respects between the first generation of Impressionists, the Pont-Aven School, the Nabis, the Belgian Symbolists and others is proof enough. If not every artist adopted all the new models, each made his or her individual choices with the backing of a particular group, and the analogies that they developed from their choices were similarly related.[45]

In the exhibition 'Weltkulturen und moderne Kunst' ('World Culture and Modern Art: the Encounter of the Art and Music of Europe with Asia, Africa, Oceania, Afro-America and Indo-America in the Nineteenth and Twentieth Centuries', Munich 1972) this consideration led me to arrange the exhibits according to the subject, technique and artistic devices adopted.[46] The bridge, the rock in the sea, the wave, the flower, the fan, the folding screen and so on were thus demonstrated to be themes prevalent in the age, chosen by any number of European artists, all stimulated by the example of Japanese woodcuts and applied arts. The content of the various sections of the exhibition – such as posture and gesture, the *mie* grimace, graphic techniques or *shimimori* technique (the 'white-on-black' print) – was arranged according to the technique and artistic devices used. The artistic exploitation of any one device is demonstrated far more effectively by reference to the use of it by several artists, than in the context of other work, employing different processes, by one individual artist. If the material were to be arranged by individual artist, the working of the Far Eastern influence, and above all the historically and artistically fascinating process of transmutation which it underwent in European art, could not be reconstructed with anything like the same precision or conviction.

Another reason for the adoption here of an arrangement according to subject matter and artistic devices was the fact that many European artists shared the same Japanese exemplars. The circulation of art magazines made possible a far wider and faster dissemination of ideas than had ever been the case before. Certain subjects and techniques suited the age so exactly that they can be said to have led to common decisions. Thus groups of European artists shared a common interest in, for instance, patterned backgrounds, tall, narrow formats, or cut-off foreground objects; other groups took a particular interest in wave ornamentation, or in Far Eastern styles of depicting plants and animals. Asymmetrical composition, with large areas of the picture left empty, was another approach to the representation of space which was explored by some European artists.

This book adopts and expands the comparative thesis of the exhibition. The range of subject matter, techniques and methods of expression has been enlarged and more exhaustively analysed.[47] There is greater attention paid to individual artists in view of their particular place in the history of Japonisme – but those chosen are only a representative selection from a group that could be extended indefinitely. It has also been possible to introduce new examples of the use made of Far Eastern techniques and, in particular, botanical models. It was not necessary to confine the examples to direct copies, for there is a very large quantity of material in which artists can be shown to have developed analogies and adapted ideas in new and original ways. Direct copies of Far Eastern models are in any case artistically unsatisfactory for the most part, for it was only through the transmutation of exotic stimuli in works of a high artistic standard that techniques were developed which liberated artists from the stagnant European traditions.

The impact made by Japonisme on European art in the latter part of the nineteenth century was manifested with greater or lesser strength in different fields. Thematically and formally, its influence was and is so manifold, and can be seen operating at so many different levels, that its effects are still far from exhausted.

The study of Japonisme

The study of Japonisme is a relatively new discipline. It begins essentially with the reports covering the international exhibitions.[1] An outstanding feature of this reporting is the close examination of specific technical characteristics of the products of various crafts, such as silks, lacquers, ceramics and bronze casts.[2]

A comprehensive literature has been devoted to the confrontation of European craftsmen and French painters with Far Eastern art. A significant fact emerging from it is that it is impossible to establish a precise or approximate date when Europe and the Far East can be said to have first encountered one another, or to chart any kind of gradual dawning of awareness of the encounter.[3] From the very beginning, all European references to the subject show an intense interest.

An important early work is Sir Rutherford Alcock's *Art and Art Industries in Japan*, published in London in 1878. Alcock was President of the Royal Geographical Society, and possessed a wealth of ethnological experience. He was the first person to classify the types of Japanese woodcut and to write about them and their iconographic and artistic significance in terms that could be appreciated by his contemporaries. In the following decade, Louis Gonse, in *L'Art japonais* (Paris 1883),[4] and Maurice Paléologue, in *L'Art chinois* (Paris 1887), contributed more specialized variations on the general

theme of Far Eastern art, but as far as dating is concerned they remain in Alcock's debt.

In the entry in his diary for 25 May 1888 Edmond de Goncourt gave expression to the passion that Far Eastern art aroused in the age:

Ah, if I still had a few years to live I would like to write a book on Japanese art of the sort that I did on eighteenth-century art, one which would be less documentary than the latter, one going further in a penetrating and revelatory description of things. This book would be made up of four studies: one on Hokusai, the modern renewer of ancient Japanese art; one on Utamaro, their Watteau; one on Korin and another on Ritsono, two celebrated painters and lacquerists. To these four studies I might join a fifth on Gakutei, the great artist of *surimono*, a man who in his delicate color prints has succeeded in joining the charm of Persian miniatures with that of European miniatures of the Middle Ages.[5]

Samuel Bing had written in his introductory article in the first issue of *Le Japon artistique*, also dated May 1888: 'This art is permanently bound together with ours. It is like a drop of blood that has been mingled with our blood, and now no power on earth is able to separate it again.'

The year 1889 saw the publication in Berlin of Justus Brinkmann's book *Kunst und Handwerk in Japan*. Brinkmann developed his account of Japanese painting and crafts from an overall portrayal of Japanese life. His book provides the first general survey of what is today recognized as the province of the academic study of Japonisme.

Philippe Burty, the authority on Far Eastern porcelain, always kept the totality of Japanese art in sight in his publications.[6] Although he himself collected woodcuts (the collection, auctioned in the Hôtel Drouot in 1897, contained some wonderful prints), his writings set an example of the understanding of the whole range of Japanese art as a single entity.

Théodore Duret, who catalogued the collection of Japanese books and volumes of prints in the Bibliothèque Nationale,[7] not only wrote about Japan, but was also an authority on the culture of other parts of eastern and southern Asia. He is yet another writer whose work displays a broadly based, synoptic comprehension of the stylistic refinements of those civilizations.

As early as 1898 Louis Gonse perceived the influence that the Far East had exercised on Europe. His analyses initiate the academic study of Japonisme as such. With the help of the Japanese art dealers Tadamasa Hayashi and Toru Wakai, he also laid the foundations of an analytical description of Japanese art.[8]

Collectors, too, often provided the stimulus for new insights, for they created unity out of disparate materials, and thus opened up new areas for research. The leading French collectors in this respect were Enrico Cernuschi, Emile Guimet, Philippe Burty, Charles Gillot, Pierre Barboutau, and not least the Goncourt brothers. But it was above all Bing who acted as a catalyst. He was the prime instigator of Japonisme in France. Not only did he make Japan and its art accessible to his contemporaries, he also expounded its way of life and introduced a new aesthetic.

Important roles were also played by Theo van Gogh, the goldsmith Henri Vever and his son Paul. Theo van Gogh was a very sound judge of Japanese woodcuts, and his influence on his brother Vincent was considerable. Henri Vever placed the Japanese sword guard above all other works of art,[9] but he also collected Japanese woodcuts.

Inevitably, the interest in Far Eastern art engendered knowledge and understanding of the techniques and artistic devices.[10] Many graphic artists practised making colour woodcuts after Japanese models. The goldsmith Alexis Falize and his son Lucien investigated the techniques of Japanese enamels, and from their analysis of the alloys they laid the foundations for the French art of enamelling, with its high artistic standards.[11] In an early number of *Le Japon artistique*, Lucien Falize described himself as a would-be 'Apostle of Japan'.[12]

In an essay written as early as 1898, Woldemar von Seidlitz drew attention to the characteristics of Japanese art that were important to European artists and also highly influential in their effect on later modern art; this was an important contribution to the infant discipline of Japonisme, for it helps later research to attain a clear view of the degree of familiarity with Japanese art that existed in the 1890s.[13]

Edmond de Goncourt, for example, in his book on Utamaro, published in 1891,[14] demonstrates an understanding and knowledge of the Japanese unexcelled by any present-day student of Japonisme. The original print run was 2,000 copies, and by 1901 it had surpassed 25,000 copies. It is known to have been read by the artists of the day and was widely discussed in the press.

Marcus B. Huish's *Japan and its Art* had appeared in London three years earlier, in 1888. In his seventeen chapters the author, whose own work as painter and craftsman shows an artistic inspiration of the highest order, imparts an analysis of Far Eastern art which is not only completely comprehensive for its age but represents the apogee of the endeavour to view Japanese art with a purely Western intelligence. Huish was the first to go into Hokusai's influence on the reproductive processes of etching and wood engraving in Europe, and he compared Hokusai with Rembrandt, Ghirlandaio and Botticelli.[15]

C. J. Holmes's book *Hokusai* (London 1898) must also be mentioned, for the chapter 'Characteristics of Hokusai's work' is probably the best summary of Hokusai's significance in European art of the second half of the nineteenth century.

Research in Japanology and Sinology during the last quarter of the nineteenth century had a decisive significance for the development of Japonisme. William Anderson, M. Franks, Ernest Hart and William Elliot Griffis are other writers who played a decisive role.

In this context, it is out of the question to separate fine art from crafts. The woodcut is by no means the beginning and the end of Japanese art, which is an indivisible whole embracing lacquers, ceramics and porcelain, painting on silk, textile design and much else. Indeed, some knowledge of Japanese textile design is essential to the understanding of the Japanese woodcut, and textile design in turn cannot be understood without

some appreciation of the extent of the importance in art of the heraldic crest, the *mon*. The fan leaf, the folding screen, the hanging scroll still remained objects for use, first and foremost, and played an important part in daily life.[16] The artists in Europe who were interested in Japonisme – and who can indeed be said to have developed it – were in complete agreement with the scholars on the need for a comprehensive, global view. If Gauguin painted nearly sixty fans in a Far Eastern style, he had good reason for doing so, and if Gustav Klimt and the Nabis collected Japanese textiles and put them to practical use, then art historians cannot overlook such articles.[17]

The aegis of the international Art Nouveau movement extends over a wealth of utterances made in the years preceding the outbreak of the First World War, which have not hitherto been considered collectively, yet as a statement they amount to far more than the sum of their parts. Great interest attaches to the attitude revealed by the artists themselves when they take up the pen: above all Walter Crane in his book *Line and Form* (London 1900), where he defines his own view of Japonisme. Thus the practical exchange of artistic experience was able to influence the formulations of art historians.[18]

Richard Graul, in *Die Krisis im Kunstgewerbe* (Leipzig 1901), drew attention to the need for a broader view in the educational curriculum, so that works of Far Eastern art could be taken as models and as yardsticks of quality. In this work, too, he introduced a synoptic view that has much in common with the later Werkbund idea.

Far Eastern architecture also made an impression on the consciousness of Europeans; it fitted well into current notions of the synthesis of the applied arts, which fed both the Werkbund idea and, in time, the Bauhaus.[19] This is a field where there is still much research to be done.

There was no slackening in the study of Japonisme in the 1920s, but there was a process of consolidation and of building on what had already been achieved, characterized by the publication in Paris in 1923 of V.F. Wéber's outstanding but now rare *Ko-Ji Hō-Ten: Dictionnaire à l'usage des amateurs et collectionneurs d'objets d'art japonais et chinois*. Weber's preface to this two-volume illustrated dictionary of Far Eastern artistic creativity summed up everything that had been achieved in the field in the last years of the nineteenth century. Its alphabetical organization showed artists, amateurs and connoisseurs the unity behind the seeming multifariousness of the material. At the same time the impulse for the artist, the collector and the art historian was direct and long lasting, for none of the arts was discriminated against by being labelled a 'craft'. Even today some writers in the field of Japonisme separate ceramics, lacquers, textiles and so forth and leave their discussion to the end, since they are still regarded as 'secondary' arts, according to a blinkered nineteenth-century definition.[20] In particular, the attempt to analyse French Impressionist paintings of the first and second generations with reference only to Japanese colour woodcuts can never be more than partly successful, because it does not take account of the bearing that other Japanese arts – textiles, lacquers, *mon* – have upon the woodcut.

Some of the research of the 1920s ventured into new areas, without delving to real depth at this stage. For instance, Henri Focillon's paper 'L'Estampe japonaise et la peinture en Occident dans la seconde moitié du dix-neuvième siècle', read at an international congress of art history in 1921, described the impact of the Japanese woodcut on French painters and the resulting innovations in composition and colouring, with reference also to Post-Impressionism.[21] But this was an immense subject, which required time to develop fully, and two World Wars hindered the work. Only in 1947 could it be continued.

Yvonne Thirion's work on the influence of the Japanese print on French painting in the second half of the nineteenth century is an important contribution, although she has published only parts of her research.[22] Certain aspects of Madame Thirion's work have been developed further by Bernard Dorival, an indication of how well established the study of Japonisme now is.[23]

In his Cologne thesis of 1957, 'Degas, der Einzug des Japanischen in die französische Malerei',[24] a Japanese, Yūjirō Shinoda, pioneered a new course, focusing his attention on the effect that the Japanese influence had on one particular artist. Shinoda was less concerned with picking out individual exemplars than with the phenomenon itself. His work makes use of the state of research up to the mid 1950s.

Many new ideas have been stimulated by research in Japan itself, for instance by the Japanese National Commission for UNESCO in 1957, which was followed by a symposium on the historical contacts between eastern and western art. The dialogue begun at the International Symposium of Fine Arts in the East and the West, held in Tokyo in 1966, was continued in Tokyo and Kyōto in 1968 at the International Round Table on the relations between Japanese and Western arts.[25]

In their work on individual subjects and in surveys written from their specialist viewpoints, such Japanese scholars as Toru Haga, Chuji Ikegami, Takao Kanda, Tai'ichiro Kobayashi, Ei'ishi Shibusawa, Kunitaro Takahashi and Chisaburō Yamada have demonstrated the important contributions that can be made by such studies.[26]

New stimuli to the study of Japonisme have frequently come from publications about individual European artists, from the 1920s to the present day. There is relevant material to be found in Adhémar on Toulouse-Lautrec, Klaus Berger on Redon, La Faille and Cooper on Van Gogh, Jannot and Chassé on Degas, Rewald (and others) on Gauguin, Sandberg and Sutton on Whistler, Dorra and Adkin jointly on Seurat, Kloner on Manet and Gauguin, Hanson on Manet's drawings, and Reff on the same artist's portrait of Zola.[27]

Clay Lancaster's publications over the last thirty years have all broken new ground, particularly in the comparison of the architectures of East and West; his importance as a writer lies in the fact that he always looks upon the products and effects of Japonisme as a bridge to the art of his own time. This area is also explored in William Current's book on the architects Charles and Henry Greene[28] and in Robin Boyd's *New Directions in Japanese Architecture*.[29]

Horticulture is another essential field of research. Josiah Conder made a start here as early as 1893,[30] with some persuasive analysis, which was followed up by Clay Lancaster in 1964. Edward S. Morse's book *Japanese Homes and Their Surroundings* was first published in Boston in 1886 and has since been reprinted many times, most recently in 1972.

There is a large number of outstanding publications on Western pottery and its relationship to Japanese pottery of the Tea Ceremony.[31] Muriel Rose's book *Artist Potters in England* was first published in 1955 and a second edition appeared in 1970; Jean d'Albis's essay on the Impressionist pottery produced at the Auteuil studio was published in 1968, and Bernard Leach's *Hamada, Potter* of 1976 is an invaluable primary source.[32]

Interior decoration and furniture is another field worthy of study in its own right: Elizabeth Aslin's essay 'E.W. Godwin and the Japanese taste', published in *Apollo* in December 1962, indicates just how wide the range of analogies is.

The flow of literature has been accompanied by a succession of important exhibitions held in Europe, America and Japan (for catalogue details, see p. 428): 'Der Japonismus in der Malerei und Graphik des 19. Jahrhunderts' (Berlin 1965), organized by Leopold Reidemeister, documented the effect of Japonisme on European graphic art and painting in the nineteenth century; Chisaburō Yamada's 'Mutual influences between Japanese and Western arts' was shown at the National Museum of Modern Art in Tokyo in 1968; 'James McNeill Whistler', at the Nationalgalerie Berlin in 1969, and 'Félix et Marie Bracquemond', a travelling exhibition shown in a number of French towns between 1968 and 1972, were devoted to artists who were most directly affected by the Japanese influence.

The exhibition 'Weltkulturen und moderne Kunst' held in Munich in 1972, attempted a synthesizing survey of the whole subject, in that thematic strands were drawn together from individual genres, and the many arts, such as textiles, ceramics, lacquers, fashion accessories, dyers' paper stencils, calligraphy etc., were presented as aspects of a whole. In 1973 the Österreich-ische Museum für angewandte Kunst in Vienna mounted the exhibition 'Japanischer Farbenholzschnitt und Wiener Sezession', a survey of the influence Japanese colour woodcuts had on the artists of the Vienna Secession. 'Hommage à Félix Bracquemond' was a special show mounted at the Bibliothèque Nationale in Paris in 1974, and applied art and painting were linked in the exhibition 'Japonisme – Japanese influence on French art 1854–1910', which was shown at the Cleveland Museum, Cleveland, Ohio, the Art Gallery of Rutgers University, New Brunswick and the Walters Art Gallery, Baltimore in 1975–76. This exhibition was an important survey of the whole field of research and its catalogue an important source work. Such specialists as Gabriel P. Weisberg, Phillip Dennis Cate, William Ralph Johnston, Martin Eidelberg and Gerald Needham have contributed an abundance of new data and findings, which will provide the foundation for critical reflection.

The literature and exhibitions referred to here have fanned the flames of new research. The Japonisme section of 'Weltkulturen und moderne Kunst' encouraged several students to undertake research projects on a variety of individual topics, some of which are not yet completed.[33] A study of Western fans was finished in 1979,[34] and a Master's thesis on the iconography of Hokusai's *Manga* in 1976.[35]

The contribution that Japanese art made to the development of a new aesthetic of ornament was explored in a dissertation, completed in 1976, on the symbolic imagery of jewellery of the turn of the century.[36]

The inexhaustibility of the theme of Japonisme is further demonstrated by Ursula Perucchi-Petri's *Die Nabis und Japan* (1976).[37] The author's precise analyses lead to convincing conclusions, which place the goals and intentions of the Nabis in their proper place in art history.

Klaus Berger's forthcoming work on Japonisme in Western painting between 1860 and 1920 will make important contributions to knowledge; this was already apparent from the conversations I had with the author at the time of the Munich exhibition in 1972.[38]

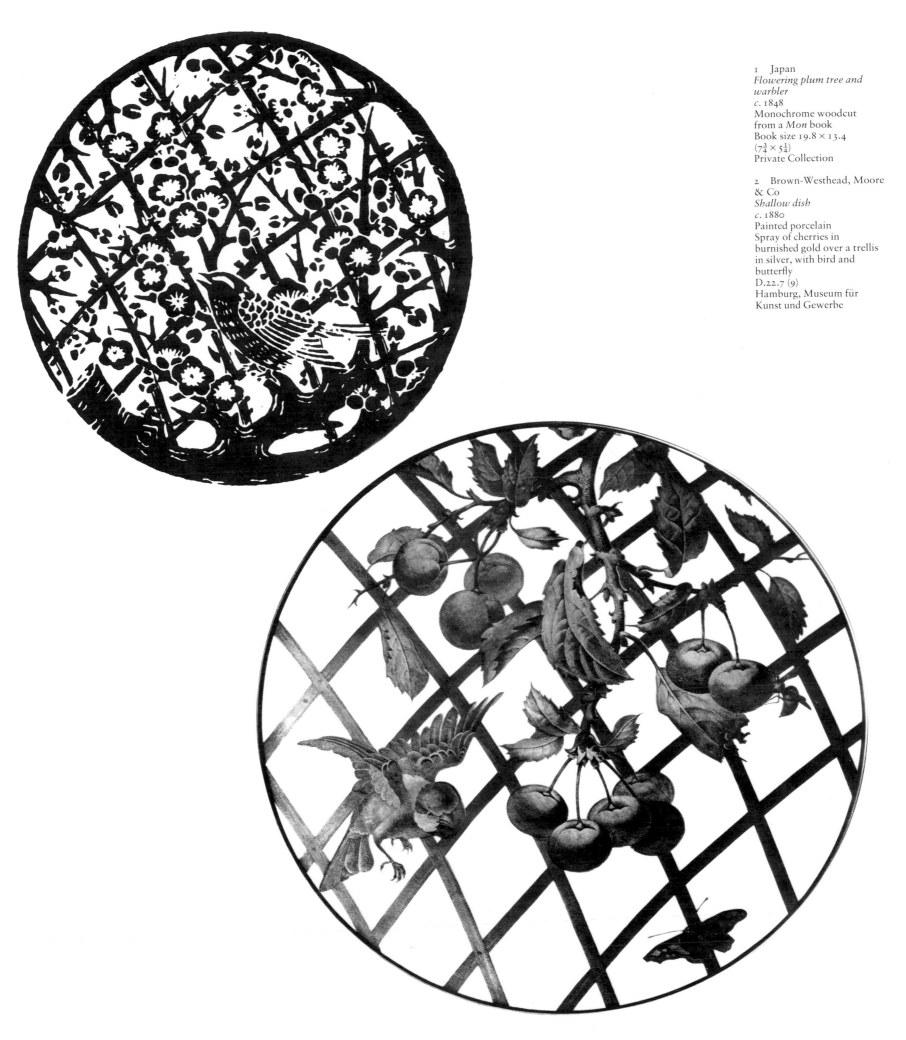

1 Japan
Flowering plum tree and warbler
c. 1848
Monochrome woodcut
from a *Mon* book
Book size 19.8 × 13.4
$(7\frac{3}{4} \times 5\frac{1}{4})$
Private Collection

2 Brown-Westhead, Moore & Co
Shallow dish
c. 1880
Painted porcelain
Spray of cherries in burnished gold over a trellis in silver, with bird and butterfly
D.22.7 (9)
Hamburg, Museum für Kunst und Gewerbe

15

A case-study: the kimono

Posture and gesture are central to the Japanese Kabuki and Nō theatres. This repertoire of movement also governs the work of the masters of *ukiyo-e*, who executed large numbers of portraits of actors. The gracefully sloping line of the back, the droop of the long sleeves, the slenderness of knee and thigh above the generous spread of the hemline, which at its furthest extent often completes a continuous line that begins with the bend of the head: no matter how often this conventional pose is repeated it never grows stale. Variations from it are minimal, and yet the actor – or the society lady – always succeeds in developing an individual posture – a gesture – from the common pose (3, 4, 52).

There are many drawings by Hokusai – and by Emil Orlik[1] – of women wearing the type of festive kimono called an *okaidori* (4, 54). The *uchikako* depicted on the facing page (5) is related to the *okaidori*: it was the dress of women of good family. It is cut to fall loosely and it ends in an undulating, trailing hem, the bottom edge of which is padded and covered in costly silk. In summer people wore several kimonos of this type, in thin fabrics, one on top of the other (55, 58). The long sleeves of the *okaidori* (5, 6, 8, 11, 15) had multiple roles to play in Japanese customs – for example, women in mourning used them to dry their tears – and so the sleeves were prominent in the literature and theatres of Japan.

The contemplative attitude in the eye-catching pose of the 'striding stance' is characteristic of the standing figure in all Japanese woodcuts, from Okumura Masanobu to Utagawa Kuniyoshi. It is a pose that Julius Kurth compared to the bend of the Japanese willow tree (*yanagi*).[2]

But the pose does not create the image on its own: the garment plays an important part. When society women, and actors too at a later date, wore several kimonos one on top of the other, it was the weight of the layers of silk that formed the outward curve at the feet, like the base of a column, and it was this that led to the incessant variation in the flow of movement. Painters of the Sung and Kamakura periods liked to use eighteen different kinds of line to represent garments.[3]

The 'inverted shading',[4] the technique of *ungen*, whereby an area of colour is raised to prominence without shading or modelling, has a large share in the creation of a precise schematic pose; that is to say that the conventions of the figures in Japanese painting derive in large measure from the treatment of the fabrics. The ordering and sinuous flexibility of the forms create a clarity and a rhythm which are powerful factors in the work of the *ukiyo-e* masters. Their depiction of movement was much admired by Claude Monet, who emulated it in a painting of his wife wearing an *okaidori* (11).

Gustav Klimt made a large number of drawings of women in kimono-like garments. In his studio he himself wore a robe cut on similar lines;[5] the Flöge sisters were kept busy making new ones for him, in fabrics printed with patterns from the Wiener Werkstätte (Vienna Workshops), sometimes designed by Josef Hoffmann

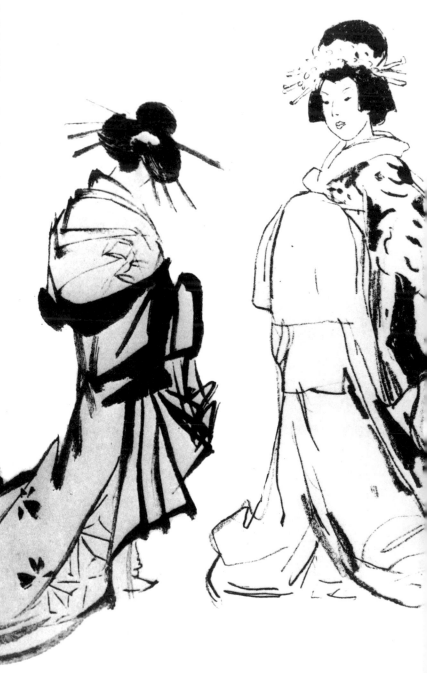

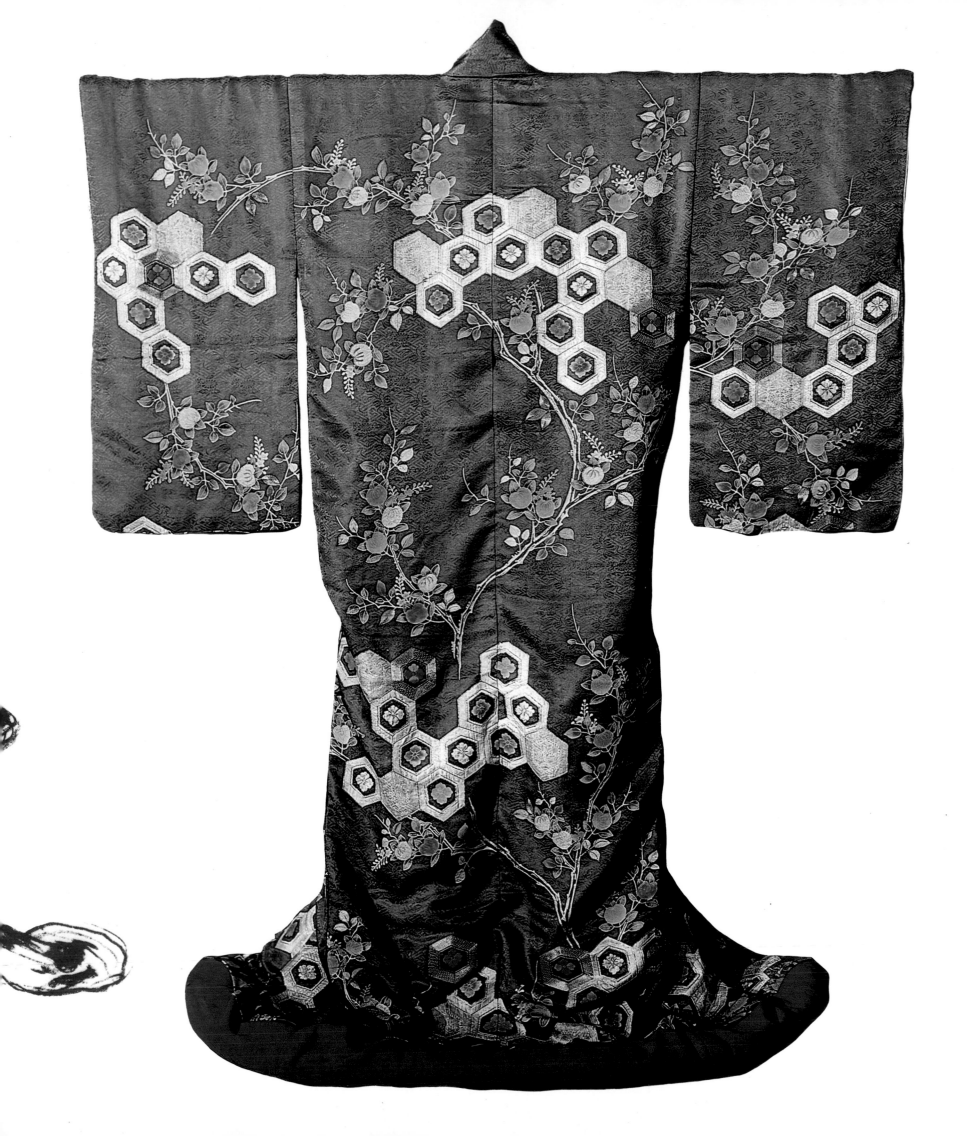

6 Georg Hendrik Breitner
The red kimono
c. 1893
Oil on canvas
50 × 76 (19¾ × 30)
Amsterdam, Stedelijk
Museum

7 Japan
Nō costume
Edo period (1603–1867)
Silk, embroidery and gold
leaf decoration
160 × 85 (63 × 33½)
Vienna, Österreichisches
Museum für angewandte
Kunst

(13).[6] Annette Kolb adopted the Japanese fashion and wore a 'kimono' lavishly embroidered with sprays of flowers (17).[7] There is nothing very surprising in the fact that the American artist Mark Tobey was wearing one when he was photographed with the great ceramic artist Shōji Hamada (16). Tobey's work will be referred to in the chapter on calligraphy (p. 406). Silk garments from Japan became very popular in Europe. One reporter at the international exhibition in Paris in 1878 wrote:

The trump card this time was played by the Orient, with the art of China and Japan. Here even the greatest mistresses of European crafts lay down their weapons in shame. Once before, at the end of the seventeenth century and the beginning of the eighteenth, China exerted an influence that had the most profound effect upon our artistic taste; now it seems as if Japan will assume that role.[8]

It is apparent, however, that Japonisme penetrated every area of the fine arts in Europe far more thoroughly

18

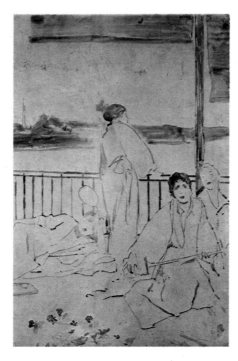

than *chinoiserie* did in the seventeenth and eighteenth centuries. The craze for Oriental art and artefacts was matched by a growing interest in the customs and way of life of the peoples of Asia. Not only did Oriental painting, sculpture and architecture arouse the enthusiasm of connoisseurs and collectors, but the applied arts, too, felt an impact that is still effective today. In day-to-day life, women's fashions were strongly influenced by the Japanese kimono and outer wrap up to about 1900, and even the way the fashionable Parisienne stood and moved between 1860 and 1900 was, so to speak, imported from Japan. At first the shapes of ladies' gowns merely hinted at the long S-line, but progressively designers strove, up to the turn of the century, to bring it to perfection.[9] In Whistler's *The princess from the land of porcelain* and in Monet's portrait of his wife in a kimono (*La Japonaise*, 11) alike, the tilt of the head, the long curve of the back, the bell-shaped line of the hem, are plainly borrowed from Japanese woodcuts. Wackerle's porcelain figure of a lady of fashion (53), dating from 1907, shows yet a further development of the pose, with the large plumed hat suggesting the same outline as the heads of Japanese women, seen in woodcuts, with their hair piled high.[10]

The tripping, short-stepped walk (54, 55), the slight forward inclination of the body, producing a pronounced bend, the bell-shaped flare of the hem, all correspond to drawings in Hokusai's *Manga*. But it was not the graceful cut of the kimono alone that encouraged the Parisiennes to choose this exotic dress;[11] it was above all the exquisitely coloured silks, decorated with asymmetrical patterns, that delighted artists and fashionable wearers alike. Whistler (9, 10), Monet (11), Breitner (6), Klimt and others attempted to reproduce the brilliance of the colours, the unfamiliar contrasts and the sheen of the fabrics in their paintings, some of which have been called 'kimono still-lifes'. The general interest aroused in

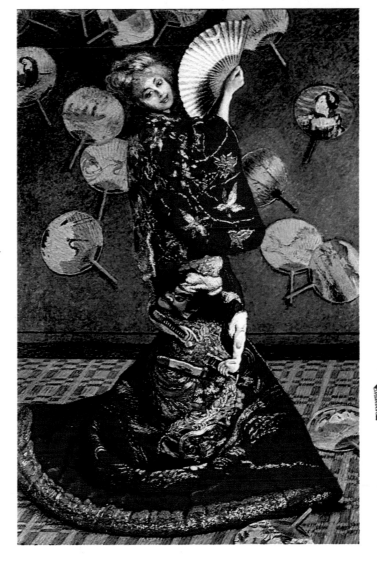

13 Gustav Klimt
Two kimonos
Wiener Werkstätte, *c.* 1910
Foulard, trimmed with black
silk crêpe
a) Fabric designed by Josef
Hoffmann
Overall l. 132 (52)
Karlsruhe, Landesmuseum
b) Overall l. 135 (53)
Private Collection

Japanese silks was reflected in the coverage of the 1878 international exhibition:

Japanese silks are much more remote from European tastes, but thanks to the industry of that race they have the advantage of being accessible to the European, and they already enjoy the flattering attention of the ladies of France. These Japanese silks, of which there is a large stock at the exhibition, are dear, because they are made of a very heavy cloth, into which, in addition, there is often woven a pattern in gold thread. It is rare to find the simple patterns of small dots, tendrils and so on, to which we are accustomed. These colourful and fantastic patterns, made up of a wonderful interplay of sprays of blossom, slender rushes, flying birds and fantastic cloud-formations, exercise an unusual charm, full of character. The colour of these fabrics is exquisite beyond compare, and causes the real importance of the patterns – as should be the case with a pattern, after all – to disappear from sight in the overall effect of the piece. There are to be seen here colour combinations so exotically effective, of such piquant attraction, that it is easy to comprehend the eagerness with which the hands of fine ladies reach out for these exquisite pieces.[12]

The colour contrasts of Japanese kimonos affected the palettes of a number of artists. A silvery silken grey with turquoise and coral was a combination chosen time and again, with dashes of intense, saturated colours like terracotta, azure, saffron and ice-green for contrast. Gold and silver threads woven into the cloth could reflect the light, while appliqué work could intensify the colours with additional tonal values.

For his painting *Lily Grenier in a kimono* (15) Toulouse-Lautrec borrowed a compositional formula from Whistler. The model is shown seated and almost directly *en face*, leaning back, so that the robe spreads out across the surface of the 'kimono still-life'. Toulouse-Lautrec made a drawing of himself in a kimono, and also had himself photographed in one (14). It was the fashionable dress of the age. Its brilliance, tonal variety and colour contrast guaranteed the artist that exquisite colour combination that he had come across in Japanese silks in exhibitions. As a commentator observed: 'There is nothing here that can remotely bear comparison with the Japanese ... the wealth of colour, the fantastic composition and the consummate elegance of the silks far surpass in execution anything in this kind of work that we have ever seen before.'[13] By the last quarter of the nineteenth century, every fashionable wardrobe contained a kimono. Dante Gabriel Rossetti, Edgar Degas, James Tissot and Gustav Klimt all owned and wore them: Klimt even had a collection of them, all of the highest quality.[14] The kimono – the kind called a *kosode* in Japan – became a favourite house-dress for ladies from about 1860 onwards; some splendid examples were exported from Japan.

In 1867 Claude Monet bought one for his young wife, who is wearing it in the painting *La Japonaise* (11). This is one of the foremost of European paintings treating a Japanese motif. Its festive appearance derives from the glowing, intense red of the silk and the magnificent appliqué decoration. Monet has consciously composed a 'kimono still-life', and the garment dictates the content of the rest of the picture. The appliqué embroidery depicting Shok, a driver-out of devils, is placed exactly at the narrowest part of the garment, midway between shoulder and hem, which spreads out in an arc of a quarter of a circle in the manner of the Japanese woodcut. Madame Monet's pose does no more than hint at a dancer's motion, but it is enough to convey a wealth of movement, emphasized by the twist of the appliqué figure. The picture has no very great depth, being cut off at the back by a wall decorated with a rhythmical arrangement of fixed fans. The open folding fan in Madame Monet's raised right hand adds to the succession of convex and concave curves making up the outline of the figure. The fans on the floor enrich the pattern of the carpet. It was clearly Monet's intention to establish a link between the decoration on the back wall, the floor and the kimono, following the example of the late *ukiyo-e* masters, who related patterned figures so convincingly to their picture planes.

Georg Hendrik Breitner devoted several years and a large number of paintings to the subject of the kimono. There are several versions of the painting reproduced here (6). Breitner was particularly fascinated by the grotesque effects created by the wing-like sleeves, and the full skirt with the splashes of pattern all over it. The shallow depth of the picture, the almost overflowing areas of colour, show the Japanese influence. Georg Breitner was in Paris from May to November 1884, and there experienced the enthusiasm for Japan to which Van Gogh made so many references. The thousands of woodcuts in Samuel Bing's galleries

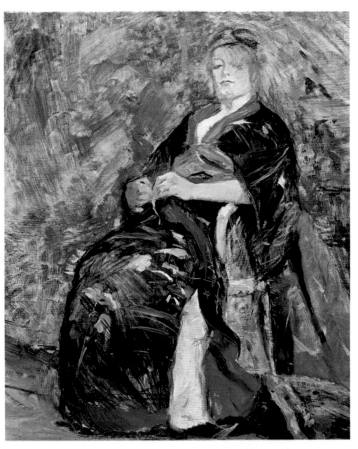

remained an obsession with Breitner for nearly a quarter of a century.

The fashion for the kimono spread to England and America. Whistler's studies for *The balcony* (9, 10) come closer to a Japanese system of composition than does the painting itself. The grouping of the figures, some lying, some sitting and some standing, corresponds to the Japanese models which Whistler here interprets in sketch form. The partly unrolled blind and the post, suggesting an inner frame, create a tension at the edges of the picture area, just as he had seen in the work of the *ukiyo-e* masters. The hint of flowers at the bottom of the picture corresponds to the way foreground objects are cut off at the edges in Whistler's Japanese models.

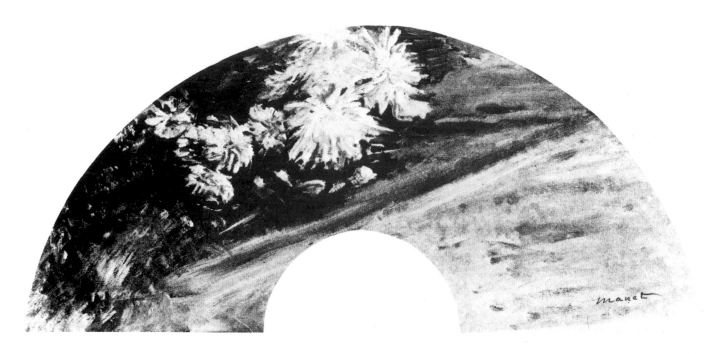

18 Edouard Manet
Chrysanthemums
1881
Fan leaf, oil on paper,
mounted on card
17×58 ($6\frac{3}{4} \times 22\frac{3}{4}$)
Private Collection

19 Edouard Manet
*The raven, with Japanese
seals and characters*
1875
Black ink, brush and pen on
paper
25×32 ($9\frac{7}{8} \times 12\frac{5}{8}$)
Paris, Bibliothèque
Nationale

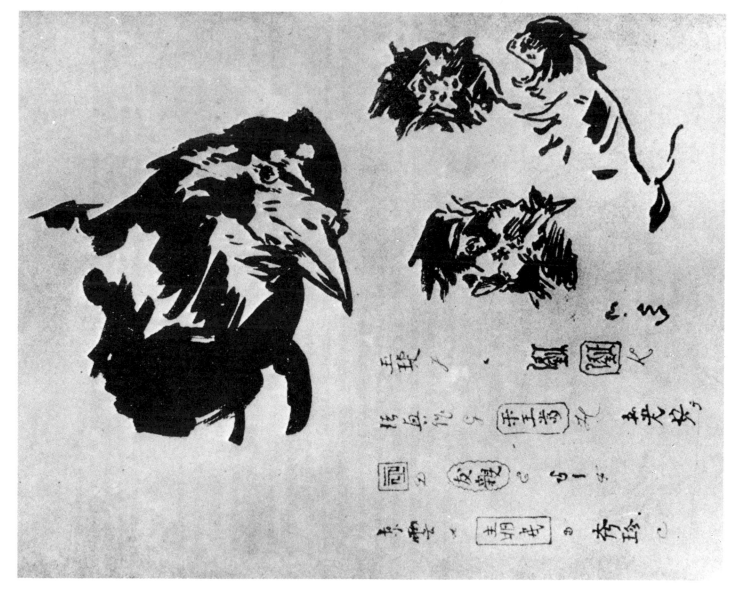

Representative artists

Manet

The rejection of *The fifer* by the jury of the 1866 Paris Salon shows how ill-acquainted official artistic opinion still was with a style of composition that ignored classical perspective. The painting illustrates all the new elements that had been introduced to French art by the Japanese colour woodcut.

The first thing that strikes the eye is the complete absence of the perspectival depth that Manet was still giving to some of his pictures in the 1860s, such as *Olympia* (1863) and *The execution of the Emperor Maximilian* (1867). The second is that Manet, so to speak, fastens the figure of the fifer, which is seen frontally, on to a neutral background. He further links the figure and its background together by painting the elements of the figure, such as the black jacket and red trousers, as flat, silhouette-like areas of colour. Manet would have seen this manner of placing a figure in isolation on the picture plane in prints by Utamaro; for example, the colour woodcut *Orie Jutaro with an umbrella* also depicts the figure predominantly in black, red and white on a monochrome background (58).[1] There are comparable examples in the work of Toyokuni, Sharaku, Kiyonaga and Shunsō.[2]

The intensity of the colours is a further reminder that a decisive re-evaluation of ways of seeing was in progress, for the value of the colour does not depend here on the effect of verisimilitude in the depiction. The brilliant local value of the colour vanquishes the usual diffuse browns of official *salon* painting.[3]

The general gloom that pervaded the bourgeois drawing room, encouraged by blinds at every window, also had official approval in painting. It was regarded with the deepest suspicion when Courbet began illuminating his landscapes with light flooding in from all sides.

One of Manet's goals was to disperse this conventional darkness, to overthrow the tyranny of shadow and half-light. The recognition of black and white as colours was important to this decision, for it had to be possible to appeal to the sanction of an analogy with the old masters – Velázquez and Hals, for example. Manet succeeded in this apparently impossible task in *The fifer* by bringing the black and white forward out of the shadows and making them equal to the local colours.

Manet was always to combine his new way of seeing things with other means of expression, and there is thus an appearance of inconsistency in the next steps he took. He did not lose hold of his essential determination to make colour and light into something more than the means of creating the illusion of perspective depth. The 'photographic' trend towards infinite degrees of tonal shading had now to be left to sheer technique. The important thing now was to regain for colour its role as part of the content of a picture. Historicism's insistence on rejecting light and brightness, and putting its trust in

20 Edouard Manet
Ballet shoes
1879
Oil, on a tambourine
D.19 (7½)
Private Collection

21 Edouard Manet
Chrysanthemums
1881
Fan leaf, oil on paper
21 × 42 (8¼ × 16½)
Private Collection

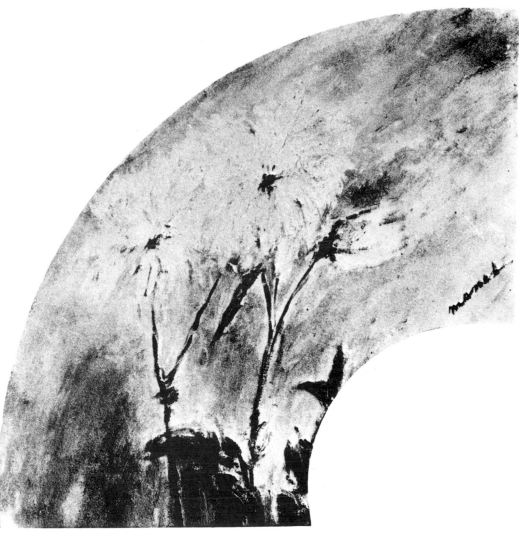

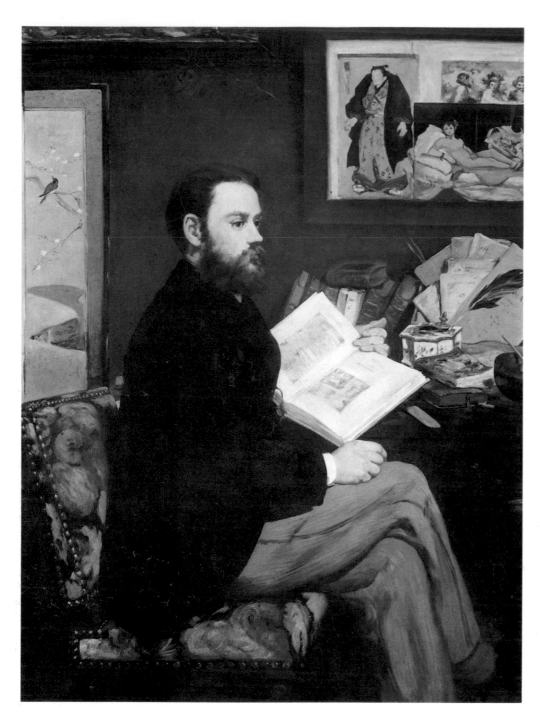

fifer, 'In my opinion it is impossible to make a stronger effect with such simple means.'[6]

With this statement Zola characterized Manet's aims and intentions more effectively than any later commentator. The painter had seized upon those elements in Japanese art that create form by simplification rather than elaboration. In an age when convention was all-powerful, when the aping of *chinoiserie* was the last word in exoticism, Manet grasped one of the essential creative devices of Japanese art, though Japanese civilization itself was at first alien to him. This is probably his major significance within the context of Japonisme.

In 1868 or thereabouts Manet painted the portrait of a writer who had championed his work in public: Zola's cogent arguments in the press had sown confusion among Manet's opponents, but had also strengthened their hostility. The portrait is significant for its expression of Manet's great openness to other artistic aims and other cultures. It unites Occidental and Oriental traditions with common experiences and techniques in a successful synthesis. It is therefore a statement of the collective spirit which was characteristic of early Impressionism.

Zola is shown sideways on, facing to the right, and sitting on an armless, upholstered chair. A striking feature is that everything is arranged parallel to the picture plane, and since there is little depth to the scene all the objects are, so to speak, stacked one on top of the other. All the objects shown – the fabric covering the chair, Zola's coat, the book, the writing implements and the pictures on the wall directly behind them – are still close to the viewer, who is thus able to register them in detail. In accordance with the Far Eastern compositional principle, demonstrated above all in colour woodcuts, this arrangement parallel to the picture plane creates a kind of two-dimensional patterned surface.

The writer's profile combines with the woodcut by Sharaku, a copper engraving after Velázquez and a reproduction of Manet's own *Olympia* to form a compositional unit. The still-life clutter of books, manuscripts and a quill pen on the writing desk also includes the cover of a catalogue displaying the name 'E. Manet'. The book held open in Zola's left hand, probably something by the Goncourts, creates a transition to the pale flesh tints of the head, which is placed exactly midway between the hanging scroll on the left and the woodcut. The dark colour simultaneously acknowledges old-master precedents in portraiture and patterns the surface in the manner of the Far East.

There is a close thematic connection between the drawing *The Parisienne* (23) and the painting *The lady with the fans* (24). In both there is a prominent pattern on the background, against which the lolling figure dressed in black stands out as a silhouette, and perspective depth is conspicuously absent. The two pictures exemplify Manet's tendency to remain preoccupied by a compositional scheme for months or years at a time.

Manet was one of the first of those Impressionists who borrowed not only themes but artistic devices from the art of Japan. The watercolour *Ships at sunset* (643)

22 Edouard Manet
Portrait of Emile Zola
c. 1868
Oil on canvas
146 × 114 (57½ × 44⅞)
Paris, Jeu de Paume

half-light or dense shading, was revealed as an unwarranted inhibition by Helmholtzian measurements taken in front of paintings and in landscape in the open air.[4]

Emile Zola, whose grasp of the way the art of his time was developing was instinctive and not merely intellectual, wrote, quite correctly: 'The influence of Japonisme was what was needed to deliver us from the [murky] black tradition and to show us the bright beauty of nature ... There is no doubt that our dark painting, our painting in oils, was greatly impressed, and pursued the study of these transparent horizons, this beautiful, vibrant colouring of the Japanese.'[5] Elsewhere he remarked, apropos of the Salon jury's rejection of *The*

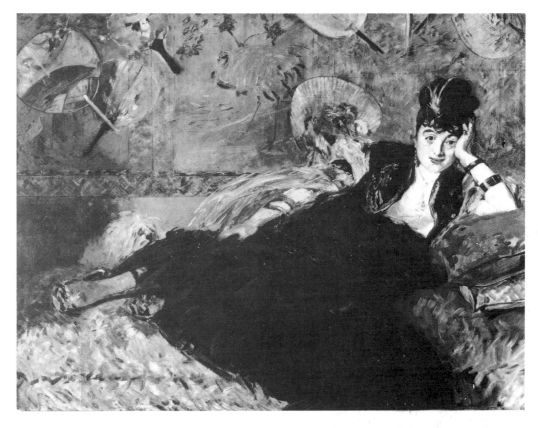

illustrates very clearly his interest in the clearly focused representation of an object – the sail – cut off by the edge of the picture. This manner of representing distance by confining the view to what can be seen beyond a truncated object in the near foreground is something that Manet borrowed from Hiroshige (644).

Manet always converted the Japanese stimulus to his own original creative ends, but he accompanied his ink drawing of a raven's head (19) with Japanese characters and *mon* emblems in acknowledgment of his model.

Until his last period he continued to draw inspiration from Far Eastern reresentations of animals, above all cats, of which he drew studies with brush and crayon (229, 230, 233) that are equal to the work of any of the great Oriental draughtsmen.

He also attached importance to the silhouette effect obtainable from the use of black, which persisted into his 'black period' of *c.* 1868–75. The homogeneous construction of a portrait like that of his sister-in-law Berthe Morisot in black (25) clearly demonstrates this intention.

On many occasions he used the format of the fan to make compositional experiments. His chrysanthemum paintings on fans (18, 21) clearly demonstrate the loose, light brushwork with which he tested alternative ideas (21). His experiment at painting ballet shoes on the round surface of a tambourine (20) succeeds according to the laws of Far Eastern painting and the principle of omission, which Degas, Gauguin and Toulouse-Lautrec, following the Japanese example, also honoured.

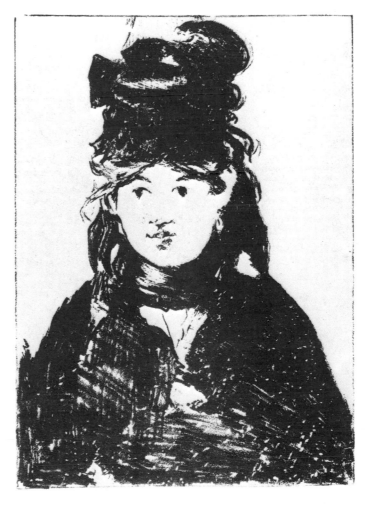

23 Edouard Manet
The Parisienne
1874
Lithograph
10 × 14.8 (4 × 5¾)
Private Collection

24 Edouard Manet
The lady with the fans
1873
Oil on canvas
113 × 166 (44½ × 65⅜)
Paris, Jeu de Paume

25 Edouard Manet
Berthe Morisot
1872
Lithograph
20.4 × 14 (8 × 5½)
Private Collection

Degas

The short-paced gait, the slight forward bend of the upper part of the body, and the emphasizing of this posture by the wearing of the broad sash (*obi*), are features that are still observed in Japan today.[1] Such stereotyped gestures and postures (52–55, 58), much more rigidly codified in Japan than in Europe, dominate the representation of figures in Japanese woodcuts. The graceful gesture 'in the sweep of a growing willow tree' (3, 4) gave the Impressionists new ideas about poses or particular actions, which they then attempted to incorporate in their work as a vital part of the composition.[2]

The motif of a standing figure which seems to incline, initiated in European art by Whistler (8, 9, 10), was painted in many variants by Manet and Monet (11). In the hands of Toulouse-Lautrec the attitude was exaggerated and became an ornamental motif, but the exotic silhouette of the walking figure with its graceful bend became common expressive currency in Art Nouveau painting. Emil Orlik gave an incomparable

26 Edgar Degas
After the bath
1898
Pastel on card
62×65 ($24\frac{3}{8} \times 25\frac{1}{2}$)
Paris, Louvre, Cabinet des Dessins

27 Edgar Degas
After the bath
1888–92
Pastel on paper
48×63 ($19 \times 24\frac{3}{4}$)
Munich, Bayerische Staatsgemäldesammlung

28 Kitagawa Utamaro
Yamauba combing her hair, with little Kintaro on her back
Colour woodcut
37.5×25.5 ($14\frac{3}{4} \times 10$)
Paris, Bibliothèque Nationale, Cabinet des Estampes

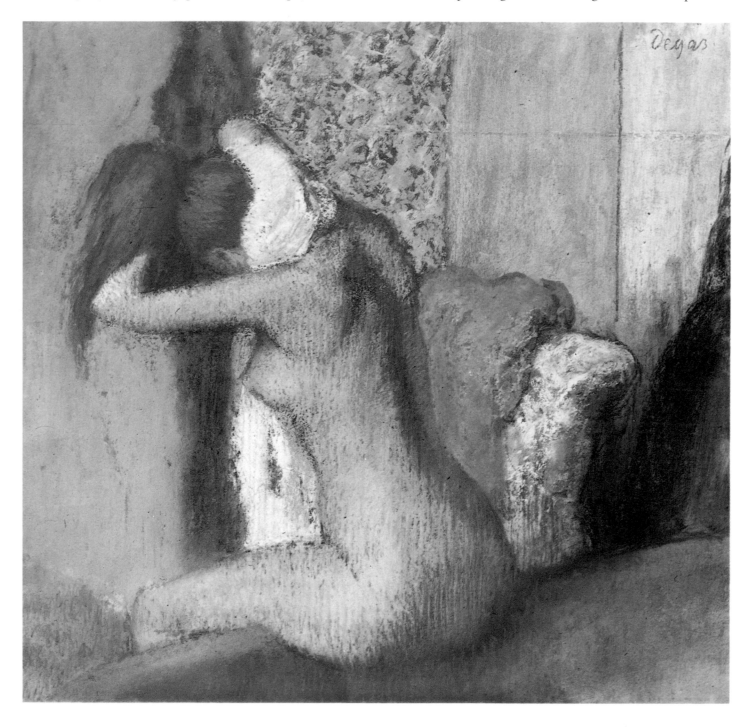

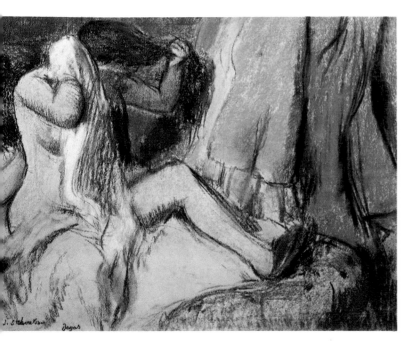

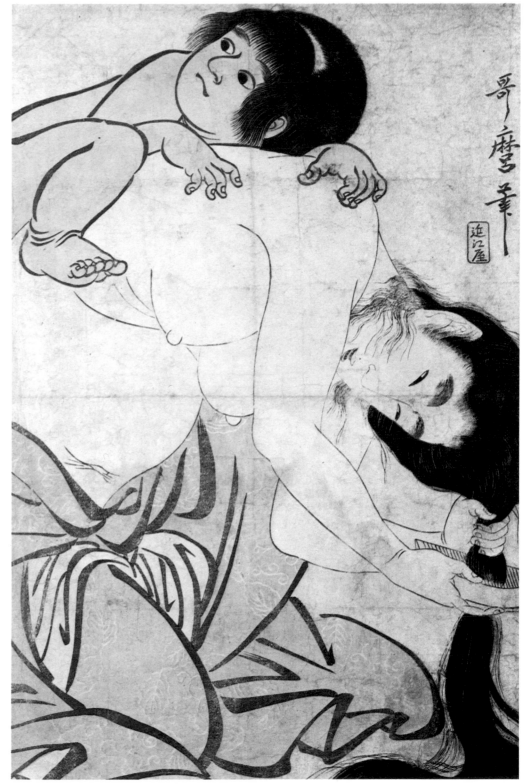

formal variety to the figure studies he made in Japan (54).[3]

Japanese artists looked at the world about them in a variety of different ways. On the one hand ceremonial deportment was often carried over into everyday contexts; on the other a whole range of primary human gesture was observed and depicted in art with an intimacy that was unknown to Europeans. The representation of mothers and children was especially sympathetic (46, 47). There were numerous variations on such subjects as the mother playing with her child, or bathing it,[4] substituting new types of maternal pose (28) for the constrained formality of European portraiture. These were conventions covering a certain range of actions, and so Japanese precedents encouraged European artists to adopt simpler forms of poses, whether for the group or the individual. Hokusai, in particular, was obviously more concerned with split-second reactions than with familiar gestures. This new way of investigating a pose made it necessary to draw what was seen as quickly as possible. None admired the speed and accuracy of the Japanese graphic artists more than Vincent van Gogh. He wrote to his brother Theo: 'The Japanese draw quickly, very quickly, like a lightning flash, because their nerves are finer, their feeling simpler.'[5] In this connection it is interesting to know that a manual had been published in Japan called *Models for Quick Sketches*.[6]

Van Gogh's words were a repudiation of the restricted expression of movement which had become a feature of gesture and posture in later nineteenth-century Europe.[7] In European art over the centuries there can be detected successive new beginnings in the depiction of movement and posture, but on each occasion what was originally fluency has settled down again into renewed rigidity.[8] This recurrent rigidity reached a highpoint in the fossilized conventions governing the representation of movement in European painting around 1870, and it was at that time that the process of adopting individual, self-determined posture and gesture began again (36). The rigid gesture approximating to a standardized notion of movement dominated not only portraiture in Europe and the United States but also, to a large extent, figure composition. Very broadly speaking, there is a contradiction in nineteenth-century figure painting, in that an individualistic formal approach is combined with standardized poses and standardized movement.

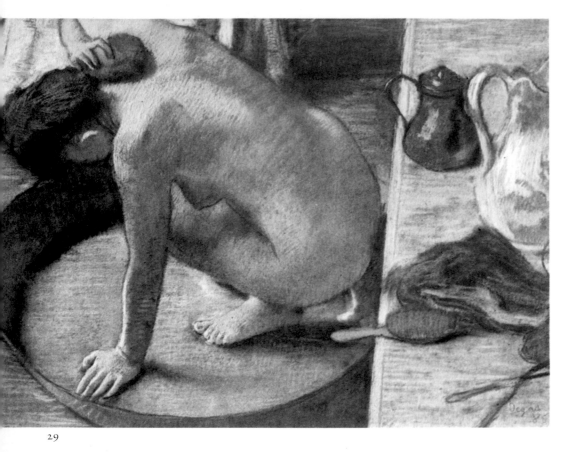

29

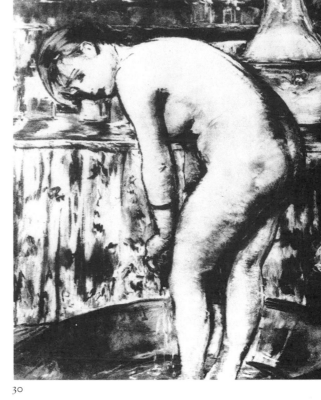

30

31

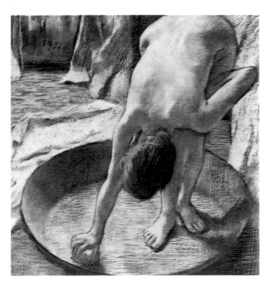

32

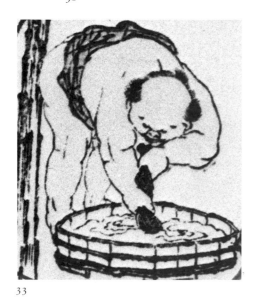

33

34

Thomas Couture (1815–79) inaugurated this trend in France, and it became well established in the work of Jean-Léon Gérôme (1824–1903), Jean-Jacques Henner (1829–1905) and William Bouguereau (1825–1905) in the last decades of the century. Elitism became codified in this way in portraiture all over Europe; in Germany, the so-called 'prince of painters', Franz von Lenbach (1836–1904), made it quasi-official.[9] By preferring certain artists, the reactionary, plutocratic society of later nineteenth-century Europe compelled figure painting in general to conform to a rigid schema,[10] according to which subjects were represented in a formal, stately pose, as if presiding over some public occasion, and possessing a regularity of form which was shown off to good advantage from one suitable angle or another. The avant-garde of the time – in particular the French, and later the German, Impressionists – were opposed to this gestural conformism and to the plutocratic prestige portrait as such. Those who depicted ordinary people were presented with subjects whose poses did not conform. Gustave Courbet's *Stonebreakers* select their own pose, appropriate to their calling and their environment.[11]

Gestural conformism and the concomitant generalization do not exist in the depiction of everyday life. The Barbizon School and the early French Impressionists saw in simple gestures a less cluttered pictorial movement which, together with the development of colour as a means of representation, were decisive in the development of this kind of painting. When movement was not subject to any plutocratic compulsion to repeat itself exactly as before, it could show greater variety than

35

29 Edgar Degas
The bath
1886
Pastel on card
59 × 81.5 (23¼ × 32)
Paris, Louvre

30 Edouard Manet
Girl washing
1879
Pastel on paper
55 × 45 (21⅝ × 17¾)
Paris, Louvre, Cabinet des
Dessins

31 Pierre Bonnard
Woman washing
1916
Oil on canvas
40.6 × 43 (16 × 16⅞)
Paris, Private Collection

32 Katsushika Hokusai
Man bathing
1814–78
From *Manga*
Colour woodcut, facsimile
24 × 14.5 (9½ × 5¾)
Tokyo, Yūjirō Shinoda

33 Katsushika Hokusai
Man washing
1814–78
From *Manga*
Colour woodcut, facsimile
24 × 14.5 (9½ × 5¾)
Tokyo, Yūjirō Shinoda

34 Edgar Degas
The bath-tub
1886
Pastel on paper
60 × 69 (23⅝ × 27⅛)
Farmington, Conn., The Hill
Stead Museum

35 Marcel Duchamp
Woman bathing
1910
Oil on canvas
92 × 73 (36¼ × 28¾)
New York, Collection Terry
Duchamp

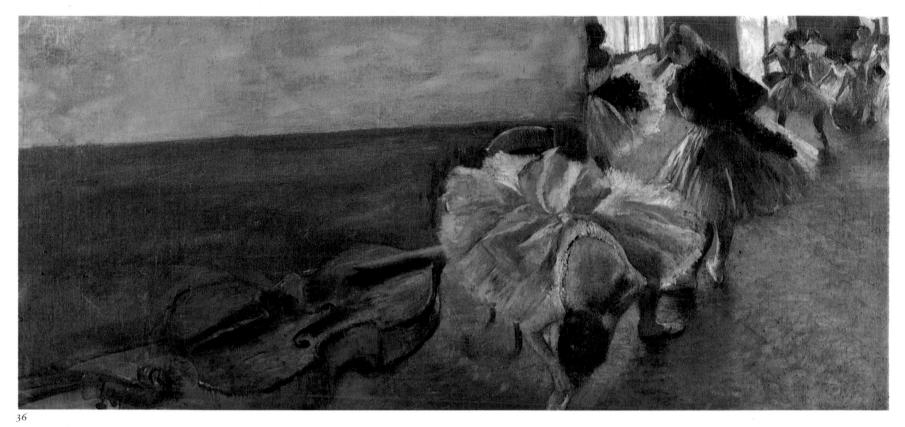

36

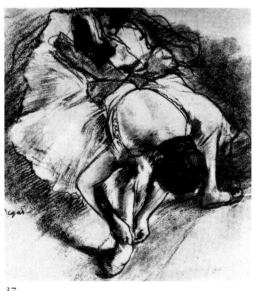

37

38

41

39

40

it had ever yet been allowed. Form was emancipated as the subjects took on shapes according to the autonomy of their individual movements, following the laws of normal physical mechanisms. The reactions of the ordinary person to the various stimuli of the world around him were manifold and full of feeling. The primitive mentality that we encounter in the work of Hokusai, the artist of the people of Japan, found its equivalent in Europe and created new subjects for art.

The kind of liveliness the Japanese were able to teach the Europeans is exemplified in a print by Kitagawa Utamaro, *Yamauba combing her hair, with little Kintoki on her back* (28). According to the legend, the hero Kintoki was the son of Yamauba and Prince Yori-mitsu, who was slain by invading hordes when in the service of the first Shōgun. Yamauba took her son and fled into the forests where she lived on wild berries and reared him at her breast. The legend of Yamauba and Kintoki was illustrated in prints by both Utamaro and Kiyonaga.

The move to this new view of posture and movement demanded of European artists a more direct communication with the subjects, such as Utamaro possessed. Hokusai too, although he had to live part of his life in seclusion, was able to make himself a part of his environment, which he studied very closely.[12]

Hokusai drew people as they went freely about their business, and in doing so he disposed of an inexhaustible

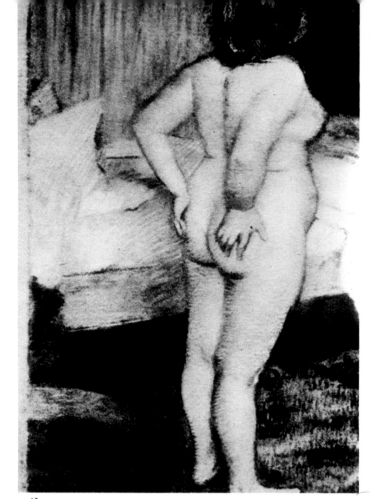

42

43

36 Edgar Degas
Dancers with double-bass
c. 1887
Oil on canvas
39 × 89.5 (15⅜ × 35¼)
New York, Metropolitan
Museum of Art, Havemeyer
Collection

37 Edgar Degas
Dancer tying her ribbons
c. 1880
Pastel and pencil on paper
43.7 × 40.6 (17¼ × 16)
New York, Private
Collection

38 Katsushika Hokusai
Sparrow dance
1814–78
From *Manga*
Colour woodcut, facsimile
24 × 25 (9½ × 9⅞)
Tokyo, Yūjirō Shinoda

39 Katsushika Hokusai
Sparrow dance
1814–78
From *Manga*
Colour woodcut, facsimile
24 × 25 (9½ × 9⅞)
Tokyo, Yūjirō Shinoda

40 Katsushika Hokusai
Foot-soldier with armour
1814–78
From *Manga*
Colour woodcut, facsimile
24 × 25 (9½ × 9⅞)
Tokyo, Yūjirō Shinoda

41 Katsushika Hokusai
Sparrow dance
1814–78
From *Manga*
Colour woodcut, facsimile
24 × 25 (9½ × 9⅞)
Tokyo, Yūjirō Shinoda

42 Edgar Degas
Nude woman, standing, back view (detail)
1886
Pastel
49 × 55 (19¼ × 21⅝)
Paris, Collection David Weill

43 Katsushika Hokusai
Sumō wrestler
1814–78
From *Manga*
Colour woodcut, facsimile
24 × 25 (9½ × 9⅞)
Tokyo, Yūjirō Shinoda

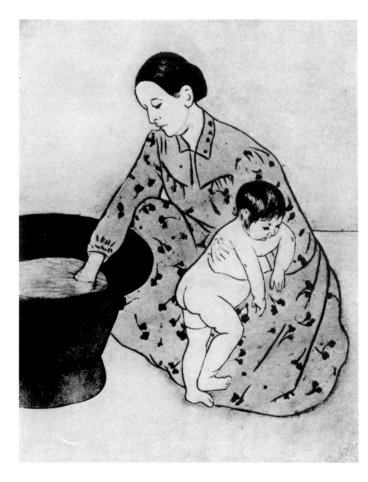

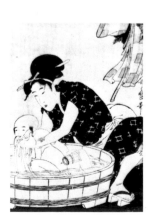

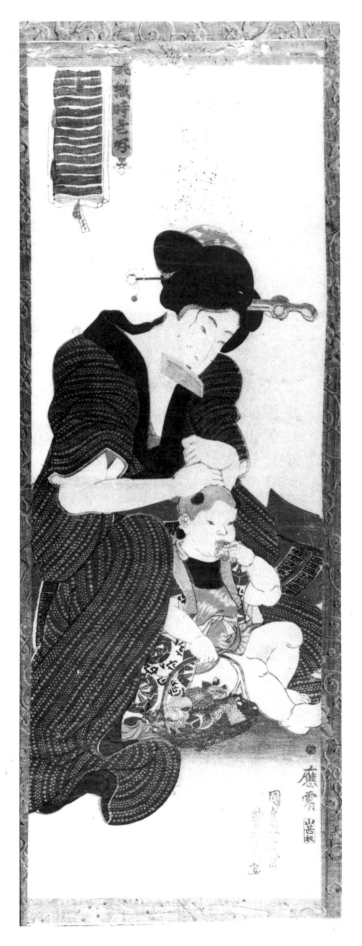

range of movement. His influence on European art is well illustrated in a painting by Degas, *Dancers with double-bass* (36). The chink-like field of the picture is reminiscent of the *ukiyo-e* in its apparently arbitrary delimitation of the scene. What is even more significant is the momentary movement of the dancer bending over in the foreground. She derives from a figure in Hokusai's *Manga*; the unusual pose has been adopted in its entirety, right down to the position of the feet. In fact there are many correspondences between Degas's pictures and figures in Hokusai's third volume (39, 40). The other fourteen volumes also contain figures which made a strong impression in Europe (41). These conventional, formulaic impressions of movement, comparable to shorthand signs, are interesting because they typify the common treatment of specific objects or actions. There are people engaged in conversation, seated or lying down (78, 79), carrying on their trades or performing everyday tasks (42, 43). It seems as if the artist has chosen especially significant forms of existence, but in fact these are the commonest human activities – people wash themselves and comb their hair (32), bend and stretch their limbs (39), put on their clothes, or lie down and dream (79). Hokusai knows no boundaries, no regions too intimate for art. He pursues posture and gesture into sleep, and beyond into dreamland. In doing so he does not depict the human condition from one view alone, but recognizes the concept of wholeness in the sequence of movements which the human being performs in the course of one

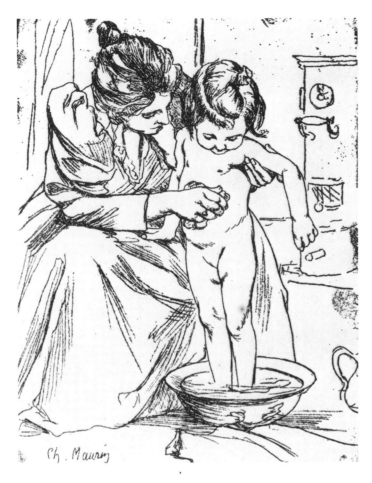

Ch. Maurin

action. In gathering together an impressive and persuasive repertoire of standing, sitting and recumbent figures, Hokusai demonstrates his sureness of eye (117–23).

The subject of women at their toilette was a familiar one in Japanese art, where it was treated with a realism that incorporated both physical grace and an almost ceremonial content (28, 49). The long black hair, the combs and long hairpins are a central and popular subject group. Thus there are numerous instances in Hokusai's work of women washing or combing their hair (28). Degas was fond of representing a woman at similar tasks, often seen very close and from the same viewpoint (26). The countless twists and turns and instantaneous reflexes are so fleeting, that Degas also ultimately succeeds in capturing the subtlest changes in facial expression as a 'mimetic trace' in his pictures.

There are numerous drawings of everyday postures and movements in volumes 1, 2, 3, 4, 6, 9, 11, 12, 13 and 14 of Hokusai's *Manga*; the striking poses of women washing themselves, in volumes 9 and 12, are likely to be the ones that made the most profound impression on Degas. In Hokusai's 'shorthand', objects that have the same form are translated into static terms. Variable and static elements alike are not directly rendered segments or interruptions of movement; but the culmination of the intensified motion of the one is the point at which the movement of the other begins. Thus while each of his figures may be individual in itself, yet they are all part of a single, collective, rhythmic pattern of movement (39).

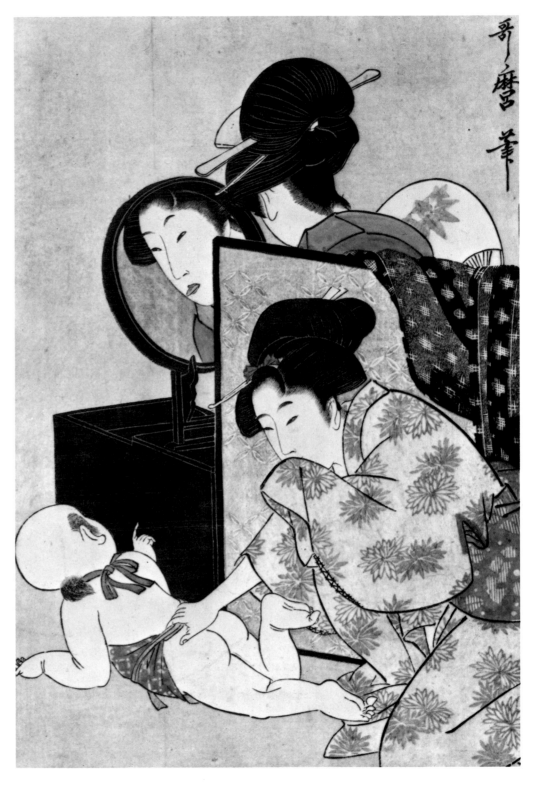

48 Charles Maurin
Mother and child
Zincograph
36.5 × 28 (14⅜ × 11)
Repr. *Pan* 1896

49 Kitagawa Utamaro
Mother playing with her child, and nurse
Colour woodcut
39.2 × 26.2 (15½ × 10¼)
Private Collection

The short step, the bend of the upper part of the body, the hand clutching at the skirt to control the trailing hem are Japanese in inspiration and characteristic of the fashionable European woman, c. 1900

52 Kitagawa Utamaro
Japanese woman (detail)
c. 1804
Colour woodcut
37.2 × 24.5 (14⅝ × 9⅝)
Berlin, Staatliche Museen
Preussischer Kulturbesitz

53 Joseph Wackerle
Lady of fashion
1907
Porcelain, underglaze
H. 60 (23⅝)
Munich, Staatliche
Porzellanmanufaktur,
Nymphenburg

54 Emil Orlik
*Woman in a kimono
walking: the dancer Sasaki-
Tomi-san*
c. 1900
Pen and pencil on white
paper
20.2 × 16.6 (8 × 6½)
Private Collection

55 Hosoda Eishi
*Courtesan with flowers and
moonlight* (detail)
18th century
Painted silk
Hanging scroll
135 × 68.6 (53⅛ × 27)
Tokyo, Private Collection

Degas's work the primary movements are directed entirely towards the attention of the viewer. The movements are those seen by the 'eavesdropper'; they would be inconceivable without Hokusai's breakdown of movement (29). In the last phase of his life, after 1900, Degas favoured line in his drawings. He once said: 'the simpler the lines and forms, the greater is their beauty and strength'. He came to regard black chalk as a less cluttered medium than pastel; in using it he could devote himself exclusively to the movement and volume of his subject. For him, the bath was an exceptional rite, and one which he knew how to portray in quick visual units. He recorded countless different stages of the bending, twisting movements of the woman crouching and kneeling in the shallow tub, in pictures (29, 34) that reveal all the unreflecting, mechanical ordinariness that Hokusai depicted in the same circumstances. What Degas's contemporaries resented – astonishingly, to us – was the way he replaced the prescriptive, exemplary, posed image with Hokusai's 'random' choice of subject.

Degas's pictures of women washing themselves radiate kinetic energies which consciously and intentionally generate specific animal reactions. Successive movements slide into each other, in a way never before depicted in paint or pastel; his crouching postures too were innovations. These drawings not only represent movement, they are themselves *mouvementés*, an effect that Degas was able to produce by his recognition, thanks to Hokusai, of the versatility of line itself as rising and falling movement. In Degas, form is augmented by a quality of physical materiality; he gave his pictures a direct visual relevance which compels the viewer to share his experience of the basic movements represented.

Without Degas's meticulous study of movement, it would hardly have been possible for the later Expressionists to depict action as they did. Toulouse-Lautrec, too, depicts exaggerated gesture in reproducing the movements of a juggler (51). He too found a model in Hokusai's *Manga*. It is interesting to note that in 1910 Marcel Duchamp painted a woman bathing which owes something to Degas (35).[16] There is a strongly patterned background, and the volume of the body is accentuated by a dark outline.

Released from the compulsion to repeat conventional stereotypes, posture and movement could now assume an autonomous existence. But in twentieth-century art the uninhibited flow of movement was subjected once again to a process of stiffening, and soon adopted as a model the fixed stillness of African art.[17]

The umbrella was an article much loved in Japan; with its ability to set the tone of its bearer's 'body language', it inspired charming compositions from many a Japanese artist. Harunobu, Kunisada and Utamaro made a speciality of the 'umbrella picture', exploiting the picturesque possibilities of teeming rain and driving snow, with the pretty geisha tripping along, her body describing the characteristic sinuous bends, holding up her gay umbrella against the background of the dark sky spotted with snow flakes (58–61).

Jules Chéret, a pioneer of the private art press in France, who was held in high esteem by no less a person than Monet, drew on woodcuts by Utamaro and

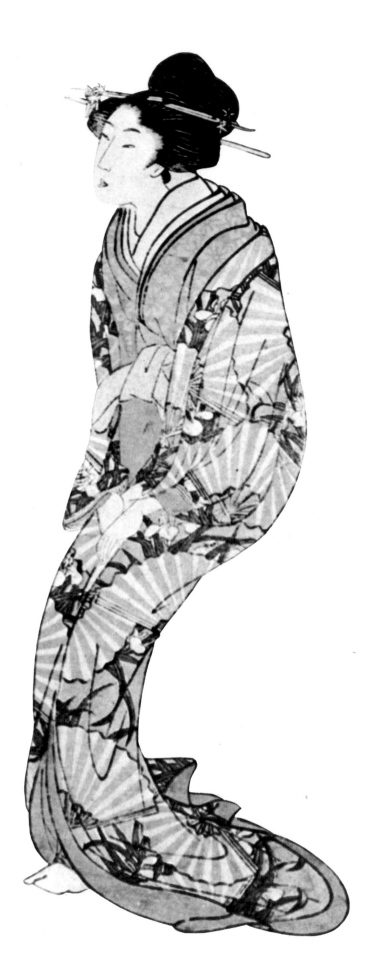

36

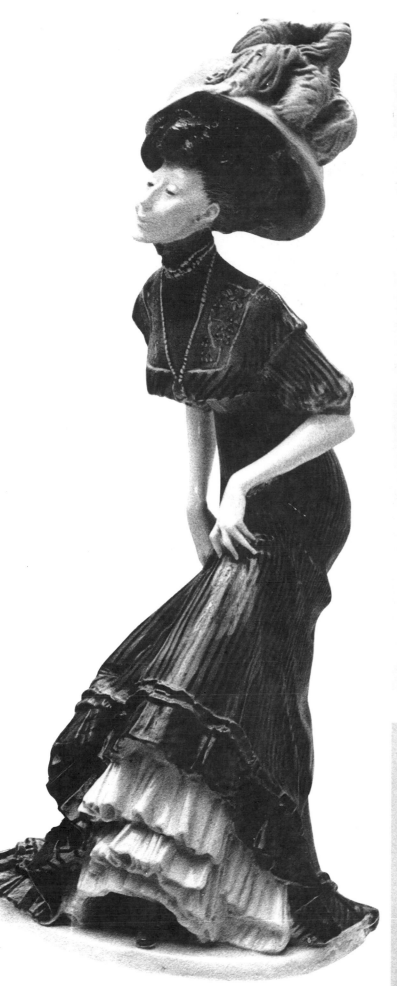

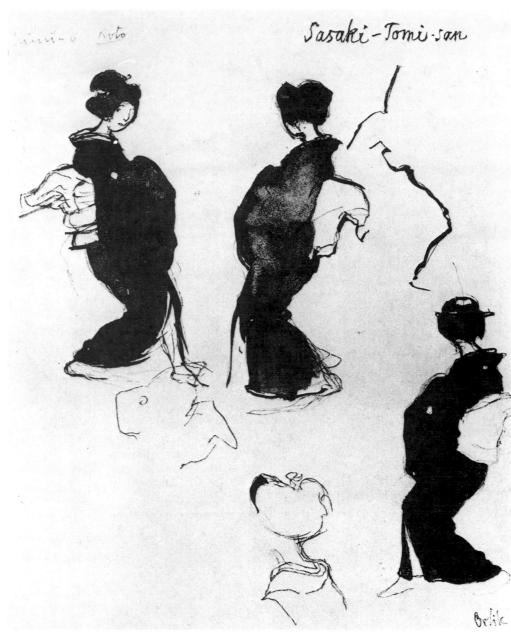

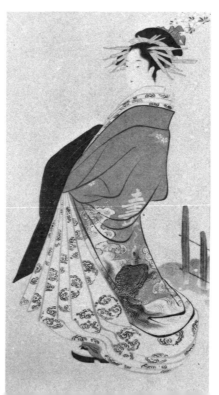

37

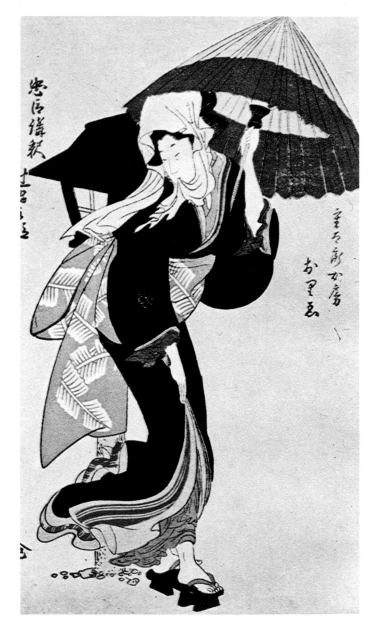

56 Jules Chéret
Poster
c. 1900
Colour lithograph
42 × 29 (16½ × 11½)
Private Collection

57 Kitagawa Utamaro
Women talking under an umbrella (detail)
Repr. S. Bing *Le Japon artistique*, 3; title-page, July 1888

58 Kitagawa Utamaro
Orie with an umbrella
c. 1790
Colour woodcut
38 × 26 (15 × 10¼)
Regensburg, Collection Franz Winzinger

Yoshitoshi in the design of the joyous posters which
made the Japanese 'umbrella picture' well known and
popular in Europe. He became a master of the floating
figure, and created far from negligible close-up images,
coloured arabesques in a fluent, joyous linear language;
his posters are large-scale lithographs (56).

59 Utagawa Kunisada
The first snow of winter
c. 1810
Woodcut, triptych
39 × 79.5 (15⅜ × 31¼)
Private Collection

60 Suzuki Harunobu
Thanksgiving for rain
c. 1768
Colour woodcut
27.6 × 20.1 (10⅞ × 7⅞)
Private Collection

61 Suzuki Harunobu
*Girl in the snow with
umbrella*
c. 1770
Colour woodcut
69.8 × 12.1 (27½ × 4¾)
Private Collection

Van Gogh

'You will be able to get an idea of the revolution in painting when you think, for instance, of the brightly colored Japanese pictures that one sees everywhere, landscapes and figures. Theo and I have hundreds of Japanese prints in our possession.'[1] As these words suggest, Vincent van Gogh had ready access to large numbers of Japanese woodcuts, which gave him a wide variety of material to study.

Van Gogh had his own, very clear ideas of Japan, which he always projected on to his artistic activities. For him, the influence of Japanese art marked a change that would sweep away the old academic, classical concepts of European art. In his letters, inexhaustible imagination and missionary zeal combine to pour out a flood of creative ideas.[2] The dream stands side by side with reality, the brightest light with opaque darkness, colour with tonal variation, space with surface; peace and harmony, too, stand side by side with uproar. Buddhism had both aroused and disturbed Van Gogh. It was the reason why he had his head shaved in 1888 and painted himself as a Buddhist monk (62). He wrote to his sister Willemien from Arles in September 1888: 'I also made a new portrait of myself, as a study, in which I look like a Japanese . . . The more ugly, old, vicious, ill, poor I get, the more I want to take my revenge by producing a brilliant color, well arranged, resplendent.'[3] He had probably seen portraits of Chinese and Japanese origin in this style, perhaps similar to the one reproduced here, a fourteenth-century portrait of the monk Musō Sogeki by Mutō Shūi (63).[4] It shares with Van Gogh's self-portrait the gaze into emptiness and the portrait-bust structure, with all the emphasis on the head alone. The

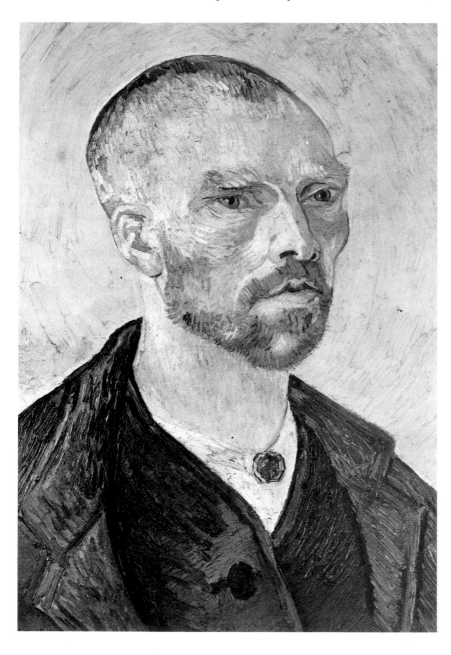

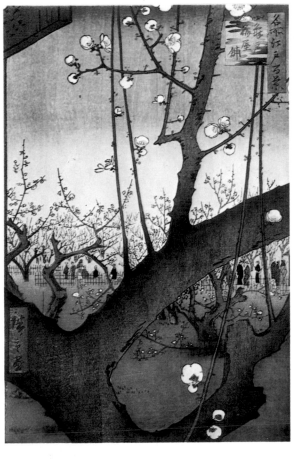

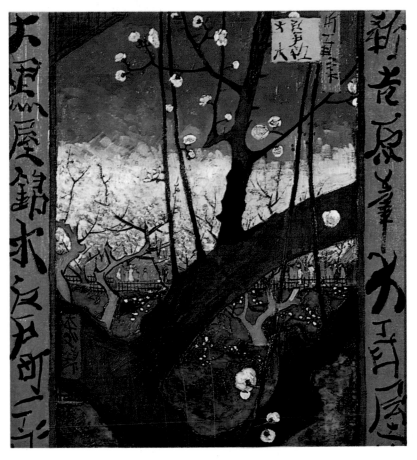

64 Andō Hiroshige
*Flowering plum tree in the
Kameido garden*
1856–58
From *100 Views of Famous
Places in Edo (Meisho Edo
hyakkei)*
Colour woodcut
35 × 22.5 (13¾ × 8⅞)
Private Collection

65 Vincent van Gogh
Japonaiserie: tree in bloom
Paris 1886–88
Copy after Hiroshige
Oil on canvas
55 × 46 (21⅝ × 18⅛)
Amsterdam, Rijksmuseum
Vincent van Gogh

66 Andō Hiroshige
Ohashi bridge in the rain
1856–58
From *100 Views of Famous
Places in Edo (Meisho Edo
hyakkei)*
Colour woodcut
33.8 × 21.8 (13¼ × 8⅝)
Vienna, Österreichisches
Museum für angewandte
Kunst

67 Vincent van Gogh
Japonaiserie: the bridge
Paris 1886–88
Copy after Hiroshige
Oil on canvas
55 × 46 (21⅝ × 18⅛)
Amsterdam, Rijksmuseum
Vincent van Gogh

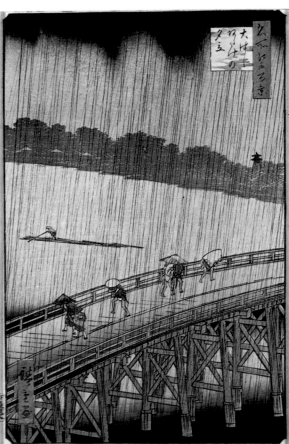

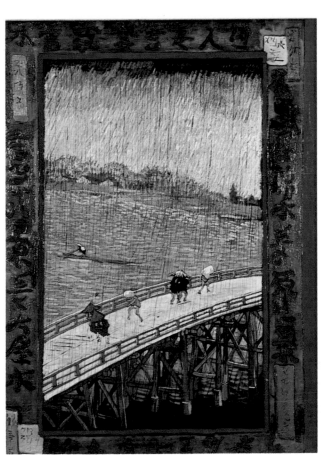

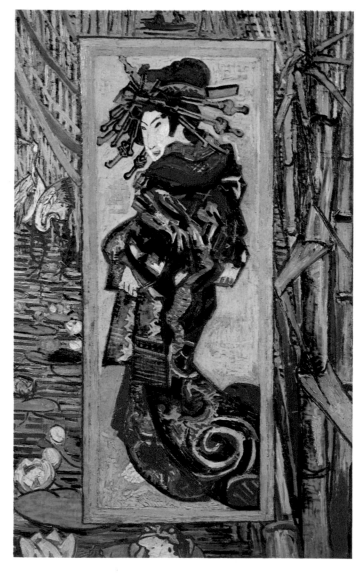

self-portrait indicates why Van Gogh studied Eastern art: he did not want simply to comprehend Japanese art through copying it, but to dig down to the very roots of Japanese culture in order to be able to generate original creative impulses of his own from the encounter. As he wrote to his sister:

Theo wrote me that he had given you Japanese pictures. This is surely the practical way to arrive at an understanding of the direction which painting in bright clear colours has taken at present.

For my part I don't need Japanese pictures here, for I am always telling myself *that here I am in Japan.* Which means that I have only to open my eyes and paint what is right in front of me, if I think it effective.[5]

In another letter, to Theo, he celebrated the spontaneous, elemental joy in colour that he found in Japanese prints: 'But whatever they say, the most common [Japanese] prints colored with a flat wash are admirable to me for the same reasons as Rubens and Veronese. I know perfectly well that they are not real primitive art.'[6]

He compared the representation of a landscape, transfigured from direct experience by a Japanese artist, with his own experience of Arles, which he saw with Japanese eyes: 'A little town surrounded by fields all covered with yellow and purple flowers; exactly – can't you see it? – like a Japanese dream.'[7] And: 'I wish you could spend some time here, you would feel it after a while, one's sight changes. You see things with an eye more Japanese, you feel color differently.'[8]

Van Gogh had learned to value brilliant colour from the *ukiyo-e* masters, and he deliberately chose some prints by Hiroshige to copy in all their bright, colourful beauty (64–67). Indeed, he went one better, adding two red borders, decorated with Japanese characters which, comically enough, advertise brothels.[9] It could be said that his copies appear more Japanese than their Japanese models. The lively composition based on forking branches continued to inspire Van Gogh over the years to paint and draw trees (167). His trunks and branches twist and bend in full accordance with the precepts of Japanese painters' manuals.[10]

The artist related the perceptions he had gained from Japanese prints to the countryside around Arles. He wrote to his friend Emile Bernard:

This country seems to me as beautiful as Japan as far as the limpidity of the atmosphere and the gay color effects are concerned. Water forms patches of a beautiful emerald or a rich blue in the landscape, just as we see it in the crépons. The sunsets have a pale orange color which makes the fields appear blue. The sun a splendid yellow.[11]

And to brother Theo he remarked: 'We like Japanese painting, we have felt its influence, all the Impressionists have that in common.'[12]

The brightness of the light and the radiance of the colours were a powerful new experience for Van Gogh when he went to Arles. Again and again in his letters he mentioned the deep blue sky, the red earth, the colours of the plant life. The complementary juxtaposition of colours in nature reminded him of the same thing in Japanese woodcuts: in both cases the colour values are intensified.[13] Hiroshige's picture of a bridge with a squall

of rain sweeping across it (66) lends this intensity of colour to the depiction of a moment of time in a natural setting. Van Gogh copied the hurrying figures, the diagonal composition, the preponderant lightness of the colours with sympathetic understanding. Once again he made an individual contribution by adding a green and red border to his copy.

As well as investigating the artistic devices of Japanese landscapes, Van Gogh also studied the compositional methods of figure representation. He took Keisai Eisen's *The actor* (69) as his model in a painting in which he placed the figure within a landscape border which still has perspectival depth (70).[14] The brushwork is evident within the areas of colour; but this painting diverges from Impressionist practice in terms of colour intensity and in its inclusion of bright linear outlines, derived from Japanese colour woodcuts, which lend his composition an ornamental character.[15]

The Japanese influence on Van Gogh's portrait painting was of major importance. There is a certain anonymity about Japanese portraits, caused by the practice of filling in the backgrounds with assertive patterns which become primary features in the composition (565, 626, 627). The human subject, parallel to the picture surface, seems to be an insertion against this background, which was often so dominant that the pattern remained constant from one actor's portrait to another, while only the head was changed.[16] The first

and second generations of French Impressionists reacted differently to this process.

There are no essential differences between Van Gogh's portrait of Père Tanguy of 1887 (71) and his *Self-portrait with bandaged ear* of 1889, except perhaps the lighter colour and looser brushwork of the later painting. The background, a wall hung with Japanese colour prints, remains the same, though the areas of space between the prints are larger in the self-portrait. The detail illustrated here (68) shows clearly that the facial features no longer express something about the subject of the painting alone: rather, they contribute to the expression of certain spheres of experience, like the decorative patterns and so on, formed by the artistic means Van Gogh has chosen. For Van Gogh, Japanese art is not only the means to an end, but also the expression of an artistic will.[17] Making common cause with it, portraying himself with its means, as Van Gogh does here, is more than Manet had any intention of doing in his portrait of Zola (22). In the Manet, painted in 1868, the Japanese prints are props, intended to convey a particular piece of information; and the structure of the picture, with all its contents parallel to the picture plane, is essentially a pictorial device, though one owing something to the Japanese woodcut. There are still elements similar to these in Van Gogh's portrait of Père Tanguy, but the *Self-portrait* is surely confessional: for all his misery, he is still able to draw comfort from Japanese art.[18]

72 Vincent van Gogh
Promenade at Arles: souvenir of the garden at Etten
1888
Oil on canvas
73 × 92 (28¾ × 36¼)
Leningrad, Hermitage

Gauguin and the white-line technique

At Papeete, on the Pacific island of Tahiti, Paul Gauguin had access to books, perhaps even during the period he spent in hospital there.[1] Japanese block books, above all Hokusai's *Manga*, were brought there by sailors when their ships called. Gauguin had certainly encountered Japanese woodcuts while he was still in Paris and at Pont-Aven,[2] but it cannot be assumed that he took his own sketches after Hokusai to the South Seas with him. Nevertheless, it is striking that around 1892–93, on Tahiti, he began to introduce into his figure compositions postures that correspond to poses in Hokusai's *Manga*, or at the very least might have been influenced by them.[3]

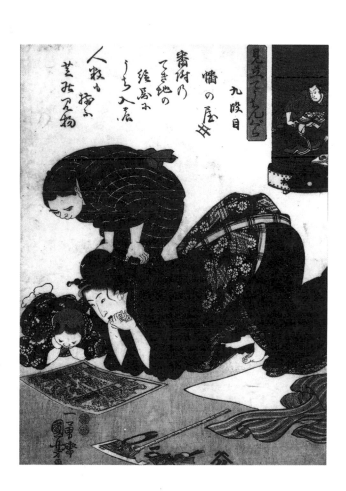

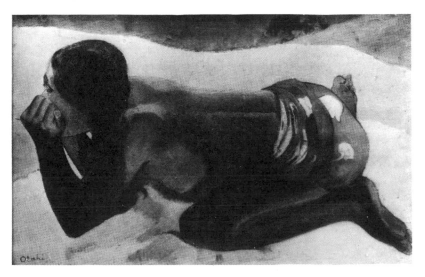

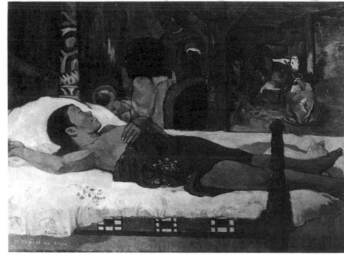

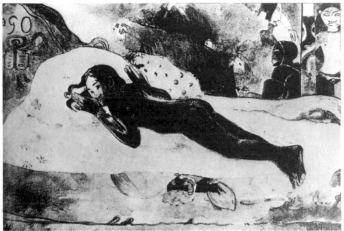

There is a strong similarity between Gauguin's representations of Polynesian women sprawling heavily and crouching with knees and elbows on the ground (75, 76) and the poses in drawings by Hokusai (78, 79). Gauguin constructed his figures sculpturally – he was not concerned with the instantaneous succession of linked movements – yet at the same time he was attracted by the basic physical gestures of his subjects, and by dint of long observation and simplification he tried to make them as timeless as arabesques.[4]

In his painting *Otahi* (75), the subject of loneliness is represented by an aboriginal woman crouching on her knees and elbows, close to the earth, alert and watchful and yet at rest. It was a pose unfamiliar to Europeans, but in the Far East it had been found to be comfortable

and relaxing and was frequently adopted, even by children at play (74).[5] Hokusai's studies of movement all originate among the ordinary people, and the actions he depicts are all natural ones. The matter-of-fact indolence of his simplified but unstylized drawings of people sleeping and taking their ease (73, 78, 79) may well have had an enduring influence on Gauguin, for he discerns not only the everyday quality of a gesture but also what is universal and sculptural about it (76). 'I painted a nude of a young girl,' Gauguin wrote, 'in that position a trifle can make it indecent.' This was a reference to his picture of Tehura lying on a bed, a prey to fear (77). The words reveal the scruples of the European, who still felt the 'indecency' of a basic pose; he continued: 'a European girl would be embarrassed to be found in that position'.[6] The fact that Hokusai had often depicted people in postures that offended the norms of nineteenth-century European prudery made him the founding father of new conventions, with which Degas, Toulouse-Lautrec and a host of second-generation Impressionists shocked their society.[7]

It is not my intention to demonstrate that one of the great masters of the European Modern Movement between 1860 and 1910 simply copied Hokusai or any other Japanese artist – studying only the copies is inappropriate to both their purpose and content. In the discovery of the autonomy of the moving figure, artists were not concerned with the meticulous representation of every finger, but only – and always – with the basic and significant gesture. Gauguin certainly learned from Hokusai, and at a very early stage, as his picture *The vision after the sermon: Jacob wrestling with the angel* shows. In this (as early as 1888) he does not select the ethereal angelic type familiar in post-Romantic painting, but finds the model he wants in one of Hokusai's sturdy *sumō* wrestlers.[8] The plumpness and clumsiness of his cats and dogs are other things that he can have found only in Hokusai (82), who had made a far closer study of all kinds of animal movement than any European artist.[9] But Gauguin did not concern himself only with form and movement in his innovations: as was the case with all the great spirits among the Impressionists, his work shows the effects of confrontation with the content and the techniques of Japanese art.[10] Manet, Monet, Degas, Toulouse-Lautrec and other painters, but also the later artists in glass such as Rousseau, Gallé and Daum, all show the effect of the same encounter.

The adoption of one Japanese technique in particular gave Gauguin access to a new field of subject matter and a new means of creative expression, and as a result his

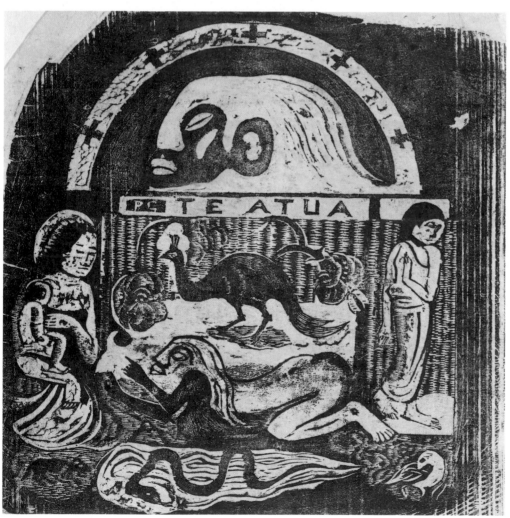

graphic work rose to its peak.[11] This was the technique of *shiro-nuki* ('picking out in white'),[12] which brings objects forward out of a dense black ground (85, 87, 89, 90). This technique was much used in Japan, because results of high artistic quality could be achieved with simplest resources.

The print had to be made from a single block, printing a uniform black, and this permitted an infinite number of artistic possibilities. Script could be easily included, as in pure calligraphy (1079), and combined with landscape compositions (86, 87, 90).

The *shiro-nuki* artists were able to highlight the finest lines or thicker strips, wider areas and dots of light (85, 87, 90) – the material world seems phosphorescent, as Gauguin describes the tropical nights in his book *Noa-Noa*.[13] The sorcery of black, the incandescence of white, have never been represented so uncannily and yet so tangibly. It was this property of the *shiro-nuki* technique that had the greatest appeal for Gauguin and his Symbolist fellows, and the medium exercised a widespread influence in European print-making around and after the turn of the century.[14]

The technique already had a long history.[15] It was developed along similar lines by Kitagawa Masahobo (1753–1806) and Nishimura Shigenaga (1697–1806);

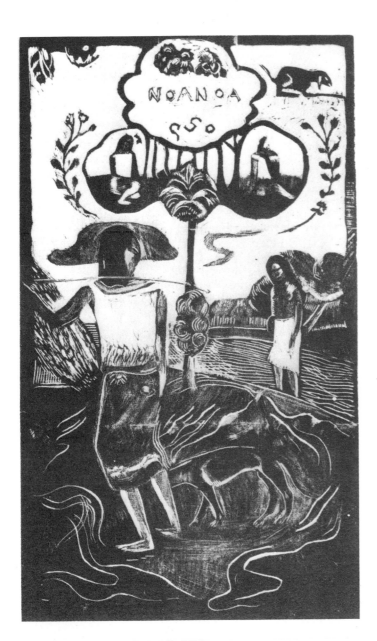

both are credited with its invention. A print was made from a single block, inked in black; the lines scored in the block were fluent, or, in chiaroscuro areas, finely layered (90). The white areas stand out magically against the black, and seem to float in a quite remarkable manner against a background in which the laws of time and space have been suspended. The powerful contrasts that could be created between larger areas of both black and white also led to compositional experiments in which artists handled details as delicately as a pharmacist balances gram weights. An important feature was the mobility of the light, which played on all the objects and forms in the composition, spotlighting them in accordance with their importance. This sacral light always had an additional, ornamental significance.

For Gauguin, the technique, which went back to the old Chinese technique of stone-rubbing, was a 'primitive' process, and indeed stone-rubbing, up to and including the *frottages* of Max Ernst, has always been considered a 'primary' genre which yields information about primitive structures.[16]

Odilon Redon was also acquainted with the technique; it was the ideal medium for his submarine realm of shadows (729).

Gauguin cut the lines in his woodcuts very finely (86),[17] as finely as the slender rays of moonlight that fell through the interstices in the walls of his bamboo hut. The technique allowed him to depict the exotic dream-world that merged in his prints with the Maori myths. Thus, for Gauguin, the woodcut became the medium for recreating the esoteric cults he discovered in Polynesia. He did not remain with the pure *shiro-nuki* technique,

83 China
The lucky dragon (detail)
From *The City of Soochow in the Sung period*
Stone-rubbing on paper
158 × 136 (62¼ × 53½)
Cologne, Ex Collection W. Netto

84 Paul Gauguin
Te Atua (The Gods)
After 1895
Woodcut, 2nd state, printed black on thin Japan paper, pasted over 1st state, printed brown on thick Japan paper
24.4 × 22.1 (9⅝ × 8¾)
Chicago, Art Institute

85 Kitagawa Utamaro
Fishing party
Triptych, l. panel
c. 1785
Woodcut, *shiro-nuki* technique
39.1 × 26.7 (15⅜ × 10½)
London, Victoria & Albert Museum

86 Paul Gauguin
Noa Noa (The Anointed)
1893–95
Woodcut, black and yellow on Japan paper
35.7 × 20.5 (14 × 8)
Chicago, Art Institute

87 K. Takagi
Kimono design, landscape
Kyōto, *c.* 1840
From a catalogue of kimono patterns
Woodcut, *shiro-nuki* technique
26 × 18.8 (10¼ × 7⅜)
Private Collection

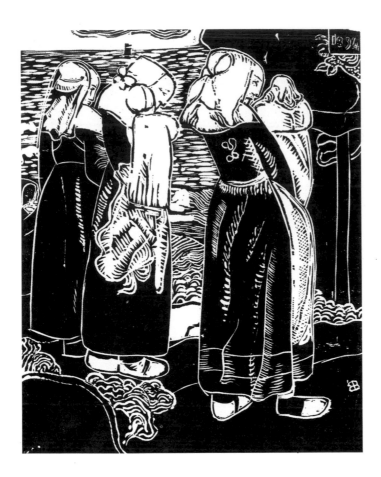

88 Emile Bernard
Breton women
1894
Woodcut
22.7 × 18.7 (9 × 7⅜)
Bremen, Kunsthalle

89 Okumura Masanobu
*Courtesan and servant with
grotesque masks* (detail)
c. 1710
Woodcut
36.8 × 27.3 (14½ × 10¾)
London, Victoria & Albert
Museum

90 Shimposai
*Samurai and servants on a
journey*
c. 1700
Woodcut, *shiro-nuki*
technique
37.8 × 35.2 (14⅞ × 13⅞)
London, Victoria & Albert
Museum

but introduced modulations into the black by pulling several copies from the same block in brown or yellow, which he then stuck together. Using transparent japan paper, he created translucent effects which generate a new and original atmosphere.[18] The indeterminacy of the depth and the infinitesimal tonal gradations unite surface and depth in a deceptive light. Gauguin's woodcuts are the most powerful expression ever given to the myths of Tahiti (84).

The *shiro-nuki* technique appealed to the mediumistic interests of some European artists in the last years of the nineteenth century. Artists such as Emile Bernard (88), some members of the Vienna Secession (91), Edvard Munch (92) and the young Aristide Maillol (93) experimented with black backgrounds in their woodcuts. These artists were not concerned with reproducing the world about them, but with illustrating the exceptional phenomena that welled from their own inner beings. Using the *shiro-nuki* technique, they abandoned the clear outlines of Art Nouveau and plunged into the dark, associative depths of Symbolism (91–93). Against a black background objects are reduced to the simplest formula, depicted by means of a spot or strip of light, varying in strength (90, 93). Similarly, light – in strips or in assemblages of spots – can imbue a motif with a mobility that is sustained by an underlying rhythmic pulse (93). The unfathomable black ground constantly urges towards abstraction (90); nature exercises less of a hold over this medium. Edvard Munch (92) and Wilhelm Laage (91) used it for nocturnal scenes, lit by a pallid moon, to impressive effect, while Aristide

50

91 Wilhelm Laage
Night, garden with lurking terrors
Woodcut
Repr. *Ver Sacrum*, Vol. 4, 1901

92 Edvard Munch
Fear
1896
Woodcut
Oslo, State Art Collection

93 Aristide Maillol
Hero and Leander
c. 1895
Woodcut, *ishizuri* technique
Mounted
27.4 × 39.2 (10¾ × 15½)
Private Collection

Maillol used it to shed a livid gleam over the legend of Hero and Leander (93). Through Gauguin, *shiro-nuki* exerted an important influence on graphic art in Europe at the turn of the century. Its traces can be recognized in the early prints of Ernst Kirchner[19] and the other members of the group Die Brücke. It supplanted the ornamental arabesques of Art Nouveau and prepared the ground for Expressionism.

94 Katsushika Hokusai
*Mount Fuji beyond
a river bank* (detail)
c. 1834–5
From *100 Views of Mount
Fuji (Fugaku hyakkei)*
Woodcut
18 × 12.4 (7 × 4⅞)
Regensburg, Private
Collection

95 Vincent van Gogh
Large tree
c. 1888
Reed pen on paper
24.5 × 32 (9⅝ × 12⅝)
Amsterdam, Rijksmuseum
Vincent van Gogh

Line and dot in Van Gogh's drawings

In 1886 Van Gogh wrote to his brother Theo: 'In a way all my work is founded on Japanese art, and if I have held my tongue about Bing, it is because I think that after my visit to the South, I may be able to take up the business more seriously. Japanese art . . . takes root again among the French impressionist artists.'[1]

His observation was correct. The second generation of Impressionists, the Nabis and the Neo-Impressionists felt the power of Japanese exemplars even more strongly than Manet and his circle. The artistic devices such as pattern-making, narrow formats, symbolism, unusual viewpoints and colour combinations, arabesques and so forth revealed the possibilities of new forms of expression which often required careful study of and initiation into Japanese art. Van Gogh boldly stated that all his work was founded on the example of the Japanese: in this may be included Far Eastern graphic

techniques. For centuries Japanese artists had followed the manuals of painting and had learned to use the brush with the utmost softness and the utmost hardness. In fact they could draw lines with the brush that were very similar to those that European artists drew with the graphite pencil, but such an outline was neither flexible nor firm enough for Van Gogh. He needed something with an easy twisting movement, like the brush, which had developed an extraordinary expressive power over the centuries in the art of the Far East. After many experiments, Van Gogh chose the reed pen, in order to get closer to the Japanese use of the individual dot and stroke. This ambition enlarges the scope of Van Gogh studies – a mere search for thematic correspondences is inappropriate to it.

By learning to look at nature 'through Japanese eyes', during 1887 and 1888 Van Gogh subjected his graphic style to a process comparable to using a half-tone screen, with the result that gradually all his forms were transformed into structures of dots and lines.

Van Gogh tried out Japanese and Chinese techniques for himself and found many uses for them in his work. In this way he absorbed the aesthetic value of features that other European artists had already discovered in Far Eastern art, such as motivic composition, *cloisonnisme* and subtle colour variation. He discovered that the sharp definition of the lower edge of the stroke or dot of the reed pen dominates the light ground in a manner far different from the hatching used by the first generation of Impressionists. The distance between each line or dot and the next must be carefully weighed, so that they acquire proper significance in the articulation of the surface as a whole.

Van Gogh had his own way of generating the currents of movement in nature and the gestures and movements of all forms. In the process of learning, he followed a path that directed him unhesitatingly towards his goal; he devoted most attention to Japanese techniques in the media of drawing and woodcut, and thus he also learned indirectly from the Chinese, who had been the teachers of the Japanese.[2] As a basic principle, he had recognized, perhaps as early as 1886, that the Japanese *ukiyo-e*, and the fifteen volumes of Hokusai's *Manga* in particular, reveal the application of a half-tone technique according to a systematic code. Hokusai, for instance, in the *Manga* and the *Hundred Views of Mount Fuji*, employs a systematic variation of dots and lines, which he applies arbitrarily to different areas of a landscape: thus an irregular pattern of dots is the cipher or symbol for the foliage of a tree (94), whereas a fine mesh of dots works like a half-tone block to indicate areas of moss, smoke, mist or climatic atmosphere (107). It is a system that enabled Hokusai to represent all manner of textures. It serves, in accordance with the precepts of the Chinese manuals, for solid structures like tree-trunks, but also for soil and sand, so that a foreground can be lightened as a means of transition to the denser texture of the centre of the picture (96, 97). Hokusai does not make as varied a use of his system of lines, which is very different from his system of dots (98); in 'comma' form, the lines serve to give a more forceful articulation to horizontal levels in landscape.

The Chinese and Japanese manuals are familiar with a great variety of lines and dots, the shorthand characters or 'grammalogues' of the botanical textbooks.[3] Rushes, gorse, cherries and junipers, ivy, wild vines and many other plants are illustrated on page after page of the manuals, reduced to fixed groups of dots and lines (99).

Hokusai often uses the bent line or comma to delineate the ragged edges of shore-lines, which articulate and order the construction of the picture. Wherever areas are to be precisely defined within a landscape, upright bundles of commas appear, rhythmically disposed, and often counterbalancing the patches of colour (98). In this form the comma also acquires a substance in that it represents rushes, grass or straw. But the system of short strokes may also be transferred to the vertical, in order to represent the character of grasses, with stems and blades set at acute angles (102). A pattern of stems and blades is liable to settle into a rhythmic system with the character of a fence or palings of regular height (98), and the same systematization can be transferred to the realistic depiction of reeds and grasses and even to the representation of bamboo canes forming a grille (616, 637). Hokusai uses many shorthand techniques of this kind, in full agreement with the Japanese tradition.

The Chinese painters' manuals were compilations usually drawn from historical material, but it is clear that the compilers' criteria were conditioned by

96 Katsushika Hokusai
*Mount Fuji beyond
a river bank* (detail)
c. 1834
From *100 Views of Mount
Fuji (Fugaku hyakkei)*
Woodcut
18×12.4 ($7 \times 4\frac{7}{8}$)
Regensburg, Private
Collection

97 Vincent van Gogh
Park in Arles (detail)
1888
Reed pen on paper
32×24 ($12\frac{5}{8} \times 9\frac{1}{2}$)
Amsterdam, Rijksmuseum
Vincent van Gogh

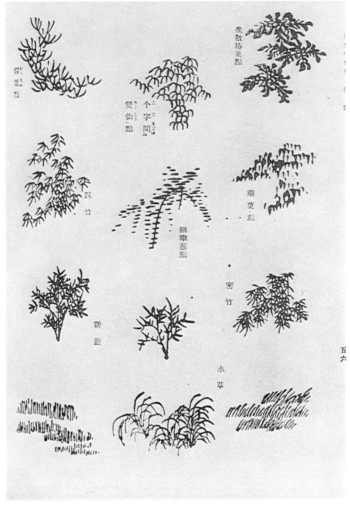

individual inclination as well as by the fashions of the age in which they lived. This is particularly interesting with regard to the subject under examination here. A good example of these manuals is the *Tung-yin hua-chüeh*, compiled by Ch'in tsu-yung,[4] which contains numerous remarks relevant to the better understanding of specific artistic devices used by Van Gogh. Paragraph 34 of the *Tung-yin hua-chüeh* stipulates:

The drawing of dots to depict moss is an extremely difficult matter. The artist must make the dots in part consciously and in part completely at random, with the spirit concentrated and the mind relaxed … There are also, however, pictures which do not require dots, that is, where the outlines and structures of mountains and rocks are already beautiful in themselves. In the use of dots to draw moss, simplicity must be regarded as the first essential.

Painters had always gleaned much practical information from Japan's famous moss gardens. The drawing of moss as a mass of dots derives from the typical features of this family of plants (100, 102).

In paragraph 68 we read: 'The strength of Wu Li's personality was exceptionally great … In the drawing of dots and in the horizontal arrangement of dots to represent small trees he again differed entirely in his conception from other painters.' Paragraph 21 recom-

mends: 'After the artist has finished painting the trees in a picture, he should consider very carefully what dots he ought to add to them.'[5]

The rules set out in these Chinese manuals had a significant influence on Japanese painters. Van Gogh became acquainted with them through Hokusai. Viewed as a system, the value of the technique of drawing forms as a mass of dots can be summarized as follows: the technique in part codified the objects in a picture, according to acknowledged rules, but as a second stage of artistic realization it should not allow the training behind the technique to be perceptible. The learning process was a long one, and artists took very seriously indeed the increasing abstraction in the rendering of things seen, arriving eventually at a completely systematic reduction of everything to dots and lines. At the age of seventy-five Hokusai wrote:

It was only when I reached the age of seventy-three that I partly grasped the true shape and nature of birds, fish and plants. Until I am eighty I shall go on making progress. When I am ninety I shall penetrate to the essence of everything. When I am a hundred I shall reach a high degree of perfection, and if I live to be a hundred and ten everything I do, every dot and line, will live.[6]

This is aptly complemented in a letter of Van Gogh's

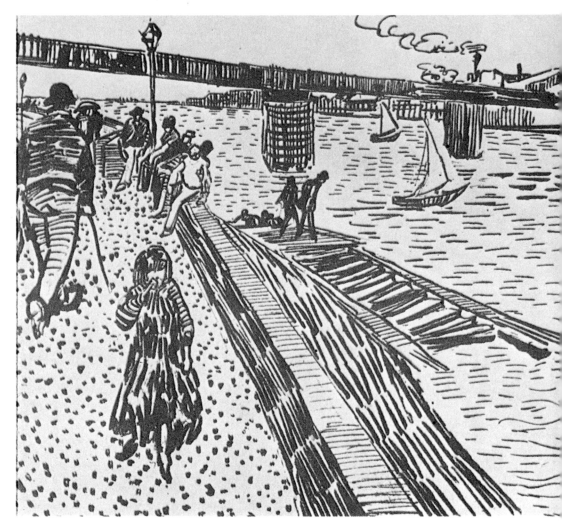

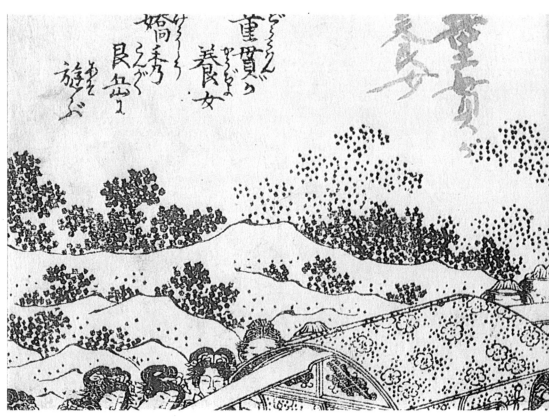

104 Totoya Hokkei
From a painters' manual
(after Hokusai in part)
1856
27 × 19.5 (10⅝ × 7¾)
Private Collection

to his brother: 'I envy the Japanese the extreme clearness which everything has in their work ... Their work is as simple as breathing, and they do a figure in a few sure strokes.'[7]

The system of lines and dots has always occupied a central and highly esteemed position in the work of Chinese and Japanese artists, where it is put into practice with great flexibility yet always with regard to a fixed schema. It is to be found in the work of Shēn Chou (1427–1509), Kao Yang (active 1600–50), Mei Ch'ing (1623–97), Kung Hsien (c. 1656–82) and others.

But anthologies of Japanese poetry, novels, manuals of all kinds, bound together in book form, for preference in the convenient *manga*, but occasionally in somewhat smaller or larger formats, contain countless instances which have a bearing on the system. It allowed the widest variety of applications, and new methods of putting it to use were for ever being tested. We find it in Hishikawa Moronobu's *Songs of Thirty-six Poets in the Yamato-e Style* (Edo 1696),[8] and again in Tachibana Morikuni's collection of poems *Ehon Tsū-hōshi* (Osaka 1730).[9]

The systematic use of dots in the manner described above is much in evidence in the monochrome prints of Kitagawa Utamaro, who published a book of views of the province of Suruga (Edo 1790). The impact that Hokusai's *Manga* made on the early French Impressionists will certainly have been matched by two other little books consisting of the topographical collections *Miyako meisho zue* (1786)[10] and *Kangetsu Shitomi* ('Sights of the province of Ise', Osaka 1797).[11] There are also the views of Edo, Kyoto and Osaka published in Edo, early in the nineteenth century, by Iwakubo Hokkei.[12] Hokkei was very strongly influenced by Hokusai, and his collection of views also displays a well-developed system of dots and lines; however, the overall effect is more rigid and hence more modish, more of his time, than that of Hokusai's work (103, 104).

56

105 Vincent van Gogh
Cottages at Saintes-Maries
1888
Reed pen
31×24 $(12\frac{1}{4} \times 9\frac{1}{2})$
New York, Museum of
Modern Art

All these books illustrate the technique of drawing with dots. The manuals also contain instructions and examples concerning the way plants grow, and how they cluster together. The branches of some plants hang down and those of others point upwards (99); some send their shoots out in every direction, and branch and twig systems differ from plant to plant (102); grasses are thicker near the root (99, 102) – all this was illustrated with calligraphic clarity. This inventory demonstrates that Hokusai and his *Manga* did not constitute a completely isolated phenomenon, and that when a demand arose in Europe for Japanese woodcuts, some of it will have been met by these other competent, and aesthetically most estimable, Japanese publications which, although today very largely unknown, must then have exercised a great influence. This extended not only to painters, but perhaps even more to craftsmen, who were able to learn something about all aspects of Japanese life from these books.

The supply of Japanese woodcuts had reached a peak in Paris by the mid 1880s. Van Gogh reported having been able to buy all the prints he wanted from Samuel Bing's enormous stock at three sous apiece. He told his brother: 'We must not undervalue the small advantage we have now in rummaging through thousands of them to make our choice.'[13]

The inventories of many European museums also list examples of Japanese pattern books, basket weaving and dyers' paper stencils (526, 527, 1026) in great quantities, sometimes in thousands. But it was the books that were most in demand, for they provided a quantity of impressive exemplars in a small space. The interest in Japanese art grew steadily, and Van Gogh wrote to Theo: 'We do not know enough about Japanese prints . . . If I had a single day to see Paris again, I should . . . call at Bing's to see those very Hokusais and other drawings of the great period.'[14]

One of the important factors in this discussion is that

57

106 Vincent van Gogh
Boats off Saintes-Maries
(detail)
June 1888
Reed pen
32 × 24.5 (12½ × 9⅝)
Brussels, Musée d'Art
Moderne

107 Katsushika Hokusai
*Landscape with rays of
sunlight* (detail)
1814–78
From *Manga*
22.2 × 15 (8⅝ × 5⅞)
Private Collection

Van Gogh did not pick out particular types of Japanese woodcuts, as would have been more usual in his day. He was interested primarily in the outstanding works of Hokusai, but he also liked the later artists, among whom may be included Keisai Eisen, Utagawa Kuniyoshi and his pupils. As he said,

Bing himself used to say to me, when I was admiring the ordinary prints, that after a while I should come to see that there are quite different things still. Loti's book *Madame Chrysanthème* taught me this much: the rooms there are bare, without decorations or ornaments. And that very thing wakened my interest in the excessively synthetic drawings of another period, which probably are to our prints what a sober Millet is to a Monticelli. You know well enough that I do not dislike Monticellis. Nor color prints either, even when I am told, 'You must get out of the habit of that.'[15]

In constructing his drawings Van Gogh decided in favour of large, simple planes which can be taken in as a whole by a viewer, who sees the subject from above, as in Japanese views. *Cottages at Saintes-Maries* of 1888 (105), for instance, shows how the system of dots can suggest the textures of masonry in the gable-ends and sand on the road and is also the source of a highly decorative element which acts like an abstract pattern. Van Gogh begins here to codify the structures of the trees and bushes in his own style. His efforts to emulate the Japanese are completely confident. From drawing he went on to painting, where he first of all tried out the use of a system of dots and lines (110). The realization of the work shows how significantly he exercised his power of observation in order to incorporate the graphic 'touch' of the Japanese in his own pictorial concepts. He wrote to Theo in 1888: 'I must do a *tremendous* lot of drawing,

because I want to make some drawings in the manner of Japanese prints.'[16]

The drawings resulting from this intention were above all those executed in Arles, between February and May 1888, which illustrate the line and dot technique that Van Gogh had developed for himself. The characteristics of the technique are again in evidence, with a high degree of variation, in work he did in Saint-Rémy, between May 1889 and May 1890, and in Auvers-sur-Oise, between May and July 1890. There can be no question of his developing an imitative technique, let alone of copying the Japanese, but the system of drawing with dots and lines – especially as used by Hokusai – gave him something from which he was able to learn (94). He did not buy Japanese brushes and ink, as Toulouse-Lautrec did;[17] he used reed pens, which he cut himself, and brown inks – bistre and sepia – because of their greater smoothness in solution. This seems to have been an important consideration, for he began, in the spirit of his models, to lay ink washes over the typical calligraphic structure of his drawn lines, adjusting their tonal gradation to the strokes of the pen. The slanting tip of the pen had the additional advantage of allowing a closer approximation to the turning motion of the Japanese hand. Van Gogh pressed on in a rapid

58

strokes is used to good effect in a painting of 1888, *Promenade at Arles* (72). In this picture Van Gogh achieves the strong colouring of a Japanese woodcut. It is a brilliant experiment, which it is hardly possible to regard as Neo-Impressionist, but which points the way to the synthesis of linear ornament and painterly colour areas of Van Gogh's last years.

There is no mistaking the evolution of an ever stronger capacity for rhythmic movement. This new painterly conception of his, contrasting with the means of French Impressionism, is an essential factor in a style which retains its validity to the present day, that is, the way in which colour areas are given mobility by the use of graphic means (72, 110). We can see for ourselves that the artist has transferred the techniques of his reed-pen drawings to his paintings. A loaded brush is used to apply the bent hooks and commas, embedding them in the impasto texture of the paint (110), but although they are grouped in bundles like the strokes in the drawings, they in no way disturb the painterly principle. On the contrary, the capacity for sensitive modulation that results from this brushwork gives the areas of colour an intensity which was lost in late Impressionism in France. The intangibility of the colours is imbued with additional expressive powers by the embedded textures of these short strokes; and their intensity is enhanced by mobility. Van Gogh chose subjects particularly well suited to his techniques: cornfields, for example, dictated the direction of the strokes, which he laid in systematic areas of dots and lines. The techniques he learned from the study of Far Eastern art dominate his mobile, flowing depiction of the French countryside.

In the late 1880s Van Gogh's representation of the mobile rhythms of nature became bolder and more

108 Katsushika Hokusai
The pilgrims (detail)
1834–35
From *100 Views of Mount Fuji (Fugaku hyakkei)*
Woodcut
25×18.2 ($9\frac{7}{8} \times 7\frac{1}{8}$)
Private Collection

109 Vincent van Gogh
Thistle garden (detail)
October 1888
Reed pen, india ink on paper
32×24.5 ($12\frac{1}{2} \times 9\frac{5}{8}$)
Amsterdam, Rijksmuseum
Vincent van Gogh

shorthand towards the Far Eastern 'dry brush' style, which is related to the individual Japanese brush style in its highly tuned, nervous vividness.

In the summer of 1888 he produced the important reed-pen drawing *Washerwomen by the canal* (114). This adds immeasurably to the understanding of Van Gogh, and illustrates his ability to assimilate Hokusai's technique. The system of dots and lines makes something ornamental out of the means whereby the Europeanized perspective is achieved. A decisive factor in this is the grouping of vertical lines in small bundles, which take on the motion of flowing water. The mobility among these bundles gives the drawing a 'burdened' atmosphere. A rhythm as of a magnetic field governs the steeply rising foreground of the picture, on top of which the houses and the sky sit like a lid.

Van Gogh continued to pursue these systems of Hokusai. In two more drawings of 1888, *Thistle garden* (109) and *Bridge over the Rhône* (101) he created a kind of 'banded' composition in immediate visual proximity. The bands of strips are each speckled with a dot or line of one particular kind. It can be seen that the artist sometimes turned his pen as he made the stroke. The system of distinguishing the separate planes of the composition with these undulating patches of different

110 Vincent van Gogh
Olive trees in red soil
Saint Rémy 1890
Oil on canvas
92.5 × 73 (36½ × 28¾)
Amsterdam, Rijksmuseum
Vincent van Gogh

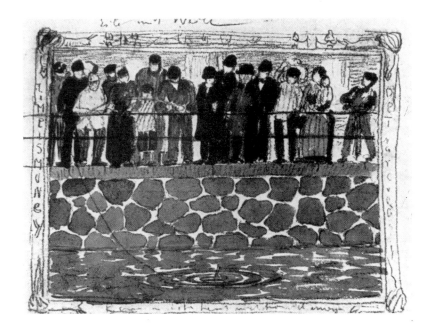

pronounced. The motion of waves and clouds whipped by the wind (106) takes on an almost symbolic effect. The experiments with the reed pen made objects simpler, took them back to their basic principles, while the pen strokes became ever more expressive. A certain abstraction emerged: the artist's use of 'grammalogues' created alienation, his handwriting became a violent stenography. He declared in a letter that this was his intention: 'Hokusai wrings the same cry from you, but he does it by his *line*, his *drawing*, just as you say in your letter "the waves are claws and the ship is caught in them, you feel it." Well, if you make the color exact or the drawing exact, it won't give you sensations like

that.'[18] Hokusai, always Van Gogh's most important exemplar, used graphic techniques to represent the atmosphere (107). Even the most minimal variations in the system of grouping strokes together were quite sufficient to depict the sky, low hills and the valleys lying between them.

Hokusai's idiosyncratic style made an impact on both German and Dutch illustrators. His influence is discernible in a wash drawing by Otto Eckmann of 1896, in which the blocks of Hokusai's cliff-faces are transferred to the masonry of a quay (111–13). A system of dots is an important ingredient in the vignettes of Jan Toorop (115).

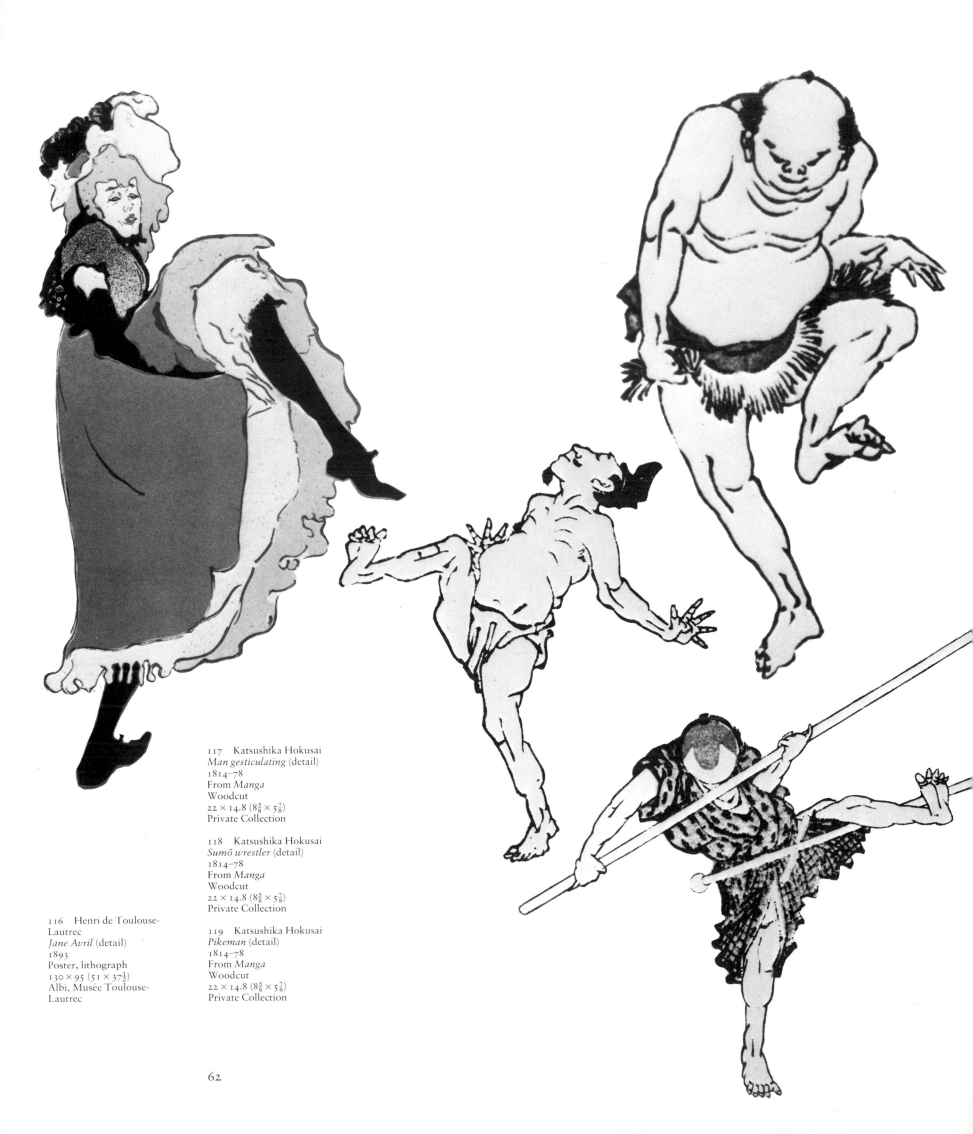

117 Katsushika Hokusai
Man gesticulating (detail)
1814–78
From *Manga*
Woodcut
22 × 14.8 (8⅝ × 5⅞)
Private Collection

118 Katsushika Hokusai
Sumō wrestler (detail)
1814–78
From *Manga*
Woodcut
22 × 14.8 (8⅝ × 5⅞)
Private Collection

119 Katsushika Hokusai
Pikeman (detail)
1814–78
From *Manga*
Woodcut
22 × 14.8 (8⅝ × 5⅞)
Private Collection

116 Henri de Toulouse-
Lautrec
Jane Avril (detail)
1893
Poster, lithograph
130 × 95 (51 × 37½)
Albi, Musée Toulouse-
Lautrec

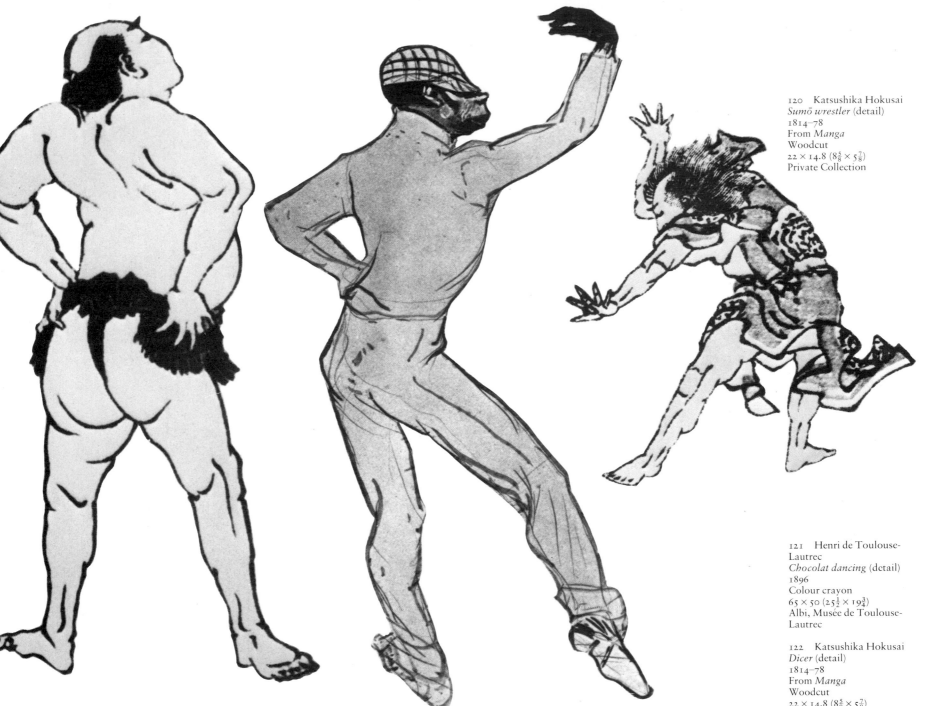

120 Katsushika Hokusai
Sumō wrestler (detail)
1814–78
From *Manga*
Woodcut
22 × 14.8 ($8\frac{5}{8}$ × $5\frac{7}{8}$)
Private Collection

121 Henri de Toulouse-
Lautrec
Chocolat dancing (detail)
1896
Colour crayon
65 × 50 ($25\frac{1}{2}$ × $19\frac{3}{4}$)
Albi, Musée de Toulouse-
Lautrec

122 Katsushika Hokusai
Dicer (detail)
1814–78
From *Manga*
Woodcut
22 × 14.8 ($8\frac{5}{8}$ × $5\frac{7}{8}$)
Private Collection

123 Katsushika Hokusai
Sumō wrestler (detail)
1814–78
From *Manga*
Woodcut
22 × 14.8 ($8\frac{5}{8}$ × $5\frac{7}{8}$)
Private Collection

Gesture and grimace in Lautrec

Growing familiarity with Japanese woodcuts gave a new impetus to the representation of the human figure during the last quarter of the nineteenth century. For the first time 'body-language', as expressed in the individual, intimate, spontaneous actions and postures of everyday life, was acknowledged to be a subject worthy of art (73–79). The new perception also influenced the way in which artistic devices – line, plane, depth, light and colour – were used by European painters and graphic artists (72).

Edgar Degas is recognized as one of the great explorers and assimilators of the Japanese influence.[1] He concentrated on two particular female subject-groups:

ballet dancers (36), and women at their toilette (29), and created for the characteristic movements and postures of these groups a code of ciphers or shorthand symbols, which revealed subjects from new angles and imbued them with new emotional stimuli. A large number of other European artists began to paint these and similar subjects.[2] For Toulouse-Lautrec the multitude of themes that he began to explore provided both a sphere in which he could live more freely and a soil to nurture his creativity. He entered a dubious environment, the *demi-monde* of Montmartre, in order to escape the constraints of the polite society of his day. At the turn of the century, the French upper classes were subject to norms which imposed deliberate limitations on individual freedom. In those reactionary, wealthy circles, certain postures, which were considered as indications of that important attribute, self-esteem, were *de rigueur*. Toulouse-Lautrec was not interested in striking attitudes, he wanted to demolish the barriers erected between one

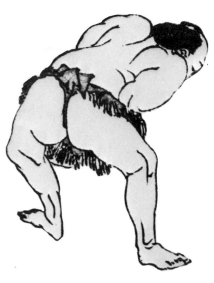

63

124

125

128

130

129

64

126

127

131

human being and another. The 'nobility' of Tingeltan-gel, the *demi-monde*, on the other hand, knew no such restraints, not even on their willingness to accept the stunted scion of the counts of Toulouse, who were connected by marriage with the crowned heads of England, France and Aragon.[3] Entering the Parisian *demi-monde*, Toulouse-Lautrec exchanged the petrified ceremonial stance of aristocratic society for a primary, impudent, often unbridled mobility of gesture which to him meant the unvarnished truth.

At first Toulouse-Lautrec followed in the footsteps of Degas, but he soon transformed the older artist's

132

65

133 Henri de Toulouse-
Lautrec
Yvette Guilbert (detail)
1894
Gouache
41 × 23 (16⅛ × 9)
Albi, Musée
Toulouse-Lautrec

134 Tōshūsai Sharaku
*The actor Ichikawa Ebizō
as Takemura Sadanoshin*
(detail)
1794
Colour woodcut, grey mica
background
36.8 × 24.4 (14½ × 9⅝)
Private Collection

135 Katsukawa Shunkō
*The actor Ichikawa Yaozō
III as the hero Sukeroku*
(detail)
1784
Colour woodcut
32.1 × 16.3 (12⅝ × 6½)
Private Collection

136 Henri de Toulouse-
Lautrec
Aristide Bruant (detail)
1893
Lithograph
26 × 21 (10¼ × 8¼)
Albi, Musée Toulouse-
Lautrec

137 Henri de Toulouse-
Lautrec
*Yvette Guilbert, singing
'Linger, longer, loo'* (detail)
1898
Colour lithograph
29.6 × 23.4 (11⅝ × 9¼)
Albi, Musée Toulouse-
Lautrec

138 Olaf Gulbransson
*Eleonora Duse as Hedda
Gabler* (detail)
1901
Pen, india ink
34 × 22.8 (13⅜ × 9)
Private Collection

133

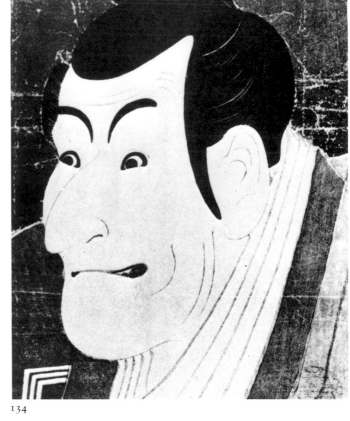

134

137

138

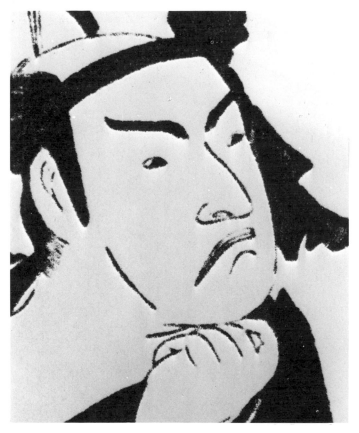

135

136

139

140

141

depiction of movement for its own sake (26, 37, 42) into a medium for derisive comment, and introduced such exaggeration into gestures as to turn them into questionable arabesques. His can-can girls show off their legs with a brazen hitch of the skirt (116), his gigolo's profile is bestial (121), actors in evening dress cavort clumsily with flailing elbows (51), the spectators in the box are isolated from the spectacle. Toulouse-Lautrec captures the rhythms, tense or fluid, of his dancers' movements. He obviously relishes underlining the precariousness of a pose with receding or advancing colours. The diagonals of the composition lead straight as an arrow out of the picture, carrying the figures with them. The fashionable clothes – hats, swinging capes, ostrich feathers, leg-of-mutton sleeves, long gloves (708), lace trimmings and so on – conspire with the wild gestures to create a form of ornamentation.[4] Toulouse-Lautrec's contribution to the new conception of movement is burlesque in action, for to him every figure was a living, breathing poster. Movement first of all catches the eye and arouses in the spectator an eagerness to watch and be entertained. The turbulence, the tangle, the scant notice taken of the spectators, the cliqueishness, the use of aggressive physical postures to disconcert the bourgeoisie was already by the turn of the century constituting a tourist attraction,[5] which had only to be captured in a permanent form to make a poster (116, 128, 129).

If reactionary polite society looked upon all this as surpassing all decent bounds, for the newly invented pleasure industry it was the acme of style and the avant-

139 Tōshūsai Sharaku
The actor Tanimura Torazo as Washizuka Hatsuheiji (detail)
Colour woodcut, grey mica background
37.8 × 25 (14⅞ × 9⅞)
Private Collection

140 Henri de Toulouse-Lautrec
At the Moulin Rouge: La Goulue and La Môme Fromage (detail)
1892
Colour lithograph
46.2 × 34.5 (18¼ × 13½)
Private Collection

141 Utagawa Kuniyoshi
Fine evening with clear skies
1836
Fan leaf
Colour woodcut
23.2 × 30.6 (9⅛ × 12)
Cologne, Private Collection

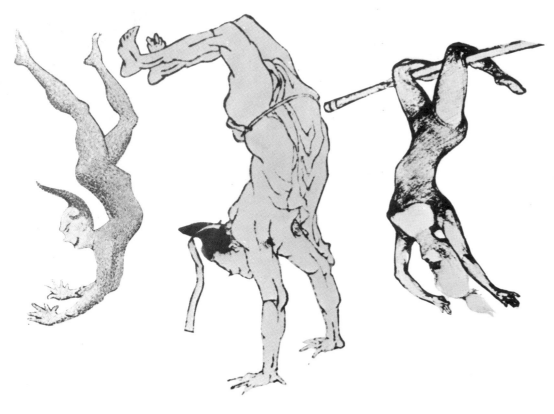

garde. Toulouse-Lautrec assaulted the wretchedness about him on two fronts, mingling the *nouveaux riches*, the licensed decadents, the wealthy loafers and the cynical dandys with the actors (136), prostitutes and so on who depended on them for their living, and he developed types appropriate to each of these professions (116, 121). He could look for both example and confirmation to the masters of the Japanese woodcut, who also, for instance, portrayed an intimate and inextricable mixture of nervous pleasure, lust, perfection and vivacity in the *shunga* (erotica, or literally 'springtime pictures') (130–32),[6] but above all to Hokusai, who took the liberty of capturing every conceivable pose known to Japanese civilization in his drawings (32, 33). In his *Manga*, Hokusai records the whole spectrum of everyday existence in a spontaneous parade of actions which in Europe were traditionally not considered worthy of artistic representation.[7] There was a further impediment for European artists, in that the European did not possess a comparable vocabulary of physical movement. In the depiction of wild, unbridled movements, or in slow, highly stylized gestures of bravado, colour, line and plane are always employed so as to make the maximum visual impact.[8] Hokusai used a range of ciphers to represent movement, conveying particular ideas and the associated phenomena by means of a kind of sign-language: *sumō* wrestlers stretch their limbs with dignified gravity[9] – from head to foot every muscle moves (120); plump dreamers sprawl heavily on the ground (78), tumblers dance (117), women twist to wash themselves (158). Hokusai is the master of movement as expression, each moment in the course of

an action is set down with a few strokes (38). Stimulated by Hokusai's *Manga*, Toulouse-Lautrec also concentrated on the momentary but typical gesture: each pose has a distinct meaning. He works into the features the outward signs of a specific group attitude: celebrities (136) and madams (140) wear open contempt on their faces. Toulouse-Lautrec differs from Hokusai in the theatrical placing of his figures, and even in his sketches broad gestures convey something of the extraordinary atmosphere of the cabaret (116, 133, 137).

Yet an individual lot was also something which the artist heightened to an expressive phenomenon, representing by artistic means isolation and rejection.[10] The kind of poses that in Hokusai often display exaggeration or a crude realism are transformed in Toulouse-Lautrec into cool but significant actions.

The consciously imitative pose was of great importance in the art of the Far East at all periods. The imitation was not obvious, indeed it is often only just discernible, and is capable of the very finest shades of differentiation in the artist's hands. Though the pose, shaped by Buddhist ritual, is conformist, it imparts precise information about the nature and observances of the category of person to which the subject belongs, and at the same time makes provision for the suggestion of patterns of movement originating in the personal space (63, 79, 432).

Apart from the expressive power of the body in general, there was a special obligation on actors to employ a range of repetitive gestures. Great actors are often portrayed with the corners of the mouth turned down: these are well-known poses associated with

particular roles, and the standardization of the mimetic expression gave the spectator specific, standard information. Each of these standard grimaces conveyed a different message: for example the *mie* grimace (when the actor crosses his eyes and pulls his mouth down to the right) purports an evil intention (135, 139). But when the actor starts the grimace with his eyes and presses his lips together, this becomes the 'triumphant *mie*', and was eagerly awaited by the audience.[11]

Expression in mime was an established practice in the Far East. The Shōguns' heralds usually had a number of 'forerunners', whose function it was to attract the public's notice by twisting and distorting their bodies into odd shapes (39). Once the people were paying attention, the herald would appear in their midst and make his announcement. Another example is the movements of *sumō* wrestlers, which Europeans have found so absurd but which have a ritual significance, and illustrate the multiplicity of gesture, movement and practised posture that the Japanese have at their disposal (118, 120, 123).

Every profession had – and still has – its own characteristic range of gesture in the Far East: one need only think of the way Japanese fishmongers carry on even today. The marked difference between the bows that are made to an older person and to a person of authority, the thousand-fold gestures in the Nō and Kabuki theatres, all fostered this multiplicity of movement. This accumulation of gesture had a great deal of appeal for the common people in particular, and the most impressive pictorial record of it was made by Hokusai (50). A particular pose or gesture performed by an actor, for example, would indicate rank and moral standing. Although Hokusai was bound by the established norms, he went further in his translation of the innate, acquired, emotional or symbolic traits of his fellow men, to which he lends a pronounced freedom. That is to say, his gestures are imbued with individual significance, for he develops a pose to the point where it becomes a fundamental attitude – something in his work that Toulouse-Lautrec found enormously stimulating. This attitude was the sum of a large number of similar or related physical traits, which were able to create a 'timeless' effect by means of the artist's 'condensation' of them. From theatrical gestures Toulouse-Lautrec constructed a vocabulary of physical expression appropriate to the personnel of the Parisian theatres, and reveals his debt to Hokusai in the fact that the mimetic origins can be traced in his work – whether of elaborate gestures or of the most subtle play of facial features (116, 137).

In the emphasis Hokusai gave to specific, much-repeated gestures he went as far as caricature, and thus aroused greater participating interest in the viewer. Outward physical actions are depicted in a style that gives inward reinforcement to the primary pose. Grimaces and mouths opened to distortion reproduce a situation as accurately as if it had been frozen (125–27). The wide-open mouth of the singer with the gesticulating hand is hardly conceivable without the example of Hokusai.

The foreshortening of Toulouse-Lautrec's dancers (121) is also a startling effect, created by a linear clarity and visual immediacy that derive from Hokusai, while the new angle from which subjects are seen is another conscious borrowing (116). The postures in the repertoire of the Japanese actor, and Hokusai's delight in seeking out vehement gestures and movements never before represented in art, uncovered impulses which in Europe remained concealed behind a mask of 'keeping up appearances'.[12]

The figure bearing the burden of expression in the work of Toulouse-Lautrec is always part of a more general expressive situation, determined by the *demi-monde* of Montmartre, or at the very least exercising some influence on his or her psychology. It is often possible to point to one pronounced, determinant trait in Toulouse-Lautrec's figures and types. The same traits were employed by Japanese actors, portrait prints of whom were imported to Paris in their thousands by Samuel Bing (134–35, 139).

These woodcuts exerted a suggestive, insinuating influence. They were the grey eminences of the age. From the *ukiyo-e*, or 'pictures of the floating world', Europeans became acquainted with ways of being receptive towards atmospheres of the least intensity. From them, too, artists developed the desire to be in the thick of things, to be present at the heart of the action, so as to experience sensory impressions to the full. Utamaro lived in the 'green houses' of old Edo, and Hokusai hid from the Shōguns among the people. Toulouse-Lautrec was an habitué of the cabarets and bars of Montmartre. No longer did an artist wish to maintain a distance from his model: on the contrary, a close relationship on a day-to-day footing was considered productive. The grace of the popular, and the oblique view taken of the wealthy, both demonstrate the new art of characterization practised by Toulouse-Lautrec (116, 133, 136, 137).

Only on the variety stage or in the circus ring was further intensification possible, through the defiance of gravity. Hokusai used to depict acrobats in extreme poses: standing on their hands or swinging on a trapeze (143). Toulouse-Lautrec appropriated these flying movements in his *Flying trapeze artist, without safety net* (144). The harlequin in Georges Seurat's *Circus* runs round the arena on his hands in the pose from Hokusai (142, 143). Precarious equilibrium, rotating arms and legs, angular limbs, people stretching, lying down, lolling, squatting, crossing their arms and legs: the fantastic variety of human movement depicted in Hokusai's *Manga* was an inexhaustible source for Degas and Toulouse-Lautrec.[13]

Instead of this inferno of expression, the Neo-Impressionists concentrated on the depiction of the figure at rest. In their landscapes Seurat and Signac put the compositional elements of the Japanese woodcut masters to the test, but in portraiture Far Eastern patterns became part of the content. In his *Portrait of Félix Fénéon* Signac paints a kimono pattern behind his subject as a substitute for body language (146).[14] The arabesques described by the elements in the pattern are extraordinarily mobile (147). The figure is almost subordinated to the ornament, the backcloth is given a primary role to play. The phenomenon points the way towards new expressive possibilities in art.

146 Paul Signac
Portrait of Félix Fénéon
1890
Oil on canvas
74 × 93 (29 × 36½)
Zürich, Collection Emil Bührle

147 Japan
Kimono pattern
Ex Collection Paul Signac
Private Collection

Vallotton's woodcuts and the Orient

Vallotton's encounter with the Japanese woodcut deserves a separate study on its own. Such a study would have the advantage of a very important historical source: the small collection of Far Eastern art which Vallotton, like Gauguin and Van Gogh before him, and his friends among the Nabis, assembled for himself, the remnants of which have survived to the present day. Woodcuts like the mountain landscape [149] and *Fine evening* of 1892, and *The sea* of 1893 are certainly inconceivable without the stimulus he gained from Japanese woodcuts, especially from Hokusai [150]. There is, to be sure, the difference that Vallotton did not work with colour, but in pure black and white, whereby both content and form attain an even higher degree of density.[1]

The admiration that French artists had for Japanese colour prints was equalled by their interest in the 'white-on-black' prints from the Far East (89, 90). Gauguin, Emile Bernard and others were well acquainted with

148 Ch'ien Huan
The four nobles among the flowers (detail: *Winter plum blossom*)
c. 1600
Rubbing from a stone engraving
128 × 30 (50¾ × 11¾)
Private Collection

149 Félix Vallotton
Mont Blanc
1892
Woodcut
25.5 × 14.3 (10 × 5⅝)
Winterthur, Kunstmuseum

150 Katsushika Hokusai
The waterfall at Yoshino in Yamato Province where Yoshitsune washed his horse
c. 1827–29
From *Trip to the Waterfalls in the Provinces (Shokoku taki meguri)*
Colour woodcut
36.9 × 25.5 (14½ × 10)
Berlin, Museum für Ostasiatische Kunst

shiro-nuki-e ('pictures picked out in white') (see pp. 45–51). Chinese white-line prints had aroused great interest at successive international exhibitions in Paris.[2] A striking feature of Vallotton's woodcuts is the clarity of the separation of white from black (152). The concentration of the contrasts is exploited even in tiny areas. In this woodcut, the separate areas of chequered, dotted, spotted, latticed and zigzagging patterns are treated purely decoratively, without sacrificing the volume of the objects in the picture and yet without any apparent intention of creating the illusion of the third dimension. Conception and method together are the source of the austere elegance, the refined originality and the well-schooled primitiveness of Vallotton's wood-cuts. The powerful tension between the areas of black and the edges, the negative ground which here achieves positive effects too, the veiling of the planes supporting

the figures, which nonetheless are firmly fixed to the negative black background – all these combine to create a floating stage on which all the figures are in motion. The Chinese white-line prints and the Japanese *shiro-nuki-e* display very similar conceptions of 'planar' two-dimensionalism. Where there is no third dimension, forms are created which release abstract and irrational emotions – created by the paradox of a ground that has no ground under it. By articulating the woodcut both horizontally and vertically with objects and figures cut off at the edge, Vallotton achieves a detached viewpoint, which heightens the intensity of the seemingly floating picture plane itself. To this end he often chooses to erect barriers and balustrades or grilles and stripes, in alternating black and white. He then subordinates his figures to this overall pattern, allows it to intersect them, spaces them between its elements, or makes them part of

151 Kuan Hsiu
The 13th Lohan Ba-ma-ta-ka (detail)
c. 1760
Rubbing from a stone engraving after Kuan Hsiu, from *The 16 Lohans*
110 × 50 (43¼ × 19¾)
Private Collection

152 Félix Vallotton
Idleness
1896
Woodcut
17.8 × 20.8 (7 × 8¼)
New York, Museum of Modern Art

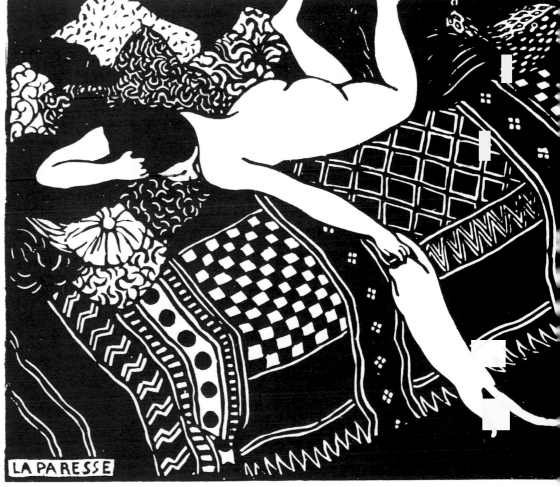

LA PARESSE

153 Utagawa Kunisada
*Kōzuke discovered by
samurai lanterns*
Woodcut
Repr. S. Bing *Le Japon
artistique*, 6, October 1888

154 Félix Vallotton
The lie
1897
Woodcut
18×22.5 $(7\frac{1}{8} \times 8\frac{7}{8})$
Private Collection

155 Félix Vallotton
The moving staircase
1901
Print, black ink on white
paper
Private Collection

156 Taiso Yoshitoshi
Women bathing
1866
Colour print
35.6×25.4 (14×10)
London, Victoria & Albert
Museum

the vertical articulation.[3] Garments, ornaments, fabrics – usually in bold patterns – naturally incline towards independent existence. The individual value and substance of objects was something the Japanese enjoyed depicting, and they stand out boldly in the monochrome prints. In a print by Utagawa Kunisada a grille on the front of the house is given the same emphasis as the principal figures in the story he is illustrating, who are all in the same plane and parallel to it (153).[4] Vallotton himself employed the vertical grille as a primary compositional element in the woodcut *The lie* of 1897 (154) and the lithograph *The moving staircase* of 1901 (155).

Among the late masters of the Japanese woodcut, Vallotton discovered Ikkaisai Yoshitoshi for himself. This artist was almost a Symbolist, whose appeal for Vallotton lay not only in his brilliant colouring but also

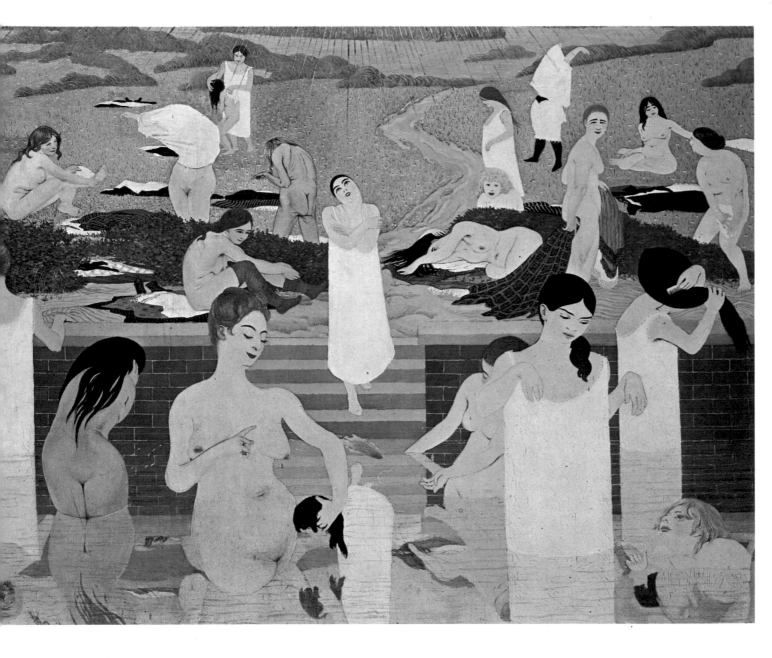

157 Félix Vallotton
Bathing on a summer's evening
1892
97 × 131 (38¼ × 51½)
Zürich, Kunsthaus

158 Katsushika Hokusai
Women washing
1814–78
Woodcut
From *Manga*
Private Collection

in the way his moving figures are articulated.[5] Vallotton's *The pool* (157), a free adaptation of Yoshitoshi's *Tsuzōku Sai Yoki* (156), shares the tendency to veil the supporting planes, this effect intensified here by the water. The way the figures seem to float becomes an avant-garde motif thanks to the reflexion of everything in the water.

In both pictures, the figures of the bathers are dependent on outline, and are thus bound more closely into the background plane. The way the women are 'stacked' in layers is an essential structural element. Each figure is isolated like a silhouette, while the multiplicity of the bodies creates a rhythm which pervades the entire picture.[6] These simultaneously frozen and yet mobile figures exemplify the exaltation of the *fin de siècle* mood, which only a short time afterwards was to be converted into the first stirrings of Expressionism.

Birds, beasts and flowers

Living creatures in art

The 1878 international exhibition in Paris gave Europeans the opportunity of making a close study of the representation of plants and animals in Japanese art. Typically, the treatment of these subjects is poetic and yet thoroughly realistic. Georges Bousquet, in the searching commentary he published on the subject at that period, stressed the close relationship that existed between Japanese artists and the world about them.[1]

By 1912, when Joseph Gauthier was discussing the ornamental potential of animals and plants,[2] the subject had long been a familiar one to artists. Gauthier's article does, however, illustrate some of the typical concerns of the years around the turn of the century.

The representation of plants was always a subject very dear to Van Gogh. In this he was typical of his times. A letter to his brother illustrates, once again, his response to the Japanese stimulus: 'I think the drawing of the blade of grass and the carnation and the Hokusai in Bing's reproductions are admirable ... Isn't it almost a true religion which these simple Japanese teach us, who live in nature as though they themselves were flowers?'[3]

The distinction of Japanese representation of plants and animals had been overlooked in Europe while *chinoiserie* was the fashion,[4] but it began to make a decisive impression in the late 1880s. The use of such subjects by book illustrators was greatly increased and benefited technically from the Japanese example. Like the Chinese, the Japanese artists had access to a large quantity of painters' manuals, which were continually replenished over the centuries with new models and examples.[5] European artists were deeply impressed by the variety of animals and plants, the positions in which they were depicted, and the fresh angles from which they were seen. Peonies and chrysanthemums were represented with convincing botanical accuracy; all the many different species were depicted with the greatest care, while being reduced, in artistic terms, to their essential values. There were comparable discoveries in the representation of animals. Japanese artists depicted insects as vividly as they did domestic animals. The Far Eastern manuals and prints offered an inexhaustible fund of inspiration and example for European book illustrators.

The international exhibitions in Europe and North America[6] ensured the dissemination of this genre of Japanese art, and its impact was immediately felt in children's books, which began to appear with original Japanese illustrations in them. This was a particularly important development because it meant that the children of the 1880s and 1890s grew up absorbing the elements of Japanese art. The result was an artistic orientation which was taken for granted in the Art Nouveau generation, and a natural receptivity towards the artistic devices of the Far East. London publishers, in particular, seized upon the resources of Japanese children's books. Griffith Farrah, Okeden & Welsh, for example, issued a series of books in 1888 with illustrations by Japanese artists, under the general title *Child Life in Japan*.[7] London newspapers, such as *The Times*, the *Daily Chronicle* and the *Daily News* gave this series outstanding notices,[8] and it went into a large number of editions. In the same year a series of volumes of Japanese poetry was published simultaneously in Leipzig and Tokyo.[9] It was distinguished by a style of illustration which can be seen as the precursor of the work produced around 1920 by Else Wenz-Viëtor and Ernst Kreidolf, who must have worked from similar models. The pictures of plants and animals were remarkably refined.

One extremely successful venture was the *Japanese Fairy Tale Series*, launched in Tokyo around 1890 and distributed via London to the United States, where it was bought in huge numbers. The format was that of small, light block books, illustrated with colour woodcuts and interspersed with English-language texts in large print, similar to the modern comic strip. The stories told were the fascinating tales of 'The Old Man and the Devils', 'The Matsuyama Mirror' and similar Japanese favourites. The series ran into several hundred titles, and once again the representation of animals and plants was outstanding.

Just why Japanese depiction of plants and animals aroused such interest in the last quarter of the nineteenth century deserves some discussion. As a result of its geographical position, Japan possesses a land fauna much the same as that of China, Korea and Manchuria. From the southern tip of the Kamchatka peninsula, the chain of islands stretches from the fifty-first to the twenty-fourth parallel. Japan's climate, which benefits from the Japanese Gulf Stream, is thus particularly favourable to a great variety of plant life. In summer the combination of plentiful rainfall and high temperatures produces a kind of greenhouse effect, promoting quite astonishing luxuriance. From the tropical zone to the Alpine climate of the ice-belt, Japan has every type of plant, including many that are also known in Europe. The animal life displays similar abundance: insects, butterflies and dragonflies are present in numerous varieties, all the colours of the rainbow, as are crustacea and fish, of which the wild carp is the most important species, and reptiles such as tortoises, salamanders and frogs. There are some notable species of birds, which include herons, wild geese, ducks, cormorants and doves. There are numerous varieties of wading birds, such as the lesser white heron or egret, the stork and above all the crane, which at one time was an object of

worship (see pp. 110–13). The many singing birds were favourites with all the Japanese artists: the lark, several varieties of thrush, and the ubiquitous sparrow. Swallows, starlings, kites, crows, rooks and ravens are common in open country. Many mammals have been introduced: the horse, donkey, dog and cat, as well as certain species of antelope and wild deer. There is one native genus of apes, which today live in reserves. The wolf, fox and badger, too, were frequently portrayed by Japanese artists.

Precise rules had been laid down governing the drawing of animals and plants. The numerous painters' manuals that circulated in China and Japan encouraged artists to analyse objects carefully in order to understand their characteristic essentials. Usually the books would characterize every aspect of the appearance of each plant and animal depicted. Chinese painters had produced animal pictures of outstanding quality: it is only necessary to think of the cranes with which they decorated screens, or of the numerous singing birds and cockerels which had such an influence on European painting. Japanese graphic artists of the nineteenth century drew the animals they could see about them every day with great devotion. A cat playing with a mouse, a dog barking with his ears laid back, a wary fox sniffing the air in all directions, ducks dabbling, all are caught to the life, at once typical and minutely detailed. These drawings are accurate enough to satisfy a zoologist, but they also illustrate the attitude of a race which lives close to nature and does not survey it from afar, like most Europeans. This is the explanation for the fact that the carver of *netsuke* could develop a sense of the grotesque side-by-side with his expertise. He needed to have studied and understood every movement a creature made before representing it in miniature. True to life and yet not naturalistic, this genre often derives from the Chinese *huai* style, which freed the animal-based ornamentation of early Chinese art from its erstwhile stiffness. There is always a symbolic element accompanying the realism, and this will have owed something, too, to the Japanese tradition of the *mon*, the rendering of a natural object adopted as a heraldic crest, so that it takes on appropriate emblematic significance.

In pictures of plants, too, there is always a deeper significance allied to the purely artistic interpretation. It was the advent of Buddhism which introduced the concept of turning an object into an emblem by stylization. Buddhism itself was represented in China by eight emblems. Foremost among them was the lotus, the symbol of summer, followed by the peony (193), as the herald of spring, the chrysanthemum (7, 530) standing for autumn, and the plum (307), standing for winter.

The months, too, were symbolized by different plants: February, the first month of the year in the old calendar, by the peach, March by the peony, April by the cherry (1, 2), May by the magnolia, June by the pomegranate, July by the lotus, August by the pear, September by the mallow, October by the chrysanthemum, November by the gardenia, December by the poppy and January by the plum.[10]

The 'poet's three friends' in Japan were cherry blossom, snow flakes and the crescent moon. These combined to create a motif replete with emotional content and romantic connotations. The contrasts inherent in the combination were a rich ground for imagery.[11] In Japan as well as in Europe, trees start to bud in February, and spring shows its contrariness by the ever-present threat that blizzards can pose to the blossom; but then the gentle light of the moon makes frozen patterns from the blossom and the snow flakes.

The poetic style of textile decoration in Japan forms a link between ornament as an artistic pursuit in itself and everyday life. The sumptuous peony is often depicted with the Chinese lion, the embodiment of power and physical strength in ripe beauty. The rich red foliage of the maple tree in autumn often serves as the decoration on a girl's *obī*. Irises (180, 182, 188), the orchids, narcissi, dicentras (884), clematis (896) and convolvulus were standard ornamental motifs. There were artists who specialized in painting only one genus of flowers and built great reputations thereby.[12]

It is impossible here to give more than a hint of the abundance of the material available to Japanese artists, which their European colleagues only became acquainted with at the great exhibitions, in private collections and in the shops specializing in things Japanese. The specialist journals, too, above all Bing's *Le Japon artistique*, played an important disseminating role. It was impossible for European artists to ignore this incursion from a great artistic culture.

There is room for research by serious art historians into the effect that this encounter had upon the design of European children's books around 1900. The first artists who revealed the signs of this influence were the English book illustrators Walter Crane, Kate Greenaway, Randolph Caldecott and Annie French (558) and in France Pierre Bonnard himself turned to the children's book. In all, the Japanese analogies are unmistakable.[13]

In Germany the publishers Gerlach & Wiedling issued an influential series of children's books between 1900 and 1920,[14] in which the effect of Japanese exemplars is discernible in the illustrations by such artists as Ignaz Taschner, K. Fahringer, A. Weisgerber, B. Löffler, H. Schulze, H. Steiner-Prag, O. Tauschek, Ferdinand Andri, Carl Otto Czeschka, R. Sieck, O. Bauriedl, H. Schwaiger, J. J. Loukota, Franz Wacik and Ferdinand Staeger. And a close acquaintance with Japanese depictions of plant and animal motifs is shown by the illustrations in *Heim der Jugend. Ein Jahrbuch für Kinder und Eltern* (1905)[15] contributed by M. Ade, P. Behrendt, Walter Crane, F. H. Ehmke, R. Engels, I. Ewers-Wunderwald, P. Horst-Schulze, P. Scheerbart, F. W. Kleukens, H. Struck, O. Ubbelohde, Heinrich Vogeler, K. Walser and others.

The examples of animal and plant illustration in the following sections are not, however, confined to the realm of the children's book. They start with the tree, a central theme of both Chinese and Japanese art, and one of the finest examples of the assimilation of Far Eastern elements into Western art.

Trees

The issue of form and its expressive content is more cogently presented in the artistic treatment of the tree in the nineteenth century than in any other single phenomenon, by virtue of the multiplicity of responses it evoked.[1]

Artistic realism in the European tradition, with its emphasis on copying 'from nature', is incompatible with the effort to render the expressive content of forms. The act of meditative concentration alienates the essence of the object from its incidental external appearance. There must be a similarity to the original object, but it must be transformed into an expression of its structure.[2] Thus, European artists needed to get away from the photographic copy from nature: the idea of the object to be painted had to be present in the artistic conception before the act of painting itself was begun.

The Chinese poet and painter Su Tung-po (1036–1101) wrote: 'Above all, trees, bamboo [174, 176, 178] and so on, possess a constant, characteristic form, and furthermore express a principle, which it is possible to offend gravely against; if the artist falls short of it, the transgression is far worse than if he fails to render the external form adequately.'[3]

159 Kung Hsien
Marsh landscape (detail)
1684
Album leaf
Ink on paper
24.5 × 24.3 (9⅝ × 9⅝)
Lugano, Collection Vannotti

That is to say, the conceptual idea of the tree or any other plant is probably more important than the physical form it happens to take. The artist must sink himself in contemplation of that essence. Su Tung-po went on to say:

Before you paint the bamboo you must first of all imagine it aright in your mind. Only then take up your brush, concentrate your attention and keep what you want to represent clearly before your eyes. Go to work with a will and make speed with your brush. Select only what you have perceived, for just as the bird of prey swoops when he has seen the hare, so your eye must fasten on its object; if you hesitate for only an instant it will be too late.[4]

Zen Buddhism, Taoism and Shintoism all influenced the development of related theories on the making of pictures.[5] Chin Tsu-yung's *Thoughts on Painting* sets down some essential principles on the shaping of trees in landscape:

In painting trees, begin with withered ones [166]. In working with the brush, make all the strokes go outwards from one point in all directions, then you are in a position to allow the twigs to sprout in all directions too. Wang Hui [1632–1717]

was alone in this respect in grasping the beauty of Li Cheng's style, which is of quite unique splendour.[6]

Their preoccupation with plants led Far Eastern artists to observe the structures of trees very closely. They employed the simplest of artistic means to represent what they saw, using the brush to follow the varied ramifications of a tree's silhouette (159). Van Gogh adapted their brush technique in his reed-pen drawings to produce a greatly simplified outline (160). His concern was to represent the growth, to show the living tree in its essence by means of fluent, simplified lines. The exterior mobility of the rapidly drawn strokes was intended to represent the time factor of the tree's growth and, simultaneously, its movement in its setting. He was following the precepts of the old Chinese theorists. Tung Chi-chang (1555–1636) once said:

Trees must at all costs appear to twist about themselves[162], but their twigs must not be too numerous [168]. The ends of the twigs should be clenched close together, and not be too loose [159, 162], while the opposite applies to the tips of the trees[161]. The learner should immerse himself attentively in this profound adage on the painting of trees.[7]

160 Vincent van Gogh
Orchard in Provence
1888
Reed-pen drawing, white highlights
39.5 × 54 (15½ × 21¼)
Amsterdam, Rijksmuseum Vincent van Gogh

161 Kung Hsien
Tree beside a river
1684
From an album of 8
landscapes
Ink on paper
24 × 24.2 (9½ × 9⅝)
Lugano, Collection Vannotti

Van Gogh once said: 'Trees should be allowed to grimace'.[8] In other words, he believed them to possess characters and personalities which they express in their movements. When Tung Chi-chang said that trees must appear to twist about themselves, he was expressing a similar view – that their movement should be represented in the picture (166).

Trees grow at all angles to the perpendicular (162), their trunks are gnarled and twisted (166). Bowed by wind and weather, with branches bent and intertwined (167), the tree heaves itself up out of the ground. Van Gogh renders the roughness of bark with heavy vertical strokes (168). The thickening of the trunk at the base of the branches is portrayed by the Chinese as a swelling roundness (166). 'In painting trees, begin with withered ones', said Chin Tsu-yung, and Van Gogh obeyed, for the dry branches stand out like petrified limbs. Hokusai, too, followed the precepts of the Chinese in his *Manga* (165). His trees are like 'pictures of old men with barky skin' (164). Chin Tsu-yung advised the painter thus:

162　Vincent van Gogh
*The vicarage garden at
Nuenen in winter*
March 1884
Pen and pencil
39 × 53 (15⅜ × 20⅞)
Amsterdam, Rijksmuseum
Vincent van Gogh

163　Vincent van Gogh
*Meadow with a tree-branch,
haystack and bushes*
Arles, May–June 1888
Pen and ink
25.5 × 35 (10 × 13¾)
Amsterdam, Rijksmuseum
Vincent van Gogh

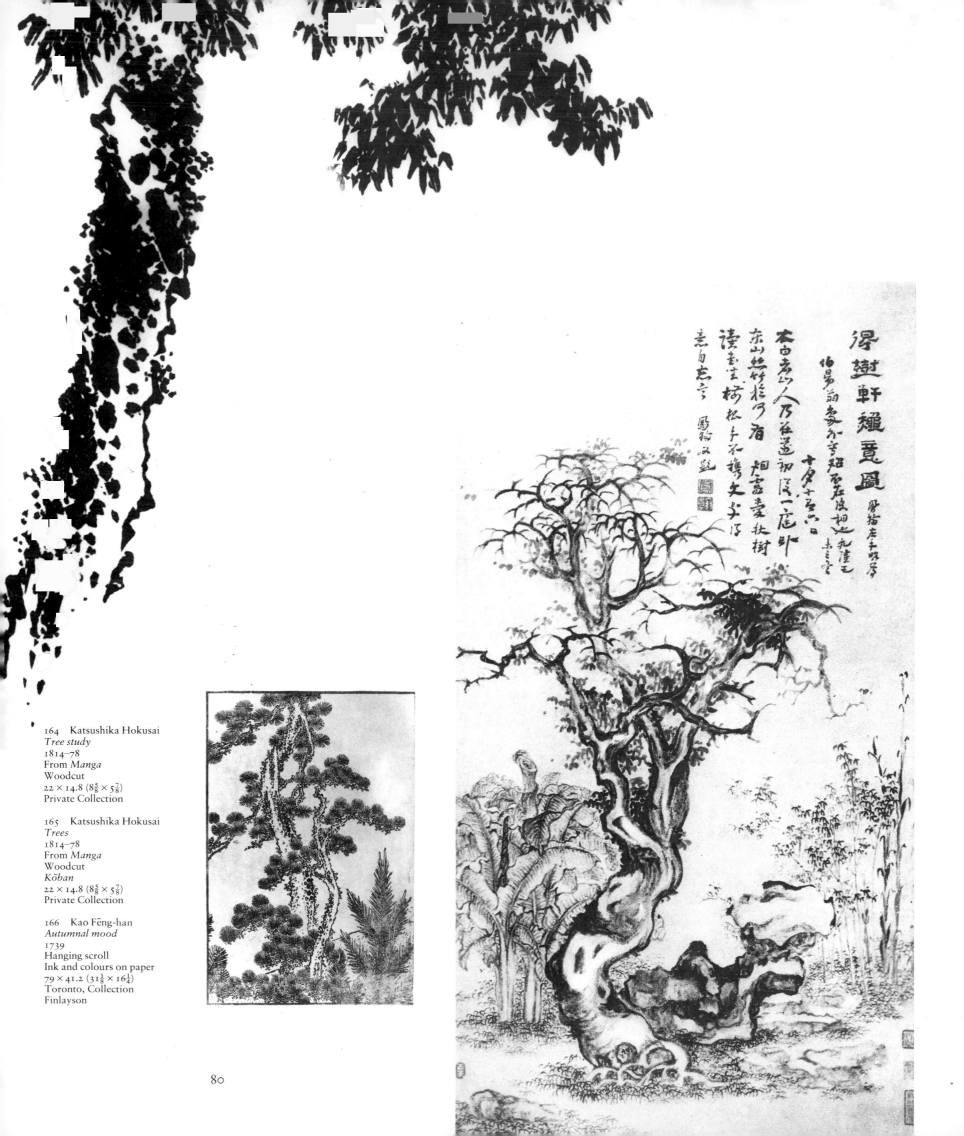

164 Katsushika Hokusai
Tree study
1814–78
From *Manga*
Woodcut
22 × 14.8 (8⅝ × 5⅞)
Private Collection

165 Katsushika Hokusai
Trees
1814–78
From *Manga*
Woodcut
Kōban
22 × 14.8 (8⅝ × 5⅞)
Private Collection

166 Kao Fēng-han
Autumnal mood
1739
Hanging scroll
Ink and colours on paper
79 × 41.2 (31⅛ × 16¼)
Toronto, Collection
Finlayson

If you paint the twigs of trees, then on trees that turn to the left they must go from top to bottom, and on trees that turn to the right they must go from bottom to top. If they are represented in a vivid and lively manner, then they are wholly apt to radiate a free naturalness. The points at which the twigs branch off may be widespread or close together. In any case the artist must be careful to make their formal expression accord with the season of the year. Moreover he must never be indecisive when he is painting them, or work in fits and starts.[9]

In his studies of trees, Van Gogh expressed the spontaneous reaction that this subject always inspired in him, and was never indecisive but mastered tree painting with firm calligraphic strokes (168).

A cluster of trees crowned with their mingled foliage was rendered like a huge ornamental motif, as by Vallotton (170) and Thiemann (172). This too had been covered by the Chinese theorists:

If you are arranging trees in a picture, you must let them connect and commingle [159] so that sometimes three, sometimes five trees form a group [161]. Moreover they should not be regular in form: some should be bent, some upright; some close at hand, some in the distance; one tall, another small. Thus they will create an unusual effect [110].[10]

Trees form streets, broad avenues or great chambers roofed with foliage. They provide accents in the landscape, and give it its character, whether pleasant (641), majestic, gloomy or frightening (163). Fairy tales and legends, in Japan and the West alike, are sparked off by a forest setting or by the mystery surrounding a single

167 Vincent van Gogh
Pine tree
1889–90
Pencil on paper
33 × 25 (13 × 9⅞)
Amsterdam, Rijksmuseum
Vincent van Gogh

168 Vincent van Gogh
Two pine trees
1889–90
Pencil on paper
30 × 20.5 (11⅞ × 8)
Amsterdam, Rijksmuseum
Vincent van Gogh

169 Japan
Tree studies (detail)
Repr. S. Bing *Le Japon artistique*, 1, May 1888

tree. The international Art Nouveau movement looked upon the tree as a symbolic form (172, 605, 614, 634), and the Symbolists revived the ancient tradition of the Tree of Life. Branches reach out to ensnare people, or they find their own limbs turning into branches. In bold decorative sweeps trees become portraits and arabesques, they form a grille across the foreground of a picture or ring it round in a rhythmic outline, allowing the eye to wander over the ornamental plane. In the art of the Far East, the tree is usually depicted in association with appropriate bird or animal life to form an eloquent symbolic entity, with the structure of the branch or twig matching the texture of the coat or feathers of the animal (206). The subtle differentiation of the textures seen at a foreshortening angle was a prolific source of ideas for artists and illustrators in the West.

Hokusai could line up a row of pine trees so that they are in constant motion (171). The mossy trunks present a bizarre, gnarled appearance. The tips of the twigs form dense, rounded points which cluster along the branches to form umbrella-like shapes. Félix Vallotton took this image further, and grouped trees to form a single canopy (170). Here too the trees are thrown into silhouette-like relief, a motif also adopted by Carl Thiemann and used for an ornamental effect that is characteristic of Art Nouveau. In Thiemann's woodcut the edge of the picture plays a part in emphasizing the mingling of the branches (172). The Japanese woodcut did more than suggest formal ideas, it changed concepts of composition in European graphic art.

Bamboo

Bamboo was a familiar element in eighteenth-century *chinoiserie*. The fashion gave rise to furniture made of bamboo and to porcelain shaped like it, and it also appeared as a decorative motif on carpets, lacquer cupboards and boxes. New decorative uses were found for it when Chinese craftsmanship made its bow at the international exhibitions in Europe from the middle of the nineteenth century. Bamboo now appeared in book ornamentation, as a border, or in vignettes; Henri Rivière, one of the earliest admirers of Chinese and Japanese art among the Impressionists, used it in his design for a book jacket (177).[1] He may well have seen related Chinese paintings in Paris. Laurent Bouvier was another French artist who found a Japanese inspiration for ornamental plates (175). The example reproduced here was included in the exhibition 'Weltkulturen' (Munich 1972). It illustrates the creation of unity from fragmentary elements drawn into a circle. There were numerous models for Bouvier to follow (176), and nearly all the larger porcelain factories produced ware decorated with similar themes, especially as there was an interest in the symbolism of the plant. The large number of painters' manuals devoted to bamboo give some idea of its importance in Chinese art (174, 599). The monk Jue Yin, who lived during the Yüan dynasty (1280–1368), declared 'when I am happy I paint the orchid, and when I am angry the bamboo.'[2]

In Chinese mythology the bamboo has a symbolic meaning, which was adopted by the Japanese. Taoists

174 Wu Chen
Rock and bamboo
Yüan Dynasty (1280–1368)
Ink on silk
Album leaf
22.5 × 18 (8⅞ × 7)
London, British Museum

175 Laurent Bouvier
Plate
c. 1868–69
Earthenware, slip and
sgraffito decoration in black
and white on red
background, clear glaze;
bamboo and birds after a
Japanese model
D. 31.7 (12½)
London, Bethnal Green
Museum

176 Japan
Plate
Meiji period (1868–1912)
Porcelain, painted
decoration of bamboo leaves
and stems
D. 34 (13⅜)
Tokyo, Private Collection

177 Henri Rivière
Winter
1892
Colour woodcut
22.2 × 15.9 (8¾ × 6¼)
New Brunswick, N.J.,
Rutgers University, Fine Art
Collection

178 China
Bamboo stems and twigs
(detail)
1701
From *The Mustardseed
Garden (Chieh-tsu-yüan
hua-chüan)*
Colour woodcut
27.1 × 16.7 (10⅝ × 6½)
Berlin, Museum für
Ostasiatische Kunst

ascribed bamboo to the *yang* principle, as they did
certain animals, on account of its extraordinarily quick
growth: it reaches its full height in a matter of weeks.
Such rapid growth was regarded as a sign of fertility,
strength and virility, in contrast to the feminine *yin*
principle. But this was not the only reason for the
importance accruing to bamboo in Asia. Everyone living
in the tropics recognizes it above all for its versatility: it
can be used as building material, to make tools,
instruments, weapons and ornaments. It is also a source
of food.

The bamboo is often depicted with animals and other
plants in a symbolic role. Thus the image of the tiger
sheltering in a bamboo forest during a storm is a famous
one, and symbolizes the weakness of even the strongest
and most dangerous of beasts in the face of the invincible
power of nature, while the bamboo itself stands for
endurance and longevity (203, 206). Bamboo belongs to
the select order of the *shikushi*, the most highly esteemed
plants in China, and the most often referred to by
painters and poets.[3] There are seven preferred themes,
each of which represents one particular association of
the plant, such as the bamboo in the rain, in a thunder
storm or beneath the rising moon.

179 Thomas Webb & Sons
Vase
c. 1885
Cased glass, carved
Water irises
H. 19.7 (7¾)
Private Collection

180 Japan
Iris
Tokyo 1899
From a painters' manual by
Taki Katei
Woodcut
25.6 × 16.7 (10 × 6½)

181 Auguste Delaherche
Plate
1899
Glazed stoneware, decorated
with iris buds and flowers in
émail cloisonné
D. 31.8 (12½)
Karlsruhe, Badisches
Landesmuseum

The Art Nouveau iris

The iris, the yellow flag or water iris, and their cousins
the lily and the orchid have an arabesque-like beauty
which is ideally fitted to lend tension to any artistic
composition in which they are included. Everything
about these plants, their tall stems, their delicately
patterned flowers, their lancet leaves, aspires upwards.
They became one of the emblems of a period in
European art that, although short, left an enduring
influence behind it. The artists and book illustrators of
the Pre-Raphaelite movement in England adopted the
iris and the lily as symbols,[1] while the lily appears as an
ornament on countless numbers of vases (179, 905–11),[2]
as well as on utensils made of silver, pewter and wood.[3]

Japanese designers produced some extraordinary
examples of the iris and the lily used as ornaments,

which had a lasting influence on Western art. Writing in 1897, Aemil Fendler remarked:

We have found the way to nature again, and it lies through Japan. No longer does the living art of our time take its nurture from past styles, no longer does it seek its models in the pattern books of the Renaissance or the Rococo ... The wonderful art of Japan offers a rare combination of untarnished natural freshness with the most refined decorative taste and the highest stylistic assurance: let us be grateful to it for showing us the right path to follow and for opening the eyes of those that have eyes to see.[4]

To begin with, the Japanese-inspired decorative use of the iris was combined with the Christian associations that the lily has in art. The French and Belgian Symbolists and the English Pre-Raphaelites used the combination repeatedly.[5] But as the subject was used increasingly as an ornamental motif, so the arabesque-like stylization in the manner of the Japanese crest came to predominate.[6]

Otto Eckmann executed his woodcut of irises (185) under the influence of Hokusai and Hiroshige. He was no longer concerned with the still-life-like flower compositions aspiring to Renaissance idealism of the kind that Dutch painters of the seventeenth century had produced in great numbers. Eckmann's picture is a close-up view of a few flowers, part of a stem, part of a few leaves, cut off severely by the edge. The petals in the foreground are strongly accentuated, so that they stand out against the lancet leaves and stems bearing unopened buds. Each individual form is treated as an ornament in itself, in conception, in structure and in draughtsmanship.[7] Carl Thiemann drew numerous variations on the iris and the yellow flag, and bizarre liliaceous forms occur again and again in his late work as components in an integrated, ornamentally conceived composition and in a slightly asymmetrical grouping, dominating the rectangular area of the picture. Thiemann even follows his Japanese models to the extent of enclosing a monogram in a rectangular frame, like a signature seal.

The very choice of format for a picture was governed by the tall slender flower heads (183). From this Ernst Hermann Walther developed a style of book ornament that was typical of the turn of the century. The tall format of some Japanese woodcuts was organized according to a principle of vertical stacking, which Walther adapted to his own use, instilling a rhythm into the vertical arrangement of the petals. The delicate filigree of the stems and flowers, too, has an affinity with Far Eastern examples, and Walther went so far as to give these designs a vertical inscription and to sign them with a monogram. Examples of Walther's work were published in the periodical *Pan* and influenced other designers.[8]

The representation of the iris in Japanese art was a topic of absorbing interest to European graphic artists in the last years of the nineteenth century, who were fired to emulate the Japanese and draw these flowers under the same technical conditions. Pattern books contained numerous examples, drawn with the same simplification of line and the use of black contours to outline the stylized forms. Painters, too, turned to the subject. Van Gogh was prompted by the example of Hokusai and

Hiroshige to paint numerous pictures of irises and lilies representing the vertical principle in their growth.[9] Pictures such as these, depicting in close-up a 'random' segment of a flower-bed or a clump of wild flowers (182, 187), have a tension arising from the grille-like pattern of verticals which makes them very different from the ordered still-lifes of earlier centuries in Europe.

The treatment of irises and lilies by the French Impressionists continued to evolve and develop as Impressionism itself did, until finally the graphic means of Japanese artists exercised an even stronger influence on the work of the Europeans. Claude Monet returned to the water-lily and the iris throughout his long career as the subjects of his 'open-air still-lifes'. In the example illustrated here (187) the line of yellow flags parallel to the picture plane unites with the background of blue water and the white cloud reflection in one plane. The serenity of these late paintings has obvious parallels in Japanese iconography.[10]

In his edition of a selection, in German translation, from the Chinese painters' manual *The Mustardseed Garden (Chieh-tsu-yüan hua-chuan)*,[11] Yang En-lin gives the following account of Chinese techniques.

The instructions in *The Mustardseed Garden* covering the representation of plants, grasses and insects have remained a constant source of inspiration to European artists to the present day. The most important are contained in the 'Four methods of painting flowering plants'.

182 Ogata Kōrin
Screen (detail)
17th century
Irises on a gold background
H. 151 (4' 11½")
Tokyo, Nezu Art Museum

87

1. Colouring in previously drawn outlines: 'This style was established by Xu Xi in the Southern Tang period (936–75). At that time artists generally painted flowers directly in colour, only Xu Xi first drew the twigs, leaves, buds and calyx in ink, and then coloured in the outline. His observations were careful, and therefore his pictures were successful in form as well as in mood.'

2. Painting without previously drawn outlines: 'The artist does not begin by drawing the outlines of the plants in ink, but proceeds immediately to paint in colour. This method was introduced by Teng Chang-you in the Early Shu period (907–25) ... He taught that artists should paint with colour from nature, in order to make the pictures true to life ... That is called "dab painting". Later, at the beginning of the Northern Tang period (960–1127), Xu Chong-si (grandson of Xu Xi) painted one colour on top of another without drawing outlines. That is called "boneless flower-painting".'

3. Ink-dab painting: 'The artist does not paint with colour, but with ink, applied in dabs. This method was laid down by Yin Zhong-long at the beginning of the Tang period (618–907) ... The different nuances obtainable with the black ink create the impression that the flowers have been painted in different colours. Later, in the Southern Tang period (936–75), Zhong Yin used ink in various shadings to indicate the depths of his flower pictures.'

4. Drawing in ink, without dabbing: 'The artist draws outlines with interrupted lines, as though there is too little ink on the brush, and then overpaints with white body colour. This method was established by Chen Chang towards the end of the Tang period. Later, during the Southern Sung period (1126–1279), the monk Bu Bai and Zhao Meng-jian developed this technique further. Zhao Meng-jian specialized in sketching narcissi, winter plum blossom, orchids (iris) and bamboo with fine, double strokes in ink, leaving the areas between the strokes blank.'[12]

The vivid language of these manuals was as important as the precise knowledge they impart about genera and species. Countless artists in the Far East concentrated on one type of plant and never painted any other. The teaching on the depiction of bamboo is one of the more striking examples. With the iconographic significance ascribed to plants and flowers in China and Japan, the artist often made a confessional declaration justifying his particular choice. The monk Jue Yin, who lived in the Yüan period, wrote: 'When I am happy I paint the orchid (iris), and when I am angry the bamboo.'[13]

Kinzin Rokuroku compiled an anthology of field and garden bindweeds which appeared in Osaka in 1816–17.[14] He was not concerned solely with botanical accuracy but also with the plants' 'relationship' to their environment. There are numerous examples of such 'specialist' or 'specific' artists in China and Japan. In the Far East people did not distinguish between the iris and the orchid. It was the symbol of victory, and belonged to the group of 'four noble plants', along with winter plum blossom, bamboo and chrysanthemum.

The iris belongs to the family of the *Iridaceae*. It is a perennial, growing out of a strong rootstock that anchors itself firmly in the ground. The sturdy, stiff and often abbreviated stems are furnished with bipartite leaves, shaped like a sword or a lily, which are grouped round the shaft of the stem (184, 186, 187). The flowers, singly, or in grape-like clusters, grow at the end of the stems. The yellow flowers of the 'victory plant' were

183 Ernst Hermann Walther
Irises
1895
From a series of designs for ornamental borders
Pen and watercolour on paper
28×8.5 ($11 \times 3\frac{3}{8}$)

184 Christian Hondard
Iris
c. 1896
Colour lithograph
22.7×32.5 ($8\frac{7}{8} \times 12\frac{3}{4}$)
Obbach, Collection Georg Schäfer

185 Otto Eckmann
Irises
c. 1895
Colour woodcut
21.5×12.5 ($8\frac{1}{2} \times 5$)
Berlin, Staatl. Museen, Kupferstichkabinett

186 Carl Thiemann
Irises (detail)
1935–36
Colour woodcut
29.9×19.2 ($11\frac{3}{4} \times 7\frac{1}{2}$)
Thiemann Estate

popular in Japan; *The Mustardseed Garden* gives precise instructions on how to paint it:

The leaves are the most important thing in depicting an orchid [iris], so the artist should begin with them. He should first draw one of the following types of brush stroke: nailhead, rat's tail or grasshopper. The second leaf takes the form of a phoenix's eye, the third that of an elephant's eye. Then the fourth and fifth strokes are drawn to represent leaves bending over. Below them comes a short leaf drawn with a fish-head, as support. The leaves of the orchid [iris] should be arranged so that some stretch upwards while others incline downwards. Thus the whole will look true to life. The leaves fall in all directions, without leaning on each other. The artist must be able to distinguish the leaves of the spring and summer iris or lily [orchid]: the leaves of the former should be delicately and finely drawn [180], those of the latter should be sturdy [188, 799].[15]

Hokusai also frequently occupied himself with irises and lilies (911), which are now to be found in the collections of the Edo period (*c.* 1846), whose owners used to have copies made from Hokusai's originals (911).[16] The strong, sturdy growth was rendered convincingly by Hokusai by means of a tension between the two planes of which the picture is composed, and which create simultaneously an optical separation. The right-hand page has more empty space in it than the left-hand. The left edge of the picture on the right-hand page cuts sharply across flowers and leaves, the left-hand page is filled with lancet leaves and stems and flowers. Yet the two parts of the picture belong together. The caesura in the centre is a decisively important interval, which strengthens the already concentrated composition still further.[17]

187 Claude Monet
Yellow flags
Oil on canvas
48.3 × 56.5
Private Collection

188 Japan
Iris (detail)
Tokyo, *c.* 1880
From a painters' manual
Woodcut
22.5 × 15 ($8\frac{7}{8} × 5\frac{7}{8}$)
Private Collection

Gourds and autumn leaves

The long, swelling form of the gourd has been a popular pictorial subject in Japan for centuries. It also features in textile designs, as a *tsuba* (sword guard) ornament (476),[1] and lends its shape to glass and earthenware vessels (877–82, 928).

These trailing plants, which grow on trellises, have an interesting linking role between trees and plants at ground level. Like climbing plants such as clematis and convolvulus, it can easily be trained by the gardener into a great variety of forms. The Japanese favoured the more outlandish shapes. Artists liked to include the aubergine (*nasubi*) with its purple pear- or bottle-shaped fruit in their pictures, for it was an omen of good luck to dream of three aubergines. In China the gourd is one of the attributes of Taoist immortality;[2] and it was much admired for its rough or shiny, spotted or occasionally very brightly coloured skin. Its growth was taken as a

189 Kitagawa Utamaro
Grasshopper and gourd
1788
From *Picture-book of
Selected Insects (Ehon Mushi
Erami)*
Colour woodcut
27.3 × 33.4 (10¾ × 13⅛)
Berlin, Museum für
Ostasiatische Kunst

190 Ichijuro Honda
Kimono pattern
1906
Colour
Woodcut
25 × 18 (9⅞ × 7)
Private Collection

191 Gaston Lecreux
Autumn leaves
1898
Colour etching
51 × 69.4 (20 × 27¼)
Private Collection

192 Camille Martin
L'Estampe Originale
c. 1900
Woodcut
51.8 × 69.5 (20⅜ × 27⅜)
Private Collection

symbol of fecundity and numerous progeny.[3] Its shape was held in reverence, and the great magicians, the *sennin* knew how to conjure the wealth and plenty of the earth out of the bottle-gourd.[4] For all these reasons, pictures of gourds were much in demand, and they exercised a particular appeal to the purchaser's imagination when the design also included insects.

Gaston Lecreux did a whole series of pictures of plants after Utamaro, in which the gourd and its foliage figured prominently (189, 191). The colour woodcuts depicting hanging plants designed by the French artist Camille Martin display uncommon graphic expressiveness and colouristic quality (192). The emphasis on planes and the pronounced contour lines are striking features. Some of these woodcuts were of very large format. The illusion of perspective depth was gradually eliminated in them, and the influence of Japanese artistic devices increased.

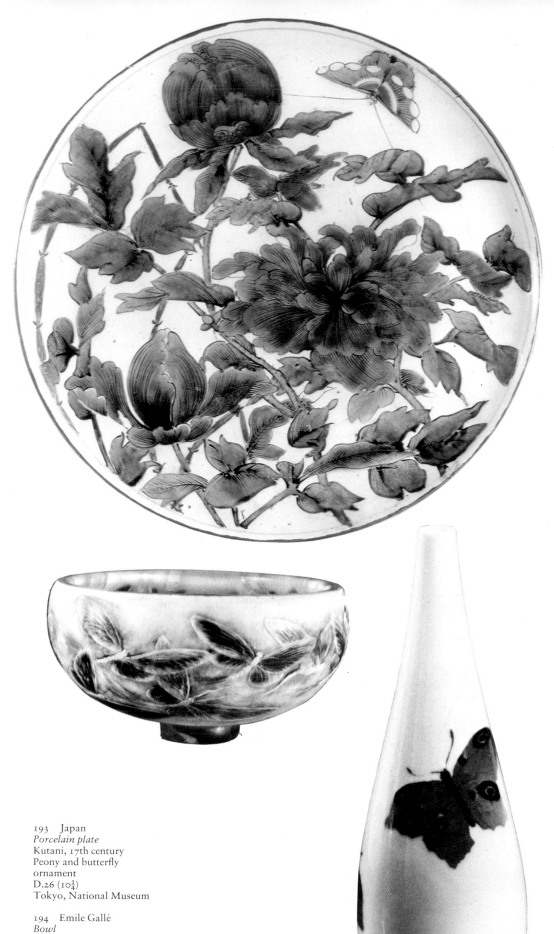

Butterfly and peony

The moth became a symbol of the *fin de siècle*; it was linked with the idea of the fairy as a hybrid, hovering creature, and it had a large part to play in Art Nouveau jewellery design. René Lalique, the great French goldsmith, created both vampires and graceful winged girls, for which he drew on the animal symbolism of the Far East for inspiration. But the butterfly, on the other hand, was a thoroughly serene phenomenon and had no sombre or sinister associations for European Symbolism or Art Nouveau. With glistening, outstretched wings, its decorative silhouette adorns countless vases and other glassware by Daum and Gallé (194).

The *bianca-sopra-bianca* porcelain vases made at the Rörstrand factory in Sweden are decorated with delicate butterflies modelled on the surface in light relief and painted under the glaze, so that they appear to float and flutter above the azure ground (198). The Royal Danish Porcelain Factory in Copenhagen also produced a line of vases with a butterfly motif (195). In the Far East the butterfly was an important motif in the decoration of porcelain and textiles, as it symbolized many different aspects of life. Most frequently of all it was depicted with peonies, for this flower's intoxicating beauty drew the butterfly to its petals like a magnet. The peony was a particularly important subject for porcelain dishes and plates. On the piece illustrated here (193) the pattern of green leaves and flowers painted in receding shades of violet is accommodated to the circular shape of the plate, so that there is a place for the butterfly too, which stands out in its brilliant orange and blue. Plates and dishes of this type made a great impact on European craftsmen in the 1870s. Théodore Deck made large plates in stoneware, to be hung on the wall as ornaments, which were decorated with strikingly beautiful designs of peonies and butterflies (197). Deck follows Japanese

193 Japan
Porcelain plate
Kutani, 17th century
Peony and butterfly ornament
D.26 (10¼)
Tokyo, National Museum

194 Emile Gallé
Bowl
c. 1895
Cased glass with inclusions, enamelled, etched, engraved and carved, butterfly pattern
H.8.6 (3⅜)
Private Collection

195 Royal Danish Porcelain Factory
Butterfly vase
c. 1900
Porcelain, two peacock butterflies painted under the glaze
H.15 (5⅞)
Darmstadt, Hessisches Landesmuseum

196 Japan
Butterfly in flight
c. 1860
From a painters' manual
Woodcut
22.3 × 15.2 (8¾ × 6)
Private Collection

models in the composition as well as the motifs of his designs, arranging his flowers and leaves asymmetrically and placing the butterflies in the areas thus left empty. Deck's favourite technique was to apply his designs in slip and colour them with enamels, resulting in a remarkable brilliance.

The butterfly has a great appeal for the imagination of the people of the Far East (805). Generally speaking, if one finds its way inside a house in Japan, it is considered a lucky sign. The Japanese look on the butterfly as an embodiment of the soul of a dead person, and the presence of a soul in this form is believed to bring luck and protection.[1] On the other hand if a butterfly arrives in a house where someone is dying, this is a bad sign, as it means that it has come to carry off their soul. There is a legend of an old man who lived out his days watching at the graveside of his beloved, until finally a large white butterfly appeared and led his soul away to join the dead. Two butterflies are regarded symbolically as the officiants at a wedding ceremony and as the companions of the young couple setting out upon life's journey, fluttering before them to lead them into a magical flowering garden.[2] Thus the butterfly is a symbol of the realm of dreams as well as of happiness.

197 Théodore Deck
Ornamental plate
c. 1875
Stoneware, *émail cloisonné*,
peony and butterfly
ornament
D.59.7 (23½)
Private Collection

198 Rörstrand
Porcelain Factory
Vase
c. 1900
Porcelain, under-glaze
painting, butterflies
modelled in low relief
Private Collection

199 Utagawa Kuniyoshi
Tiger (detail)
c. 1839
Colour woodcut
70.2 × 24.8 (27⅝ × 9¾)
Regensburg, Collection
Franz Winzinger

200 Ludwig Heinrich
Jungnickel
Tiger's head (detail)
c. 1905
Colour woodcut
36 × 31 (14⅛ × 12¼)
Vienna, Österreichisches
Museum für angewandte
Kunst

201 Japan
Fan with tiger ornament
Repr., Weber, *Ko-Ji Hō-Ten*, II, Paris 1923

The tiger

The tiger was not a native of Japan. It was introduced at the same time as the Buddhist religion, from India and China. It came to symbolize strength. The Japanese believe it to be of divine origin and to have descended to earth from the constellation of the Great Bear. It thus occupies a supernatural place in Japanese mythology, like the phoenix and the dragon, which stands for the living vitality of nature and lives, like the raven, in the sun. The tiger, on the other hand, is the creature of the moon, prowling at night and hiding at sunrise.[1] Its whiskers and claws were considered to have therapeutic powers and were used in the concocting of elixirs.

The tiger is often depicted in the company of the *sennin*, who were elevated by their asceticism to the status of demi-gods. The priest Bukan (Feng-kan in China)[2] is shown riding a tiger. But inevitably, because it is so dangerous, the tiger is also associated with evil and darkness: Japanese devils are represented wearing tiger skins. Yet the most popular of all Japanese ways of depicting the tiger shows it sheltering from the storm in a copse of bamboo trees (206). This symbolizes the impotence of the powerful beast – and hence of the individual – in the face of the might of nature.[3]

Numerous legends testify to the tiger's great wisdom. For instance, the story *Tora no ko watashi* tells of a tigress and how she contrives to transport her three cubs across a broad river. Then there is the tale of the tiger carved in wood, which escaped from a burning monastery on Mount Kapsan and hid itself in the forest so effectively that, in spite of its marauding raids, it was

94

202 William H. Bradley
Two seated leopards
Black ink on white paper
16 × 19.5 (6¼ × 7⅝)
Private Collection

203 Japan
*Ornamental sword guard
with tiger*
Early 19th century
Chased iron, gold inlay
8.2 × 7.7 (3¼ × 3)

204 Japan
Tiger
Tokyo 1862
From a painters' manual
Woodcut
22.6 × 14.8 (8⅞ × 5¾)
Private Collection

205 Utagawa Kuniyoshi
Yōkō (detail)
1853
From *Mirror of 24 Examples
of Filial Piety
(Nijūshi-kō dōji kagami)*
Colour print
21.5 × 34.8 (8½ × 13¾)
Berlin, Museum für
Ostasiatische Kunst

weeks before it was recaptured – a tribute to its intelligence and ferocity, and the myth-making power of its unknowable nature (205).[4]

In China and Korea artists painted large hanging scrolls on which the depictions of the wary, slinking big cats are more than pure artistic statements – they express profound admiration for the animal (206, 207). These were among the models that inspired European painters of the late nineteenth century. The figure of the crouching tiger or leopard is a motif often found in Art Nouveau. The tension expressed in the pose, the feline suppleness, the decorative marking of the coat, the eyes glittering in the wedge-shaped head were depicted again and again in the years around 1900.

Paul Ranson, an associate of the Nabis, took the scrolls of the Far East as his model (as did Hokusai) in the creation of pictures in which the tiger and its setting make a purely two-dimensional pattern (208, 209). The flame-like markings of the tiger's skin form a single entity with the writhing outline of its body and the highly stylized, ornamental background. Ludwig Heinrich Jungnickel was another Western artist to treat the subject; his medium was the colour woodcut, in which he depicts the ferocity of the animal, concentrated in its head (200). Because of this very ferocity, the animal was frequently chosen as the ornament on Japanese sword guards, in the hope of imbuing the wielder with bellicosity and strength, thus bringing him victory (203). In China the tiger ranked as the greatest of all quadrupeds, carrying the sign *wang* ('king') on its brow.[5]

206 Japan
Tiger
Colour woodcut
Repr. S. Bing *Le Japon artistique*, 5, September 1888

207 Korea
Ascribed to Sim Sajon
Tiger
18th century
Hanging scroll
Ink and colours on paper
96 × 55.1 (37¾ × 21¾)
Seoul, National Museum of Korea

208 Katsushika Hokusai
Tiger
1814–78
From *Manga*
Colour woodcut
Facsimile
24 × 25 (9½ × 9⅞)
Tokyo, Yūjirō Shinoda

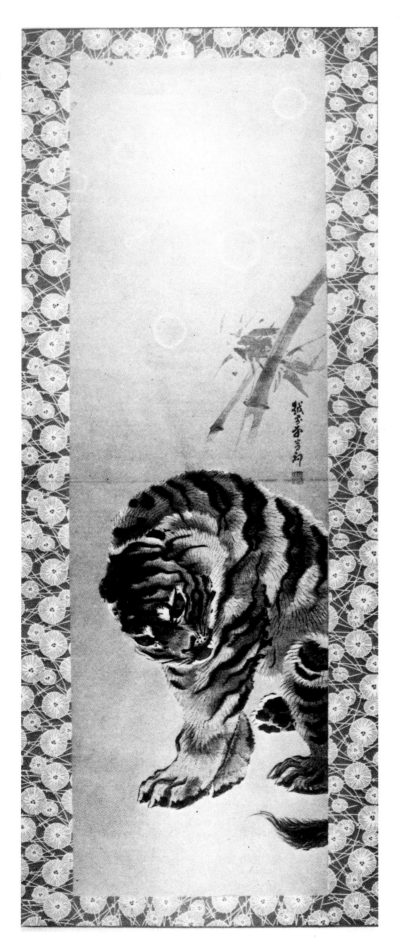

209 Paul Ranson
Tiger in the jungle
1893
Colour lithograph
36.8×28.6 $(14\frac{1}{2} \times 11\frac{1}{4})$
Cleveland, Museum of Art

The cat

In literature and in art, the cat has always been a focus of attention. In ancient Egypt it was worshipped as a god, and when the owner died the cat was killed and mummified too, then buried in its own tomb to make the journey to the underworld.[1] Cats are depicted as creatures of power in Egyptian sculpture and reliefs. East and Central Africa and the Near East are generally supposed to have been the cradles of feline life. The priests of ancient Egypt brought them from Meroe in Southern Nubia, whence they spread further afield.

It was in about the year 1000 when the cat was first introduced into Japan, by way of India and China. It found its métier in temples, hunting the rodents that attacked sacred Buddhist texts. As a newcomer, it attracted attention and admiration at the imperial court. It brought with it into the country all the lore and superstition that had become attached to it in China, and the Japanese imagination soon added more. Cats were believed to be dangerous demons, with the power of transforming themselves into young girls, monks or old

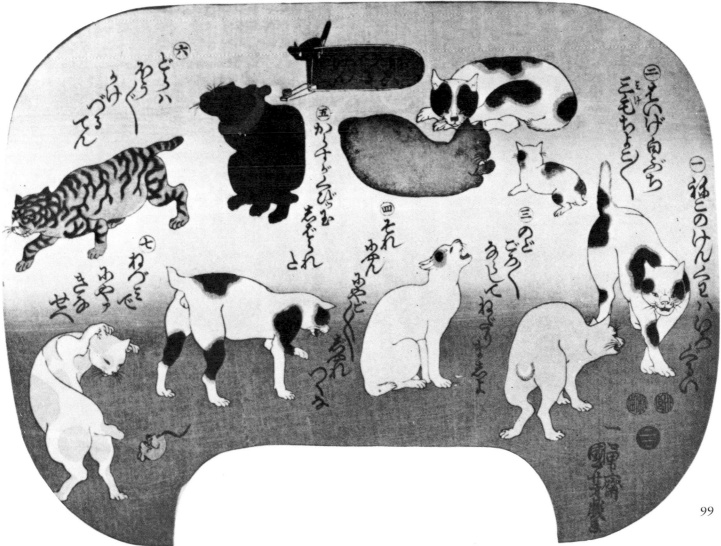

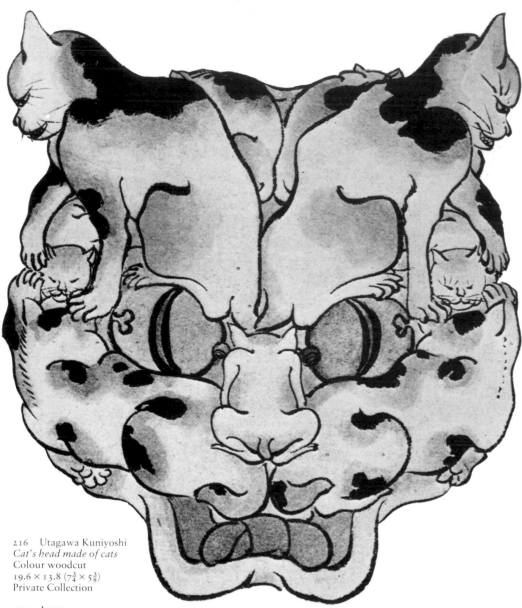

women, in order to deceive ordinary people and cast spells on them. They were also said to gain the gift of speech when they grew old, and somebody who killed one then would gain power over another person.[2] Japanese fishermen even took cats to sea with them, securing them in the crow's nest to give warning of dangerous storms, since they believed that the souls of shipwrecked sailors inhabited the bodies of cats.

The cat was often credited with the same talents as the fox, whose reputation for cunning is not confined to Europe. *Baké-neko* ('Kitty'), was the nickname given to itinerant female singers and musicians, who were regarded as an audacious and artful breed; it was a tribute to their wiles, for they were reputed to be able to make the devil himself dance to their playing.

In Far Eastern countries, the cat was held to possess demonic powers on the one hand, and endearing human characteristics on the other. Monster cats with two tails, which bring bad luck with them, are the protagonists of many legends, such as the story *Hak-ken-den* by Ba-kin. The witch Neko-baké took feline form in order to dine on small children; and two unhappy lovers ran away from their families and were turned into a pair of cats. Conversely, there are Japanese legends that tell of heroic

216 Utagawa Kuniyoshi
Cat's head made of cats
Colour woodcut
19.6 × 13.8 (7¾ × 5⅜)
Private Collection

217 Japan
Sleeping cat
Tokyo 1874
Drawing of a censer (detail)
From a painters' manual,
after the Tosa School
26.3 × 18.5 (10⅜ × 7¼)
Private Collection

218 Aubrey Beardsley
The black cat
Chicago 1894–95
Illustration for *The Works of
Edgar Allan Poe*

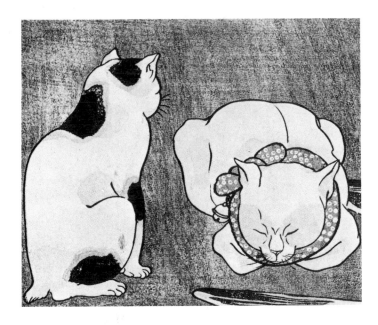

female cats defending their young to the death, and of cats risking their lives in fearful battles against rats who had threatened to harm young girls or priests.[3] Cats in general were seen as showing great compassion towards other species – in fact in more recent times there have been scientifically attested cases of cats suckling the young of hares, and even of rats and mice.[4]

It is not surprising, then, to find that the domestic cat occupies a special place in Japanese block books (216, 228). Hiroshige (232), Hokusai, Utamaro and Kuniyoshi (212, 215) depicted the domestic cat in all its manifold variety of posture and motion: often the accuracy of their observation led them to draw something very close to caricature (216, 219, 222, 224, 231). In the West, children's literature from around 1900 to the 1920s

219 Utagawa Kuniyoshi
Proverbs illustrated by cats
1852
Colour woodcut
39 × 26 (15⅜ × 10¼)
Leiden, Rijksmuseum voor
Volkenkunde

220 Karl Schmidt-Rottluff
Recumbent cats
c. 1910
Watercolour on paper
35 × 55 (13¾ × 21⅝)
Munich, Staatliche
Graphische Sammlung

221 Japan
Censer in the shape of a cat
(cast)
17th century
Bronze gilt
8 × 17.2 (3⅛ × 6¾)
Private Collection

222 Utagawa Kuniyoshi
The actor Ichikawa Kuzō II
(detail)
Colour woodcut
33.5 × 24.4 (13¼ × 9⅝)
Berlin, Museum für
Ostasiatische Kunst

223 Henri de Toulouse-Lautrec
Cat and mouse
1896
Colour lithograph on vellum paper
7.3 × 16.4 (2⅞ × 6½)
On the menu for a dinner given by May Belfort
Private Collection

224 Utagawa Kuniyoshi
Proverbs illustrated by cats
1852
Colour woodcut
39 × 26 (15⅜ × 10¼)
Leiden, Rijksmuseum voor Volkenkunde

225 Edouard Manet
The cat and the flowers
1869
Etching and aquatint
20.3 × 15.2 (8 × 6)
Private Collection

226 Félix Vallotton
The flute
Woodcut on Japan paper
22.4 × 18 (8⅞ × 7)
Lausanne, Galerie Paul Vallotton

included a large number of tales about cats, illustrated in the style of Japanese art.[5] Illustrators of these books needed to possess a precise knowledge of feline motion: the way cats slink along (211), pause and crouch ready to spring; the way they roll themselves into a ball to sleep (217); their manner of seductively rubbing themselves against the human being they want to beguile (212); but also the way they behave with their kittens (215), and the way they revert to the wild when out on the roof at night (230). Their playfulness is something that Japanese artists depicted in countless studies, trying to capture their agility and mobility. A cat playing with a reel of thread is a popular subject (232).

Utagawa Kuniyoshi developed the art of composing picture puzzles, often of a highly surreal nature, out of the shapes of cats (216).

The cat's well-developed sense of smell is the reason why the Chinese used to make incense-holders in the shape of cats (217). These very graceful little figurines had a not inconsiderable influence on the manufacture of European porcelain and earthenware: the early cats made at Nancy by Prouvé and Gallé are an impressive example (214). The Chinese censers in this form were often made in a very simplified shape (221). When cast in bronze they were delicately chased in imitation of the cat's fur, while porcelain cats were often painted. Carl Frederik Liisberg's prowling cat from the Royal Danish Porcelain Factory in Copenhagen[6] has a simplicity of line which illustrates the influence of the Far East on Art Nouveau forms (210).

The French Impressionists, the Nabis and Art Nouveau book illustrators drew cats of all shapes and

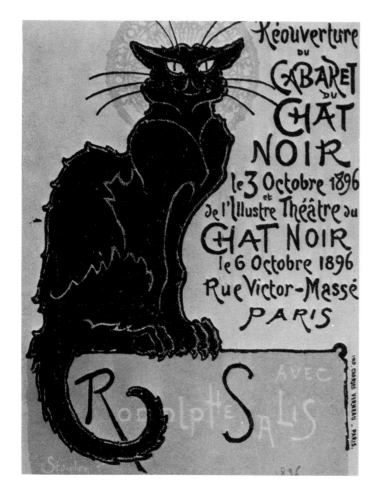

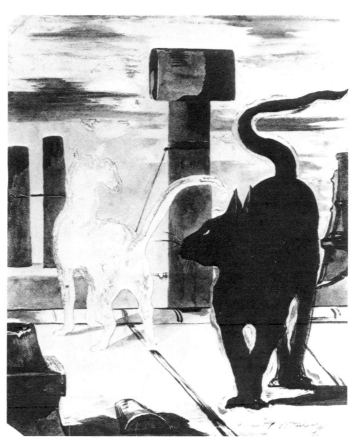

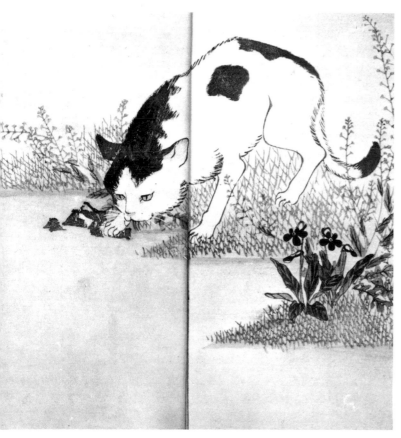

227 Théophile Alexandre
Steinlen
*Poster advertising the
cabaret 'Chat Noir'*
1896
Lithograph, carmine and
black on yellow paper
135 × 94 (53 × 37)
(Paper size 139 × 96:
54¾ × 37¾)
Private Collection

228 Japan
Cat by the water
Tokyo *c.* 1880
From a painters' manual
Colour woodcut
24.7 × 15.2 (9¾ × 6)
Private Collection

229 Edouard Manet
Cats (detail)
1868
Black chalk on white paper
12.8 × 9.7 (5 × 3¾)
Paris, Louvre, Cabinet des
Dessins

230 Edouard Manet
Cats' rendezvous
1868
Brush drawing and wash
43 × 34 (16⅞ × 13⅜)
Private Collection

231 Utagawa Kuniyoshi
Proverbs illustrated by cats
1852
Colour woodcut
Ōban
39 × 26 (15⅜ × 10¼)
Leiden, Rijksmuseum voor
Volkenkunde

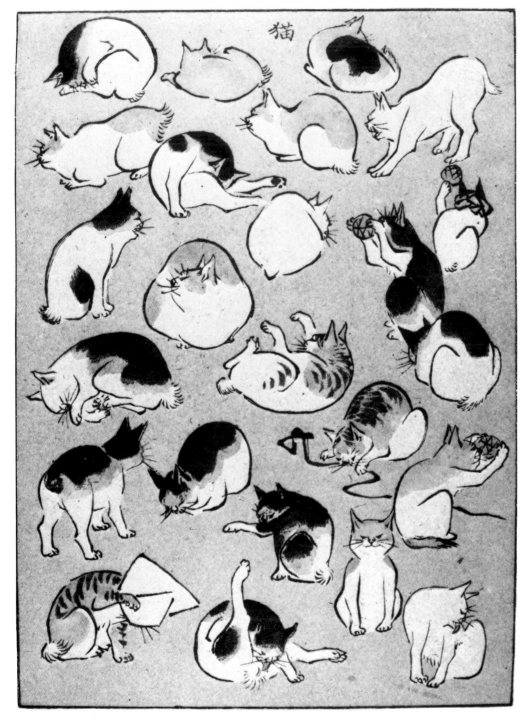

sizes. Manet took cat studies by Andō Hiroshige as a model for his own studies of feline movement and pose (232, 233). He sketched cats on the pages of letters to his close friends.[7] He was very successful in capturing the essential characteristics of the animal. His drawing of cats meeting on a roof, in the manner of Grandville, is very poetic (230). He intended the picture for use as a poster publicizing a book on cats by his friend Champfleury. Manet provided the other illustrations in the book as well, lithographs executed in a style lacking in perspective depth, so that the cats stand out in silhouette against a dark or light background, and the overall impression is of a world of fable and fantasy.

The cat drawn by Aubrey Beardsley in his illustration to Edgar Allan Poe (218) emphasizes the animal's symbolic associations. The black, satanic, male cat was a fabulous being in Japanese legend, and returned in the same guise to Europe in the symbolism of Art Nouveau.

232 Andō Hiroshige
Cat studies
Woodcut
Repr. S. Bing, *Le Japon artistique*, 24, April 1890

233 Edouard Manet
Cats (detail)
1868
Etching
17.6 × 21.8 (7 × 8½)
Chicago, Art Institute

234 Félix Vallotton
Cats
Berlin 1895
Vignette in *Pan*
Woodcut
Private Collection

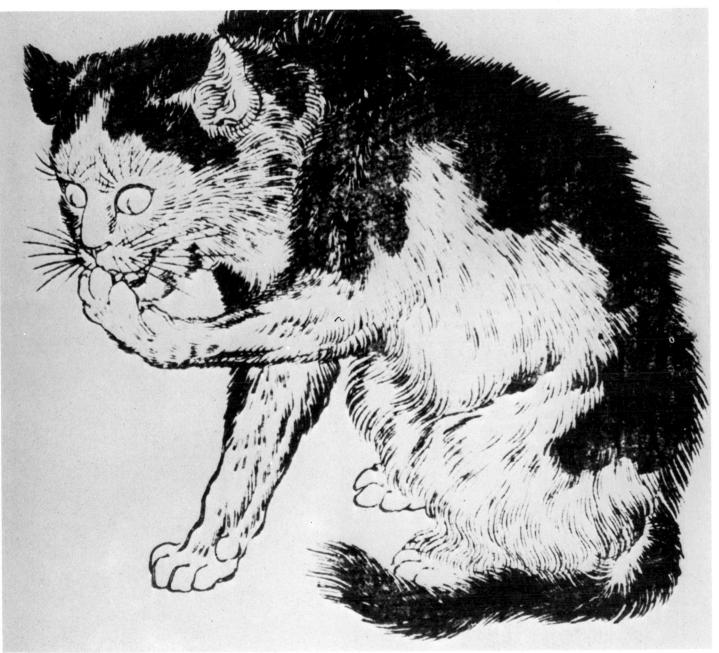

235 Edouard Manet
Two cats
1868
Pencil on paper
14.8 × 10 ($5\frac{7}{8}$ × 4)
Paris, Louvre, Cabinet des
Dessins

236 Japan
Cat
Tokyo 1886
Colour woodcut
18.7 × 12.5 ($7\frac{3}{8}$ × 5)
Private Collection

237 Emil Rudolf Weiss
Cats
1899
Black ink on white paper
6 × 12.4 ($2\frac{3}{8}$ × $4\frac{7}{8}$)
Repr. *Pan*, 1899

238

Waterfowl

Water birds are to be found all over the globe. In China the wild duck was always crossed with the domestic variety. Ducks, and to a lesser extent geese, feature prominently in Far Eastern stories and fairy tales. The Japanese, though fond of various species, had a special love of the mandarin duck, with its tuft of feathers on the head, mane-like collar on the sides of the neck, and fan-shaped wing tips sticking up vertically on the back. The mandarin duck was also known in China. The shelduck – midway between a goose and a duck – and the mallard, with its brightly coloured plumage, were popular among Japanese painters and woodcut artists (238). Chinese and Japanese painters produced consummate works on the theme of ducks, swans, and geese seen against the setting sun or caught in the motions of flight (265, 579, 645).

The duck is strictly monogamous and for this reason was used in the Far East as a symbol of conjugal love and fecundity.[1] Bronze wedding jugs in China and Japan were made in the shape of a mallard or mandarin duck. A favourite wedding present in China was a solid cast gold or silver goose (242). Painters observed waterfowl closely and portrayed them and their daily quest for food with scrupulous accuracy (238). Far Eastern animal books devote many pages to them.[2] The noble curve of the neck, the rich patterning of the plumage, and the iridescent colour of the drakes were a never-ending source of pictorial inspiration. Japanese New Year greetings cards (*surimono*) frequently carry paintings of waterfowl.[3] This iconography then made its mark on

239

240

241

242

243

244

245

246

Western art in pottery, terracotta figures, and cast metal objects.[4] Nineteenth-century Japanese painting manuals, which reached Europe via the international exhibitions, further contributed to the spread of this concise, elegant pictorial subject.[5]

The swan became a kind of mascot of the European Art Nouveau movement (243, 245). Ornamental as it is in reality, its impact on European illustrative art – which lasted well into the 1920s and led to a new conception of how to render living forms in the realm of animal art – was due primarily to the simplifying vision of the Japanese.

242 Haruaki
Wild goose asleep
c. 1850
Gold
H.3.2 (1¼)
Washington, D.C., courtesy of the Freer Gallery of Art

243 Emile Decoeur
Swan
c. 1905
Stone, running glaze
H.42.5, L.21 (16¾ × 8¼)
Starnberg, Collection Helga Schaefer

244 Japan
Wild goose in reeds
Tokyo 1858
From a painters' manual
Colour woodcut
24.7 × 16.8 (9¾ × 6)
Private Collection

245 Otto Eckmann
Two swans
c. 1900
Colour woodcut
16.7 × 33.4 (6 × 13)
Berlin, Ehem. Staatl. Museen in Berlin, Kupferstichkabinett

246 Katsushika Hokusai
Wild geese
1814–78
From *Manga*
Colour woodcut
25 × 17 (9⅞ × 6¾)
Repr. S. Bing
Le Japon artistique, 8
December 1888

Birds of prey

Mythology gives the hawk special status: it is a divine being.[1] In Japan when seen with Mount Fuji it is a symbol of good luck (247). Hawking came to Japan as a result of Chinese pictures which themselves went back to Persian falconry. Many Far Eastern depictions of hawks are known in Europe – above all screens showing them on their perches. Specific birds of prey are also depicted in Japanese painting manuals and in Hokusai's *Manga*.[2] The compact, well-proportioned bodies and powerful beaks are striking; long pointed wings rhythmically striped and speckled lengthways on the underside (the second flight-feather is the longest) convey nobility. This manner of depicting wings led to a kind of plumage motif which was later developed into a pattern of decoration (1066–73).

In legend hawks are dazzling birds, often contrasted with the dusky coloured eagle.[3] According to Homer the hawk was the swift messenger of Apollo, and in Egypt it was held to be sacred: a hawk enclosed in a square was the symbol of the goddess Hathor.[4] In Andō Hiroshige's polychrome woodcut *Yumantsubo in the snow* from *A Hundred Views of Famous Places in Edo* the plummeting hawk is portrayed in all its mythical grandeur. The

250 Hanabusa Itchō
Hawk
Woodcut
Repr. S. Bing
Le Japon artistique, 15
July 1889

251 Japan
Hawk
Repr. S. Bing
Le Japon artistique, 15
July 1889

252 Katsushika Hokusui
Hawk
1834
Woodcut by Hokusai
Repr. S. Bing
Le Japon artistique, 16
August 1889

gleaming bird hovers above the snow-covered earth in a star-spangled sky (247). Carl Czeschka takes the theme of the stooping hawk from Hiroshige and complements it with a second bird (249). The feather patterning, which recurs with slight variation in the Japanese woodcut, was also developed as a stylistic motif by Bonnard (pp. 388–89).

Peter Behrens strives to bring together the decorative power of the wings and the landscape setting. The arabesque achieves greater graphic clarity through Japanese influences on Art Nouveau (248).

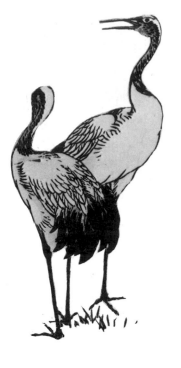

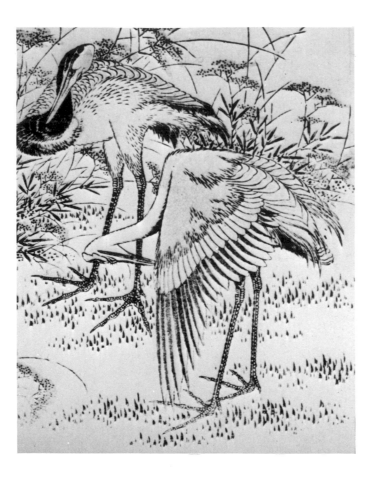

253 Japan
Cranes (detail)
Tokyo 1878
From a painters' manual
Woodcut
24.9 × 16.8 (9¾ × 6)
Private Collection

254 Katsushika Hokusai
Cranes
Woodcut
Private Collection

255 Minton china
Crane
c. 1880–90
Tile, glazed stoneware
H. 60, w. 20 (23.5 × 8)
Karlsruhe, Badisches
Landesmuseum

256 Japan
Crane
Woodcut
Repr. S. Bing
Le Japon artistique, 22
February 1890

257 Walter Klemm
Heron
c. 1905
Woodcut
44 × 33.5 (17⅞ × 13¼)
Private Collection

258 Japan
Heron
Fan
Woodcut
Repr. S. Bing
Le Japon artistique, 23
March 1890

Cranes and herons

In Japan the crane is the pictorial symbol of long life. It accompanies the Sen-nin Rin-na-sei or bears the god Teirei in its wings.[1] With a pine branch in its beak, the crane flies over Horaizan, the heavenly land of the blessed in the eastern sea. Herons of all kinds – the great white, the large egret – often congregate in public places together with cranes, as they are extremely sociable by nature. Herons have those long, streaming feathers that are so sought after as ornaments for wedding dresses. The stork also belongs to the heron family (260). Towards evening, at the beginning of the hunting season, the flocks of herons and cranes become very agitated. Far Eastern painters produced numerous scenes showing their constant up-and-down motion of flight and landing (579). Diagonal lines of flight (262, 263), mute swan formations (266), wild ducks and geese (265) were also favourite subjects.

The quest for long life and happiness among the peoples of the Far East, especially in the early Chinese civilizations, engendered a need for symbols and targets for their hopes. These ideals they thought to find in certain creatures such as the tortoise, the crane, or the deer, which seemed to them both to live long and to be happy in their existence.[2] Because of their happy significance, these birds were depicted in an endless variety of ways.

In this respect the crane had even more positive qualities to recommend it than the heron. It was adopted as a symbol of vigilance, and was indeed used by Japanese peasants as a guardian to watch over their poultry and fish. The crane assumed the role of the farm dog, though with greater responsibilities and with greater devotion to its duties. Japanese families honoured it as a bringer of good luck because of its courage and alertness.[3] Usually these creatures accompany the venerable old Yurojin – a figure from ancient Chinese mythology, represented as a wise old man with an oversized, gourd-shaped head, white hair, and staff with scroll of life. His companion crane passes through the phases of a gradual divine maturation process, which culminates, after blue and white cranes, in the black crane which lives for two thousand years (259).

It is for such reasons that the walls of temples and houses – and even objects (258, 264) given as wedding presents – were commonly decorated with pictures of cranes. Cranes are well known for becoming very affectionate in captivity. Stories tell of their boldness in combat: for example, the legend of the crane's victory over the pygmies.[4]

Of all flowers, the lily was the predominant motif of the international Art Nouveau movement; and when it came to animals and birds the crane enjoyed the same pre-eminence. Naturally graceful and decorative in shape, it is perfectly suited to flat surfaces, and its feathers gleam brightly against a dark background (255, 257).

259 Japan
Cranes
After Japanese free-hand
drawings
Heliograph
27.8 × 21.2 (11 × 8¾)
Popular edition by M.
Hessling Verlag
Leipzig, 1885

260 Théodore Deck
Bowl
1875–80
Faience, slip painting
Flying cranes with rushes
and flowers on light
turquoise ground
H.12.4 (4⅞)
Private Collection

261 René Lalique
Vase
c. 1910
Flat bottom, spherical,
opaque, colourless glass
H.16.2 (6⅜)
Private Collection

262 *Ver Sacrum*
Detail of Cover
Year 2, Vol. 9
Vienna 1898–1903

263 Walter Leistikow
Flying cranes
1899
From *Pan*
Colour lithograph
21.5 × 27.6 (8½ × 10⅞)
Private Collection

264 Japan
Dish
Seto ware 19th century
Porcelain with white ground
and white glaze, painted
with blue under-glaze, rust
red and gold. Close pattern
of cranes and pine branches
H.8, d.53 (3⅛, 20⅞)
Vienna, Österreichisches
Museum für angewandte
Kunst

265 China (ascr. to Ma
Fēn)
A hundred wild geese
Southern Sung dynasty
(1127–1279)
India ink and colour on
paper
127 × 43 (50 × 16⅞)
Honolulu, Academy of Arts

266 Japan
Wild duck in flight
Tokyo 1858
From a painters' manual
Colour woodcut
24.7 × 16.8 (9¾ × 6⅝)
Private Collection

Cock and hen

In China and Japan the cock symbolizes high esteem and is often depicted with peonies, which stand for spring and point to a happy future.[1] Phoenix cocks were bred in China and Japan. These are noble, proud creatures with long, lustrous tail feathers and dignified manner. Cocks were kept at imperial courts, and major Chinese and Japanese painters portrayed them; the cock reappears continually in late *surimono* art too.[2] The bizarre silhouette of this bird excited the attention of calligraphers and attracted European illustrators and painters, who developed numerous pictorial motifs after Chinese and Japanese models.

Through old legends and cults, the cock also acquired religious significance. According to one Chinese tale dating from the regency of Emperor Yao – who with great wisdom and skilful foreign policy managed to maintain peace in his empire for many years – it symbolizes peace. The great gong that hung at the gate of the imperial palace ready to summon the soldiers to arms remained unused in Yao's reign, and served only as a favourite shelter for the cock and his hens[3] – and so the power of peace became vested in the behaviour of these birds. Another story relates the ingenious escape of Yao's son from imprisonment in a fortress, involving a servant imitating a cock crowing.[4]

The cock, as holy bird in the I-sé temples of the god Ama-teras, summoned the sun to rise every morning.[5] In the fifth century it became a symbol of martial strength, through the popular court entertainment of cock-fighting.[6]

267 Ferdinand Andri
Cock and hens in meadow
(detail)
1903
Colour woodcut
16.6 × 15.5 (6½ × 6⅛)
Private Collection

268 Théodore Deck
Plate
c. 1875/85
Faience
Cock and hen with branch of flowers (after Hokusai)
D.41.3 (16¼)
New York, Private Collection

269a Pierre Bonnard
Standing cock (detail)
1904
Illustration to Jules Renard
Histoires Naturelles
Lithograph
23 × 18 (9 × 7⅛)
Paris, Bibliothèque Nationale

269 Henri de Toulouse-Lautrec
Cocks (detail)
1899
Black drawing
23 × 17.3 (9 × 6¾)
Private Collection

270 Japan
Cock and hen
Dyer's stencil
Meiji period (1868–1912)
Paper
42.2 × 58.6 ($16\frac{5}{8}$ × $23\frac{1}{8}$)
Vienna, Österreichisches
Museum für angewandte
Kunst

271 Ōoka Shumboku
Cock on bamboo pole
Woodcut
Repr. S. Bing
Le Japon artistique, 9
January 1889

271a Utagawa Toyohiro
Cock and hen
Woodcut
Repr. S. Bing
Le Japon artistique, 21
January 1890

272 Carl Thiemann
Cock
1907
Colour woodcut
28 × 28 (11 × 11)
Private Collection

273 Japan
The imperial cock
Tokyo 1864
From *mon* book
21 × 14 (8¼ × 5½)
Private Collection

The raven

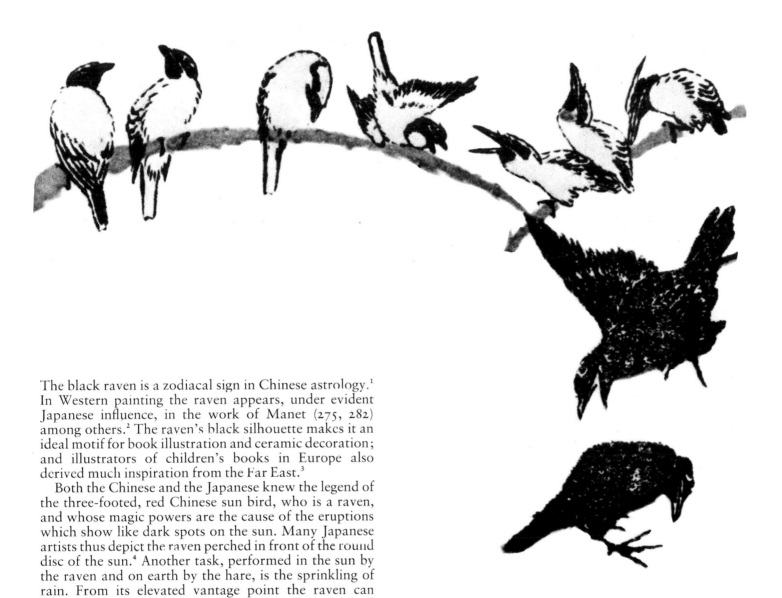

The black raven is a zodiacal sign in Chinese astrology.[1] In Western painting the raven appears, under evident Japanese influence, in the work of Manet (275, 282) among others.[2] The raven's black silhouette makes it an ideal motif for book illustration and ceramic decoration; and illustrators of children's books in Europe also derived much inspiration from the Far East.[3]

Both the Chinese and the Japanese knew the legend of the three-footed, red Chinese sun bird, who is a raven, and whose magic powers are the cause of the eruptions which show like dark spots on the sun. Many Japanese artists thus depict the raven perched in front of the round disc of the sun.[4] Another task, performed in the sun by the raven and on earth by the hare, is the sprinkling of rain. From its elevated vantage point the raven can contemplate the earth and all its hustle-bustle and philosophize in peace and quiet.[5]

A story tells of the famous Tenno Jim-mu, whom the Shintoists venerate as a demigod. On a military campaign in a foreign country he and his troops were safely led through unknown enemy territory by a giant raven.[6] This legend illustrates the most common significance of the raven – as the messenger of the gods. This accounts for the many representations of ravens, both sculpted and painted, that are to be found in Japanese monasteries.[7]

Despite all these essentially positive characteristics, the raven was also, as in medieval Europe, a bird of ill-omen: thus it came to be the denizen of places of execution, of mist, and of darkness. For the Japanese the night cry of the raven meant bad news: it announced that somewhere a great fire had broken out.[8]

274 Katsushika Hokusai
Birds
1814–78
From *Manga*
Colour woodcut
24 × 15 (9½ × 5⅞)
Private Collection

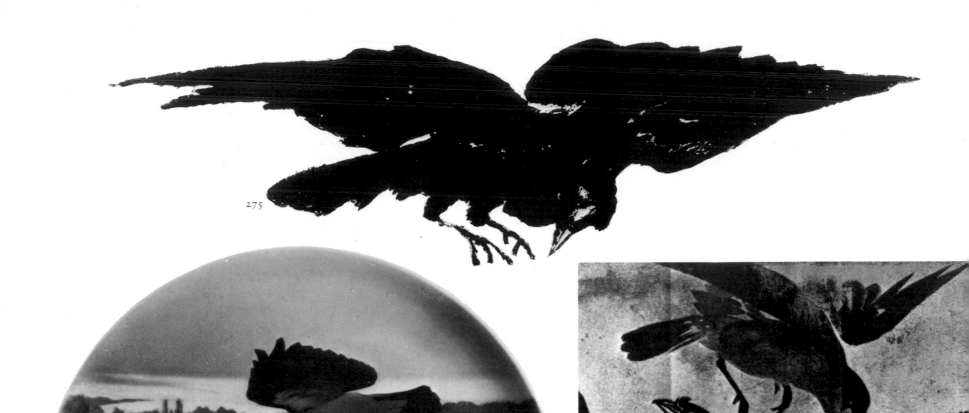

275

276

277

278

275 Edouard Manet
The raven
India ink on paper
6 × 24 (2⅜ × 9½)
Ex libris for Edgar Allan Poe
Cat. Alain de Leiris, No. 440

276 Carl Frederik
Liisberg
Decorative plate
c. 1900
D.29.7 (11¾)
Royal Copenhagen
Porcelain factory
Berlin, Staatl.
Museen Preussischer
Kulturbesitz,
Kunstgewerbemuseum

277 Japan
Raven in flight (detail)
Woodcut
Repr. S. Bing
Le Japon artistique, 22
February 1890

278 Japan
Three ravens
Kyōto 1865
Woodcut
Private Collection

279 Tsuda Seifu
Raven in the snow
1904
From *Small Collection of
paintings*
Colour woodcut
24 × 36 (9½ × 14⅛)
Private Collection

280 Haida glass, North
Bohemia
Cylindrical vase
c. 1910
Engraved circles, stylized
branches with ravens etc.
Black and gold
H.17.4, d.11 (6⅞, 4⅜)
Nuremberg,
Landesgewerbeanstalt

281 After Ogata Kōrin
Crows
Woodcut
Repr. S. Bing
Le Japon artistique, 23
March 1890

282 Kawanabe Kyosai
Two crows on a branch
(detail)
c. 1870
Colour woodcut
74.9 × 25.7 (29½ × 10⅛)
London, Victoria & Albert
Museum

283 Edouard Manet
The raven
1875
Black chalk on paper Cat.
Alain de Leiris No. 437

279

280

281

282

283

284　Carl Strathmann
Attacking fish
c. 1895
Pen, mixed technique on
paper
31.6 × 45.3 (12½ × 17⅞)
Private Collection

285　René Lalique
Spherical vase
Leaping fish
H.9.6, d.9.4 (3¾, 3¾)
France
Private Collection

286　Japan
Fish
Dyer's stencil
Meiji period (1868–1912)
Paper
42 × 58.6 (16½ × 23⅛)
Private Collection

287　Nora Exner
Fish
1903
Colour woodcut
18.4 × 16.3 (7¼ × 6⅜)
Offprint from *Ver Sacrum*
Private Collection

288　Hermann Gradl
Fish service (plate)
1904/5
Porcelain with green and
violet under-glaze, gilded.
Scalloped edge
Nymphenburg porcelain
Zürich, Kunstgewerbe
Museum

289　Japan
Wild carp
Woodcut
Repr. V. F. Weber
Ko-Ji Hō-ten I
Paris 1923

The wild carp

Well over four hundred kinds of fish – of greatly varying types and, above all, shapes – are to be found in Japan. The iconography of fish is comprehensive, and the zoological works are impressive both scientifically and artistically. For centuries Japan has recognized that this vast supply of fish is its most vital asset for survival.

Fresh waters inland contained an enormous variety of fish. In them lurked the divine wild carp (286, 289). The leaping salmon was also revered. Jugs and vases in semi-precious stone (292, 293) or bronze were often made in the form of leaping carp or salmon. These were intended as brush holders, and ultimately became symbolic of the poet, scholar or calligrapher. The *shachihoko*, similar to a dolphin (whose head becomes a demon's mask), is often to be seen rippling along the roof ridges of large castles in Japan.[1]

The illustrations show how strongly the Art Nouveau artists identified with Japanese fish pictures. Georges Despret (294) and Ernest Baptiste Leveillé (291) developed the theme of leaping fish along Far Eastern lines, replacing the semi-precious materials with glass. Carl Strathmann conveys the wildness and glistening colours in his picture *Attacking fish* (284). Nora Exner reveals the surface relationship between water and animate bodies in her colour woodcut (287), and

Hermann Gradl finds inspiration in Japanese dyer's stencils for the pattern on his 'Fish' dinner service (288). René Lalique created many variants on the theme of the leaping fish on highly decorative spherical vases (285).

The wild carp has long been, and remains, a symbol of courage and strength. Its symbolic significance stems from the life it has to lead in its natural habitat, constantly struggling against turbulent, rushing streams with eddies and waterfalls, and from the resulting homage rendered to it in Chinese legend.[2] The story tells how a carp once, after a tremendous effort, succeeded in leaping up a waterfall. As soon as it had done so, it was turned into a dragon, and from that day forth it possessed almost godlike power.[3] There is a saying that every carp that leaps the Ryu-mon Falls becomes a dragon. This process of transformation is a kind of allegory of the spirit achieving liberation from the world of the finite.[4] The carp is therefore often used as a talisman for good fortune and wealth.[5]

As well as standing for strength of will, the life force, and energy, the carp is also a symbol of fertility. On Boys' Day, all families in which a son has been born during the past year attach a large brightly coloured paper carp with open mouth to a pole, so that it dances in the wind (290).

290 Andō Hiroshige
Boys' Day in Suidobashi
1857
From *100 Views of Famous
Places in Edo* (*Meisho Edo
hyakkei*)
Colour woodcut
35 × 22.5 (13¾ × 8⅞)
Cologne, Museum für
Ostasiatische Kunst

291 Ernest Baptiste
Leveillé
Vase with leaping carp
c. 1895
Coloured, mould-blown
glass with gold leaf
H.30.5 (12)
Private Collection

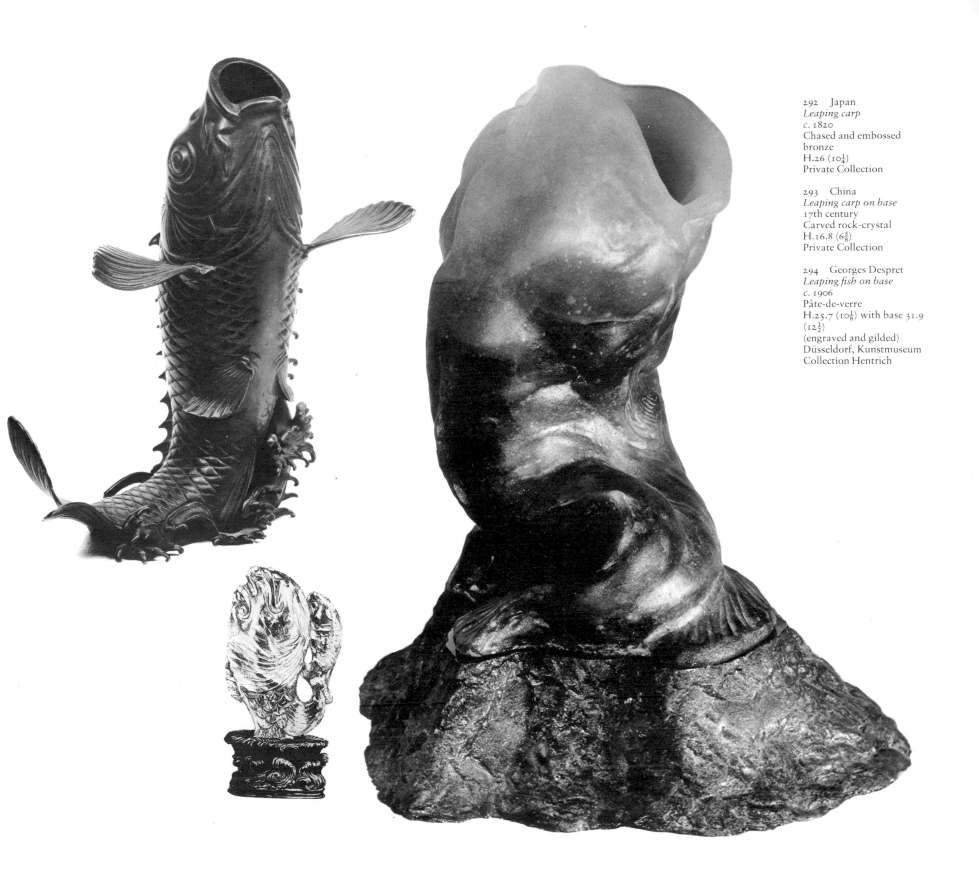

292 Japan
Leaping carp
c. 1820
Chased and embossed
bronze
H.26 (10¼)
Private Collection

293 China
Leaping carp on base
17th century
Carved rock-crystal
H.16.8 (6⅝)
Private Collection

294 Georges Despret
Leaping fish on base
c. 1906
Pâte-de-verre
H.25.7 (10⅛) with base 31.9
(12½)
(engraved and gilded)
Düsseldorf, Kunstmuseum
Collection Hentrich

295 Emile Gallé
Bowl with foot
1904
Cased glass
Dragon-fly cut in relief
H.14 (5½)
Private Collection

296 Japan
Cicada on a Japanese cypress
(detail)
From a painters' manual
Tokyo 1878
Woodcut
18 × 12 (7⅛ × 4¾)
Private Collection

297 Japan
Cicada (detail)
Tokyo 1878
From a painters' manual
Woodcut
18 × 12 (7⅛ × 4¾)
Private Collection

298 Vincent van Gogh
Studies of three cicadas
July 1888
Pen and ink
17.5 × 18 (6⅞ × 7⅛)
Amsterdam, Stedelijk
Museum

Insects

In 1787, Kitagawa Utamaro brought out, in imitation of
the Chinese *Mustardseed Garden*,[1] his colour woodcut
book *Illustrations of Selected Insects* (*Ehon mushi
erami*), and at the same time announced the forthcoming
publication of three other works on birds, mammals,
and fishes.[2]

The Japanese people had always shown an awareness
of the cosmos as a whole and an appreciation of
everything that life had to offer. Yet Japanese artists also
saw the world from very close to – a vision described as
'under the elbow' in Japan.[3] *Mushi erami* or *mushi erabi*
means 'selection of insects', and refers to a custom at the
imperial court in Kyōto. According to tradition it was
customary to collect chirping insects and present them in
little cages to the emperor as a gift – a wonderful
chirruping would then fill the rooms of the palace at
night when the moon shone and the emperor stepped out
onto his terrace to gaze at the stars.[4]

European artists were brought closer to this realm of
beauty by the precise and scientific insect studies of the

299 Katsushika Hokusai
*Kikyo bell-flower and
dragon-fly*
1830
Colour woodcut
25.3 × 37 (10 × 14⅝)
Private Collection

300 Emile Gallé
Vase
1895
Cased glass
Dragon-fly etched in relief
H.26.8 (10½)
Private Collection

301 Edouard Manet
Dragon-fly (detail)
1874
Book illustration for a poem
by Charles Cros
5.3 × 5.8 (2⅛ × 2¼)
Private Collection

Chinese and Japanese; all the more so since such a theme had hitherto been virtually excluded from consideration by European art.

Manet chose the dragonfly,[5] with its delicate filigree wings, as the motif for a book illustration (301), following in the footsteps of the Japanese woodcut masters. Later, Van Gogh made a pen-and-ink study of cicadas (298). No longer was painting exclusively a matter of atmosphere, a sense of openness creating its own kind of space, as it had been for the first generation of French Impressionists: it now focused on the smallest visible creatures in our environment, the insects.

Emile Gallé repeatedly used the dragonfly as a decorative motif for vases (295), often over life-size (300), and it was admired by the Symbolists. Gallé had seen Japanese botanic and zoological textbooks and had taken animals and plants from them.[6]

The impact of Japanese painters on European artists was decisive. One consequence, in the first quarter of the twentieth century, was the insect book with its wealth of detailed studies showing the Japanese influence. One volume of poems exerted a considerable influence on the use of the dragonfly motif under Eastern inspiration. This book contained eighty-seven Japanese poems translated into French under the title *Poèmes de la libellule* and appeared in 1885. It was illustrated by the Japanese artist Yamato, who had established contact with the editor, Théophile Gautier's daughter Judith – more or less the 'agent' for Far Eastern literature in France around 1880. The book reached a wide public and was a demonstrable stimulus to the popularity of the dragonfly theme.

The *wave*

302 Bruno Paul
*Dream of a modern
landscape painter
(Kandinsky)* (detail)
1897
For *Simplizissimus*
India ink with white
highlights
watercolours, charcoal
40.9 × 30.1 (16⅛ × 11⅞)
Munich, Staatl. Graphische
Sammlung

303 Franz M. Melchers
*Decorative title page for
Poèmes par Thomas Braun*
1897
Colour woodcut
Private Collection

304 Ogata Kōrin
*Inkstone case with wave
pattern* (detail)
25 × 16 (9⅞ × 6¼)
Tokyo, National Museum

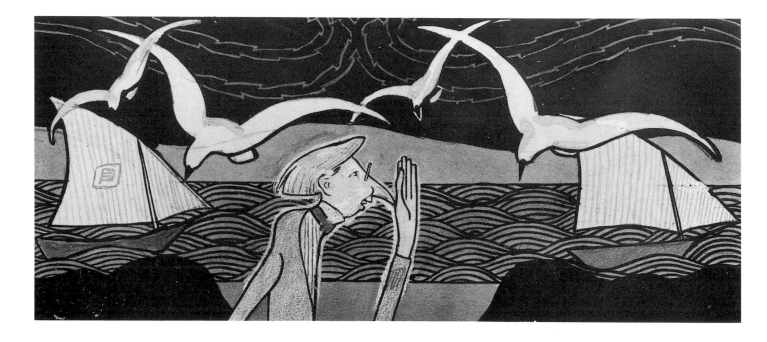

The wave as a pictorial theme and ornamental pattern in Japanese art had a profound impact on European painting, graphic art, and applied arts in the second half of the nineteenth century.[1] The highly stylized wave formula underwent an intensification of decorative force in Europe, especially in the Art Nouveau movement, so much so that for a time it was the single distinctive feature of one style of that movement, the *Wellenbandstil* ('Wavy Ribbon Style').[2]

Two basic forms are directly traceable to the common stock of stylistic motifs in the Far East. First of all we have the heterogeneous, sweeping wave of Ogata Kōrin (330): this conveys movement through a sort of floral decorative design, and can be traced back to the broad wave line (342). The second form must be seen as essentially rather more decorative. It is related to the Japanese *mon*, and in its stylization leads to the heraldic emblem. The motifs of the crest of the wave and of individual swirling eddies both belong to this form, and both lend themselves to quasi-geometrical treatment.[3] From the great Chinese masters to the late Japanese *ukiyo-e* designers, interest in outline forms remained constant.[4]

The wave as the subject of a painting is perhaps best known in Katsushika Hokusai's woodcut *The great wave off Kanagawa* (308). The large-scale ornamental theme of the foaming wave was not new to the Japanese,

305 Japan
Waves
Tokyo 1856
From a painters' manual
Woodcut
22.7 × 15 (8⅞ × 5⅞)
Private Collection

306 Jōō
Casket
After 1817
Wood, gold dust lacquer with gold and coloured lacquer relief, inlaid mother-of-pearl
Top of lid: rock in sea with pines and flying cranes
Inside of lid: flowering prunus and moon
18.5 × 15 (7¼ × 5⅞)
Vienna, Österreichisches Museum für angewandte Kunst

307 Japan
Plate
Porcelain, under-glaze
Prunus and waves
D.26 (10¼)
Private Collection

127

as it had already appeared on splendid screens in the Muromachi period (1336–1573) (325).[5] Hokusai's woodcut presents a remarkably stylized view of nature. Reality is codified in a single, frozen pictorial image which is yet eloquent of the boundless sea.

Hokusai's celebrated wave did not become so popular simply on account of its superb draughtsmanship: the theme itself is powerful and impressive, and comprehensible to all peoples and cultures. This woodcut had a formative influence on the wave painting of generations of painters. Japanese art developed a perfect system for rendering living representations of the phenomena of physical nature. This detailed form of painting – exclusive observation of natural objects in isolation, and

study of them from all angles – was itself a means of exploring nature.

European painters and graphic artists (and industrial artists too) produced many variations on the wave theme around the turn of the century.[6] Henri Jossot (1866–1951), who later changed his name to Abdul Karim Jossot on becoming a convert to Islam, was one highly individual graphic artist and painter in France during the Art Nouveau period. He worked mainly as an illustrator on the Paris publications *L'Estampe originale*, *Le Rire*, and *La Plume*. As a popular artist he was able to produce witty, stylized drawings and caricatures. In *The oarsman* (310) he achieves a bold parody of Hokusai's *Wave*, which at the time was arousing rapturous

309 France
The wave
c. 1900
Gold and paint on wood
72×163 ($28\frac{3}{8} \times 64\frac{1}{8}$)
Paris
Private Collection

310 Henri Jossot
The oarsman
Woodcut
37×32 ($14\frac{5}{8} \times 12\frac{5}{8}$)
Munich, Private Collection

129

311 Arnold Emil Krog
Sea and gulls
1888
Hard-fired porcelain
cylindrical vase, painted all
over with under-glaze
technique
H.36 (14⅛)
Royal Copenhagen Porcelain
Factory

312 Andō Hiroshige
*The great wave on the beach
of Satta-Sunshu in Suruga
Province*
1858
From 36 *Views of Mount
Fuji (Fuji sanjūrokkei)*
Colour woodcut
34 × 23.8 (13⅜ × 9⅜)
Regensburg, Collection
Franz Winzinger

313 Ernest Chaplet
Vase with wave decoration
19th century
Stoneware, light grey
ground, partially unglazed,
the bottom part green,
greenish-blue glaze, white
foam (kaolin clay –
barbotine enamel technique)
H.21 (8¼)
Copenhagen, Danish
Museum of Arts and Crafts

enthusiasm in Europe. Using a basically similar motif, he
draws it out into a large arabesque, which gives a kind of
poster effect. The unifying colour tone and the linear
strands of the waves, which link every part of the picture,
are well adapted to the content of the print. The giant
wave is knocking a man out of his boat; and so the
technique of cutting off the figure at the edge of the
picture is correspondingly exaggerated.

Georges Lacombe (1868–1916) also gives a detail of a
breaking wave (321) which is clearly influenced by
Japan. Totoya Hokkei, under the influence of Hokusai,
had already produced wave pictures that are even more
exaggerated close-ups, but his intention was illustrative
(319). Hokkei renders his waves more ornamental than
Hokusai, and it may have been this that prompted
Lacombe to make *his* wave study more two-
dimensional. Here we have a detail of a wave (321) seen
both realistically and yet at the same time decoratively.
Similar studies of breaking waves are to be found in
volume 7 of Hokusai's *Manga*.[8] Lacombe, who worked

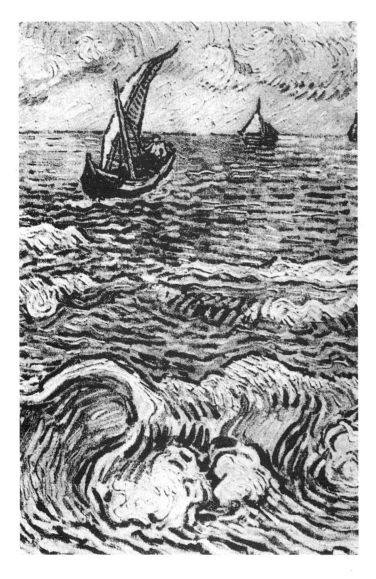

314 Vincent van Gogh
The sea at Saintes-Maries
(detail)
June 1888
Oil on canvas
44 × 57.5 (17⅞ × 22⅝)
Otterlo, Rijksmuseum
Kröller-Müller

315 Totoya Hokkei
Mekari festival
(Holy ritual of cutting
seaweed in Nagato)
1830
From *Famous Places from*
Different Provinces
(Shokoku meisho)
Colour woodcut
17.5 × 38 (6⅞ × 15)
Private Collection

316 Maruyama Okyo
Screen with dragon and
wave pattern (detail)
c. 1780
Gold and colours
Tokyo, Private Collection

317 Japan
Waves
From a painters' manual
Tokyo 1883
Woodcut
18 × 12 (7⅛ × 4¾)
Private Collection

with Sérusier and who owed much to Gauguin's art, made numerous paintings of the Brittany countryside and coastline.[9] The great store of Japanese sea and wave pictures had by then exercised a lasting influence in France. Lacombe's wave 'still-life' is a typical variation on the theme. Lacombe[10] introduces odd peacock-feather-type decorative motifs into his surf. The curling outline of the wave is contrasted with its atmospheric background – an opposition which the Japanese often included in their works. However, the origins of the genre go back to the large folding screens of Ogata Kōrin.[11] On these the leaden rhythms of the foaming sea are combined with the ornamental crests of the waves, flicking out in decorative patterns. Hokusai (308), Hokkei (315), and above all Andō Hiroshige were all greatly inspired by Kōrin. Hiroshige's *The great wave on the beach of Satta in the province of Suruga* (312) evokes the wildness of breaking surf.

The theme seemed naturally suited to European vase and bowl decoration.[12] Arnold Emil Krog (1856–1913) placed Hiroshige's *Great wave* on a cylindrical vase and called it *Sea and gulls* (311). The splashing crest of the wave makes a bright decorative shape on the vase and enhances its volume. Krog had noticed that Chinese and Japanese vase decoration lent extra volume, and he and others worked together on this, to create unity between the walls of the vessel and the ornamentation.

The great French potter Ernest Chaplet (1835–1905) followed the same system. Against the light brown ground of a partially glazed vase he applied Hiroshige's *Wave* in a relief of white clay (313). In this way he managed to create, as it were, an encircling band of ornamentation which conveys a certain vigorous natural motion and also gives the vase a close decorative unity. Van Gogh introduces this almost calligraphic wave shape into painting in quite a different manner, yet still in an impasto technique (314).[13] He also thoroughly studied Japanese wave pictures.

The naturally picturesque shapes of waves rolling towards the shore were captured in stylized graphic line by Japanese and European painters and printmakers. The Japanese instruction manuals were the logical prerequisite for a schematic style of art which, with a single quick glimpse, with extreme reduction of forms, could lay bare the essence of the subject depicted. The great subject was the wave, which, in the vast variety of its movements, was caught in a climactic, unforgettable single unity. Whole generations of painters have tackled the swirling movements of the wave.[14] Japanese painters evolved the most refined sense of the rhythmic flow of wave movements with their opposing centres of gravity, the rise and fall of the crests (308, 317). They attempted to record the exact peak of the wave and the break that follows. This demanded untiring observation. Thus, the curved groove, where the trough of the wave joins imperceptibly into the wave ahead, is perceived as merely a shape of the water surface in its forward motion, not the water itself. This awareness of the natural world occurs in Chinese and Japanese wave pictures right through to Hokusai (317, 322). All the wave-rings stemming from one centre of agitation together constitute a wave system (322), and this wave

318 China, Ch'ing dynasty
Silver wave with rock-crystal ball
H.59.4 (23⅜)
Philadelphia, Museum of Art

319 Totoya Hokkei
Mekari festival
1830
Colour woodcut
29.3 × 19 (11½ × 7½)
Private Collection

320 William H. Bradley
(ascribed to)
Big wave
c. 1900
Inspired by Totoya Hokkei's
Mekari festival
Black pen on white paper
26 × 16.8 (10¼ × 6⅝)
Private Collection

321 Georges Lacombe
Breaker rolling in
1892
Oil on canvas
49 × 65 (19¼ × 25⅝)
Musée de Rennes

322 China
Waves in the moonlight
12th/13th century
India ink, paint, and gold
on silk.
30.7 × 32.5 (12½ × 12¾)
Private Collection

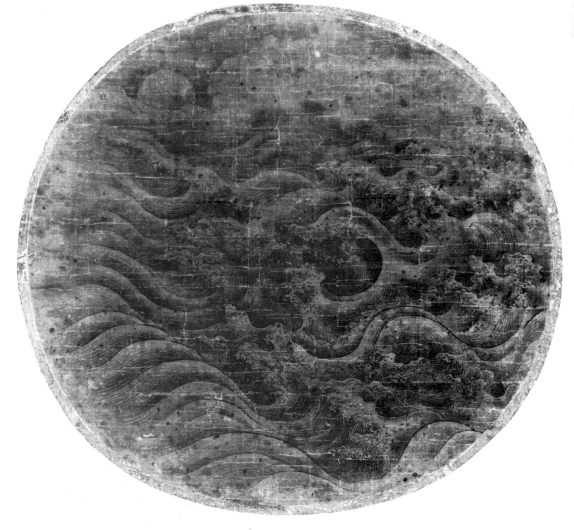

system, which the Japanese love to depict on scrolls, screens, and *kakemono*, all kinds of implements and textiles, and above all in woodcuts, is an ever-recurrent theme in art, and particularly European art.

Chinese painting manuals lay down firm rules about the artistic method. There were clear guiding principles for depicting the wave theme, and these were honoured for centuries. Much the most precise instructions for the river wave occur in the *Mustardseed Garden*, where we read:

The crests of the mountains are often strange, as are those of the water. When the moon shines so marvellously over the sea the waves toss like white horses. When a gentle breeze is blowing there are hardly any waves. At such moments great rivers, seas and small ponds all are as smooth as mirrors. Wu Dao-xuan, also called Wu Dao-zi (eighth century, painter of the Tang period, 618–907), painted water in such a way that on looking at the picture one would seem to hear the sound of rushing water at night. He was just as expert, however, at showing waves whipped up by the wind.[15]

Ogata Kōrin (1658–1716) also certainly knew this book. He is considered to be the greatest Japanese decorative genius. One of his masterpieces is the wave screen[16] in the Metropolitan Museum in New York. He paints the raging sea with transparent and opaque colours on gold paper. His powerful brush technique, which he acquired at the Kanō school, is naturally suited to decorative aesthetic work: 'He uses only three colours, but to magnificent effect: gold for the background, white for the foam on the waves, and a thickly applied, ominous blue which makes the waves stand out emphatically.'[17]

323 F. Siedlecki
Edging strip
Moon on the sea
c. 1908
Black brush and pen on
paper
8.5 × 27 ($3\frac{3}{8}$ × $10\frac{5}{8}$)
Private Collection

324 Japan
Stormy sea (detail)
Six-panel screen
India ink on paper
171.45 × 365.76 ($67\frac{1}{2}$ × 144)
Cleveland Museum of Art
J. H. Wade Fund

325 Ogata Kōrin
The Sea at Matsushima
Edo period
Six-panel screen
Colours on paper
Boston, Museum of Art

326 Wenzel Hablik
Waves
1909
Etching
19.5 × 19.8 ($7\frac{5}{8}$ × $7\frac{3}{4}$)
Schleswig-Holsteinisches
Landesmuseum, Schloss
Gottorf

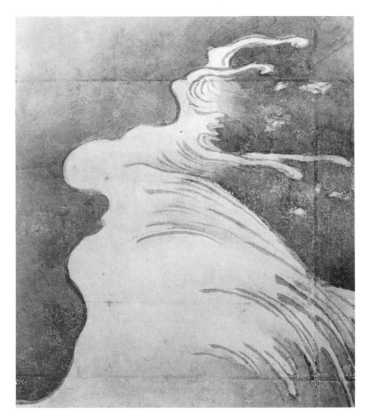

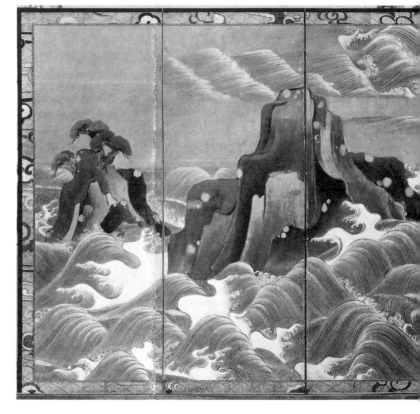

Even more important is the pair of screens *Plum trees by a stream* in the Atami museum in Shizoka-Ken (330). The decoratively treated waves here entered Japanese art history as *Kōrin-nami*, or Kōrin waves. 'Right up to the present day artists have copied them as avidly as patterning on lacquer, ceramics, and textiles.'[18]

Hokusai also gives us a fine wave system in his little book of combs, now in the National Library in Tokyo.[19] It is a prototype attempt to convey a significant theme through a small everyday object. To Hokusai nothing was without significance. The great cosmic course of nature could for them be concentrated on the tiniest surface of even the most apparently unworthy object. In his comb book Hokusai depicts the restless sea with hissing breakers pounding in from different directions.

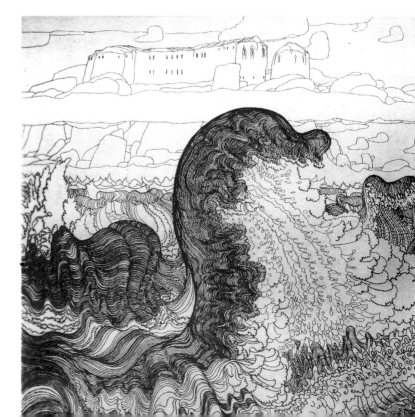

134

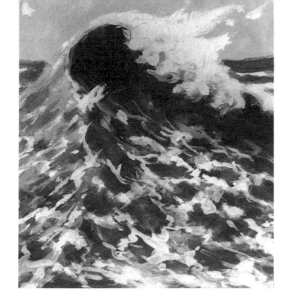

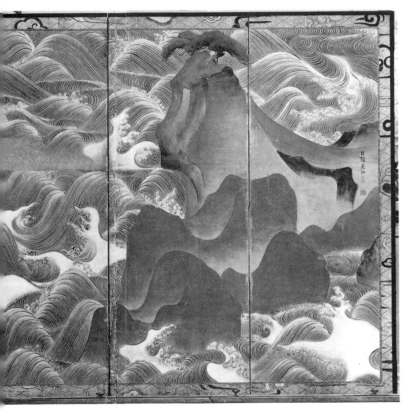

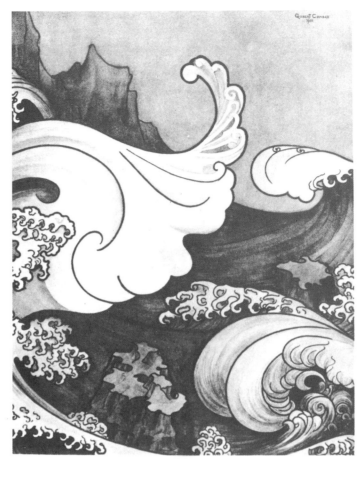

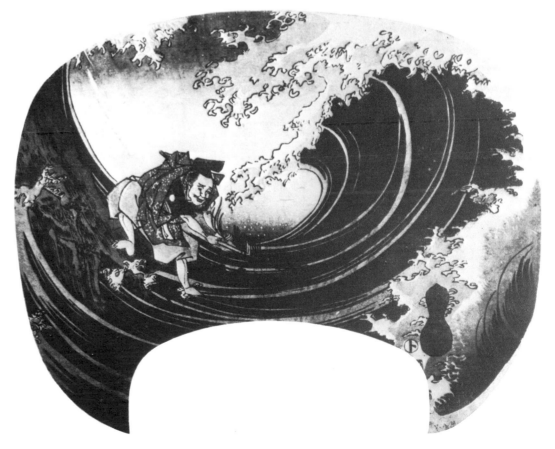

Later on the surging sea is rendered with wave lines swooping up and down, rhythmic mountainous waves, their tops torn by the wind, or the rippling eddies of the water's surface. He then strikes out further to portray billowing mounds of water, engulfing boats, great waves building up, and their long lashes of spume, and their folding movement as they tumble back down into themselves. From these observations he developed fixed types of wave-crest, which inevitably became stylized. Finally these waves become pure ornament, and we have the long, semi-circular comb back – a superb example of the rhythmic reworking and transformation of nature into ornament.[20]

The wavy band is an ancient theme. As a single continuous wave or 'running dog' it figures in the purely

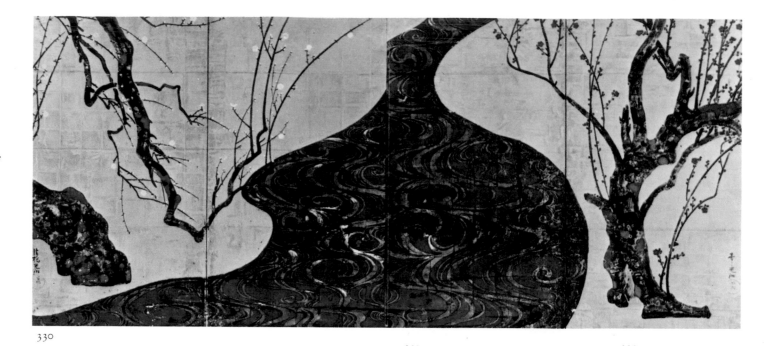

330

332

333

geometrical meander, the angles of which became curved
and smooth. The wavy line separates areas of painted
decoration (often blue on gold); Japanese textile art
made particularly effective use of it as a hem pattern. In
repeat patterns it covers whole sections of surface area,
and is an integral motif of the decoration of swords and
vessels of all kinds. It is a highly popular decorative
element on plates and dishes.

 Together with this all-purpose billowing wavy line,
the Japanese also evolved a swirling system of individual
lines[21] which are given coherence according to the shape
of the surface – lacquered caskets and containers,
writing boxes, or medicine boxes (*inro*) – in licking
sweeps and curls or in rhythmic union with each other
(306). This wavy line system could be made as abstract as
the artist wished, and naturalistic floral elements are
integrated into the arabesque background pattern in all
their living, organic vigour (307). The wavy line became
an important motif in Japanese art; its intrinsically

331

337

338

ornamental value is infused harmoniously into a vision of ornamentalized nature.

European Symbolist art[22] also adopted the wave: as a dominant, gigantic, living thing (326) or as a force dragging men into the depths. Abstractly handled waves flower in watery troughs (328); or the moon looms between two billowing crests (323).

The schematic wave formula was considerably altered in Europe, especially by the exponents of Art Nouveau. The stylized sense of movement changed (333–35, 506). The rhythmic dynamism of the Art Nouveau graphic line developed from the wave systems of the Far East, for the same decorative notions came to apply here, and was translated empirically into new optical idioms. Around 1900 they had spread to every country in Europe. Their distinctive schematic lines became symbolic of the era (337–41, 797–804).

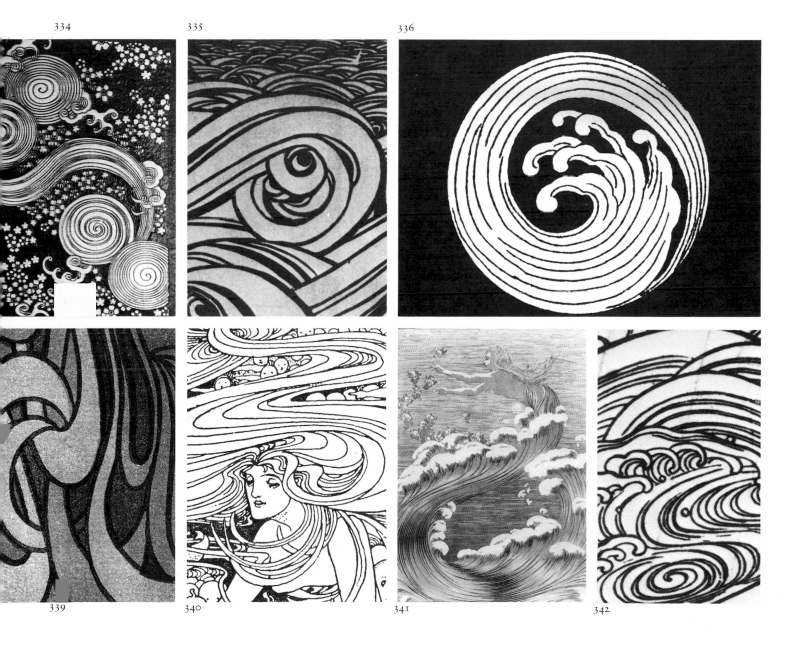

334 335 336

339 340 341 342

339 Peter Behrens
The kiss (detail)
c. 1896/7
Colour woodcut
27.1 × 21.5 (10 × 8½)
Schweinfurt Collection
Dr Georg Schäfer

340 Ethel Lacombe
Book illustration (detail)
Repr. *The Studio*, 22
November 1900

341 Fritz Endell
The wave
Paris 1900–02
Colour woodcut
30.9 × 22.5 (12⅛ × 8⅞)
Munich, Staatliche
Graphische Sammlung

342 Japan
Eddying waves
Tokyo 1883
Painters' manual; after
Katsushika Hokusai by
Etaku
Woodcut
25.7 × 17.5 (10⅛ × 6⅞)
Private Collection

The bridge

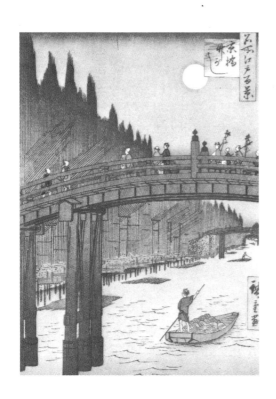

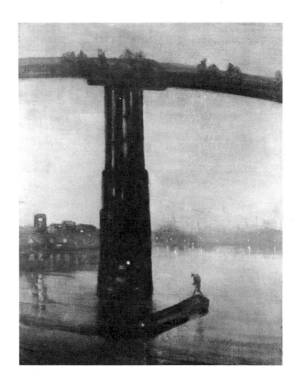

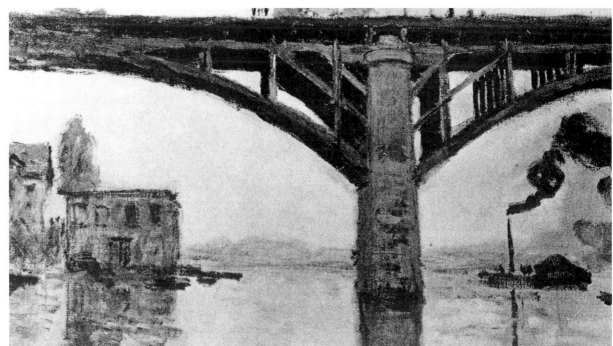

Bridges are not uncommon subjects in European painting. The theme, however, became richer as a result of *ukiyo-e* influences. As a close-up detail, with its structure clearly delineated, it became a focal point of interest. The French Impressionists above all combined the reflection of structural elements in the water with the moving, all-pervasive light of the open air. The Japanese saw in the bridge a construction that was perfectly integrated with the structure of the landscape. The bridge piles might echo the trunks of nearby trees; a small valley might be enclosed under the soaring arch;

or, a somewhat different effect, the bright streak of the bridge might enliven a flat landscape. The effects were many and various.

James McNeill Whistler was directly influenced by Japanese colour prints, particularly those depicting bridges.[1] Inspired by Hiroshige's woodcut *Edo bridge*, from *A Hundred Views of Famous Places in Edo* (1857), he produced his painting *Nocturne in blue and gold (Old Battersea Bridge)* (1872/75). The pier of the bridge rises to the top of the picture like a huge scale-beam (345). The startling single-detail perspective is perfectly selected,

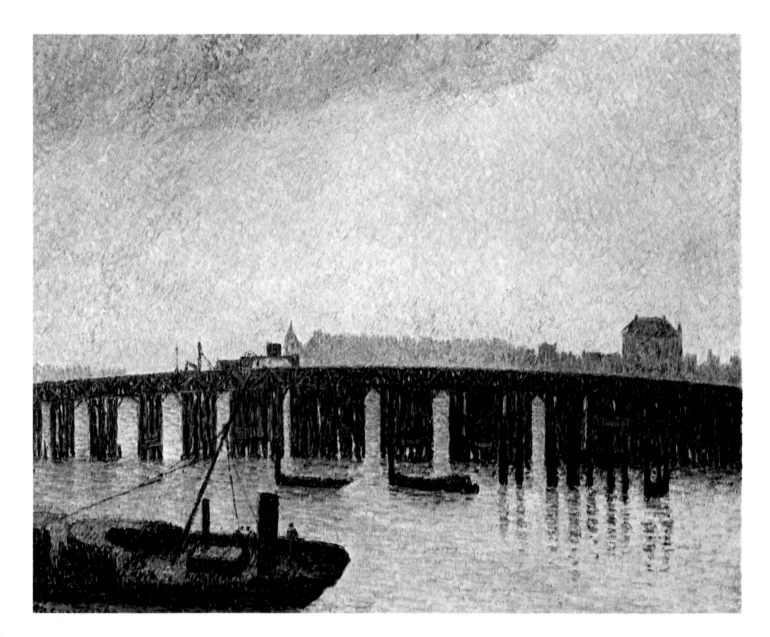

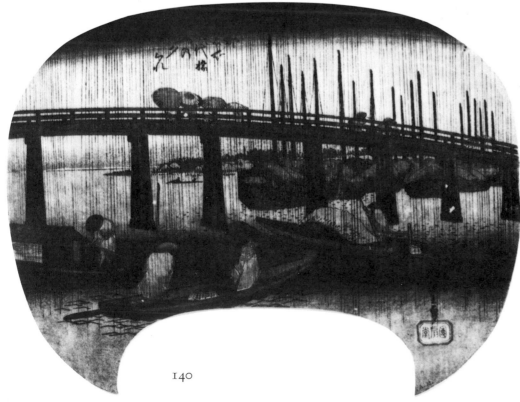

and the pier rises like a blackish-blue pillar against the blue-green of the night sky. The tangible atmospheric impression of Western art is combined with Oriental scale and selection. The 'Japanese painter of Chelsea' continued to study Japanese ways of painting bridges and employed them on London bridges, producing numerous drawings and etchings. The etchings of *The broad bridge* and *The tall bridge* date from 1878. Whistler's new vision, inspired by Hokusai and Hiroshige, offers a dual pictorial unit, created on the one hand by the actual borders of the picture, and on the other by the frame effect of the bridge – the view leading past the pier into the distance. One important aspect of this style of composition is an open landscape, as often appears in Hiroshige and as appears in Whistler's masterpiece *Old Battersea Bridge*. Here are landscapes that the viewer can almost see continuing beyond the boundaries of the edges of the picture. What is not

actually there must be conveyed sympathetically; as in the Japanese tradition, extreme selectivity is intended to encapsulate the whole.[2]

Claude Monet (1840–1926) is another great European painter of bridges. Early on, he had discovered the bridge as the central point of a landscape in the work of Eugène Boudin, and had made a careful study of Constable and Turner. Japanese woodcuts brought a fresh source of inspiration which was to influence his work for a long time.[3] The bridge as an enormous weighing arm (347), the railway bridge crossing diagonally into the picture (365), the sharply drawn outline against the horizon (357) – all these Monet makes into convincing works of art. At the same time the coalheavers (355) under the bridge are drawn actively into the composition by the heavy arch of the bridge. However, the wooden bridge with its struts (354–58) best shows the fruits of the Japanese influence.

352 Siegfried Berndt
Landscape with bridge,
Saint-Cloud
c. 1900
Colour woodcut
24.2 × 32.2 (9½ × 12⅝)
Private Collection

353 Andō Hiroshige
Mount Fuji seen from
Ryōgoku in the Eastern
Capital
1858
From *36 Views of Mount*
Fuji (Fuji sanjūrokkei)
Colour woodcut
34 × 22.2 (13 × 8¾)
Private Collection

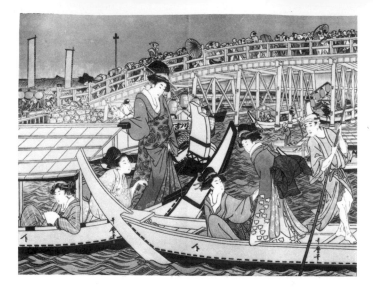

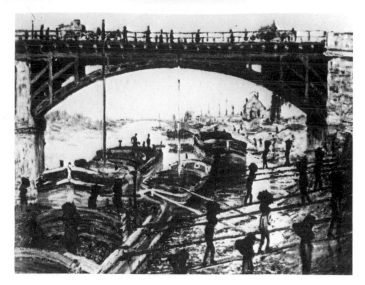

354 Kitagawa Utamaro
*Festival on Sumidagawa
Bridge*
Colour woodcut
Repr. S. Bing
Le Japon artistique, 12
April 1889

355 Claude Monet
The coal-heavers
1875
Oil on canvas
55 × 66 (21⅝ × 26)
Paris, Private Collection

356 Andō Hiroshige
*The Rōnin crossing on the
Ryogoku Bridge*
From *The Vassals
(Chushingura)*
25.1 × 37 (9⅞ × 14½)

357 Claude Monet
The wooden bridge
1872
Oil on canvas
54 × 73 (21¼ × 28¾)

358 Andō Hiroshige
Bridge in winter
Colour woodcut
Repr. S. Bing
Le Japon artistique, 16
August 1889

359 Walter Klemm
The bridge
1909
Woodcut on paper
16.2 × 22.8 (6⅜ × 9)
Repr. *The Studio*, 50, 1910

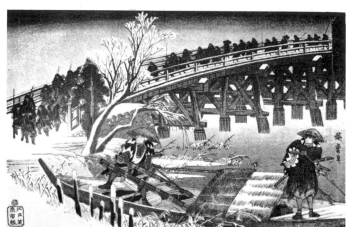

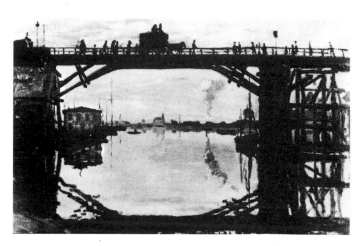

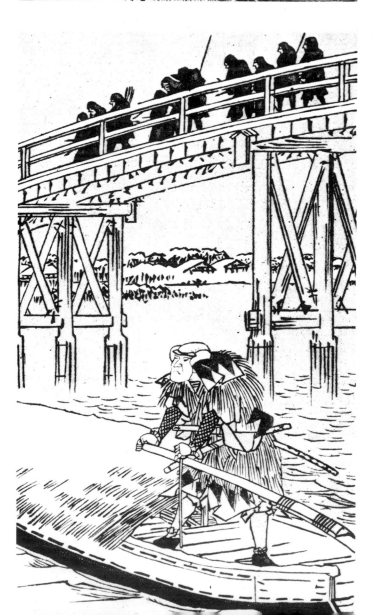

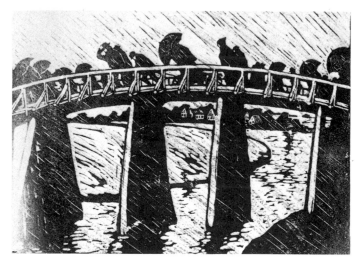

As a painter of bridges Monet himself exerted considerable influence. To give just one example, see the colour woodcut of the bridge of Saint-Cloud (352) by Siegfried Berndt.[4] Using the Japanese woodcut technique, Berndt attempts to come to closer grips with his theme, almost to recreate the original model. The bridge became an even more major theme in Art Nouveau graphic art and painting, as the constructional features lent themselves to transformation into vignette-like pure design, and the articulation of the piers into ornamental arabesques (360–63). Around the turn of the century the

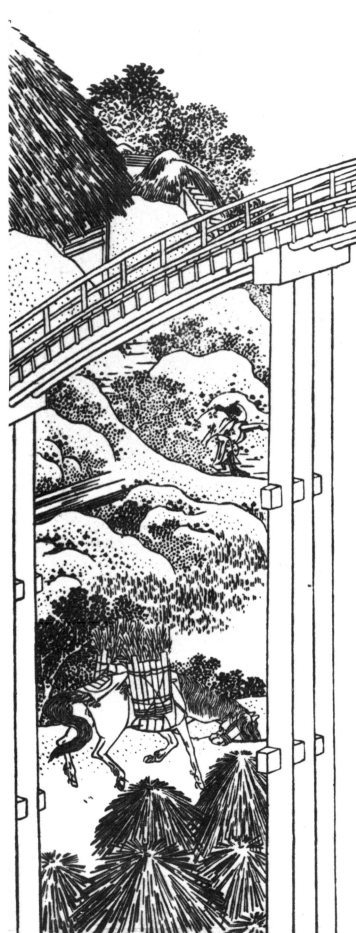

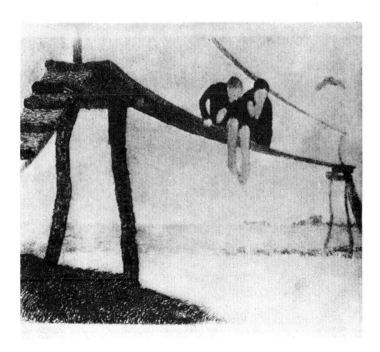

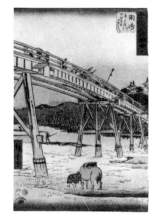

364 Edward McKnight
Kauffer
In Watford
1915
Colour lithograph
80 × 34 (31½ × 13⅜)
Private Collection

365 Claude Monet
*The railway bridge at
Argenteuil*
c. 1873
Oil on canvas
55 × 73 (21⅝ × 28¾)
Paris, Louvre

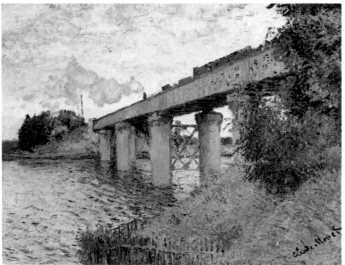

bridge (364) made a successful symbolic subject for poster art.[5]

Monet's *Railway bridge at Argenteuil* and *Bridge over the Seine at Argenteuil* are proof of Monet's supreme mastery of this subject in old age. When he moved to Giverny in 1883 his main painterly preoccupation was his garden with the lily pond and the Oriental hump-backed bridge.[6]

Bridges constantly recur in Chinese and Japanese painting. The reader of horizontal scrolls such as the thirteenth-century *Kasagi-Mandara* (Yamato Bunkakan Museum, Nara) seems to cross each bridge in the tale as he comes to it.[8] Here bridges link the abodes of the saints. A bridge immediately above the bottom of the picture leads into the landscape in Yosa Buson's (1716–1738) *Chikuhei-Hoin* ('Visit to a hermit in the bamboo grove', private collection, Ashiya, Japan),[9] a bridge low down in the landscape leads into it. Any long road traversing a landscape is likely to begin at a bridge. Precise guidance is given concerning it in the Chinese manuals:

In a landscape painting one should never neglect bridges ... because wherever the terrain is interrupted one can use one to continue the line of road, and thereby lead people deep into the beauties of landscape. They furthermore enable one to give contextual unity to the arteries of living breath that run through the entire picture, and thus they are an eminently suitable device for pictorial invention. One should consider according to the surrounding countryside whether the bridges one introduces should be stone or wooden. They should not be merely arbitrarily stuck in.[10]

The bridge is also part of the geological structure of the landscape. It is both the meeting point and the point of departure of paths, tracks and roads.

Hokusai devoted a series of woodcuts to the bridge, just as he did to the waterfall. The general title of the series is *Wonderful Views of Famous Bridges in the Provinces* (*Shōkoku meikyo kiran*).

The Japanese were the best wood craftsmen in the Far East. Their traditions in woodwork went way back, and their bridges were constructions which one would not merely use but also admire. There was great interest in the artistic and constructional achievements of the bridge builders. They could not just be erected wherever one liked, wherever it might appear best to cross the river.[11] A bridge could not simply be imposed on the landscape – it had above all to fit in with it. A finely built bridge as a technical wonder in a beautiful landscape was a favourite theme of the *ukiyo-e* masters.[12]

All types of bridge, from the round-backed bridge of Chinese origin to the simple Japanese bridge of flat stones, from the beam supported by posts to the giddy suspension bridge, were depicted over and over again in colour woodcuts. Artists were at pains to show clearly the technical details of bridge construction without disturbing the beauty of the landscape. The supporting frame of a large bridge was rendered as in a technical drawing. The bracing of the saddle beams on the main carrying timbers, and the meticulously reproduced abutments and stays, become aesthetic elements in the woodcut. The innumerable traverses, complete with strutting-pieces, of the strut-frame bridge afford an excellent supply of those verticals which Hokusai loved

to introduce into his horizontal landscapes. Sometimes his bridges are treated as huge still-lifes, seen very close to (343, 358). The piers with their cross-braces are enormous ornaments in the total landscape. Between the piers we glimpse beautifully framed views (361, 363), which have a kind of shock effect and make the bridge structure an opening into another pictorial world.

A bridge can also be made to dominate all three segments of a triptychal picture surface. Utagawa Kuniyoshi (1798–1861) uses this compositional device in his colour woodcut *The battle on the Gojo bridge*. The

hump of the bridge cuts diagonally across the entire picture. The view under the bridge and between the piers into the landscape is always carefully considered (348, 349). It draws the attention into the picture, yet without creating a vanishing-point.

Hokusai's extraordinarily imaginative, almost abstract images of bridges (360) still influenced European painting at the beginning of this century; their influence can be detected in Joseph Stella. In them the bridge becomes a vehicle of colour and form that is in some respects quite independent of the object represented.

366 Katsushika Hokusai
Ariwara Narihira's poem
From *100 Poems Explained by the Nurse (Hyakunin isshu uba ga etoki)*
Colour woodcut

Rocks in the sea

European painters of the Romantic and Realist schools were of course already painting craggy cliffs in the nineteenth century, but such cliffs were always subsidiary motifs to the main theme; seventeenth- and eighteenth-century marine painting offers literary illustrations in which rocks in the sea are viewed as desolate islands; and the Copenhagen and Düsseldorf schools in the second half of the nineteenth century brought added drama to the subject under the influence of English painting. But towards 1900 the motif of the rock in the sea became a major theme in European landscape painting. Japanese woodcuts of course played their part in this. Jagged rocks in the sea, cliffs eaten into by the water, sharp reefs and rearing outcrops of rock encircled by spray became themes in their own right, as artists painted their weird, unique conformations. Impressionism, Symbolism, and Art Nouveau all made this theme a characteristic motif.[1]

The Impressionists appreciated the glistening colours of the sea and the dark rocks, the reflections of light in the whipped-up water, and the movement by which firm solids became broken up or the frothing sea froze.[2]

The Symbolists portrayed the power of the elements in numerous enchanted or sinister rock formations,[3] lending a kind of primordial force to the legendary nature of their Japanese models (382).[4] (Buddhism and Shintoism contributed to the significance of rocks in the sea, considering them to be the seats of saints and deities.[5]) Art Nouveau saw in the same strange rocks and cliffs a certain ornamental graphic potential, susceptible to stylization, as a standard motif, in the vignette form and the arabesque.

The subject was especially popular between 1870 and 1920, as the Post-Impressionists in France also repeatedly portrayed it.[6] Armand Séguin, the chronicler of the Pont-Aven painters, wrote in *L'Occident*: 'With the constant friction of the waves, cliffs take on the shapes of unknown monsters, which they perhaps at one time lodged. The edge of a wave forms a white arabesque against the blue of the sea . . .'.[7]

Rocks in the sea appear in countless versions in Chinese, and above all Japanese painting. For China they symbolized long life, for Japan constancy. Beings who have progressed to ever higher incarnations through good works are portrayed on a rock above the sea. In China, as with the 'Kōrin waves' of Japan, waves were depicted by a special technique.[8] It is always by means of a rock or small island jutting out of the sea that these wave rhythms acquire extra, swirling arabesques. The stone is worn away by the water, yet on the other hand it always gives to the water a new direction and turbulence. Buddhist Japan also connected rocks with

146

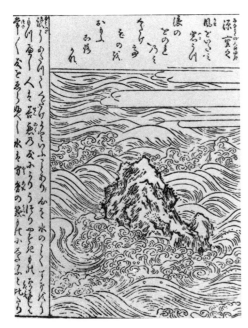

the deity Kannon (Kuan Yin), Kannon who dwells among them.[9] Not only rocks loom above the sea: so also does Daruma (Bodhidharma), the founder of the Buddhist contemplative sect.

The Japanese *ukiyo-e* masters produced countless works on this theme of the sea-girt rock. Needle-sharp cliffs, giant towering mountain tops, round, polished, rock protuberances, or jagged rock formations emerge from restless seas. The rock developed as a theme according to specific techniques, and was precisely defined. The Chinese manual *The Mustardseed Garden* has this to say about the subject:

As one starts painting one should clearly bring out the three dimensions of the stone. We judge men perhaps by voice or build. Stones constitute the very framework of heaven and earth, and they convey their own peculiar atmosphere. A stone without atmosphere is just a lump ... However, no stone should look dead under one's brush. Stones have a great variety of forms, which derive from their relation to the ground surface, a spring, or the sea. There is no secret of art, only one magic word: 'living' ...[10]

Oriental painters depicted 'living' rocks as a form of portraiture. In each case the individual structure was precisely rendered. The more bizarre and ancient, the more suited they were for use in art. These 'portraits of stones', as we shall call them, also influenced European painting, especially in their movement with the sea's surface. 'The edge of a wave forms a white arabesque against the blue of the sea', Séguin writes. This ever-changing arabesque is a recurrent theme of European painting, from Rivière (374), via Gauguin (371), to Monet (368). Rocks in the sea are the central motif, with notable variations in the painting of Monet in particular. It was no accident that a Tokyo museum acquired Monet's *Belle-Ile-en-mer* (368). This work has particular affinity to Japanese painting, as the waves crest and break white around the hard, dark rocks in the azure-blue sea.

The Japanese used two devices over and over again to create this arabesque: turbulent water and hard rock. The famous Japanese gardens with their stones in ornamentally arranged sand symbolize the sea and

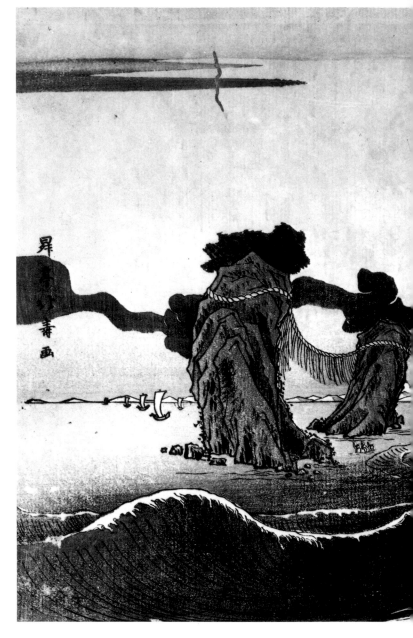

islands of the Japanese empire (1019): Japan is itself a rock in the China Sea. A reef is an aesthetic symbol of opposites. The waves breaking against the rocks were often depicted in essentially decorative simplicity of form. Monet must have seen Hiroshige's (369) and Hokusai's (394) work in Paris, as he attempted to convert the colour woodcut into painting using the same compositional principles. It has recently become known that he himself owned the polychrome woodcut *View of Naruto whirlpool* (369).[11] He builds his rocks out of silhouettes, and suggests the agitation of the water's surface through white highlighting, the brushstrokes following the movement of the waves. The unenclosed picture space, now limitless, reflects the Far Eastern vision, here rendered by Impressionist means.

Henri Rivière in the early 1890s saw the sea as a succession of vivid details under the influence of the

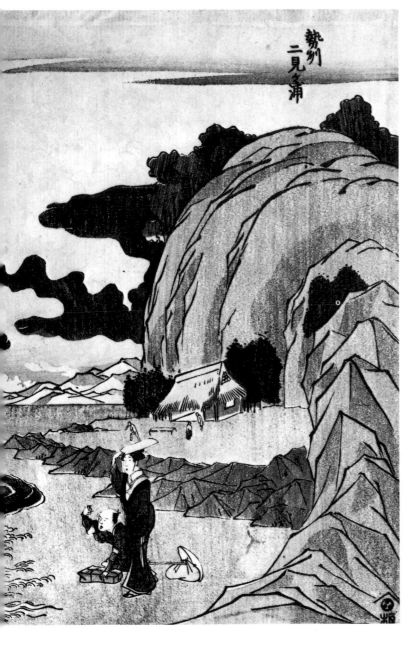

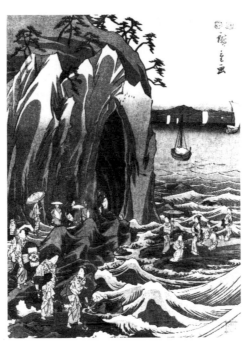

Japanese *ukiyo-e* style. Hokusai's *Manga* also influenced Rivière's style (377): in volume 7 we find the same view, from above, of a broad, broken wave trough with a reef. This 'close-up' approach demands very precise treatment of the subject elements, which the artist has reduced to minimal basic forms. Rivière, who knew Hokusai's waves, and who consistently emulated the wave cycles of the Japanese, began under this influence to simplify his individual forms. The rocks are depicted with sharp, ridge-like lines (374), and where there is moss growing the style is concrete and almost ornamental. The spray consists of shadowless, multiform flecks in the light-coloured sky surface.

The same theme was important too in Japanese industrial art, especially lacquerwork (370, 387). The wooden box (370) for writing paper (*yatate*) is decorated with black lacquer, with a picture of waves and rocks in

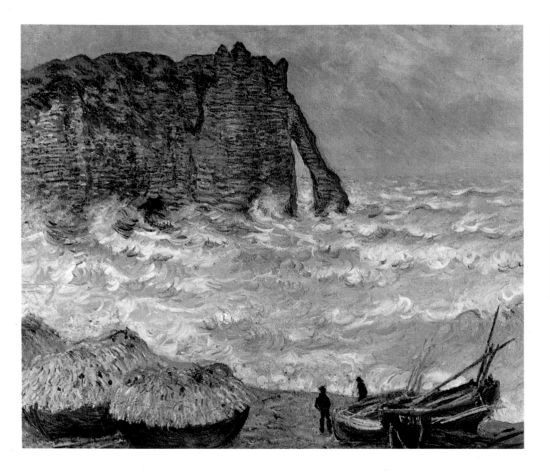

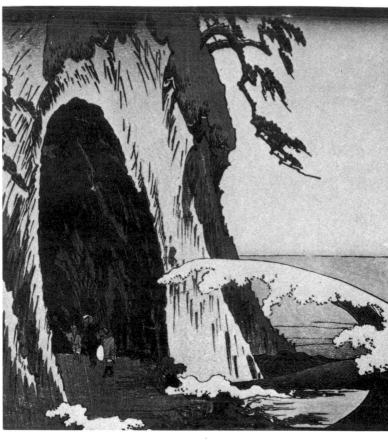

383 Claude Monet
Storm at Etretat
1883
Oil on canvas
81 × 100 (31⅞ × 39⅜)
Lyons, Musée des Beaux-
Arts

384 Ando Hiroshige
*Cliff cave on the island of
Enoshima in Sagami
Province*
1832
From *Famous Places of
Japan (Honchō meisho)*
25.2 × 38.1 (9⅞ × 15)
Colour woodcut
Private Collection

gold lacquer on the top. The precision of craftsmanship here reveals a gift for accurate observation. The rocks have pieces of tortoise-shell inlay, which look like eyes, and the waves owe their superb ornamental quality to the inspiration of Kōrin.

Henry Moret exploited the same technique of detail seascapes. A group of rocks in the sea (372) is presented as a reduced theme. The composition is weighted on the left, after the *ukiyo-e* principle (but in the eighth volume of Hokusai's *Manga*, too, we find rocks in the sea which are, as it were, instructions for mastering the theme). Moret invests the stark, rugged stone with a unifying outline. The paintwork in this area consists of numerous patches of differently modulated colours.

Arched cliffs and fissured rocks on the coast at Etretat (383) inspired Monet to execute several versions of them. Similarly the hollowed-out cliff arch of La Manneporte (385) occupied him for a considerable time. During this period he must often have thought of the caves of Hiroshige (384), who created a highly original composition linking sea and cave together, and who produced a monumental, stylized picture of the Kannon Temple in Bingo Province with a hollowed-out cliff. One of the most popular themes was the rock 'finger' climbing out of the sea (387–94), as seen by the Japanese. Such a rock was held to be the sign of an all-powerful divinity. Its extraordinary shape also lent itself to depiction in lacquerwork with gold in the *ikakeji* technique (387).

385 Claude Monet
La Manneporte, Etretat
1883
Oil on canvas
65 × 81.3 (25¾ × 32)
New York, Metropolitan
Museum

386 Japan
Rocks in the sea
After Ogata Kōrin
Osaka 1846
Colour woodcut
19.6 × 14.2 (7¾ × 5⅝)
Private Collection

Gauguin had already taken over the theme of the rock tooth in the sea (388), and he influenced Emile Bernard, who painted pictures of the precipitous coast of Brittany with its cliff needles in a manner that verges on abstraction (392). As a logical development from this, Lucien Lévy-Dhurmer's picture (393) is imbued with an eminently modern spirit of alienation. Monet too went several times to the pyramids at Port-Coton (389) to paint these rock needles in a stormy sea after the style of Hiroshige (390, 391) and Hokusai (394). Both choice of detail and the handling of a strange cliff-face or single rock were enhanced by the Japanese vision, and became a theme in their own right, to be continued and developed later by the Expressionists.

387 Japan
Lid of a writing-box
Edo period (1603–1867)
Wood with black lacquer
ground thickly strewn with
gold dust
H.12, W.11 (4¾, 4⅜)
Venice, Museo Orientale

388 Paul Gauguin
Rocks in surf
1889
Oil on canvas
49 × 64.5 (19¼ × 25⅜)
Private Collection

389 Claude Monet
*The pyramids at Port-Coton
in a stormy sea*
1886
Oil on canvas
65 × 81 (25⅝ × 32¼)
Moscow, Pushkin Museum

390 Andō Hiroshige
Rocks at sea
Colour woodcut

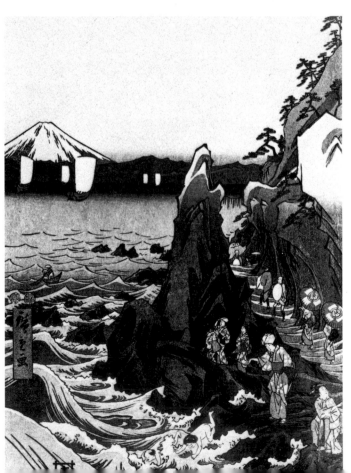

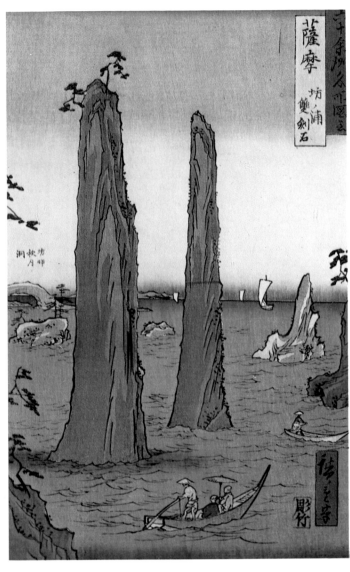

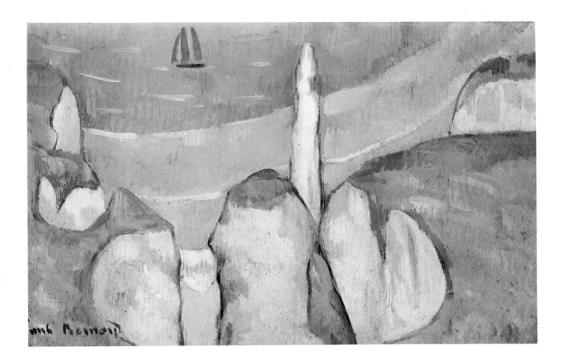

391 Andō Hiroshige
The sword-rocks
1853–56
From *Famous Places from
more than 60 Provinces
(Rokujūyoshū meisho zue)*
Colour woodcut
36.6 × 24 ($14\frac{3}{8}$ × $9\frac{1}{2}$)
Regensburg, Collection
Franz Winzinger

392 Emile Bernard
*Vertical cliff on the coast of
Brittany near Le Pouldu*
1890
Oil on canvas
33.5 × 51.5 ($13\frac{1}{4}$ × $20\frac{1}{4}$)
Paris, Collection Michel-
Ange Bernard-Fort

393 Lucien Lévy-Dhurmer
White rocks
Pastel on paper
59.5 × 44.5 ($23\frac{3}{8}$ × $17\frac{1}{2}$)
Repr. *Art Deco
Art 1900*, 12, March 1875

394 Katsushika Hokusai
Sword-rocks in the sea
1814–78
From *Manga*
Colour woodcut
24 × 14.5 ($9\frac{1}{2}$ × $5\frac{3}{4}$)
Private Collection

The folding screen

395 Pierre Bonnard
Street scene (Promenade des nourrices frise des fiacres)
1899
Four-panel screen
Colour lithographs
147 × 186 (57⅞ × 73¼)
Hamburg, Museum für Kunst und Gewerbe

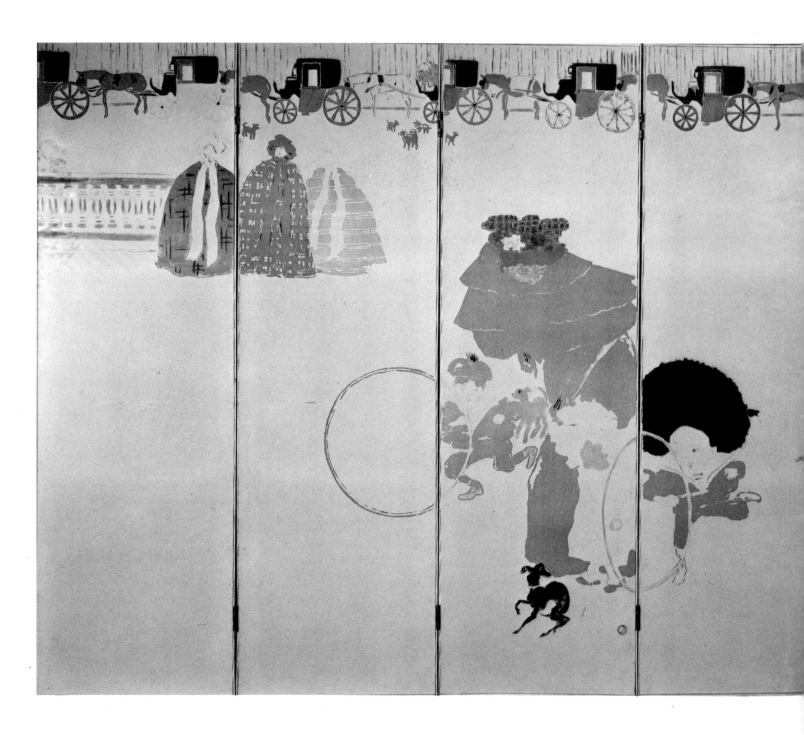

Unlike the screens belonging to the eighteenth-century fashion for *chinoiserie*, screens under the Japanese influence in the nineteenth century were often decorated by important painters; the Impressionists exploited the compositional possibilities of the different leaves of a folding screen, at the same time profiting from its functional aspect. Oriental screens were highly prized.

'From the Japanese exhibition the screen with the silver heron, and the other with all that flora in lacquer, stone, ivory, porcelain, and all kinds of metals are for me the two most beautiful articles of furniture to have been produced by any people since the world of industrial art began.'[1] This observation of Edmond de Goncourt's, made in 1878, indicates plainly just what kind of impact Oriental screens had in Europe. Screens had become an indispensable accessory for any drawing-room, boudoir, or (above all) artist's studio. There was barely a painter who did not have a screen with which to break up the single open area of his studio – to arrange the space according to the living tastes of the age.

The décor of the 1880s incorporated a large measure of illusionism. Screens of all kinds were used plentifully within rooms to create series of spaces leading into each other, each formed by carefully positioned props and cleverly placed furniture, with green plants dominating everywhere. In a house, rather as in a museum, screens were used to improvise smaller, more private rooms, and for concealment – as a preparation for what was waiting to be admired next. In 1880 Franz von Lenbach wrote from Rome to Frau von Wertheimstein: 'With a few Asiatic folding screens which I acquired here second-hand I was able to divide up the vast high rooms [in the Palazzo Borghese] so that now there is a more personal, intimate atmosphere.'[2]

In the life and work of artists in the nineteenth century, and also to some extent in the twentieth, the screen was more than a mere domestic article. It afforded possibilities of new creative activity in direct relation to its functional design. This opportunity of experimenting with space and time on a flat surface that could yet be moved – its individual folds seen in isolation, or hinged away from or towards each other as desired – introduced a new element into European art, both as a subject and as a support for painting. We know that Monet bought some screens,[3] and in early and late French Impressionist pictures screens often occupy a position of central importance. Whistler re-echoed his picture space with the painted screen acting as a wall in the middle ground.[4] For many painters screens were useful for eliminating depth of space in favour of a foreground 'stage setting'.

The Nabis – Bonnard, Vuillard, Denis, Redon and others – made copious use of this device and themselves painted screens, taking Oriental examples as their models. There were certain conditions for the style, and above all the composition, of screen painting. The pictorial surface is necessarily large, and provided European painters with a working area that encouraged combination of European traditions with new inspiration. Screen painting was in fact a vitally important and fruitful field of artistic research in Europe at the end of the nineteenth century, and the peculiar techniques of the genre – taken directly from the Japanese – influenced

396 Torii Kiyonaga
Woman with child carrying a kite
Title page for S. Bing
Le Japon artistique, 10 February 1889
(This picture prompted the design on Bonnard's screen.)

397 Pierre Bonnard
Children playing
c. 1895
Sketch for a four-panel screen
Pen and ink on paper
18.6 × 27.5 (7⅜ × 10⅞)
Private Collection

a great variety of other creative forms. On closer inspection, the handling of the space is seen to fall into specific fields. Chinese manuals demand that:

The essential element in a landscape picture is quiet emptiness, portrayed free of all objects. This makes it important, in arranging the composition, that the continually flexible movement of animate, live space should never be brought to a standstill. In general an established rule in the building up of any scene is that either there should be empty space on the left and the subject portrayed on the right, or vice versa. Exceptions to this rule and other complicated formulations can only come from the painter's own feelings at any one time.[5]

The combination of different creative forms in the screen has hitherto been only sketchily recognized, although it continues to exert a great influence even today. Bonnard and Roussel developed many types of composition which were also to be found in Chinese and Japanese work. Thus for example the entire surface might be articulated by a grille form (397), or else a large empty surface might be counterbalanced by substantial figures. The top of the screen could be made into a narrow decorative band in its own right (395). Maurice Denis, in the second generation of French Impressionists, introduced a new element into screen painting with perspective depth (401), while Odilon Redon explored the medium with heterogeneous, overlapping abstract patches of colour (400). In 1905 he designed decorative screens with *Buddha and the red tree* (1905/06) as the central motif. Already in 1902 Redon had produced his screen *The world of the chimeras* for Madame Ernest Chausson, striving to create, within the emptiness of the screen surface, a suggestion of dreams and immersion in a world of shadows. The infinite, he felt, should be explicitly conveyed. He seeks here a superabundance of sumptuous surface depiction, and exploits the thematic independence of isolated small details with this end in view – though in a shorthand, codified form. Under the influence of Buddhist screen art he endeavoured to do away with all material weight and solidity.

Bonnard also worked towards new discoveries in those pen-and-ink sketches in which, contrary to the Far Eastern tradition, he creates a kind of fence of figures at the top. In his screen *Street scene* (395) a group of figures appears on the right-hand side without any regard to the division into panels. The figures, composed almost entirely in silhouette, are perfectly suited to the surface area. The empty space on the left constitutes the active central energy field from which the details above derive their life. The row of cabs and the balustrade with the three ladies make a kind of decorative design. The sense of activity is conveyed by the different planes, which lead from the back of the composition. The interplay of foreground and background leads the eye constantly from one detail to another in a rhythmic surface line in which all harshness and suddenness is avoided. In his large lithograph in the form of a four-panel screen, of which 110 copies were printed, he followed Japanese models, transforming the parallel empty surfaces into a brilliant illusion of space in which upward progression creates depth. The basic empty surface remains, and the

figures are carved out of it in positive or negative ornamental form. The upright surface thus created needs no illusionistic tricks – the quality is uniform. The painter also thus achieves a total harmonization of the individual screen panels. The figures seem to hover in a way that is incompatible with the Western imaginative idiom. Indeed, their state is conveyed as one of expectant, fixed waiting in contemplative rapture. We can therefore deduce that no connection with their surrounding space or accompanying surface planes is desired. Bonnard fully realized this intention, eliminating pictorial limitations. Comparing the foreground figure-group with its source in Kiyonaga (396), we can see clearly how Bonnard adapts Japanese postures, becoming even more Japanese than his model.

The formula of a richly patterned succession of figure representations is also to be found in Japanese screens, and in Bonnard. Two particular screens of this type are the *Matsuura-byōbu*, a famous and magnificent pair which originally belonged to a noble family of northern Kyūshū, the Matsuura. They feature precisely this principle of the decorative row of figures as a rhythmic foreground motif; it adheres to *ukiyo-e* principles, and has had a great influence on European painters.[6] Bonnard could also, however, depict interior spaces, in which individual sections were defined by small- and large-scale patterns arranged in interdependent compositional series. At the same time these pattern sections created a system which resulted in an essential unity.[7]

Ker-Xavier Roussel chose an in-between system of figure-rows and open landscape figuration, full of bright light, successfully illustrating the theory of the Impressionist frameless picture (628). The viewer is led to create his own imaginative extension of space, and the panels are manipulated so as to form a unified whole, compositional borders being introduced in the form of tree-trunk outlines in the two side panels.

In connection with the Nabis and their interest in the painted screen it is important to remember the intensely subjective and improvisatory nature of the Impressionist approach to artistic creation. Spontaneity was built into the actual structure of the screen, which in turn was able to offer all the variations of emphasis within a single pictorial conception, that could be obtained by means of the side panels. Bonnard and Vuillard had realized that in the Japanese screen much could be suggested with extreme economy of expression, especially in composition sequences, and this realization was a major influencing factor in their lithographs. Like the Japanese, they use details to imply the whole; and the theory that what is not specifically expressed must be felt by empathy was the central realization of European painters – becoming most obviously visible in the work of Toulouse-Lautrec (1062). This disappearance of the box-like space of the Renaissance ideal of perspective was a vital development for modern art.[8]

An interesting type of screen is the simple, fixed wooden model produced by Gallé after Oriental models (398). Consisting of a single panel, it is usually carved in relief on both sides, and is sinuous and flowing in outline. The three-panel screen by Georges de Feure also has a solid, carved wooden frame enclosing each silk-

covered panel (402). It constitutes an autonomous object, dominating a room like a piece of sculpture.[9] In China this type of screen would have wooden insertions, to give scope for rich inlay work.

Maurice Denis treats his screen differently from Bonnard, in that his tapestry-like colour schemes follow the rectangular arrangement of planes (401). Distances have become ascertainable through the diminution in size of objects. Denis' screen has a trellis-work fence which is articulated according to the panels of the screen. The result is an illusion of real space, creating precise impressions of distance. Empty space as unpainted surface area is no longer the principal theme. This new conception is even more strongly evident in Paul Klee's screen *Landscape on the Aare* (399), the perspective of which is dependent on a very definite vantage point. Height here equals depth – a way of portraying nature learnt from the Orient. The scene is viewed from above, which allows us to see the river winding between the hills, and permits the step-like disposition of elements within the pictorial space. Klee developed the screen into a dividing wall with window-like decoration, so that it became more architectural in its effect, creating new space (a method very similar to that of the Far East).[10]

Redon's red screen (400) is an extreme example of this same compositional approach. Here the three surfaces are covered with abstract patterns of colour modulations.[11]

It has hitherto been insufficiently noted that Chagall also made screens (406) according to Oriental compositional principles. Yet his thematic variations on objects hovering in space are eminently adaptable to the Far Eastern emptiness of the screen surface. This hovering quality provides an interesting comparison with Japanese screen painting. Chagall imbues things seen in isolation with a kind of poetry completely devoid of the spatial relativity of pictorial illusion as found in the Renaissance tradition. He is not concerned here with imitative Realism: it is an anti-anthropocentric vision that goes beyond the everyday world, acquiring affinities to abstract art.[12] Japanese screens reflect similar concerns; this refined expression of reality is close to Buddhist meditative mysticism.[13]

It is understandable that in China and Japan these tall, narrow flat surfaces attracted painters. The existing vertical picture was a further encouragement to this style of composition, and gradually led to the Toji folding-screen landscapes. Here the verticals of the 'tall picture' genre are integrated with the flowing right-to-left horizontal scroll painting (*emaki*) style. *Emaki* works had an incalculable influence on screen painting, as in them space was ordered not only up and down, but also sideways, in 'stations'. At the same time the fact that the individual panels of the screen could be moved resulted in a new visual approach, a different method of handling light, and a rhythmic articulation of spatial development.

It was customary in Chinese and Japanese houses to change the pictures according to the time of year. Pictures were also hung up in honour of any interested visitor. In this way they did not pall, as do pictures one sees every day. Screens must have been similarly regarded. The frames of many screens were like mounts which did not disturb the rhythmic effect of change. Patterned, soft pastel-coloured strips of silk were tailored to the panels. These strips of silk had a function similar to that of the hanging scroll – a form going back to the flag paintings of Buddhist and South-East Asian art.[14]

In early times the folding screen had a specific use in religious ritual. Its appearance denoted closely guarded rites. On the whole, pairs of screens were used, each with six panels. They stood protectively around the principal cult image of the Buddha.[15] Because of the possible different arrangements of the pictorial surfaces, the pictures on them did not have the same parallel regularity as those on sliding doors – which, stylistically, were first-cousins to screens.

In Japanese art screens were brought to a consummate pitch of achievement by Sesshū.[16] This painter always produced his screens in pairs, the content and composition of which were interrelated, the subject often being the seasons. The supreme exponent of the art in the Kamakura period was Hasegawa Tōhako,[17] who preferred to work in black and white. His extreme reductions of colour and form resulted in masterpieces of screen painting, conveying the subtlest differences in the moods of nature. Ogata Kōrin was another towering figure in the genre.[18] He it was who had the greatest influence on European painters. He had a decorative style which he fused with a sort of stylized realism. Above all he expressed the Japanese love of nature through reduced, schematized forms. His technique of the curling wave-line (330) influenced not only Europeans but also his own countrymen; his wave style was transferred to lacquered boxes and textiles.[19]

The artistic techniques proper to Japanese screen art cannot be gone into in detail here. The following information is based on observations of some relevance to European artists. In particular it is intended to illustrate the connection with the techniques of French artists.

In this context there are two principal types of screen painting (which, however, are not exclusively limited to the screen). The first is the splendid, richly figured screen with layers of gold, done in all kinds of techniques, which evolved into a significant art form in Japan. The non-representational ground of reflecting patches of gold and silver, together with the beauty of the colours, which may occasionally be transposed into variants of representational value, give this type of screen an aristocratic and festive look. In the Oriental imagination gold was the 'true colour'. Applied to the vertical surface of the screen, it supplied not only colour, but also gleaming brilliance and numerous visual effects which created exactly that sense of 'irrational' space for which the artists strove (403).

The extreme opposite of this style is to be found in Zen Buddhist painting (404). Here black is employed as the pervasive link between all colours. The subtle black of india ink is exquisitely handled. It is the perfect agent through which to bring out essential simplicity. The artist reduces everything to variations of black according

398 Emile Gallé
Screen on four feet
Autumn leaves
Wood, carved and inlaid
H.168 (66⅛)
London, Victoria & Albert
Museum

399 Paul Klee
Landscape on the Aare
Left four panels of a five-
panel screen
c. 1900
Oil on canvas
144 × 48 (56¾ × 18⅞) each
panel
Berne, Private Collection

400 Odilon Redon
The red screen
1906–08
Tempera
74 × 168 (29⅛ × 66⅛)
Private Collection

401 Maurice Denis
Screen with doves
c. 1904
Oil on canvas
164 × 54 (64⅝ × 21¼) each
panel
Saint-Germain-en-Laye,
Private Collection

402 Georges de Feure
Three-panel screen
c. 1900
Frame: carved wood
Fabric: silk, embroidered
and painted
172 × 227 (67¾ × 89⅜)
Paris, Musée des Arts
Décoratifs

to his own schematized idiom. He sees them back to their essential value, liberates them from a kind of husk, and takes pains to put nature in evidence. The highest goal is intelligible simplicity, achieved through the simplest means. The progress back to the primal formation of things leads to a kind of abstraction which aims for the supernatural via what is most natural. This graded ink painting combines with white, which signifies the emptiness of the ground. Between these two extremes – white and black – there is that tense polarity which Japanese painters considered as their ultimate goal, and which was achieved above all in monochrome screen painting.

White is here equated with universal pictorial light, as the Impressionists sensed. Empty space is usually countered by packed wealth of configuration. This principle may be observed in both the screen-painting techniques we have just discussed. In both instances the

areas left plain have a vital function, described in the Chinese manuals as follows:

Any spot where something is depicted defines nothingness within the picture, and there where nothing is to be seen is the true existence of pictorial reality. In this way immediacy is brought to a picture. When the student has totally absorbed the significance of this precept he will no longer have to fear the possibility of descending to inessentials, and he will at once have grasped the supreme principle of his art.[20]

As we have seen, the technical characteristics of the screen derive from its multiplicity of movable hinged surfaces. Japanese painters, however, ignore the breaks between the individual pictorial fields. What is limited is at the same time, for them, limitless. When necessary for the composition, the screen as a whole, regardless of the breaks between the panels, is governed by sections, or areas within sections, of emptiness. The breadth of space

403 Japan
Kimonos hanging on a frame
17th century
Six-panel screen
India ink and colour on
paper with gold leaf
170 × 366 (66⅞ × 144⅛)
Tokyo, Idemitsu Museum

404 Isshi Bunshu
Sixteen Lohans
c. 1640
India ink on paper
173 × 373 (68⅛ × 146⅞)
Tokyo, Idemitsu Museum

405 Natalia Goncharova
Sketch for a five-panel screen
c. 1920
Pencil drawing on yellow
tinted paper
63.5 × 105 (25 × 41⅜)
Vienna, Private Collection

406 Marc Chagall
Screen
c. 1964
Colour lithographs in
wooden frame
147 × 191 (57⅞ × 75¼)
Hamburg, Museum für
Kunst und Gewerbe

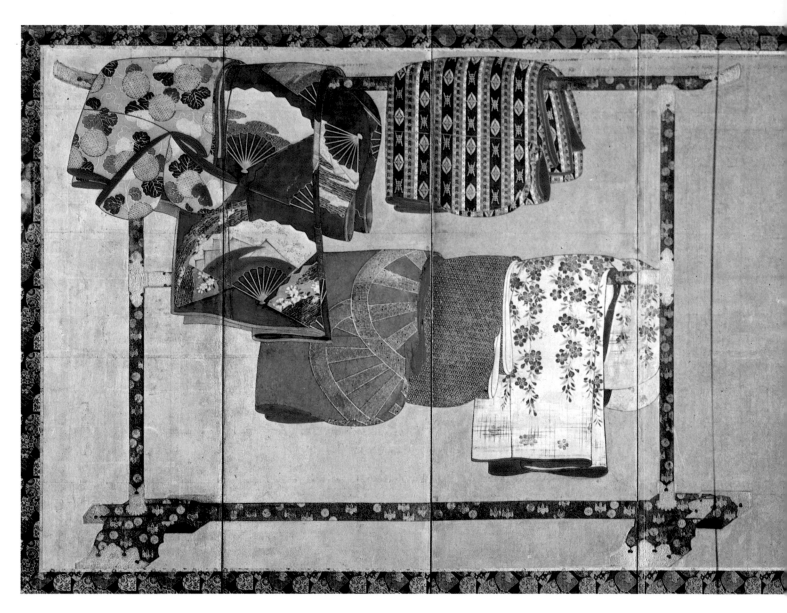

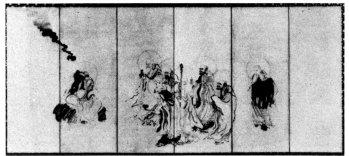

is also part of the closeness. The things close to the viewer are equally 'enclosed' in space. There is no visual opening into the picture in the European sense. The picture is 'open', over and beyond the successive vertical compositional elements. It is important in this context that all sense of the three-dimensional is withdrawn into the surface, for in screen painting depth and flatness of space are identical. As already indicated, empty space, in contrast with a concentration of pictorial objects, creates an accentuated surface more eloquent than a background. It is the unifying link between volume and pure surface art. Objects hover and can become immersed in the pictorial ground, which can itself assume different meanings. This pictorial ground is unlike its equivalent in European art, since it does not merely carry the picture in a technical sense, but is a kind of creative dimension of surface space, totally, subtly governing whatever is depicted in it. Because of this quality of possessing 'space without space', the screen was always an important art form which freed modern art from the constraints of realist representation.[21]

The fan

The semi-circular fan had a great impact on both Impressionist and Art Nouveau painters. The interest in original approaches to landscape details and figure groups meant that fans became testing grounds for chosen compositions.[1] Manet for instance gives us a rider maintaining a somewhat precarious balance, yet vividly animating the whole picture (419). As a complete contrast there are the painted fans of the Vienna Secession, the segments of which unfold to reveal a dense wealth of ornamentation. These two widely differing examples show that fan painting was an ever-recurring, ever-varying area of interest for painters.

At the same time it afforded European artists a rich field for compositional research, resulting in numerous different techniques. Most commonly the painted surface of the fan represented a peep-hole into another, pictorial dimension. The swift, incisive vision of the Impressionists, with their love of the isolated detail, led to an attempt to render this 'telescopic' landscape view with momentary intensity – above all as movement. Unlike the painted fans earlier on in the nineteenth century, those of the French Impressionists feature severely sliced off landscapes and figures. Pissarro arbitrarily cuts off certain figure groups in his foregrounds. The resultant 'detail' effect successfully reflects the immediacy of real-life landscapes in miniature.[2]

The sky is always depicted as the vaulted firmament. The impression of depth created by manipulation of planes makes the fan a sort of visual sliver of distance, similar to what the Japanese, in their semi-circular woodcuts, called the 'pictorial duel'. Yet in the fan painting of Pissarro (413),[3] we can already detect that same asymmetry which Toulouse-Lautrec (414) made use of later. Elegantly composed figure groups on one side, with only a restricted view on the other into the distance, emphasizes the curved picture surface anticipating the lateral shifting of balance towards a greater intensity of space that was later to find favour. This approach, corresponding to that of the Barbizon painters with their presentation fans, and even to that of the mid-nineteenth-century Munich school,[4] finds its complete antithesis in the fans painted by Degas and Toulouse-Lautrec. In his fan *Dancer with double-basses* Degas creates a sense of rhythmic movement, set off by the dancer, which provides pictorial weight to counterbalance, and at the same time stress, the emptiness on the other side of the fan. Grouping on one side only, leaving an empty space on the other, often produces substantial asymmetry in the semi-circular fan – an effect sought after also by Japanese and Chinese fan painters.[5]

Degas's interest in the fan was not so much in the object itself, but in the compositional challenge posed by the peculiar shape of the pictorial surface. *Ballerinas resting back-stage* shows how he resolved the problem, presenting a kind of peep-hole view of the subject.[6] A stage flat in the foreground obstructs the scene, in accordance with Japanese methods of composition, and cuts the dancers short, so that in some cases only their heads are visible. The spontaneous structure of the picture, which reduces the stage space with wings arranged in step-like progression, is principally the effect of the fan shape. The group of figures looks as if hovering in mid-air. Among the principal influences on Degas was the Japanese court fan painter Tawaraya Sōtatsu (c. 1570–c. 1640),[7] who lived in the Daigo-ji temple in Kyōto. His fans show unusual views, notably seen from above, just as in Degas's *La farandole* (407). Degas is also close to Sōtatsu in his use of colours, showing a preference for browns, pinks, ochres and whitish tones, used to strangely abstract effect.

India ink, besides being employed to create living, moving calligraphy, commonly appears on Oriental fans. The subtle fluidity of line and schematic representational style of the india ink technique makes it best suited to small, highly individual genres.[8] One example of this is a fan by a mid-nineteenth-century Japanese painter, Seikō (415). With great economy of means a man and his monkey are depicted, the man demonstrating what his monkey can do. The thin, flowing medium of india ink, applied with a pointed brush, provides the 'shorthand' according to which the picture is conceived. The man kneeling in profile on the left-hand side of the fan holds in his hand the thin cord at the end of which, in the 'void' on the right, the monkey is performing. The monkey is a delicate silhouette caught in motion, and the man, with large hat and raised left arm, echoes the movement. The cord and the animal alone suffice to fill the empty right-hand area, which imbues the scene with activity. There is no crowding, and the empty ground is immanent and undefined. The peculiar fan format is an essential element of the composition. The painter adjusts to it. Everything in the semi-circle finds its own appropriate, contributory place through the painter's individual sense of composition, within the occasional constraints of the demands of pictorial balance.

The Italian Giuseppe de Nittis painted fans (417) using a flower and plant decoration bearing a distinct Oriental stamp.[9] The casual scatter-pattern of drifting autumn leaves is well suited to the unusual fan shape. The constricted angle of vision reveals vine leaves – matt, green, brown, and yellow – clinging to the background. The speckled effect and the broken glaze textures of the colours are close to Japanese fan decoration, which De Nittis must have seen. Nature here is reduced, conforming with the background not only in theme and colour, but also in its outlines. Following the precepts of *The*

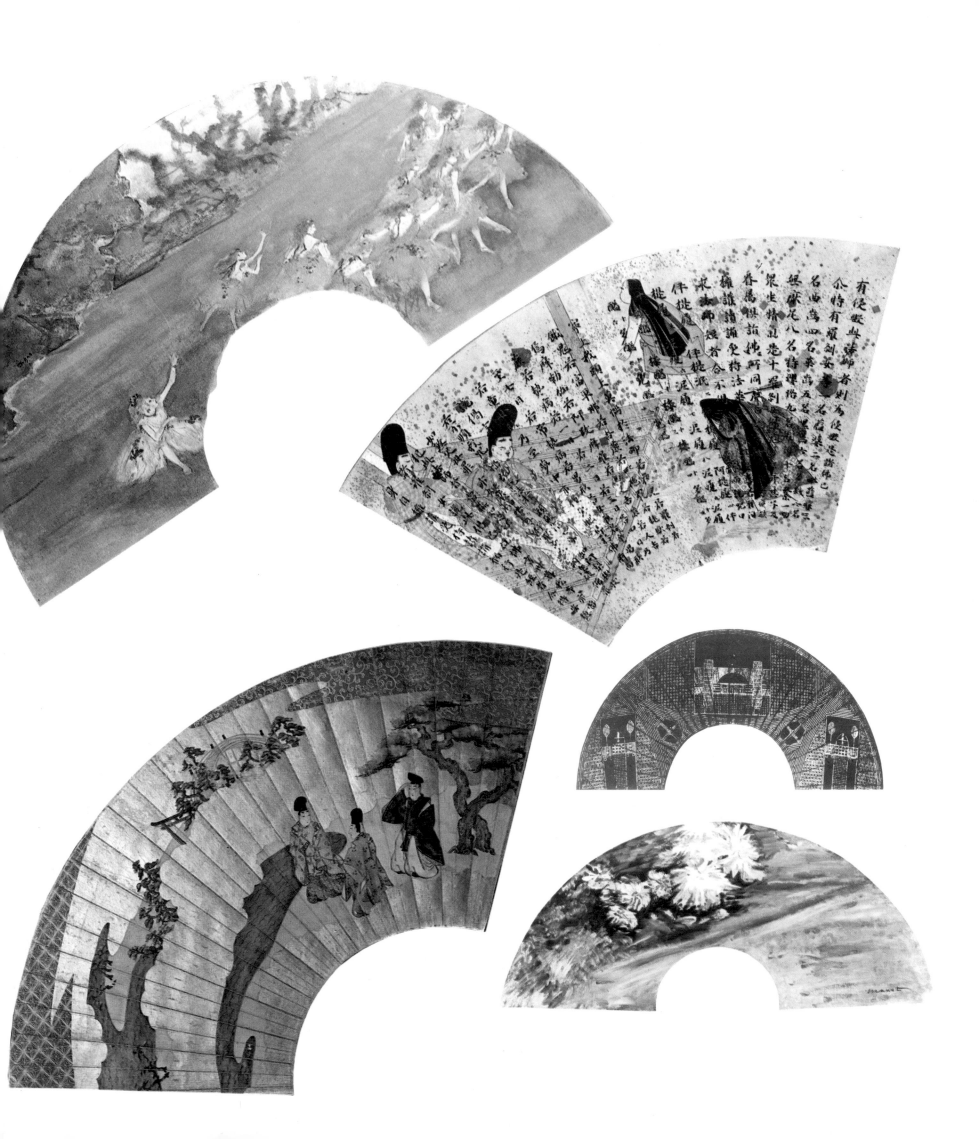

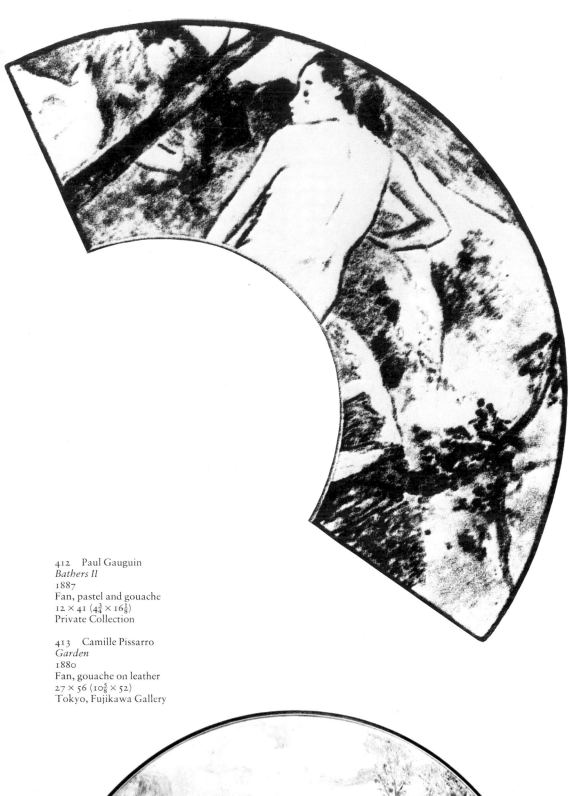

Mustardseed Garden, De Nittis chooses to paint chrysanthemums and bamboo,[10] a much painted subject in Chinese and Japanese art. The leaves are arranged with great care, in organic development from the fan motif, which is treated as a brush exercise, and from certain styles of india ink (*no-hsi*) painting: 'Although the leaves should be painted with only a few brushstrokes, they should nevertheless have a graceful fluidity in harmony with the wind.' This advice for flower painting comes from *The Mustardseed Garden*. It was on such themes that De Nittis seized, giving them visual expression under the influence of the great models he had seen.

Innumerable fans and fan types were seen at the great international exhibitions.[11] Degas and Toulouse-Lautrec certainly did not miss them. Their methods of composition make this quite clear. Gauguin also produced painted fans. We know of no fewer than twenty such works by him, all very different in subject, as this list indicates: *Summer landscape*, *Landscape near Rouen*, *Landscape after Cézanne*, *Still-life*, *Seated Breton women*, *The battle scene in Martinique*, *Little Breton shepherd boy*, *Kitten eating from a bowl*, *Breton scene*, *Eragny-sur-Epte*, *Still-life with fan*, *Profile of a woman*, *Te Raan Ralu*, *Arearea* (*Joyeusetés II*), *Maratu Metua No Tehamana* (*Ancestors of Tehamana*), *Woman with mangos*, *Girl with a fan*, *Oudine*.[12]

Gauguin attempted to convey large-scale human figures within the scale of the fan (412). He forges a unity between Oriental principles of composition and his own synthetic requirements, and thereby creates a new technique, representing a totally original visual approach. The figures as solid-looking objects, still close to the *cloisonnisme* of Bernard, break in on the curved pictorial field of the fan, filling it out, and often achieving that dominance that Oskar Kokoschka was later to attain in *his* fan paintings.[13]

Toulouse-Lautrec on the other hand came close to the Oriental principle. He had brushes and paints sent him from Japan in order to emulate his models more exactly. The Japanese brush has greater malleability and is more robust than any produced in Europe. 'India' ink from China and Japan also has greater versatility, giving richer half-tones and tone variations.[14] The compositional method in Toulouse-Lautrec's fan painting *At the Cirque Fernando* (414) is perfectly plain. The figure group is unstable, integrated with a slightly precarious balance into the semi-circular ground. A line on the right indicates the edge of the circus ring. The elephant stands on his tub, the clown, whip in hand, in front of him. There is a sort of alternating movement between the side and the back views, which conveys the dislocation of space with the minimum of means. The swiftness of the brushwork, delineating the figures in calligraphic style, conveys all the potential movement implicit in the scene. In the curve of the ringside, which runs differently from the curve of the fan, the painter's visual conception is forcibly merged into the given physical shape to create a dynamic spatial 'moment'. 'The Japanese paint like lightning', said Van Gogh;[15] and Toulouse-Lautrec adopts the same pictorial concepts and techniques. His success in creating an impression of space with these

412 Paul Gauguin
Bathers II
1887
Fan, pastel and gouache
12 × 41 (4¾ × 16⅛)
Private Collection

413 Camille Pissarro
Garden
1880
Fan, gouache on leather
27 × 56 (10⅝ × 52)
Tokyo, Fujikawa Gallery

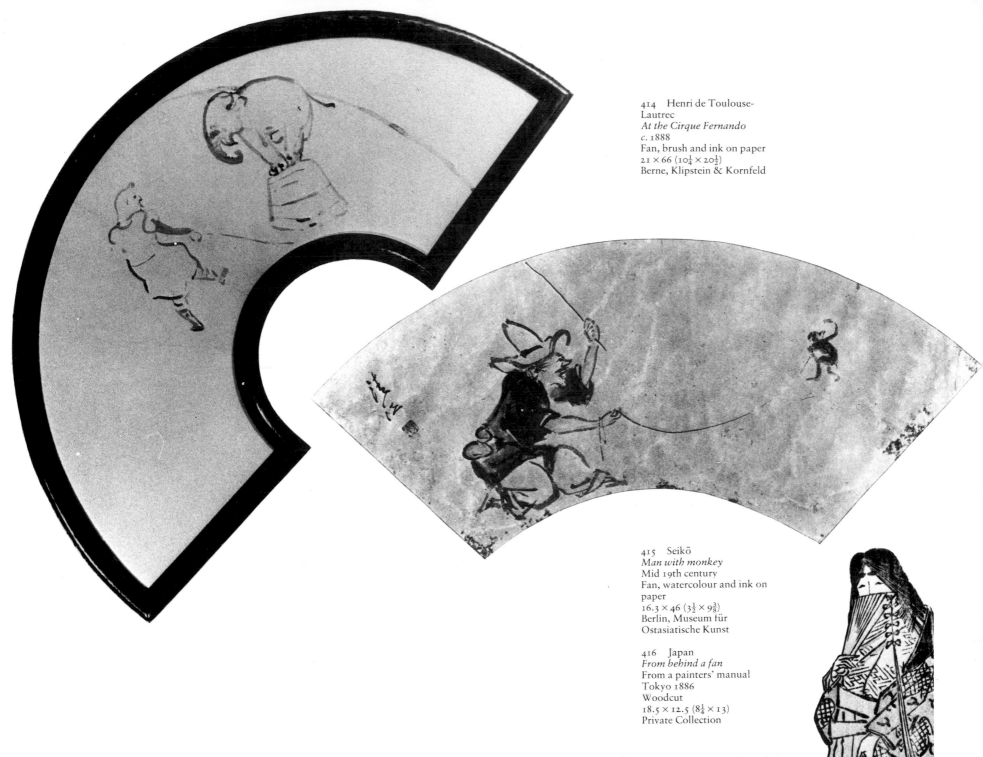

414 Henri de Toulouse-
Lautrec
At the Cirque Fernando
c. 1888
Fan, brush and ink on paper
21 × 66 (10¼ × 20½)
Berne, Klipstein & Kornfeld

415 Seikō
Man with monkey
Mid 19th century
Fan, watercolour and ink on
paper
16.3 × 46 (3½ × 9⅜)
Berlin, Museum für
Ostasiatische Kunst

416 Japan
From behind a fan
From a painters' manual
Tokyo 1886
Woodcut
18.5 × 12.5 (8¼ × 13)
Private Collection

simplified strokes reveals a close knowledge of Japanese models.

Fan painting still had a certain function around 1900; both before and after this time the fan was an essential fashion accessory.[16] After 1900 fan painting was once more brought to an astonishing artistic level by no less a figure than Kokoschka, who created outstanding fans for Alma Mahler (421, 425). He followed the old principle of segment painting, yet without adopting the method entirely. He extended the pictorial space over several sections, and painted figures arbitrarily across the segments (425). However, the standing figures are made to match the segments, to create a sense of the vertical when the fan is open, and, as it is closed up, a stronger, more powerful Expressionistic grouping of slender figures. The deliberate exuberance of the colours is all the more effective against the red and black lacquer

of the visible slats – a late and important example of European fan painting.

The history of Oriental fans is a history of eras. Here I can give only a brief summary, drawn from my account in the exhibition catalogue 'Weltkulturen und moderne Kunst'.

The fan is in general an attribute of metamorphosis in the Far East.[17] The folding fan, as we still know it today, consists of a row of long, narrow segments taped together, or of thin slats over which a wide covering sheet is stuck.[18] The great artists of both China and Japan designed silk fans. The main types were the *ogi* (folding silk fan), *hiogi* (folding fan of *hinoki* wood for court ladies), and the *uchiwa* (screen, or round fan).[19]

Expensive examples were produced according to the most varied techniques (418, 420). 'Softly gleaming in

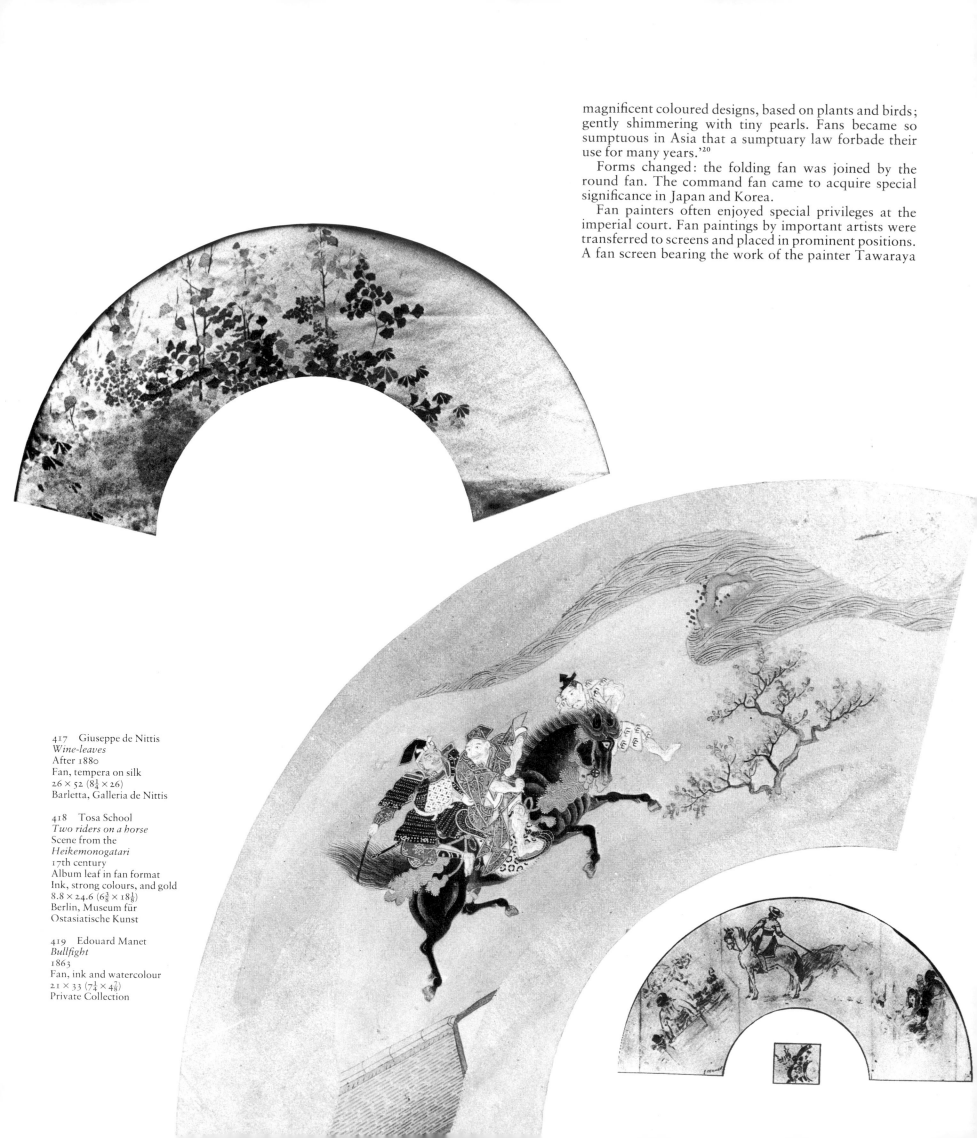

magnificent coloured designs, based on plants and birds; gently shimmering with tiny pearls. Fans became so sumptuous in Asia that a sumptuary law forbade their use for many years.'[20]

Forms changed: the folding fan was joined by the round fan. The command fan came to acquire special significance in Japan and Korea.

Fan painters often enjoyed special privileges at the imperial court. Fan paintings by important artists were transferred to screens and placed in prominent positions. A fan screen bearing the work of the painter Tawaraya

417 Giuseppe de Nittis
Wine-leaves
After 1880
Fan, tempera on silk
26 × 52 (8¼ × 26)
Barletta, Galleria de Nittis

418 Tosa School
Two riders on a horse
Scene from the
Heikemonogatari
17th century
Album leaf in fan format
Ink, strong colours, and gold
8.8 × 24.6 (6⅜ × 18⅛)
Berlin, Museum für
Ostasiatische Kunst

419 Edouard Manet
Bullfight
1863
Fan, ink and watercolour
21 × 33 (7¼ × 4⅞)
Private Collection

Sōtatsu is to be found in the Daigo-ji temple in Kyōto; it tells us much about the importance and use of the semi-circle in Japanese art.

In Georg Buss's history of the fan reference is made to European painters' manuals, along Oriental lines, aimed above all at amateur painters – for fan painting had become an immensely popular activity in Europe in the second half of the nineteenth century. The following advice is given: 'Also with reference to the painting there are one or two hints to be observed. When using gouaches, the colour should not be too thickly applied,

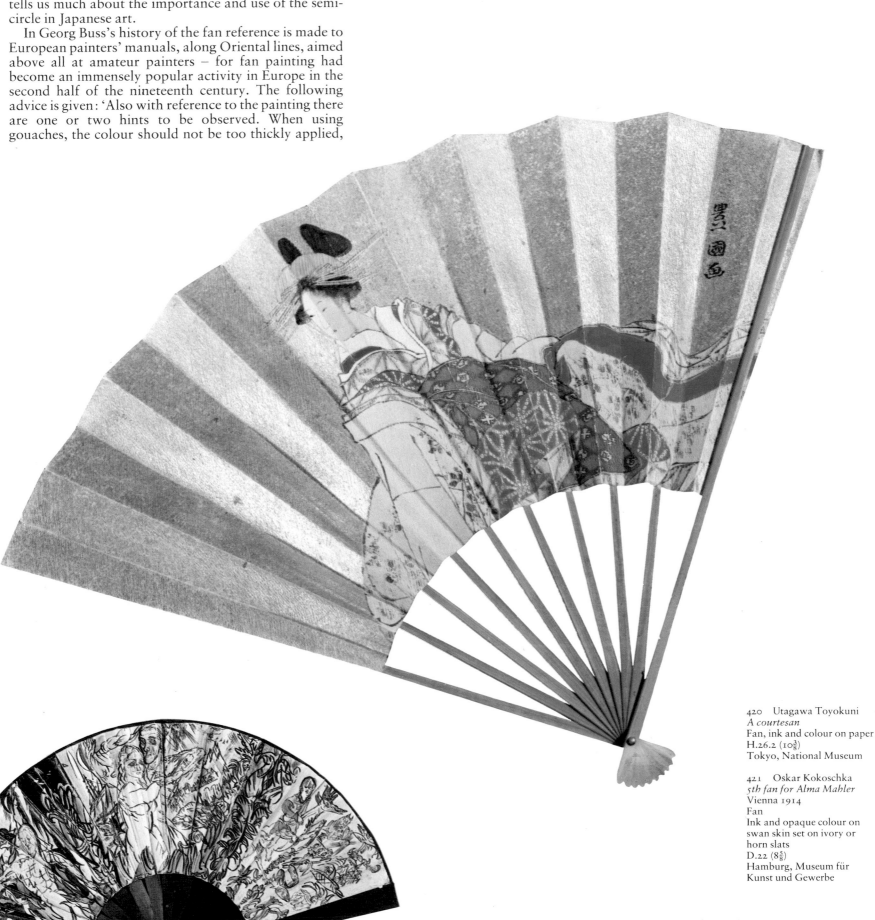

420 Utagawa Toyokuni
A courtesan
Fan, ink and colour on paper
H.26.2 (10⅜)
Tokyo, National Museum

421 Oskar Kokoschka
5th fan for Alma Mahler
Vienna 1914
Fan
Ink and opaque colour on swan skin set on ivory or horn slats
D.22 (8⅝)
Hamburg, Museum für Kunst und Gewerbe

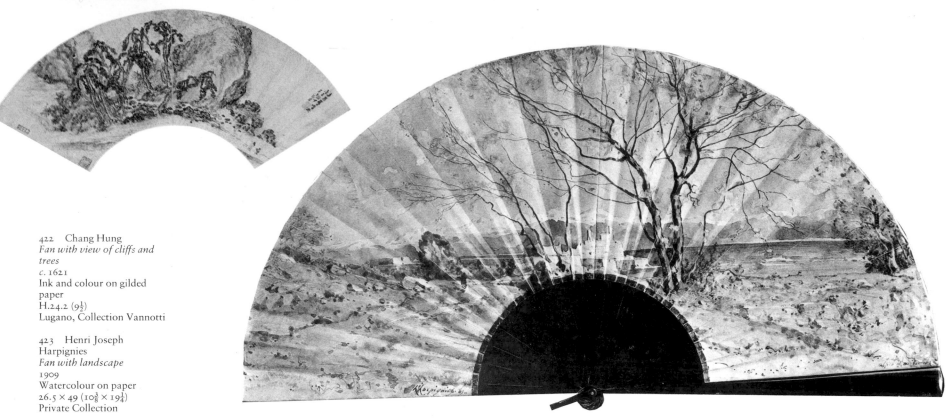

422 Chang Hung
Fan with view of cliffs and trees
c. 1621
Ink and colour on gilded paper
H.24.2 (9½)
Lugano, Collection Vannotti

423 Henri Joseph Harpignies
Fan with landscape
1909
Watercolour on paper
26.5 × 49 (10⅜ × 19¼)
Private Collection

424 Chang Hung
Fan with landscape
1625
India ink and colour on paper
18 × 46 (7⅛ × 18⅛)
Lugano, Collection Vannotti

as all elevations will immediately flake off. In choosing the colours, account should be taken of whether the fan is intended for day or for evening use.'[21]

Just as the decorative comb, hairpin, and hatpin (inspired by Japanese designs) were all fashionable accessories, so too the fan was a must for the fashionable lady of nineteenth-century Europe. As such, day and evening fans were quite distinct from each other. The fan was bought to match its user's dress.

Though with quite different aims in mind from those of the amateurs, professional artists also took up fan painting. In numerous French Impressionist paintings fans appear – and sometimes they contribute significantly to the general design of the picture, as in Monet's *La Japonaise* (11).

In Japan too, fan composition (with all its subtle nuances of angle) was practised both by important artists and also by a large number of laymen and men of letters, who took to the genre as enthusiastically as the Europeans after them. As well as the upward curving semi-circle, the Japanese used the same shape curving downwards. Many examples of this exist: for instance Koryūsai's *A man and woman quarrelling*, a similar scene to the Nō drama *Kakitsu-bata*. However, the format of the screen fan (a rectangle tending towards a square, with rounded corners), had many variants (215). This format was repeatedly modified by Kuniyoshi as an experimental picture surface. Nevertheless the usual format in fan painting remained the neat semi-circle, and this was raised to a high art form by many Chinese (424) and Japanese (418) painters.

Kano Nuinosuke's fan *Village with fishing-boat in the mountains* shows how landscape could be integrated into an idiosyncratic format. Much better known are the innumerable sprigs of blossom with birds inspired by *The Mustardseed Garden*. Figures were also incorporated into the semi-circular fan, as in *Two riders*

168

425 Oskar Kokoschka
4th fan for Alma Mahler
Vienna 1913
Fan
Ink and opaque colour on
swan skin mounted on ivory
or horn slats
D.21.5 (8½)
Hamburg, Museum für
Kunst und Gewerbe

426 Ludwig von Hofmann
*Fan, with landscape, woman
and peacock*
c. 1900
Watercolour on gauze
H.19.3 (7⅝)
Karlsruhe, Badisches
Landesmuseum

427 Japan
Fan, with river scene
From a painters' manual
Tokyo 1878
Woodcut
18 × 12 (7⅛ × 4¾)
Private Collection

on a horse (418). Countless numbers of fans carry pictures of poultry, especially cocks. The festive-looking fans with a gold ground (408, 409) depict scenes from everyday Japanese life. A landscape is usually present, and hump-backed bridges and pines are the conventional motifs of fan decoration. The moving object is also a common theme in fan painting, as the 'peep-hole' view of this format provides fine possibilities for rendering movement. Birds in flight – cuckoos, siskins, sparrows – are a recurrent theme. Fan paintings offered 'a glimpse into the everyday', as one Japanese proverb puts it.

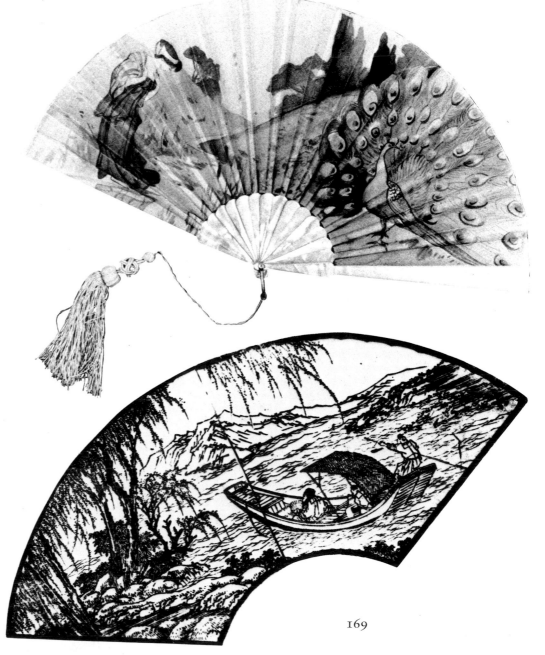

169

Pillar pictures and vertical formats

The choice of distinctive formats by second-generation French Impressionists led to a distinctive pictorial 'statement'.[1] At the centre of interest was the Japanese hanging scroll, known as *kakemono-e*, the peculiar narrowness of which gave scope for surface spatial illusions that could not be achieved on a regular rectangle.[2] Formations of figures stacked vertically, with subtle overlapping and cutting off, resulted in the illusion that the pictorial space had been done away with. By removing the need to have each figure standing on the ground, a sense of anti-gravitational buoyancy was created. This new optical vision came to the Post-Impressionists as a new pictorial experience (429).[3] The substantial verticals which Vuillard incorporates in his pictures are a complete negation of the normal rectangular system (431). Depth becomes a decorative oblique without any illusionistic effect of distance. The aim in this tall format is always emphatic ups and downs. Vuillard is particularly concerned to destroy the viewer's own fixed standpoint, disorientating him with multiplicity of planes. The vertical paintings of the Nabis thus become fragments, thought out to the tiniest detail, in which a 'snatch' of subject is intensely and thoroughly explored.

The dimensions for the particular formats in the Oriental woodcut are precisely defined: the *kakemono* measures 57 × 30 cm. (22½ × 11¾ in.), the *hashira-kake* (also *hashira-e* or *naga-e*) 32 × 15 cm. (12½ × 6 in.), the large *tanzaku* 36 × 18 cm. (14 × 7 in.), and the very slim, small *tanzaku* 36 × 11.5 cm. (14 × 4½ in.). The generic name for tall, narrow paintings is *tat-e*. *Tat-e* was a sort of experimental form for narrow-scale work, in which figures, objects, and landscapes were compressed and compacted together.

The compositional techniques of the Chinese *kakemono* had as great an influence on Europe as did the Japanese woodcut. These vertical strip compositions were to be found in China already in the sixth century. They became plentiful in this period, and acquired new expressive potential with the inclusion of horizontal planes. The Chinese *tun-huang* form, in which there is no compositional feature to mark the left and right edges, and which soars up into open space at the top, is a set type in Japanese art.

The tall, narrow format exercised a strong influence in Japan as early as the fourteenth century. *The Nachi Waterfall* (745), painted on silk, in the Nezu Museum in Tokyo[4] is an impressive example of this genre, measuring 166 × 59 cm. (65 × 23 in.). It is all the more remarkable in being intended for ritualistic purposes – the composition is centred on the waterfall, and the natural scene portrayed conveys the religious meaning: the waterfall, equated with a spiritual being, constitutes

428 Katsushika Hokusai
Sketch
1814–78
From *Manga*
Colour woodcut
24 × 14.5 (9½ × 5⅝)
Private Collection

429 Claude Monet
Fragment of *Déjeuner sur l'herbe*
1865
Oil on canvas
418 × 150 (164⅝ × 59)
Paris, Louvre

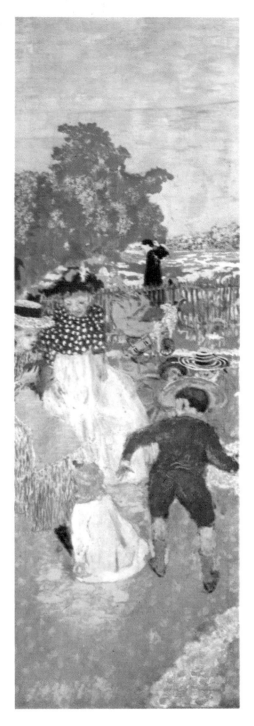

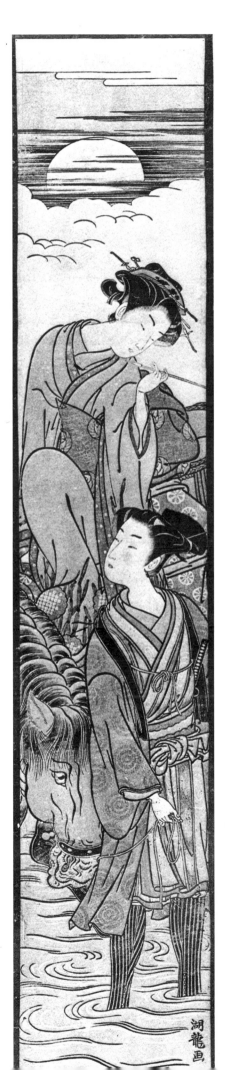

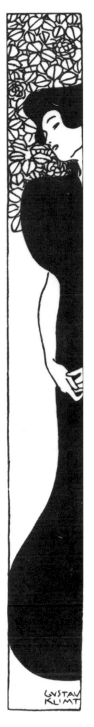

430 Isoda Koryūsai
Youth on the back of a man picking a flowering branch
c. 1770
Colour woodcut
69.5 × 12.2 (27⅜ × 4¾)
London, Private Collection

431 Edouard Vuillard
The nannies
1894
Colours on canvas
212 × 72 (83½ × 28⅜)
Paris, Musée National d'Art Moderne

432 Isoda Koryūsai
Night scene: girl on a horse with a young man
1770s
Colour woodcut
67.8 × 10.9 (26¾ × 4¼)
Berlin, Museum für Ostasiatische Kunst

433 Gustav Klimt
Woman standing in front of flowers
1898
Pen and ink
Repr. *Ver Sacrum*
Year 1, Vol. 3

434 Gustav Klimt
Three children and young woman
1898
Charcoal on paper
Repr. *Ver Sacrum*
Year 1, Vol. 3

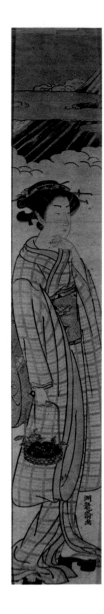

435 Isoda Koryūsai
*Girl carrying basket. Mount
Fuji in the background*
2nd half of 18th century
Colour woodcut
67.5 × 11.5 (26⅝ × 4½)
Cologne, Museum für
Ostasiatische Kunst

436 *Poster for the 6th
Secession exhibition*
1900
Japanese colour woodcut,
lithograph
102 × 30 (40⅛ × 11¾)
Vienna, Österreichisches
Museum für angewandte
Kunst

437 Isoda Koryūsai
Girl with cresset
c. 1860–70
Colour woodcut
68.5 × 12.4 (27 × 4⅞)
Vienna, Österreichischs
Museum für angewandte
Kunst, Exner Bequest

438 Gustav Klimt
Judith II (Salome)
1909
Oil on canvas
178 × 46 (70 × 18⅛)
Venice, Galleria d'Arte
Moderna, Ca'Pesaro

439 Japan
*Girl behind half-open
sliding-door*
18th century
Hanging scroll
Colours on paper
130 × 38 (51⅛ × 15)
Cologne, Museum für
Ostasiatische Kunst

440 Gustav Klimt
Girl with three flowers
1899
Repr. *Ver Sacrum*
Year 1, Vol. 3

441 Kolo Moser
Girl with sheaves
1898
Repr. *Ver Sacrum*
Year 1, Vol. 4

442 Max Kurzweil
*Poster for the 17th Secession
exhibition*
1903
Lithograph
90 × 31 (35⅜ × 12¼)
Private Collection

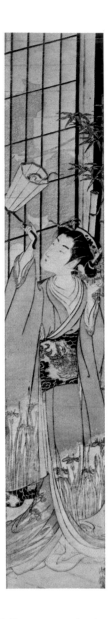

SECESSION
VEREINIGUNG
BILDENDER
KÜNSTLER
ÖSTERREICHS
VI. KUNST-
AUSSTELLUNG

the central axis, and the towering cliffs rise with the water up to the sky, where the orb of the sun is seen. The physical format determines the content, and all further Japanese tall, narrow paintings are conditioned in content by the shape of the pictorial field.

Monet took on this genre of painting as early as 1865. In his *Déjeuner sur l'herbe* (429), 418 cm. high and only 150 cm. wide, he is already beginning to stack his figures and cut them off, rendering the picture surface more dense and compact with tree trunks. Later he chose flowers and wild grasses as decorative themes for wall panels. Under Japanese influence flowers were also for the French Impressionists something more than mere arabesques but less than still-lifes. Monet adopted a tall, narrow format for his *Japanese lilies* (450), reminiscent of Japanese pillar and *kakemono* pictures. The blooms are consciously made more ornamental, and to create a certain impression of spontaneity some of the petals are cut off by the edge of the picture, as occurs in Japanese models. The painter also adds a vertical signature in sealing-wax red, after the fashion of Japanese *mon* emblems and stamps.[5] This painting was conceived as

172

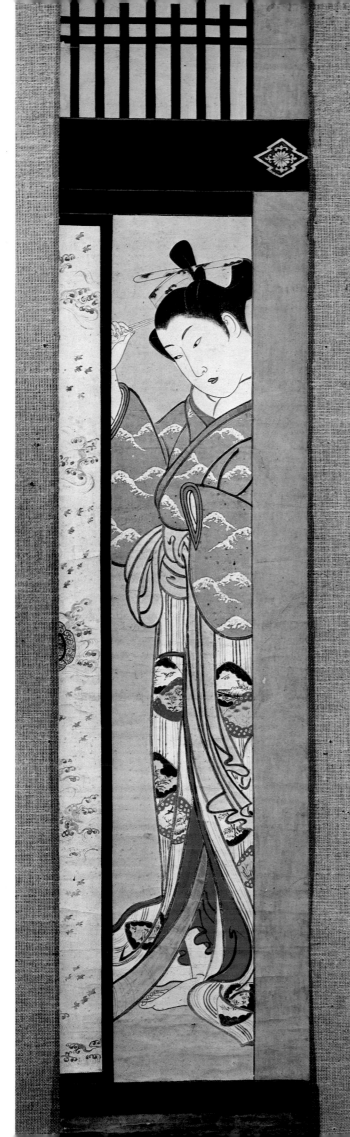

decoration: it was executed for Paul Durand-Ruel's dining-room in the rue de Rome. Monet returned again and again to these decorative panels, finding inspiration in his garden or on excursions to the Ile-de-France. On one occasion he took orange branches with fruit hanging from them, which had been sent up from the Côte d'Azur, as his subject. On 6 September 1883 he wrote to Durand-Ruel: 'I think I now know how I should do the panels for your dining-room.' Woodcuts depicting flora in the precise Japanese style could be found in small galleries and large antique shops all over Paris.

Hokusai presents the tall, narrow format almost didactically in volume 15 of his *Manga*. The different effects of a high- or low-positioned horizon are contrasted. A thin section of empty space, placed high, is reached by a piling-up of landscape elements; the opposite is a soaring sky above a reduced, narrow patch of earth – geological layers being replaced by air, cloud, and atmosphere. Between these two extreme treatments of space the tall, narrow format offers innumerable possibilities for varying the pictorial balance, with weighting to the left, to the right, or centrally. Such

443 Pierre Bonnard
*Woman with white-dotted
dress, Seated woman with
cat, Woman in chequered
dress, Woman with blue
shawl*
1892–98
Four panels of a screen
Oil on canvas
Each panel 160 × 48
(63 × 18⅞)
USA, Collection Mrs Frank
Jay Gould

444 Nishimura Shigenaga
*The actor Sanogawa
Ichimatsu I*
c. 1743
Woodcut, hand-coloured
69.4 × 16.5 (27⅞ × 6½)
Regensburg, Collection
Franz Winzinger

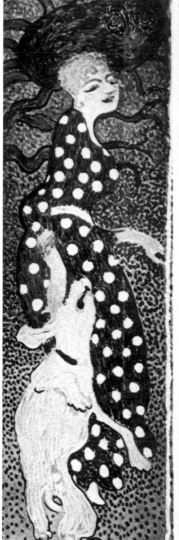
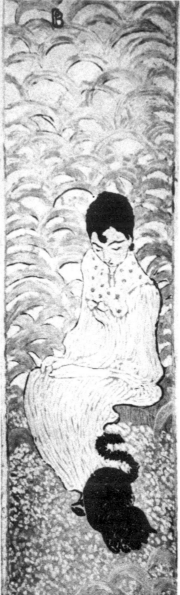
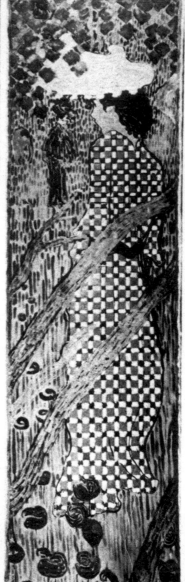
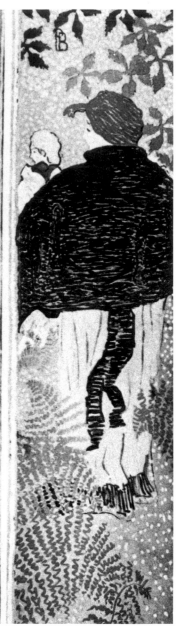

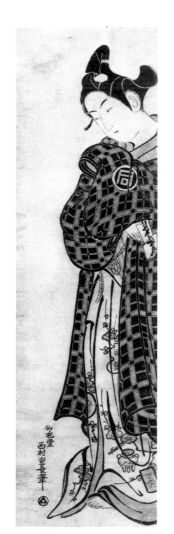

variety makes it always an interesting and stimulating
genre.

For European artists, who were already familiar with
these works, re-discovery lay chiefly in the realm of the
picture format and the artistic devices of mastering this
format. From now on it became almost a new pictorial
form, conditioned by different laws. Rather than right-
to-left movement within the composition, the surging,
upward thrusting verticals were now the essentials that
were to be imitated.[6] They contain the rhythm of all
upward motion. And the Oriental artist's sense of
landscape climbs in sheer, giddy ascents to nature itself
(745).

The restricted, narrow – preferably vertical – format,
which was not exclusively used for landscapes and figure
representation, also served to help convey written
information (444). The long vertical surface gave the

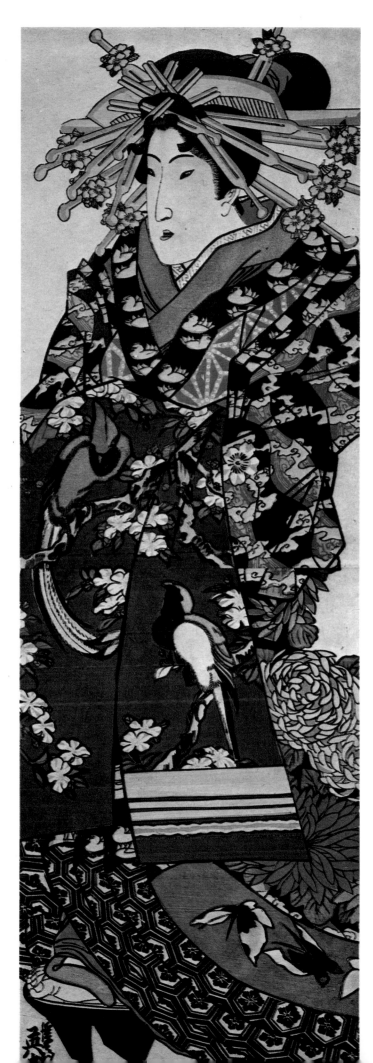

445 Keisai Eisen
Courtesan in festive robes
c. 1830
Colour woodcut
73.7 × 24.8 (29 × 9¾)
London, Victoria & Albert
Museum

artist an opportunity to develop a calligraphic style in his brushwork. The Japanese woodcut, especially in the small *tanzaku* format, was described as 'a jewel of strip composition'.[7] From the figure compositions of Torii Kiyomitsu, Suzuki Harunobu (60, 61), and Isoda Koryūsai (430, 432, 437) to the work of late masters of the colour woodcut, the tall, narrow format was used to set off the minutest hint of movement or as a vehicle for that dense compactness of composition through which is conveyed a sense of dislocated space. Based entirely on the outline shape of what is depicted, compositions in this format encourage a kind of direct vision to which all secondary details are superfluous (449).

There can be no doubt that this pictorial conception was highly fruitful for European artists. Comparison of French and other European artists' vertical works is instructive, as it reveals similarities not only of format, but also of compositional techniques.

It is among the Nabis that we find the masterpieces of this style of art. Bonnard (443), Vuillard (431), and Denis (446) all used this format to portray the human figure in their own ways. Denis, together with Sérusier, was the theoretician and spokesman for the Nabis. He made practical experiments with the decorative principles of painting, exploring pattern and ground. The portrait of Madame Ranson (446) is the product of his theoretical work, which was fundamentally influenced by Japanese colour woodcuts. The background with its ornamentally handled wallpaper motif merges with the subject's clothing. Everything in the picture is depicted in flat parallels: chair, skirt, wall. Even the high-lighted cut-out figure of Madame Ranson herself is treated according to the Japanese woodcut style. In fact this picture caused some considerable interest among the Nabis as a group, precisely because it so closely assimilates the Japanese mode.

The basic principle of the Japanese small *tanzaku* is a vertical figure composition adapted to the narrow format. This compositional form found innumerable variants in Japanese art. The vertical impulses are interrupted either by carefully introduced horizontals or by abrupt superimposition of figures (449, 452).

The tall, narrow format became ever more important in European art around 1890, because of its need for extreme concentration of compositional design. Figures are set off sharply in silhouette against a background. The old Japanese theory of absolute congruity of ornamental lines came to operate here too.

Bonnard's figures in this narrow genre have a certain compositionally satisfying anonymity (443). He seems to aim for a static textile effect.

Vuillard treated the format in various different ways. He succeeded in developing the genre further, also into the field of landscapes. The viewer is made to plunge through the narrow cleft of the picture frame direct into a different vision of nature. Depth is no longer horizontal in the way it is in a screen, or as it was in the first half of the nineteenth century: the landscape is now seen from a bird's-eye view. Vuillard renders the *Place de Vintimille* in this perspective – dissolving towards the bottom of the picture. The precision of the objects, which are merely given in outline, derives from their absolutely clear

relation to the pictorial depth, which is at the same time the centre of the picture. There everything becomes most distinct; the picture then fades off again into silhouettes towards the top, as if seen through a camera lens.

Cut-off branches, chandeliers or telegraph poles enhance the immediacy of this vision. Vuillard's incisive graphic style produces the sketch-effect of improvisation and of the action of a single short moment, which is strengthened by the extreme use of isolated detail. His painting achieves that swiftness and exactitude of vision which, with the help of the format, stirs awareness of the passing, still unconcluded instant.[8] Here too, although in a quite different way from screen painting, the detail appears to contain the whole (449): all that lies beyond the confines of the picture must be imaginatively sensed by the viewer.

However, Vuillard was capable of getting even closer to his Japanese models, as *The nannies* (431) shows. Here the figure group, set against the bland, flat surfaces of the background, forms an almost three-dimensional compositional climax within the narrow vertical picture format. At the same time the fleck-like style and the patterning of the clothes form a distinct surface unity. Japanese techniques of linking are a major influence, as is also abundantly clear from Vuillard's lithographs. The vertical and horizontal emphasis, the flattening out of the ground, and the decorative disposition of the various accessory elements in this picture would be unthinkable without the example of the Japanese woodcut. The silhouette-like delineation of mass and the colour combinations serve to make the similarity all the greater. Yet Vuillard also creates his own personal effects, tailoring his capturing of postures and expressions, his breaking-up of paint into individual colour values and moving colour surfaces, and indeed all his powers of artistic creativity, to the format.

Many other painters followed Vuillard's example. Gustav Klimt (433, 434, 438, 440) enhanced his flat-surface style of figure conformation through rhythmic compression of outline. Posters in the same unusual format proved successful eye-catchers (436, 442).

Maurice Denis in *Madame Ranson with cat* endeavoured to transpose the Japanese woodcut to figure painting. The format – rather than being, as it were, pumped full of space, as in the Nabis' landscapes – was exploited like an enclosed stage-set. Also of significance is the way line and surface are joined in this painting. As in Japanese ink drawings, dark figure outlines are at one and the same time integrated with the interiors and yet still separate and autonomous. The same is true of strongly dominant decorative motifs on clothes and wallpaper backgrounds. Curving lines are contrasted with the silhouettes of arms and heads, to create a certain aesthetic tension which engages the viewer's attention. Through schematized abbreviation of formal elements (which influenced the poster style around the turn of the century; see 442, 453) this format acquires a similar function to that which we find with Roussel, Bonnard and Klimt.

As Denis's picture shows, the vertical format avoids all sense of frontal projection out of the picture surface. The figure grows out of an overall pictural context –

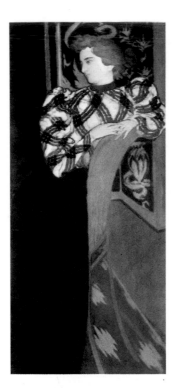

even the blouse is dependent on its context – and the head is set in two-dimensional profile, on top of this ornamentally rendered body, as in Japanese woodcuts, where an idealized depiction of an actor's face was often transferred to a different body and clothes.[9]

Gustav Klimt was the most successful exponent of the vertical format in Europe. He felt close affinities to the Japanese figurative style and studied this format closely, using it often. In his *Judith* (438), dating from 1909, we see a compact piling-up of compositional elements which suitably illustrates the drama. The clustering of large and small shapes, in which naturalism rubs shoulders with abstraction, is a highly compressed artistic idiom that goes radically beyond hitherto prevailing norms. The extreme narrowness of the picture creates that sense of overwhelming crescendo which the subject requires. Here the lack of any geographic location also conveys the feeling of a timeless trance. As often in Far Eastern figure representation, the human form appears to hover – in hybrid existence with its setting. The figure of Judith is inextricably part of the groundless ground.

Klimt uses the Japanese format to produce a certain expressive intensity.[10] The absence of geographic location is also discernible through the crammed layering of formal elements, which make the format a sort of gateway into the actual subject matter. There is no background, only a ground which fuses subject and ground together in the same ornamental unit. The artist has evolved a new form, aspiring towards a mid-polarity between the space that is looked into and the space that is felt to surround the viewer.

The Oriental tall, narrow format introduced compositional methods that had a direct influence, in various directions, on modern art.

450 Claude Monet
Japanese lilies (detail)
c. 1883/4
Oil on canvas
119.5 × 37 (47 × 14⅝)
Paris, Galerie Durand-Ruel & Cie.

451 Andō Hiroshige
Peony
Colour woodcut
44 × 7.6 (17⅜ × 3)
Private Collection

452 Kikugawa Eizan
Hawkers
19th century
Colour woodcut

453 William H. Bradley
Decorative border for 'His Book'
1896
India ink on paper
Book format 25.5 × 13 (10 × 5)
Repr. *L'Art ancien* S.A., 65, 9
Springfield, Mass., The Wayside Press

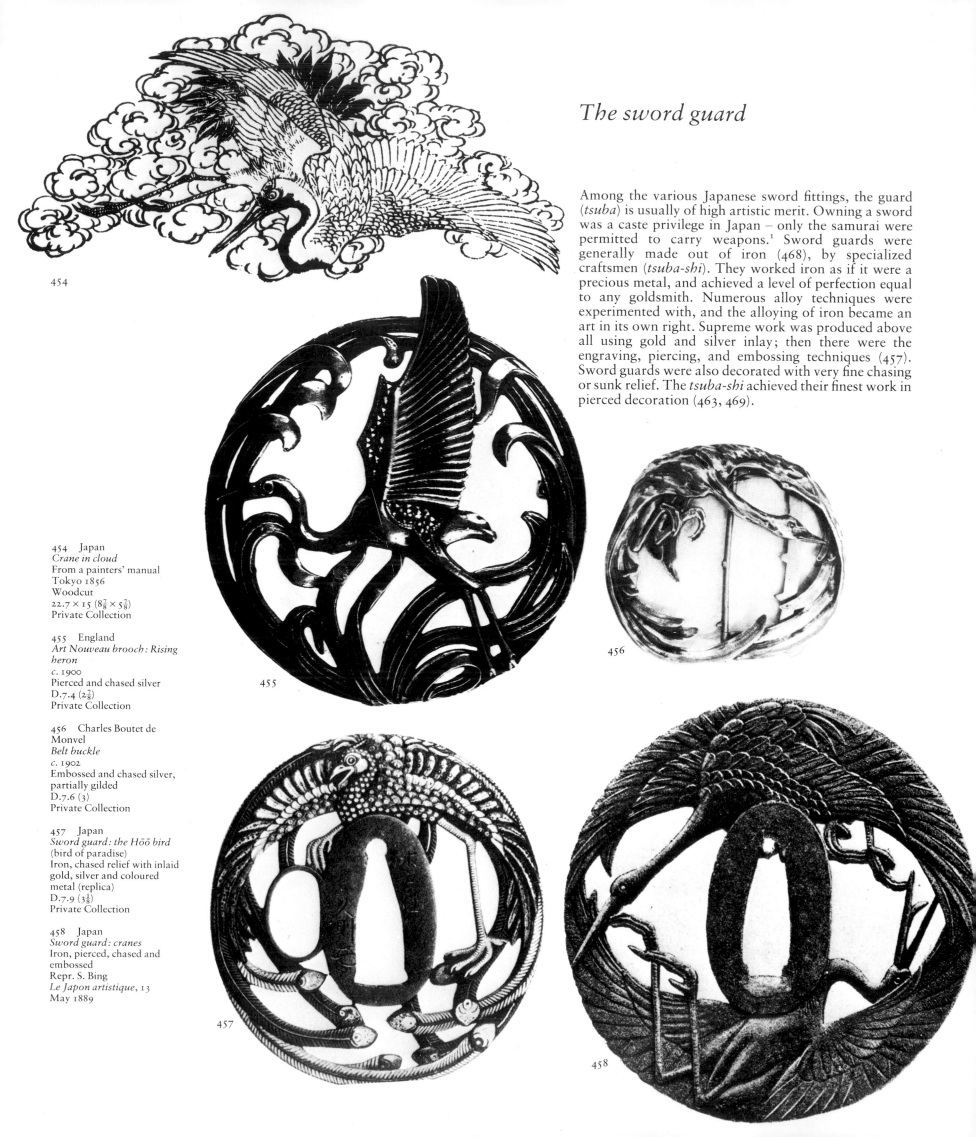

The sword guard

Among the various Japanese sword fittings, the guard (*tsuba*) is usually of high artistic merit. Owning a sword was a caste privilege in Japan – only the samurai were permitted to carry weapons.[1] Sword guards were generally made out of iron (468), by specialized craftsmen (*tsuba-shi*). They worked iron as if it were a precious metal, and achieved a level of perfection equal to any goldsmith. Numerous alloy techniques were experimented with, and the alloying of iron became an art in its own right. Supreme work was produced above all using gold and silver inlay; then there were the engraving, piercing, and embossing techniques (457). Sword guards were also decorated with very fine chasing or sunk relief. The *tsuba-shi* achieved their finest work in pierced decoration (463, 469).

454

455

456

457

458

454 Japan
Crane in cloud
From a painters' manual
Tokyo 1856
Woodcut
22.7 × 15 (8⅞ × 5⅞)
Private Collection

455 England
Art Nouveau brooch: Rising heron
c. 1900
Pierced and chased silver
D.7.4 (2⅞)
Private Collection

456 Charles Boutet de Monvel
Belt buckle
c. 1902
Embossed and chased silver, partially gilded
D.7.6 (3)
Private Collection

457 Japan
Sword guard: the Hōō bird
(bird of paradise)
Iron, chased relief with inlaid gold, silver and coloured metal (replica)
D.7.9 (3⅛)
Private Collection

458 Japan
Sword guard: cranes
Iron, pierced, chased and embossed
Repr. S. Bing
Le Japon artistique, 13
May 1889

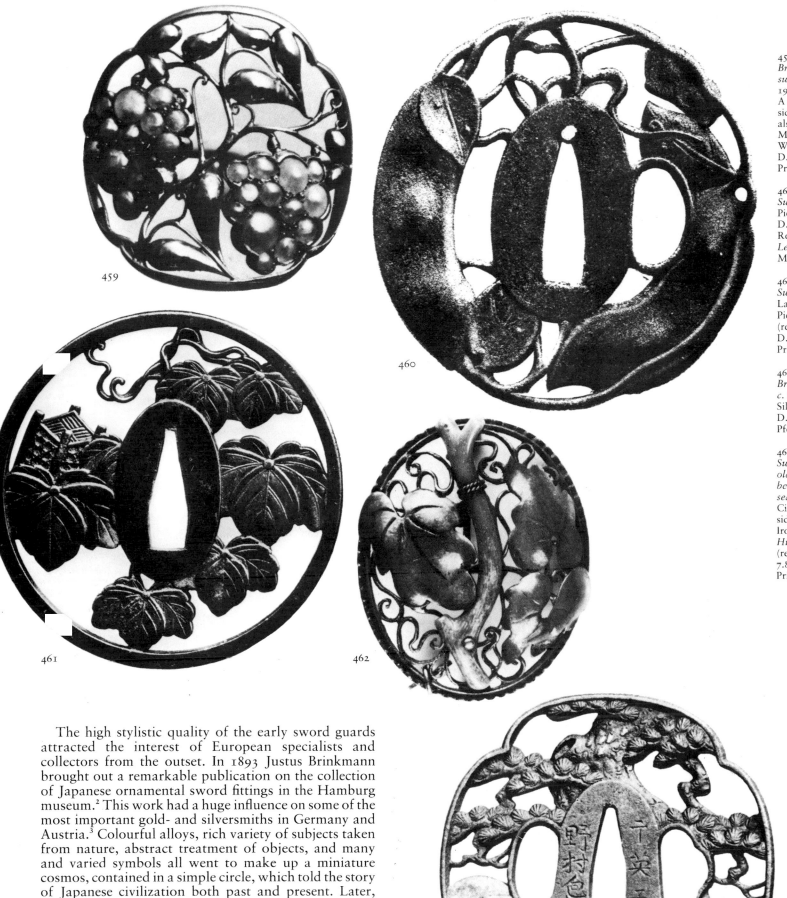

459 Josef Hoffmann
*Brooch in the shape of a
sword guard*
1911–12
A circle articulated into four
sides; gold (a smaller version
also made as a ring)
Made by the Wiener
Werkstätte
D.5.5 (2⅛)
Private Collection

460 Japan
Sword guard: bottle-gourd
Pierced iron, embossed
D.7.8 (3⅛)
Repr. S. Bing
Le Japon artistique, 12
May 1889

461 Japan
Sword guard
Late 17th, early 18th century
Pierced iron, chased relief
(replica)
D.8.2 (3¼)
Private Collection

462 Theodor Fahrner
Brooch
c. 1913
Silver, pierced and embossed
D.4.5 (1¾)
Pforzheim, Schmuckmuseum

463 Japan
*Sword guard: old man and
old woman (Jō and Uba)
beneath a pine tree on the
seashore*
Circle, articulated into four
sides
Iron chased according to the
Hiko-né-bori technique
(replica)
7.8 (3⅛)
Private Collection

The high stylistic quality of the early sword guards
attracted the interest of European specialists and
collectors from the outset. In 1893 Justus Brinkmann
brought out a remarkable publication on the collection
of Japanese ornamental sword fittings in the Hamburg
museum.[2] This work had a huge influence on some of the
most important gold- and silversmiths in Germany and
Austria.[3] Colourful alloys, rich variety of subjects taken
from nature, abstract treatment of objects, and many
and varied symbols all went to make up a miniature
cosmos, contained in a simple circle, which told the story
of Japanese civilization both past and present. Later,
besides the basic round form of the sword guard, the
four- and eight-sided curved figures, together with their
multiform variants, influenced and inspired European
jewellers (459, 463, 486).

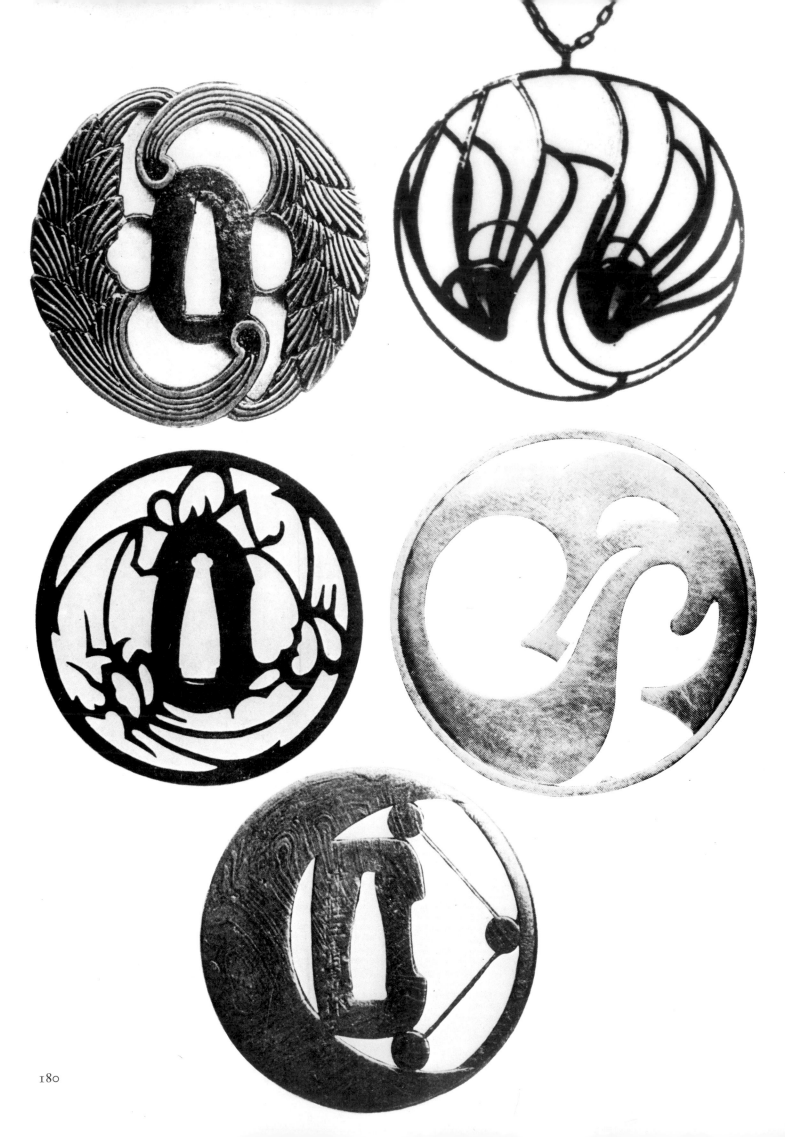

464 Japan
Sword guard: two bundled
Myō-ga plants
17th century
Pierced iron, encrusted with
brass in the *Yoshirō zōgan*
style (replica)
D.8 (3⅛)
Private Collection

465 Josef Hoffmann
Pendant
1902
Silver and chrysoprase
D.4.8 (1⅞)
Vienna
Private Collection

466 Japan
Akasaka-style sword guard
17th century
Three insects with long
feelers
Pierced and chased iron
(replica)
D.7.7 (3)
Private Collection

467 Henry van de Velde
Monogram brooch EvS
1906
Gold and silver
Made by T. Müller, Weimar
D.3.8 (1½)
Hagen, Karl-Ernst-Osthaus-
Museum

468 Japan
Sword guard
Edo period (1603–1867)
Moon and three stars within
a circle
Asymmetric ironwork
chased (replica)
H.7.5, w.7.2 (3, 2⅞)
Private Collection

180

469 Japan
Three bundles of branches
Tokyo 1856
Design for a sword guard
from a painters' manual
Woodcut
22.7 × 15 (8⅞ × 5⅞)
Private Collection

470 René Lalique
*Belt buckle: orchid with
thorn branch*
c. 1900
Gold, enamel, rubies
H.7.5, w.6.7 (3, 2⅝)
Hamburg, Collection Hans
Brockstedt

The first known pierced sword guard dates from the thirteenth century, but some scholars date the origins of this form to the fifteenth century.[4] European preferences were for the Gotō, Yokoya and Nara periods, although the Umetada school and the Shōami masters in the seventeenth and eighteenth centuries also inspired European goldsmiths.

Most outstanding are the products of combinations of materials – alloys of iron, bronze, gold, silver, and brass and similar metals – and of different artistic techniques. Pierced metal sword guards were provided with a second 'impression' to act as a foil for the filigree branches and flowers. Thus if the subject is a ginkgo leaf in silhouette, cut out of the surface of the *tsuba*, the same shape can also be embossed on top. The form of the leaf can then feature again, engraved or inlaid.[5] There are also piercing techniques which show the negative of what is being portrayed (466).

Sword guards from the provinces of Dewa and Satsuma (466), and those fashioned according to the *hiko-né-bori* technique, exhibit a tense, powerful manipulation of volume.

Among European metalworkers,[6] symmetrical or asymmetrical construction of the *tsuba* made it a tempting field for purely compositional experimentation.[7] The Art Nouveau preoccupation with floral motifs was the ideal decorative raw material for work in this medium (486, 487, 488, 491). All the studying of nature had been done: now it was rendered ornamentally. Grasses, stems and branches, flower umbels and herbaceous plants could now be set inside a circle or oval or other appropriate form (464, 470, 478, 480). Overlapping appeared, together with curving lines following the outline of the disc (467, 468, 470, 479, 481), which became ever more strikingly simple until a single tendril, branch, or cut-out animal silhouette sufficed to produce a marvellously expressive object. Such work required consummate artistry and extreme sensitivity; both qualities were shown by Lalique, Vever, Fouquet, Cranach and other superb craftsmen.[8]

Acquaintance with the decorative sword guard provided a valid alternative to the heavy vulgarity of European jewellery in the late nineteenth century, which was threatening to become bogged down in considerations of material value alone. The new goal was to ennoble materials through artistic ability and technical skill. Thus originality of form in the representation of simple things replaced automatic use of high-carat precious stones. The best-known goldsmiths at the turn of the century were all inspired by the pierced metal and inlay work of the Japanese sword guard.[9]

The French goldsmith Lucien Falize (1837–1897) – not to be confused with his father Alexis Falize (1811–1898) – made a copy of a sword guard by the Japanese craftsman Oda Naoka from Satsuma. He mistakenly called the motif *Garden bean* (485),[10] when in fact what is represented is the bottle-gourd, which was highly venerated by the Buddhists (see pp. 90–91, 324–25), and which commonly appeared on the sword guard of the Satsuma school as a good-luck symbol.[11] Samuel Bing

had in fact shown just this piece in his periodical *Le Japon artistique*, in which he devoted much space to the decorated *tsuba*. One can assume that the general public became aware of the ornamental diversity and potential of the sword guard through this channel.

Around 1900 Charles Boutet de Monvel chose for his silver buckle (456) the motif of the flying crane which is also found in the crest of the Japanese province of Owari.

In the English silver brooch with the rising heron (455) the Japanese wave formations at the top and the bracing of the bird with the edge are clearly observable. In both European and Japanese examples the disc is fully taken up with the wings and feathers of the flying crane (455, 458). The effect of the piercing can be enhanced by fine chased work (457). The crane in the clouds (454),[12] has always been a symbol of long life in Japan. The crane is often seen with a pine branch in its beak, flying over Horaizan, the abode of the blessed in the eastern sea: it thus occurs widely on crests as well (808–11).

The French goldsmith and jeweller Henri Vever (1854–1942) collected Japanese prints and sword guards. He was a pupil of A. Millet at the Ecole des Beaux-Arts in Paris. Japanese craftsmen worked with tortoise-shell in his Paris workshop.[13] He had an important collection of sword guards and had studied the technique closely. Edmond and Jules de Goncourt noted in the *Journal* of 1892–95: 'Japanese dinner at Riche's. In this world of Japanese curio-hunters, X——— and the jeweller Vever – the keenest of all – were outbidding each other madly.'[14] Some of the sword guards in Vever's collection later went into that of the Comte de Tressan, which went up for auction at Sotheby's in 1973.[15] These pieces tell us which were Vever's favourite techniques or schools: we find that, together with the early sword guards of the Gotō-Yūjō and Kaneie schools, it was the technically accomplished schools of the seventeenth, eighteenth and nineteenth centuries that most appealed to him. The Heianjō sword guard was a particular favourite, on account of its exquisite pierced work.[16] He also collected Gotō-Yūjō-style guards, for their superbly worked discs of coloured metal.

The sword guard must also have been influenced by the so-called *mon*, or crest, of ancient Japanese families. At any rate clear connections can be discerned (810).

European goldsmiths attempted to make the most of round discs similar to the crest or sword guard. The space described by a round silver band was filled to bursting; ornamental stalks coil in tense imprisonment against the outside ring (484, 486, 487).

The brooch by Josef Hoffmann (459), inspired by the 'four-sided circle', has bunches of fruit made of pearls, surrounded by golden leaves. The translation of the circle into a basically four-sided figure is strikingly managed. The Satsuma sword guard often has compact individual motifs that are naturally suited to the round format. Hoffmann follows this tradition, assembling self-contained ornamental elements, as the pearl bunches illustrate. Theodor Fahrner (1868–1929)[17] also creates a single unity out of a powerful branch shape and broad, convex leaves with thin, intertwining tendrils (462). This effective use of contrasts occurs with

471 Henri de Toulouse-Lautrec
Ex libris M. Guibert
c. 1894
India ink on paper
Albi, Musée Toulouse-Lautrec

472 Japan
Head
Tokyo 1856
From a painters' manual
22.7 × 15 (8⅞ × 5⅞)

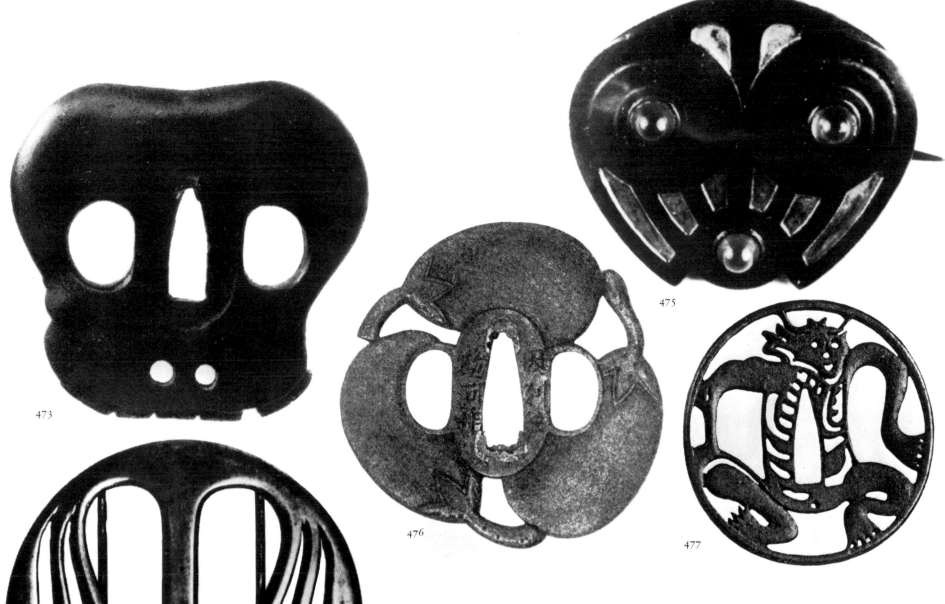

extraordinarily rich variation in sword guard decoration. The pierced pattern creates inverse, negative patterns which European jewellers, inspired by the Japanese *tsuba-shi*, often deliberately exploited.

The sword guard shape presented European goldsmiths with certain specific problems: the invariable presence, in the original Japanese model, of a central slit for the sword blade to fit into, and two *hitsu* (holes) for the *kozuka* (secondary blade) and the *kōgai* (sword pin).[18]

Toulouse-Lautrec, in the book plate modelled on a guard which he designed in 1894 (471), re-positions the central slit horizontally in the bottom of the circle. The *hitsu* holes make a vestigial appearance up against the edge of the circle on the right. This entertaining sketch reveals the artist's careful balancing of broad and narrow areas of black. As in the sword guard, all the pierced sections are in conscious, close relation to the outside circle: the guard had to be strong enough to be effective in a fight. Toulouse-Lautrec, having grasped this point, attempts to make it quite clear in his caricature. In some cases these holes in the guard are actually incorporated into the decorative motif, and developed, for instance, into dragonflies, symbolizing battle; or else the three holes are used together to form a human skull, which stares threateningly down the sword towards the adversary (473).[19]

473 Japan, Myōchin school
Sword guard in the shape of a human skull
c. 1600
Iron
W.8.8 (3½)
Copenhagen, Museum of Industrial Art

474 Gablonz Technical School/Isargebirge
Belt buckle
1903
Pierced and embossed silver
D.5.9 (2⅜)
Vienna, Österreichisches Museum für angewandte Kunst

475 G. Gassner
Brooch
c. 1900
Gilded silver set with chrysoprases
23 × 26 (9 × 10¼)
Pforzheim, Schmuckmuseum

476 Japan
Sword guard: three aubergines
c. 1700
Engraved iron (replica)
D.7.8 (3⅜)
Private Collection

477 Japan
Sword guard
Edo period
(1603–1867)
Pierced iron, slightly shaped
D.7.8 (3⅜)
Private Collection

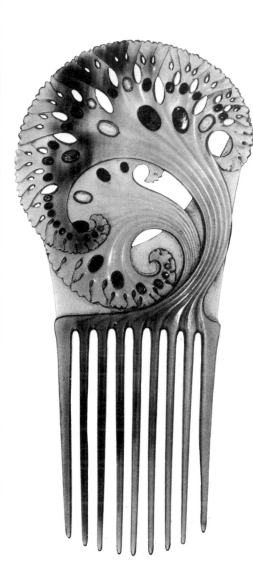

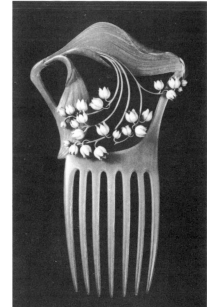

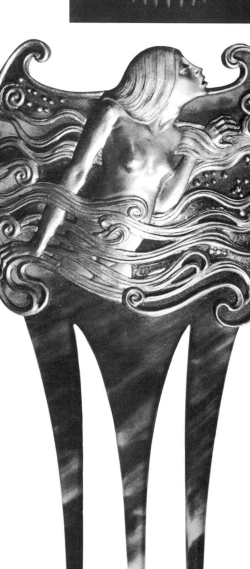

504 René Lalique
*Decorative comb with lily-
of-the-valley*
1900
Horn, gold, enamel
H.15.5 (6⅛)
Paris, Musée des Arts
Décoratifs

505 Georges Fouquet
*Decorative comb with
abstract wave design*
c. 1905
Horn, enamel, opals
18 × 8.1 (7⅛ × 3¼)
Private Collection

506 Eugène Grasset
Naiad comb
Horn, gold, enamel
16 × 7 (6¼ × 2¾)
Paris, Musée Galliera

Decorative combs in the Japanese manner were also produced in the workshop of Louis Comfort Tiffany in New York (501). The back of this one is set with pearls, which seem to dance about on little eddies of waves, highlighting the effective simplicity of the object.[8] The small gold lacquer comb with mother-of-pearl butterflies (502) is an extremely widespread style of ornament, containing all the symbolism of lovers.

The black lacquer combs[9] with mother-of-pearl inlays (503) are magnificent objects. They would appear like precious stones in the coiffures of Japanese beauties – only famous courtesans were allowed to wear several combs of this type. Japanese portraits of actors and courtesans (*oiran*), and even of ideal beauties, almost always have the most magnificently varied hair ornaments. Even the maids (*kamuro*) and secretaries (*shinzō*) of the courtesans wore subtly decorative hair ornaments. Famous woodcut artists, from Hishikawa Moronobu to Utagawa Kuniyoshi and his school, all meticulously rendered the various adornments in the hair of their subjects. Utagawa Toyokuni's portrait of the actor Segawa Kikunijō III (498) presents an exceptionally precise collection of all the various combs and hairpins. The head of a beautiful woman would be wreathed with long, radiating pins, so the masculine features of men playing female roles required vast coiffures and even more exaggerated *kushi* (combs), *kanzashi* and *kōgai* (hairpins). Combs were elaborate and worn as works of art in the most diverse ways;[10] first cousin to the comb was the hairpin, which would project decoratively, and to a European bizarrely, out of the thick black sea of hair of the Japanese woman.

The manner in which these ornaments were worn expressed fashionable elegance, position,[11] distinction, or special honour. The Japanese ornamental comb (*kushi*) is usually basically rectangular in shape, but slightly curved at the top. Okumura Masanobu also depicted very beautiful combs with flat tops. The teeth of the comb are cut so as to hold well in the hair. They are cut too short to reach the scalp, thus leaving enough area for the ornamental surface to be clearly visible (513). As we see here, this visible ornamental surface may be a very generous quarter, or even a half circle – echoing the oval of the face, and so all the more effective.

This form of female adornment, evolved over centuries, was taken up by the fin-de-siècle European Art Nouveau designers as a daring statement of their aesthetic.[12] Georges Fouquet produced a multi-toothed comb decorated with an abstract wave pattern made out of horn, enamel and opals (505). It could equally well have been designed by August Endell, as they were both heavily influenced by Japanese ornaments. The shimmering opals give the stylized wave a poetic magic, while the asymmetrical construction of the organically related lines is close to the schematized idiom of the Japanese crest (*mon*). René Lalique contrasts this abstract design with an early floral form,[13] his lily-of-the-valley flowers springing directly out of the broad, sweeping leaf that constitutes the top of the comb (504). The flower heads, in gold and enamel, are arranged in front of an asymmetrical open space with a compositional skill that no Japanese sword designer could have bettered.

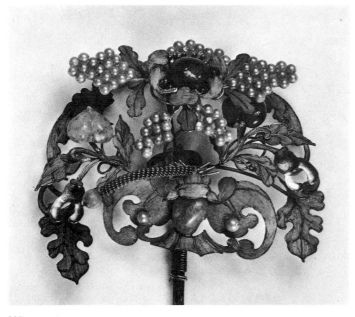

507

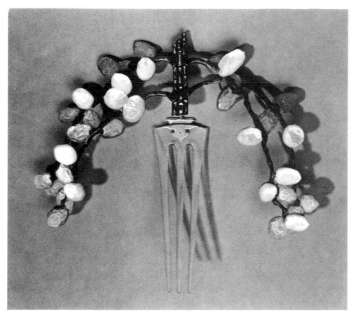

508

509

510

509 Japan
Hairpin with vine leaves
2nd half 19th century
Partially gilded silver, coral
H.17 (6¾)
Vienna, Österreichisches
Museum für angewandte
Kunst

510 Lucien Gaillard
*Decorative comb with two
flower umbels*
c. 1900
Horn, pearls
15.5 × 11.1 (6⅛ × 4⅜)
Frankfurt,
Kunstgewerbemuseum
European hair-arrangements
were relatively loose, and
thus necessitated long teeth
to hold the hair. For this
reason the European twin-
toothed comb is a
combination of the hairpin
and the decorative comb.

507 China
*Hairpin with plants and
insects*
19th century
Silver pin, filigree in gilded
silver with kingfisher
feathers
15.5 × 14 (6⅛ × 5½)
Vienna, Österreichisches
Museum für angewandte
Kunst

508 René Lalique
*Decorative comb with sprigs
of blossom*
c. 1900
Horn, gold, pearls, and
tourmaline
H.12.5 (4⅞)
London, John Jesse Gallery

511 Henri Vever
Comb
1900
Ivory, opals, and translucent
enamel
Cyclamen
H.20, w.9.5 (7⅞, 3¾)
Paris, Musée des Arts
Décoratifs

511

512 Chōkōsai Eishō
*Courtesan in everyday
coiffure plucking her
eyebrows*
c. 1794/1800
Colour woodcut
36.7 × 24.5 (14½ × 9⅝)
Munich, Private Collection

513 Kitagawa Shikimaro
*Courtesan with large coiffure
painting a fan*
1st half 19th century
Colour woodcut
36.4 × 24.3 (14⅜ × 9⅝)
Private Collection

Description of the combs on
the opposite page, from top
to bottom, left to right. All
date from the late Edo or the
Meiji periods.

514 *Comb with cock in a
garden*
Tortoiseshell, embossed
black and gold lacquer, set
with coral
3.7 × 8.3 (1½ × 3¼)
Private Collection

515 *Comb with butterfly*
Tortoiseshell, black lacquer,
silver gilt, filigree
4.7 × 9.6 (1⅞ × 3¾)
Private Collection

516 *Comb with cranes in
flight over waves*
Ivory, embossed black and
gold lacquer
4.3 × 10 (1¾ × 3⅞)
Private Collection

517 *Comb with trunk and
blossom of prunus*
Tortoiseshell, red and gold
lacquer over black, with
inlaid silver blossom
5.4 × 13.4 (2⅛ × 5¼)
Private Collection

518 *Comb with crickets,
beetles, and flies*
Ivory and gold lacquer
3 × 8.5 (1⅛ × 3⅜)
Private Collection

519 *Comb with umbrella*
Ivory and black lacquer,
design in embossed gold
lacquer
3.1 × 9 (1¼ × 3½)
Private Collection

520 *Comb with lobster*
Ivory and embossed red
lacquer
5.2 × 12.8 (2 × 5)
Private Collection

521 *Comb with butterflies
and herbaceous plants*
Tortoiseshell, embossed gold
lacquer on black
3.7 × 10 (1½ × 3⅞)
Private Collection

522 *Comb with golden
pheasant*
Tortoiseshell, red lacquer on
black, inlaid mother-of-pearl
4.6 × 9.6 (1¾ × 3¾)
Private Collection

523 China
Hairpin with flower-vase
19th century
Silver pin, silver gilt filigree,
and kingfisher feathers
H.18 (7⅛)
Vienna, Österreichisches
Museum für angewandte
Kunst

524 Torii Kiyonaga
Actor with sunshade (detail)
1784
Right-hand section of a
triptych: the meeting of the
courtesan Agemaki (the
beloved of Sukeroku) and
her rival Ikyū
Colour woodcut
37.7 × 25.8 (14⅞ × 10⅛)
Private Collection

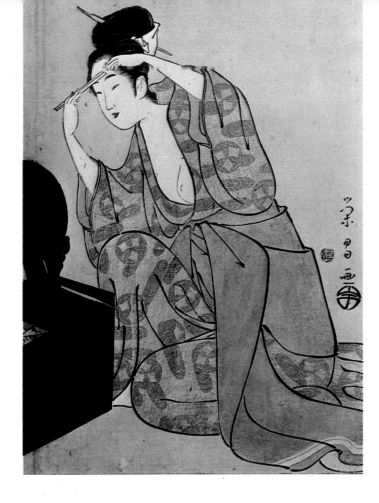

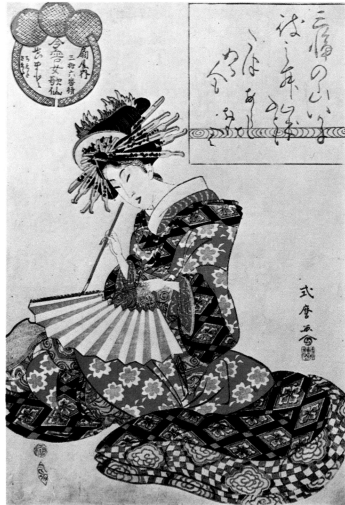

193

Eugène Grasset adopts yet another subject: a naiad swimming in waves rendered in a Japanese ornamental fashion (506). Even the top of the comb is fashioned in the shape of two wave crests folding in on each other.[14] This design has a sensuous elegance which proves that these European craftsmen, like their Japanese counterparts, see a work of art in the meanest everyday object.

We find this same sensitivity and high degree of craftsmanship in Henri Vever's cyclamen comb (511). The artist achieves an effective resolution of the figurative floral form and somewhat abstract patterns of lines in gold and *cloisonné* work. The goldsmith Lucien Gaillard employed Japanese tortoise-shell carvers in his workshop (who signed his combs), and obtained superb examples of flower figuration.[15] In his twin-toothed flower hairpin (510) he combines graphic ornamental methods with Japanese pearl decoration. Not only did this hairpin move on its shaft, but each individual flower stem was made up of tightly coiled spirals, so that every part would move. This technique was adopted now and again by Art Nouveau designers in Europe. The inclusion of pearls and stones of all colours, together with kingfisher feathers, created an odd, fantastic effect, which well suited the colourful clothes of the ladies.

Chinese hair adornments were also beautifully and imaginatively conceived (523), and hairpins with floral decorative motifs along Chinese lines were also worn in Japan (524). Chinese women would wear wide pins with short shafts in pairs rather than singly. There was an enormous variety of hairpins in the late Edo and Tempo periods. Flowers, leaves and animals (507) were all freely and copiously depicted. As an offshoot of the comb, engraved pendants were worn dangling on little chains, richly and ingeniously trimmed with coral.[16]

Most Japanese hairpins are symmetrical and made from a combination of all kinds of materials. They had a strong influence on European goldsmiths. Lalique, Vever and Fouquet had seen Chinese models and took them as a base for their own designs. One much-used theme was the spray of blossom with coral and small pearls. Such a design appeared in the late Edo period for the first time – an exquisite piece of jewellery which went perfectly with the exuberantly patterned kimono.

It was the combined ornamental and naturalistic technique that Lalique especially adopted. The irregular design of stems of flowers, which Japonisme brought to a remarkable level of beauty in France around 1900, appears in constantly new variations in hair ornaments.[17] A willow with drooping branches crowns a three-toothed hairpin (508). The branches are set with tourmalines and pearls, reflecting the influence of Kōrin-style colour combinations.[18]

Both in Europe and the Far East the purpose of the comb was to hold the gathered hair (often arranged like a wig) in a certain spot – to create a pause, as it were, in the hair arrangement. In Europe women's hair was loosely piled, and this resulted in the development of the long multi-toothed comb (514–22). By contrast the hair of the Japanese lady would generally be heavily oiled and almost, so to speak, sculpted, in stepped cascades. The hair was back-combed in thick waves and built up at a backward angle in differently shaped 'storeys' (525). The tension was generally accentuated by the comb in the first 'storey', and represented a division between it and the frame of hair over forehead and temples. The first sweep of hair above forehead and nape of the neck was succeeded by the middle 'storey', which extended to the back of the head. This was then tied in a bundle with ribbons of some sort, and the rest of the hair was left to form a tail (447). This way of arranging the hair differed from century to century,[19] but the comb retained its basic shape, merely acquiring sumptuous ornamentation. The exposed surfaces on the sides and above the teeth provided workers in ivory and tortoise-shell with an ideal opportunity for exercising their skill and imagination. Combs were decorated on both sides with sea creatures, flowers and blossom, birds and all kinds of natural phenomena (514–24). More exclusive examples incorporated costly pierced work, inlaid tortoise-shell, and beautifully set precious stones (499, 514).

Although tortoise-shell was the favourite material for combs, as it best withstood the deterioration due to contact with hair, we should, nevertheless, devote a little space here to lacquered ornamental combs. Fine work was produced here, as well as in the realm of writing boxes and perfume containers – work which was, moreover, in the great tradition of lacquer craftsmanship. Black was the predominant colour used for lacquered combs, but red was fairly common too. The main feature was the decoration, which was usually in gold and silver lacquer (516, 520). Chased gold and silver would sometimes be set into these combs. Coral and tortoise-shell of all shades create tiny marvels of decoration, occasionally so elaborate as to constitute actual miniature pictures on their own. Hokusai even produced books of sketches for decorative combs, which were then actually made. (According to Duret, these books were known in France.)[20] Taking one theme – the wave – he explores the format of the top of the comb, seeing an infinite variety of potential subtle combinations with the wave-like constructions of the coiffure. Starting with a naturalistic approach to the wave crest, his designs become progressively more abstract, finally achieving the quality of pure patterning. The time he devoted to them shows how important this functional object of adornment was to him.

As we have seen, combs denoted privilege, distinction or rank, and came in different types and styles. An eminent courtesan would therefore wear a large number of magnificently worked combs, which would appear to be doing battle with her hair. The blue-black hair and white ivory, or the sheen of mother-of-pearl, together with brightly coloured clothes, produced dazzling contrasts. Combs were often made to harmonize or contrast with kimonos or with the light colour of the face make-up, so that here too there could be deliberate, fashionable harmonies and contrasts. Black lacquered combs, for example, were preferred with white make-up and blacked-out teeth. Aesthetic reasons were not, however, the be-all and end-all of the choice of comb: it would also denote the season, as well as social status.[21]

Domestically speaking, it had a purely practical function, as can be seen from many woodcuts: it prevented the hair from falling over the face. Simple, yet

structurally beautiful box-wood combs reveal a host of variations in form, without ever becoming less than functional. From the quarter-circle curve grows a narrow, pointed shaft, which could be used either as a pin or a scratcher.[22] The vast range of different shapes illustrates how versatile they were – indeed Sumō wrestlers developed their own special combs for their particular hairstyles.

On public occasions, or when going out, and depending on the event, different combs would be worn. These combs were inherited from one generation to the next, and a strict etiquette governed their positioning in the up-swept coiffure. Courtesans could wear up to three combs arranged in strict symmetry next to each other.

Another object worn in conjunction with the comb was the *kanzashi*, a kind of long hairpin. It too evolved from a purely functional artefact to become a fashionable accessory which lent distinction to its wearer. *Kanzashi*[23] could be worn in pairs, asymmetrically, in the front 'storey' of the coiffure, pointing upwards if desired. In different periods their use changed to suit different hair fashions,[24] and often the head is surrounded by an aureole of these objects. Up to six *kanzashi* could be arranged in a semi-circle, from the curve of the temples up to the middle of the hair arrangement (513).

The *kanzashi*, which still retained its function of holding back the hair, came in all shapes and sizes. Basically it consists of a stick, up to 30 cm. (12 in.) long, the top end of which has a kind of pommel, usually splendidly worked in gold, silver or copper into some three-dimensional shape (ball, gem, spray of blossom, twigs). Little bells or other amulet-like pendants would hang from the *kanzashi* (509, 524). For practical reasons the stick or shaft was often rippled, or there were two shafts, to give it some kind of grip in the hair. Two shafts was the most convenient design, as this structure suited almost all materials – whalebone, ivory, jade. It also afforded possibilities of combining materials.[25]

Many masters exercised their genius in depicting combs and hairpins. Highpoints in the art were reached by Torii Kiyomitsu, Suzuki Harunobu, Kitagawa Utamaro, Utagawa Kunisada, Utagawa Kuniyoshi and others. Their portraits often acquire a special dignity and exclusiveness due to the head adornments worn by the subject. The Japanese still value this form of jewellery today. Exhibitions of combs are not uncommon, and large collections of combs attest to the importance of creative activity in this sphere.

In nineteenth-century Japan the forms described above were enriched by a long-toothed comb[26] (at that time with usually only two or three, but sometimes up to six teeth) cut in various ways, the upper part offering numerous possibilities for carved work. Ever new effects were obtained through the lustrous gleam of tortoise-shell and the white of ivory against the black of the hair, and through chased and inlaid surface decoration. This type of comb was rarely worn with hairpins, as because of its size it was in itself a fully independent, self-contained fashion.

Towards the end of the nineteenth century this kind of hairstyle using the comb came to be adopted in Europe too. High-piled hair became the latest thing. Vast coiffures followed, and the comb became a vital component of fashionable attire – indeed when receiving visitors it became a veritable vehicle of ostentation.[27] European goldsmiths and master-craftsmen seized on this fashion, and as if in competition with their Japanese models, produced works which, in terms of sheer artistic quality, are capable of standing beside any examples from the Far East.

René Lalique produced significant work in this field, such as, for example, his comb with a cock's head, worked in enamel, in the form of a diadem. It is a fully three-dimensional head, the beak wide open, holding a gleaming amethyst. The gold is a superb example of pierced metalwork, and gives a clear indication of Lalique's brilliance as a craftsman. Others who made notable combs were Alfons Mucha, Georges Henry, Philip Wolfers and Lucas von Cranach.

The *kanzashi* was taken up in Europe in the form of the hatpin. Japanese-style hairpins were sometimes worn in the hair too, but this fashion remained secondary, as European women wore their hair too loosely to support such pins. It was for this reason that the hatpin became a great fashion in Europe. It had the same prominent, bizarre silhouette as the *kanzashi*.

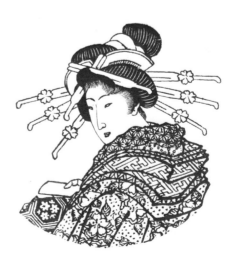

525 After Kitagawa Shikimaro
Courtesan with elaborate coiffure
Black zincograph
H. 6.2 (2½)
Private Collection

195

526 Japan
Dyer's stencil: pine branches
among clouds
Meiji period
Oiled paper
42–43.3 × 58.6–63.8
(16–17 × 23⅜ × 25⅛)
Vienna, Österreichisches
Museum für angewandte
Kunst

The dyer's stencil

527 Japan
Dyer's stencil: flowering branches behind a grille
Meiji period
Oiled paper
22.2–31.2 × 40.5–41.5
(8¾–12¼ × 16–16⅜)
Vienna, Österreichisches Museum für angewandte Kunst

528 William H. Bradley
Pausias and Glycera (detail)
1895
Book illustration
Lithograph
36.5 × 24 (14⅜ × 9½)
Private Collection

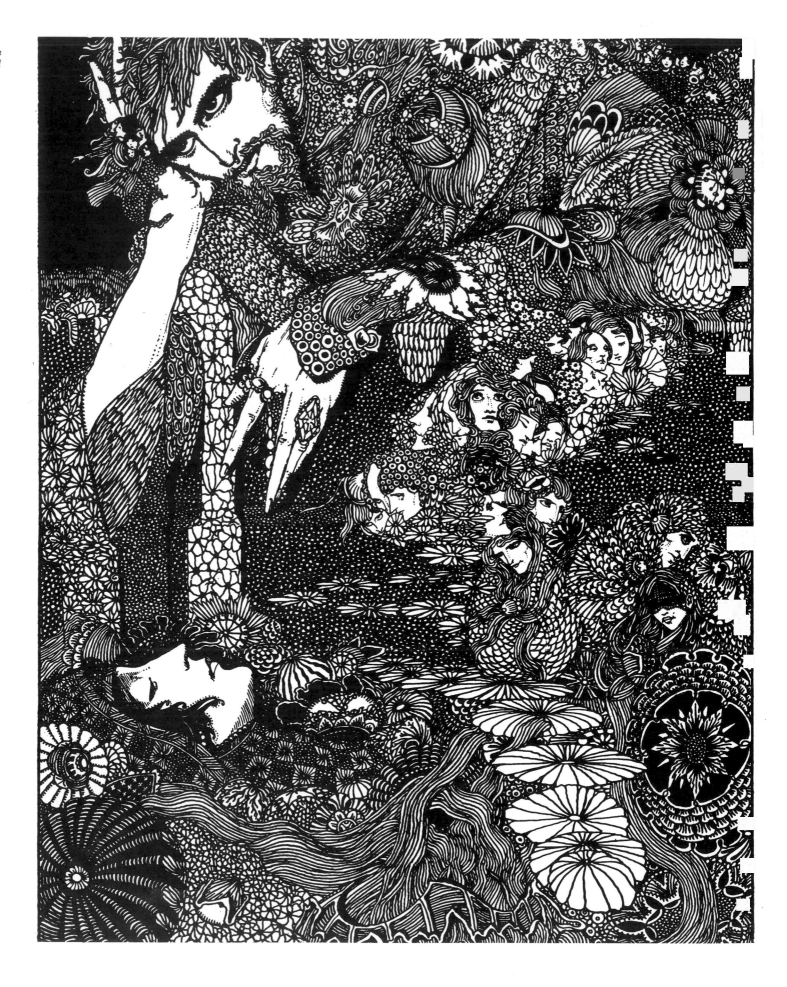

529　Harry Clarke
Illustration to Edgar Allan Poe 'Tales of Mystery and Imagination'
London, 1919
Half-tone engraving
25.3×19 ($10 \times 7\frac{1}{2}$)
Private Collection

Japanese paper stencils for dyers (*katagami*) became an ever more important influence on the European decorative arts around 1900. In 1873 the Osterreichische Museum für Kunst und Industrie bought several thousand *katagami* from Japan at the Vienna international exhibition. This store of information and material for creative direction had a profound effect on art. The Vienna Secession and Wiener Werkstätte artists had both seen *katagami*.[1] Klimt, Hoffmann, Kolo Moser and others all started to do work modelled on Japanese decorative designs.[2]

These stencils were made from the fibrous bark of the mulberry tree, which was similar to paper, and which was made waterproof with the juice of unripe, fermented fruit and oil. The tools used for cutting them out were knives and punches.[3] First of all the pattern was cut into a pile of sixteen sheets. The bottom and the top sheet with the pattern drawn on it were thrown away, and the others were glued together, two at a time, and often given a protective net of human hair or silk thread to stop them tearing or becoming crumpled.

The pattern would be cut either negatively or positively into the stencil. A coat of indigo over a negative stencil would produce a blue pattern on a white ground. To obtain the same result with the more commonly used positive stencil, a resist had to be used. That is, with the help of the stencil a rice-starch paste was applied to the exposed parts of the material, the stencil removed, and colour applied. The paste, with dye sticking to it, was then washed off. Conversely, to obtain a white pattern on a blue ground the resist technique had to be employed with a negative stencil.

Stencils were used for dyeing woollen and silk cloth for the general populace. This cloth was cheaper than woven silk or embroidery. At the same time it offered scope for various techniques: simple 'blue prints', colourful materials produced either with several separate stencils or with several separate resist-dyeing sessions one after the other, and materials on which the areas that had been covered by the stencil were then painted or embroidered after dyeing.[4]

This stencil method with its easily aligned, repeated patterns (532–39) had an enormous influence on Art Nouveau book design.[5] Everyday things such as flowers (533), branches (537), trees, birds (269, 531, 532), functional objects (623), and landscapes (541) were observed in a manner that went beyond realistic representation, though without detracting from their intrinsic qualities (schematized visual forms based on a naturalistic approach always have an essential moving force of stylization).[6] The motifs were on the whole floral, i.e. vegetal in the generic sense, in inspiration. They flow and curve like copies of organic forms (544). Free surfaces are as if woven with dominant line patterns (543), and rhythmic articulations alternate with strict dividing bars (527).

This approach of linear composition was grasped by European artists and convincingly translated. William Bradley, one of the most gifted exponents of the Japanese colour stencil, explored every technique of the genre (528). The thin linear curves become grillelike, stylized surface compositions which produce to

530 Japan
Dyer's stencil: chrysanthemums
Meiji period
30 × 60 (11¾ × 23⅝)
Private Collection

531 Japan
Dyer's stencil: cranes among pine branches (detail)
Meiji period
30 × 60 (11¾ × 23⅝)
Private Collection

199

532 Ferdinand Staeger
*Bird's nest with view of the
Moldau terraces*
c. 1905
Illustration to *Kleinseitner
Geschichten* in the style of a
dyer's stencil
Pen-and-ink on paper
7.8 × 13.6 ($3\frac{1}{8}$ × $5\frac{3}{8}$)
Private Collection

533 Josef M. Auchentaller
Chrysanthemums
1898
Repr. *Ver Sacrum*
Year 1, Vol. 7
5.8 × 19.5 ($2\frac{1}{4}$ × $7\frac{5}{8}$)
Private Collection

534 Japan
Dyer's stencil: maple leaves
(detail)
Meiji period
Oiled paper
22.2–31.2 × 40.5–41.5 and
42–43.4 × 58.6–63.8
($8\frac{3}{4}$–$12\frac{1}{4}$ × 16–$16\frac{3}{8}$ and
$16\frac{1}{2}$–$17\frac{1}{8}$ × $23\frac{1}{8}$–$25\frac{1}{8}$)
Vienna, Österreichisches
Museum für angewandte
Kunst

535 Margarete von
Brauchitsch
Embroidery design
c. 1900
Pen-and-ink
16.5 × 27.5 ($6\frac{1}{2}$ × $10\frac{7}{8}$)
Private Collection

536 Japan
Dyer's stencil: clematis
(detail)
Meiji period
Oiled paper
22.2–31.2 × 40.5–41.5 and
42–43.3 × 58.6–63.8
($8\frac{3}{4}$–$12\frac{1}{4}$ × 16–$16\frac{3}{8}$ and
$16\frac{1}{2}$–17 × $23\frac{1}{8}$–$25\frac{1}{8}$)
Vienna, Österreichisches
Museum für angewandte
Kunst

perfection the most charming dark and light floral ornamentation (527, 528). Here we can see quite clearly the close relation to the Japanese models – which have continued to exert their influence right up to the present day. The wide selection of themes developed in the Japanese stencil stimulated the imagination of European designers into dreaming up many and varied adaptations and parallels.[7] In the background of his close-up of a bird's nest (532) Ferdinand Staeger depicts a thick cluster of buildings: this reflects the Japanese precedent of the traces of the net-like criss-crossing of certain areas with silk threads or human hair (526, 537).[8] Staeger also exploits the contrasting chiaroscuro effect.[9]

Margarete von Brauchitsch, the Munich Art Nouveau embroideress, was by contrast quite differently inspired.[10] Her designs concentrate on the repeated rhythm of the Japanese stencil. The movement of a pattern is thus more important than multiplication of details (540).

Josef Auchentaller in his vignette *Chrysanthemums* (533) exploits the vigorous curves of individual flower stems within the long rectangular frame. As in his Oriental models, the blooms are projected onto the surface, although the basic shapes cannot be said to be truly stylized.[11]

The compositional techniques mentioned above were also, of course, those of Japanese *katagami* designers. The stencils of the Meiji period (1868–1912), for example, are characterized by particularly precise cutting. All aspects of nature are investigated for decorative material (530, 531). Floral patterns could be made into abstract ornamentation, for use then as repeated, purely decorative motifs. The flexibility of the stencil technique was not always the same. Every style, from geometrical ornamentation to an exact realist depiction of things, could be contained within an elongated format (543). The stencil is usually rectangular in shape, varying in width from one example to the next. As the art evolved, the cutting technique was improved, and the web-like manner of ornamentation (534), with individual forms that almost look as if they had been engraved, became widespread. This graceful patterning was usually interrupted by larger decorative motifs (543, 544) set in either symmetrical or asymmetrical opposition to each other, or in symmetrical pairs. The large motifs in stencil decoration usually had a flattened, two-dimensional quality. This surface patterning – often incorporating a chequered motif – found its complete opposite in landscape representation, which had spatial relationships. Herons and pine trees (531), carp (286), irises growing in the water (540) were favourite themes.[12]

The use of the silhouette, with its strong sense of movement, made for highly evocative results, and European artists and printers developed it in their own fashion. In England, a new two-dimensional illustrative style was evolved (453). One of its essential features was the reticulated ground, derived direct from Japan (530),[13] in which fragmented light is trapped within an ornamental network; a leading exponent was Harry Clarke (529).[14]

Henry van de Velde makes the most of this ornamentation to break up his lines (545). He tries to avoid the forcefulness of the repeated design (which was also

538

537

539

537 Japan
Dyer's stencil: pine branches (detail)
Meiji period
Oiled paper
40.5 × 43.8 (16 × 17¼)
Vienna, Österreichisches Museum für angewandte Kunst

538 William H. Bradley
Endpaper
c. 1902
Pen and ink
32 × 14.6 (12⅝ × 5¾)
London
Private Collection

539 Japan
Dyer's stencils, climbing clematis (detail)
Meiji period
Oiled paper
22.2–31.2 × 40.5–41.5 (8¾–12¼ × 16–16⅜) and 42–43.3 × 58.6–63.8 (16½–17 × 23⅜–25⅛)
Vienna, Österreichisches Museum für angewandte Kunst

540 Japan
Dyer's stencil: irises in the water
Meiji period
Oiled paper
22.2–31.2 × 40.5–41.5
($8\frac{3}{4}$–$12\frac{1}{4}$ × 16–$16\frac{3}{8}$)
Vienna, Österreichisches
Museum für angewandte
Kunst

541 Franz von Zülow
Arable landscape
1913
Signed by hand and dated
Cut paperwork, artist's own
reprint
22.5 × 15.5 ($8\frac{7}{8}$ × $6\frac{1}{8}$)
Vienna
Private Collection

the trend of the time), using sporadic visual breaks to interrupt that sense of rhythm which emerges so effectively in Japanese *katagami*. By contrast the panel by Hector Guimard (546) clearly reveals a more monumental and emphatic treatment of this same rhythmic quality.[15] These are just two examples of how the Japanese tradition was translated into European terms.

Franz von Zülow,[16] from Vienna, also started out from *katagami* with his paper cut-outs around 1912 (541, 542), yet he remains within the European tradition of spatial representation. We see here an interesting antithesis to the surface ornamentation of the Japanese examples, where surface parallels bind all the objects and ornamental motifs together as if in a two-dimensional net. Zülow's work, on the other hand, gives decided emphasis, and therefore depth, to the negative ground, with either close- or loose-meshed, web-like compositional textures.

Another direction, taken by William Bradley in his poster style, was the reduction of the great repertoire of Japanese ornamental devices and motifs to a single norm suitable to all contexts (538).[17] The result of this is a loss of stylistic vividness, as Bradley no longer examines the real formal value of things, but merely applies a preconceived vision. The pictorial interest becomes merely illustrative and too closely bound up with literary content.

542 Franz von Zülow
Road with poplars
1912
Cut paperwork, artist's own
reprint
22.5 × 15.5 (8⅞ × 6⅛)
Vienna
Private Collection

543 Japan
Dyer's stencil: grille
Oiled paper
Meiji period
22.2–31.2 × 40.5–41.5
(8¾–12¼ × 16–16⅜)
Vienna, Österreichisches
Museum für angewandte
Kunst

544 Japan
*Dyer's stencils: bamboo
rings and flowers*
Meiji period
Oiled paper
22.2–31.2 × 40.5–41.5
($8\frac{3}{4}$–$12\frac{1}{4}$ × 16–$16\frac{3}{8}$)
Vienna, Österreichisches
Museum für angewandte
Kunst

545 Henry van de Velde
Decorative border
1893/4
For the magazine *Van nu en
straks*
Woodcut
28 × 22.5 (11 × $8\frac{7}{8}$)
Private Collection

546 Hector Guimard
Part of a grille
c. 1900
Cast, wrought, and chased
iron
31 × 47 ($12\frac{1}{4}$ × $18\frac{1}{2}$)
Paris
Private Collection

Artistic devices

Ornamental patterns

Japan possesses an enormous variety of decorative patterns (5, 7, 555) – in its silks, its woodcuts (445, 556), its lacquer- and woven work (1026), its book designs, and in all sorts of other areas as well. Textiles are the central sphere of interest here. Textiles depicted in woodcuts often feature even more striking decoration. European artists at the end of the nineteenth century recognized their abstract potential, ornamental vigour and new colour combinations (6, 438). The English painter and illustrator Walter Crane remarks in *Line and Form*: 'The Japanese are equally deliberate decorators. Their wooden block colour prints, kakemonos [i.e. *ukiyo-e*] are quite definite pattern paintings, in which the pattern motif is as strong as, or stronger than, the graphic or figurative motif.'[1]

Crane distinguishes between a pattern motif and a graphic or figurative motif. Here for the first time an artist has recognized the dual aspect of Japanese ornamentation (549). On the one hand there is the ground pattern, and on the other there are the separate pattern motifs superimposed thereon – often with both planes remaining. When considering the introduction into Western art of the ground-pattern technique, Japanese textiles are a prime and deciding factor.

The numerous instruction manuals that appeared in large editions in Europe around the turn of the century[2] deal with thematic information of use to painters. Occupying pride of place are the design patterns of the applied arts, which derive directly from Japanese and Chinese models.[3]

A great number of Far Eastern motifs also entered the mass consciousness through the magazine *Gartenlaube*.[4] The reproductions in this always brought out quite markedly the primary and secondary patterns. Exclusive publications such as *Pan*, *Die Insel*, *The Yellow Book*, *The Studio* and *Ver Sacrum* then later selected somewhat better quality examples and reproductions. These were always striking in the vigorous sweep of their visual proportions and their net-like, rhythmic compositional structure, which was articulated according to its own peculiar laws of overlapping, of all-embracing lines, and of mosaic-style juxtapositioning. (It must be borne in mind, however, that such observations are essentially Western.) Underlying this structure was a tense compositional form. Stylizing elements in the large- and small-scale heraldic patterns govern the special shapes that occur, notably on kimonos and on Nō (5, 7) and Kabuki costumes: vaguely circular, totally asymmetrical composite forms which act against the unity of the object in order to create a tension and extreme shift of emphasis within the compositional area (439, 445, 447). The pattern is as it were cut off by each part of the garment, which gives that characteristic 'patchy', apparently arbitrary look that is in fact achieved through supreme concentration of composition (5, 7, 555).

Far Eastern clothes and silks attracted much attention at the international exhibitions of 1862 (London) and 1867 (Paris), and they were exhaustively described in innumerable reports. On the subject of Far Eastern silks at the Vienna international exhibition of 1873, Friedrich Pecht, the Vasari of nineteenth-century Munich art history, observes:

Japanese decoration owes its wonderful fascination to its own peculiar system of large forms and colour patches, which are often broken up into innumerable small ones, or to large forms assembled out of small ornamental motifs [556]. One also sees beautifully printed patterns with gold decoration, which also obey the basic principle of systematic irregularity [7, 564]. Naturally there is repetition every so often. But this is handled with such ravishing charm that I have never before been so tempted to buy. One takes one's leave of these enchanting, magnificent fabrics only to find that they are lodged in one's memory as an ideal.[5]

Pecht perceives the device of superimposition of patterns. He also grasps the artistic motif of the irregular sequence. The critic Julius Lessing wrote in a similar vein from the Paris international exhibition in 1878:

Stripes and small squares have come into European weaving under the influence of Asia through technique purely and simply, and hence are so closely bound up with weaving that, at least occasionally, the fashion is for patterns of stripes and squares more or less in the foreground. We should not complain about modern silk weaving. After more than fifty years of sad and dreary silk patterns, this material has (under the influence of the Orient) once again acquired interest and subtlety and style, and every year France sends us hundreds of patterns which even the most severe artistic critics find impeccable from the point of view of taste, opulence, and quality – the patterns of China and Japan ... which have entered the design repertoire of European weaving and are used as models for new designs.[6]

Japan has one of the oldest traditions of silk weaving. A specialized and technically highly developed art, it was from time to time infiltrated and influenced by ideas from China, India, and the Middle East.[7] The Nara period (AD 710–94) is considered as the genesis of the industry, but modern products still have the same beauty and magnificence of colour as those manufactured centuries ago. By tradition silk was worn at ceremonies and festivities at court. Nō actors and Gagakuu musicians dressed in splendid silk robes. The Kabuki was later enlivened by colourful, flowing silks. The role of silk in art reached a high point in the Momoyama period (second half of the sixteenth century). It epitomized this rich culture. Plays, pastimes and everyday activities were all graced with the same

ornamentation, symbolizing the joy of life. There was barely any Japanese painter who could ignore woven silk, in the form of clothing. Woodcuts reveal the by now inexhaustible variety of ornamentation.[8]

The surface-spatial colour woodcut compositions of *ukiyo-e* were also crucial, showing a cross-section of society at large. The patterned, colourful clothes depicted in these woodcut figure representations dictated the appearance of each sheet.

The central theme of early and middle period *ukiyo-e* was the human figure draped about with masterpieces of Japanese textile art. Sometimes we see rosettes and stylized tendrils, variously depicted in a ground network of geometric forms (445). The secondary pattern was called the *shokko* or *shippo* pattern. The most splendid prints are those depicting sumptuous Samurai dress or court clothes (*kamishimo* and *suō*), luxuriantly decorated Nō costumes and kimonos (*kisode*, *furisode*), and clothing with superbly ornamented belts (*obī*). Actors in *suō* costume, in the role of Shibaraku, cut a magnificent figure with, for example, the great Mimasu arms of the Ichikawa (547). The colours are rust red, green, and grey.

We are then also shown patterned over-clothes or coats (*hō-uchikake, chihaya haori, kazugi*). These, in a sense autonomous textile paintings, having a definite sense of still-life about them, aroused the interest of European painters and artists in the sphere of the applied arts.[9]

The late *ukiyo-e* masters introduced an ever greater degree of decorative patterning into their figure pictures. Clarity of decorative shapes was supported by glowing brightness of colour (445). Through the Japanese woodcut, therefore, French, Belgian, English (557), Dutch, German, Austrian (436, 438), Italian and American (566) artists all began to appreciate the significance of design, which had hitherto not been adequately examined.

Directly or indirectly, Japanese textile art had a decisive influence on European art and gave it a considerable stimulus. Of major importance too were the Japanese block books with kimono designs (564), which were especially familiar to French craftsmen. The *ukiyo-e* masters' transpositions of textiles to a pictorial surface, with the high artistic quality of their rendering of textile decoration, made impressive and memorable documents for European artists and craftsmen. Here, rather than in the actual imports of Japanese silks, lay the reason for the immediate popularity and influence of Oriental textiles.

An important reason for the popularity of these decorative techniques in Europe was the standardization and at the same time the variety of their modified geometrical forms. The Western artist was attracted to a creative schematization of form, combined with a certain systematic irregularity: this style was likened to the coats of mendicant friars, which were made up of patches of all sizes. From this apparently arbitrary, yet in fact subtly disciplined convention of dress, Oriental clothing developed in many directions. Often only half of the robe would be patterned, obeying the principle of contrasting full and empty space. Alternatively the

design would be determined by a rhythmic grille pattern, or recurrent crests or abstract forms. These large pattern motifs always appear to be projected out from the edge of the robe. There is an element of the 'wandering shadow' in the way the pattern seems to glide across the tissue as the robe moves (564). An important factor is the multiple structuring of the surface – that is, the application of other materials to the basic material of the robe, so that a kind of subtle layered effect is achieved. The textile surface acquires a motion of its own through embroidery and the addition of sections of different cloths, with different textures. According to how they are sewn on, these look padded, abruptly contrasting, transitional, or like a contour, smoother or rougher than the main material. In colour woodcuts these combinations are rendered to perfection (445). A complex overall effect is arrived at, in which the tactile sense is as much involved and stimulated as the visual. One essential aspect of this decorative style is that it takes no account of the shape of the wearer. Certain elements of this 'shapelessness' were taken up later by the painters of the Vienna Secession.'[10]

Nō and Kabuki theatrical costumes were often intended to stylize and dematerialize the actual human body of the performers. The *suō* robe is the most vivid example of this alienation of shape (547, 694). The shape of the textile body-covering appears in its primary form, acting as a symbol, a standard type or codification of a meaning, or rather of a specific social identity.

Decorative motifs are examined in the 1972 exhibition catalogue 'Weltkulturen und moderne Kunst'.[11] (The following description is taken from the catalogue text.)

The various categories are: (1) Geometric-abstract motifs (549, 554, 569); (2) Naturalistic motifs (445, 550, 558, 561); (3) Figurative objects seen as pure ornamentation (557, 563, 623). It is therefore valid to talk about an ornamental vision of nature (445): the real formal value of things is brought out without detriment to their inner significance. Schematized forms based on naturalistic observation are always the product of active inner stylizing elements. Through them spiritualization and sublimation are made visible – brought empirically to sensate form.

The three categories listed above can in turn be related to three compositional principles.

1. The all-embracing grille or grid, with overlapping (526–28). This method has produced astonishing results in all periods of textile production. All kinds of natural phenomena are used as visual inspiration for this kind of pattern, which appears to sprawl or march over the surface area, yet always ordering, subdividing and enlivening it. Always a repeated motif, it alternates between quiet and reflective or deliberately florid compositional force. Elaborate examples of this technique modulate the surface area with appliqué (5, 7, 555), which makes the basic surface less dominant. Organic forms dictate the floral, flowing, curving line motifs (558). Intersecting, strong, structural lines are based on weaving patterns – rhythmic articulation interacting with marginal markings (560, 561, 563).

2. The enclosed area (1023, 1026). This technique creates sectioned-off areas. Decorative borders, wavy

lines and pattern stripes predominate. In them we see the ubiquitousness of Oriental ornamentation. Much use is made in this system of the well-tried devices of linearity, which appear over and over again in the applied arts of the Far East, and which profoundly influenced European art in the nineteenth century.

3. The centralizing motif. A fundamental device here is that of repetition of a *mon* heraldic form, integrated into the basic unity of the background material (793). Usually the *mon* or crest is circular (797–804), and anything capable of being portrayed in a round form can be contained within it (813). The heraldic books[12] (791–95) are filled with an almost inexhaustible variety of possible motifs. They analyse and show the origins of motifs, and illustrate what artists have been able to do over the centuries with a simple circle, which is yet the symbol of life itself. Crests are to be found everywhere, and they are an absolutely integral part of Japanese textile art. The crest was a generally understood language, which knew no sociological barriers. Around 1900 the principle strongly influenced the work of the Vienna Secessionists.

Comprehension of Oriental decorative patterning became greater as a result of the international exhibitions, and there were certain people who appreciated the central, determining factors. In the catalogue to the Vienna international exhibition in 1873 we read:

With the Japanese there is never any question of the whole surface being covered, as with the Indians and the Chinese. They show a totally inimitable understanding of how to extend a swaying branch or a thin bamboo-shoot with feather-like leaves across an entire surface, depicting only as much of it as is absolutely necessary, in order to arouse in us a sense of its living reality, yet nevertheless with the most delicate observations of graceful, swinging movement.[13] Not everything is embroidered. Much is only painted or printed onto the cloth, in which case the shiny silk threads then serve merely as contours or superimposed highlights. Gold dots are scattered everywhere with consummate skill, so that the whole gleams and glitters. Then a single flower or twig, perfectly delineated in all details, is set within the circle[14] in a supreme display of compositional ability, so that it draws the eye to it, as the centre of the whole design – all the other parts being subordinated to it like the elements of a beautifully executed painting [5, 7, 555].[15]

However, perhaps the following observation goes deeper:

The forms on the dully gleaming silk surface shine forth from the ornamental pattern. The Japanese decorative sense is anti-axial, single-centred, often delicately florid, or tending towards unity within all-embracing borders: in short, it can cope with the most unusual formats – even clothing [564].[16]

Much artistic endeavour went into silk decoration in China and Japan, and was the source of inspiration of all textile work and also of woodcuts and printing generally. Japanese painters (who were frequently closely associated with textile art) produced marvellous pictures using as their main theme colourful clothes in streets, squares, theatres and houses. We are told in the 'Weltkulturen' catalogue:

Hishikawa Moronobu was obviously closely connected with this art. His grandfather Shichieiomon was a textile dyer in the town of Hōta, his father Kichieiomon Michishige was a skilled embroiderer, and he himself drew designs for textile patterns – which was how he discovered his talent for painting. In this context it was important that dyers' stencils (Moronobu also designed some of these) employ a precise graphic method. Hardly any other black and white medium is as superbly and artistically decorative as this. With stencils the pattern-ground principle is already visible in the actual stencil; it has to be borne in mind, however, that this is often intended to be placed over another pattern, either a rough, rep-like weave or a slightly raised pattern within the material itself. The compositional principles listed here (a-c) are all used, to very varied effect, in stencil work.[17]

Stencils always have a concrete, tense reliance on their edges – leading successfully to graphic continuity of pattern in the finished work (544).[18] One important feature of the textile industry in Japan is the pattern designs, which were printed in black, red or olive green, and which appeared as long ago as 1667. They are direct precursors of the printing technique adopted in the woodcut. Originally of Chinese inspiration, their foreign elements in it were completely transformed.

The *ukiyo-e* masters contributed significantly to silk printing. No less an artist than Moronobu produced silk prints using the woodcut technique. The famous Minkō (who called himself Shokei)[19] started off as an embroiderer. He lived in Osaka and became one of the *ukiyo-e* masters, adhering to the Tashibana school.[20] Ishikawa Toyonobu Shochōken painted fabrics in the Chinese manner.[21] Harunobu is accounted the inventor of blind blocking, which figures, free of contours, on rep-like cloth. Shumman loved silvery grey tones in textile work. His gift for creative ornamentation is evident in his exceptionally finely executed designs, which reflect his attraction to costly materials. He even went so far as to incorporate patches of silk and gold threads in his seals.[22]

Long, trailing robes and wide mantles dictated certain postures and modes of behaviour. The *okaidori*, a feminine garment with long sleeves, necessitated a particular way of holding the arms (52). The male *haori* lent its wearer a somewhat massive bulk (705). The prestigious leg garment known as the *hakama* resembled a cloud of cloth. Those privileged to wear it would seem to be floating, especially as the armless 'shawl' extended the shoulders until they looked like wings (694).

The idiosyncratic posture and demeanour of movement of women as they stand, sit and lie down in thousands of woodcuts reflect a very definite, prescribed protocol. It was in the theatre, however, that the most elaborate conventions applied. Here the way in which textiles were cut and arranged became a veritable art form, expressing more than mere coverings of the bodily volume. In Kabuki the actor was almost secondary to his costume. It was up to him to control this autonomous mass of material, to display it to full advantage. In the lion dance, for instance, the actor's skill can be judged by the swirling of the swathes about his legs – by the extent to which he becomes an 'abstract' object, most alive when moving as pure textile form. This crescendo of movement was especially well caught by the later woodcut artists. Often the figure of the human being pales into insignificance in comparison with the

547 Utagawa Toyokuni
The actor Segawa Rokō IV
c. 1807
Colour woodcut
39.2 × 25.7 (15⅜ × 10⅛)
Private Collection

548 Gustav Klimt
*Fulfilment. Cartoon for
Stoclet frieze*
1905–09
Various techniques on paper
194 × 121 (76⅜ × 47⅝)
Vienna, Österreichisches
Museum für angewandte
Kunst

configuration of clothing, which becomes the main point of interest (547, 550).

In the hands of the late masters of the Japanese woodcut this theme acquires even greater urgency. The decorative motifs become larger and more prominent, and the colours more brilliant and pervasive. The figure, engulfed by the ornamentation in the woodcut, usually reveals the triumph of the voluminous object-world (445, 449, 562). With the same end in view, European painters and craftsmen worked under the inspiration of the *ukiyo-e* masters. In their quick adoption of these ideas they started off on the road to abstraction.[23]

The actor playing Shibaraku with well-known and powerful gestures (547, 710) displays a large heraldic motif on his over-mantle. His highly decorated gown becomes an almost sculptural base for it, and his head has only secondary functions. It is, as it were, up-staged – in fact totally swamped – by the patterning, in which a dominant element is the large areas of coral red which

serve as backing to the white crest. Once in costume, the actor sinks deliberately (and with great art) into anonymity.

European artists around the turn of the century were enormously struck by this. The artists of the Vienna Secession adopted the pattern-ground principle and developed it with remarkable results. Klimt's figures exhibit a certain anonymity, while by contrast his ornamental motifs acquire an extraordinarily personal quality (554). The combination of large and small pattern motifs, and the patches of gold and silver, which stand out almost three-dimensionally, are reminiscent of features of the Japanese woodcut. The reduction of all bodily volume and the refined quality of workmanship make Klimt's pictures seem like monumental *surimono*.

Gustav Klimt had thoroughly absorbed the Oriental pattern-ground principle. He owned a fine collection of Japanese kimonos and Nō costumes, modelled his own work on Japanese woodcuts and *emaki-mono* (scrolls), and decorated his studio with *kakemono* (hanging scrolls) and *ōban*. Klimt always wore a kimono-like

549 Japan
Textile pattern
Mon motif on grille ground
(double pattern)
18th/19th century
Wool and silk
44 × 29.3 (17⅜ × 11½)
Stockholm, Ostasiatiska
Museet

garment (13, 13a), a suit of Samurai armour stood in his ante-room, and the Flöge sisters made him magnificent kimonos based on examples in his collection. He had studied Japanese textile art closely – he knew of the device of the large crest counter-balanced by a base pattern. Every figurative shape is ornamentalized or incorporated within a repeated heraldic pattern.

The controlled simplicity of his sitting or standing figures is contrasted by their ornate, luxurious dress – all gold and silver and teeming colour ornamentation. Such techniques are reminiscent of Japanese *shomen-zuri*, mica printing, obtained with special polishing plates when printing with silver leaf. Of relevance here too is the *kingin-zuri* technique, by which a special lustre is produced with gold, silver, and copper powder. Tight packing of the pictorial space, intentional lavishness, yet without vulgar excess, diversity of form and overlapping of rich textures, structured gradation of the slightly agitated picture surface through variation of surface thicknesses, use of colour for sheer aesthetic value, and the contrasts of different colour combinations within the composition all together create a kind of transcendental image that as it were denudes reality and from it achieves abstraction (438, 554).

Just as in the Oriental models, there is no striving for total abstraction; a high degree of material value still remains and is intensified by simplifying pictorial forms. Throughout the painter's *oeuvre* this concentration of patterning is developed, to reach a peak in this system.

His treatment of the Japanese crest principle together with that of the continuous pattern produces a remarkable combination of styles (554, 563). All the decorative forms mentioned in this commentary Klimt uses either singly or in groups. Like the Japanese print artist Shumman, he explored the possibilities of using collages of other materials. For him ornamentation was the means of overcoming the human form. Inspired by the Japanese *ukiyo-e* masters, he did away with figure volume, which European academic art treated with the most absolute realism. This radical change actually took place in his own work. His large-scale wall paintings became broad surface decoration. The high point of this artistic progress came with the frieze for the Palais Stoclet in Brussels in 1910 (548, 554) and most especially with the Beethoven cycle (563).

There were long years of preparation. He designed crests in his sketch books and transferred them as repeated motifs to his large-scale works. In the Palais Stoclet frieze all figurative values have become totally and perfectly absorbed into ornament. Only small sections of faces are still recognizable. Otherwise all bodily features are submerged, as in the Japanese woodcut, in kimono-like clothing – which in turn recalls the patched robes of Buddhist monks. The asymmetry of all the forms, large and small, and the recurrence throughout the picture surface of the now fully autonomous decorative units, further emphasize the pure surface quality of the work (564). The motifs bind

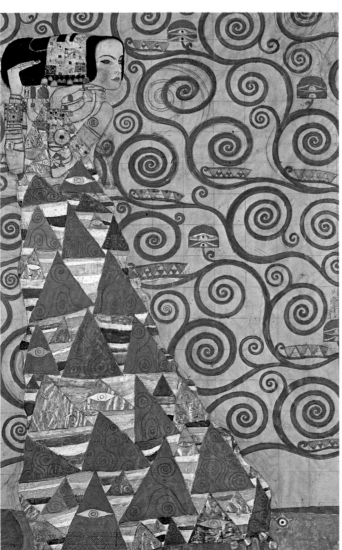

together the compact ornamental construction, leading the eye for ever onward, as in screen-painting (562, 563).

The physical volume of all the figures was united with the pattern-ground. Japanese colour woodcuts and textile art provoked much enthusiasm and stimulated much creative imitation and adaptation. Modern European art had taken the first steps along a new path.[23]

Bonnard and Vuillard, and also in a certain sense Roussel, reveal a common vision in the pattern-ground technique. Lyrical harmony, and the mysticism that enveloped Maurice Denis and Sérusier, did not particularly appeal to them. Bonnard manages to embed his ornamentalized figures in the pattern-ground according to his own individual perception of space. Figures, and indeed everything, become part of a single surface texture in his work (571). The surrounding space is not seen as being anonymous, as it often is in Klimt's work. Klimt uses a very restricted depth of ground, while Bonnard and Vuillard ornamentalize depth itself, as it had come to be treated in the Western tradition. This pictorial approach is perhaps the most important development in art around the turn of the century. Unlike the group of first-generation French Impressionists centred around Manet, Monet and Pissarro, Bonnard and Vuillard do not attempt to convey the tonal qualities of daylight, but rather to ornamentalize it. Such elements as light, air and water are integrated into an ornamental scheme with everything else in nature. This leads to a quite new, self-sufficient, interacting repetition

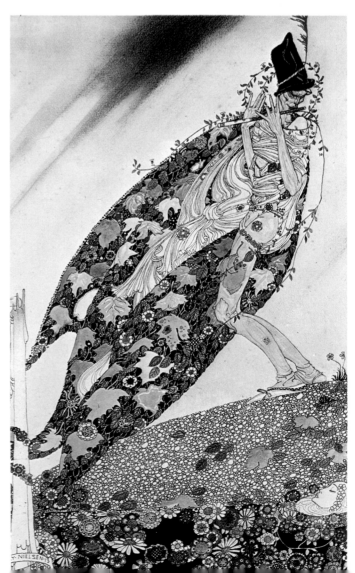

555 Japan
Karaori, Nō costume
Light blue and gold
chequered ground with
maple leaves
Silk brocade
143 × 153 (56¼ × 60¼)
Tokyo, National Museum

556 Utagawa Kuniyoshi
*Tokiwa-Gozen travelling
with her three children*
After the manner of the
*Tales of Clever and Brave
Women (Kenjo reppu den)*
c. 1844
Colour woodcut
35.3 × 24.5 (13⅞ × 9⅝)
Cologne, Private Collection

557 Kay Nielsen
The gust of wind
1913
*Illustration for 'The Book of
Death'*
Watercolour over black ink
on white paper
20.8 × 12.7 (8¼ × 5)
London, Private Collection

of forms, which aims at devaluing individual figurative
values (431, 551). In the long run, the result had to be the
abstraction of figurative volume and of environment,
with the picture remaining always a fragment of a
greater whole. From the very beginning, Klimt restricted
his spatial depth, achieving the right sense of surface-
parallels to suit his geometric pattern schemes (438, 548,
554). Both Bonnard and Vuillard must also have seen the
dot system of Van Gogh and the Neo-Impressionists,
with which they bound the surfaces of their paintings
into a unity. At all events they sought to combine both
artistic methods.

Van Gogh was much more interested in Bonnard and
Vuillard than in Signac and Seurat, as is shown by the
way he subordinates his dot technique to certain inner
surfaces, and struggles to elaborate two-dimensional
decorative principles. Vuillard creates a strong unity
between wallpaper and clothing patterns, presenting his
box-like rooms and their fittings as highly decorated
surface parallels, thus retaining the linear definitions of
spatial illusion, yet at the same time placing the whole
composition on a single plane. This produces a colourful
net or mosaic of large and small pattern motifs, which

212

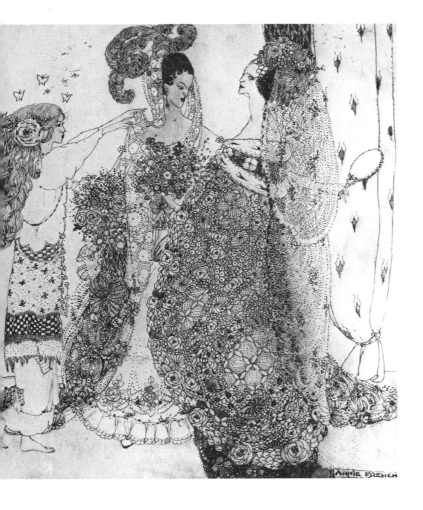

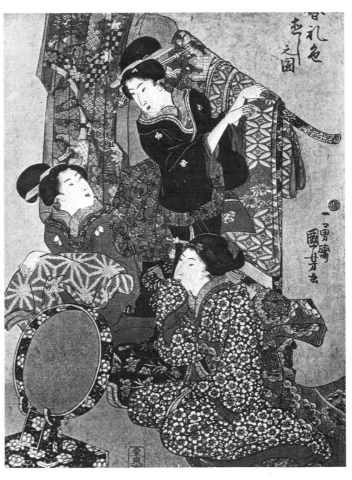

558 Annie French
The ugly sisters
Watercolour over black ink,
highlighted with gold, on
parchment
22.5 × 20.7 (8⅞ × 8⅛)
Edinburgh, Scottish
National Ballery of Modern
Art

559 Utagawa Kuniyoshi
Women choosing kimonos
Colour woodcut

gives the picture a dancing, decorative spirit. Maurice Denis described the spatial harmonies of this patterning effect as 'happy dissonance'.[24] Unity – or tense division – of the pictorial surface is achieved by dot motifs, as on carpets and tiles, which then lose their individual value. Speckle-like squares, stripes and decoration of all kinds enliven the picture surface and keep it constantly moving. When H. R. Hahnloser asked Bonnard what he owed to the Japanese, the answer was 'chequered patterning' (571).[25] As in the works of the Japanese *ukiyo-e* masters, pictorial depth exists in the imagination of the viewer. Bonnard, Vuillard and their friends evoke an ornamentalized surface space seen from very close to. Bonnard, the *Nabi japonard*, achieves immediate simplification. Like Vuillard, he does away with the rectangular notion of space (the box-space of Renaissance-style illusion) wherein the perspective in which objects are viewed is all-determining. Now the goal was complete congruency between the surface forms in the unbroken decorative pattern and the figurative object itself. Under the influence of Japanese painting and textile art, European painters turned to that decorative compositional approach which made

extreme simplification of objects possible. In choosing subject matter, artists followed the Japanese woodcut preference for the close-up, showing decorated objects and, more importantly, ornate clothes (562). The figures in their chequered, spotted, flowered robes (565–71), become part of the wallpaper or curtain pattern. The ground absorbs everything that is represented on it. Like the *ukiyo-e* masters, the Nabis were also closely associated with textile art. Bernard designed textile patterns in Lille in 1890, and more than once worked on tapestries. Vuillard himself possessed a Japanese kimono,[26] which he used as a colourful piece of room décor and often included as a patterning device in his pictures. His paintings are often carpet, wallpaper, or curtain still-lifes, in which the textile patterning principle is the main focus of interest (568). In his painting *Vallotton and Misia* (551), dating from 1899, space is created by a sort of stacking of figurative elements. The close placing of the various harmonizing colour areas one behind the other, in different proportions, does not permit of any suggestion of depth in the sense of central perspective. Spatial relations are blocked and unified by colour values and surface border

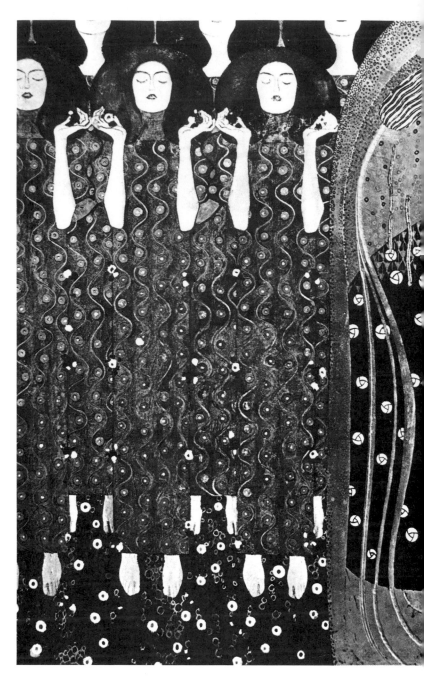

560 Japan
Textile design
c. 1850
Brocade
80 × 80 (31½ × 31½)
Private Collection

561 Arthur H. Mackmurdo
Textile design with cromer bird (detail)
c. 1884
40 × 60 (15¾ × 23⅝)
Private Collection

562 Torii Kiyonaga
Musicians and actors on stage
c. 1784
Colour woodcut
37.6 × 25.8 (14¾ × 10⅛)
Regensburg, Collection
Franz Winzinger

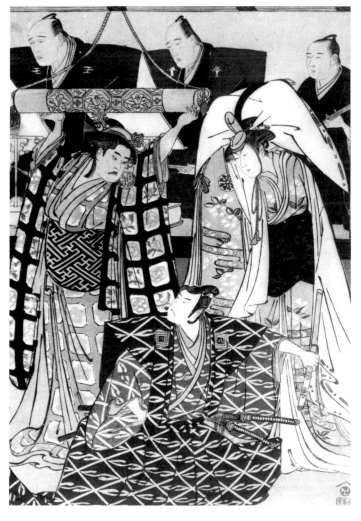

outlines, as in the Japanese woodcut, which within a small pictorial area imposes strict order on the various ornamentally rendered individual forms.

Ideas and inspiration stemming from the Japanese colour woodcut came out in European painting in diverse ways. Even among the Nabis there were differences in vision and technical approach from one studio to another. Among the early works of Japonisme are the watercolours and colour etchings (566) of Mary Cassatt.[27] She treats three-dimensional objects similarly to the two-dimensional, essentially decorative wallpaper, carpet and clothes. Harmonization of the third dimension into the second is the aim of these light-colour prints, which aroused the admiration of Pissarro. He wrote to his son Lucien:

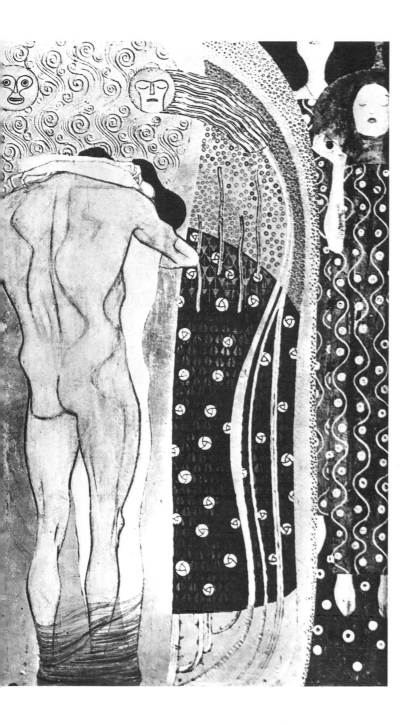

Pissarro, the master of Impressionism, who could well afford to pass judgment, describes these works as unusual and beautiful because of their diaphanous surface colours, free of all shadow. In this, Cassatt emulates the bright, light pictorial character typical of the woodcut. She was able to integrate a surface-related pattern scheme into the pictorial composition in a way which Pissarro found stimulating.[29]

The most essential ingredient of Japan's influence in the field of pattern and decoration was its silk clothes. Nō costumes were exhibited at the international exhibitions in London, Paris and Vienna, and European artists felt that in the decoration of Japanese silk robes they were seeing a combination of all art forms. ·Gold leaf, patchwork-like appliqué and relief embroidery all, as pure decoration, went to determine the nature of Nō and Kabuki costumes (555). The painterly freedom and whimsicality of the designers resulted in huge-scale patterns crossing over the shoulders of the garment or stretching right down the length of the back: the *kambun* design fascinated not only the *ukiyo-e* masters, but also the artists of Europe and America. The elegance and grace of this style of clothing was further enhanced by the *obī* which was worn with it, and which constituted the focal point of the design (445). Woodcuts depicting these garments are commonly referred to as 'textile still-lifes'.

European book illustration was also influenced to a considerable degree by these contacts with Japan. In

563 Gustav Klimt
Beethoven frieze
1902
Casein paint on stucco, 7 sections, each
220×240 ($86\frac{1}{2} \times 94\frac{1}{2}$)
Vienna, Österreichische Galerie

564 Japan
Design for kimono
1937
Polychrome print with gold and silver
Produced by Azuma Ltd
36.5×27.3 ($14\frac{3}{8} \times 10\frac{3}{4}$)
Munich, Private Collection

Remember your experiments in Eragny, well, Miss Cassatt has done it. That subdued, subtle, delicate tone without splodges and the ink running. Wonderful blue and fresh pink tones! ... The result is superb, as beautiful as with the Japanese, and it's done with printing-ink!

and again:

I feel I have to speak with you, while I'm still feeling so influenced by what I saw yesterday at Mary Cassatt's, about her colour etchings, which she intends to exhibit at Durand-Ruel's. We open on Saturday at the same time with the patriots (the above-mentioned Société de Peintres Graveurs) who, between you and me, are going to be beside themselves when they realize there is another exhibition of more unusual and more beautiful works right next door.[28]

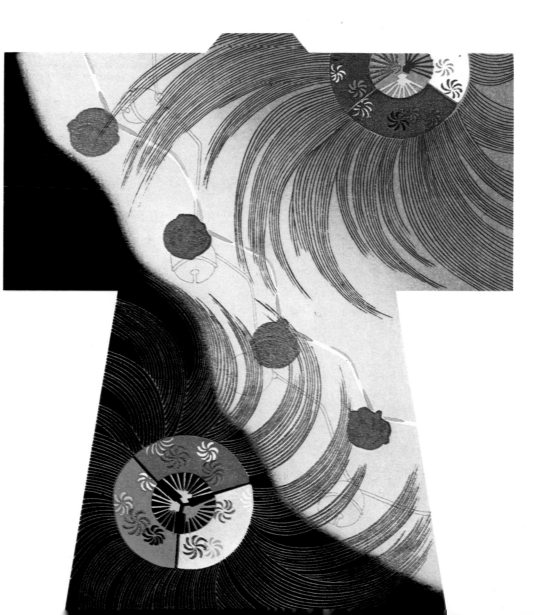

children's books, especially, this was so. In good books around 1900 clothes often acquired a certain figurative independence, and decoration became an expressive medium in its own right. Comparison of Utagawa Kuniyoshi's *Tokiwa Gozen travelling with her three children* (556) with Kay Nielsen's *The gust of wind* (557) clearly illustrates this. The gust of wind itself is also a much-loved subject with Japanese artists. The energy and fullness of movement is enhanced by the streaming of the densely patterned material, which seems imbued with a vital symbolism. A single gesture is made to express a great deal, through the resulting structures of lines and the bright colours contained within them. However, for Europeans, luxuriant patterning of figures acted as a kind of alienating device in the pictorial effect – through it Symbolism, too, acquired decisive new techniques.

Annie French – active in Glasgow around 1900 – also made use of patterned clothes as an expressive medium (558). Her illustrations, in the style of Beardsley, create the impression of floating garments through thin, brittle fold-lines, connected with the figure delineation. Back views after the Japanese fashion were popular, as was the quarter-face technique. The textiles thus acquired their primary significance through extreme reduction of all essentially human aspects.

The linear nature of the Japanese woodcut was adopted and actually enhanced around the turn of the century by the Vienna Secessionists. The patterns sometimes give a reticulated or screened effect (552, 553), so dense and regular is the ground pattern into which the figures are integrated. Another technique is the breaking down of figures into large-scale patterning which then forms a single arabesque. The finest, and in a sense the definitive, example of large patterning over a secondary decorative ground is Klimt's Palais Stoclet frieze (548), with its tendency towards abstraction. The artist's autographed working drawing for the frieze is executed in tempera, watercolour, gold and silver bronze paint, chalk, pencil and zinc white on coarse paper, and is accompanied by numerous handwritten directions for the execution of the work. The décor of the room is conceived according to a unifying design. Over the whole area of the mosaics (which extend for over seven metres on both longitudinal walls) we see the motif of the Tree of Life, into which are incorporated allegories of expectancy and fulfilment. Klimt realized only the seven-section left-hand wall composition with *Expectancy*. In strict symmetry, according to the pattern-ground technique, the spiralling branches and twigs of the Tree of Life, which rises up in the middle of the picture, grow across the whole extent of the pictorial ground.

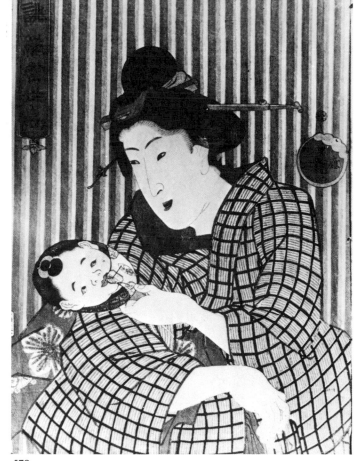

567

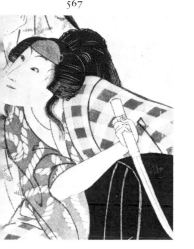

567

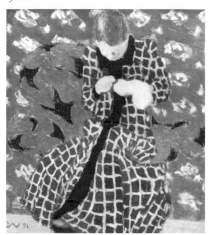

568

570

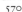

569

571

567 Utagawa Toyokuni II
*The actor Iwai Kumesburo I
in the female role of Yatsuno
Koman wearing a currently
fashionable check kimono*
(detail)
Colour print with blind
blocking
Berlin, Museum für
Ostasiatische Kunst

568 Edouard Vuillard
The embroideress
1891
Oil on cardboard
27 × 22 (10⅝ × 8⅝)
Paris, Musée National d'Art
Moderne

569 Julius Klinger
Poster
c. 1912
Colour lithograph
148.5 × 99 (58½ × 39)
Private Collection

570 Utagawa Kunisada
*Japanese woman in check
kimono. Striped fabric in the
latest fashion (Atsuraiori
tōsei jima)*
c. 1845/6
Colour woodcut
35.5 × 26 (14 × 10¼)
Düsseldorf, Private
Collection

571 Pierre Bonnard
The check shirt
1892
Oil on canvas
Paris, Musée d'Art Moderne
Collection Charles Terrasse

217

Diagonal composition

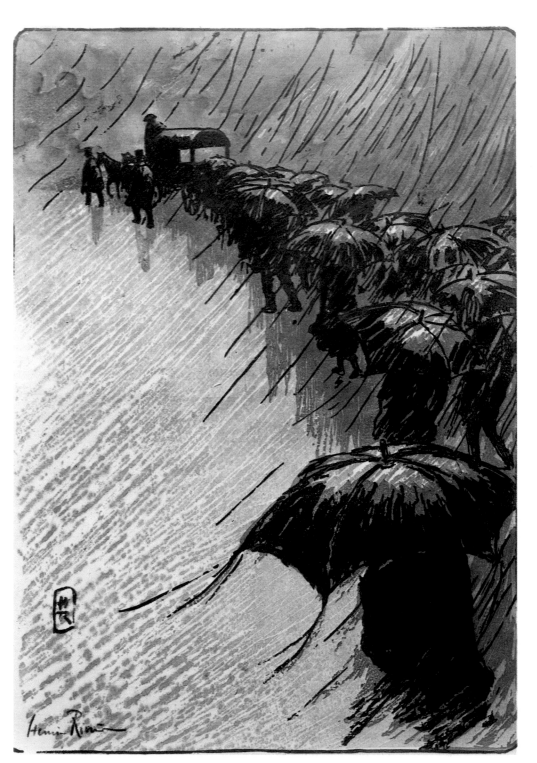

The diagonals in the work of Far Eastern woodcut artists (573, 574, 731), painters and craftsmen[1] are sufficiently striking for their function in a picture to be immediately recognizable. These diagonals can, in certain cases, even run as counter-diagonals, for instance from bottom right to top left as well as from top right to bottom left. A good illustration of this is the woodcut by Hiroshige, *Sudden rain in Shōno* (573). The rain is lashed leftwards over the trees, the figures coming up from below hurry in the same direction, only the flat plane of the ground slopes to the right. Hiroshige here uses direct contrasts of directions to evoke the dramatic moment of the downpour.[2]

Henri Rivière's *Funeral under umbrellas* (572), dating from 1895, is similarly handled, except that the illusion of depth is transmitted in a European translation of the Japanese idiom. The artist thus is not only stimulated by the Far East, he also makes free with the European perspective tradition of foreshortening, to obtain greater intensity in this sphere. It is clear from the precise definition of the pictorial field that Rivière had made a close study of Hiroshige's *Sudden rain in Shōno*. The umbrellas, with their points and sharp corners, stand out against the light ground as the rain streaks down from right to left. Such objects had not hitherto been deemed worthy of portrayal in art. Only on acquaintance with the Japanese *ukiyo-e* masters did European painters begin to depict them.

This dominant visual device avoids the rectangle principle by, so to speak, shifting the spatial boundaries outside the picture surface – thus opening up the pictorial space, so that it can be extended beyond the sides of the picture as the viewer desires. To the baroque vision of official academic art this free continuation of pictorial movement in real space was strange and incomprehensible.[3] The painters of the late nineteenth century had taken seventeenth-century Dutch landscapes as their models.[4] The diagonal as a distinctive visual device in the Japanese woodcut so to speak cuts across traditional stylistic pluralism, and contributes to

the move away from conventional landscape views (702).[5] This distinctive feature of Japanese painting, used above all by Hokusai (579) and Hiroshige (573, 574), greatly influenced European painting and graphic art. Artists were struck by the sense of depth thus created in Japanese pictures – by the way the eye is led so decisively into the distance, and by the possibilities of manipulating this distance through the sharp diminution of things and the dramatic narrowing of the diagonal. The *ukiyo-e* masters developed various ways of dividing the composition with the diagonal, creating all kinds of shapes.[6] Usually the content of the picture stands in tense relation to the space, the diagonal slants setting off a continual interplay of forces between space and surface. The diagonal lines can shoot swiftly off into the distance (574, 576), or they can proceed in step-like progression, creating pictorial depth through staggered diagonal placing of objects.

Birds in flight were a much used diagonal motif.[7] Already in Chinese painting and in numerous painters' manuals we find precise arrow-head bird formations in rising or falling slants (579). It is a pleasing motif which also appears commonly in European painting and graphic art. The woodcuts of Carl Thiemann contributed significantly to understanding of Far Eastern art forms around the turn of the century (578).[8]

One basic device of Japanese painting was the enmeshing of individual or group compositions with the actual edges of the picture, reinforcing the emphatic diagonal structure. The cut-off is a universal technique of Japanese woodcut art. This creates detailed 'close-up' views, the precision of which clearly brings out the essential 'type' of each object, as the physical closeness makes for subtle observation of surface structure. The rightward-sloping composition of the three swans in flight (578) conveys movement through linear structure. Here, despite the limitations of the surface, we have impressive examples of its treatment. Through gradations of space it is possible to break up the stiffness of the straight diagonal, to effect a continuous smooth passage from one detail to another, and from one plane to another. Rhythmic variations of the diagonal can be obtained by playing broad and narrow, and near and far elements, off against each other. The *ukiyo-e* masters were able to integrate everything, even static objects, into the pictorial field in such a way that all contributed to the unbroken visual progression of the unwavering line leading into the distance.

We can here distinguish between two methods of diagonal composition: the unwavering compositional line just mentioned, and the stepped version, which leads stage by stage into the distance. Hiroshige employs both devices, and both should be briefly commented upon. As examples, let us take *Ama-no Hashidate in the province of Tango* (574), and *Return of the fishing boats to Yabase* (576). The first is constructed along the lines of the tall, narrow detail format, and the promontory shoots up like an arrow from the bottom right-hand corner, to the top left. The jagged, narrow peninsula crooks round at the bottom, emphasizing the sense of pictorial movement, and the pines lean in obedience to the same directional force – an example of how objects

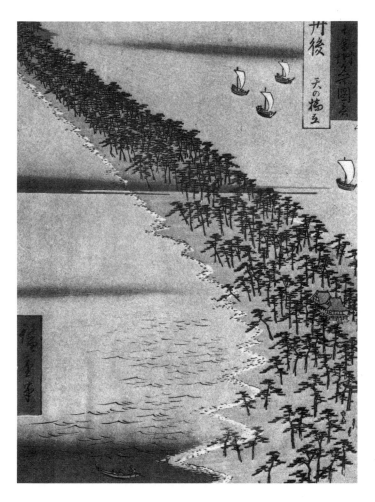

572 Henri Rivière
Funeral under umbrellas
c. 1895
Etching
21.5 × 17.7 (8½ × 9)
Paris, Bibliothèque
Nationale, Cabinet des
Estampes

573 Andō Hiroshige
Sudden rain in Shōno
c. 1832–34
From 53 *Stations of the East
Sea Road (Tokaido gojūsan
tsugi)*
Colour woodcut
22.3 × 34.7 (8¾ × 13⅝)
Private Collection

574 Andō Hiroshige
*Ama-no Hashidate in the
province of Tango*
1853–56
From *Famous Places from
more than 60 Provinces
(Rokujū yoshū meisho zue)*
Colour woodcut
36 × 24 (14⅛ × 9½)
Regensburg, Collection
Franz Winzinger

575 Eugen Kirchner
November
c. 1896
Repr. *Pan*, 1896, II, Vol. 3
Aquatint
32 × 20.1 (12⅝ × 7⅞)
Obbach, Collection
George Schäfer

enhance the passage of the eye by repetition of the movement on a smaller scale. The pines carry the eye up to a thick mass of trees at the top. The suggested pointedness of the thin, stage-like peninsula is thus echoed in the trees. In considering the construction of pictorial space here, it is significant that the upright elements create diagonals in contrast with the three horizontals parallel with the picture plane. From this arises a sort of system of co-ordinates with three axes meeting at a junction of angles – and which can thus be exploited to different artistic effect.

Already in the late 1870s and early 1880s Manet was using a pronounced downward angle of vision with open picture borders on all sides.[9] In his painting *Rue Mosnier with flags* (582), dating from 1878, he presents his composition running out into real space from a raised viewpoint.

Within these systems of axes landscapes can either be given dynamic interest through striking directional emphasis or made more dramatic through startling natural phenomena. In particular, depth and breadth were conceived in a new way. In the second compositional technique – the graded 'steps' leading into the distance – the visual progress is carried out by means of whatever reasonably large objects the painter wishes to include in his composition.[10] Of critical importance in this technique are the points at which these objects join together and lead on from one to another. In both techniques the device of the diagonal is conditioned by the steep, downward angle of view. Receding depth and the view from above are both suggested in a style in which all spatial barriers can be lifted. Here a continuum of space can be achieved wherein the beholder, deprived of any earthbound viewpoint, experiences the sensation

of being involved, suspended as it were, in the pictorial movement.

The *ukiyo-e* masters were influenced by *emaki* art (horizontal scroll painting). This extremely important genre (584) affords the viewer a 'moving landscape', in a spatio-temporal sense, in which the viewer is physically involved.[11] The unrolled section of the scroll – an arm's breadth at a time – lies available for examination, from right to left, and the picture proceeds as the person looking at it rolls it on with his right hand. *Emaki* boast an extraordinary variety of diagonal compositional devices. The fact that the detail open to view at any one time is selected by the viewer gives the genre a unique compositional flexibility.

Hirokage includes in his *Amusing Views of Famous Places in Edo* an illustration of the Gion celebrations (581). An essential feature of this scene is the street, diagonally drawn between the houses. It carries the eye immediately over the festive procession into the pictorial depth. Hirokage is working in an old tradition here, as the screen example (580) shows.[12] Europe, however, did not discover this technique until the second half of the nineteenth century.[13] Bonnard, who deliberately adopted Japanese principles (585), quite often presents a diagonal street pattern, built up almost geometrically, with spherical patches in gentle colour tones introduced into

578 Carl Thiemann
Wild swans over the Amper marshes
c. 1937
Colour woodcut
26.3 × 41.5 (10⅜ × 16⅜)
Private Collection

579 Katsushika Hokusai
Birds
1823
From the book *Ippitsu gafu*
Colour woodcut
21.8 × 16.5 (8⅝ × 6½)
Cologne, Museum für Ostasiatische Kunst

the background. With three or four such patches he produces a highly effective sense of distance, creating space in leaps and bounds. Following the Japanese example, this distinctive constructional progression is harmonized with figure groups reducing in size and with vertically overlapping compositional elements (tree-trunks, etc.). Like a wide-angle lens, this 'lengthens' the view. Bonnard went further than his Japanese models in this style of composition. The large surface mosaic made up of natural and man-made phenomena determines the bright picture surface, as in the work of the Japanese *ukiyo-e* masters.

All movement runs parallel to the picture plane within the borders of the narrow strip, or else the interruptions of the lines are intended as breaks in the landscape. Architecture, roads, geological strata of land, rivers or lakes can all be successfully depicted with this diagonal technique, as long as the rhythm of the running line is maintained. Swift movement and spatial depth, in the form of surface parallels and the diagonal motif, are combined and do not clash. This makes the *emaki* a totally comprehensible art form.

Diagonal compositions bring out what is interesting and important in the subject matter. Spectacular storms and unusual natural phenomena appear in late *ukiyo-e* works as sharp diagonal 'surface patterning'. Hiroshige renders the teeming rain with long, deft strokes that look almost as if they could have been etched. In the same way people under their umbrellas hurry off in a diagonal

580 Unknown master of
the Miyagawa school
*Different kinds of
entertainment*
18th century
Two-panel screen
Ink and colour on paper
143 × 143 (56¼ × 56¼)
Tokyo, Idemitsu Museum

581 Utagawa Hirokage
Gion festivities
1859
From *Amusing Views of
Famous Places in Edo (Edo
meisho dōke zukushi)*
Colour woodcut
37.1 × 24.8 (14⅝ × 9¾)
Regensburg, Private
Collection

direction (573). Both action and atmospheric evocation are conjured up by this one compositional device.

An artist who copied Hiroshige's compositional ground layout in many of his own works was Emile Bernard (586). He possibly went even further in terms of technical structure.

The arrow-like diagonal 'depth-line' makes for severe reductions in size. Eugen Kirchner (575) works on the same principle in his aquatint *November*, using the compositional methods developed by the Japanese to convey the blusteriness of the weather. The diagonal perspective, seen from above, is extremely pronounced. The silhouette-like figures give the sense of distance by their relative sizes; the way they are inserted into the scene follows the same all-determining constructional line.

Both Van Gogh and Vuillard also used the downward, slanting viewpoint. In Vuillard's lithographs, however, we find more positive forms, created by the integration of surface forms with diagonal movement of depth. In Van Gogh's *Les Alyscamps* (583) a peculiar painterly 'dimension' is evoked through the vertical dividing up of space and the intrinsic values of the arresting colours. Starting from close to the painter, the picture leads directly away by means of cut-off tree trunks. The picture as it were advances as a function of visual stops along a perspective way that is clearly related to Japanese models (584). By contrast, in Vuillard's diagonal compositions line is always predominant, serving as a kind of framework for his matt-coloured silhouette figures.

The influence of the diagonal principle in Europe was rich and varied: the Neo-Impressionists, too, adopted it as an essential compositional device. Signac, Seurat, Cross and Rysselberghe all made use of diagonals in the sense of arrow-head directional lines or staggered rows of figures. The same Japanese compositional methods obtained even in Expressionist graphic art. As in *emaki* art, the 'architectural' build-up of the individual diagonal compositions is carefully managed through vital structural stages, which go to produce superbly sustained effects of step-like gradation.

Developing from this, the street scenes of the late *ukiyo-e* masters in particular (580) would exploit as it were one rectangular side of the space created in the picture (576), leaving the right- or left-hand area of the picture surface completely free. Through this system, the viewer is in a sense precipitated, via the various visual stopping-points and numerous verticals (which stand in direct relation to the distance depicted, according to the basic principle of the diagonal), into the furthest depth. Such works are consummate illustrations of the directional force of the diagonal system.

582

583

585

584

586

587

582 Edouard Manet
The Rue Mosnier with flags out
1878
Oil on canvas
65×81 ($25\frac{5}{8} \times 31\frac{7}{8}$)
Private Collection

583 Vincent van Gogh
Les Alyscamps
1888
Oil on canvas
71×91 ($28 \times 35\frac{7}{8}$)
Otterlo, Rijksmuseum
Kröller-Müller

584 T. Ekotoba
Ban Dainagon
12th-century scroll painting
H. 31.5 ($12\frac{3}{8}$)
Colours on paper
Tokyo, Collection Sakai

585 Pierre Bonnard
Street corner
1895
Lithograph
27.2×35.3 ($10\frac{3}{4} \times 13\frac{7}{8}$)
Bremen, Kunsthalle

586 Emile Bernard
The bank of the Seine at Asnières
1887
Oil on canvas
39×59 ($15\frac{3}{8} \times 23\frac{1}{4}$)
1887
Lausanne, Collection
M. Samuel Josefswitz

587 After Andō Hiroshige
View of the Tōkaido highway
Tokyo 1869
From a painters' manual
Woodcut
22.8×14.5 ($9 \times 5\frac{3}{4}$)
Private Collection

588 Andō Hiroshige
*View of Sekiya village from
Masaki*
1856–58
From *100 Views of Famous
Places in Edo (Meisho Edo
hyakkei)*
Colour woodcut
33.3 × 22.2 (13⅛ × 8¾)
Vienna, Österreichisches
Museum für angewandte
Kunst, Exner Bequest

589 Théodore Deck
Decorative plate
Paris *c.* 1875–80
Painted porcelain
D.29.8 (11¾)
'Picture within a picture':
tondo and *kakemono* within
a circle
Cologne, Kunstgewerbe-
museum

590 Paul Gauguin
*La Belle Angèle (portrait of
Mme Satre)*
1889
Oil on canvas
92 × 72 (36¼ × 28⅜)
Paris, Jeu de Paume

Composite formats

The *ukiyo-e* masters developed a way of grouping different formats which they referred to as 'the contest of framed pictures' (*kibori gakuawase sanzu*). This phrase (which appears on a *surimono* by Ryūryūkyō Shinsai, *Picture of the Kugutsume Kaneko*),[1] is used of a compositional style in which the most disparate pictorial forms – circle, oval, fan-shape, double circle, gourd-shape, and the more usual rectangle and square – are used in conjunction, one format within another. The style was more subtle than this, however: the secondary formats contained within the principal pictorial structure could also be cut-off, overlapped, or arranged in distinctive progression as desired.[2]

Japanese painters saw in their immediate sur-roundings related pictorial themes which inspired them to elaborate this unusual compositional technique. The circular window, a common feature in Japanese houses (1032) which also recurs sometimes as a wall recess (*tokonoma*), afforded a direct 'detail' view outdoors.[3] Seen together with interior objects such as *kakemono*, pillar pictures, *ikebana* vases etc., these could create combinations of shapes that lent themselves to pictorial depiction. Hiroshige's colour woodcut *View of Sekiya village from Masaki* (588) is an example of this circular-window view. On the right a sliding wall is clearly depicted, and our eye is taken past branches with blossom in the foreground, away into the distance of the

landscape. There are numerous Japanese painters' manuals which deal with the theme of the 'picture within a picture' or the 'contest of pictures', as it was a much loved theme for lacquer box decoration. Connoisseurs and art lovers developed particular affection for the genre because of its potential for somewhat bizarre effects.

Gauguin and his friends at Pont-Aven also found it stimulating and worthy of imitation (593). He had evidently seen and been inspired by Hokusai's *Hannya laughing* or Kuniyoshi's *Hero Tametomo*. The cut-off 'telescope' view conveys the glimpse of the witch in the visual field that has been half covered over. In *La Belle Angèle* Gauguin uses the technique to combine true-to-life portrait painting with a rather enigmatic picture in the background (590). Mixing formats became popular in Europe, and for the most part compositional forms originating from the Far East were used.

In his instructions on panel painting, which aimed at detailing how Japanese lacquerwork could be copied, Franz Lanek in 1903 brought out a series of almost 400 bound volumes of prints, which went through many editions. Each one measured 25 × 53.5 cm. (10 × 21 in.) and consisted of so-called artists' sketches. Here we see absolutely plainly the relationship to the Japanese woodcut. Examples of techniques for combining colours within a compositional field were given, and these became very widely adopted in their Europeanized versions. The decorative plates produced by the Paris manufacturer Th. Deck (589) and by the English firm Brown-Westhead, Moore & Co. of Hanley, Staffordshire (591) are just two examples among many which either faithfully reproduce purely Japanese-style herons and plants or give a European harvest-time landscape set against 'Japanese' flowers.

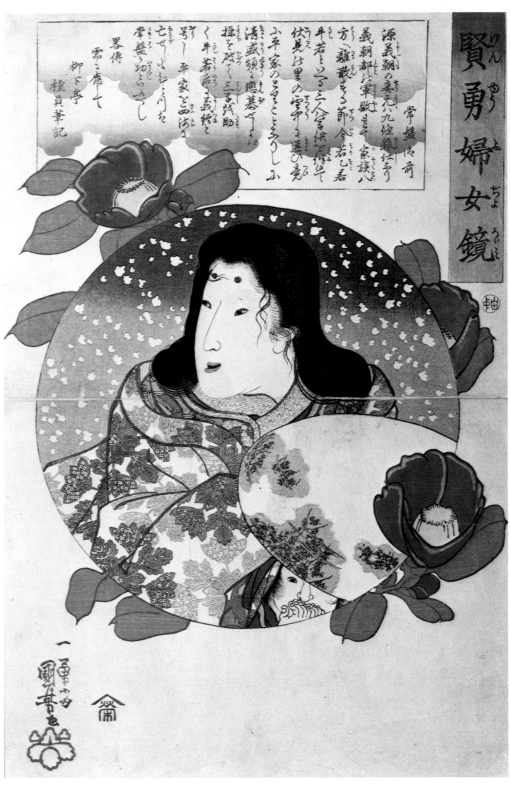

591 Brown-Westhead, Moore & Co.
Plate
c. 1880
Painted porcelain with gold and silver design
D.22.7 (8⅞)
Hamburg, Museum für Kunst und Gewerbe

592 Utagawa Kuniyoshi
Tokiwa-Gozen
c. 1843
From *Mirror of Clever and Brave Women (Kenyū fujo kagami)*
Colour woodcut
37 × 24 (14⅝ × 9½)
Private Collection

593 Paul Gauguin
Leda (sketch for a plate)
1889
Zincograph
D.20.5 (8⅛)
Berlin, Staatliche Museen
Preussischer Kulturbesitz,
Kupferstichkabinett

594 Edouard Vuillard
The négligé
c. 1891/2
Oil on cardboard
25 × 35 (9⅞ × 13¾) (oval)
Paris, Private Collection

The circular portrait format within a rectangle was a noble genre used in Japan for illustrating tales of heroism (592, 595). The usual combinations were an oval or circle inside a rectangular or square surface, rather like a *mon* emblem, containing a portrait, a landscape or a figure. Many painters made use of this highly distinctive format grouping, including Shumman, Hokusai, Kuniyoshi, and above all Yashima Gakutei. Most commonly portraits formed the subject matter. These would be accompanied by a brief written text. On the whole the people portrayed were successful actors or actresses. Europe took up this format: Vuillard, for instance, chose a slightly flattened circle as a pleasing, almost mobile picture surface, in which to place a seated woman (598). He treats it experimentally, introducing deliberate verticals to counteract the 'squashed' effect of the flattening of the circle (598).

The circular format inside a rectangle also had a functional use in that it would arrest and lead the eye forward, as if through a window. The second-generation Impressionists were especially fond of this glimpse effect, and in this departed from their great mentors. In his sketch for a plate (593) Gauguin chooses odd scraps of subject matter – a laurel branch and a snake, chicks

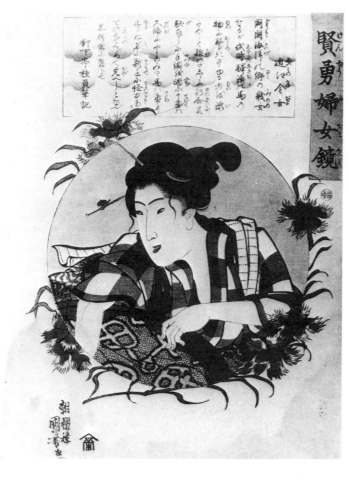

595 Utagawa Kuniyoshi
Kane from Ōmi
From *Mirror of Clever and
Brave Women (Kenyu fujo
kagami)*
c. 1843
Colour woodcut
37 × 24 (14⅝ × 9½)
Düsseldorf, Collection
Willibald Netto

596 Katsushika Hokusai
*The ghost who eats up
children*
1830
From *100 Stories (Hyaku
monogatari)*
Colour woodcut
24.7 × 18.6 (9¾ × 7⅜)
London, Victoria & Albert
Museum

597 Egon Schiele
Chrysanthemums
Oil on canvas
60.5 × 93 (23⅞ × 36⅝)
Vienna, Private Collection

598 Edouard Vuillard
The embroideress
Oil on cardboard
10.5 × 9.2 (4⅛ × 3⅝)
Private Collection

running around (symbols of fertility), flowers, and
finally the cut-off swan with the profile of Leda behind it.
Such collections of isolated motifs within a circular
compositional field have a long tradition in Japan,
notably in the *mon* genre.

Vuillard, one of the leading lights of the Nabis, goes
his own way in his picture *The négligé* (594). Not only
does he compress the figure within the overturned oval
like a wound-up spring, but he gives the bedstead and
chair such clear-cut treatment, as if seen through the eye
of a telescope, that they seem to assert themselves even
on the space outside the picture. The closeness of the
painter to his subject, conveyed by the immediacy of the
picture plane, reflects the approach of the Japanese
ukiyo-e artists. Hokusai, who for the Symbolists and
Nabis was an outstanding, intensely original master of
composition, produced a series of *A Hundred Stories*
(*Hyaku monogatari*) (596), in which he uses an
extremely bold layout with rectangles bitten out by
quarter- or semi-circles in a highly individual way. *The
ghost who eats up little children* could pop up anywhere
– and does, in the most extreme of picture formats.

Art Nouveau artists showed a liking for circular
pictures within a long horizontal format. Walter
Leistikow, Richard Grimm, Ernst H. Walther, and T. T.
Heine often employed this combination in their
illustrative work. In Leistikow's vignette *The Müggelsee
near Berlin* (1031) the broad-angle view and the circular
telescopic close-up are bound into a single pictorial
plane.

Because it was so generally popular, this com-
positional form also recurred several times in the
magazine *Die Gartenlaube*. The wide circulation of this
magazine sent out ripples which, ironically enough, even
made themselves felt in the painters' manuals in Japan.
Themes from *Gartenlaube* were translated back into the
Japanese idiom – as the Prussian eagle apparently
glaring at a bee in one instance illustrates. The combined
format technique was taken up by the printers of
ephemera, and picture postcards even today sometimes
testify to this inclusion of other forms within a rectangle.

Trellis and grille

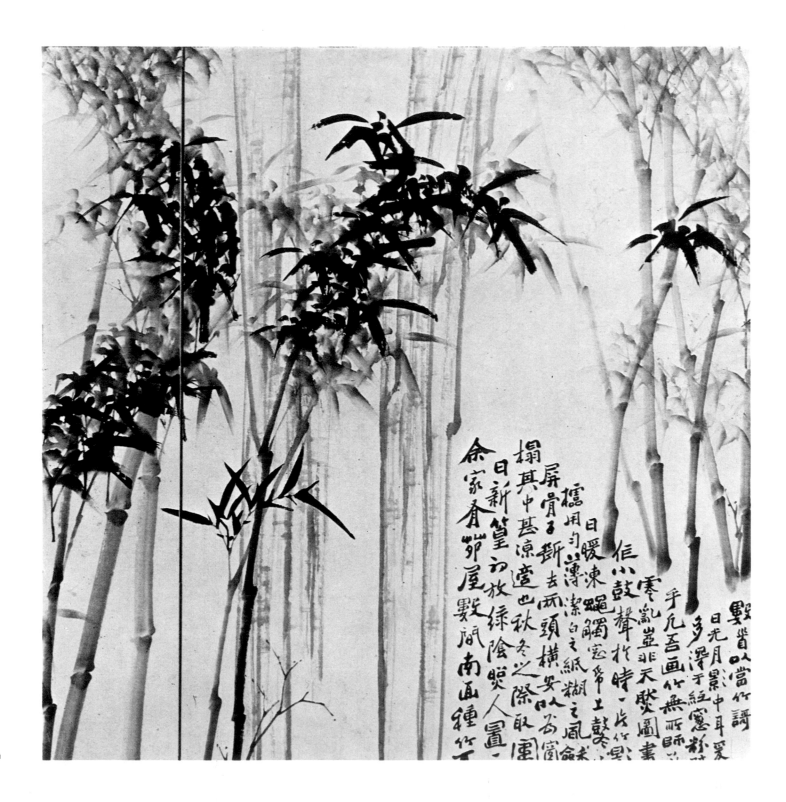

599 Tien-Shēng
Bamboo
Ch'ing dynasty
Ink and colour
Detail from a four-panel
screen
Tokyo, National Museum

600

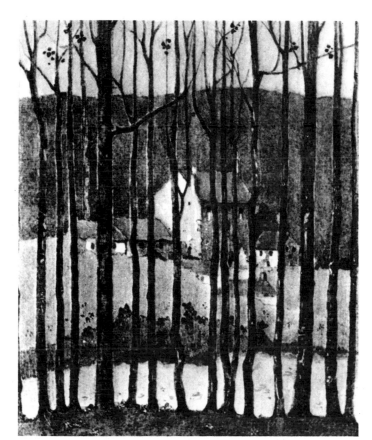

601

602

603

604

605

600 Edouard Vuillard
*Theatre programme for
Björnstierne-Björnson, 'Au
delà des Forces'*
1897
Lithograph
21.3 × 31.6 ($8\frac{3}{8} × 12\frac{1}{2}$)
Zürich, Private Collection

601 E. H. Taylor
The edge of the wood
Repr. *The Studio*, Vol. 56,
245, 1912
Private Collection

602 Tsuda Seifū
From *Small collection of
paintings*
Kyōoto 1904
Colour woodcut
24 × 36 ($9\frac{1}{2} × 14\frac{1}{8}$)
Private Collection

603 Tsuda Seifu
Small collection of paintings
1904
Colour woodcuts on hand-
made india paper
24 × 36 ($9\frac{1}{2} × 14\frac{1}{8}$)
Private Collection

604 Carl Thiemann
Grunewaldsee II (detail)
1909
Colour woodcut
29 × 38.5 ($11\frac{3}{8} × 15\frac{1}{8}$)
Private Collection

605 Willy von Beckerath
*Trees forming a railing:
landscape near
Frankenhausen*
1910
Pencil on Bristol-board
49.5 × 44.3 ($19\frac{1}{2} × 17\frac{1}{2}$)
Private Collection

606 Andō Hiroshige
*Ushiwakamaru learns how
to fence*
c. 1834–35
From *Biographical Story of
Yoshitsune (Yoshitsune
ichidai zue)*
Colour woodcut
33.6 × 22.5 (13¼ × 8⅞)
Private Collection

607 Félix Vallotton
Clump of trees (detail)
1922
Oil on canvas
170 × 73 (66⅞ × 28¾)
Lausanne, Galerie Vallotton

608 William H. Bradley
Book cover (detail)
1894
Design for a book binding in
linen
23.6 × 17.3 (9¼ × 6¾)
Private Collection

609 Willy von Becherath
Trees in Holstein
1918
Black ink and chalk
49 × 68 (19¼ × 26¼)
Private Collection

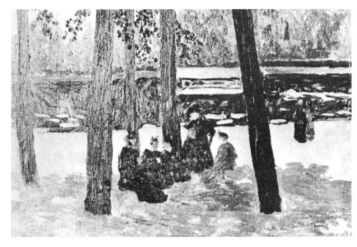

610 Pierre Bonnard
Boulevard
1895
Colour lithograph
17 × 43 (6¾ × 16⅞)
Private Collection

611 Maurice Denis
The beeches at Kerduel
(detail)
1893
Oil on canvas
45 × 42 (17¾ × 16½)
Saint-Germain-en-Laye
Private Collection

612 Edouard Vuillard
*Women sitting together in
the shade* (detail)
c. 1894
Oil on canvas
31 × 40 (12¼ × 15¾)
Paris, Private Collection

The outside walls of Japanese houses are sometimes equipped with sliding grille walls known as *shoji* (981, 990). The rooms inside are defined by similar, lighter walls (*fusuma*). The grille structure consists of closely joined, flattened strips. These strips are so arranged as to produce a sort of trellis with rectangular individual sections (1029).

Every metre (3 ft) or so there are stronger vertical strips, thicker in diameter than the inner ones. These serve as a framework. Covered with paper, the screen appears through a light, bright wall surface (984, 1023, 1040). The pattern is clearly visible during the day (990), and also at night with lights on inside (690). The paper covering the walls is light and plain, though sometimes it is decorated with gold-dust clouds, between which appear simple spatter patterns. A kind of frieze extends over the walls between the *kamoi* (beams set into the upper runner track of the sliding walls) and the boarded

613 Claude Monet
The four poplars
1891
Oil on canvas
82 × 81.5 (32¼ × 32⅛)
New York, Metropolitan
Museum of Art, Havemeyer
Collection

614 Gaston de Latenay
Nausicaa
c. 1893
Lithograph, painted in
watercolour
37.5 × 27.5 (14¾ × 10⅞)
Private Collection

ceiling of the room. This frieze can also feature grille-like patterns.

Mention should also be made of the diagonal screen pattern for fences and walls in gardens, which often recurs as a decorative motif in wooden walls (1026).

Japanese tea houses have sliding walls similar to the type just described. The same feature is also found in temple buildings and Buddhist monasteries. Sliding walls form a sort of pattern background to daily life as represented in the Japanese woodcut, and they figure in stage designs whenever an interior or a house has to be suggested in the theatre (690).

One highly ornate form of board-like grille is the *ramma* – a frieze situated below the roof, designed to allow free circulation of air. Much has been written about the *ramma*. It has always been a popular collectors' item. All kinds of subjects can be portrayed through the carving and fretting of its apertures. Waves

615 Gustav Klimt
The beech wood
c. 1902
Oil on canvas
100 × 100 (39⅜ × 39⅜)
Dresden, Moderne Galerie

616 Katsushika Hokusai
*Mount Fuji in a bamboo
grove*
1834–35
From *100 Views of Mount
Fuji (Fugaku hyakkei)*
Colour woodcut
Book size 26.2 × 22.5
(10¼ × 8)

and birds, pines and cranes, anchors between vertical beams, compositions of flowers and leaves, and much else besides, make the *ramma* an ever-varied, creative compositional form. The motifs developed therein also had an influence on the applied arts in Japan, providing inspiration for dyers' stencils (*katagami*), lacquerwork and textiles.

The grille structures of sliding walls and fences, reproduced in woodcuts (619, 627), were seen by European artists as beautifully effective, veil-like spatial blocking devices. Utamaro (617) uses them to create different pictorial planes, either more or less cluttered, according to the conventions of the woodcut genre.

European painters, including, for instance, Manet, made use of this grille motif as a device for structuring their picture composition (618). Gauguin and Vuillard (620, 621) also employed the same method.

Yet the grille motif appeared in forms other than the

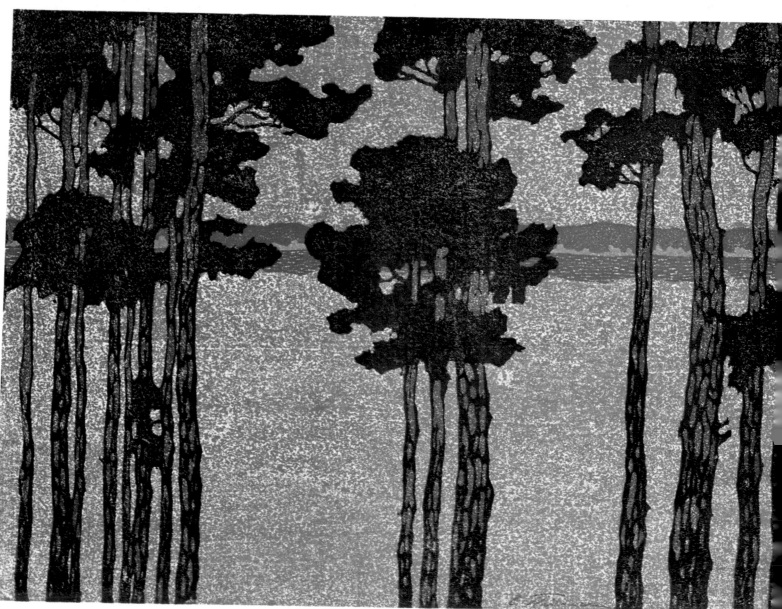

634　Emil Orlik
Returning home
1906
Woodcut, part coloured
46.2 × 46 (18¼ × 18⅛)
Regensburg, Ostdeutsche
Galerie

635　Japan
Majestic hinoki forest
(type of cypress)
Photograph
24 × 18 (9½ × 7⅛)
Private Collection

636　Carl Thiemann
Grunewaldsee II
1909
Colour woodcut
29 × 38.5 (11⅜ × 15⅛)
Private Collection

623　Japan
Dyer's stencil
two anchors
Meiji period
Vienna, Öste
Museum für
Kunst

624　Emil N
Dancing figu
grille
1924
Woodcut in t
Japanese dye
9 × 17 (3½ × 6
Private Colle

625　René L
Dog collar
c. 1900
Gold, ename
swallows am
Hamburg, M
Kunst und G

had been developed as a spatial illusion through central and colour perspective, had now to be seen in terms of almost tangible proximity.

Gaston de Latenay's *Nausicaa* illustration (614) is conceived with Japanese woodcut principles in mind, as is evident from the way the clouds 'cling' to the grille of trees. The dotted ground behind the trees is reminiscent of Hokusai. In his view of *Mount Fuji in a bamboo grove* (616) Hokusai brings planes and distance together into a unified whole. Already in the eighteenth century the Chinese painter Tien-Shēng suggests space and landscape vistas through a grille pattern of bamboo (599) on a screen. This visual approach and the techniques by which it was realized are formalized, but they remain accessible to comprehension. The pictorial field is always sharply delimited, and there is always some kind of grille motif which initiates a general reduction of dimensions of objects. The tense relationship of the slender stems to the borders of Tien-Shēng's picture makes this clear. In Impressionism nature was a sensation of colour tones: now, through the Japanese influence, it became an ornamentalized prospect seen through a grille.

637 Katsushika Hokusai
Mount Fuji in a bamboo grove
1834–35
From *100 Views of Mount Fuji (Fugaku hyakkei)*
Colour woodcut
26.2 × 22.5 (10¼ × 8)

638 Japan
Bamboo forest
Photograph
24 × 18 (9½ × 7⅛)
Private Collection

639 Alfred Mohrbutter
Chestnut trees beside a lake
c. 1900
Wall tapestry (Weaving School in Scherrebek)
200 × 115 (78¾ × 45¼)
Schleswig, Landesmuseum

640 Suzuki Harunobu
The seven beauties of the bamboo grove (detail)
Colour woodcut
26 × 39 (10¼ × 15⅜)
Tokyo, National Museum

641 Maurice Denis
The dance of Alcestis
1905
Oil on canvas
80 × 108 (31½ × 42½)
Munich, Private Collection

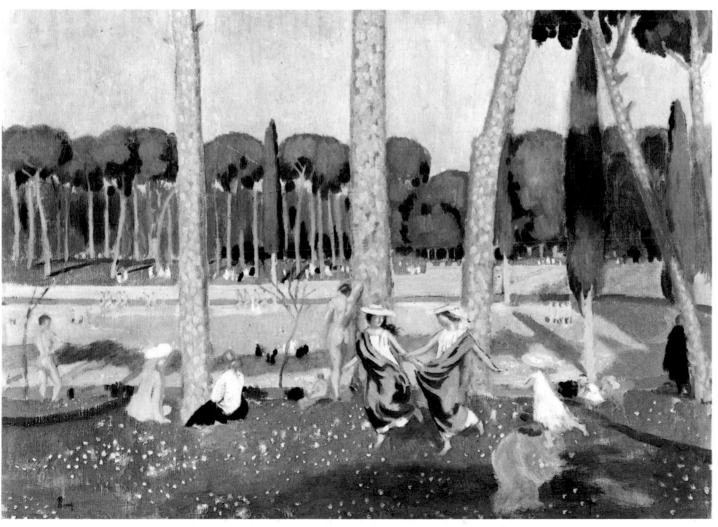

642 Henri Rivière
Ships at sunset
c. 1897
Colour woodcut
28 × 36.5 (11 × 14⅜)
London, Private Collection

643 Edouard Manet
Ships at sunset
1869
Watercolour on paper
42 × 94 (16½ × 37)
Private Collection

Truncated objects and oblique angles

Japanese painters did not hesitate to allow a human hand or the lower part of a leg to protrude on its own into the picture (659). Ship's hulls, or truncated sails (642–45) are more extreme examples of this cut-off technique than sprays of blossom, which, though pictorial excerpts, still form a whole.[1] Such an excerpt, itself portrayed in detail, was supposed to stimulate the eye to leap directly into the distance – which is then depicted in layers, one behind the other. It was not only in the late woodcut that it was usual to cut off the object at the edge of the picture. In the horizontal picture scrolls of the twelfth and thirteenth centuries events are depicted as though seen through a chink (584). The action of the picture is seen from high above, evidence that this form of composition had a long tradition (663). This was the aim of these pictorial devices, which were taken up very soon by Edouard Manet and others. As early as 1869 Manet chooses an extreme type of excerpt composition with a cut-off sail in *Ships at sunset* (643).

644 Andō Hiroshige
Mount Inasa at Nagasaki in Hizen Province
1853–56
From *Famous Places from more than 60 Provinces (Rokujūyoshū meisho zue)*
Colour woodcut
33.2 × 22.5 (13⅛ × 8⅞)
Vienna, Österreichisches Museum für angewandte Kunst, Exner Bequest

645 Andō Hiroshige
Saijō in Iyo Province
1853–56
From *Famous Places from more than 60 Provinces (Rokujūyoshū meisho zue)*
Colour woodcut
33.5 × 22.4 (13½ × 8¾)
Vienna, Österreichisches Museum für angewandte Kunst, Exner Bequest

Manet has obviously been influenced here by a Hiroshige woodcut (644, 645).[2]

Henri Rivière, too, favours this theme in his painting of 1897 (642), proof of the long-lasting and penetrating influence of Japanese models. With his woodcut *Mount Inasa at Nagasaki in Hizen Province* (644) Hiroshige provided the decisive example of a truncated object which, in the shape of an only half-visible striped sail, introduces the exaggerated leaping viewpoint – the eye jumping from one thing to another, from one plane to another. To Western critics, this new way of looking at the world was completely unconventional, and a 'dangerous dismantling of nature' was spoken of.[3]

The cut-off boat then became a frequently-repeated pictorial theme between 1870 and 1910. Rivière, Seurat and the Art Nouveau illustrators used this new point of view. In *The harbour at Honfleur, c.* 1886 (650), Seurat only includes a narrow strip of a ship's prow with rigging. Numerous examples of this theme exist in the work of artists such as Suzuki Harunobu, Torii Kiyonaga and Taiso Yoshitoshi.[4]

The European painters had learned from the Japanese *ukiyo-e* masters that the truncated object could often be more important than one whose form was completely visible. The mast of a ship, a person's arm or the prow of

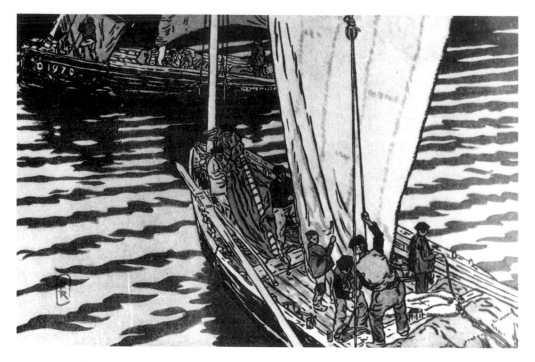

a boat were ordinary and familiar objects which were presented to the observer in order to suggest to him the immediacy and transience of the event portrayed.[5]

The painter and woodcut artist Carl Thiemann takes up the theme of the cut-off boat (649), seen from below, one example of the varied ways in which Japanese compositional elements can be interpreted.[6]

To what extent this method of truncating objects then passed into the field of book illustration can be seen, for example, in C. O. Czeschka's illustration to *The Nibelungs* of 1908 (664). Walter Leistikow's vignette for the periodical *Pan* (665) also relates to Japanese models. With the extreme truncation of objects, asymmetrical compositional elements also gain in importance.[7]

The vista presented to the eye is often glimpsed accidentally and in extreme close-up. The painter experiences the object only in part but, because of this, he does so more directly. Certain illusions of suddenly stepping into the picture, of leaning forward into it, of flying past it, are made convincingly manifest (642–63).

The Chinese painters' manuals, of which *The Mustardseed Garden* is the most important, are concerned to capture in a condensed and vivid manner, the accidental nature of the object, to create an abiding moment, and to cause the observer to complete the object in his imagination. The object is, however, always a familiar one to the Far Eastern observer, and its iconographical significance is determined by the form and content of the painting. The symbolic meaning of the flower, the animal, the cloud or the wave, just to name a few examples, is laid down, codified as it were, so that the completion of the object is a matter for the experience and the collective consciousness of the observer.

The splitting of an object is no rarity in Far Eastern painting.[8] Flying cranes, swimming carp or other creatures, implements of all kinds, and even the human figure, can appear, by means of a sharp caesura, with one part on one, one part on another page of a book or section of a screen (330, 404). This system of division can also be observed in the narrow strip or pillar picture (*hashira-kake*). Here the overlapping is executed in a particularly exaggerated manner. The head of a girl or a very small part of a figure can dominate the picture (452), by far the greatest part lying outside the frame. Such truncation, which appears capricious to the European,[9] occurs over and over again in the pillar picture.

A great number of *ukiyo-e* masters used this compositional form which seems so radical in the West, above all Torii Kiyomitsu, Isoda Koryūsai, Torii Kiyonaga, Kitagawa Utamaro and Hosoda Eishi. But in other picture formats, in the *kakemono-e*, in the large *ōban*, in the *aiban*, *chūban*, *hoso-e*, in the large and small *tanzaku*, in the *koban*, the wide *surimono*, in the *yoko-e* and of course in the *tate-e* (the set pictorial formats), overlapping is clearly visible.

The Japanese colour woodcuts come alive because of the exaggerated cut-off technique used. In their asymmetrical overlapping of frame and subject matter they provide a stereotyped abbreviation of the objects depicted, and the dynamism of the cut-off often corresponds to that of the event or process portrayed.

In Europe, after the Japanese woodcut became known, there is scarcely an artist of the nineteenth and twentieth centuries who did not take up this compositional principle. It would be possible to write a history of nineteenth- and twentieth-century art from the point of view of the exaggerated depiction of distance and the extremely truncated asymmetrical figure alone.[10] The French Impressionists and even the Expressionists tended towards the exaggerated cut-off, which they varied in a richly individual way. The fact that they dared to leave out half the body or even face in a portrait

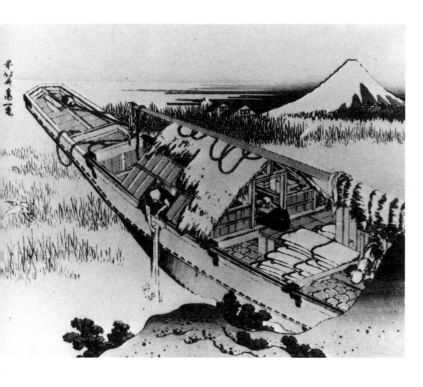

648 Katsushika Hokusai
View from Ushibori in Hitachi Province
1830
From *36 Views of Mount Fuji (Fugaku sanjūrokkei)*
Colour woodcut
25.9 × 38.8 (10½ × 15⅓)
Private Collection

649 Carl Thiemann
In Frankfurt Harbour
1906
Colour woodcut
24 × 24 (9½ × 9½)
Private Collection

650 Georges Seurat
The harbour at Honfleur
c. 1886
Oil on canvas
79.5 × 63 (31¼ × 24¾)
Otterlo, Rijksmuseum
Kröller-Müller

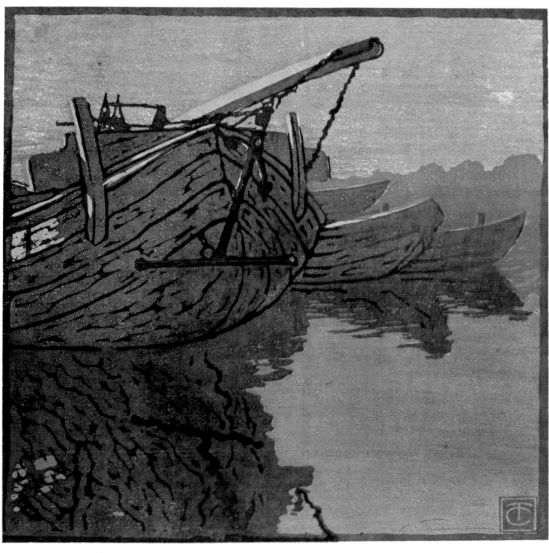

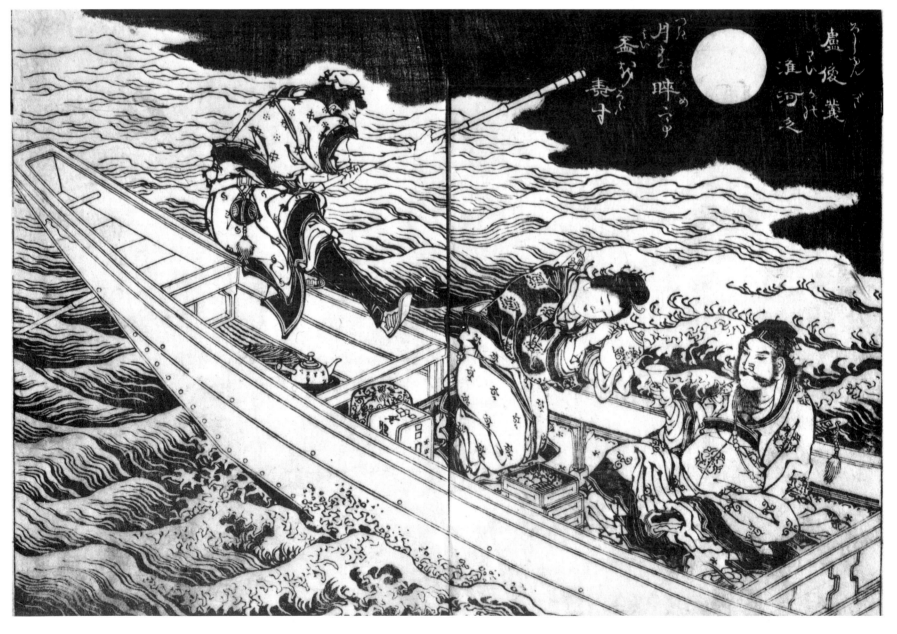

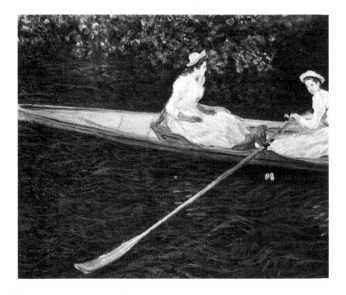

(440, 441) or let it be cut off by the lower edge of the picture, was not in accord with the conventional climate of the European monarchies of the nineteenth century.[11] The fashionable painters of all movements who based themselves on a Renaissance ideal placed their portraits and figures in the exact centre of the picture which was, as it were, identical with the central social hierarchy for which they were painting and which determined this concept.[12] Thomas Couture, Charles Gleyre, Alexandre Cabanel, Jean-Léon Gérôme, Jean-Jacques Henner, Adolphe William Bouguereau: these were the celebrated painters of the French Second Empire and Third Republic who looked with contempt on the new cut-off compositions of the Impressionists. The most eminent German painter, Franz von Lenbach, who had a decisive influence on the society portrait in late nineteenth-century Germany, notes in 1885: 'The Impressionists – these choppers-off of necks and heads – despise the closed form of the human body which has been taught to us by the Old Masters.'[13] The historical viewpoint of the last quarter of the nineteenth century was, however, to be altered by new principles of composition. The Japanese colour woodcut contributed decisively to this.

Manet and Monet repeatedly painted cut-off rowing-boats (652, 655, 657) which were inspired exclusively by Japanese models. These compositions were undertaken with great sympathy and exact observation. They are always seen from the point of view of someone gliding past, which for the French Impressionists of the first and second generation was important, for with it could be combined the swift changes of natural light.[14]

Toulouse-Lautrec exaggerates these truncated figures until they become almost absurd. In the poster *Jane Avril* of 1893 (660), the painter takes a Hokusai print as his model.[15] In the immediate foreground, very near the eye, a hand holds the neck of a double-bass on a plane parallel to the foreground. It juts out as it were from nowhere, indicating the active surroundings of the poster, just as the spar does in Hiroshige's woodcut *The Benten Shrine seen from Haneda Ferry* (659).

659 Andō Hiroshige
The Benten Shrine seen from Haneda Ferry
1856–58
From *100 Views of Famous Places in Edo (Meisho Edo hyakkei)*
Colour woodcut
35.3 × 24 (13⅞ × 9½)
Cologne, Museum für Ostasiatische Kunst

660 Henri de Toulouse-Lautrec
Jane Avril
c. 1893
Poster, lithograph
78.5 × 60 (30⅞ × 23⅝)
Paris, Bibliothèque Nationale, Cabinet des Estampes

The figure of Jane Avril dancing the can-can on a diagonally cut-off stage is part of an asymmetrical composition that leads to an unstable equilibrium, which in turn is necessary to set off the massive and rigid framing effect of the foreground cut-off elements. The latter, however, govern the direction and form of the imagined continuation of the scene beyond the frame.

The Japanese colour woodcut changed European principles of composition directly with this system. It created new methods of depicting distance, new sight-lines and a new illusionistic portrayal of the momentary and the direct. Here too it stimulated a trend which culminated in modernism.

A similarly positioned cut-off is provided by Hiroshige in his woodcut *Cartwheel on the sea-shore* (661). In the years 1877 to 1880 this woodcut caused great interest among Parisian painters and was probably on show in Paris at the international exhibition of 1878.[16] Degas was influenced by this composition in his *Race course* (662). Here the situation is captured as though in passing and the figure of the man with the top-hat is so cut off by the right-hand edge of the picture that only a third of him is visible.[17] Almost universal is the truncated head which is developed by the Europeans almost to the point of deformity.[18] The group of shoulder-length figures, positioned side by side and one behind the other, was a compositional form taken up by Maurice Denis from the Japanese colour woodcut. The translucent colouring of his lithographs, which he combines with compositions influenced by Far Eastern models, was the ideal of the Pont-Aven School, a school which retained its influence for over a quarter of a century. As with many other artists, the stimulus for Maurice Denis's lithographs came from Kitagawa Utamaro.

Soon the truncated portrait was to be carried even further. Paul Gauguin's *Portrait of Meyer de Haan* goes to the extreme. In an almost violent manner he places the head of his subject in the upper left-hand corner behind a table-top running diagonally to the right. Though looking down onto the table-cloth, one sees the face irrationally from below. The language of the picture, which avoids any realistic concept of space, disturbs the point of view of the observer so much that the truncated object becomes deformed. Although Pierre Bonnard gives us a greater depiction of depth in his picture *Meal under the lamp* – so that the lamp gets into the picture as a vivid still-life in itself – the main figure is cut off so that the portraits of dog and man form a macabre unity. This deformed character is accentuated by the disturbed proportions elsewhere in the picture, and by the colour harmony.

661 Andō Hiroshige
Cartwheel on the sea-shore
c. 1857
From *100 Views of Famous
Places in Edo (Meisho Edo
hyakkei)*
Colour woodcut
35.3 × 24 ($13\frac{7}{8} \times 9\frac{1}{2}$)
Cologne, Museum für
Ostasiatische Kunst

662 Edgar Degas
The race course
c. 1877–80
Oil on canvas
66 × 81 ($26 \times 31\frac{7}{8}$)
Paris, Louvre

663 Japan
Diary of Lady Murasaki (detail)
Picture scroll
Kamakura Period
Colours on paper
H.21 ($8\frac{1}{4}$)
Osaka, Fujita Art Museum

668　Japan
Man resting at a tree
From a painters' manual
Tokyo 1858
Woodcut
23 × 14.6 (9 × 5¾)
Private Collection

669　Vincent van Gogh
The sower
1888
Oil on canvas
73 × 92 (28¾ × 36¼)
Zürich, Collection Emil
Bührle

670　Utagawa Kuniyoshi
Pilgrims with their shrine
c. 1835
From 53 *Stations and 4 Post-*
towns of the East Sea Road
(*Tokaido gojusan eki*
shishuku meisho)
Colour woodcut
22.8 × 35.2 (9 × 13⅞)
Private Collection

671　Edgar Degas
The song of the dog
c. 1876
Lithograph, only state
35.2 × 23.1 (13⅞ × 9¼)
Boston, Museum of Fine
Arts

672　Kitagawa Utamaro
On a terrace (copy, detail)
22.3 × 24.8 (8¾ × 9¾)
Repr. *Le Japon artistique*,
8, December 1888

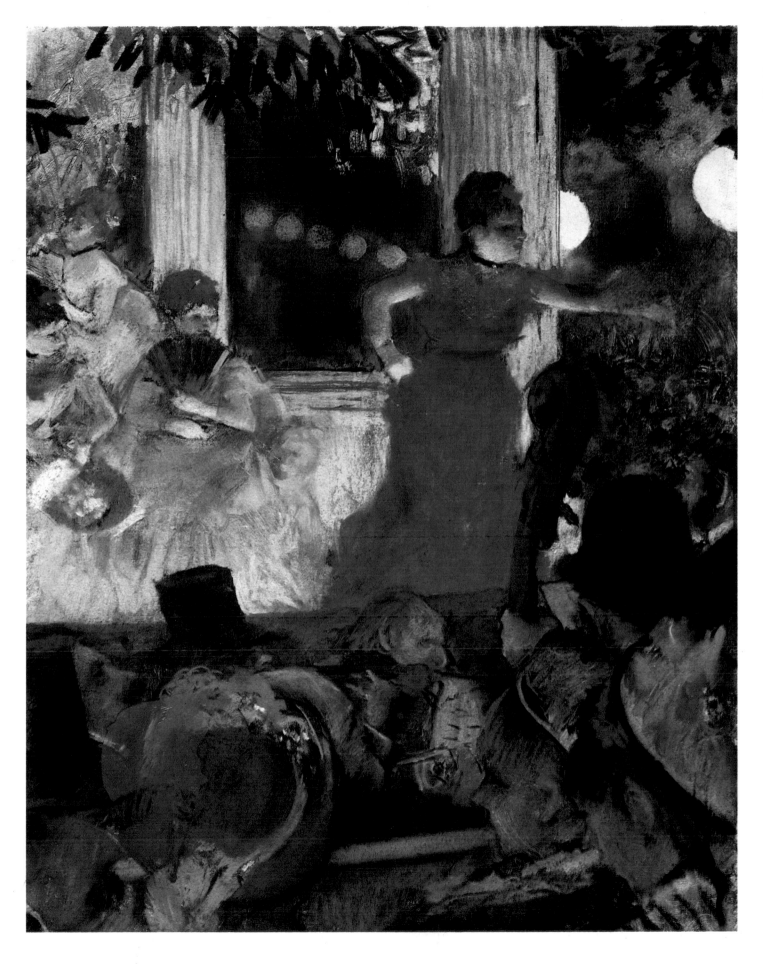

673 Edgar Degas
The café-concert, Les Ambassadeurs
1876–77
Pastel on monotype
37 × 27 (14½ × 10⅞)
Lyons, Musée des Beaux-Arts

679

679 Andō Hiroshige
The Izumo Shrine in the mist
1853–56
From *Famous Places from
more than 60 Provinces
(Rokujūyoshū meisho zue)*
Colour woodcut
34 × 23 (13⅜ × 9⅛)
Switzerland
Private Collection

680 Claude Monet
Waterlilies (detail)
1920–26
Oil on canvas
1.97 × 12.74 m (77½ × 497⅛)
Paris, Orangerie

681 Vojtech Preissig
Trees by stream (detail)
1905
Aquatint
36 × 27 (14⅛ × 10⅝)
Prague
Private Collection

682 Andō Hiroshige
*View of Mount Fuji with
river and bridge*
1856–58
From *100 Views of Famous
Places in Edo (Meisho Edo
hyakkei)*
Colour woodcut
36.4 × 21.2 (14¼ × 8¾)
Private Collection

680

681

682

683

683 Katsushika Hokusai
*A View of Mishima Pass in
Kai Province* (detail)
1823–32
From *36 Views of Mount
Fuji (Fugaku sanjūrokkei)*
Colour woodcut
25.3 × 39.2 (10 × 15)
Vienna, Österreichisches
Museum für angewandte
Kunst

684 Edgar Degas
Jockey before the race
c. 1881
Oil on canvas
108 × 74 (42½ × 29⅛)
Scotland, Private Collection

685 Edouard Vuillard
The harbour at Honfleur
Oil on cardboard
c. 13 × 11.5 (5⅛ × 4½)
Bagnols-sur-Cèze, Musée
Léon Alègre

686 Akseli Gallén-Kallena
*Winter landscape with 5
crosses*
1902
Oil on canvas
75.3 × 43.5 (29⅝ × 17⅛)
USA, Private Collection

685

684

686

257

The silhouette

687 Japan
Silhouette of an actor
Kyōto 1820–30
From *Actors behind the Scenes*
25 × 17 ($9\frac{7}{8}$ × $6\frac{3}{4}$)
Private Collection

688 Aubrey Beardsley
Self-portrait
c. 1894
Brush and india ink
14.5 × 9.8 ($5\frac{5}{8}$ × $3\frac{3}{4}$)
Private Collection

In his book *Kunst und Handwerk in Japan* Justus Brinkmann reports that

windows like ours do not exist in the Japanese house. Their place is taken by translucent white paper which is stuck onto a wooden lattice on the outside of the outer sliding partitions, the *shoji*. When, in the evening, the people moving around inside the house by lamplight throw their shadows onto the paper sliding partitions, passers-by are provided with all sorts of shadow-play [690]. The painters used such shadow pictures, and in the applied arts too an effective use of the silhouette was often made.[1]

In 1903, in the periodical *L'Occident*,[2] Armand Séguin published an essay which summed up the aim and object of the Pont-Aven painters. He writes of the familiar theme of Norman or Breton peasant women: 'The white of the coif contrasts with the black of the dress; when they are at work the curve of their silhouette appears all the more harmonious to us.'[3] The genesis of the art of the silhouette can only be sketched in here. After the Japanese colour woodcut had become known, European painters, especially the French Impressionists, chose dark colour masses on a light ground, thus standing out against it, closed, dense and sharply contoured (22, 25, 692, 693, 695). They now began not only to use the numerous Japanese themes but, as in the Japanese woodcuts, to shape the body of what is being represented

689 Aubrey Beardsley
How Queen Guenever made her a nun (detail)
1892
From *Morte d'Arthur*
Zincograph
28.3 × 16.5 ($11\frac{1}{8} × 6\frac{1}{2}$)
Private Collection

690 Utagawa Kuniyoshi
Evening gathering (theatre scene)
c. 1843/46
Triptych
Colour woodcut
35.8–36.1 × 23.9–24.5
($14\frac{1}{8}–14\frac{1}{4} × 9\frac{3}{8}–9\frac{5}{8}$)
Private Collection

691 Katsushika Hokusai
Man climbing up a rope
1814–78
From *Manga*
Colour woodcut
25 × 17 (9⅞ × 6⅝)
Private Collection

692 Edouard Vuillard
Two sisters-in-law
1896
Colour lithograph
35.8 × 28 (14 × 11)
Milan, Galeria dei Levante

693 William Nicholson
Sarah Bernhardt
1899
From *Twelve Portraits*
Colour lithograph
28 × 22 (11 × 8⅝)
London, Collection
Heinemann

694 Utagawa Kunisada
Actor in black kimono
(detail)
From the play *Vassals*
1847–50
35.8 × 23.9 (14⅛ × 9¾)
Colour woodcut
Private Collection

like a pedestal, to make it stand out from its background by means of dark colours, and finally to depict it strongly as a silhouette.[4] Typically, sharply contoured areas of colour are treated with the brush in the same manner as in the woodcut, which, as a printed surface, prefers sharp outlines. In this way graphic elements and their effects are absorbed into European oil painting.[5]

Already in the Kamakura period, Fujiwara Takanobu paints the samurai Minamoto-no-Yoritomo (705) in his black robe which stands out as a flat silhouette from the gold background. Van Gogh had seen similar paintings on silk either in the original at the international exhibitions in Paris or in reproductions, since his brother Theo was a dealer in Far Eastern art.[6]

Particular painters were especially favoured by European artists, for example Utamaro, whose woodcuts were originally influenced by Shunsō and Kiyonaga. He became famous for his depictions of geishas and tea-house girls and his poetically conceived lovers (712). His daring type of composition impressed many European painters and draughtsmen in the second half of the nineteenth century.[7] Utamaro was an outstanding technician of the wood-block print.[8] Around 1794/95 he developed the so-called mica print (*shomen-zuri*), which exhibits a lacquer-like sheen in the dark areas. This technique involves the use of a special plate and the ink being first mixed with a fairly viscous glue solution. By burnishing or polishing the printed areas, he achieved a dense, saturated area of colour with a well-defined

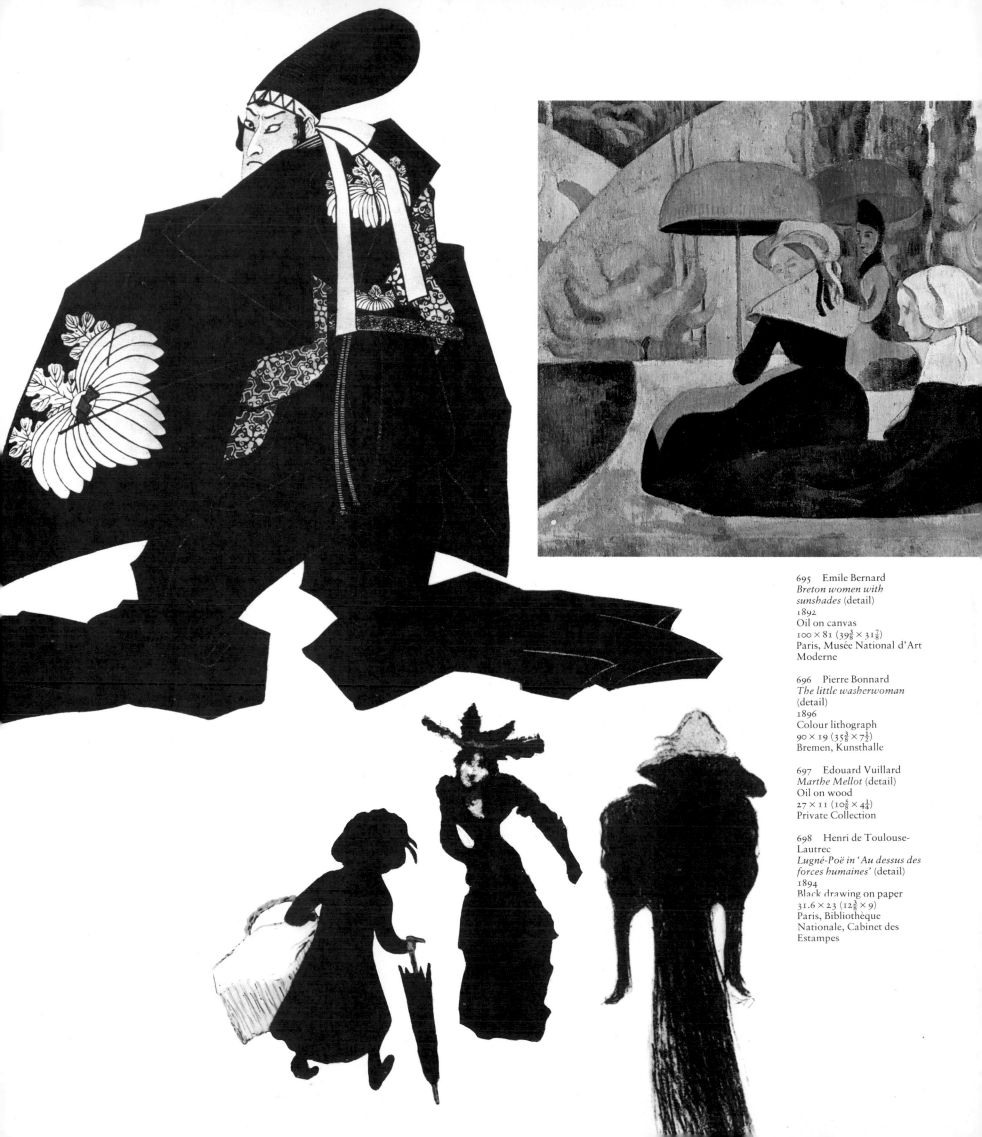

695 Emile Bernard
*Breton women with
sunshades* (detail)
1892
Oil on canvas
100 × 81 (39⅜ × 31⅞)
Paris, Musée National d'Art
Moderne

696 Pierre Bonnard
The little washerwoman
(detail)
1896
Colour lithograph
90 × 19 (35⅜ × 7½)
Bremen, Kunsthalle

697 Edouard Vuillard
Marthe Mellot (detail)
Oil on wood
27 × 11 (10⅝ × 4¼)
Private Collection

698 Henri de Toulouse-
Lautrec
*Lugné-Poë in 'Au dessus des
forces humaines'* (detail)
1894
Black drawing on paper
31.6 × 23 (12⅜ × 9)
Paris, Bibliothèque
Nationale, Cabinet des
Estampes

outline which was used for the black hair of geishas and courtesans (712).[9]

Decisive here are the differences in the depiction of various materials. Light, delicate flesh colour stands out against the ornamental mass of the hair, which in turn contrasts with the flowered background. In their compositions, *ukiyo-e* render the strange outlines of the kimono as well as of Nō and Kabuki costumes in a strikingly simplified manner. The sleeves stand out in sharp lines. The wide, long curves of the back are continued in and underlined by the kimono (694, 689). The black, artistically arranged hair-style with its decoration of hairpins and combs stands out against the light background as a dominant ornamental form (498, 525). The movements of the figures are always organized to give a linear silhouette effect. The gradation in the Japanese woodcut from dark to light achieves a composition full of movement (694).[10]

This gradation can appear in the picture as a combination of surfaces but simultaneously also as a spatially structured background. Probably the most memorable examples and models are the Japanese dyers' stencils (*katagami*) which treat the differing shapes of the contours in a purely black-and-white silhouette style and in doing so achieve a unique art form (526–46). The most finely differentiated patterns of lines and solids, the most subtle overlappings, shifts of emphasis and lattice-like patterns appear here.[11]

Félix Vallotton's graphic *oeuvre* (149, 152, 154, 157) is already completely under the influence of dyers' stencils and the Japanese black-and-white prints reminiscent of

699 Armand Séguin
Avenue of trees
1893
Etching
30 × 18 (11¾ × 7⅛)
Private Collection

700 Tsuda Seifu
From *Small Collection of Paintings*
1904
Colour woodcut
36 × 24 (14⅛ × 9½)
Private Collection

701 William H. Bradley
Cover design 12 (detail)
March 1895
From *The Inland Printer*
De luxe print on handmade paper
22.7 × 30 (8⅞ × 11¾)
Private Collection

702 Charles Guilloux
Tree silhouettes in landscape
1893
Colour lithograph
21 × 28.5 (8¼ × 11¼)
Private Collection

703 Henri Gustave Jossot
Evening blaze
1897
From *Die Jugend*, 30, 652
Half-tone engraving
20 × 18.2 (7⅞ × 7⅛)
Private Collection

704 Josef M. Auchentaller
Lakeside with pine trees
c. 1900
18.6 × 12.8 (7¼ × 5)
Private Collection

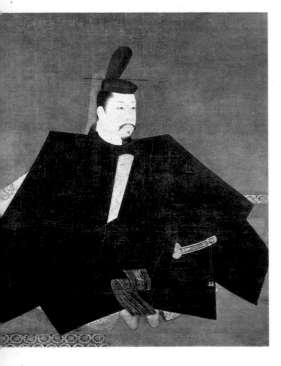

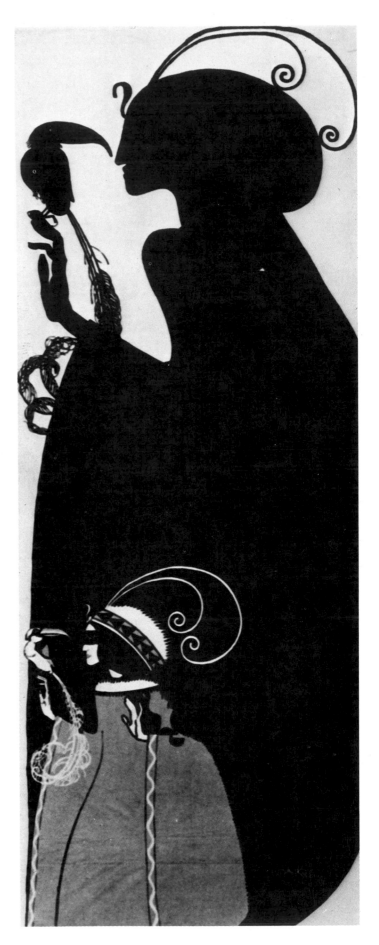

cut paperwork; but in the case of Emile Bernard, who introduced the *cloisonniste* (heavy outline) style, we are still dealing with the beginning of this development. As well as medieval tapestries and stained-glass windows it was the *ukiyo-e* masters who influenced him. Van Gogh referred to this connection in a letter to his brother Theo: 'The exhibition of Japanese prints has well and truly influenced Anquetin and Bernard'.[12]

The *cloisonniste* style makes use of that technique which, as *cloisonné* enamel work, was already brought to a considerable flowering in the Middle Ages. In this process, strips of wire are soldered onto a base, to create areas into which the coloured enamel is placed, and then fired. The result is coloured surfaces with black borders. The visual similarity to the leaded stained-glass windows of the Middle Ages is obvious.[13] The printing techniques of graphic art, which also favour outlines, tend in certain areas, for example in the Japanese colour woodcut, to use internal contours which correspond optically to *cloisonnisme*, since in the woodcut process bridges are also used to separate colour areas.

The silhouette technique using solid areas of colour was employed by the early woodcut designers in many ways. It was constantly refined until the late *ukiyo-e*, when the solid colour could also appear without a border, and in this way formed an even stronger coloured silhouette than when it was delineated by means of bridges. Bernard extended the *cloisonniste* technique, within the coloured silhouette style, by making it into a theoretical ideal.[14] He demanded autonomous colours which should approximate to local colour: solid colour decoration as an uninterrupted

aesthetic effect, in contradistinction to the Impressionistic differentiation of colour nuances (695).

These observations, at first analytical, were later developed into a synthesis. Already in the 1880s Bernard was aiming at a combined style which was still influential at the beginning of the 1890s. In it, he combined the silhouette-like linear structure of the solid black mass with coloured areas (695). Bernard was therefore an important innovator, who, among the members of the Pont-Aven School, best understood the technique of the Japanese *ukiyo-e*.

Necessarily connected with this concept is the removal of colour as shadow. In 1888 Bernard and Laval were still exchanging opinions about the importance of shadow. More vital, however, is Gauguin's remark to Bernard, accepting the idea of colour as shadow only 'in so far as we are trying to make the light more evident ... Look at the Japanese who can draw so wonderfully. What life in open air and sunshine without any shadow!'[15]

Shadow, which for the Impressionists was not darkness but colour, had a spatial function and gave the figures that volume which was devoured in late Impressionism by the brightness of the light. The *cloisonnistes* – as the Pont-Aven painters were called – distanced themselves from this late Impressionist

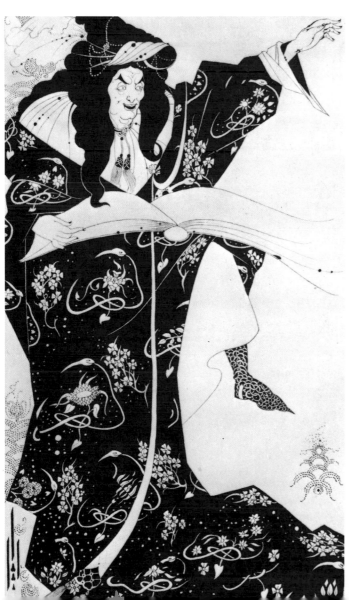

708 Henri de Toulouse-Lautrec
Cover of the Yvette Guilbert album
1894
Lithograph from a brush and ink drawing
41×38.2 ($16\frac{1}{8} \times 15$)
Private Collection

709 Aubrey Beardsley
Virgilius the sorcerer
c. 1893
Frontispiece for *The Wonderful History of Virgilius the Sorcerer of Rome*, ed. David Nutt
Pen and ink on paper
22.8×13.8 ($9 \times 5\frac{3}{8}$)
Chicago, Art Institute

710 Utagawa Kuniyoshi
Actor
c. 1856
Colour woodcut
35.8×23.9 ($14\frac{1}{8} \times 9\frac{3}{4}$)
Private Collection

tendency and decided to use the outlined or free-standing unified colour mass – the coloured silhouette – which gives no illusion of atmospheric depth. Gauguin goes on to say:

Therefore I deny as far as possible everything that creates illusion, and since the shadow is the deceptive mirror-image of the sun I am inclined to leave it out. If, however, in your picture the shadow fulfils a necessary function, then that is a different matter; instead of a figure you only paint its shadow, that is an original idea whose strangeness you have allowed for.[16]

In this connection a remark by Edmond de Goncourt is interesting. He says as early as 1885 that he has already indicated to what extent the Japanese, in drawing plants, use the shadow thrown by the plants.

When I was feeding the goldfish in the pond today, which at that moment was strongly lit up by the sun, I was astonished to what extent the shadow, the shadow of the fish on the floor of the pond, resembled the fish in Japanese sketchbooks. Furthermore, depictions of the shadows of objects or living creatures seem to have occupied the Japanese very much. I recently bought a sketchbook of figures in black which resemble certain silhouettes by Charmontelle and which only depict the silhouettes of Japanese men and women on a white background [687].[17]

Goncourt's remarks are illuminating because the silhouette technique, which resembles cut paperwork, is influenced by the Japanese dyers' stencils and the black-and-white illustrations of Japanese novels, as well as by the woodcut technique, and these influences are taken up again, varied and altered by painters according to their individual talent.

Edouard Vuillard uses these solid black silhouettes as arabesques in many variations (692). For the *Revue Blanche* in 1895 Pierre Bonnard draws bizarre silhouettes (696) which are similar to those in Hokusai's *Manga* (691). Typical is the flowing, almost undulating outline which in its limitation is contrasted with the unlimited – the empty space (706, 708).

In the 1890s, as a woodcut designer under the influence of the Japanese dyers' stencils and silhouettes, Vallotton developed the black-and-white contrast which is typical of him, without intermediate nuances and transitions (149, 152, 154, 155). Black and white are for Vallotton the basic elements of composition. By using the most sparing means he still depicts everything with precise clarity. In this way Vallotton became the stimulus for the Expressionist woodcut.[18]

Degas, also a great devotee of Japan among the French painters, is able, in his etching *Mary Cassatt in the Louvre*,[19] to form out of the strongly-contoured homogeneous black a flexible and structured silhouette which must again be seen in close conjunction with the works of Hokusai. The fleeting movement is not tied to the solid mass, but the lightly diversified contour makes the transition from one movement to the next.

Toulouse-Lautrec, on the other hand, is concerned first of all with the precise recording of the outline which also leads on to the solid shape (471, 698). The characteristic moment in the fleeting movement is depicted by a vibrant or oscillating outline.[20] In his lithographs Toulouse-Lautrec develops that cogent, condensed silhouette style which carries Bernard's *cloisonnisme* to its conclusion. The aim was to introduce the sharply cut solid in a modulated and clarifying manner: 'suggesting instead of stating' (also termed *ombres chinoises*). The silhouette style develops in two ways. The shadow is removed from the colour and is set free as a homogeneous black; the colour can therefore exist autonomously – as a solid coloured silhouette (129).

This style, which appears in European art even within the depiction of landscape at the end of the nineteenth (702) and the beginning of the twentieth century, undergoes various changes outside France. Because of its lack of shadow it is tied more strongly to the solid area and thus paves the way for a process of abstraction which leads by means of schematic coloured areas to a pattern of solids, which then become diagrammatic and ornamental. Here, too, composite forms again come into being, linking the linear effect of silhouette and solid black area with other, coloured components.[21]

Solid black is used in the most diverse variations by Aubrey Beardsley (689, 706, 709), who intensifies this silhouette style into a hybrid, memorable and unique form which in its extreme subtlety tends towards that decadence which can already be seen in the late Japanese *ukiyo-e* masters. Long curving lines, dramatically silhouetted black expanses in front of a light background, through patterning and free-standing individual ornaments constitute, as the points of emphasis of the composition, the individual character of this art. In this way Beardsley achieves a unique stylization and symbolism in his figures. This capricious form of the autonomous silhouette (433, 704, 707, 711) is then developed creatively by the Vienna Secession artists, who use the coloured solid silhouette even more.[22]

Vuillard, by using white as a contrasting element in his lithographs, makes the silhouette look as if it is suspended in the air. But this white, floating brightness remains secondary compared to the black. Thus Vuillard makes the dark silhouette into a primary compositional element which can be seen clearly in his *Two sisters-in-law* (692). The painter thus manages to represent that inaccessible space which is peculiar to the Nabis' pictures and which often allows red to be added as an intensifying feature. The black figure here has become a definite arabesque. The crouching woman is as though caught in mid-motion; she and her position, as well as the internal drawing, are blurred. The eye is led in leaps over the arm of the chair and the white dress to the black arabesque and back again. The yellow wallpaper in the background is only a foil for the suspended, reposing, black silhouette. The angle from which it is seen is slightly raised and corresponds to the bending woman who determines the flow of the movement. The bent pose of the figure in the silhouette was often carried by Vuillard almost to the point of deformity. It is noticeable that the Nabis in general do not choose a sharply contoured silhouette but a more broken contour with transitions to other coloured silhouettes. The contrasting aims of these opposites are in accordance with Bernard's original theory; in his *cloisonnisme* he

developed coloured silhouettes on the Japanese model.[23]

In the further development of the idea, Art Nouveau takes the Japanese black silhouette as its model. Extreme examples can be found in landscapes above all. Concentrating completely on the outline of the object, William Bradley creates moving shadow forms which are open in all directions and transcend the Japanese model (701). There are certainly similar compositions in Japan, but these are always confined by the frame. In 1893 Charles Guilloux completed an ornamental landscape for *L'Estampe originale* (702) in which the trees take on silhouette-like forms. The light penetrates from the background, atmosphere is created by means of a spray technique which is unusually combined with the black silhouette. By making the landscape abstract, though still entirely comprehensible in a realistic manner, the way is paved for abstractionism.[24]

Henri Jossot too (703) and the Viennese Josef M. Auchentaller (704) develop this even further by means of the perfect silhouette style.[25] The style in Europe had reached its highpoint. The black silhouettes create

pictorial abstractions which have nothing to do with the European cut paperwork of the early nineteenth century. By means of its enormous enlargement, Franz Wacik's poster for the Silhouette Ball of the Vienna Secession on 22 February 1912 (707) created a mysterious effect which corresponded to the mood of the period and made the ball in the Secession building in Vienna into a 'silhouette garden', as the critic Ludwig Hevesi remarked.[26]

The silhouette, after the Japanese model, as the theme of a carnival party was a fantastic idea which made the artistic event of Japonisme appear alive and real. This party, as Hevesi remarks, 'was comparable to the Chinese shadow plays which in the Far East entertained the popular masses for centuries . . . The huge silhouettes flitted ghost-like over the walls . . .'[27] In the condensed, large, black solid form the human figure is given an abstract expression which was to influence modern painting and illustration in Europe most strongly. The confining of the sharp, dark contour line in an abstract structure of solids was to be a task for the Expressionist painters of the beginning of the twentieth century.

711 Gustav Klimt
Lady in feathered hat
1910
Oil on canvas
79 × 62.5 (31⅛ × 24⅝)
Graz-Wetzelsdorf
Collection Victor Fogerassy

712 Kitagawa Utamaro
Pensive love
c. 1790
From *Selected Poems on the Theme of Love (Kasen koi no bu)*
Colour woodcut
36.2 × 24.3 (14¼ × 9½)
Private Collection

Symbols, themes and abstractions

The spirit world

The first generation of Impressionist painters in France had investigated natural light down to the smallest detail. Light in its evanescence, in its transparent brightness and its coloured reflections, became the principal element in a picture thanks to a swiftly developing painting technique. Light in the picture was 'copied', both in its evanescence and in its stationary effect; its actual physical changes were painted; its effect on other media was investigated by means of the brush. Natural light was investigated with all its effects, so that it became possible to dissolve solid objects in light. This led Monet to paint the façades of cathedrals as though they were loose and 'soft', as though the stone had lost all

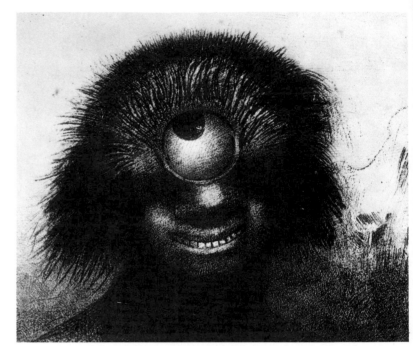

713

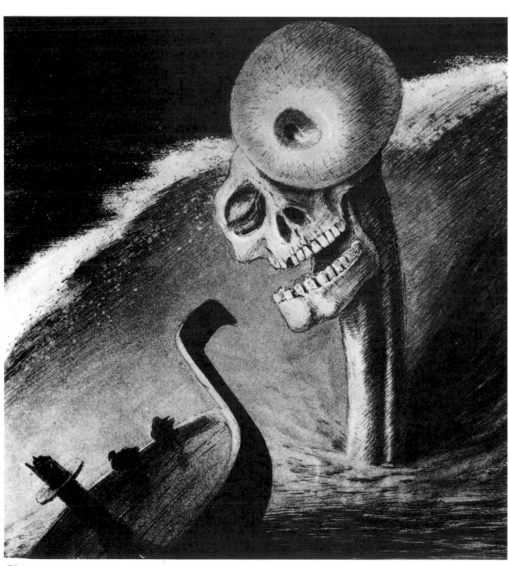

714

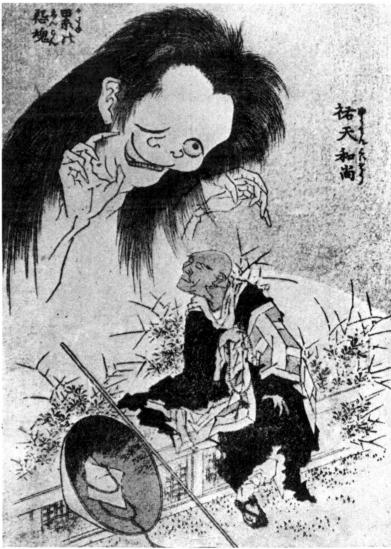

715

its hardness; and it transformed Monet's waterlilies into a reflection of the coloured skies. The Impressionists saw nature as through a lens; their vision was so sharply concentrated on the qualities and the time-space location of light that the real, three-dimensional, tactile form of the Realists no longer had much to say to them. The painter was reduced to a reflecting eye; but, as Renoir remarked of Cézanne, 'What an eye!'

By contrast, the succeeding generation of painters in France, to which the Nabis, the Prophets, belonged, no longer wanted in their painting merely to see: they wanted, as Denis put it, 'to re-think'. Similarly, European Symbolist painting took up at this period an opposing position to that of the depiction of evanescence. It was concerned rather to depict fairy-tale regions, strange worlds, ghosts and monsters, signs and symbols (529).[1]

The Japanese ghost cult, which dominated daily life, was at the centre of the popular Kabuki theatre, reached its intellectual zenith in the Nō play and became known in Europe through the woodcut, and especially through the numerous volumes of Hokusai's *Manga* (715). The courage to depict deformity, which in Hokusai's work can easily lead to the grotesque, shows that a religious element could become one with the bizarre, the popular. There is much here that is philosophically and existentially profound; this stimulated the Europeans, and Odilon Redon above all must have found in Hokusai's works the confirmation of his own aims (716). Certainly Goya had also provided him with numerous impressions of this kind; but he found confirmation in Hokusai's work, on which his friends, the Nabis, had modelled themselves.

Redon, whose wife Camille Falte was a Creole, confessed his allegiance to the Orient in a comment on colour modulations: 'The most important were handed down to us by the Orientals. Solid colour made to shimmer by laying shade on shade: vibrating tone.' Of his friend Rodolphe Bresdin he said: 'He liked to work in the garden, with the scrupulous exactitude of a Chinese.'[2]

In 1891 Redon, also a friend of Signac and Seurat, took Gauguin's place as the mentor of the Nabis, that group of artists which had already often enough cited the

713 Odilon Redon
Cyclops (The deformed polyp floated on the banks, a sort of cyclops, smiling and hideous)
1883
From *Les Origines*
Lithograph
21.3 × 20 ($8\frac{3}{8} × 7\frac{7}{8}$)
Paris, Bibliothèque Nationale, Cabinet des Estampes

714 Alfred Kubin
Horror
1900–08
Pen and ink wash sprayed on paper
27.3 × 27.3 ($10\frac{3}{4} × 10\frac{3}{4}$) (picture)
32.5 × 30.8 ($12\frac{3}{4} × 12\frac{1}{8}$) (sheet)
Landshut, Collection Karl Russ

715 Katsushika Hokusai
The murdered Kasane appears to the monk Yūten
1814–78
From *Manga*
Colour woodcut
Facsimile
22.8 × 15 ($9 × 5\frac{7}{8}$)
Tokyo, Yūjirō Shinoda

716 Odilon Redon
Cyclops
c. 1900
Oil on wood
64 × 51 ($25\frac{1}{8} × 20$)
Otterlo, Rijksmuseum Kröller-Müller

717 Utagawa Kuniyoshi
The sea monk
c. 1844–46
From *Pairs for the 53 Stations of the East Sea Road (Tōkaidō gojūsan tsui)*
Colour woodcut
36.8 × 25.2 ($14\frac{1}{2} × 9\frac{7}{8}$)
Düsseldorf, Private Collection

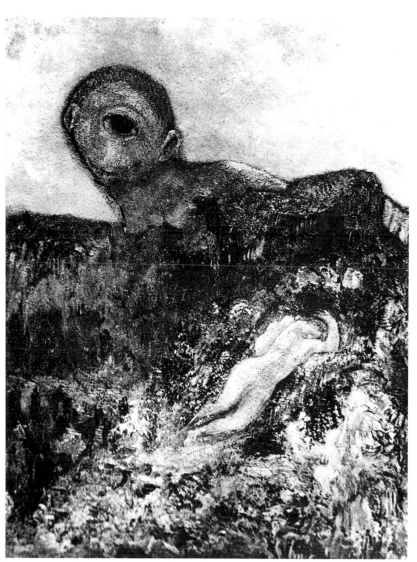

716

717

730 Ernst Stöhr
Cloudburst
c. 1898
Border design, later used in
Ver Sacrum
Pen and ink
15.6 × 4.6 (6⅛ × 1¾)
Vienna, Private Collection

731 Katsushika Hokusai
Landscape in the rain
1814–78
From *Manga*
Colour woodcut
25.7 × 17.5
(10⅛ × 6⅞)
Private Collection

732 Andō Hiroshige
*Yamabushi Valley in
Mimasaka Province*
1853–56
From *Famous Places from
more than 60 Provinces
(Rokujūyoshū meisho zue)*
Colour woodcut
33.8 × 22.5 (13¼ × 9⅞)
Vienna, Österreichisches
Museum für angewandte
Kunst

733 Ernst Stöhr
Cloudburst and fire
c. 1898
Border design, later used in
Ver Sacrum
Pen and ink
15.6 × 4.6 (6¼ × 1¾)
Vienna, Private Collection

The Japanese woodcut had at its disposal a great capacity for variation, and it possessed a rich diversity of techniques to ensure that the setting to be depicted could be most magnificently transfigured. The mica print (*shomen-zuri*, or 'shiny printing') produced reflexes of light within the print which European painters had never before seen in this form. A similar effect was achieved by prints using gold, silver or a copper powder (*kingin-zuri*). The mica print also transformed everyday objects into abstracts, making them appear autonomous and isolated. In addition there are the marvellous embossing techniques (*kara-zuri, kimekomi*) which give movement to the surface by means of their shadowy forms. These techniques lead away from any naturalistic imitation into the realm of abstraction, yet without changing the form of the object.

In Japan there is a type of picture called a *bunjin-ga* or symbolic landscape. It is the quintessence of nature, as distinct from the 'real' nature which merely appears as it does. Other glimpses of nature have been handed down to us also. *Buryō Tōgen* and *Eishū Senkyo*[1] are paradisal, ideal landscapes. For the Japanese painter, nature was always filled with such visions. From the waterfall to the smallest rivulet, all objects in nature were worthy of being represented.[2] The waterfall was displayed in a large-scale ornament; the rivulet was a silvery undulating ribbon, equally subject to ornamental interpretation. This comprehensive view of natural events was determined above all by diverse attempts at abstract vision.[3] It is striking that the late *ukiyo-e* masters in their strictly stylized landscapes prefer the accidental aspects of nature. Hokusai and Hiroshige choose sensational events in the landscape in order to transform the effect of reality into symbolic, unique pictorial events: gusts of rainy wind, storms, cold, the sea with its powerful waves, raging waterfalls, darkened ravines, lightning at evening, pointed needles of rock in the sea. In the same way, water seeping away into the sand, or a little

734 Gototei Kunisada
*The actor Ichikawa Danjūro
as Naru Kami-shōn-in*
Colour woodcut
37.5 × 25.5 (14¾ × 10)
Regensburg, Collection
Franz Winzinger

735 Utagawa Toyokuni II
Nocturnal rain over Oyama
c. 1834
From 8 *Views of Famous
Places (Meisho hakkei)*
Colour woodcut
22.5 × 35.2 (8⅞ × 13⅞)
Private Collection

736 Ernst Ludwig Kirchner
Crossing the Elbe in the rain
1908
Etching
18 × 23 (7⅛ × 9)
Private Collection

737 Emil Nolde
Storm
1906
Woodcut
15.8 × 19.1 (6⅛ × 7½)
Private Collection

738 Emil Nolde
Trees in the rain
1910
Woodcut
7.2 × 10.5 (2⅞ × 4⅛)
Private Collection

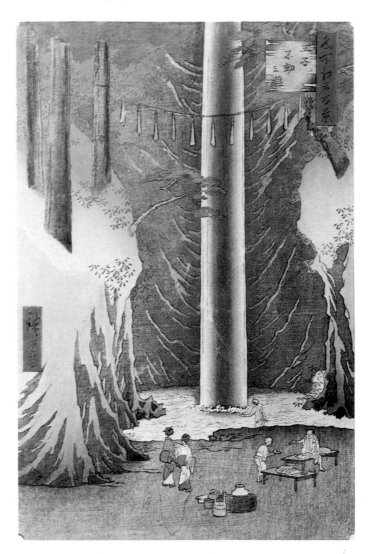

twisting brook between the trees, could become a momentous theme (763). The many Japanese painters' manuals in the form of block books give much information about microcosmic and macrocosmic phenomena, and there are impressive examples in volumes 3, 6, 8 and 12 of Hokusai's *Manga*.

Art Nouveau designers in Europe took up such themes as the rivulet between the trees and, inspired by Japanese models, created numerous variations. From a raised point of view a high horizon is constantly depicted from which the ornamental ribbon of water flows towards the observer.[5]

Henry van de Velde (764), Otto Eckmann (765), Maurice Denis (766, 767) and Thomas Theodor Heine (769) all depicted twisting watercourses in the manner of the Japanese models.[6] An infinite number of examples from other artists could be cited.

Another important motif that was taken up in Europe is that of nature in turmoil, driven rain (730–38), rolling sea, grotesque cliffs, abrupt river-banks, darkening clouds, banks of fog. The realistic effect is compressed in an elegant and bizarre way by means of a dense, taut presence of reality which the European painters of the nineteenth century had never conceived of.[7]

Hokusai's *Great wave off Kanagawa* (308) is an example of this anti-naturalistic conception, which in its linear structure suggests the dynamic flow of the natural event. In their very essence, natural objects are at once severe and relaxed, calm and turbulent, droll and simple. Above all it is the simple object which is most striking:

739 Andō Hiroshige
The waterfall of Ōji Fudō
1856–58
From *100 Views of Famous Places in Edo* (*Meisho Edo hyakkei*)
35.3 × 24 (13⅞ × 9½)
Private Collection

740 Gustave Moreau
Waterfall in a cave
Oil on cardboard
62 × 37.2 (24⅜ × 14⅝)
Paris, Musée National Gustave Moreau

741 Erich Heckel
Large landscape with glacier
1959
Woodcut, third state
54.7 × 53.3 (21½ × 21)
Essen, Museum Folkwang

the smooth bamboo grove (616), the straight high cedar, the linear mountain range, the harmonious rising contour of Mount Fuji;[8] all this achieves a condensed view – stylization renders the essence of nature (635, 638). Fog-banks in the rain focus our attention on the landscape; the mist transforms solid objects into a wraith-like flatness. When the atmosphere becomes turbulent, then more action comes into the landscape. The threads of the rain cut through the picture diagonally like wooden beams (732), the waves of the sea hurtle like waves of lead. The colours of the sky appear graded according to their colour values. Beauty of colour is added to the intrinsic stylizing element, so that the glowing colour itself often appears independent of the object which bears it (387, 391, 739, 743). A rich variation of shades contrasts with the colour accents, shades which Hokusai is able to give equally to the background and the foreground.

Edmond and Jules de Goncourt wrote in 1892: 'As we were leafing through Hokusai's prints of Mount Fuji, Manzi said to me: 'Look, here are Monet's large patches of yellow'; and he was right. For one never knows enough of what our landscape artists have borrowed from these pictures, Monet above all, whom I often meet at Bing's in the little attic with the Japanese prints'.[9]

Colours used with this intensity tend to transcend imitative realism.[10] The stylization of forms and the expressive use of colour are artistic devices which define the European avant-garde. Van Gogh tells of his own discovery of the colour values in a distant landscape when he writes to his brother Theo:

But here in Arles the surrounding landscape seems to be flat. I have discovered a wonderful red region planted with vines and with mountains of the most delicate purple in the background. And landscapes in the snow with the white mountain peaks

742 Katsushika Hokusai
The Ono Waterfall on the Kiso Road
c. 1828/29
From *Trip to the Waterfalls in the Provinces (Shokoku taki meguri)*
Colour woodcut
36.3 × 25.3 (14¼ × 10)
Vienna, Österreichisches Museum für angewandte Kunst, Exner Bequest

743 Gustave Moreau
Sketch
Oil on cardboard
66 × 31.3 (26 × 12¼)
Paris, Musée National Gustave Moreau

744 Katsushika Hokusai
The waterfall at Yoshino in Yamato Province where Yoshitsune washed his horse
c. 1828/28
From *Trip to the Waterfalls in the Provinces (Shokoku taki meguri)*
Colour woodcut
36.9 × 25.3 (14½ × 10)
Berlin, Museum für Ostasiatische Kunst

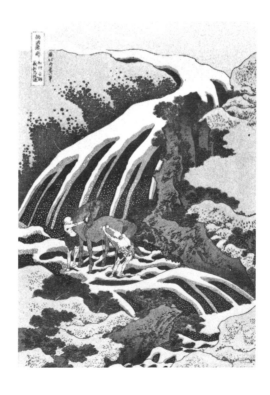

745 Japan
The Nachi Waterfall
14th century
Colours on silk
166 × 59 (65⅜ × 23¼)
Tokyo, Nezu Art Museum

746 Katsushika Hokusai
*The Kirifuri Waterfall at
Kurokamiyama in
Shimotsuke Province*
c. 1830
From *Trip to the Waterfalls
in the Provinces (Shokoku
taki meguri)*
Colour woodcut
36.9 × 25.5 (14½ × 10)
Berlin, Museum für
Ostasiatische Kunst

747 Erich Heckel
*24th yearly sheet
Waterfall*
1954
Woodcut
17.2 × 13 (6¾ × 5¼)
Essen, Museum Folkwang

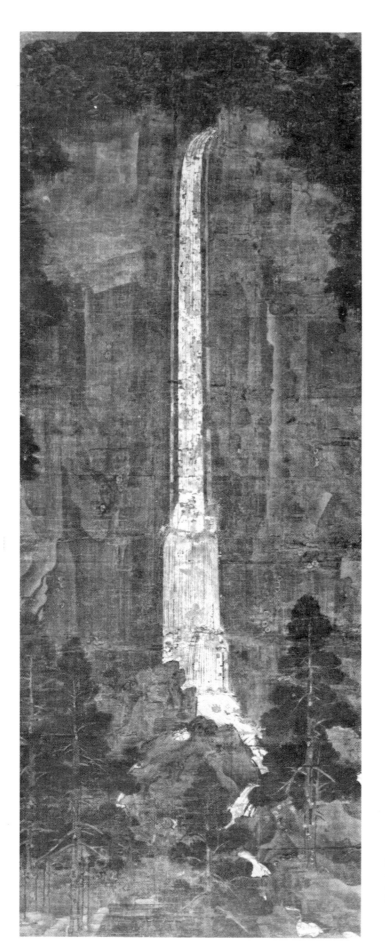

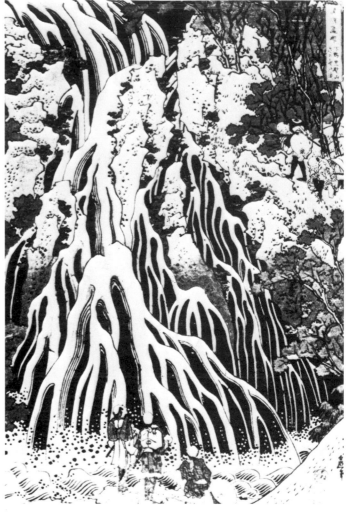

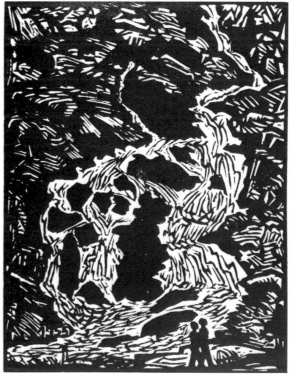

282

748 Hans Schmithals
Glacier Stream
c. 1902
Oil on canvas with chalk
122 × 75 (48 × 29½)
Munich, Städtische Galerie
im Lenbach-Haus

749 Geiami
Waterfall with bridge
1480
Brush and india ink
37 × 24.8 (14½ × 9¾)
Tokyo, Nezu Art Museum

750 Keisai Eisen
Bridge on Ina River at Nojiri
c. 1835–42
Colour woodcut
24.3 × 36.4 (9½ × 14¼)
Tokyo, National Museum

against the sky just as brilliant as the snow – that was like the winter landscapes of the Japanese.[11]

As well as colour, shape is firmly outlined. The sacred Mount Fuji acts as the measure of all things. Lines rise up equally on both sides towards the snow-covered peak. Japanese artists have depicted the mountain in countless variations (629, 755, 756). It was above all the colour woodcuts that Europeans saw,[12] and soon European mountain ranges were being depicted in the same way as Mount Fuji. Ferdinand Hodler[13] (753) had studied Hokusai in detail, and Van Gogh (754) also grasped the graphic importance of this mountain.

Hans Christiansen, however, aims at a perfect combination of flat surfaces in his woodcut *Fire* (757). The volcano spits fire in an undulating ornamental Art Nouveau line. The whirlpool (751) and glacier (752) are represented in the same rotating fashion. Hiroshige depicts *The whirlpool at Naruto in Awa Province* in a dramatic and vivid way. This woodcut is one of the series *Famous Places from more than Sixty Provinces*,

751 Andō Hiroshige
*Whirlpool at Naruto in
Awa Province*
1853–56
From *Famous Places from
more than 60 Provinces
(Rokujūyoshū meisho zue)*
Colour woodcut
33.6 × 22.5 (14⅜ × 8⅞)
Vienna, Österreichisches
Museum für angewandte
Kunst, Exner Bequest

752 Hans Schmithals
Composition in Blue
c. 1900
Pastel
131.5 × 79.5 (51¾ × 31¼)
Munich, Bayerische
Staatsgemäldesammlung

753 Ferdinand Hodler
Mount Niesen
1910
Oil on canvas
82 × 105 (32¼ × 41¼)
Basle, Kunstmuseum

754 Vincent van Gogh
Study for Père Tanguy
1887
Pencil on paper
21.5 × 13.5 (8½ × 5⅜)
Amsterdam, Rijksmuseum
Vincent Van Gogh

755 Katsushika Hokusai
*Thunderstorm underneath
Mount Fuji*
1823–29
From *36 Views of Mount
Fuji (Fugaku sanjūrokkei)*
Colour woodcut
24.3 × 36.4 (9½ × 14⅜)
London, Private Collection

756 Katsushika Hokusai
*View of Mount Fuji with
rising dragon*
c. 1835
From *100 Views of Mount
Fuji (Fugaku hyakkei)*
Colour woodcut
26.2 × 22.5 (10⅜ × 8⅞)
Private Collection

757 Hans Christiansen
The four elements (detail,
fire)
1898
Sketch for a book illustration
Gouache
32 × 24 (12⅝ × 9½)
Flensburg, Städtisches
Museum

created between 1853 and 1856. Around 1900 Hans Schmithals created the landscapes which he termed *Compositions*. He possessed an important collection of Japanese colour woodcuts, mostly depictions of nature by Hiroshige and Hokusai,[14] including Hiroshige's *Whirlpool at Naruto*. Inspired by this woodcut, he created his glacier composition which depicts a natural phenomenon in ornamentalized fashion. His chosen technique, pastel on a smooth surface, preserves in its delicate gradation of colour the character of the Japanese colour woodcut. A decisive factor is his use of light colours, related to the background. Even more decisive is the ornamental play of the lines, which turns the natural process into an arabesque in a remarkable display of condensed yet flowing stylization. The swirl of ice which begins just below the upper edge of the picture (752) is a mirror image of the Hiroshige model which, according to the same ornamental principle, provides us with a vortex at the bottom edge in order to allow the foaming mountainous waves to rise up over them to the right and to the left.

'A certain measure of "abstraction", therefore, – as elsewhere in Far Eastern art – not only does not endanger concreteness, it can even intensify it by elevating it at the same time to a higher aesthetic form,' writes Dietrich Seckel in his book *Emaki*.[15]

The strongest abstractions and conceptual images are developed by Japanese painters when they tackle their famous waterfalls; their depiction conveys an almost realistic degree of visual information. The waterfall is a central motif in Far Eastern art. *The Nachi Waterfall* (745) is one of the masterpieces of the fourteenth-century Kamakura period, of which there are numerous reproductions. It is more than just pure landscape painting, it is one of the most important religious pictures of Japan.[16] Under the influence of nature worship, the landscape here becomes a mirror of divine powers. In highly contrasted colours and a high vertical format, the work shows a waterfall sweeping like a meticulously positioned ribbon, down the pictorial axis.

The 'bright stream', as the waterfall is also called, is central to the Japanese view of nature: it is a constant feature and also an event; it is the element which brings movement, yet is kept between bounds, dominating the structure of the rocks. This early painting was followed by a wealth of important depictions of waterfalls. In picture scrolls, the waterfall always constitutes a lingering caesura in the course of the 'optical journey', like the viewpoint which the Japanese have always willingly taken up at the sites of particularly revered natural phenomena. In *Ippen shonin eden*, Roll II, a work of the late thirteenth century, Ippen goes on a pilgrimage to the Shinto shrine at Kumano in Kii Province (Central Japan), where the 120 metre (nearly 400 feet) high Nachi Waterfall, revered at this place as a sacred being (*kami*), pours out its raging masses of water.[17] This example points to the ancient tradition of depicting waterfalls which was continued into the nineteenth century, and which in Hokusai's series *Trip to the Waterfalls in the Provinces (Shokoku taki meguri, 746)* reaches another highpoint. The manner of depiction of the waterfall was laid down in painters'

751

752

753

754

756

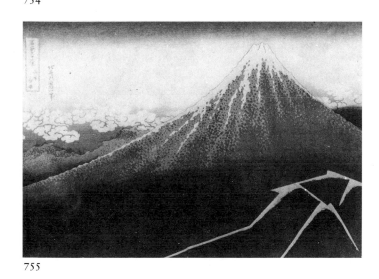

755

757

manuals such as *The Mustardseed Garden*, which sketch the compositional principles and the various methods of depicting them:

Stones are the 'bones' of the mountain. Waterfalls are the 'bones' of the stone. It is said that water is soft in character. How then can it be referred to as 'bones'? Yet water can hollow out mountains and split stones. Its force is immensely great. For this reason the painter Jiao Gang [seventeenth century] believed that water was a 'bone'. A small rivulet and tiny drops can become a great current, an ocean. Every drop of water is the blood and marrow of the world. A 'bone' with no marrow is not capable of life. For this reason a mountain receives its 'bones' first from the water. The old masters painted waterfalls with great care; it is reported that they took five days to paint a waterfall.

One can depict waterfalls in various ways. The picture by Huang Kung-wang [1269–1354], for example, shows, in its full length, a waterfall which has dug its bed in a green mountain. Where it falls down steeply it has the effect of a 'bone'. There are the following further types of depiction: a waterfall between scattered stones, a waterfall broken by clouds, a threefold waterfall, a narrow waterfall, a large waterfall, a waterfall at the opening of a valley, a waterfall among steep rocks, a waterfall partially covered by rocks, two waterfalls joined together, etc. [739–50].[18]

The *ukiyo-e* masters work according to an artistic principle which imitates the formal character of every object in nature. The waterfalls are like huge frozen icicles (739, 742), rigid and yet in motion. Straight lines are dominant in many representations, yet they can be transformed into a huge web consisting of many rivulets. The curved element is the extreme opposite of the straight lines. Between these extremes, however, there are numerous formal types which constantly surprise one. The waterfall can look like a finger, or its turbulent vortices can rotate in a spiral, always ready to become transformed into a large-scale ornament.

Hokusai's waterfalls are fantastic sensations in nature which reach their peak in a system of intertwined ornament (744, 746). There is in them an energetic turning towards the actual and towards pre-existing reality (746). Hokusai's interest in the natural phenomenon of the waterfall is not imitative, nor is it idyllic or pantheistic: it is rather, in the Buddhist sense, a partial reference to an event; it expresses a religious, metaphysical concept. Hokusai's familiarity with the diverse types of movement of waterfalls on the basis of their geological structure, and his knowledge of atmospheric phenomena, led him to cryptographic conventions of

760 Lucien Adrion
Cannes harbour
c. 1918
Oil on canvas
100 × 81 (39⅜ × 31⅞)
Private Collection

761 Hung-jên
Landscape
1656
Brush and india ink
Lugano
Collection Vannotti

representation (742) which convey more than realism is able to express. Hokusai's waterfalls become an abstract web (746) spreading like a river-delta over the surface of the picture; or they stand frozen, like great organ pipes, amidst a stage-set of rocks. They pour from the pointed rocks into branching valleys, giving an ornamental effect. They dive behind silhouetted masses of rock and pour in numerous rivulets into the valley. The material qualities of the waterfall and its surroundings are ornamentalized, in a heightened concretization, until they become transparent. The waterfall can be represented as a bright surface, even as an almost luminous strip. The natural event is summed up, each element equally near to the eye. Individuation and multiplicity, emptiness and fulness, depth and nearness, are one.

The picture which Hokusai gives, thanks to the painters' manuals and his own imagination, is diverse. It is precisely this diverse representation of a natural phenomenon which led European painters in the second half of the nineteenth century, and most markedly around 1900, to take up the depiction of the waterfall in the manner of Hokusai's woodcuts.

Gustave Moreau painted numerous finished pictures and sketches of imaginary, ideal waterfalls. His streams fall like molten lava into a grotto in the rocks (740, 743). In his depictions of landscape Moreau often adopts a gloomily exotic magnificence. These still little-known sketches convey, above all, mysterious colour effects which obscure the impression of the material, the physical. Moreau was Chassériau's pupil, and combines, in his painting, colours which give an Oriental, jewelled effect and geological structures which indicate Far Eastern influence.

Erich Heckel provides a tardy Japanese analogy in his woodcut *Waterfall* of 1954 (747). In this woodcut the branching rivulets and cascades are reduced to parallel planes in Hokusai's manner. The dark background combines with the light, splinter-like forms of the water to form an abrupt and dramatic composition.

Japanese painters felt very close to dramatic natural events, and their tropical rain-showers demonstrate the vehemence of the moment. Kunisada I (734) and Toyokuni II (735), in their figurative pictures and in their pure landscapes portray the heavy, slanting rain which hurls itself from the clouds. This clearly comprehensible motif in all its grandeur was an apt one for the German Expressionists. Ernst Ludwig Kirchner (736) and Emil Nolde (737) depict the fury of the weather in an

762 Tsuda Seifu
From *Small Collection of Paintings*
1904
Colour woodcut
36 × 24 (14⅛ × 9½)
Private Collection

763 Japan
From a painters' manual
Tokyo *c.* 1860
Colour woodcut – double-page spread
28 × 19 (11 × 7½) page size
Private Collection

764 Henry van de Velde
Angels watch
1893
Appliqué embroidery
139.7 × 233 (55 × 92)
Zürich,
Kunstgewerbemuseum

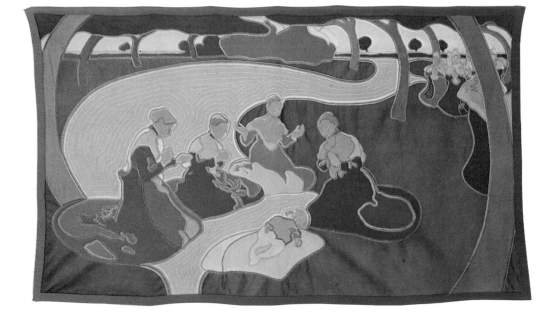

expansive woodcut technique which precludes the 'atmospheric' expression of emotion.

The Japanese were able to depict dramatic natural events vividly by extracting the elements of air and water as clearly recognizable matter. Rain was for them an ever-present theme. The Japanese rain squall is shaped in the *ukiyo-e* into a system of lines which is subject to certain rules concerning its direction. Hiroshige and Hokusai have given us impressive examples. Kirchner sees in this process of reduction, which is capable of impressive effects, impulses towards landscape effects which had never before been portrayed in Europe. The rain as an ornament consisting of lines which stand out sharply and individually from the background is, in its autonomy, traceable to Far Eastern art. This same process of abstraction has analogies in Kirchner's later development.

Japanese compositional methods also establish certain distortions in the depiction of depth, which can be varied in the most diverse ways. Hiroshige directed the

288

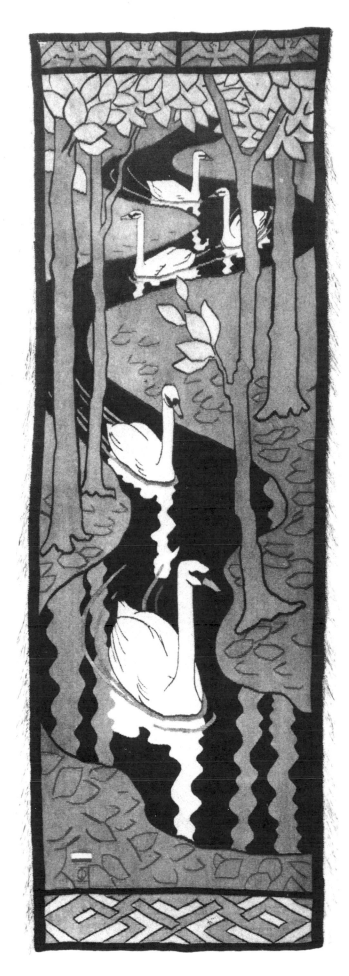

765 Otto Eckmann
Swan tapestry
Designed 1897
Wool
H.238 (94), w.75 (29½)
With fringe 94 (37)
Private Collection

766, 767 Maurice Denis
Winding Stream
c. 1892–93
Illustrations to André Gide,
Le Voyage d'Urien
Ink on paper
sheet sizes:
766 18.5 × 10.5 (7¼ × 4⅛)
767 18.5 × 18.5 (7¼ × 7¼)
Private Collection

768 Tsuda Seifu
From *Small Collection of
Paintings*
1904
Colour woodcut
36 × 24 (14⅛ × 9½)
Private Collection

769 Thomas Theodor
Heine
Winding Brook
c. 1898
Pen and ink
22 × 19.5 (8⅝ × 7¾)
Private Collection

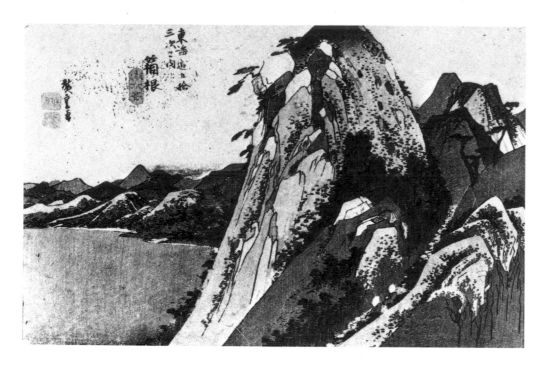

770 Andō Hiroshige
The lake at Hakone
1832–34
From *The 53 Stations of the
Eastern Sea Road (Tokaidō
gojūsan tsugi)*
Colour woodcut
22 × 35 (8⅝ × 13¾)
Vienna, Österreichisches
Museum für angewandte
Kunst, Exner Bequest

771 Georges Seurat
*The promontory at Hog,
Grandcamp*
1885
Oil on canvas
64.5 × 81.5 (25⅜ × 32⅛)
London, Tate Gallery

772 Andō Hiroshige
Mountain ravine with moon
1832
From *28 Views of the Moon
(Tsuki nijūhakkei)*
37.2 × 16.5 (14⅝ × 6½)
Vienna, Österreichisches
Museum für angewandte
Kunst, R. Lieben Bequest

773 Katsushika Hokusai
Angling
c. 1826
From *1000 Waterscapes*
(*Chie noumi*)
Colour woodcut
25.8 × 38.2 (10⅛ × 15)
Tokyo, National Museum

774 Claude Monet
The cliff at Dieppe
1882
Oil on canvas
65 × 81 (25⅝ × 31⅞)
Zürich, Kunsthaus

775 Alfred Sisley
English coast
1897
Oil on canvas
53 × 64.5 (20⅞ × 25¾)
Hanover, Niedersächsische
Landesgalerie

776 Claude Monet
Fishing huts at Varengeville
Charcoal on paper
20.2 × 27.4 (8 × 10¾)
Private Collection

eye of the observer by leading off from one side of the picture (773). This method was not new to Europe; however, the strange shape of Hiroshige's rocks, and their spotty vegetation, were developed by European painters in order to make the view of the distant landscape more abstract. Monet often blocked off one side of the picture with a rock or cliff, and for this the steep cliffs of Dieppe (774, 776) were particularly appropriate. Sisley found similar cliffs on the English coast, and, inspired by Japanese woodcuts, he depicted them rising up diagonally.

Two other types of composition became important for the Europeans under the influence of Chinese and Japanese landscapes. These are the near and distant landscapes, seen from a sort of bird's-eye view (758–61). We find this viewpoint in a moderate form in a fairly tall rectangular format (773) and in an extreme variation which can be traced back to the *kakemono* or pillar picture (777, 778). With the view from above, which at the same time is a view from afar, the distant landscape, depicted in the tall narrow format, is perceived as a rising slope.

In 1871, in *Variations in violet and green* (759), Whistler had already used a high viewpoint under the influence of Hiroshige (758). Whistler painted this picture under the inspiration of the tonal colours in the Japanese woodcut, which, by means of subtle transitions in light colours, create depth. The stacking of objects in the picture one behind the other is another feature borrowed from the same model, as is the use of diagonals.

Lucien Adrion (760) chooses the same method in 1908; the light tonality tells us this, also the minute detail of the placing of objects in space, which is used as the basic element in the composition. In China this type of picture, as Hung Jēn's landscape makes clear (761), was already completely developed by the seventeenth century, and its compositional form had been tried and tested over several centuries. The extremely tall narrow format often combined the high viewpoint with the stacked landscape to produce an ideal, atmospheric concept. This concept corresponded in Japan to the intentional abstraction of nature.

Thus, in a deep ravine, the crescent moon could be

782 Japan
Sword guard
17th century
Iron, pierced with the
characters of a poem by
Yama-be no Akahito
D.8.2 (3½)
Private Collection

783 Emil Orlik
Artist's seal
First pub. 1902, cat. 14th
Exhibition of Vienna
Secession
Private Collection

784 Max Bernischke
Vignette
c. 1901
Pen and ink
16.2 × 16.4 (6⅜ × 16½)
Vienna, Private Collection

Signs and emblems

According to Far Eastern ideas, plants, animals, and everyday objects are far more closely interconnected than they are in Western cultures; they are among the mythical archetypes which combine the unconscious with the conscious.[1]

The mandala, or disc, divided in four and set in a square, is an emblem symbolizing the universe, and is used as an aid in meditation.[2] The state seal as a symbol frequently takes the form of a square in a circle or vice versa. The Shri-Yantra consists of a square outer frame around concentric circles in whose centre are fitted nine interpenetrating triangles. It indicates a temple with four towers and, according to Buddhist concepts, is to be understood as the heart of all believers. Those triangles pointing downwards signify the female principle, those triangles pointing upwards indicate the male principle. The centre point between the triangles symbolizes the

783

782

784

undifferentiated Brahma.[3] The Buddha picture from Sarnath near Benares shows a significant compendium of symbols. The backrest and seat of the god consist of a square which is the equivalent of the faithful. The seated Buddha himself forms a triangle. The great disc over the backrest is the symbol of illumination (*bodhi*).

The circle as an archetypal symbol is probably most significantly developed in the Far East. In the mandala the squaring of the circle is anticipated – a symbol which in the European Middle Ages already enjoyed great importance.[4] The circle, without beginning and end, symbolizes limitlessness in time and space. But it can also be the Wheel of Life – the 'universal round'. If the circle is divided vertically by a line it becomes the image of creation, or represents a combination of god and man. An S-shaped line signifies the polarity of the universe. In China this symbol indicates the interplay of growth and decay in the cosmos. The bright, creative, male principle is *yang*, the primeval force of the sun. The dark, receptive, female principle is *yin*, the fruitful earth, or the moon.[5]

The circular symbol of life draws all things into its radius; the process of stylization often leads to an

785 Alfred Roller
Artist's seal
First pub. 1902, cat. 14th
Exhibition of Vienna
Secession
Private Collection

786 Japan
Square and circle combined
From a *mon* book
Tokyo 1864
21 × 13 (8¼ × 5⅛)
Private Collection

787 Kanju
Octagonal sword guard
Iron, pierced with 8
geometric *mon*
D.7.1 (2¾)
Private Collection

788 Kolo Moser
Vignette
c. 1900
Pen and ink
8 × 8.5 (3⅛ × 3⅜)
Vienna, Private Collection

295

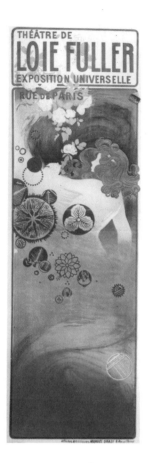

789, 790 Manuel Orazi and
Auguste-François Gorguet
*Posters for the theatre of the
dancer Loïe Fuller erected
for the 1900 international
exhibition in Paris*
Berlin, Staatl. Museen
Preussischer Kulturbesitz

791 Japan
Iris flower in circle
See 786

792 Japan
*Chrysanthemum in
geometric form*
See 786

793 Siegfried Berndt
after Honda Ichijiro
*Design for kimono fabric
Chidori birds over waves in
mon form*
Copy: gouache, partly
sprayed
27.2 × 19.8 (10¾ × 7¾)
Original Kyōto 1906
Colour woodcut
25.2 × 18 (9⅞ × 7⅛)
Private Collection

abstract decoration in the circle, but it still remains
linked in the main to reality (798, 799). It is also possible
for a symbol to have several different meanings. The
'butterfly' symbol (805) can, for example, be stylized
until it turns into foliage. In the same way, by
emphasizing the background it can become merely a flat
decoration. Seen from the side or from the front, the
butterfly can be elevated into a linear ornament.

The elements of fusion to the point of transformation
and abstraction are provided by the Japanese *mon*, or
family crests (793). These symbols appear on the coats
(*haori*) worn over the kimono (547, 694). They were
either left white by means of a resist process during the
dyeing or else neatly embroidered on. Usually the *mon*
was applied five times, on either side of the chest, in front
on each sleeve and once between the shoulder-blades;
but sometimes it appeared only once, on the back
between the shoulders. The kimono was similarly
decorated. The followers of a samurai wore their
master's crest, but in a larger version. The crest worn by
actors of the Ichikawa family in the Shibaraku scene was
also worn strikingly large. Its form, unusually, was
square; *mon* worn by other actors were usually circular
(547, 710).

In Japanese decorative art through the centuries the
form of the *mon* varied and proliferated.[6] It appears on
lacquerware, on textiles, or on the ridge tiles of houses,
becomes a seal, and sometimes even resembles a
porcelain mark.

These crests made a deep impression on European
craftsmen. They had been developed by means of slits
and calculated geometric cuts in a circle, and yet

296

exhibited that ornamental naturalism which was the basis of Art Nouveau. Publishers' colophons, modelled on the Japanese *mon* principle, were very successful in Europe and were developed into standard emblems which have retained their effectiveness to the present day, for example the colophon of Insel-Verlag (812).

Mon devices could be combined with several secondary motifs. Stylized landscape backgrounds were also in demand, and these decorative combinations were usual in the more ornate kimono designs. Manuel Orazi and Auguste-François Gorguet borrow this type of decoration in their poster for the dancer Loïe Fuller's theatre, erected in 1900 for the international exhibition in Paris (789, 790). Related compositional possibilities are provided by a Japanese textile design in which *chidori* birds are symbolic devices seen together with waves (793). In the black *mon* they can appear individually (794) but in the design for a kimono fabric they can appear superimposed on a background. The same is true of the round symbols in the Orazi poster, which can be contrasted with Japanese *mon* pictures (789–92).

The clear-cut linear outlines of *mon* led in Europe to new varieties of graphic composition. The contrast between the black and white surfaces was eagerly taken up by Art Nouveau artists (797, 800, 803, 804).

794 Japan
Chidori bird in a circle of waves
See 786

795 Japan
Chidori bird in a circle
See 786

796 Japan
Three chidori birds on the crest of a wave
See 786

797 Charles Ricketts
Vignette
Crouching water-nymph
surrounded by waterlily
leaves
London 1891
Illustration to Oscar Wilde,
A House of Pomegranates
Offprint as single sheet
Handmade paper
28 × 24.5 (11 × 9⅝)
Private Collection

798 Japan
Mon
See 786

799 Japan
Mon
See 786

800 Walter Crane
Arum lily in a circle
c. 1890
Pen and ink
D.7.5 (3)
London, Private Collection

797

798

799

800

801

802

803

804

801 Japan
Mon
See 786

802 Japan
Mon
See 786

803 Alfred Roller
Vignette
c. 1905
Pen and ink
15.6 × 13.2 (6¼ × 5¼)
Vienna, Private Collection

804 Kolo Moser
Vignette
Vienna 1899
Pen and ink
D.8.4 (3¼)
Repr. *Ver Sacrum*
Private Collection

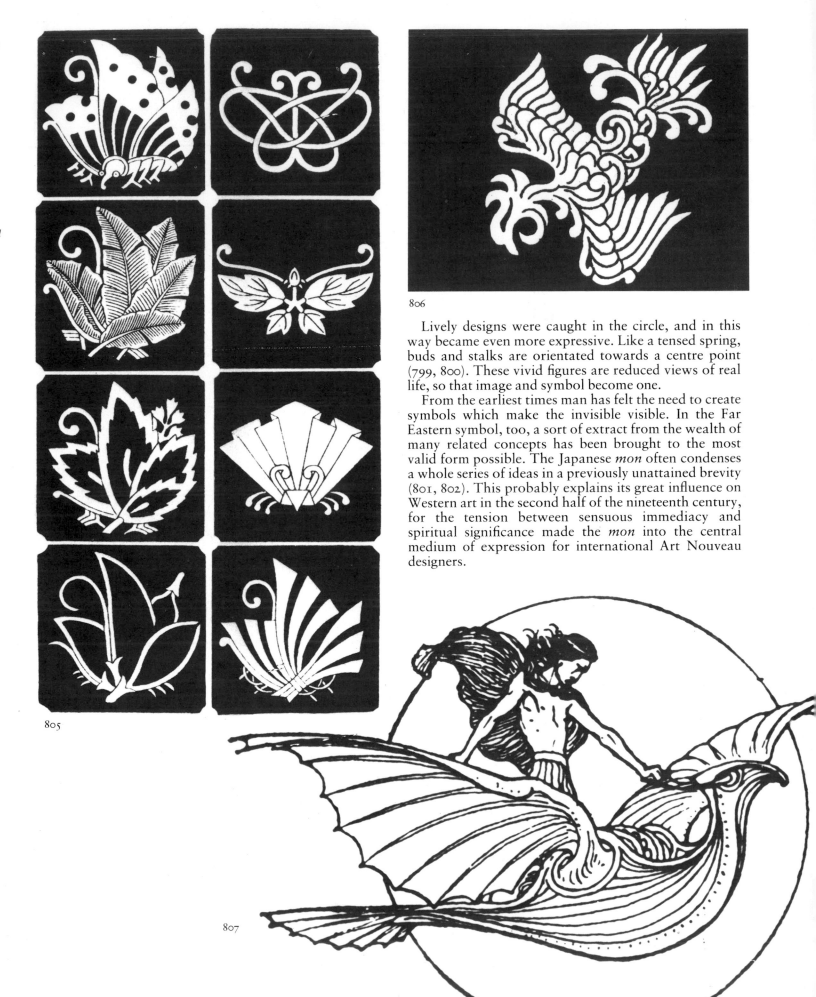

805 Japan
*Heraldic designs in the form
of butterflies*
From a painters' manual
Tokyo 1864
21 × 13 (8¼ × 3⅛)
Private Collection

806 Japan
Phoenix
Heraldically stylized in
Chinese manner
See 786

807 Fidus (Hugo
Höppener)
Vignette
Berlin 1906
From K. Henckel *Mein Lied*
16.7 × 13 (6½ × 5⅛)
Private Collection

806

Lively designs were caught in the circle, and in this way became even more expressive. Like a tensed spring, buds and stalks are orientated towards a centre point (799, 800). These vivid figures are reduced views of real life, so that image and symbol become one.

From the earliest times man has felt the need to create symbols which make the invisible visible. In the Far Eastern symbol, too, a sort of extract from the wealth of many related concepts has been brought to the most valid form possible. The Japanese *mon* often condenses a whole series of ideas in a previously unattained brevity (801, 802). This probably explains its great influence on Western art in the second half of the nineteenth century, for the tension between sensuous immediacy and spiritual significance made the *mon* into the central medium of expression for international Art Nouveau designers.

805

807

808

809

812

810

813

811

808 Japan
Crane
See 786

809 Heinrich Vogeler
Vignette, Crane in a circle
1900
Pen and ink
23.9×15.5 ($9\frac{3}{8} \times 6\frac{1}{8}$)
Private Collection

810 Japan
Crane in circular form
See 786

811 Japan
Crane
See 786

812 Emil Rudolf Weiss
Insel Verlag colophon
Leipzig 1899
Colour lithograph after a
pen drawing
D.8.6 ($3\frac{3}{8}$)
Private Collection

813 Japan
Sailing ship
(Model for the Insel Verlag's
colophon)
See 786

Ceramics and glass

Semi-precious stones and glassware

In the eighteenth century, European porcelain, ceramics and lacquerware were all influenced by China. The imitation and the testing of Oriental techniques opened up new insights. Eighteenth-century *chinoiserie* was concerned principally with motifs. With the beginning of the nineteenth century the world of Islam increasingly became an important influence on the art and culture of Europe, and also stimulated a detailed examination of an alien life-style. As well as architecture, the applied arts were seen as a rich and undiscovered territory which helped to develop creative insights. Islamic glass-making attracted widespread interest. The finishing of the surface by means of enamelling and engraving influenced the form of hollow glassware. Rose-water sprinklers and mosque lamps were new forms in contrast to those handed down since the Baroque. This increased knowledge led to a greater understanding of other non-European cultures.

Around 1860 it was again the Far East which, in the Japonisme of the second half of the century, exerted a decisive influence. For the glass-makers of Europe, Chinese jade and glass offered important points of departure for the working of the surface and the

814 François Eugène Rousseau
Vase
c. 1878–85
Glass crystal in the manner of Chinese *objets trouvés*, applied decoration
H.17.2 (6¾)
S. Germany, Private Collection

815 China
Vase
19th century, Ch'ing Dynasty
Rock crystal, *objet trouvé*, carved and engraved
H.14 (5¼)
Paris, Musée Cernuschi

816 Emile Gallé
Vase
c. 1905
Milky glass with corn-
flower-blue overlay, etched
thistle leaves signed on side
in Japanese manner
H.17 (6⅝)
S. Germany, Private
Collection

817 China
Snuff bottle
18/19th century
Ch'ing Dynasty
White glass with blue
overlay
Flaming pearl and dragon in
clouds over waves
H.7.7 (3)
Vienna, Österreiches
Museum für angewandte
Kunst

819

820

821

818

improvement of the metal. The shape and structure of
the vessel came to be based on those objects of semi-
precious stone which occupy a special place within Far
Eastern art.

The development of Chinese glass itself had been
influenced by the method of working semi-precious
stones and minerals. Various cameo techniques, relief
and intaglio carving , and partial overlay, were taken for
granted. These examples became the models for the
European glass-makers in the third quarter of the
nineteenth century. A systematic examination of these
techniques began. The metal (the raw material of glass)
was constantly improved, especially by the French
glassworks and factories, and the decoration of the
surface was just as intensively developed. The ap-
pearance was still modelled on semi-precious stone,
whose characteristics were to be assumed by the glass, by
means of enamelling and trailing – where the applied
decoration stands out considerably from the walls of the
vessel (814, 820) – and partial overlay (819, 852). The
working of the vessel walls with tools brings about
hollows and undercutting (822). By means of irregular
inclusions in the molten metal the vessel walls achieve an
asymmetrical movement with a concentric effect, and
also reveal their connection with the amorphous shapes
of the living rock and of minerals (814). The relationship

of these forms to stone carving is striking. It becomes
ever more obvious that China was the model.

The study of Chinese jade carvings influenced French
glass production for long periods after 1890 (833, 839,
844, 850). At the beginning two possible forms stand in
contrast to one another: translucent (819, 839) and
opaque glass. The translucent, rock-crystal-like metal is
the primary form but the amethyst and topaz-like
colouring are also early, as well as crackling (814), the
admixture of coloured oxides (850) and the irregular
accidental form (815, 819, 834). The opaque material
was already determined by Chinese carvings, and in
China itself contrasts already existed between the
material carved to a paper thinness (831) and the thick-
walled, irregular *objet trouvé*, where jadeite was
preferred for its coloration (818). The opaque surface in
minerals with two and more layers gave rise in glass-
making to many variations (816, 817, 818). Just as in
ancient China, a slight opacity in the translucent glass
was seen as giving it that jewel-like effect characteristic
of the semi-precious material, jade, itself.[1]

Important too is the dull, often greasy shine of
European glass around 1900, which has been taken over
from real jade (819, 833). (Jade is divided by the
connoisseur under various visual and tactile headings
which are supposed to indicate typical characteristics,

822

823

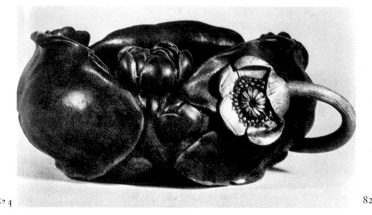

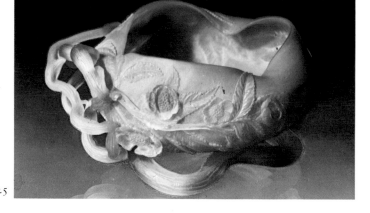

824

825

e.g. mutton fat jade, moss jade, etc.) The roughness or smoothness was imitated above all in Nancy, with polishing methods developed over a long period. As with the Far Eastern jade objects, the tactile qualities of glass were developed.

Hitherto, in the literature on Art Nouveau glass, there have been only general references to the Far East. There is a rich collection of snuff bottles in the Victoria and Albert Museum (London) which shows a similarity to the French glass collections of around 1900. However, Chinese snuff bottles (817) were not Gallé's only models, as has often been maintained. Already before the appraisal of Chinese glass and jade vessels by Alexander Nesbit in the 1878 glass catalogue of the Victoria and Albert Museum, Gallé, and also Rousseau, had been influenced by other examples from the Far East. Rousseau is thought to have known Japanese pattern books. The iconography of Gallé's decoration is already being more systematically researched, and so the attempt may be made to investigate form and surface structure in connection with the Far Eastern influence more precisely (see pp. 326–35).

The traditional symbolism attached to minerals and stones in the Far East struck a chord in European Symbolism and Art Nouveau. Through the decoration of glass vessels with similar themes, an artistic genre

came into being with many points of reference. Glassware took on an expressive character in the hands of the French glass-makers of the last quarter of the nineteenth century. The vase became an autonomous work of art with a high intrinsic value. Jewels, glass – 'expressive' materials – as well as translucent minerals, became highly significant for the whole circle of French and Belgian Symbolists. A certain atmosphere is created in the literature of the period through references to fine glass, and to the dull shimmer of semi-precious stones and their refraction of light. In its connection with symbolic decoration, glassware is unsurpassed.[2]

The glass-makers of the Nancy School and their imitators had recourse between 1880 and 1910 to nearly four hundred identifiable Far Eastern floral decorative motifs which, either individually or in combination, carry a symbolic message (844), together with a selection of animal symbols. For example, in China the iris has the same significance as the orchid; in Japan it is the symbol of victory but also 'the ancestor of perfumes'. The orchid is compared to the breath of a beautiful woman or the fame of a great man. Furthermore, this plant is an emblem of love and beauty, and of numerous progeny. Expressive decoration arises from a combination of 'speaking decoration' with milieu and life-style. Under-water motifs in a miniature carving, for example, stand

826

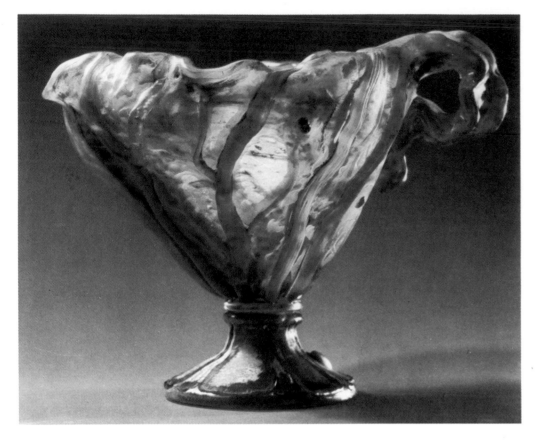

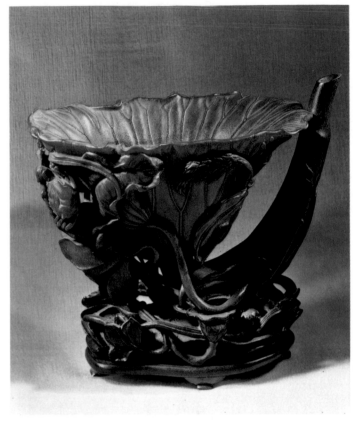

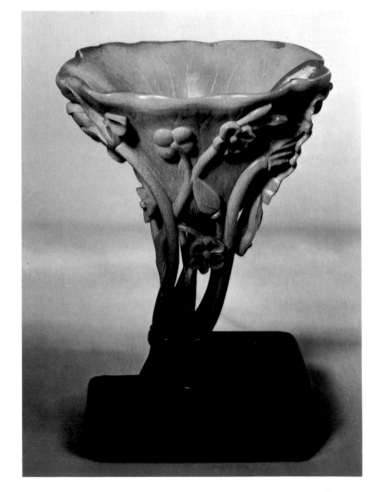

827 Emile Gallé
Vase in shape of Far Eastern goblet
c. 1898
Glass, coloured and pincered above the foot, with trailed decoration
H.14 (5½)
Private Collection

828 China
Goblet in shape of open flower
18th/19th century
Ch'ing Dynasty
Rhinoceros horn, carved
H.13.5 (5¼)
Berlin, Staatl. Museen
Preussischer Kulturbesitz
Kunstgewerbemuseum

829 China
Goblet in shape of open flower
17th century
Ming dynasty
Rhinoceros horn, carved
H.19.5 (7⅝)
Vienna, Museum für angewandte Kunst

for the whole of nature. Marshland elements used expressively can, in their function as microcosmic model, suggest a macrocosmic illusion (850).

It is often the consistency of the molten glass and its surface that provides the dominant effect. This often goes beyond mere expressive decoration and allows one to experience underwater light, to see opacity brought to life by means of small living creatures. The French Symbolist writers made depictions of the underwater world into the recurrent theme of their inspiration. André Fontainas, who repeatedly used this theme around 1900, is probably the central figure here. The expressive quality of nature seen in excerpt form is at the centre of their perception and of its symbolic meaning: the moonlit night with poppy heads, the moth on the cinnamon bushes, or Mount Fuji with clouds (844) and pine trees, are all connected with an impression which expresses more than botanical, zoological or topographical representation, for the nocturnal atmosphere is evoked by the opaque colouring with its soft refraction of light (868). Diffuse moonlight and the celestial bodies themselves are a favourite motif on French glass vases around 1900.[3]

The French school of Symbolist writers often chooses atmospheric moon motifs as its theme. Henri de Régnier writes his lines on 'The Yellow Moon'; Maurice Maeterlinck, Jules Laforge, Ivan Gilkin and others also belong to this circle. The underlying mild and yet intensive light evoked by their imagery is in harmony with the decoration of Art Nouveau glassware. One major French glass-maker provided the basis for this concept: François Eugène Rousseau, whose work was

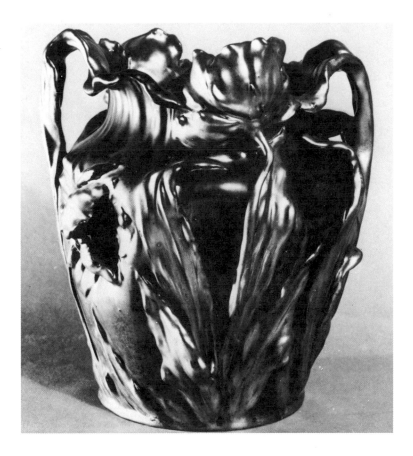

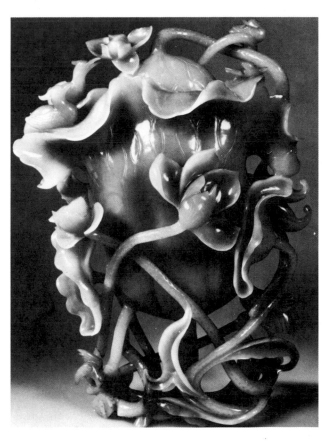

830 Vilmos Zsolnay
*Vase in the manner of a Far
Eastern jade vessel*
c. 1900
Stoneware with lustre glaze
H.27.2 (10¾)
Private Collection

831 China
Jade
18th century
Carved with lotus leaves,
flowers and birds
H.19.7 (7¾)
Geneva, Collection Baur

taken over and developed by Ernest Baptiste Leveillé. Consciously and systematically, Rousseau attempts to model his glass, both in consistency and in form, on Far Eastern examples. As early as 1867 he began, in his *service japonais*, to develop unusual forms under Far Eastern influence. In 1878 he produced his well-known smoky topaz or rock-crystal glass objects with crisselling after the Chinese model (814, 815, 851). These objects executed in glass crisselled or coloured with metallic oxides are an important influence on French glass production. Rousseau takes the thick-walled Chinese vessels of semi-precious stone even more directly as his model in his numerous attempts to recapture the lost technique of reproducing in glass the impurities in stones and minerals (844, 851). Collectors' items from the Italian Renaissance, particularly again of Far Eastern origin, with metal stands and settings from the sixteenth century, provided him with lasting inspiration.[4]

This jewel-like glass, whose bizarre effect is due to a mixture of chromium, iron, cobalt and manganese oxides, probably also inspired Emile Gallé. By 1889 Gallé had already been singled out by E. D. Vogüé in his *Remarques sur l'exposition de 1889*: 'Let us bless the whim of fate which has caused a Japanese to be born in Nancy.' Since 1884 Gallé had been producing vases inscribed 'E. Gallé à la Japonica fecit Nancy' (839). So far six vases with this inscription have been found. These pieces exhibit a close relationship with carved vases of semi-precious stone from China (815). It is not only the thick sides but also the irregular silhouette which is intended to convey the impression of an *objet trouvé*. Gallé produced vases with conical stumps of branches or

bark-like surfaces (839); Far Eastern cherry blossom occurs again and again.

All these pieces convey the same constant, jewel-like surface; Gallé emphasized this feature throughout his career. About twenty years later, in order to satisfy public demand, Gallé had to put again into practice in a new series the experience gained in the *à la japonica* series. In his *cristal jade* (1900) he develops a fine-grained opaque, greenish-yellow glass (833). The term *cristal jade* presumably refers to the *verre de jade* developed in 1893 by the Nancy firm of Daum, and betrays the European desire to equal the highly prized legendary stone, just as the forms are related to Chinese brush and water pots (832), ginger and incense jars. *Cristal jade* (833) is characterized by a high translucency and a high refraction of light. Its surface appears denser than that of the products of other manufacturers such as Daum. The undulating shape of the vessels, the thread handles and turned edges are strikingly realized in the lead crystal. The techniques of turning in and pincering the edges are used in a virtuoso manner.

In his *cristal jade* Gallé used variously tested engraving techniques, intaglio, surface and relief engraving after the Far Eastern model. A. V. Walter, Henri Bergé, and the Daum brothers also chose forms, above all for ashtrays (846), which were of Far Eastern origin. Georges Despret designed a fish with a stand in *pâte de verre* which goes back directly to a Sino-Japanese model (294).

The Daums' *verre de jade*, already exhibited in 1893 and therefore before Gallé, uses similar effects to Chinese glassware when it imitates vessels of semi-

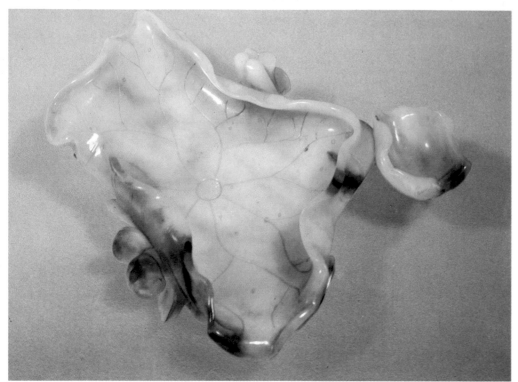

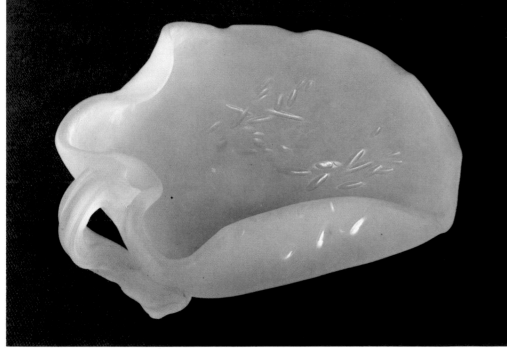

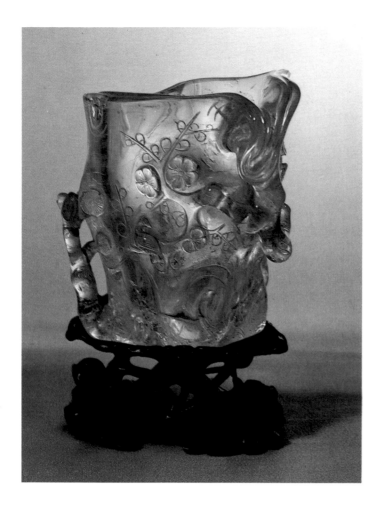

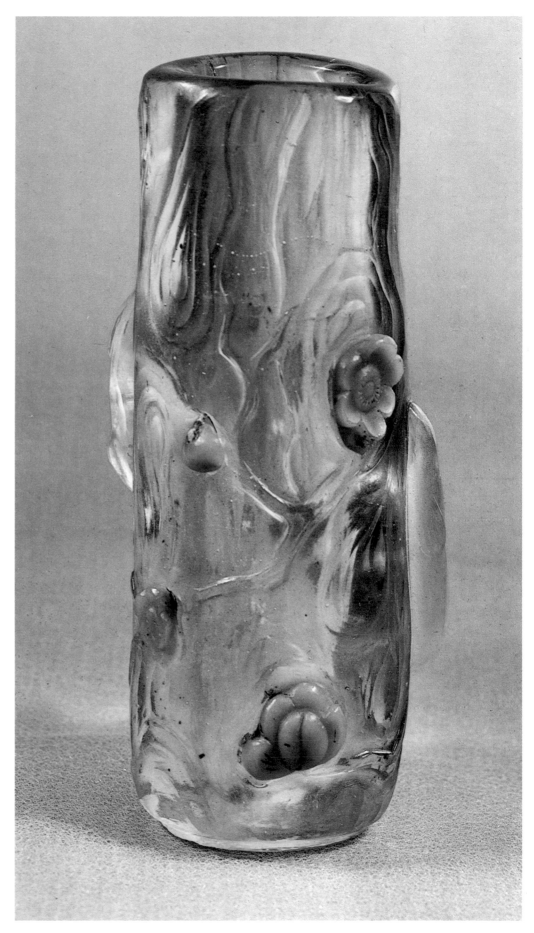

832 China
Water pot in shape of lotus leaf
18th century
Carved jade
H.6.4 (2½)
London, Victoria & Albert Museum

833 Emile Gallé
Dish with handle
c. 1900
Cristal jade
H.6 (2⅜) d.25.4 (10)
Düsseldorf, Kunstmuseum

834 Emile Gallé
Water pot
1899
Glass crystal engraved and carved with shell pattern
H.4.6 (1¾), l.1908 (7¾)
New York, Ex Museum of Modern Art

835 China
Water pot
18th century
Ch'ing dynasty
Carved jade
H.8.3 (3¼)
Private Collection

836 Leningrad
Vase in shape of gourd
c. 1900
H.12.7 (5)
Private Collection

837 New England Glass Co.
Vase
c. 1885
Coloured glass, pulled and pincered
H.28.6 (11¼)
London, Private Collection

838 China
Vase
19th century
Ch'ing dynasty
Carved rock crystal
H.14 (5½)
Paris, Musée Cernuschi

839 Emile Gallé
Glass vase in shape of hollow tree stump with cherry blossom
Nancy 1884–89
H.12 (4¾)
Frankfurt, Private Collection

846

849

847

848

846 Daum Brothers
Bowl (ash-tray)
1908–14
H.7.9 (3⅛), d.22 (8⅝)
Düsseldorf, Kunstmuseum
Collection Hentrich

847 Daum Brothers
Vase
1910–15
H.11.3 (4½)
Düsseldorf, Kunstmuseum
Collection Hentrich

848 China
*Hollowed-out stone with
frog and cherry blossom*
Ch'ing Dynasty
Carved soapstone
H.5 (2), l.15.5 (6⅛)
Private Collection

849 Emile Gallé
*Vase in shape of Far Eastern
goblet*
1898
Cased and flashed glass, with
applied decoration and metal
foil inclusions
H.17.3 (6¼)
Paris, Private Collection

850 Emile Gallé
Vase with lid
1892
Glass crystal with metal
oxide inclusions, carved and
engraved. Underwater
decoration, slight vertical
ribbing in the manner of
Chinese rock crystal carvings
H.26.8 (10½)
S. Germany, Private
Collection

851 François Eugène
Rousseau
Cup-shaped vase
c. 1890
Crackle glass with oxide
inclusions in rust brown
H.24 (9½)
Munich, Private Collection

852 Emile Gallé
Vase
c. 1898
Glass, coloured blue-grey to
resemble lapis lazuli with
inlaid minerals and metal foil
inclusions
H.42 (16½)
Munich, Private Collection

851

852

850

Vessels on stands

There are numerous examples in international Art Nouveau of bowls, glass vases and figurative objects with stands, though the origin and significance of the stand has so far not been researched. European glass and ceramic artists have examined examples of stands from almost all the Chinese dynasties and then copied them freely.[1]

The Sung and Ming dynasties in particular produced beautiful objects and vessels of jade (nephrite and jadeite) and chalcedony which were provided with equally magnificent stands. François Eugène Rousseau in particular took these vessels with stands as his models.[2] Permanent stands for European vases were usually of metal (854, 856) and their appearance and function was often taken to such bizarre extremes that the stand made the vessel appear of secondary importance.[3]

In Far Eastern tradition the stand is a symbol of Mount Sumeru, the axial point of the world.[4] The vessel of the godhead, or the miraculous alms bowl, should be imagined as hovering on the summit of the mountain. The imposing height and design of Far Eastern stands indicate their importance. The symbol of the sacred mountain was not the only model here; with those

853 Japan
Vases with stands
Woodcut
From a painters' manual
22.6 × 14.8 (8¾ × 5¾)
Tokyo *c*. 1875
Private Collection

854 Ernest Chaplet
Vase with metal stand
Paris *c*. 1910
Porcelain
H.17 (6¾)
Private Collection

855 China
Vase with wooden stand
K'ang-hsi Period
(1662–1722)
Porcelain, Hu type
H.18.4 (7¼)
Vienna, Österreichisches
Museum für angewandte
Kunst

856 Emile Gallé
Vase with metal stand
1888
Cased glass with floral
decoration
H.31 (12¼) without stand
Paris, Musée Galliera

vessels of semi-precious stone which incorporate plant forms, the base suggests roots which go deep into the earth. A fruit bowl resting on a stand in the form of roots can be seen on a Chinese screen of the K'ang-hsi period (1662–1722) in the Victoria and Albert Museum in London.[5]

The bowl on a stand of roots was of great significance for Buddhists since it represented a link with the centre of the earth. The fertility goddess Kuan Yin[6] in particular was often represented with a great stand of roots on which she placed the life-giving vessel. In this way the kingdom of the shades and the elementary earth gods were linked. Usually a mass of various exotic plants to indicate fruitfulness are depicted springing from the bowl.

The goddess Kuan Yin was also often represented with ducks which in Japan are symbols of marital harmony.[7] The goddess also forms a unit with the earth dragon and the children sitting on it.

The meanings of the vessel are numerous and can be interpreted variously. The vessel of ancient China had a religious significance. They were storage vessels for the sacrificial wine (863) or food. Those vessels of semi-precious stone often took their form from the sacred bronzes, usually with inscriptions that interested Gallé in particular.[8] Because of its fantastic shape Rousseau took the *kuang*, or pouring vessel, as his inspiration.[9] The vessel resting on a round stand often exhibits a curved lid with a dragon's head (862). The middle Chou period vessel resembling a sauce-boat, called an *I*, also recurs in Rousseau's work, though with a stand consisting of a whirlpool with a dragon rising from it (864).[10] This type was again produced in the Ch'ien-lung period (1736–95) in jadeite and nephrite. These examples usually rest on specially constructed wooden stands which are supposed, by carefully calculated artistic means, to separate the cult vessel from the everyday world (862).

A piece of decorative glass, far from being mass produced, was regarded as a jewel in Europe around 1900. During its creation, the piece was dependent on many accidental circumstances. The perfect harmony of each unique successful object against all odds was displayed by placing it on a stand. Such pieces, of course, stand out from the run-of-the-mill. This is true above all of the experimental pieces, much worked over and treated by the master himself or provided with an inscription. The constantly changing signature also emphasizes the development of these rare vessels.

I should like to add a few brief remarks here on the as yet unresearched phenomenon of the stand. Three types can be distinguished: (1) the temporary stand (855); (2) the permanent stand (856); (3) permanent and temporary stands added by specialized workshops. Reference must also be made to a piece of furniture as a stand. It was possible for a glass vase, already mounted on a stand of its own, to be placed on the console shelf of a piece of furniture. This provision of a double stand betrays a certain attitude on behalf of the owner towards the object.

1. The temporary stand (815, 838) in the Far East is very common. It is temporary in that the bowl or vase

857 China
Lotus blossom bowl
with stand
K'ang-hsi Period
(1662–1722)
Nephrite
H.17.2 (6¾)
Kansas City, Private
Collection

858 Emile Gallé
Vase with stand
Cased glass with metal foil
inclusions
H.13 (5⅛)
Munich, Private Collection

need not have been created together with the stand. This concept was imitated in Europe, and it was discovered that the stand could emphasize the vessel and make it more rhythmical (814, 850, 867). In England, Morris and Ruskin dealt with the question of the stand several times, and Rousseau used Far Eastern stands for his vessels and had stands made in the same manner.[11] The lightness and subtlety of the filigree-like decoration of the Far Eastern stand, usually of wood, caused the object to 'hover' in a way particularly suited to set off Art Nouveau glassware (850, 858). But fluted forms with a circular plan and cushion-shaped forms with a square plan were also popular. Gallé used this as a model for a piece in silver. (A good example, a carved vase with Turk's cap lilies in pink, purple and dark blue, exists in a private collection.)

2. The permanent stand forming a whole with a glass object. Numerous examples from the Nancy School and other centres of glass-making demonstrate the close connection of the vase with the permanent stand (856). This is frequently part of the artistic design. In general the stand remains here the base for the vessel rising above it. Both parts form a unit and are subject to the figurative process.

Chinese lidded vases exerted a not inconsiderable influence on European glass-makers. As urns according

to Far Eastern religious rules they were richly decorated (873). The foot of the vase is usually small so that the stand became necessary to enable the vessel to stand securely (850). Usually the vessel was slim and only very slightly bulbous. Foot and neck were very much narrowed, the walls were decorated with reliefs, and double handles created a definite symmetry (871, 873). The handles could also be shaped like branches. Rousseau often chooses two elephant heads as handles (871). In Europe the glass itself was opaque, streaky, crackled and cased and, above all, it was coloured variously when in the molten state (850, 856). The impulse to imitate jade or other semi-precious stones in colouring and form is obvious (825). The most elaborately worked pieces always exhibit harmonious proportions which take account of the stand.

The vases or bowls which Gallé, for example, creates together with stands appear out of proportion without them. Many important Art Nouveau glass objects displayed in the cases of a museum have a strangely flattened or badly proportioned effect with is usually due to the fact that they have lost their stands (852). Many vases by Gallé, Tiffany and Daum have a very delicate balance and cannot stand on their own, since the base of the object is too small. A good example is a glass vase

316

859 Auguste Delaherche
Bowl with silver mount
1900
Stoneware
H.9.3 (3⅝), d.17.3 (6¾)
Berlin, Staatl. Museen
Preussischer Kulturbesitz
Kunstgewerbemuseum

860 China
Bowl with stand
Sung Dynasty (960–1279)
Nephrite
16.5 (6½) with stand
Milan, Museo
Poldi Pezzoli

with a carved wooden stand by Durand (850). Here Gallé has taken a Chinese lidded vase as the model for his reception of Far Eastern ideas. The tiny diameter of the foot of the vessel is decisive here. The vase obviously needs a stand.

The wood-carver Edgar Paul Durand[12] made several stands of this type for Gallé, and they must be seen as one unit with the glass object. Gallé chose a shape for his stand curving outwards from a raised base and then in again; the decoration is unified by means of the underwater motif. The extreme height and slenderness of Gallé's stands are remarkable features which, as in the Far Eastern models, raise the vessel above the objects of the everyday world.

3. Permanent or temporary stands added by specialized workshops. The Nancy School employed numerous firms to produce stands for their important glass objects. In particular these were metal mounts which were connected with the stand (856). The undercut decoration on Chinese jade vessels was repeatedly taken as a model for European mounts.[13] (It would be a very rewarding specialized research task to find out which workshops made stands for the French glass-makers.)

Permanent or temporary stands were also created by notable Art Nouveau artists, most frequently by gold-

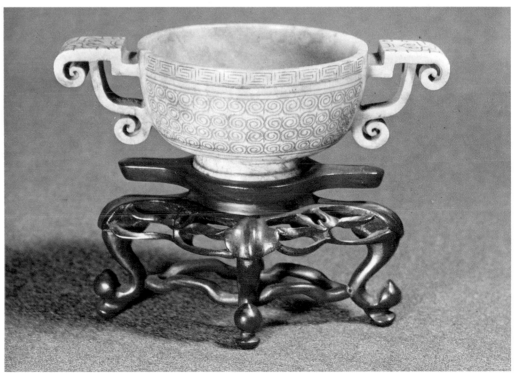

317

861　China
Sacrificial vessel dragon handle
c. 1600
(late Ming dynasty)
Jade, carved and engraved
7×16.7 ($2\frac{3}{4} \times 6\frac{5}{8}$)
Private Collection

862　China
Sacrificial vessel with stand and lid
Ch'ien-lung Period
(1736–95)
Nephrite, carved and engraved with phoenix and dragons
13.8×17.4 ($5\frac{1}{2} \times 6\frac{7}{8}$)
Private Collection

863　China
Sacrificial vessel with dragon handle
Northern Sung dynasty
(960–1127)
Nephrite, carved and engraved
H.26 ($10\frac{1}{4}$)
London, Victoria & Albert Museum

and silversmiths but also by sculptors, architects and designers. They made mounts and stands for glass vessels. Among them the most important were Louis Majorelle, Emile Mottheau, Joseph Chéret, Eugène Feuillâtre, Eugène Gaillard, Georges Hoentschel, Charles Plumet, Pierre Roche, Henri Vever and others. Workshop co-operation between Art Nouveau artists brought interesting combinations of vessels and stands into being. Unfortunately the valuable metal mounts have often been removed.[14]

Inspired by the shapes of Far Eastern stands, Europeans went further in creating the permanent stand. The glass vessel, on a slightly-raised foot, is set in a floral metal mount which is inspired by filigree-like undercut soapstone vessels (830). Convincing examples of this are two vessels in the Victoria and Albert Museum in London: a carved crystal vase with a gilt stand and a floral mount by Baccarat of around 1890 and a jade-like flat glass vase in the shape of a flower trumpet with a metal mount in the manner of Chinese water-pots.[15] Both show how the stand in the Far Eastern manner contributes decisively to the effect of the piece.

In 1896 Philippe Wolfers also creates a vase (868), which shows how Chinese jade carving inspired European silversmiths to invent constant new variations of Eastern prototypes.

Nineteenth-century Japanese bronze stands for bowls also exhibit shapes resembling huge waves stylized in a

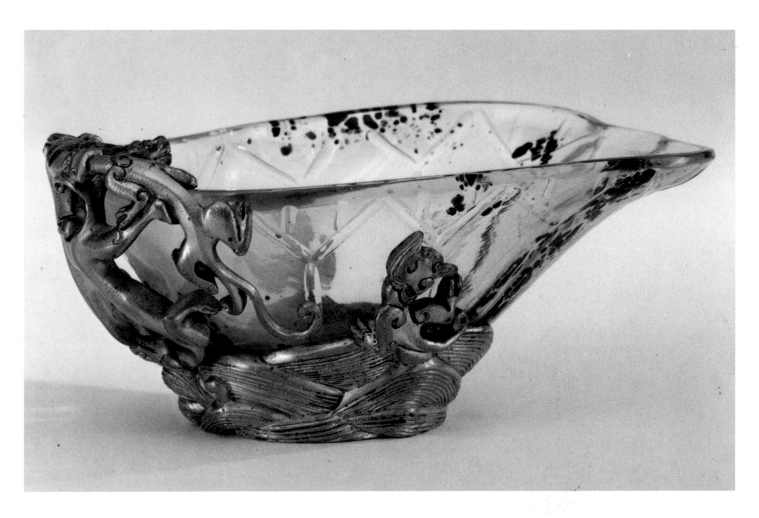

filigree-like construction.[16] European glass-makers had
probably seen these stands.

The discussions of the presentation of glassware at the
international and industrial exhibitions, and those of the
Vienna Secession, around 1900 are evidence of specialist
knowledge and lively interest.[17] The interest in glass-
ware, especially in the French examples, is great and
lasting. Gallé received four gold medals at the inter-
national exhibition of 1878, for, among other things, the
Chinese-inspired *clair-de-lune* vase with carp and
marine plants. In 1889 he received the Grand Prix and
gold medals and was also created a *chevalier* of the
Légion d'honneur.[18] The Daum brothers were honoured
in a similar way.[19]

Thanks to the well-thought-out design for and new,
bright light in the halls of the international exhibition,
the decorative glassware made an especially strong
impression on the visitors.[20] It is essential that vases,
bowls and services be displayed on the furniture of
important designers. The spokesman of the Vienna
Secession reports, for instance, on 'the deep blue
cupboard in the Pointillistes' room which, strangely,
fitted in so well with their colours. High up on it, of
course, shimmers glassware from Klostermühl'.[21]

In the Europe of around 1890 cupboards were
constructed more and more frequently for the display of
decorative glassware, especially decorative vases (874).
The standing and hanging shelf and the hanging

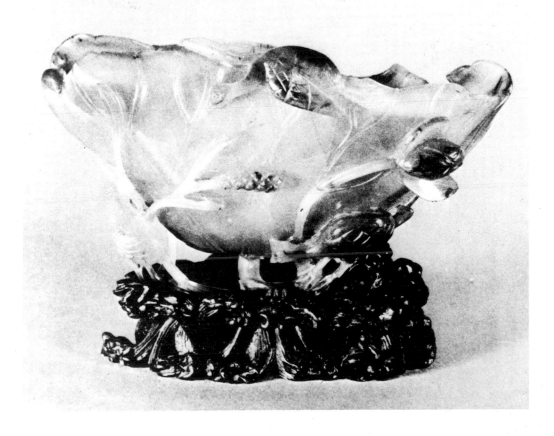

866 China
Baluster vase with stand
K'ang-hsi Period
(1662–1722)
Shadowy blue glaze, ribbed
decoration
H.28.6 (11¼)
Private Collection

867 Ruskin Pottery
Vase with wooden stand
1905–08
Pottery
H.15.3 (6)
Stand 6.2 (2⅜)
Private Collection

868 Philippe Wolfers
Vase 'La Nuit'
1898
Blue, pink and red enamel,
silver mount
H.16 (6¼)
Brussels, Private Collection

cupboard are all designed for this new function. These and many other types of furniture are fitted on both sides with symmetrical niches, consoles and fixed stands for decorative vases (875).

The dresser of the years after 1871 with its large centre compartment also fulfilled this function, though this type related to the French dresser of the sixteenth-century and also to the South German and seventeenth-century sideboard. The wealthier classes in the last quarter of the nineteenth century attached importance to stylistic imitation down to the ornamental vessels. The basic idea is realized with a certain capriciousness – 'everything which is there has a right to be there', and in this way everything reminiscent of antique vessels was collected, from the imitation German beer mug and the Venetian winged glass to the Islamic mosque lamp. The display was grotesque, for the niches were overladen with the most diverse objects. This new function of Art Nouveau furniture was to present a calculated display of decorative vessels (875). This display was important to its possessor and encouraged him to acquire decorative vessels.

In order to explain this phenomenon, let me just sketch in three types of furniture:

1. The development of the cupboard consists of side openings with consoles and stands, while niches can break up the front. Glass-fronted cupboards, side-boards, dressers, standing and wall shelves are given a much softer silhouette and thus achieve that lightness which complemented the decorative glassware and lit it from all sides. Cupboards and shelves of the Art Nouveau period therefore take on floral shapes on whose branch-like shelves the glassware floats like buds or blossom. These ornamental, protruding, apparently floating supports carry stand-like consoles (875) which, when seen together with the vessels, highlight the piece of furniture. That these measures were very much intended emerges clearly from the design drawings of important Art Nouveau architects. This highlighting of furniture is, however, not new. What *is* new around 1900 is the display of objects, in which the piece of furniture takes on secondary functions. The vessel as an *objet d'art* with a heightening effect shows a new, as yet unrealized, intrinsic value. The decorative glassware on the multi-stand cupboard appears as a dominating central element.

2. In contrast with the ornamental furniture which acted principally as a 'vase support' is the constructivist furniture of 1900 which emphasizes function. Henry van de Velde, Peter Behrens, Josef Hoffmann, Otto Wagner and Kolo Moser are all able to give their cupboards an unusual accent by means of decorative vessels (often French and of high quality) and so combine furniture and moveable objects into one aesthetic statement. Henry van de Velde had his patrons confirm that these smaller art objects would also be part of his overall design. Kolo Moser in Vienna acted similarly and the decorative vessels were often designed by the architect for the room in question.

3. A further type of furniture is the 'furniture sculpture', an object seen in every century. Three-dimensional figures holding chests, seats, beds, etc. are

871 François Eugène
Rousseau
Vase with stand
c. 1885
Cased glass with oxide and
gold foil inclusions, 2
chimaera heads on the
narrow sides
H.30 (11¾)
Karlsruhe
Badisches Landesmuseum

872 Emile Gallé
Vase with lid and stand
1892
Glass crystal with inclusions
to resemble Chinese rock
crystal
H.26.8 (10½)
Private Collection

873 China
Vase with lid and stand
K'ang-hsi Period
(1662–1722)
Nephrite with inclusions,
decorated with animal
symbols and 2 chimaera
heads on the narrow sides
H.22.5 (8⅞), w.11 (4¼)
Private Collection

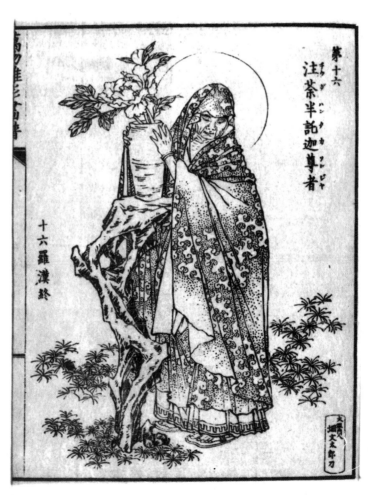

no rarity. Three-dimensionality is its primary characteristic and therefore determines the form. In Art Nouveau this furniture is again exalted into a special category, into a large-scale stand with an abstract effect which was created solely for the display of vases.

This type of furniture also appears in the shape of a table. Just as the Chinese display-tables for pairs of large vases has a cult character, so these strange Art Nouveau vase-tables give the large decorative vessel a special position. Glassware is so vital to these 'multi-stands' that without the vessels the piece of furniture appears like a cut-off torso. In summing up, one can say that the decorative vessel receives its definitive place when displayed by the piece of furniture – it is conceived by the architect together with the furniture so that it seems as if 'arrested' where it stands. It is of interest that, according to contemporary periodicals and commentaries, 30 per cent more of the objects displayed in this way were glass vases rather than ceramics.[22]

The decorative glass vessel at the turn of the century is therefore given visual importance by means of its display, which roughly corresponds to the visual importance of vessel display in Far Eastern cabinets. Only the porcelain cabinets of the seventeenth century form a similar display, but here the quantity devalues the individual piece.

In Far Eastern temple areas the sacred vessel is often removed from the everyday world by means of a stand. By means of the 'arrested' liberation of the high-quality Art Nouveau vase on equally high quality pieces of furniture, this vase receives a new accent and therefore separation from the everyday objects, as in the Far East or classical times and becomes an autonomous work of art.

874 Edward William Godwin
Sideboard
c. 1867
Mahogany, executed by William Watt
H.259 (102¼), w.157 (61¾)
d.56 (22)
London, Victoria & Albert Museum

875 Hector Guimard
Sideboard with fireplace
c. 1899–1900
Walnut with enamelled glass panels
H.252 (99½), w.183 (72)
d.65 (25⅝)
Lille, Maison Coilliot

876 Japan
Lohan with root stand and vase
Woodcut
Tokyo *c.* 1875
From a painters' manual
22.6 × 14.8 (8¾ × 5¾)
Private Collection

The bottle-gourd form

In the Far East the gourd is a symbol of long life and numerous progeny. It is also one of the attributes of the atavastic immortals.[1] The gourd must have been always to hand in abundance, either growing wild or on the cultivated plots of the peasants. With its flesh removed the gourd's hard exterior was sufficiently firm to serve as a receptacle. These vessels hardened with time; they were dried over the fire and fitted with straps to hang as flasks from the wayfarer's belt. The natural gourd shape, for example the bound double gourd, was in daily use as a cooling vessel.[2] For this purpose it was waxed on the outside and suspended in running water.[3] The Japanese carved gourd shapes out of wood and used them as tea caddies; or else carried them in silk bags at the belt. Gourds appear in numerous Chinese and Japanese scrolls, screens and woodcuts. They appear frequently in Hokusai's work.

In magic, great powers were attributed to the gourd. Li Tieh-Kuai, the mythical pupil of Laotse, is represented as a begger with a gourd; strange forms rise from the gourd and vanish with the clouds. The gourd also appears frequently on *netsuke* attached to the *inro* or other containers carried by the Japanese.[4] But the most beautiful gourd shapes are to be found in ceramic art. Japanese stoneware with its roughness, its grainy surfaces, its waxen and greasy glaze effects, was particularly suited to imitating the natural variety of gourd shapes and their fantastic surfaces. The gourd inspired artists using the most varied techniques: Oribe, Ki-Seto or Rakuware. In Japanese the word *shabi* signifies the conformity of an object to its function and vital essence. The gourd has a relentless vigour in its growth; it can flourish in the most adverse conditions. This tough plant was bound to become a model for symbolic concepts.

When the Prince of Satsuma exhibited masterpieces of Japanese pottery at the 1862 international exhibition in London, their importance was recognized by a number of specialists, and especially by the English potters.[5] The Satsuma bottle in the Victoria and Albert Museum, of the seventeenth or eighteenth century, is one of the most important pots in this genre (882). It is based on the gourd shape.

The bottle-shaped pots of Adrien Pierre Dalpayrat (881) would hardly have been possible without these models. As in the other examples, the plump, generous shape combined with the grainy smoothness characteristic of the gourd give them a tactile quality.[6]

Taxile Doat was *sculpteur* at the Manufacture Nationale in Sèvres from 1877. He created his tactile ground with the technique of *pâte-sur-pâte*. The ribbed form of the gourd (879), passing down to four 'feet' at the bottom gives mobility to the smooth porcelain through the interplay of reflected light. The effect is heightened by the lightly buckled, grainy surface of the pot, which harmonizes with the mottled decoration.

The bottle-gourd shapes of the Porzellanmanufaktur in Berlin are also worthy of mention. The ox-blood glaze appears strongly bleached on the ridges. Even compared with Chinese examples, this 'Seger' porcelain has been brought to a high degree of technical perfection and artistic quality. This helped to heighten European understanding and insight of the advanced cultures of the East. Jean Carriès takes up the grooved and mottled surfaces of the gourd species. He examines these carefully in his striving for extreme accuracy, and at the same time abstracts the shape of the pot through the use of snakeskin glaze. Over a dark brown slip, flowing gold with thick rills and droplets is used to heighten the effect.

In Japanese ceramics the form of the calabash, a variety of bottle-gourd, was often decorated with painted colours; or else it was left plain, as an object for use (877).

If we analyse its assimilation in the sphere of ceramics, the form of the gourd is subject to strong abbreviations pressing towards the bare essentials of the form, illustrating, in their porosity and weatherbeaten character, the traces of long survival.

878a 878b

879

880

882

881

325

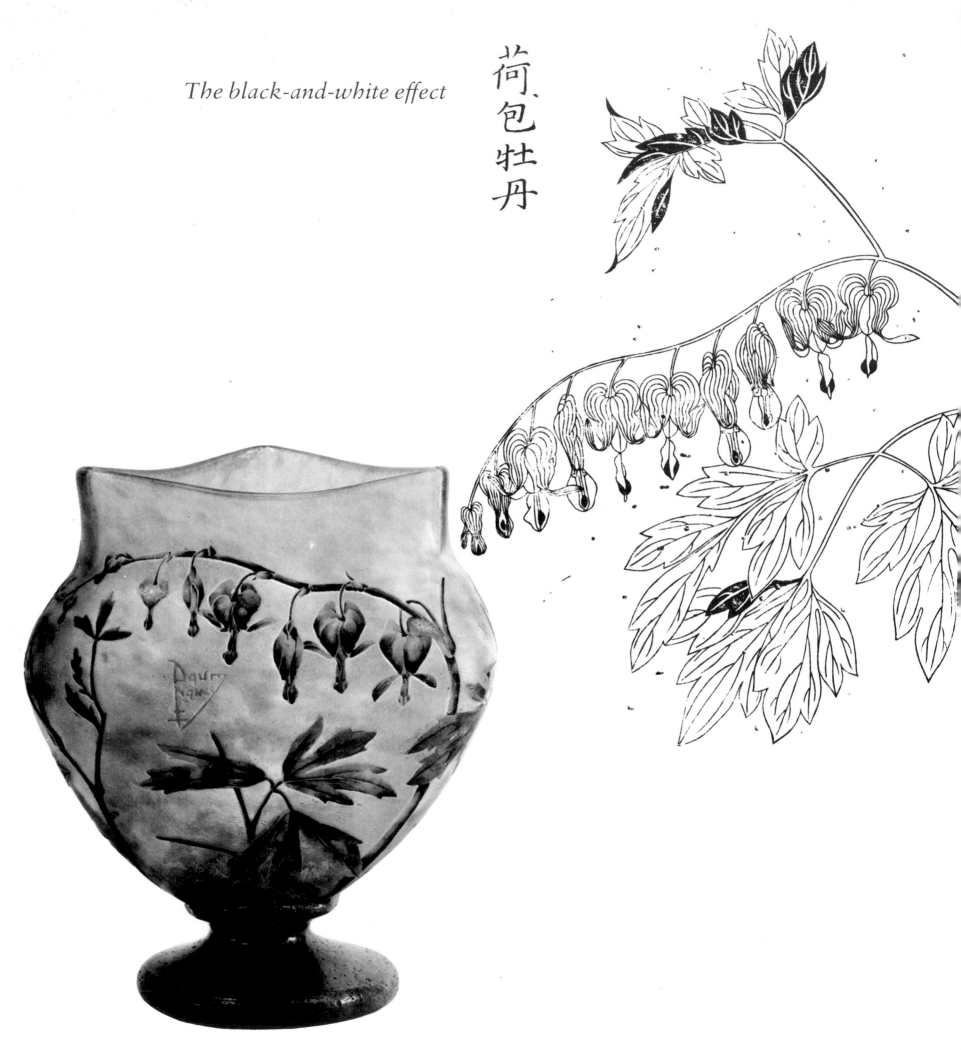

The black-and-white effect

荷包牡丹

The Japanese painter Nishikawa Sukenobu wrote in 1742 in an appendix on painting in his illustrated book of myths *E-hon yamato huji*: 'In plants, the distribution of light and shade must be properly understood; when painting the leaves or stalks, the upper surface must show the sunlight, and the lower or darker parts remain in shadow (887). These observations must be accurately studied.'[1]

The Japanese painter of plants always starts with a confidently delineated, expressive line reproducing all the characteristic details of the plant (884). There is no hatching in the manner of *katagami* stencil work, because everything is reduced to light on a dark ground or vice versa. Leaf structures are rendered fanned out as in a silhouette. Things superimposed on one another are fitted into the one plane by staggering the various layers (895). In this way leaves and flowers in motion can be 'arrested' on the surface by means of a minimal spatial shift – here, too, the Japanese artist achieves a high degree of illustrative legibility and the largest range of information possible.

In the eighteenth and nineteenth centuries, specialized books on botany and medicine in Japan took over this technique of drawing plants.[2] The upper sides in a group of leaves could be drawn in white with black veins, and the lower sides in black with white veins. This made the picture even clearer (898). This method also creates the possibility of arranging the picture decoratively, subordinating it to the composition desired by the artist (887). The forms of the buds, leaves and blossoms were raised to the level of a comprehensible and vivid pictorial sign which could be reproduced at will.[3]

The typical marks of the species were always retained, and, as they tended to form a pattern they could easily be arranged as a pattern repeat.[4]

There is one genre of European craftsmanship which is particularly suited to this form of representation: the ornamental glass vase with flower and leaf decoration.[5]

In the 1870s and 1880s the diversity of European grinding techniques and decorative forms created a plethora of styles in glass finishing and surface treatment, from which there arose no new points of departure.[6] The body of the pot was already suffering to the point of destruction through the methods of deep cutting and grinding. Technical means were pushed to the limit and the overall shape of the vessel was annihilated.[7] In such a situation, the representational technique of the Japanese flower artists had a lot to recommend it. Not only did it provide a rich repertoire of forms, but it made deep grinding of the pot body seem unnecessary (856, 886).

Furthermore, there was a desire for more variety in the forms of ornamental vases. Japanese flower and leaf decoration, rediscovered around 1900, contributed to an original creative development of the glass body in terms of volume (843).[8]

In the production of ornamental vases around 1890 in Europe it is clear how the plant decoration enhances the volume of the shape. The lack of shadow in Japanese plant drawing, the clear outlines, and the crossing of curved lines – all bound together by the rhythm of dark/light contrasts – contributed to this enhancement

883 Daum Frères
Bulbous vase on a base
c. 1903
Opaque white glass, red brown and green overlay, decoration of bleeding hearts after Japanese models
H.21 (8¼)
Private Collection

884 Japan
Bleeding hearts
1843
From *Botanical Handbook of Shrubs* (used as pattern book by Gallé and Daum Frères), II, 12
26.8 × 19 (10½ × 7½)
S. Germany, Private Collection

885 Emile Gallé
Vase
c. 1900
Green glass, etched, enamelled, partly gilded, bleeding hearts ornament in red and white relief enamel on ground etched to resemble ice glass
H.25 (9⅞)
Private Collection

886

887

椪葉
珊
瑚

886 Ericot
Vase
c. 1900
Coloured glass, etched and
engraved, leaf and berry
ornament
H.32.8 (12⅞)
Private Collection

887 Japan
Leaves and berries
1843
From *Botanical Handbook
of Shrubs*, I, 14
26.8 × 19 (10½ × 7½)
Private Collection

888 Legras & Cie
Vase
c. 1910
Colourless glass, with
brownish inner casing and
white and green overlay,
etched and cameo carved leaf
and berry ornament
H.17.6 (6⅞)
Private Collection

889 Emile Gallé
Vase
c. 1918
Mould-blown glass, matt,
opaque white ground,
multiple overlay in shades of
brown, etched, rowan berry
ornament
H.39.5 (15½)
Private Collection

890 Fachschule Haida
Vase
Before 1905
Crystal glass, etched,
engraved grape ornament
stylized in the manner of
Japanese models
H.15.4 (6)
Vienna, Österreichisches
Museum für angewandte
Kunst

891 Fachschule
Steinschönau
Vase
Before 1905
Glass, purple overlay, with
matt, carved vine ornament,
engraved tendril and
blossom ornament on the
ground
H.28.5 (11¼), d.25.8 (10⅛)
Vienna, Österreichisches
Museum für angewandte
Kunst

892 Fachschule Haida
Vase
Before 1905
Etched ground, dark red
overlay, tendril and berry
ornament
H.19.6 (7¾)
Vienna, Österreichisches
Museum für angewandte
Kunst

893 Daum Frères
Vase
c. 1900
Cased, powder-decorated
glass, low-relief blackberry
ornament, after a Japanese
pattern book
H.62 (24⅜)
Private Collection

894 Fachschule Haida
Vase
Before 1905
Pink glass with wine-red
overlay; vine and berry
ornament etched in the
overlay, circles etched in the
ground
H.16.2 (6⅜)
Vienna, Österreichisches
Museum für angewandte
Kunst

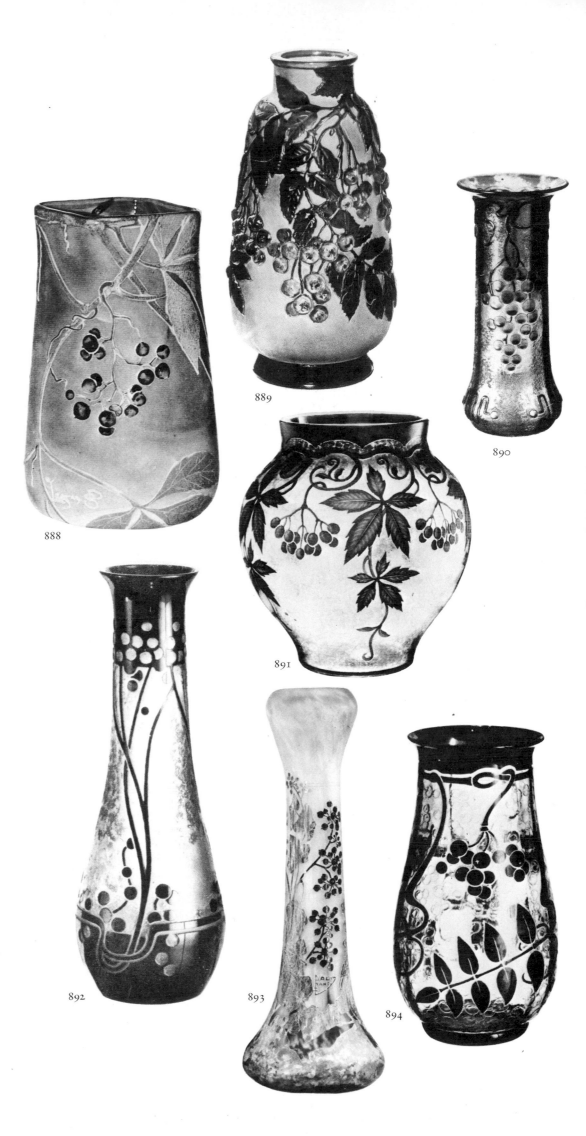

888

889

890

891

892

893

894

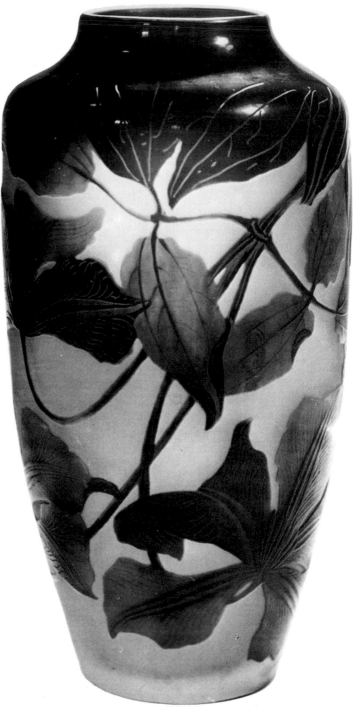

of the volume. Graver, grinding wheel and, later, etching mask were able to reproduce the ornamentalized forms exactly. The simple but vigorous outlines of leaves, stems and buds are exactly copied (896). The serrated edges of the leaves are often executed just as precisely as in the Japanese botanical text-books (886), and the incised veins of a leaf are perfectly realized (891, 896). The ground areas are as shallow as possible, especially where multiple overlays of coloured glass are treated using the Chinese technique of jade-polishing (883).[9]

With the growing demand for Japanese design, the manufacturers of ornamental vases were very eager to get information and direct instruction from the Japanese.[10] The case of the Japanese painter and botanist Tokouse Takacyma is well known.[11] He spent 1885–88 in Nancy and came in contact with Emile Gallé. But Gallé, who had already encountered the engraved snuff-bottles in the Victoria and Albert Museum in London in 1871, probably saw Japanese botanical books when visiting Takacyma. By the end of the 1880s one could buy Japanese woodcuts in the department stores in Paris. There are indications that the design studio of the Daum workshop in Paris had access to the work *So-moku Ki-hin Kaga-mi*, published by painters and botanists in Kyoto in 1828.[12] Individual parts – mostly boughs – are copied exactly on the ornamental vases of the brothers Daum. The typical colour range of the Daum studio in Nancy may also derive from this source. But the great treasure-house of forms and pictures collected by Samuel Bing in Paris also animated the Japanese trend and provided detailed information.

In May 1888 Bing's magazine *Le Japon artistique* – also printed in French, English and German – was published. In this, plant studies from the great arsenal of the Japanese sample books were reproduced, and used directly for engraved glass.[13] As the writings of W. Anderson (1879), T. Duret (1874), Louis Gonse (1883),

330

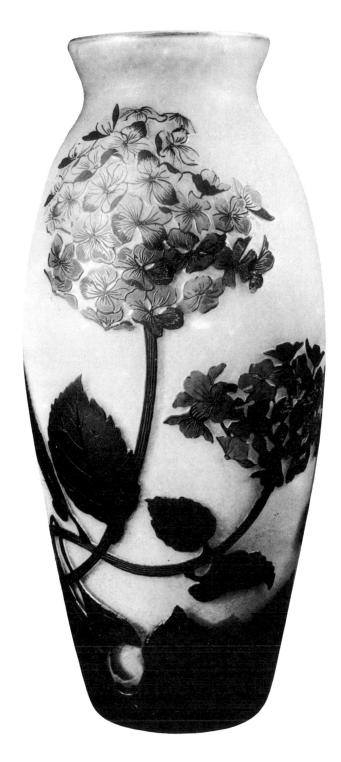

897 Saint-Louis, Argental
Vase
c. 1900
Light brown glass, darker
brown overlays, etched
hydrangea ornament
H.40.1 (15¾)
Private Collection

898 Japan
Flowering bush
1843
From *Botanical Handbook
of Trees and Bushes*, I, 1
26.8 × 19 (10½ × 7½)
S. Germany, Private
Collection

Ernest F. Fenollosa (1885), Karl Madsen (1885), and
Edmond de Goncourt (1891) – to name but a few – began
to appear, public participation in the concept of
Japonisme became stronger and stronger.

Philippe Burty was an art critic and – from 1881 –
Inspecteur des Beaux-Arts. A connoisseur and pas-
sionate collector, he enjoyed the friendship of the
Goncourt brothers. No one has so far disproved that it
was he who coined the word 'Japonisme' in his 1872/73
series of articles under that title.

The collector Enrico Cernuschi also possessed an
exquisite collection of engraved Far Eastern glass, and he
was interested in the early works of Gallé. Emile Guimet
also deserves a place: he collected with great perspicacity
and provided a direct stimulus to the great French glass-
finishers. Equally important are the international
exhibitions of 1862 in London, 1867, 1878, 1889 and
1900 in Paris, 1873 in Vienna and 1904 in St Louis. The
importance of these encounters cannot be overstressed;
here people not only stared and studied, they also bought
Japanese and Chinese artworks, or urged institutions to
acquire them.

But the decisive thing was always direct contact with
Japan. In this respect the art dealer Tadamasa Hayashi
and his compatriot Wakai played a particularly
important role. Alongside Louis Gonse, editor-in-chief
of the *Gazette des Beaux-Arts*, these dealers had a
significant share in the 'Japan cult' that was developing
in Paris. With his book *L'Art japonais* (1883) Gonse
exerted a strong influence on artists, primarily those in
France. So there is nothing far-fetched in the assumption
that the Japanese botanical block books were quickly
snapped up as reference material. The *Botanical
Handbooks of Trees and Bushes* must also have been
known to Gallé and Daum (898–902). They had been
published in Tokyo in 1846 but had more recently been
rediscovered in Kyōto.[14] This series in particular, with its

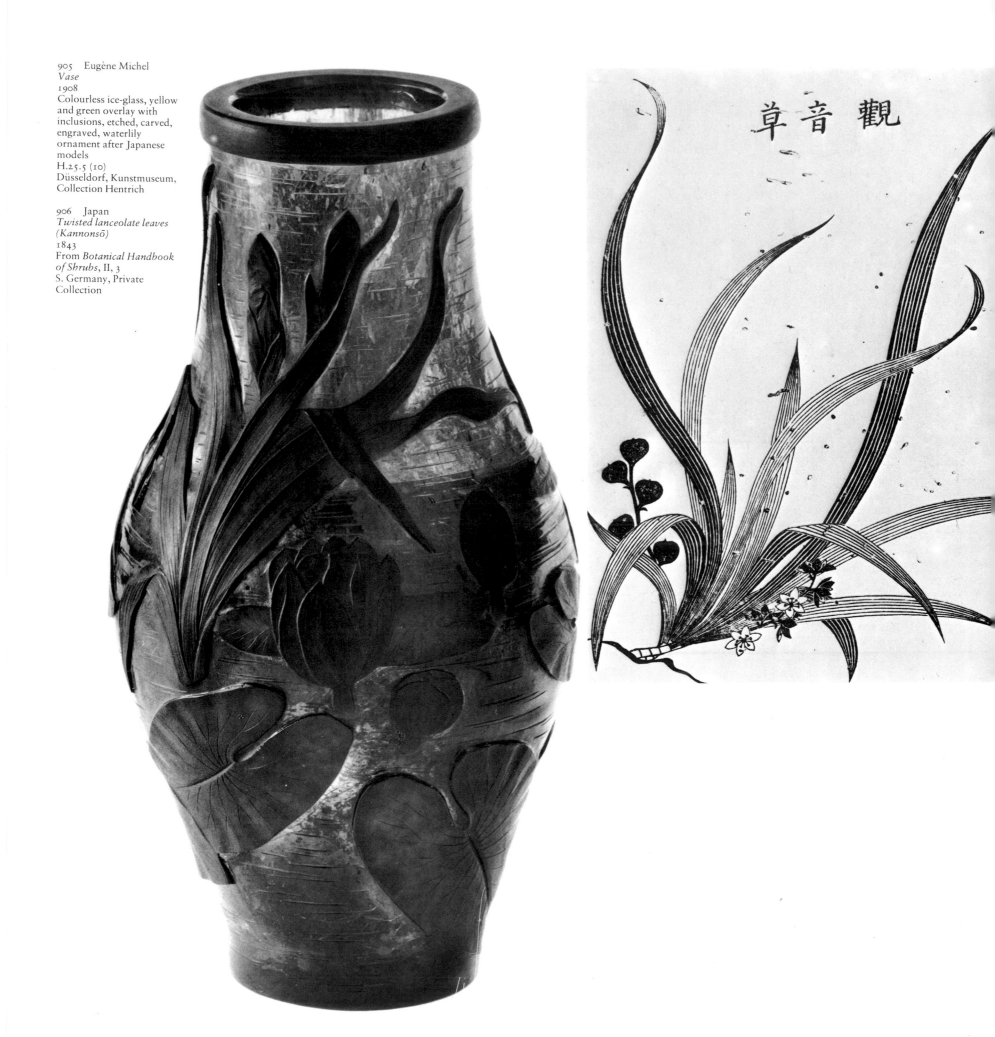

905 Eugène Michel
Vase
1908
Colourless ice-glass, yellow
and green overlay with
inclusions, etched, carved,
engraved, waterlily
ornament after Japanese
models
H.25.5 (10)
Düsseldorf, Kunstmuseum,
Collection Hentrich

906 Japan
*Twisted lanceolate leaves
(Kannonsō)*
1843
From *Botanical Handbook
of Shrubs*, II, 3
S. Germany, Private
Collection

草音觀

334

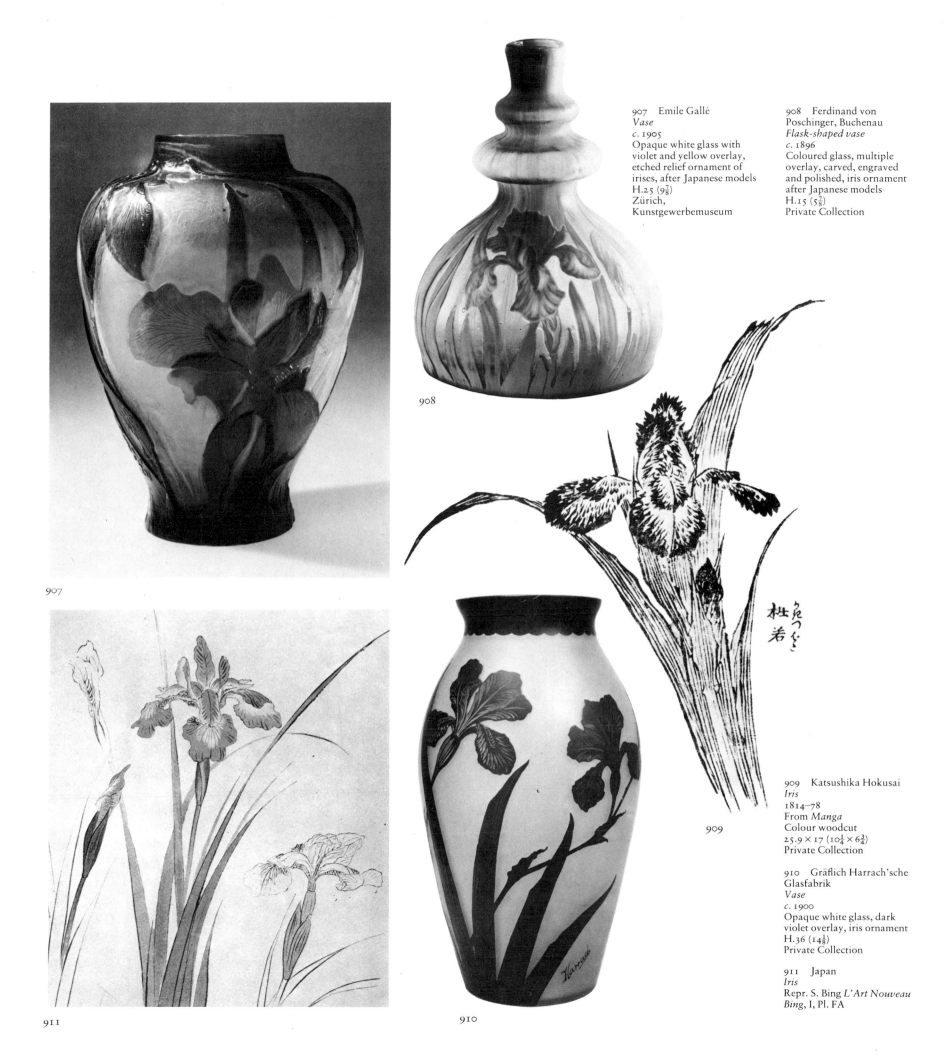

907 Emile Gallé
Vase
c. 1905
Opaque white glass with
violet and yellow overlay,
etched relief ornament of
irises, after Japanese models
H.25 (9⅞)
Zürich,
Kunstgewerbemuseum

908 Ferdinand von
Poschinger, Buchenau
Flask-shaped vase
c. 1896
Coloured glass, multiple
overlay, carved, engraved
and polished, iris ornament
after Japanese models
H.15 (5⅞)
Private Collection

908

907

909 Katsushika Hokusai
Iris
1814–78
From *Manga*
Colour woodcut
25.9 × 17 (10¼ × 6¾)
Private Collection

909

910 Gräflich Harrach'sche
Glasfabrik
Vase
c. 1900
Opaque white glass, dark
violet overlay, iris ornament
H.36 (14⅛)
Private Collection

911 Japan
Iris
Repr. S. Bing *L'Art Nouveau
Bing*, I, Pl. FA

911

910

335

912 China
Globular vase
16th–17th century
Porcelain, three-coloured
dragon ornament, enamel on
green *biscuit*
H.41.3 (16¼)
London, Victoria & Albert
Museum

913 Martin Bros., Southall
Vase
1902
Martinware
H.23.8 (9⅜)
Private Collection

914 Théodore Deck
Dragon vase
c. 1895
Lead-glazed stoneware
H.36.9 (14½)
Hamburg, Collection Heuser

915 China
Flask-shaped vase
Early 15th century
Porcelain
H.45 (17¾)
Tokyo, Collection Ataka

916 China
Flask-shaped dragon vase
1820–50
Porcelain, celadon glaze
H.25.5 (10)
London, Victoria & Albert
Museum

917 China
Lizard vase
17th century
Kuang-tung ware
H.28.7 (11⅜)
Vienna, Österreichisches
Museum für angewandte
Kunst

918 Theo Schmuz-Baudiss
Lizard vase
c. 1900
Stoneware
H.29.8 (11¾)
Stuttgart,
Württembergisches
Landesmuseum

919 Stevens & Williams
Vase
c. 1928
Colourless glass, white
interior casing, lustre painted
ornament
H.19.8 (7¾)
Düsseldorf, Kunstmuseum,
Collection Hentrich

920 Edmond Lachenal
Lizard vase
After 1900
Stoneware, yellow crackled
glaze on white ground
H.29 (11⅜)
Munich, Private Collection

337

923 Christine Atmer de
Reig
Stem cup
1970
Porcelain
H.12.4 (4⅞)
Hamburg, Private Collection

924 China
Stem cup
Ch'ing dynasty
(17th–18th century)
Porcelain with cobalt blue
underglaze
H.11.5 (4½)
Stockholm, Östasiatiska
Museet

925 Henri Simmen
Vase
After 1900
Stoneware, celadon glaze,
Ebony base, ebony lid with
ivory knob
H.20.5 (8)
Munich, Private Collection

926 Minton
Vase
19th century
Porcelain
H.37.2 (14⅝)
London, Victoria & Albert
Museum

927 China
Vase
Ch'ing dynasty
(17th–18th century)
Porcelain
H.31.5 (12⅜)
London, Victoria & Albert
Museum

Chinese ceramic forms

Japonisme in Europe did not only look to Japanese models. It also took account of China, and this was facilitated particularly by the manifold exchanges between the Far East and Europe in connection with the *chinoiserie* of the eighteenth century. The Japanese model gave rise to a stronger assertion of individual independence. In the nineteenth century there was also a change of attitude towards non-European peoples. The concept of differing ways of life emerged; and a connection was established between man's existence and surrounding nature. Japonisme was to confirm the multiple possibilities of mutual adaptation and demonstrate the profusion of individual types that result from this. Even the shaping of the objects of daily use gradually came to be imitated – as could be seen in the great public exhibition of the time.

The presentation of Japanese art reached a climax with the Paris Exhibition of 1878. French writers in particular wrote numerous and extensive commentaries on the Japanese section. The official report of the exhibition had this to say:

the only innovation is the inclusion of Japanese formal elements in French art. These charming, fantastic creations are the focus of attention. The artists set about making boxes or bowls using Japanese shapes and decorating them with leaves and blooms in the inimitable manner of the Japanese. This would be all well and good were it not for the presence of the Japanese themselves in the exhibition, were it not for the fact that the simplest chiselled bronze by their ordinary nameless craftsmen is so much more beautiful, lively and inspired than

the most expensive gold and silver pieces by the manufacturers of Paris and London. In all instances where the Europeans have stepped into the genres cultivated by the Japanese, the gulf between the good Japanese works and those of the Europeans is so striking that a comparison is hardly possible.[1]

This report gives an idea of the drastic changes taking place in European crafts as a result of the encounter with Japan. Japan's influence was felt in all spheres, from textile design to metalwork. Attempts were even made to imitate lacquer items in *papier mâché*. Félix Brac-quemond, eagerly studying Hokusai's *Manga*, made etchings that faithfully copied the Japanese, and these were used to decorate the *service japonais* commissioned by François Eugène Rousseau, which later became so famous.

The Chinese vase forms gained renewed recognition in their effect on Japan, and were understood as fundamental forms. The imitation of Chinese vases had already been fashionable in Europe, especially in the eighteenth century. The porcelain collections were full of imports from the Far East, alongside pieces by European manufacturers. The predilection for copying the pottery of the Far East has persisted into the twentieth century. When the potters grappled with difficult techniques or glaze experiments, they would do so on the basis of some Eastern form, and often demonstrated their successes in a very characteristic, formally Eastern shape.

The firm of Samson in Paris produced copies of Chinese porcelain pieces of the *famille noire* and *famille verte*, and imitated Japanese porcelain decorated in the

928 René Lalique
Vase in gourd form
After 1900
Glass, etched and engraved,
bottle-gourd ornament
H.19.2 (7½)
Private Collection

Kakiemon style. But it was not long before this work went beyond the bounds of mere copying.

For experiments of this type, the potters preferred the shapes of the Ch'ing Dynasty, or Manchu period. The Manchus came to the assistance of the last adherents of the Ming Dynasty in putting down a rebellion, and then in 1644 proceeded to take over the empire for themselves. They moved their residence to Peking and awarded themselves the title 'Ta Ch'ing' ('Great Pure').[2]

The extension of the empire to include Korea, Manchuria, Mongolia, Turkestan, Tibet and Nepal brought many geographical and cultural novelties. Large parts of Indochina became dependencies of the Manchus as well.[3] Pottery went through an important period of fertilization through this territorial extension and through trade with Islamic countries. The K'ang-hsi period (1662–1722), the Yung-cheng period (1723–1735) and the Ch'ien-lung period (1736–1795) mark important stages in this process.

The renewed stimulus of Chinese art contributed to the development of a new style in the production of porcelain in late nineteenth-century Europe. The Royal Porcelain Manufactory in Copenhagen played a leading role as a result of the efforts of Arnold Emil Krog, its director from 1885. His revival of underglaze blue painting heralded an artistically important phase. The underglaze blue of the Manchu period had various shades: the K'ang-hsi potters achieved the best results. A stem cup in luminous blue is illustrated here (924). This very elegant pot may derive from a shape of the Hsuan-te period.

Naturally the twentieth century harks back to these important traditions. Through the development of science, trade routes and increasing geo-politics, cultural dividing lines have become more and more weakened and it is perfectly understandable that European ceramic artists have never broken contact with the Far East.

The standing bowl by Christine Atmer de Reig does not use the blue glaze but a kind of peach-blossom combination of colours (923). Nonetheless, this glaze sprinkled with purple is an example of the kind of successful experiment that has continually enriched the potter's art.

The monochrome white glaze on baluster-shaped vases also demonstrates an attempt to reduce, to simplify, by omitting the painterly decoration which generally covers the whole pot in the Manchu period. The Chinese vase (927) of stoneware material has a tucked-in curved neck over a strongly arched shoulder which is further decorated with two animal masks bearing fixed ring-handles in their mouths. The English vase by Minton and Co, Stoke-on-Trent (926) is closely related in shape to the Chinese.

Another decorative element stemming from the Far East was the application of motifs onto the body of the pot, and the technique of perforating the wall of the pot itself. This method of decoration, seen in Chinese porcelain of the eighteenth century, was particularly emphasized by the workshops of Rorstrand (near Stockholm) (198) and Bing & Grondahl in Copenhagen. Ceramic artists were stimulated by the multicoloured porcelain of the late Ming and early Ch'ing. The term 'three-colour decoration' (Chinese *san ts'ai*) was apposite in the sense that the pots usually used a selection of three colours from the normal range (turquoise, violet or aubergine, blue, yellow and white), with the colours separated from one another by crosspieces. In this type of porcelain the alkali lead silicate glazes, tinted with metal oxides, are applied directly onto pots that have been biscuit fired. They are fired again at medium heat in the 'muffle furnace'. These pots have been a stimulus to ceramic artists from Art Nouveau to the present.

The process of Europeans taking over these and other forms (933–35) always brings with it the necessity of grappling with the content of the advanced cultures of the East. The issue was no longer what it had been at the time of *chinoiserie*, the search for unknown forms: now it was to exchange direct cultural experience.[4]

Celadon and white porcelain

929 China
Bowl
Sung dynasty
(960–1267)
Ch'ing-pai porcelain
Incised rosette ornament on
inner surface, peony stems
on outer face, lobed rim,
glazed
H.6 (2⅜), d.9 (3½)
S. Germany, Private
Collection

Celadon glaze is used on porcelain of a number of shades. The basic colour is monochrome green that appears related to some shades of jade. Jade is an important cult stone in the Far East. Its colours range from moss green to white, yellow-green to red-brown, ice blue to smoke grey, and all these shades have influenced pottery.

Yüeh-yao ware stems from the district of Shao-hsing in the northern part of the province of Chekiang, once called Yüeh. The bodies are an earthy grey. The feldspar glazes are light and transparent with a grey-green shade. Whether this colouring was intended to imitate the patina of bronze or the surface of jade is not relevant here. There has, in any case, been a great and continuous demand for these greenish to white-green pots over the centuries.

Celadon ware has passed through a lengthy development. The technique was already perfected in the period of the Five Dynasties (907–60). The variants, such as speckled and Hong-chou celadon, are complicated special forms. Celadon achieved its highest artistic quality in the period of the Southern Sung (960–1279), and production continued right into the Ch'ing Dynasty. In this period Chinese ceramics achieved notable improvements in terms of balanced artistic form. The dignified monochrome glaze ennobles the stretched, flowing or plumply arched vessels.

Northern celadon is olive green, with incised decoration under the glaze. It is related to Korean ware. Impressed patterns of lotus or peony tendrils, fish in waves, etc., are frequent.

The white porcelain of the Sung Dynasty, Ting-yao, produced in Chien-tzu T'sung in the Ch'u-yang-Hsien region, is a highly prized product of the Northern Sung period (around 1100). Generally produced for household use, these pots were also used for presentation purposes. The bowl shape is very frequent. The undecorated body is turned very thin: these are some of the most beautiful examples of Far Eastern ceramics. Some have decorative arabesques merging into the pale background, and this enhances the nobility of the volumetric form.

European potters were particularly fascinated by Ting-yao ware, because the impeccable form was not influenced by colour or structure. Jan Boutjes van Beek, Walter Popp, Ursula and Karl Scheid have achieved notable results with the technique, and the younger potters have recently begun to take up white porcelain based on the Chinese Ting-yao.

930 Stig Lindberg
Stockholm
Bowl (centre)
Porcelain
D.13.6 (5⅜)
Vienna, Österreichisches
Museum für angewandte
Kunst

931 Ursula Scheid
Bowl (left)
Porcelain
D.16 (6¼)
Deidesheim, Museum für
moderne Keramik

932 China
Bowl (right)
Sung dynasty
(960–1267)
Ch'ing-pai porcelain, in
lotus-flower form
D.17.5 (6⅞)
Stockholm, Private
Collection

933 China
Bowl
Sung dynasty
(960–1267)
Lung-ch'üan yao stoneware
D.16.4 (6½)
Stockholm, Collection
Johannes Hellner

934 Bernard Leach
Bowl
1963
Porcelain with celadon glaze
D.24.5 (9⅝)
Paris
Private Collection

935 China
Bowl
Lung-ch'üan yao stoneware
with celadon glaze
H.10 (4), d.22.3 (8¾)
S. Germany, Private
Collection

345

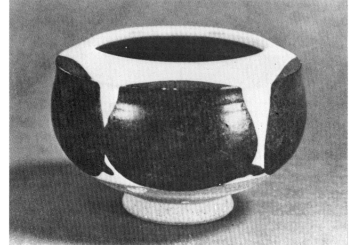

936 Konrad Quillmann
Bowl
c. 1965
Stoneware, made of pale fire-
clay, indigo glaze on beige
H.9.5 (3¾), d.(5⅛)
Deidesheim, Museum fur
moderne Keramik

937 Japan
Bowl
Yi dynasty (15th–16th
century)
Pale clay, white glaze
H.8.2 (3¼)
Tokyo, National Museum,
Hirota Collection

938 China
Small pot
Northern Sung dynasty
(10th–11th century)
Tz'u Chou yao ware
Clay, slip and sgraffito
decoration in black and
white, glazed
H.7.2 (2⅞)
Tokyo, National Museum
Hirota Collection

939 Meigetni
Bowl
India ink on paper
Inscr. 'The rice bowl is
necessary, even when it is not
in use.'
26 × 54.1 (10¼ × 21¼)
Tokyo, Private Collection

Japanese tea ware and modern pottery

Japanese tea bowls, tea caddies and water vessels have
had a long-lasting, stimulating effect on European
potters from the end of the nineteenth century up to
today.[1] Clay with its impurities, as dug out of the
ground, is a raw material which emphasizes plainness
and simplicity. To achieve a strong, granular surface,
Japanese stoneware uses clay mixed only with sand. This
material, moulded into shapes handed down from
antiquity, was appropriate for the content of the Tea
Ceremony. This ritual of tea drinking demanded
surroundings as simple and unassuming as the objects of
the ritual itself, which somehow symbolize this simplic-
ity.[2] In the Tea Ceremony the most important vessels
are the tea caddy (*cha-ire*) (946–50), which holds the
powdered tea, and the tea bowl (*chawan*) out of which
the participant takes small 'dense' sips of hot tea.

The oldest tea caddies are Chinese oil flasks of the
Sung Dynasty, and the oldest tea bowls are Chinese rice
bowls of the same period. Korea too, the cradle of Far
Eastern ceramics, with its simple but well-proportioned
forms and surfaces, was an inspiration to the Japanese
potters.

346

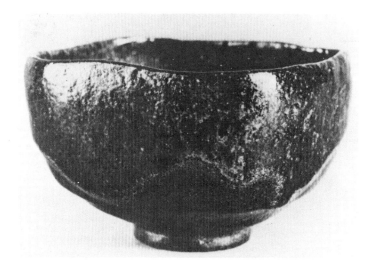

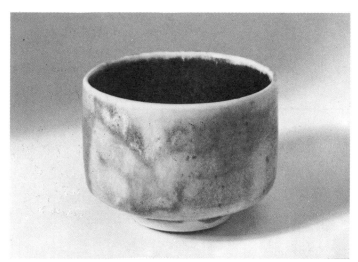

Tea bowls, distorted in firing or crazed, were like the earth they came from. The tactile surface of the *chawan* was supposed to be rough and handy, like the stones found in the fields, by rivers or on beaches.[3] The small bowl became the sacred object of Japan, as evidenced in the famous tea bowl of Koetsu, 'Fujisan', from the early seventeenth century.[4] In the famous old tea houses, prominent Tea Masters collected magnificent bowls, and the search for simple objects persisted. High artistic quality appeared to lie in extreme simplicity. This does not, however, correspond to the Zen idea. Tea Masters over the centuries did not select according to aesthetic principles; their choice of objects was intuitive, the results of Zen inspiration. Thus, austerity or asymmetry of form was desirable, but not obligatory. And whether a pot was old or of high quality was of no significance. Unity, or uniformity as expressed in sets of pots, was also rejected, because this did not correspond to the chance unity of the Zen idea. For this reason, bowls and tea caddies could come from China, Korea, Northern or Southern Japan. The decisive thing was the incorporation of the vessel – or rather of the *chain*, the person involved with its use – in the Tea Ceremony. In the early days of the Tea Ceremony, vessels were imported from China. This was before the time of Sen-no-Rikyu (1521–91),[5] who brought about a reduction in basic standards of plainness and simplicity, even extending this to the natural materials surrounding the tea. As a result of multifarious forms, techniques and attitudes, each of the provinces of Japan developed its own wares. One of the most important was that produced by the Raku family in Kyoto.[6] Raku ware (940) was considered particularly appropriate to the Tea Ceremony. Its silky smooth, plump surface 'flattered the hand'; the exploratory grip of the connoisseur – or rather the initiate – was intimately connected with the object in use. The origin of this form must be sought in the sixteenth century. This type of bowl symbolizes or embodies solemn devotion, and the disciplined rise of the pot wall is equivalent to that deepening contemplation which buttresses the spirit.

Japanese ceramic art rests on a subtle aesthetic which can be grasped, both sensuously and intellectually, by those with a sympathetic leaning towards the subject. Fundamentally this art demands that the object be adapted to its use. The basic principles of the potter were the following. Powerful form is a question of a consistent process; the tea bowl signifies concentration and silent absorption in the object, the *wabi*; *shibui* signifies the discipline, the consistency, the unpretentiousness, the raw quality, the austere essence. The pot must not express intention; it must revert to its fundamental values. The beauty of discretion is the first commandment; chance and everything mathematically conceivable are concealed in this aim. Therefore asymmetry in form and content is not dictatorial, and not brash; it is anonymous and yet totally itself.

The Tea Ceremony became a unified ensemble: the tea house with its garden (998), the plants and stepping-stones (1012), the water pot and the tea bowl, the ladle and tea caddy, the *tatami* mats and the sacred recess or *tokonoma*, the scroll painting and the artistically

940 Japan
Tea bowl
Edo period (1603–1867)
Black *raku* ware
H.7.5 (3)
Tokyo, National Museum
Hirota Collection

941 Wilhelm G. Albouts
Bowl
1967
Pale stoneware, ox-blood glaze on inner surface, pale orange and green on outer surface
H.7 (2¾), d.10.5 (4⅛)
Deidesheim, Museum für moderne Keramik

347

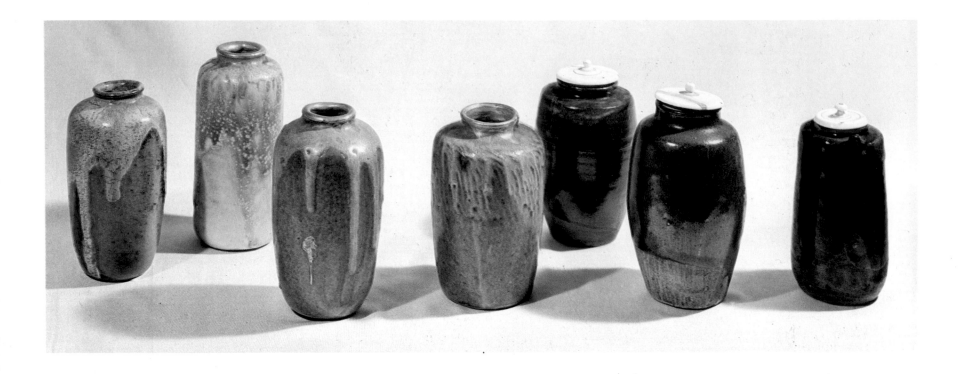

positioned twig, the deportment of the Master and the absorption of the guest: the harmony of all things pervading the atmosphere, as apprehended by Rikyu.

In keeping with the introverted world generated by the Tea Ceremony there was nothing loud or obtrusive in the *chain*'s collection. For the 'tea service' itself, the most restrained shapes and glazes were preferred. For example, the Ido ware of Korean origin was prized, with its sinking grey-blue glaze covered by a network of *craquelure*. Tea Masters also considered bowls of Chien-yao ware particularly appropriate. These pots, of Chinese origin, were called *temmoku* in Japan. The dark, iron-rich stoneware body was taken as a model by potters of twentieth-century Europe. In the guest's hand the smoothness of the dense glaze is tangible as it trickles down in droplets to the foot-ring. Descriptions of this type of pottery repeatedly emphasize the unusual colour structure of the glaze. It is like the 'breast feathers of a partridge', says the chronicler, or like 'the fur on a hare's back' – hence the generally accepted designation 'hare's-fur glaze'.

Classical *temmoku* offered many variations, for example the greeny-black glaze slightly lightened by the stretching of the glaze pigment towards the rim of the bowl. This formation in *temmoku* bowls is referred to as 'tea dust' (957). These bowls were copied frequently and are produced to this day at Seto, in Owari province.

The more rustic type of blue-white ware, called *sometsuke* by the Japanese, was also beloved by the Tea Masters right from the beginnings of the Tea Ceremony. These pots have a gay, carefree character. The shape has an easy firmness and the colouring sits beautifully on the yellow background of the *tatami* mats. Greenish celadon (935), with its quiet tones, is also very frequently found in the tea rooms of Japan. The celadon group must have had the largest range of variation, and was directly connected with its country of origin, China. The feldspar-rich monochrome glaze was capable of adaptation to every kind of use. In early Tea Ceremony times in Japan, celadon Sung bowls were the most common.

When the influence of the Tea Society began to grow in Japan, the demand for tea utensils also grew, and in the sixteenth century the indigenous production of these wares in the Seto kilns acquired a great reputation (963). The work of Kato Toshiro, considered the founder of the Seto centre, lay at the centre of this development.

At definite intervals there arose the preference for simple rural ceramics. Besides demonstrating religious allegiance to a central authority, this broke down the trend towards heightened aesthetic stylization. Naive, coarse pots with hefty shapes and gentle reddish-brown bodies were brought in from the provincial kilns. The pots from Iga, Tamba and Shigaraki (979) have a naturalness and carefree joy in the making that is peculiar to them. But most impressive is the Bizen ware, with its unglazed walls bearing the traces of daily use. Shino ware from the Nagoya district is one variant of tea ceramics highly prized by connoisseurs. For all its plainness, there is an impulsive strength in the economic curve of the walls with their lightly waving rims and firm socket-like foot-rings. Their glaze is compared with the flush of yellow pearl. Its creamy flow contrasts well with the foaming green tea. The lovely surface is enhanced by the abstract signs adorning it. These are applied in copper oxide with confident strokes of a brush or stick.

Karatsu ware (969) represents a high point in the Korean type of tea ceramics. It comes from the north of Kyushu. The calligraphy adorning the pots is unexcelled. It forms part of the matt background, yet speaks out eloquently and poetically. Satsuma ware from Kagoshima (882) is also among the highest of artistic achievements.

949 Georges Hoentschel
Covered pot
1898
Stoneware
H.14.5 (5¾)
Paris, Collection Alain
Lesieutre

950 Japan
Tea caddy with ivory lid
18th century
Stoneware, dark brown glaze
H.9.3 (3⅝) (without lid)
Vienna, Österreichisches
Museum für angewandte
Kunst

951 Jean Carriès
Vase
c. 1890
Stoneware, cream and gold
flow glaze over brown glaze
H.20 (7⅞)
Paris, Collection Alain
Lesieutre

952 Japan
Wine jar
1765–1812
Flow glaze over brown glaze
H.19.5 (7¾)
London, Victoria & Albert
Museum

953 Jean Carriès
Vase
c. 1894
Blue and white flow glazes
over brown
H.14.8 (5⅞)
Munich, Private Collection

954 Jean Carriès
Vase
c. 1890
Stoneware, reddish and
white glazes making a
mottled, snakeskin effect
H.20 (7⅞)
Munich, Private Collection

955 Japan
Flask
Running glaze
Repr. S. Bing, *Le Japon
artistique*, 8, December 1888

The significance in Europe of Japanese tea ceramics is something that has not yet been fully comprehended, but public interest in it is growing; potters and collectors have of course valued this art from the beginning.[8] The Japanese style removes the bondage of luxuriant decoration. The freedom to leave the pots unadorned creates decisive new potential. It has brought a liberation of form and an escape from the European stylistic pluralism of the late nineteenth century.

Around 1900 European potters began to carry out basic research into their Far Eastern models. They attempted to analyse the bodies and glazes with the aim of emulating them. Flow glazes were central to their interest, and to their efforts to create analogies. The random effects, the colour combinations, the smoothness and roughness, and the unrestricted flow of the glazes corresponded to Japanese models; and the calligraphic art of Japan had already shown the effectiveness of a casual trickle or a broad fleck.

A group of avant-garde French ceramic artists exhibited their work in the great 'Exposition de la Céramique' in Paris in 1897. Among them were Eugène Baudin, Alexandre Bigot, Adrien Pierre Emile Dalpayrat (881), Albert-Louis Dammouse, Auguste Delaherche, Taxile Doat, Edmond Lachenal and – one of the most important – Jean Carriès (953, 954). Carriès had worked as a chemist and as a sculptor. In his workshop at Saint-Amand-en-Puisaye he lived the secluded life of an old Japanese potter. He had seen Japanese stoneware at the international exhibition in Paris in 1878 and been greatly impressed by it. Following the example of the Japanese, he tested the simplest materials, the materials to be found in the immediate vicinity of his workshop, for his glazes (951).

In the tradition of Zen Buddhist tea ceramics, he chose taut shapes pushing outwards from within. His flow

956 Ralf Busz
Bowl
1965
Stoneware, reduction fired
H.7.8 (3), d.14.2 (5⅝)
Private Collection

957 Gerald Weigel
Bowl
1968
Stoneware, beige inner
surface, dark brown glaze on
outer surface
H.8.6 (3⅜), d.11.4 (4½)
Private Collection

958 Hans Heckmann
Bowl
c. 1967
Stoneware, shiny black glaze
run over ochre
H.7.5 (3), d.12.4 (4⅞)
Private Collection

959 Heidi Kippenberg
Bowl
1968
Stoneware, reduction fired,
white, beige and black
running glazes
H.9 (3½), d.12.5 (5)
Private Collection

956

958

957

959

960

961

962

963

glazes are supported by powerful swellings, broad shoulders and necks. Carrying forward the Japanese tradition of speckled decoration, he pioneered the application of gold on the pot, not only as a covering on cracks, but as a colour mass (951). The gold is patinated and subdued to fit in with the yellow-brown, grey and rusty tones of the background (953).

Georges Hoentschel also made stoneware pots in the manner of the Japanese and modelled himself on his friend Carriès. He favoured livelier colours and more dramatic glazes (942–45). The application of gold on his pots was inspired by Carriès. Hoentschel was a collector, he knew Samuel Bing, and his collection contained some important Far Eastern pots.

In England too, and in Germany and Austria, centres were being formed, potters were scrutinizing their products from the point of view of introducing Far Eastern techniques in the field of stoneware and porcelain-like materials for new production. In England these were Minton, Wedgwood, Pinder Bourne and Brownfield. The most important single ceramic artist to come out of the English tradition was Bernard Leach.

Leach was born in the Far East, received his artistic education in England, and then went to Japan to study techniques there. He was committed to the traditional Japanese aesthetic of Zen ceramic and became the mediator in Europe between the Eastern and Western potter's art. In 1920 Leach returned to England from Japan in company with the Japanese potter Shōji Hamada (974). The two of them set up the St Ives Pottery in Cornwall. Leach and Hamada, like Carriès, used only local materials, adding impurities for the sake of roughness and irregularity. Leach can be considered the father of the movement in ceramics which then began, and which raised the whole issue of European potters grappling with a Japanese Zen Buddhist formal language (934, 961).

In Germany the most important apostle of Far Eastern ceramic art was Boutjes van Beek (1899–1969). He intensively concerned himself with the Chinese glazes (961), primarily the ox-blood glaze on Lang-yao ware. Later he took up Ting-yao and Chien-yao. In his experiments, Boutjes van Beek stumbled on the glazes of the Sung Dynasty, and achieved considerable success in the technique of oil-spot glazing, a variant of Japanese *temmoku*. In his old age his efforts were crowned by products of the hare's-fur glaze of Chinese *chien-yao*, known to every collector.

Richard Bampi (1896–1955), too, with lengthy experimentation, took up high-temperature stoneware and through this found his way to the Far Eastern traditions. His glaze colours are very pure and luminous, especially the 'apple green' and later the pure white, the Ting-yao of the Chinese. The bloom and radiance of the bright white on his stoneware impressed the ceramic world, and after his death his students carried on his work. The search for new forms and glazes was not over.

Walter Popp (1913–77) was the creator of new methods in Germany. He revered Bernard Leach, and in his own extremely original way he followed in the footsteps of his spiritual teacher. Popp was a connoisseur of Far Eastern ceramic art, but he never copied it. He translated his enthusiasm for the forms and surfaces of Eastern ceramics into new and highly original creations

(973, 975). Popp was a great improviser, single-minded in his research, but creating impulsively, in the manner of Japanese *wabi*. This combination made him a good teacher, and he formed a school of his own. His students quite naturally so prized his work that a broken flow-glazed mug of his was mended with gold in the tradition of the Japanese (966).

Today, too, Japanese tea ceramics are a stimulus. Ralf Busz chooses compact shapes and combines them with a glaze related to the tea-dust effect on a pale body subjected to repeated reduction firing. The swelling shape shows a disciplined craftsmanship and restrained grasp of form inherited from the Japanese (956). Hans Heckmann turns his bowls and mugs according to an austere stereometric principle. By virtue of extreme simplification the slightest deviation takes on significance, so that the black shiny glaze is highly effective over the light fireclay body (958). In contrast to the succinctness of Heckmann's object-language, Gerald Weigel takes the gentle but taut traditional shapes as his model, and brings out the tea-dust effect in beige-white and brown-black rivulets. The rim is elegantly formed. With a slight tension it passes over into the wall of the pot, which is shaped to give the hand a good grip (957).

966 Walter Popp
Bowl
c. 1960
Stoneware, reduction fired; crazing in the glaze repaired with gold
H.8.8 (3½), d.9.2 (3⅝)
Private Collection

967 Japan
Tea bowl
Edo period
(17th century)
Raku stoneware, cracks repaired with gold lacquer
H.8.4 (3¼), d.9 (3½)
Munich, Private Collection

968 Japan
Bowl
Edo period
(18th–19th century)
Raku stoneware
H.7.6 (3), d.11.5 (4½)
Paris, Musée Cernuschi

969 Japan
Tea bowl
17th century
Karatsu ware
Calligraphic ornament,
applied by brush
H.12.3 (4⅞)
Private Collection

970 Ogata Kenzan
Tea bowl
17th–18th century
Raku ware
H.8.6 (3⅜)
Paris, Ex Collection Holm

969

970

971

972

971 Heidi Kippenberg
Bowl
1971
Light grey-brown stoneware,
decorated by brush in green
and pink
H.9 (3½), d. 12.5 (5)
Deidesheim, Museum für
moderne Keramik

972 Antje Brüggemann
Vase
1971
Stoneware; lower part, dark
blue glaze, upper part, pale
brown with black brush-
marks on a pale blue
medallion
H.13 (5⅛)
Deidesheim, Museum für
moderne Keramik

354

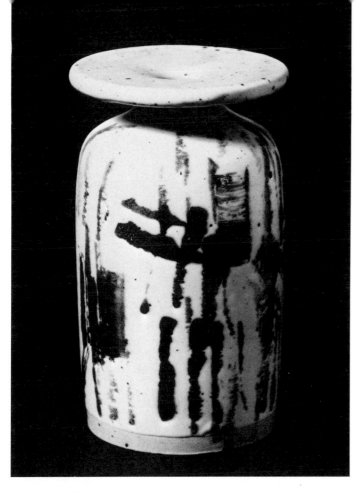

Heidi Kippenberg heightens this principle both in the form and in the use of superimposed flow glazes which acquire bizarre textures in reduction firing. The grainy body above the foot-ring and the smooth glazes create exciting contrasts similar to the masterly achievements of the Japanese potters (959). The animated patterns in the rim area in Japanese ware had affected the European potters early on, for the undulating line has manifold associations, such as are manifested, for example, in primeval or fossil forms. Floral echoes and root-like forms also hint at timelessness and the dawn of history. Surfaces that bear evidence of rustic work processes are generally to be found in the remote provinces in the Far East. The Tea Masters frequently preferred them to the courtly forms. Signe Lehmann-Pistorius tries to combine elementary, fragmented rims with a variety of cloth structures. Out of this come bizarre vessels with a driving presence (978). Horst Kerstan, by contrast, is the master of the solid clay base. The surface of stoneware has a painterly significance for him, and he brings this out in the spontaneous flow of his thick, bubbly glazes. His bowl has a firm, steadfast shape; the thick body presses outward, together with the flowing glazes. With these pots Kerstan achieves direct connection with his

973 Walter Popp
Vase
1975
White stoneware, black calligraphic ornament applied by brush
H.19.5 (7⅝)
Deidesheim, Museum für moderne Keramik

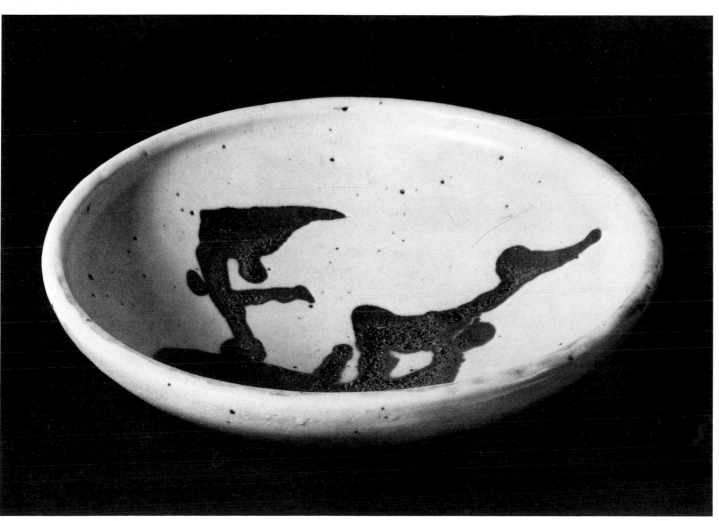

974 Shōji Hamada
Rectangular vase
c. 1930
Moulded stoneware, white and grey-green glaze
22.5 × 16 × 9 (8⅞ × 6½ × 3½)
Paris, Collection
Dr Dao van Ty

975 Walter Popp
Shallow bowl
1965
Stoneware, grey clay, beige glaze with brown calligraphic ornament
H.7.5 (3), d.28 (11)
Deidesheim, Museum für moderne Keramik

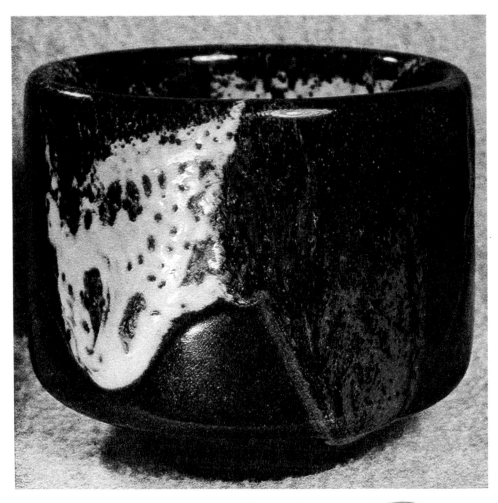

976 Horst Kerstan
Bowl
c. 1966
Stoneware, white, rust and
black overglaze
H.10.2 (4), d.12.9 (5⅛)
Private Collection

977 Japan
Tea bowl
Edo period
(1603–1867)
Black *Seto* ware
H.8.8 (3½)
Private Collection

Japanese models. A specifically European feeling for form is foreshadowed in the original creative impulses that these pots betray (976). The rhythmically undulating rim, tilted slightly inward like a fruit form, and yet nevertheless resting on a relatively strong wall has characteristics that can also be demonstrated in Japanese tea ceramics. Pieces that had been slightly distorted in firing were likely, by virtue of their interesting surface, to be deliberately set apart by the potter and picked out by the Tea Master. Randomness, which underlies pottery so much more than any other craft technique, comes into its own because randomness is understood as a piloted situation, as a determining factor. A bowl that is placed first in the kiln, that has others piled up on top of it, can easily be distorted or marked by pressure from above. Cracks or surprising colorations appear when pieces are placed too near the heat centre. All these things are quite open, yet determined by *wabi*. The Zen Buddhist does not acknowledge chance, so everything is for him a pointing finger, a pre-determined encounter.

The potter's workshop is continually in contact with the incalculable, but in the moment of coming together with the unknown an alliance of 'familiar exceptions' is struck. Like many potters, Konrad Quillman had a feeling for this familiar coincidence. His stoneware, made of light fire-clay, carries original glazes in blue-violet on beige. The individual foot-ring supports the bowl in the European manner (936). The floral effect of the form, with its intentional fluidity, deviates from the Japanese tradition and blazes a path for stronger modifications of the model.

Wilhelm G. Albouts concentrates his conception back into a compact, simplified form. The dark ox-blood glaze of the interior emphasizes the light outer wall, and strengthens the effectiveness of the exterior glaze of delicate orange and light green (941).

Margarete Schott, like Bernard Leach, has taken up the six-sided bowl form of Chinese origin (960, 962). Built up from flat surfaces, this form stems from a basic stereometric conception which is less susceptible to chance. The articulation can be imposed much more definitely on the porcelain body; angular articulation is directly confirmed.

The Europeans have repeatedly elected to decorate their pots with calligraphic brush strokes on the pot wall. The randomness of the brush strokes is raised to a creative element, which simultaneously enhances the three-dimensionality of the vessel.

Heidi Kippenberg (971) and Antje Brüggemann (972), stimulated by Walter Popp's example (973), execute their signs with dark on a light background or light on a dark background. The sign placed on the convex wall balances the surface and the body of the pot without introducing regularity. These improvisations carry elements of meditation and can pass over into calligraphy (974–80). Walter Popp sometimes decorated his pots one after the other, in an uninhibited stream, with the greatest intensity of form. In the extremely free handling of the brush, these series display a kind of shorthand. In this technique, Far Eastern models are again combined with European analogies to create a kindred vitality.

978 Signe Lehmann-Pistorius
Large pot
1978
Montage of pieces made on the wheel and pressed together. Pale stoneware with fire-clay content, relief textures, dark brown, rust, olive and turquoise glazes
H.17 (6¾), d.14 (5½)
Private Collection

979 Kōho Kūchūsai
Tea bowl
17th century
Shigaraki ware, decorated with outline of Mount Fuji
H.8.7 (3⅜), d. mouth 12.4 (4⅞), foot 4.2 (1⅝)
Tokyo, National Museum, Hirota Collection

980 Japan
Tea bowl (chawan)
Edo period
(1603–1867)
Stoneware, cracks repaired with gold lacquer
D.9 (3½)
Munich, Private Collection

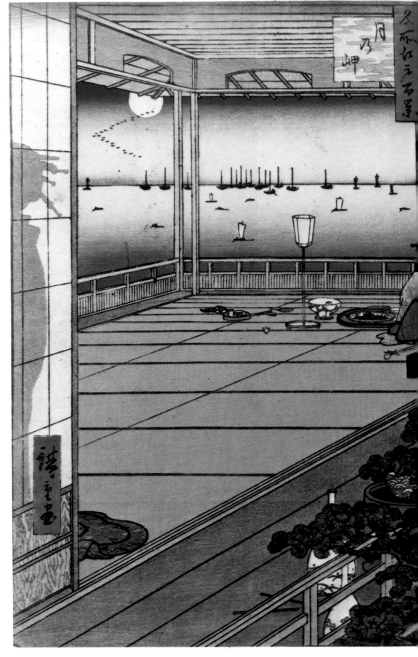

The colouring of Japanese architecture derives from its matt tones, with simultaneous emphasis on dark and light as the natural determinants of mood, varying according to the light. The harmony of the interior derives from the grain of the wood and the dull sheen of its surface. But the decisive factor is the opening of the house to the garden (988, 990). The house is part of the garden and the garden part of the house. This orientation, combined with the transformation of interior into exterior and vice versa by means of movable walls (*fusuma*) in the individual rooms, and the flexibility, the exchangeability, as well as the possibility of building additions to the house, made the house a focus of a whole system of design for everyday life.[6]

Because of its climate, Japan provides a rich selection of timber for building. Slim cypress varieties, *hinoki*

985 Richard Neutra
Moore Residence
Ojai Valley, Calif.
1950–60
View to the north, showing
how the landscape becomes
part of the room

986 Richard Neutra
Kramer House
Corona, Calif., 1953
Sliding walls dissolve the
distinction between in- and
outdoors. Only the pillars
remain as vertical elements
in the 'landscape
composition'

987 Philip Johnson
Johnson House
New Canaan, Conn.
1947–49
All exterior walls are glass,
creating an open effect
comparable to a Japanese
house. The simplified
ground-plan is like Japanese
modular systems

988 Japan
Hiun-Kaku
View across the
ambulatorium and part of
the inner room into the
garden of the Nishi Hongan-
ji at Kyōto, the principal seat
of the Jōdo Shinshū sect. The
garden dates from 1630 and
is a reconstruction of the
Kokei garden at Castle
Fushimi

wood for example,[7] were the prerequisite for the highly developed method of wooden building. Japanese carpenters were also richly stimulated by the different textures provided by firs such as the eastern hemlock, by varieties of cedar and the *aka-matsu* group, the red pines and pitch-pines (*kuro-matsu* and *zelkowa, serrata makino*).[8]

Built-in furniture giving optimum use of space, and the concomitant parallelism of everything to the walls; clarity of construction in both ground-plan and elevation; the directness of the natural materials – these were the factors which have caused Western architects, from the end of the nineteenth century up to the present to come to grips with this form of building.[9]

Similar divisions of light-weight latticed surfaces, of vertical stripes in a modular system, were tested in theory and in practice by the architects of the international Art Nouveau and Modern Movement.[10]

Peter Behrens, Charles Rennie Mackintosh, Louis Sullivan and later Walter Gropius and others were determined to present the wall as a veil-like surface. The results, always hovering between construction and design, bear a structure similar to the Japanese building method. Frank Lloyd Wright, Ludwig Mies van der Rohe and, above all, Bruno Taut expressed their new knowledge practically and theoretically.[11] Taut was the first European architect to bring home to the Japanese, through his writings, the beauty and significance of the Katsura Palace in Kyoto (990, 1002).

It was Lloyd Wright and Taut who pointed out the important method of the 'open ground-plan' with sliding modules.[12] In general, the ground-plan of a Japanese house is rectangular, though chance features of the site as well as the wishes of the client often lead to asymmetrical additions in great profusion. The extensions always remain bound to the unified system, because interior and exterior form a unity. The ground-plan of the house is determined by the dimensions of the mats to be laid out in it. Generally a mat is a rectangle of 3 to 6 *shaku*, approximately 1 to 2 metres (3–6ft). It is a common practice to refer to rooms as being *x* mats in size.[13] (Houses are also taxed according to the number of mats.) This unit of measure in the ground-plan determines all the other measurements: walls, sliding doors, height and breadth of rooms, etc. It also determines the size of the slightly raised alcove of the *tokonoma* (picture recess) with its neighbouring shelf for the tea things. The *tokonoma* is a sacred place in a Japanese house. It is here that sacrifices are presented, and the hanging scroll displayed or removed for particular occasions. A flowering branch and the incense-burner are placed in the *tokonoma* like makeweights to adjust the composition of the space.

Because of exact planning and the possibility of adding extensions at any time, the Japanese house is functional to the highest degree. Simple precautions take account of the likely activities of the occupant at different times of year.[15] The house 'breathes'. In summer it is fully opened (990, 995, 998, 1011). Leaves and flowers seem to grow right into the rooms (1009), and the fresh air reaches every corner. The widely cantilevered roof, saddle-hipped (998) or half-hipped

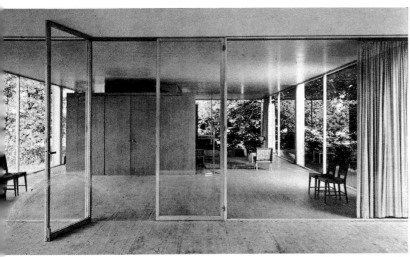

991 Ludwig Mies van der Rohe
Illinois Institute of Technology
Chicago 1945
The 'atrium' garden forms part of a single area articulated by the vertical supports

992 Ludwig Mies van der Rohe
Farnsworth House
Fox River, Plano, Ill.
1946–50
Glass walls mean an all-round view. The vertical supports echo the garden trees

993 Richard Neutra
House in the Swiss Alps
After 1957
The view is articulated by the overhang of the roof and slender pillar

994 Harwell Hamilton Harris
Granstedt House
1938
Pushed back, the sliding wall admits the exterior view

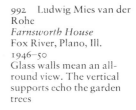

995　*The life of Prince Shōtoku*
1065
Folding screen
H.185 (73)
Tokyo, National Museum
This picture demonstrates the age-old architectural principle of the correspondence between the view into a house and the view from that house. The removal of front and side walls in the palace allows the eye to travel across a system of architectural modules

996　Richard Neutra
J. N. Brown House
Fisher Island, Atlantic Ocean, 1936

997　Richard Neutra
Tremaine House
Monte Cito, Santa Barbara, Calif.
1948
The open wall system in both these houses allows the interior and the exterior to perform complementary optical functions. The distinction becomes fluid thanks to functional and technical advances

(*irimoya*), has gables with shorter hips added. It is lightly curved to the eaves. The *hiwada* roof made of bast strips of *hinoki* wood is even more original. The rich modelling of the surfaces is designed down to the last detail. The roof provides shelter from the sun and from the drenching tropical rain, yet light floods into the rooms.

The house is raised above the ground (1001, 1002). In the tropical summer every plant in the garden drips; and this is also an acoustic experience. In such circumstances it is pleasant to sit in a raised position and look down on the damp moss (1013).[16] The house rests on slim posts which are set on hewn stone blocks (*dodaishi*) (998, 1001). The arrangement of these supports and their height in relation to the whole is strikingly harmonious, especially in the Katsura Palace in Kyōto, built in the sixteenth century (1002). The distance from the ground to the floor-boards is approximately one metre (3ft); the space in between makes for continuous ventilation. Occasionally this space is boarded up, as the Katsura Palace shows, or it is taken up with in-fill masonry. Beneath this ambulatory, which in the case of the Katsura Palace is strongly designed, the construction system of posts is clearly displayed (1002). A shallow pond with lotus and iris is generally positioned very near the ambulatory.[17]

Briefly summing up, we can say that the ancient
method of construction, the edifice raised on posts, the
adjoining ambulatory as a 'hinge' to the garden, the wide
opening of the walls thanks to the sliding doors, the
bright, glistening light in the rooms – all these factors
provided models and stimuli to the architects of Europe
and America, in particular Frank Lloyd White, who
made the principle of 'organic architecture' acceptable
world wide.[18]

In 1908/09 the architects Greene & Greene built the
David Gamble Residence in Pasadena, California (1005).
The construction of the house on posts is clearly visible.
The garden comes to meet the airy verandas and
ambulatories. With its shifting levels it comes close to the
load-bearing, freely functional beam construction of the
Japanese.[19]

Mies van der Rohe's Farnsworth House at Fox River,
Illinois (1007), is also raised clear of the ground, and this
combines with vertical posts within the house as well as
with the verticals of the surrounding trees. Interior and
exterior interpenetrate, although the geometrical con-
struction provokes a sharp counterpoise to luxuriant
nature. Careful profilation of the load-bearing skeleton,
arrangement of the surfaces, subtle walls which preserve
their identity despite their transitional functions – all

these bear witness to a high degree of economical planning.[20] This glass and metal house was begun by Mies van der Rohe in 1946 and completed in 1950. It is built on a simplified system of supports. This bears three apparently suspended surfaces: the floor, the roof and the platform for the terrace. The effect of suspension is achieved by a finely calculated ordering of the supports and this is rendered perfectly visible through the opening of the house to the sides and to the foundations. The 'Moonlight Terrace' of the Imperial Palace in Kyōto also displays a suspended floor passing without a break from interior to exterior.[21]

Such features are still more prominent in the Villa Savoye by Le Corbusier (1006).[22] The superstructures above the flat edifice flank an ornamental garden which prepares the transition to the natural vegetation of the environment. In this building Le Corbusier shows himself a master of clearly articulated parts. Look at the way the roof structures and the stilted storey are put together. With great precision he asserts the right angle, just like the Japanese, and is equally consistent in pursuing the smooth white surface articulated by the dark window strip. In this building the architect has created free analogies with Japanese forms, without ever stooping to mere borrowing.[23] The lightness and transparency of the building is convincing, inviting one to commune with the natural environment.

The back of the Farnsworth House (1004), the side facing the garden, also presents a direct transition to luxuriant nature, just as the Japanese houses do. A cantilevered surface in the form of a balustrade sticks out from the room as a firm architectural component in the landscape, similar to the cantilevered ambulatory of the New Palace in Katsura, Kyōto (1003).

Richard Neutra took up these similarities, and recaptured the process, in the house he built for Edgar Kaufmann in the Colorado desert (1010). Neutra pursues numerous possibilities for opening the house to nature. In her book on Neutra, Esther MacCoy writes that his extensive use of frameless overall glazing, beneath a broad overhanging roof, makes it unnecessary to position the house towards a particular view.[24] Stepped connecting sections, strangely open to the outside world, are pushed out into landscape space like flexible airport walkways. The sight-lines running through the house are contrasted in the extreme. The 'open plan' is here raised to the level of a principle and achieves its own artistic identity. Japanese domestic architecture and functional construction strive for similar goals.

The posts in a Japanese house carry the whole edifice and support the ambulatories and the roof (984, 995, 998, 1001). Posts, with the function of caesuras dividing a flat surface, have also been an important feature of Japanese painting. The composition of a picture is often solely dependent on the sequence of vertical posts.

Individual supports each have their separate significance in a Japanese house. The vertical member between the *tokonoma* and the *chigaidana*, the ancillary chamber with a suspended shelf,[25] delineates a sacred place and is often marked out by a bronze nail-head. Pillar pictures are attached to it. In Japanese thought, the post is like the archetypal tree, endowed with special

powers. These supports are often set up in the *cha-noyu* rooms or under the roof as an uncut log. They also occur as double posts in some great 'houses of many mats'. (Greene & Greene took up the double post construction in the David Gamble House in Pasadena, 983.)[26] One of Hiroshige's woodcuts illustrates the interior of a tea house with a view over the sea, with a light but outward-reaching construction (984).

Neutra wishes to realize a kind of 'weightless' building through the use of steel construction. Thin supports and floating mantle forms enclose the interiors where these are not open to the garden. In his houses in the USA Neutra subdivides the walls in a manner closely related to the Japanese use of posts (985, 996, 999). Domestic architecture arranges the surrounding landscape into views in which the vertical supports are a reference point. Through his vertical caesuras Neutra develops viewing openings into the landscape near and far (985).

The result is an ideal view from the living-room, a view which would not have been possible from this position without the architecture. We can conclude from this that a new relationship to the land, to the environment, to the plants and structures and typical features of the local area has appeared, and Western architects with their varied constructions are exploiting this new relationship as did their Japanese predecessors.[27]

Philip Johnson, born in Cleveland, Ohio, in 1906, gained a profound knowledge of Japanese building while he was Director of the Department of Architecture at The Museum of Modern Art in New York. A pupil of Marcel Breuer and later an associate of Mies van der Rohe, Johnson built his own house in New Canaan, Connecticut in 1949 (987). Johnson has never lost his feeling for volume in a building,[28] a quietly delineated volume which always forms a unity with the surrounding nature. Struts and posts do not represent divisions or caesuras; they are complementary to the surrounding space, they 'reflect' the trunks of trees. The landscape is part of the house and vice versa.

The Japanese house, too, is a part of its natural environment. The forests of bamboo and cedar exemplify the same post structure in their slim stems rising to bear the foliage of the trees. The big tropical leaves often have an almost geometrical structure, hanging down like green blinds covering the smooth trunks of the various wild banana trees (1020). The view from a Japanese house usually travels over the vegetation which appears in the gap revealed by a sliding wall, and the effect is often almost pictorial (1011).

The *kamoi* rafter, representing the termination of the *ramma*, carries the upper runner of the sliding walls. *Ramma* are wooden in-fill panels, with perforations created either by lattice work (1029) or by elaborate carving. The ornamentation of *ramma* is often similar to *katagami* stencil work. From the purely functional point of view, this frieze is an opening to facilitate the circulation of the air. Many commentaries and books have been written about the *ramma* and its design. With its horizontal rectangular shape it sometimes consists of a fine lattice formed of thin sticks (544, 623, 625, 1030). The simple *ramma*[29] was of great interest to Western

architects, with its rectangle of somewhat stronger lattice-work struts placed above narrow white wall strips or sliding walls (1029). Japan has always used a simple lattice construction for dividing walls. With regard to European painting one might describe the combination of the *ramma* with the subdivisions of the sliding wall as an anticipation of the pictorial design method used by Mondrian. The Vienna Secessionists were also strongly influenced by this.

The abstract, grid-like character of the sliding walls is determined by the white paper that covers them. The lattice is sharply revealed against it (984).

In the Crown Hall in Chicago, built 1952–56, Mies van der Rohe uses surface subdivisions that correspond to those used in Japanese houses (1028). The perforations in the wall of a Japanese house are usually next to the *tokonoma*, the sacred place. They are not the same as European window forms. They are like piloted, arrested glances through a lattice. They are a kind of large peep-hole[30] with a definite planned vantage point which directs the eye to Mount Fuji, or to a cherry bough, for example (1024, 1032).

It is a complicated matter to describe the interior of a Japanese house, because it is rendered flexible and variable by the sliding walls. The care devoted to the selection of timber is striking. The ceiling is usually made of finely grained strips of wood whose pattern blends smoothly between one strip and the next. The interior contains some built-in furniture, but the main effect derives from the dark surround of the *tatami* and the vertical divisions of the wall (990, 1011).

The real ornament of the interior is the garden. The vertical divisions are carried on outside by the trunks of the trees, especially when the glowing colours of the various seasons are reflected back into the rooms. The plainness of the rooms themselves demands the garden view as a picture. Wall ornaments, and even collections of paintings, are profoundly antagonistic to this mentality. Neutra and Mies van der Rohe have adopted and developed these principles in their own original way (989, 1000, 1008). Neutra uses the close view of tree trunks as illusionistic posts, as if incorporated from the very first in his construction designs – he does his planning in collaboration with nature (993, 1008).

1001 Reizei Tamechika (Tameyasu) (1823–64)
Kagami Uri
Tosa school
Hanging scroll, body colour and glaze on silk
100.6 × 48.8 (39⅝ × 19¼)
Tokyo, National Museum
The house rests on short posts and *dodaiishi*. The opened walls show off the light but stable construction

1002 *The chū-shoin*
Katsura Palace, Kyōto
16th century
Veranda overlooking the
garden, bamboo terrace for
enjoying the moonlight

1003 *The New Palace*
Katsura, Kyōto
17th century
From the south, garden
elevation with ambulatorium

1004 Ludwig Mies van der
Rohe
Farnsworth House
Fox River, Plano, Ill.
1946–50
View of the terrace, showing
the supports on which the
whole building rests

1005 Greene & Greene
David Gamble Residence
Pasadena, Calif. 1908
Ambulatorium after
Japanese models

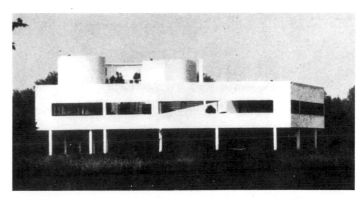

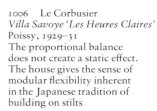

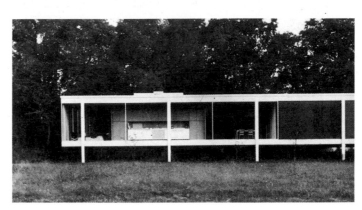

1006 Le Corbusier
Villa Savoye 'Les Heures Claires'
Poissy, 1929–31
The proportional balance
does not create a static effect.
The house gives the sense of
modular flexibility inherent
in the Japanese tradition of
building on stilts

1007 Ludwig Mies van der
Rohe
Farnsworth House
Fox River, Plano, Ill.
1946–50
The structure, raised on
posts and containing
variably arranged interior
cellular modules, forms a
harmonious entity with the
chiaroscuro of the landscape
setting, like a Japanese house

1008 Richard Neutra
Tremaine House
Monte Cito, Santa Barbara,
Calif.
1948
The complete openness to
the exterior lets the trees
provide vertical articulation
beneath the horizontal line
of the roof overhang

1009 *Katsura Palace*
Kyōto
Momoyama period
As the eye is led from the
vertical structural members
to the trees, to the shrubbery
and on to the water's edge,
the areas in and out of doors
form a single entity

1010 Richard Neutra
Edgar Kaufmann House
'House in the desert'
Colorado Desert, Palm
Springs, 1946
The interior areas all face
outwards to the garden

Gardens

1011 *Katsura Palace* Kyōto
Just as the walls can either enclose or open up a building, so too the bamboo fence and the screen of trees divide up exterior space

1012 The steps can be followed by the feet, or the eye can traverse the garden alone. The line of flags serves both functional and aesthetic purposes. Such paths provided some of the inspiration of 'land art'

1013 Japanese moss gardens have a softness and sponginess which are apparent to the eye as to the touch. The different mosses grow in myriad shades of green beneath dripping shrubs and dwarf trees, set among stones and little streams

1014 North-east corner of the *Daisen-in* garden in a Kyōto monastery, laid out in 1509 according to Zen principles by Sōami. The stones are arranged in groups signifying either the formal, objective *shin* or the symbolic, subjective *sō*.

The wide opening of the house was a feature even in Japan's early history.[1] A section of a screen painting of the year 1069 depicts monastery buildings in the province of Heian, with the community of the faithful listening to the teachings of Shōtoku.[2] Thin posts carry the lightly curved roof (995). The buildings are similar to the garden houses which are open on three sides for the purpose of enjoying the surroundings. Since squatting on the ground in summer is generally ill-advised because of the damp, large pedestals resting on posts are set up in the gardens for people to sit on. Sometimes they are fitted out with flexible awnings.[3]

The European conception of the Japanese garden is something that requires no particular elucidation. However, Europe took over only a small part, and many details were sharply altered. Just as in China, so in Japan, garden design rests on the imitation of Universal Nature. The Japanese description of the garden – *sansui*, mountain and water – gives an impression of the heritage of garden design. It is not a utility garden but a reflection of Utopia within a tiny space. Often gardens are laid out behind a shop, a workshop or an office. In a private house this ornamental garden (*niwa*) is always laid out opposite the living room. Frequently it is not used for walking in or spending time in; it is a garden for journeys of the eye. Such gardens are often divided by large irregular stepping stones (*shiki-dai*) rather than paths. For the Japanese these flagstones are a symbol of his homeland, that collection of islands bedded in the sea like stepping stones extending out from the Land of the Rising Sun, Shiki-shima.[4] The artistically well-appointed garden, with small boulders surrounded by shingle, is a reflection of this idea (1014, 1019). The Golden House of the Third Ashikaga Shōgun, north-west of Kyōto, is surrounded by such a garden. In addition, many

1015

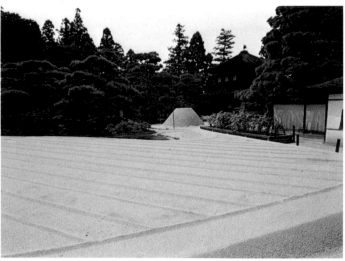

1017

1018

1015 Greene & Greene
The Blacker House
Pasadena, Cal., 1907
A pool with a much indented
edge, fringed by stones in the
Japanese manner

1016 Margaret Bourke-
White
God's great rake
c. 1969
The raked sand of the
Japanese garden had already
served as a model for the
large-scale scoring of the
land by the plough. The
transitory unfolding of this
process is made static or
flexible by the use of still
photography or videotape.
'Land art' in its large-scale
shaping of a flat surface is a
'great garden of emptiness',
kūtei, a symbol of boundless
space.

1017 *Gingaku-ji,
Ginshadan,* 'the sea of silver
sand', Kyōto. The garden is a
geometrically structured flat
surface, more like a relief
sculpture than 'land art'. It is
a primeval landscape, whose
structure has been 'frozen',
an untouchable space which
assumes sacred qualities

1018 Richard Long seeks to
'take nature by the hand' in
stony, sandy wastes, and to
create art in harmony with
the processes of geological
change. For him stones are a
symbolic link between the
dawn of time and the present
day.

1019 The Zen Garden of
the Ryōanji Temple, Kyōto
In the 'garden of nothing'
(*mu-tei*) the arrangement of
sand and 15 rocks,
painstakingly selected and
laboriously brought from
remote islands, symbolizes
the sea and cliffs

1016

1019

1020 Japan
The structure of a banana leaf is an example of grille-like articulation in a natural growth
Photo: Fritz Lüdtke

1021 Japan
Bamboo fence
The growth rings mark horizontal divisions on the vertical posts

1022 Japan
Bamboo fence
Articulated horizontally and vertically, the means of enclosure directs the eye around the garden

1023 Japan
Dyer's stencil
Meiji period
Sliding walls and bamboo as alternative forms of grille pattern

1024 Japan
Inset window with ornamental grille, seen behind branches: a *mon*-like composition

1020

1023

1021

1022

1024

Opposite page:

1025 Keisai Eisen
The courtesan Nanato in front of a sliding wall (detail)
From *8 Scenes from the Yoshiwara (Yoshiwara hakkei)*
38.5 × 26.3 (15⅛ × 10⅜)
Private Collection

1026 Japan
Patterned weave
Meiji period
Coloured straw
33.5 × 41 (13¼ × 16⅛)
Vienna, Österreichisches Museum für angewandte Kunst

1027 Japan
Bamboo fence, Kyōto
The vertical, grille-like arrangement of the posts extends the fabric of the building

1028 Ludwig Mies van der Rohe
Crown Hall, Chicago
1952–56
The vertical system of division is emphasized by the black uprights and white wall areas

1029 *Katsura Palace*
Kyōto
17th century
The clear geometrical articulation of panels like this has been a source of inspiration to Western architects

1030 Hosoda Eishi
Japanese woman standing at the corner of a house
The structure is typical of Japanese houses between
c. 1700–1900

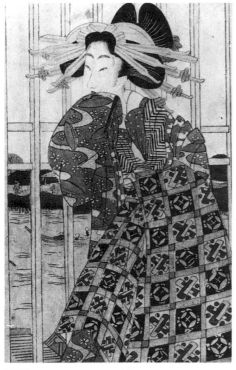

1025

1026

1027

1028

1029

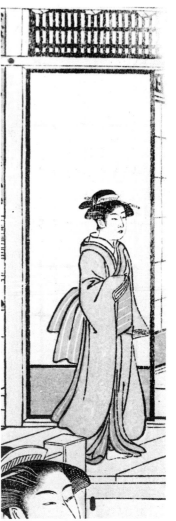

1030

monasteries and public buildings have lay-outs of this type, still maintained today according to the ancient guidelines.[5]

Boulders are central to Japanese garden design; the Japanese have a direct relationship with stone and its forms. The search for appropriate boulders for the tea house built in the Englisches Garten in Munich in 1972 illustrated the principles involved. This search, which was conducted in the Isar valley,[6] took a considerable time because in size, colour and shape the stones had to fit well in their surroundings. The boulders in the gardens of Tokyo and Kyōto were brought fom the most distant provinces, sometimes at great expense. Forms eaten away by the sea and boulders of red rock are prized, and still fetch high prices today. Mostly they come from the island of Sado, an island off the north-west coast of Japan.

Neutra grasped well the connection between boulder, house and garden, and incorporated it in his designs (997). The primitive stratification and angularity of the stones, surrounded by luxuriant plants, contrasts with the constructional system of the house.[7] Certain areas are walled off with rough-cut masonry, and this too falls in the category of the further development of the structures of stone. The impression is extended in an original manner by the use of irregularly placed stone flags.

The elemental boulder is an integral part of the widely opened house. Tall standing stones with inscriptions were also favoured. The inscriptions generally refer to the effect of a beautifully planted garden. For instance: 'The sight of plum blossom makes the ink run smoothly in the writing room.'[8] Manifold were the sensitive responses to a blossoming garden. Japanese apricot, *sakura*, chrysanthemum and lotus – these were and are the favourite plants of the Japanese. They are given pride of place in every garden.[9]

Iris and Japanese lily, camellia and azalea are also much in demand. The three 'Conquerors of Winter' are Japanese apricot, fir and bamboo.[10] In their unity these plants create a meaning, and put the garden lover in the mood which Sen-no Rikyu sought from the observance of established rites.[11]

The garden, as a dewy ground, *roji*, is a place for relaxation, for tea ceremonies. The planting of the garden around the Japanese tea house is therefore especially important. This part of the garden must heighten the mood and encourage the ritual perseverance of the guests at the ceremony.[12]

Great attention is devoted to the hedges in a Japanese garden. Generally they are combined with secondary plants into a single growth. Their role is to close off a vista or to delimit a particular section of the garden. When the sliding walls open, wisteria hangs in the opening, or alternatively the *sode-gaki*, the 'sleeve hedge', arranges and subdivides the vertical and horizontal components of the architecture.[13]

Modern house design in the West has also made use of these horticultural conceptions. Mies van der Rohe integrates low-hanging maple boughs into his architectonic plan (1000). Neutra brings fast-growing birch close to his roofs, or lets bushes and shrubs cluster round the balustrade, as at Lake View Residence.

Moss-grown stone lanterns were adapted from those in the temple gardens. Generally they are placed in water, with stepping stones leading to them. In large gardens where the ground is suitable the description *sansui*, mountain and water, is literal. Secluded ponds are placed in the gardens, visible from afar, L-shaped and scalloped, not forgetting the obligatory small islands of rock. Winding frothy brooks pour into these still, small ponds overgrown with lotus and iris. Slender young clumps of bamboo are placed on the banks with small bridges arching out from them. The channels connecting the ponds are often a sea of blue iris. Shady arcades of clipped bushes alternate with pergolas built out over the ponds and smothered in wisteria. The cascading flowers are propped up with light bamboo canes, so that the effect is that of a violet cave with stalactites. Metallically gleaming fish float and dart in the ponds and channels like magical starfish whose ancestors were goldfish.

At the Blacker House in Pasadena, California, built in 1907, Greene & Greene included a Japanese garden which reconstructs this indescribable variety and moulds house and garden into a single whole (1015).

Bizarre textures are an important aspect of Japanese horticulture. In the Katsura Palace in Kyōto, sliding walls open to reveal views abruptly cut off by a green wall of densely interlacing plants. The curtain of boughs, leaves and flowers in the glancing light from outside makes a moving screen which is graphically impressive – and often designed to be so by the gardener.

Stepping stones disappearing into the depths of the water create a pattern displaced into the distance when viewed from the proper vantage point. The garden is an inexhaustible source of viewpoints, and draws one in irresistibly.

The famous Japanese moss gardens present textures of incomparable individuality (1013). Hundreds of varieties are cultivated and maintained. There are sectors where extraordinary tactile formations appear, and the Japanese connoisseur appreciates them as such. A moss garden presents the opportunity to observe differentiations of colour that have never been seen before. The tactile and optical characteristics of the moss gardens are softness, sponginess, submarine wateriness and unfathomability (1013). They are the exact opposite of the pebble gardens with their appointed paths, boundaries and stone islands. This horticulture outstrips by far all the varieties of 'Land Art' (1016, 1018); above and beyond their circumscribed, fantasy-laden refinement, for all their artificiality and genuine naivety, these gardens are highly poetic and make convincing works of art.

1031 Walter Leistikow
The Müggelsee near Berlin
c. 1900
Tail-piece in the style of a
Japanese 'picture within a
picture'
Pen, black ink on white
paper
8.4 × 19.8 ($3\frac{1}{4} \times 7\frac{3}{4}$)
Private Collection

1032 Japan
View out of a round window
Nature seen as a 'detail' like
this becomes the province of
the Fine Arts

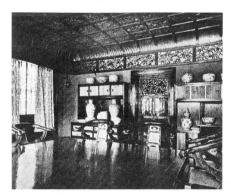
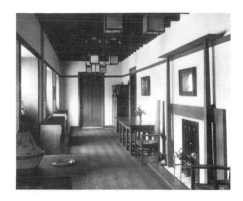

1033 James Abbott
McNeill Whistler
The Peacock Room
1876–77
Washington, Freer Gallery of
Art
Gold decoration in a Far
Eastern style

1034 The dining room of
Mr Mortimer Meupe's house
in London, c. 1897–98
Repr. *The Studio* 1899, XVII

1035 Charles Rennie
Mackintosh
Windyhill, Kilma Colm
1899–1901
The room area is articulated
by the vertical members and
the arrangement of the
furniture parallel to the walls

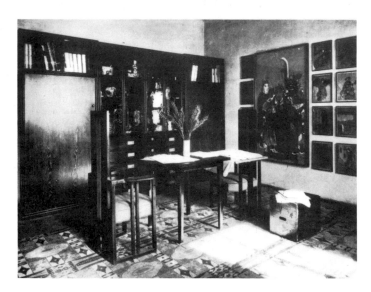

1036 Josef Hoffmann and
Gustav Klimt
Anteroom to Klimt's studio
in Vienna
Predominance of the
rectangle. The cupboard on
the left housed Klimt's
valuable collection of
kimonos

1037 *Katsura Palace*
Kyōto
The area of the mats (each
91×182, $35\frac{7}{8} \times 71\frac{1}{4}$)
determines the division of
the roomspace. The
uninterrupted diagonal
views allow an idea of the
cubic volume

Interiors and modules

European and American architects' interest in the Japanese house has brought a change in furnishings too.[1] Interior design in the nineteenth century was still under the influence of *chinoiserie*. In the plurality of styles in the later part of the century, 'oriental' salons proliferated greatly.[2] Tables and chairs based on Chinese models were still interspersed with Chippendale forms. Wallpapers with Chinese patterns were much in demand. Collectors' cabinets in the shape of pagodas were strategically placed in the rooms. Standard lamps in the manner of Chinese stone lanterns and Eastern porcelains were much sought after by collectors.

The catalogues of famous furnishing stores, like Campell & Püling in Berlin, in the 1880s and 1890s offered 'Oriental' living-rooms replete with entire collections, all with the advice of experts.[3] Chinese carpets were particularly in demand. Original kimonos and mandarin garments were draped on the walls alongside short swords.[4]

The Peacock Room (1033), by James Abbot McNeill Whistler, was an anticipation of this development. The model for this room was the interior of a Buddhist temple. The room is dominated by large peacock panels in gold after the manner of Eastern gold lacquer. Shelves and cupboards in the manner of Japanese 'band of mist borders' are introduced below these panels; they flank a kind of dresser and carry vases and other objects for display.

The international exhibitions of 1851 and 1862 in London, of 1867, 1878, 1889 and 1900 in Paris, of 1873 in Vienna and of 1904 in St Louis, presented a profusion of Chinese furnishings, porcelains, bronzes, screens and paintings. In addition, the Japanese village in Vienna attracted a great deal of attention.[6] There arose a combination of Chinese and Japanese analogies and influences which Europeans could hardly disentangle.[7]

Certainly throughout the whole sequence of exhibitions from 1851 to 1904 the Japanese influence became stronger and stronger.[8] Japan provided the choicest works of art for sale. Because of their impoverishment during the Tempo period the Japanese nobility were obliged to dispose of their prized works of art, many of them sacred relics preserved over the centuries in the *kura* (the private store, insured against fire, of every prosperous Japanese).[9] This process was surely a most painful undertaking, but by now Japan must have reacquired a large part of these treasures.

Through these works of art Japan became known. Millions were enraptured by her craft products; a Japan cult began to spread. The stylistic concept of Japonisme was launched in the 1870s; the word itself was probably coined by Philippe Burty in 1872.[10] In all these exhibitions the Japanese contributions and the Japanese buildings attracted the largest number of visitors. Systematically, with a sense of purpose, with taste and great economy, efforts were made to depict Japan as a romantic paradise, a land to be yearned for, and these efforts have been effective right up to the present.[11] In 1899 *The Studio*, vol. 17, p. 175, presented illustrations and commentary on the house of Mr Mortimer Meupe in

1038 Figini and Pollini Exhibition room, Milan Triennale 1933
The dark, slender posts, open walls, ceiling opening and, not least, the absence of furniture are the determinant features of this room. Patterned tiles and dark, *tatami*-like mats derive from Japanese analogies

1039 Josef Hoffmann *Room for an American client* 1904
Carried out by the Wiener Werkstätte. The vertical division of the walls follows Japanese models. The ebonized furniture is parallel or at right angles to the walls. The basic module is a cube. Form and function are visibly related

London, a house which shows the extent to which Europeans were prepared to enter into symbiosis with the Oriental lifestyle (1034).

The interpenetration of a way of life and an attitude to art is something that goes much deeper than merely copying a style. The West was honestly concerned with opening up its stagnating artistic production to the influences of the advanced cultures of the Far East. The Scottish architect, crafts designer and graphic designer Charles Rennie Mackintosh is a case in point. His interiors at Windyhill, Kilma Colm (1035), are an attempt to synthesize Japanese wall divisions and Western furnishings. His undertaking – a difficult one – was to integrate the items of furniture with the walls. Mackintosh achieves his aim not with the Japanese method of built-in furniture, but by 'fixing' the position of the furniture in advance, parallel to the wall, and in relation to the background.[12] The connection is further strengthened by white walls and dark verticals and horizontals, with a frieze-like subdivision of the surface by means of posts and inlaid strips (1035).

Gustav Klimt attempted this too when he designed the anteroom to his studio in Japonistic 'Secession' style (1036). The Japanese paintings in the room are an indication: they are framed and hung together in a large rectangle. Boardlike slatted seating designed by Josef Hoffmann is geometrically positioned parallel with the big cupboard and the wall.

Enthusiasm for the Japanese house was growing,[13] but the simplified geometrical dwelling style as developed by Adolf Loos also demanded new furnishings.[14] In the course of his studies in Chicago, Philadelphia and New York, Loos had acquainted himself with the building methods of Frank Lloyd Wright, and he drew his own conclusions from them, as can be seen in his plans for the Villa Dr Beer on Lake Geneva.[15] But it was in the Wiener Werkstätte, the Vienna Workshops, that a synthesis was achieved, and the character and mood of a Japanese house was translated into three-dimensional furniture production. The interchangeability of individual pieces or of whole series or 'programmes' of furniture was achieved by standardization according to a modular system, developed under similar pressures to those that had produced the standard Japanese wall divisions.[16]

The Wiener Werkstätte, through cool research on basic principles, channelled the formalistic haphazardness of floral international Art Nouveau into systems capable of reaching a broader market, though without mass production. The Wiener Werkstätte, a production cooperative for modern crafts closely linked to the artists of the Vienna Secession group led by Klimt, was founded in 1903 by Josef Hoffmann and Kolo Moser.[17] They began their work in premises at No. 32, Neustiftgasse, Vienna, 7. New proportional nuances were developed and applied, and at the same time they introduced a stricter discipline in form. They combined the vertical support system of the Japanese with the enclosed volumes of European furniture. Their furniture uses small-diameter supports, so that armchairs, tables and chairs have a latticed appearance. Justice to the materials demands, as in the Japanese model, recognition of the texture of the material used (1039).

This was probably the most significant advance made by the constructional wing of European and American Art Nouveau. It motivated progressive-minded craftsmen and architects to heed their Oriental models and develop a refined selection of natural materials, and this in turn enabled them to dispense with ornamentation.[18] As in Japan, but for different reasons, a kind of collective design was developed, and design was understood as a collective language and as the signal or expression of a co-operative, in Japan a religious, principle.

The rooms and furniture that Josef Hoffmann designed for an American client in 1903/05 are geometrically planned with cubic simplicity, displaying total frugality of ornamentation (1039).

The timber is oak, ebonized and then whitewashed – a treatment that would warm the heart of any Japanese joiner.[19] The units of measure are predetermined, because the depths of the furniture are standardized and the height of the seating is half the height of the wall cupboards. The height of the tall cupboard is four times that of the chairs, stool and small table.[20] Here too it is evident that the furniture owes everything to the clearly articulated wall (1039).

The endeavour to apply the stimuli of the Japanese house to problems of interior design reaches a new level in the *Casa studio per artista* shown at the Triennale, Milan, in 1933 by L. Figini and G. Pollini. There is nothing even resembling furniture. The geometric tile pattern on the floor and the opened ceiling with its peculiar direction of the light represent a process analogous to Japanese design and yet show an independent solution, a deviation from the model, even though the slender load-bearing posts and opening of the wall betray the Japanese genesis of the conception. The long-lasting effect that Japanese building style has had on Europeans, and the strength with which they have maintained it without ever fully abandoning their own heritage, is astonishing.

It remains to comment on the surface or wall of the garden fence, which is closely connected with the house (1021, 1022). The Japanese use a very wide range of structures and materials in their garden fences (*kaki*). Plaited bamboo, or bamboo canes in a row, are favoured. There are many books giving information on the vast design potential in the garden fence.[21] Hokusai reproduces numerous such fences in his *Manga*. Buried in the shadowy depths of the garden, these bamboo walls often merely serve to arrest the beholder's eye. They stand there in the twilight of the tropical undergrowth like backdrops to the rich green of the sombre cedars and other conifers.[22] These terminal surfaces are sometimes reminiscent of vertical *tatami* mats attached to bamboo stakes. Probably the most decorative kind of fence construction is that composed of slim bamboos packed close together with stronger posts at regular intervals (1027). The bamboo fences, with their imaginative lattice structures are not the only ones that merit attention. Japanese fences made of wooden planks, brushwood, reeds, straw and bark have also had a stimulating effect on European garden designers in recent times, offering many ideas for replacing the 'obligatory' wire fence.

1040 *Katsura Palace*
Kyōto
The numerous divisions of
the wall and door surfaces
are typical of the
Momoyama period. The
dark *hinoki* wood is in vivid
contrast to the light colour of
the sliding doors. The
Katsura Palace lies between
the Katsura River and the
Nishiyama Hills. The
interior and the garden,
overlooked by the terrace,
complement each other

Calligraphy

From Zen to Tachism

Oriental ink painting, a subdivision of calligraphy, was rediscovered by European painters in the nineteenth century. At this point they were able to recognize new values in the ciphered quality, the abbreviating view of things, and take these up as a stimulus and finally even as a determining feature in their own art. This development proceeds logically in two directions. At the outset we have the Chinese scroll (1042), which exists in the form of the horizontal scroll and the hanging scroll.[1] Then comes the album-leaf (161), an intimate Oriental genre with a middle position between scroll and book. Different masters can be placed together in an album; their specialities are categorized as landscapes, human figures (1050, 1054) and plant studies (166). These albums were a very rich stimulus to European artists.[2] Fan paintings were also important. Works in this extreme format served the European artists as a field for experiment in matters of composition and technique (162–69).

The effect of the models was variable, but artistic interest was awakened during the second half of the nineteenth century. Nearly all the European artists of that period took an interest in ink painting and wrestled with the problems it presents, of a brief, intensive look at their subject and its traces of movement.[3] During the second half of the century it came to be accepted that the academies and other teaching institutions should teach and apply the brush technique of ink painting. In France

1041 Henri de Toulouse-Lautrec
Jane Avril
1893
Lithograph
25.2 × 22 (10 × 8⅝)

1042 Gibon Sengai
Daruma
Edo period
1603–1867
India ink on paper
16.9 × 5.7 (6⅝ × 2¼)
Tokyo, Idemitsu Museum

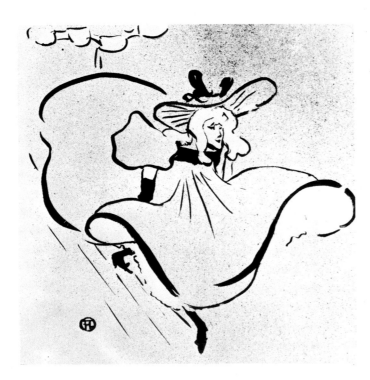

380

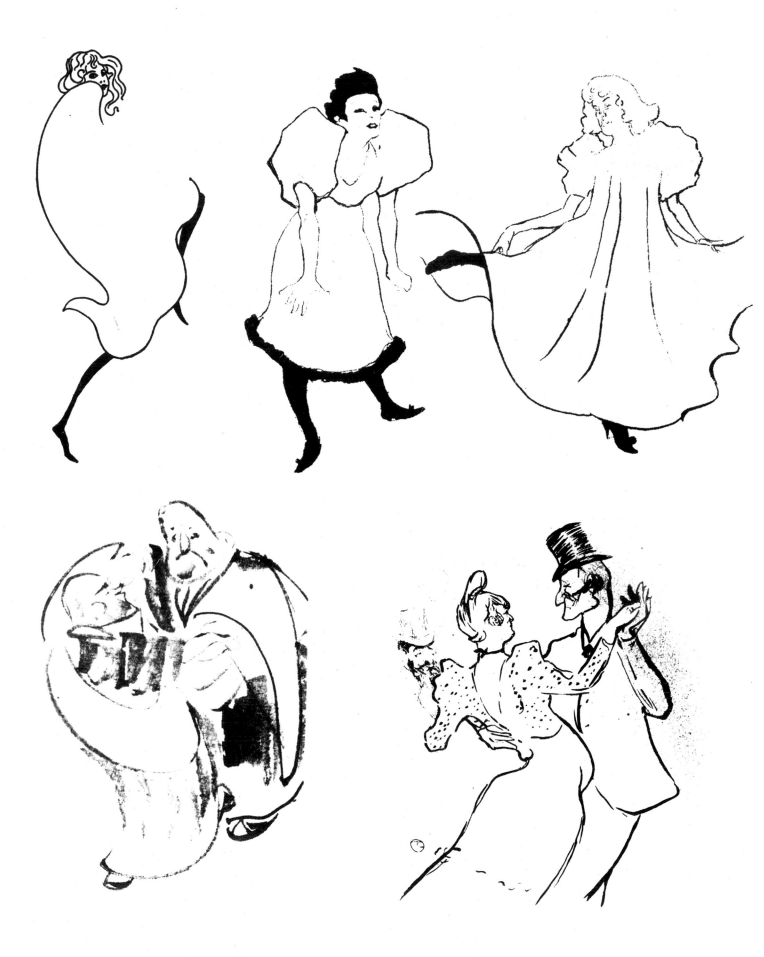

1043 Thomas Theodor
Heine
Illustration to 'Die Barrison'
by Pierre d'Aubecque
Berlin 1897, p. 23

1044 Henri de Toulouse-
Lautrec
Lithograph
24 × 19.5 (9½ × 7⅝)
Repr. *Le Rire*, 3 August 1895

1045 Henri de Toulouse-
Lautrec
May Milton
1895
Lithograph poster
78 × 60 (30¾ × 23⅝)
Paris, Bibliothèque
Nationale, Cabinet des
Estampes

1046 Gibon Sengai
The Kōan of Pai-chang and
the wild duck
Edo period
1603–1867
India ink on paper
96.3 × 27.2 (38 × 10¾)
Private Collection

1047 Henri de Toulouse-
Lautrec
La Goulue
1894
Lithograph poster
30.8 × 25.3 (12⅛ × 10)
Paris, Bibliothèque
Nationale, Cabinet des
Estampes

1048 Ogata Kōrin
Shōki walking
c. 1700
Repr. S. Bing, *Le Japon
artistique*, 23, March 1890

1049 Henri de Toulouse-
Lautrec
Le motographe (detail)
1899
Pencil and india ink on paper
50 × 60 (19¾ × 23⅝)
Paris, Private Collection

1050 Shih K'o
Patriarch and tiger
Mid 10th century
India ink on paper
167 × 49.8 (65¾ × 19⅝)
Tokyo, National Museum

the development of ink painting was further enriched by the general level of technical expertise and the artistic stimulus that was felt from the Far East.[4] Early Impressionism was an important factor in the developments to come. The school of Barbizon used this technique; we have excellent ink paintings by Corot, Millet, Daubigny and Rousseau. Just to name a few of the important painters of the first generation of Impressionists, Manet, Monet, Degas and Toulouse-Lautrec all perfected and enriched the art of ink painting in the tradition of the Oriental artists.

Of the French painters, Toulouse-Lautrec was the first to develop a playful handling of line. Strolling, dancing, singing and the broad poses of the figures in the music halls – these pictures show a spontaneous grasp of the behaviour and psychology of his models (1041). With a single stroke Toulouse-Lautrec reconstructs the movement of the dance in a kind of shorthand. This stroke is like an autonomous trace of movement, expressing more than a fully executed painting could (116, 121, 1045). The painter sees the spontaneous single gesture and with multiple strokes carries it over into the next gesture, so that cycles of movement appear. This can be demonstrated in the work of Degas too (26, 27). A momentary pause in a gesture (1044), the charged immobility of a standing figure (42), or – in contrast – the flinging movement of a dancer (51), are all expressed in the actions of the body (1047) and material in motion (1041). The indicator of this is the stroke or running fleck of ink, which circumscribes the figure and gradually makes itself independent.

The uninhibited movement of the dance is characterized in short dabs or long sweeping lines. These permit of

1051 Franz Kline
Horse and rider
c. 1944
India ink drawing
25.1 × 19.1 (9⅞ × 7½)
Artist's Estate

1052 Gibon Sengai
The Uso bird
Edo period
1603–1867
India ink on paper
Japan, Private Collection

1053 Karel Appel
Animal
1957
Painting over collage
23.6 × 17.5 (9¼ × 6⅞)
Private Collection

interpretation as signs, because general processes are being transformed into definite situations by the shorthand of the line (1041). The super-sensitive strokes of Toulouse-Lautrec's ink drawings are particularly impressive. They encapsulate and reactivate remembered sensory impressions in a linear structure.[5]

In Toulouse-Lautrec's studies of dancers, the balanced stance of a dancer is presented with a few dabs of the brush or fine curved strokes (1045). Many painters and graphic artists in Europe took up this approach afterwards. The illustrators of the European weeklies and art periodicals are a good example.[6] Thomas Theodor Heine deserves to be mentioned: in his illustrations to the book *Die Barrison* depicting the career of a dancer, the codified intensive stroke is worked up into an arabesque (1043).

It was the Japanese calligrapher Gibon Sengai, abbot of the Shofukuji Temple in Tokyo, who showed Toulouse-Lautrec the way. Lautrec presumably took an interest in Sengai's work under the influence of the international exhibitions of 1878 and 1889. Bing published Sengai reproductions in *Le Japon artistique*.[7] In Lautrec's drawing technique the simplified selection of lines is striking, as well as the desire for uninhibited flow of the brush work. He had ordered brushes and ink from Japan[8] for the purpose of strengthening the spontaneity of his graphic 'handwriting'. The free handling of the brush is very evident in the sketches for the poster *Le Divan japonais* (1059, 1060). But this attitude was just a stage in his progress towards the expression of a new life-style, a world in motion, where subjective expressions are revealed in the play of ink.

Sengai seems to have communicated a new consciousness to Toulouse: a desire to dissolve himself completely in the painting process. For the painter, the visible line is at the same time an inner rhythm of motion, and he converts this into highly differentiated structures (1055, 1057). Conception and execution already coincide in the painting action of Toulouse-Lautrec, for his figures are inventions of the moment which include a working-up of realistic detail (1047). The essence of what is seen is simplified yet again, for with small means much can be said. An eye, a hair or two, the ciphers for mouth and nose: these are rudiments in the spirit of Sengai. In their very brevity they carry a high overload of meaning (1062). The aspects of human character in the 'head calligraphies' of Toulouse-Lautrec represent a narrowing down of specific behaviour. The mimic traces, achieved in a manner similar to that of Sengai by means of ironic deformation, are already an 'abstracting' type of expression (1057).

Added to this is the blurring of what is visually perceptible by means of the 'whiplash line'. The contrasts between broad streaks and passing trickles, between an erring comma stroke and a centred full stop, create a certain imprecision of vision (1049).

1054 Miyamoto Musashi
Daruma, first patriarch and founder of Zen Buddhism
Momoyama period
(1568–1603)
India ink on paper
65 × 31 (25½ × 12¼)
Paris, Galerie
Jeanette Ostier

1055 Henri de Toulouse-Lautrec
Sketch in a letter to Maurice Joyant
April 1901
Ink on paper, mounted
17.3 × 24.2 (6¾ × 9½)
Private Collection

384

However, calligraphic structures are quite differently perceived by the Europeans. Because of the ideographic script of the Far East, things can be presented equally well in strictly circumscribed signs or in running, sweeping characters. The codified form can be presented heraldically or as an arabesque, as a sign in a circle, sharp like a silhouette. The second generation of French Impressionists chose the pluralistic form, following their chosen Oriental models. They took up a variety of ornamentation based on scales or plumage (1066–73) which became highly stylized in the hands of the Nabis and later the English Art Nouveau illustrators. In Europe around 1900 the whole range of possibilities between rapid sketching and ornamental patterns was open. Sequences of similar forms resulting from repeated dabs of the brush create associative chains within a very restricted space, scales and feather patterns are particularly suited to this method (1068, 1069, 1073). An extremely free-flowing sketch can be constrained into a standardized form by means of interior fields (1068, 1069). In this technique a kind of piloted randomness is converted into rhythm.

European graphic artists of the second half of the nineteenth century were even more intensively preoccupied with Oriental ink painting. We will discuss the technical aspect and give an outline of historical developments.[9]

A major feature of Oriental ink painting is the fact that the viewer himself reconstructs the artistic process; the technical process is rendered transparent. The picture surface is very important in this technique. In Asia, particularly China and later Japan, this surface is symbiotically united with the painterly writing process: the picture surface or ground has a direct connection with the painting process. For this reason, complex preparation of the surface is avoided; the surface is hardly ever primed. The Oriental ink artist is very conscious that he can be a painter and simultaneously a writing-master conversant with calligraphic brush technique. He can unite both possibilities without masking the spontaneity of his artistic/technical method (1042, 1061).

Over the centuries European artists had been at pains to erase all evidence of the brush and the direct appearance of brush marks with their specific peculiarities. The colours were applied in several layers and then varnished so that the graphology of the hand, the evidence of the brush, could no longer be traced. But in the course of development a change appeared in Europe too, in the sense that drawing established its autonomy. The division of the artistic process into two parts – the sketch (*bozzetto*) and its gradual transformation into the finished picture – was replaced by spontaneity, corresponding more and more closely to the Oriental process. The art of drawing among the Italians from the fourteenth century on exerted an important influence on

1056 Suiō Eiboku
Sekiri Daruma (detail)
18th century
Hanging scroll
India ink on paper
200 × 44 (78¾ × 17¼)
Tokyo, Eisei-Bunko

1057 Henri de Toulouse-Lautrec
Maurice Joyant (detail)
1899
India ink on paper
50 × 35.5 (19¾ × 14)
Paris, M. G. Dortu

1058 Gibon Sengai
Daruma
Edo period
1603–1867
India ink on paper
107.5 × 40.2 (42⅜ × 15⅞)
Private Collection

1059 Henri de Toulouse-
Lautrec
Le Divan japonais
1892
India ink drawing
21.4 × 19.7 (8⅜ × 7¾)
Paris, Private Collection

1060 Henri de Toulouse-
Lautrec
Le Divan japonais
1892
India ink study for the poster
of 1893
80 × 64 (31½ × 25¼)
Private Collection

1061 Gibon Sengai
Cat
Edo period
1603–1867
India ink on paper
39.9 × 51.2 (15¾ × 20¼)
Private Collection

1062 Henri de Toulouse-
Lautrec
Ooops!
15 January 1895
6 × 5 (2⅜ × 2)
Repr. *La Revue blanche*

this process. Nonetheless, in the framework of European development overall, drawing remained a secondary component in comparison to painting, and the absolute status of the brush line as a personal 'handwriting' was not achieved. This is in marked contrast to Oriental ink painting, where the principle of omission welds the whole pictorial process together in an elliptical manner (1063, 1064). Consider the *haboko* pictures (*ha*, break; *boko*, ink): the artistic process is handled in terms of 'broken' or detached ink strokes.[10]

The Japanese artist Sesshu Tōyō was one who devoted himself exclusively to perfecting this technique. It is noteworthy that he travelled to the homeland of this art, namely China, in 1468, and absorbed important influences there. It was in the Ashikaga period that this ink technique gained its position as the leading art form in Japan. The graphology of the handwriting is an index of the importance and skill of any particular master. The action of the brushstroke reveals the attitude of the master and his school.[11] The Sung period produced the best examples. A writer of the Sung period says that the works of the ink painters are 'seal impressions of the heart' (*ya-tzu*).[12]

Spontaneity is a requirement in Oriental ink art, because a work has not only to display the specific gifts of the artist but also to convey his mood. This implies a strengthening and differentiation of the effect that the Oriental viewer can reconstruct from the picture. But in Europe a combination of writing and painting did not take place. The precision of calligraphic strictness combined with improvisatory brushwork could not be attained here. The content and codification which is embedded from the start in the script served overall in the East as a significant component of brush drawing (599, 1042, 10/6).

The technical requisites have been refined over the centuries in the Far East, to the extent that writing and painting brushes are like seismographic instruments of the highest utility. The way the brush is held and moved is adapted in a virtuoso manner to any given situation. It was not only a question of calligraphic accuracy; the binding factors lay much more in the technical process of producing a swelling or shrinking line, with more or less pressure or lifting of the brush. Calligraphic laws determined the flow of lines, restricted only by the degree of elasticity in the brushwork. Chinese as well as Japanese ink painting is determined by the values resulting from the swing of the brush within the linear structure. This black-and-white technique with considerable tonal differentiation falls within the sphere of interest of those European artists whose preference is for a spontaneous painting process. It is a feature of the technique itself that three-dimensional rendering of the forms is lacking, because the type of shading used in European art for this purpose does not occur. In an elliptical manner the flat script is more than a flat surface yet less than a three-dimensional space. It acquires an ever stronger character as a signal by using codified forms which provide information about the objects depicted by means of minimal spatial gradations. Flatness or depth are brought together by the most minimal traces of shading relief (599, 1093).

1063 Gibon Sengai
Nan-ch'üan dismembers the kitten
Edo period
1603–1867
India ink on paper
29 × 52 (11⅜ × 20½)
Private Collection

1064 Gibon Sengai
Hotei yawning
Edo period 1603–1867
India ink on paper
92.5 × 27.5 (36⅜ × 10⅞)
Private Collection

1065 Henri de Toulouse-Lautrec
Marthe Mellot
Cover design for *L'Image*
October 1897
Colour woodcut
29.5 × 21.7 (11⅝ × 8½)
Private Collection

1066 Pierre Bonnard
Fruit picking
c. 1891
India ink and pen on paper
22.6 × 16.2 ($8\frac{3}{8}$ × $6\frac{3}{8}$)
(mount)
Private Collection

1067 Edouard Vuillard
Young woman
1891
India ink and pencil on paper
18 × 18 ($7\frac{1}{8}$ × $7\frac{1}{8}$)
New York, Collection
Alfred R. Stern

1068 Japan
Eagle
Edo period
1603–1867
Woodcut
Repr. Louis Gonse, *L'Art
Japonais*, 1886

1069 After Katsukawa
Shunchō
Falcon attacking a heron
(detail)
Woodcut
Repr. Louis Gonse, *L'Art
japonais*, 1886

1070

1071

1072

1073

1070 After Katsukawa
Shunchō
Falcon attacking a heron
(detail)
(see caption to 1069)

1071 Aubrey Beardsley
The Climax (detail)
1894
Illustration to *Salome* by
Oscar Wilde
Zincograph on vellum
16.5×9.6 ($6\frac{1}{2} \times 3\frac{3}{4}$)
Private Collection

1072 Aubrey Beardsley
1892
Illustration to *Le Morte
d'Arthur*
Private Collection

1073 William H. Bradley
The Kiss (detail)
November 1896
Zincograph
26×20 ($10\frac{1}{4} \times 7\frac{7}{8}$)
Reproduced in *Bradley: His
Book*

389

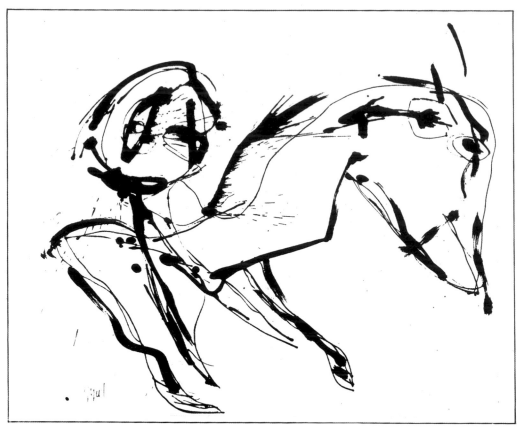

1074 Karel Appel
Horse
1957
Brush drawing on paper,
mounted
21.2 × 34.5 (8⅜ × 13⅝)
Private Collection

1075 Karel Appel
Figurative calligraphy
1953
Oil on canvas
125 × 100 (49¼ × 39⅜)
Private Collection

Through all this the eyes of Chinese and Japanese artists and connoisseurs have developed a sharpness which is not directed towards the literary/illustrative aspect of the works but towards the reconstruction of their artistic and technical impetus.

In some cases the handling of the brush (in a technical sense) has even become collectivized. For example, the painters of the Sung period preferred to hold the brush at an angle to the painting surface. The products of this brushwork are identifiable by the fact that the thickening of the lines is always oriented in one direction. We can distinguish examples of brush work with regular thickening of lines related to the direction of painting. Numerous combined techniques were developed, producing definite effects characteristic of the various Chinese periods. This concentration on technical methods of representation, often sharply delimited, has brought about a situation in which artists, in line with their artistic intention, make very exact choices even within each category of their materials.

The many Chinese treatises on painting give very interesting guidelines, in particular on the layered use of colour tones where the picture is dominated by one tone-scale, for instance the grey or brown-grey of the ink.[13]

As in the articulation of the line, an elliptical procedure is also developed from the rhythmic use of the ink tones. These are adjusted to the phenomena of nature, particularly the light, according to a logical sequence. Combinations of artificial light and overall brightness of natural open-air lighting are used not so much to create atmospheric effect, but rather to present

the atmosphere as a symbol or suggestion of illusionistic depth. Technical handling of the application of ink to the painting surface is also determined by rich experience and Buddhist contemplation. Combinations of washes and dry profiled ink processes create a harmony that no longer seemed possible in European painting. Picture surfaces of silk and rice paper were the appropriate media for reflecting the ink processes, since the experienced artist knew in advance and could reckon with the reactions of the surface to the ink in the moment of application. Experience dictated modesty in terms of technique, and finally extreme restraint, so that big effects were achieved with minimal technical means.

If we compare this with brush usage in Europe, it is clear that such differentiation was not attempted, at least in the seventeenth and eighteenth centuries. Certainly it can be shown that the orientation towards a swift grasp of momentary processes by means of brushwork was getting stronger in this period, and that here too the observer was stimulated by the spontancity of the painter's 'handwriting'; but the support as an autonomous surface did not achieve the same importance as in the Far East. In Rembrandt's graphic work pictorial content and brush language are welded into a whole, and in the course of the eighteenth century this was taken up in illustrative work. But the content and the brushwork are held in equilibrium, and it is very rare that a painter's calligraphic handwriting acquires primary significance.

The driving force in the Far East is Zen painting, called *zenga*, which is directly connected to poetry. Painting, and literary creation as well, submits not to

1076 Ekaku Hakuin
Daruma
India ink on paper
230×78.5 ($90\frac{1}{2} \times 30\frac{7}{8}$)
Tokyo, Idemitsu Museum

1077 Gibon Sengai
Daruma
Edo period
1603–1867
India ink on paper
158×68.5 ($62\frac{1}{4} \times 27$)
Rome, Biblioteca Ismeo

391

1078 Christian Dotremont
A Lapp winter's day, hence dark . . . (En hiver un jour lapon donc de nuit)
1971
India ink on paper
136 × 201 (53½ × 81)
Paris, Galerie de France

1079 Japon
Sumō banzuke
(Announcement of a *sumō* wrestling contest)
110 × 83 (43¼ × 32¾)
Private Collection

1080 Pierre Soulages
Composition No. 30
1956
Oil on canvas
162 × 114.5 (64 × 45)
Munich, Bayerische
Staatsgemäldesammlungen

reason but to illumination and enlightenment. Painting is one pillar, tea and poetry are the others. In Zen art the concepts 'step-wise' and 'suddenly' are highly significant because they imply the temporal Way.

Chinese Zen (Ch'an) Buddhism differs considerably from the Buddhism of India, its land of origin. The Japanese cult combines worldly consciousness with the Chinese concepts of the sacred to form a transcendental Buddhist philosophy. Reality is understood as ideal knowledge, yet knowledge which is definitely selected and practised in terms of a chosen manner of life. Learning to master one's own spirit is the centre of this doctrine.

In the Far East writing is the universal medium of communication – present even in visual art. In addition, the 'presence' of the sign is much stronger, so that the word/image situation is codified in the script. The sign-like written word, often syntactically self-sufficient, rises above the level of spoken language and verbal communication. The result is a magic pictorial pluralism which precludes any search for meaning; certain direct signals are triggered on the basis of familiarity. General readiness to react to the trigger mechanisms of pictorial signals can be observed in the Far East today; such things still determine the reactions and behaviour of the people to a large extent. The collective subconscious creates a system of calligraphic patterns which is hardly accessible to Europeans. As a result, the stimulus of Far Eastern calligraphy had to travel by quite different paths. This statement is valid for all artistic contacts between Europe and the Far East. Mark Tobey recognizes this when he writes:

Some critics have accused me of being an Orientalist and of using Oriental models. But this is not so, for I knew when in Japan and China – as I struggled with their *sumi* ink and brush in an attempt to understand their calligraphy – that I would never be any but the Occidental that I am. But it was here that I

1081

1082

1084

1083

1081 Eduardo Chillida
*Abstract composition in
black and white, collage*
c. 1968
16.1 × 19 (6⅜ × 7½)
Munich, Private Collection

1082 Franz Kline
Caboose
1961
Oil on canvas
107 × 79.7 (41⅛ × 31⅜)
New York, Marlborough-
Gerson Gallery Inc.

1083 Georges Mathieu
Jewellery design
1956
Black ink, brush and pen on
paper
19.7 × 32.8 (7¾ × 12⅞)
Private Collection

1084 Gerd van Dülmen
Calligraphy
1979
Oil on brown card
90 × 110 (35½ × 43¼)
Private Collection

1085 Nantenbō
Daruma
1839–1925
India ink on paper
103 × 30.6 (40½ × 12)
Tokyo, Idemitsu Museum

1086 Emil Schumacher
Arch
1969
Etching
105 × 70 (41⅜ × 27½)
S. Germany, Private
Collection

394

1087 Hans Hartung
T 1938–31
1938
Oil on canvas
33 × 22 (13 × 8⅝)
Private Collection

1088 Akaba Untei
Calligraphy (detail)
1972
India ink on paper
318 × 90 (125 × 35½)
Tokyo, Private Collection

395

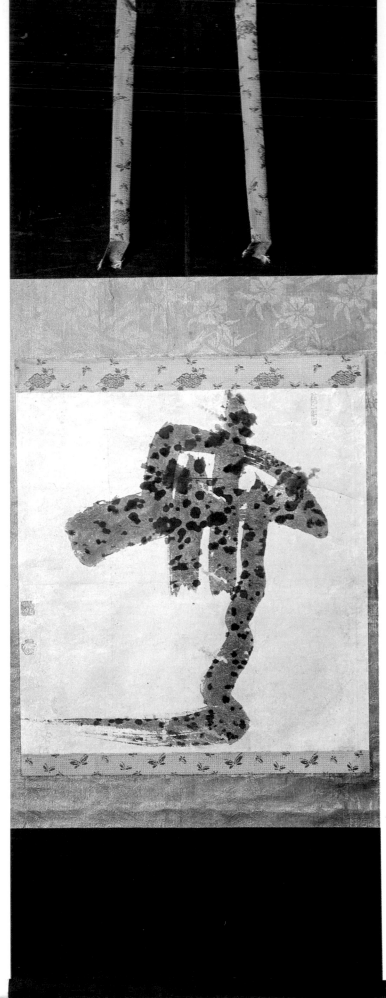

1089 André Masson
Kabuki No. 1
1955
Gouache
18 × 25 (7⅛ × 9⅞)
Paris, Galerie Louise Leiris

1090 Gibon Sengai
Symbol of the void
Edo period
India ink on paper
57 × 66.5 (22½ × 26⅛)
Tokyo, Idemitsu Museum

got what I call the calligraphic impulse to carry my work on into some new dimensions. . . . With this method I found I could paint the frenetic rhythms of the modern city, the interweaving of lights and the streams of people who are entangled in the meshes of this net.[14]

The strand in modern art called Action Painting, Abstract Expressionism and Tachism gets its names from its use of spontaneous flecks of paint. Yet these terms are but a substitute for a stylistic concept, a style-substitute. In the development of modern art,

This strand occupies an important position. Michel Tapié's concept of 'Art autre' – a mythical concept – is used to describe it; and also 'Tachism', an old term coined by Gustave Geoffroy to characterize the Nabis. In addition there is the denomination *informel*, which arose in the circle around Jean Paulhan. (This term occurs already in Rimbaud, to whom Camille Bryen refers. For him, *informel* [unformed, formless] means the destruction of every form of expression; it means 'dehumanization', which amounts to 'anti-painting' as he himself practised it.)[15]

Tachism, tentatively allocated to the period from the end of the 1940s to the mid-1960s, can no more be tied down to particular time-limits than ink painting. From Tachism and *art informel*, which dominates or will dominate the second half of the twentieth century over and over again, many connections can be drawn to calligraphy. Action, the swift process of the act of painting and the improvisation of random brush-play, of pouring paint from a tin or sloshing it onto the canvas – these are processes of 'unformed' art, and also processes of spontaneous calligraphy to a certain extent. *Informel* and Tachist artistic utterances are stimulated considerably by the Oriental method, but deviate widely from it in the manifold statements they develop.

The Europeans select the most varied stimuli, and each goes his own way. Even the frame of reference is different from that of the Far East. Unlike the Oriental artist, the European artist has no intention of taking up the norms, attitudes and behaviour of a group of people in his visual language. In the work of the European artists influenced by Oriental calligraphy there appear negative features of varying intensity which degenerate finally into in-group frames of reference. Studying the differing attitudes of Tobey and his so-called 'Pacific School', one can recognize the various criteria or 'standards' that have developed and differentiated themselves according to individual experience. Conforming behaviour, in the spirit of the schools of Oriental calligraphy, does not exist. Each artist creates his own categories, and the rules derived therefrom make up a subjective code, or private language.

The European painters who have drawn upon the art of the Far East nevertheless have at their disposal a large range of choices as a result. In the course of his creative work the consciousness of the painter is extended – in all

1091 Julius Bissier
Symbol of male-female oneness
1934
India ink on Japan paper
24.5 × 16.6 (9⅝ × 6½)
Düsseldorf, Kunstsammlung Nordrhein-Westfalen

1092 Hans Hartung
Drawing
1937
India ink on paper
47.8 × 30.5 (18¾ × 12)
Paris, Collection Hans Hartung

1093 Gibon Sengai
The Moon
Edo period
India ink on paper
60 × 127 (23⅝ × 50)
Tokyo, Idemitsu Museum
The text reads: 'When I see the shadows thrown into the emptiness of space, how boldly the autumn moon rises up.'

397

directions. This creative process was known to the European painters. Through their calligraphic exercises they learned the ability to grasp the creative process more consciously and apply it directly in the spirit of Zen to the domain of life. The academics put the quesion thus: Is there Oriental influence or not? Much more important than this are the general learning processes triggered by Far Eastern calligraphy, because the artistic signals produce a plethora of reactions and the issue is to select the most adequate of these. This circumstance should be analysed very precisely if one wants to draw any conclusions, because the motivation of an artist is always related to a very particular individual aim. André Masson summarizes this as follows:

The idea of a stage has governed the form of Western painting, and still does so today. But heavy storms are gradually demolishing the boards and scaffolding. Then space will become what it is for the Zen painter: the spirit of the painter. Painting will no longer be a succession of objects, ground up, formless, dried out, cracked up, overloaded. It will – in a mystical way – itself become an object of meditation.

The painter of the Far East, painter of what is significant, was filled with this conception in the great moments of his history. He had learned to live this highest vision.

Nothing could be more remote from Western attitudes. In China or Japan the relations of the initiate to a method of painting that he is striving for are infinitely less superficial than in the West. Think about the fact that in the hands of Mouki or Sesshu a modest plum branch beginning to bloom (a classical motif) does not trigger some simple pleasurable reaction – like a question answered or a desire satisfied. This 'roughly sketched' branch, contrasting with the delicately 'suggested' buds, barely opened and so vulnerable when the spring is there underground but the air is still tight with the bonds of winter – this is an unveiling of the invisible struggles that divide the universe, this is also a symbol of the fleeting existence of Man in this 'world of dew', of the eternity of what is passing. This a spiritual and cosmic hurricane which sweeps the observer up and carries him along as it carried the one who rode on the storm. This brushstroke is the spirit of the branch, this other one is the spirit of the blossom coming into being. . . . The novel lyrical calligraphy of the Japanese can rise to the point of pure effusion. The painter gives a sign, and it is understood. For he has grasped 'the tone of the spirit, animated by the

1095 Pierre Alechinsky
*Variations on Sengai's
Symbol of the universe*
1960
Lithograph and india ink on
paper
55 × 76 (21⅝ × 29⅞)
Munich, Galerie van der Loo

stirring of the soul', and he wafts it into the spirit of the observer as a bell in the evening air wafts its vibrations into seemingly endless space. We have a lot to learn in this respect, as individuals and collectively. This way of looking art and life in the eye is so foreign to us. Despite that, I believe that a better understanding of Chinese and Japanese painting – whether figurative or calligraphic – has arisen in the last few years.[16]

André Masson, born in 1896, felt his vocation to be painting and studied first at the Academy in Brussels, exchanging this in 1912 for the Academy in Paris. He went through a period of Cubism under the influence of Juan Gris; he was closely connected with the Surrealists, especially Miró and Ernst, joined their group and took part in their exhibitions up to 1929. He made 'automatic' drawings and was deeply influenced by his love of literature (Blake, Sade, Kafka and Nietzsche, as well as Chinese poetry and philosophy). Masson left the Surrealists in 1929, since their activity did not interest him in the long term. In 1937, however, he returned to France and was reconciled to them. This second Surrealist period lasted until 1947.

Franz Kline approached the 'calligraphic exercises' from other artistic regions. His ink drawing of a rider (1051) displays an unrestricted flow of black – the hurried handwriting improvises the real motion of the subject in a single all-embracing *ductus*. In contra-distinction to the attitudes of the Europeans the Japanese painters have a respectful attitude to nature, not a purely aesthetic attitude. The Chinese painters around Shih K'o (end of the Fifth Dynasty) provided modern Western painters with a new orientation with their method of laying out large flat areas and developing the form out of these.

Ogata Kōrin (330, 1048) and Gibon Sengai (1042, 1046) follow 'the line which sets everything in motion', the line which presents the traces of movement in flecks, beams, dots and strokes which communicate the content. The swelling and decreasing motion of the brush is like a reflector of the artist's personality. These are not literary pictures, but they do present 'scenes' and often include a number of situations in one picture. The evocation of situations was brought to a high art in

1096 Julius Bissier
Calligraphy
1961
India ink on paper
50.3 × 65 (19¾ × 25⅝)
Basel, Galerie Beyeler

1097 Mokuan Shōtō
Calligraphy
c. 1670
India ink on paper
156 × 78.5 (61⅜ × 30⅞)
Paris, Galerie Beurdeley

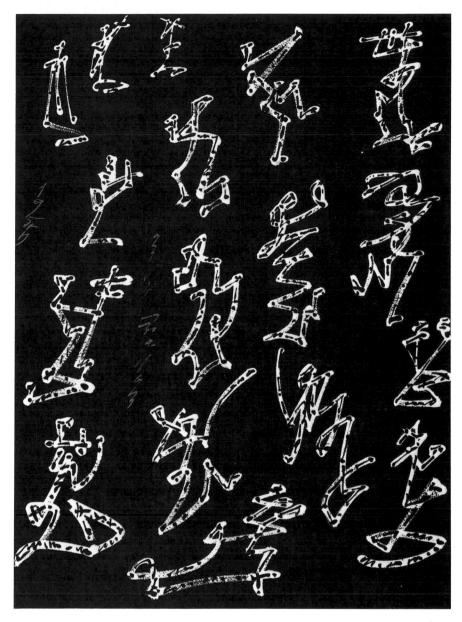

董齋盛義書 荻廷屋鳥燕

1098 Japan
Dedicatory text
Late 18th–early 19th century
Woodcut, white on black
28×23.5 ($11 \times 9\frac{1}{4}$)
Private Collection

1099 André Masson
Chinese actors
1955
Colour etching
57×76 ($22\frac{1}{2} \times 29\frac{7}{8}$)
Paris, Galerie Louise Leiris

1100 Asger Jorn
*Title-page of the album
'From head to foot'*
1966–67
Lithograph
90×63 ($35\frac{1}{2} \times 24\frac{3}{4}$)
Munich, Private Collection

an abstract symbolism with emotional side-effects. The trend towards colour fields, encircled patches of colour, unites excitement and repose – and stands in opposition to randomly running colour traces.

The 'gestural painting' of Adolph Gottlieb is a kind of regression to rigid communicative signs, for by the use of convention gestures can and do become a sign language. To this extent Gottlieb *is* striving for greater comprehensibility within the sphere of life he is familiar with. Big signs fixed and braced in the form of beams on a frame-related surface communicate a new *gestalt* quality whose concomitant is an aesthetic of shifting proportions. 'This has nothing to do with Oriental calligraphy', Pierre Soulages assures us. 'For me these black signs represent the possibility of saying everything at once.'[21] Edge-related compositions are clearly emphasized in the work of Soulages (1080), Mark Rothko, Eduardo Chillida (1081), Franz Kline (1082) and others. The energy content of the big brushstrokes does not lie, as it does in Far Eastern calligraphy, in the quality of floating on a spaceless ground. Nor is the configuration open on all sides: often only a section is presented (1082). Through this planned edge-relatedness there emerge other reference points, and these are associated with the general context of the experience of Western painters (1080, 1082). The fields of utterance of the Western

405

painters are nevertheless very broad. In his free handling of the 'whiplash line', Gerd van Dülmen proceeds from the spontaneous flow of the script-sign, but then he waits and later reworks the structure on the micro-level. So his painting process is spontaneous only in the beginning phase; spontaneity is then superseded and differentiated by a variety of working processes (1084).

But there is a third form of play to be demonstrated. Modern painting has been affected not only by Far Eastern calligraphy, but also by the Islamic Kufic script. An important feature of this calligraphy is the fact that it is always bound to the page of the Koran; the ordering of the rows of signs is subordinated to this. Dependence on this format is demonstrable even in monograms of the sultans. Christian Dotremont fits his cuneiform characters into three columns in a horizontal rectangle according to this system (1078).[22]

Jean Degottex goes through the original script exercises for the Western painter and, writing according to the European system, articulates a large black surface (1103). This is not a matter of known signs being transformed; rather the rhythmic flow of the European *ductus* from left to right is spontaneously hurled onto the surface. The left-to-right reference makes the signs more familiar; in comparison with the motions of Oriental calligraphy, his work introduces a certain element of European autonomy. The familiar flow reinforces the sense-impressions of the viewer. The picture is not 'legible', but this use of the picture surface does produce a stronger conceptual image.

For many European and American painters the calligraphic painting process remains an adventure, because no one can predict what will happen on the canvas. No system is binding; each picture has its own system. Georges Mathieu informs us about such individual conceptions. In 1957, one hour before the opening of his exhibition in Tokyo, Mathieu painted a picture 15 metres long in the display window of a big department store in the presence of a crowd of onlookers. He declares, not without arrogance:

Without knowing it, I gave this people, who have been seeking for nearly a century to combine the privileges of their traditional art with the seductions of Western painting, an answer to their question. I painted in oils, straight out of the tube, I used big flat brushes and long thin ones, I struck the canvas with folded towels dipped in liquid paint, I worked out the backgrounds by simply moving along the horizontal canvas. I improvised my signs before their eyes in an atmosphere of religious ceremony. I was in ecstasy from the close contact with the people; I worked '53,482 times as fast as Utamaro', as a statistician happily informed me. In this manner, without noticing it, I brought about the fusion of their 1000-years-old art and European oil painting, which has influenced and seduced them since the time of the Impressionists.'[23]

Mark Tobey was active on the West Coast of America and belonged to the Pacific School. In 1934 he went to live in a Zen temple in Japan and also spent some time in China studying Chinese calligraphy.

It is an indisputable fact that Tobey's essentially reflective work found a way, in and through the East, to express what cannot be expressed. . . .[24] Tobey's *White Writing Paintings* are permeated with the spirit of Zen. Like the calligraphy of the Zen masters, they express their inner self and are no longer concerned only with the outer form. Like the Zen painters, Tobey was a mystic, more interested in his inner visions than in the external phenomena of the world around him.[25]

Tobey's work is not bound by spatial limits (1101). The expansion of his paradoxical surface-space is contingent on a kind of multiplication which owes everything to the pictorial structure itself.

Working under different presuppositions, Jackson Pollock introduced the idea of the 'all-over field'. Apparently without emotion, he trickles the paint from edge to edge of the painting and beyond (1102). He deliberately starts wrong, and then goes on to build up the drip process to a perfected surface structure formed out of threads of colour. The distance to the object is muted, yet the tendency towards action and the motivation towards a definite goal and direction are strongly evident in these drip paintings. Pollock developed rhythmic qualities in his random pouring method. The artist's hand as a determinant is largely excluded, yet the plurality of threads forms its own individual language which pays tribute to the calligraphic manner as the highest mode of expression.

1105 After Katsushika Hokusai
Calligrapher at work
1814–78
From *Manga*
Colour woodcut
Repr. Rutherford Alcock
Art and art industry in Japan
London 1878, p. 12
20.5 × 12.5 (8 × 5)

Notes on the text

Historical survey (pages 8–11)

1 Gronau, D. and J. Sembritzki, 'Feste, Theater und Literatur im Verhältnis zu den modischen Strömungen ihrer Zeit', cat. 'China und Europa', Berlin 1973, 114ff.

2 Eggeling, Tilo, 'Die chinoise Innenraumdekoration des Barock und Rokoko'; Bothe, Rolf, 'Der Einfluss Chinas auf europäische Textilien und Tapeten'; Baer, Winfried, 'Zur Chinamode im Kunstgewerbe'; Eggeling, Tilo, 'Die Chinoiserie in der Vorlageornamentik des 17. und 18. Jahrhunderts'; all in cat. 'China und Europa' (n.1).

3 Crane, Walter, Of the Decorative Illustration of Books Old and New, London 1896, reissued 1972, 132f.

4 Quoted in Pennell, E. R. and J., The Life of James McNeill Whistler, London, Philadelphia 1908, I, 118.

5 Munsterberg, Hugo, Zen-Kunst, Cologne 1978, 93.

6 Le Japon artistique, 36 monthly numbers, Paris 1888–91.

7 Bing, Samuel, 'Introduction', Le Japon artistique, 1, May 1888.

8 Perucchi-Petri, Ursula, Die Nabis und Japan, Munich 1976, 13.

9 Heuser, Maria and Hans-Jörgen, cat. 'Französische Keramik zwischen 1850 und 1910', Munich 1974, 68ff.

10 Weisberg, Gabriel P., 'Félix Bracquemond and Japonisme', Art Quarterly, XXXII, Spring 1969, 56ff.

11 Heuser (n.9).

12 Gabriel P. Weisberg has made important contributions to the study of Japonisme, not only with his work on Bracquemond (n.10) but also in other publications: see below, bibliography, p. 417.

13 See, for instance, a vase decorated with elephants' heads in the Österreichische Museum für angewandte Kunst in Vienna.

14 Zola, Emile, Salons, Paris 1959, 241f. Zola, Malerei, Berlin 1913, 240.

15 International exhibition in Paris 1900, 'Complete catalogue of the German Exhibit', Berlin 1900.

16 Pecht, Friedrich, Kunst und Kunstindustrie auf der Wiener Weltausstellung 1873, Stuttgart 1873, 296f. Lessing, Julius, Bericht von der Pariser Weltausstellung, Berlin 1878.

17 La Porte Chinoise was already established in 1853, as were Le Céleste Empire at rue Saint-Marc 20 and Curiosités at rue de Rivoli 220. See Allemand, Geneviève, 'Le rôle du Japon dans l'évolution de l'habitation et de son décor en France', diss., L'Ecole du Louvre, Paris 1964.

18 Joyant, Maurice, Henri de Toulouse-Lautrec, 1864–1901, Paris 1926–27, I, 77.

19 Quoted in Hall, H. van, Repertorium voor de Geschiedenis der nederlandse Schilder- en Graveerkunst 1936, 628–32.

20 Van Gogh, Vincent, The Complete Letters, 3 vols, New York, London 1975, letter 510.

21 Inada and Vignier, Estampes japonaises tirées des collections de MM. Bing, Bonasse etc., et exposées au Musée des Arts Décoratifs en janvier 1911, Paris 1911.

22 Durand-Ruel sale catalogue, 'Collection Samuel Bing', 6 vols, Paris 1906.

23 Van Gogh (n.20).

24 Geffroy, Gustave, 'Le Japon à l'Ecole des Beaux-Arts, 16 mai 1890', reprinted in La Vie artistique, 1st series, 1892, 85ff.

25 Inada and Vignier (n.21). Hôtel Drouot sale catalogues: 'Objets d'art japonais et chinois, peintures, estampes, composant la collection des Goncourt', 1897; 'Dessins, estampes, livres illustrés du Japon réunis par T. Hayashi', 1902. Ernest Leroux sale catalogue, 'Catalogue des peintures et estampes. Collection Philippe Burty', 1891.

26 Cat. 'Estampes d'Outamaro et de Hiroshige exposées dans les Galeries Durand-Ruel', preface by S. Bing, Paris 1893.

27 International exhibition in Paris 1900. Complete catalogue, p.226.

28 Perucchi-Petri (n.8), 18.

29 Terukazu, Akiyama, Japanische Malerei, Geneva 1961, 180.

30 Hakenjös, Bernd, Emile Gallé. Keramik, Glas und Möbel des Art Nouveau (Material zur Kunst des 19. Jahrhunderts, 17), Munich 1975.

31 Leroy, L., 'L'exposition des impressionistes', Charivari, 25 April 1874, 207ff.

32 Novotny, Fritz, Cézanne und das Ende der wissenschaftlichen Perspektive, Vienna 1938, 37f. Rasch, Wolfdietrich, 'Fläche, Welle, Ornament. Zur Deutung der nachimpressionistischen Malerei und des Jugendstils', Festschrift Werner Hager, Recklinghausen 1966, 61ff.

33 Seckel, Dietrich, Buddhistische Kunst Ostasiens, Stuttgart 1957, 148f.

34 Wichmann, S., Die Gruppe als Gruppenerfolg in der Bildnismalerei des Franz von Lenbach und seiner Zeitgenossen, Munich 1975.

35 Zola (n.14).

36 Gebser, Jean, Die Fundamente der aperspektivischen Welt, Ursprung und Gegenwart I, Stuttgart 1949, 38. Novotny (n.32).

37 Seckel (n.33), 182f.

38 Seckel (n.33), 182.

39 Perucchi-Petri (n.8), 60f.

40 Badt, Kurt, Modell und Maler von Jan Vermeer, Cologne 1961, 32f.

41 Seckel, Dietrich, Einführung in die Kunst Ostasiens, Munich 1960, 375.

42 Barnicoat, John, A Concise History of Posters, London 1972.

43 European artists made a detailed analysis of the artistic methods of the Far East. Thematic exemplars were studied first, but then the individual technical components were investigated in both theory and practice. See Graul, Richard, Die ostasiatische Kunst und ihr Einfluss auf Europa, Leipzig 1906; Hofstätter, Hans H., 'Die Entstehung des "Neuen Stils" in der französischen Malerei um 1890', diss., Freiburg 1954.

44 Hans Hofstätter speaks of the 'unity of experience', Geschichte der europäischen Jugendstilmalerei, Cologne 1963, 32f.

45 Thirion, Yvonne, 'L'influence de l'estampe japonaise sur la peinture française', diss., L'Ecole de France, Paris 1947–48 (exc. Musées de France, October 1948). Hofstätter (n.43). Scheyer, Ernst, 'Far Eastern art and French Impressionism', Art Quarterly, VI, 1943, 116ff.

46 The placing together in a group of works which employ or experiment with comparable techniques is the only way of proving the adoption of a model; the choice of one particular method or technique is the yardstick for including otherwise disparate works in the same group. The vertical division of a picture by the arrangement of a grille-like line of objects across the near foreground, the diagonal separation, or the intersection, of planes etc. may be used to solve different artistic problems, but our concern is with the common means, not the individual ends.

47 Subject-matter, techniques and methods of expression are interrelated in Far Eastern art. Flowers and animals are often depicted in chiaroscuro technique, and almost ornamentally expressed. There are good examples of this in dyers' paper stencils, lacquers, calligraphy, textiles, etc.

The study of Japonisme (pages 11–14)

1 London, 1851, 1862, Paris 1867, 1878, 1889, 1900, Vienna 1873, Philadelphia 1876, Chicago 1893, St Louis 1904. See Beutler, Christian, Weltausstellungen im 19. Jahrhundert, Munich 1973.

2 Lessing, Julius, Bericht von der Pariser Weltausstellung 1878, Berlin 1878.

3 See Geffroy, Gustave, 'Le Japon à l'école des Beaux-Arts, 16 mai 1890', La Vie artistique, 1st series, 1892, 85ff.; Munsterberg, Hugo, 'East and West in contemporary Japanese art', College Art Journal, XVIII, 1958–59.

4 Gonse, Louis, L'Art japonais, 2 vols, Paris 1883. See also 'Les Japonais, premiers décorateurs du monde', Le Japon artistique, 2, June 1888; 'L'Art japonais et son influence sur le goût européen', Revue des arts décoratifs, XVIII, 1898, 97ff.

5 Paris and the Arts, 1851–96. From the Goncourt Journal. Ed. and transl. by G. J. Becker and E. Philips, Ithaca, N.Y., London 1971, 254.

6 See especially Chefs-d'oeuvre des arts industriels, Les émaux cloisonnés anciens et modernes, Le Japon artiste and the three lectures on Japanese pottery and porcelain printed in Revue des arts décoratifs in 1885. For full details of these and other titles by Burty see bibliography, p. 417.

7 Duret, Théodore, Livres et albums illustrés du Japon … à la Bibliothèque Nationale, Paris 1900. Kobayashi, Tai'ichiro, 'Nihon-Bijutsu oyobi Inshogaka to Théodore Duret' ('Japanese art, Impressionism and the work of Duret'), Koku-Ka, 571, 572, 1946.

8 See especially 'L'Art japonais et son influence sur le goût européen' (n.4).

9 Canz, Sigrid, 'Symbolistische Bildvorstellungen im Juwelierschmuck um 1900', diss., Munich 1976, 6f., 13.

10 Clavery, E., 'Art japonais, art européen', Bulletin de la Société Franco-Japonaise, 17 December 1909.

11 Josse (Lucien Falize), 'L'Art japonais. A propos de l'exposition organisée par M. Gonse', Revue des arts décoratifs, III, 1882–83, 334.

12 Falize, Lucien, 'Travaux d'orfèvre', Le Japon artistique, 5, 1888, 57.

13 Seidlitz, Woldemar von, 'Die Bedeutung des japanischen Farbenholzschnitts für unsere Zeit', Kunst und Kunsthandwerk, I, 1898, 233ff.

14 Goncourt, Edmond de, Outamaro, le peintre des maisons vertes, Paris 1891.

15 Huish, Marcus B., Japan and its Art, London 1888, 242 ff.

16 Seckel, Dietrich, Buddhistische Kunst Ostasiens, Stuttgart 1957, 127f.

17 Hernandez, Antonio, 'Die Rolle Ostasiens in der europäischen Kunst', Das Werk, 49, 1962.

18 See Crane, Walter, Of the Decorative Illustration of Books Old and New, London 1896, and 'Poetic ornament. A friendly dispute between Walter Crane and Lewis E. Day', Art Journal, 41, 1902, 270ff.

19 Henry van de Velde, who was committed to the Werkbund idea, wrote, 'What I say would be incomplete if I failed to mention that just as the Neo-Impressionists showed us the new line at a moment when it was not to be detected either in architecture or in ornamental style, so the sudden revelation of Japanese art awoke in us the sense of line … It took the power of the Japanese line, the power of its rhythm and the accents of that rhythm, to shake us from our slumber and to influence us … The Japanese line was our salvation.' ('Die Linie' [1910], Zum neuen Stil, ausgewählte Schriften van de Veldes, Munich 1955, 191.)

20 The results of this outlook, which predominated in so-called 'establishment' or public art, endure to the present day. See Braun-Feldweg, Wilhelm, Industrial Design heute, Hamburg 1966, 21ff.

21 Actes du congrès international d'histoire de l'art, Paris 1923, I; see also Focillon, Henri, La Peinture française au 19e et 20e siècle, Paris 1928.

22 See bibliography, p. 417.

23 '"Le corsage à carreaux" et les japonismes de Bonnard', La Revue du Louvre et des musées de France, 19th year, 1969, 1, 23.

24 Diss., Cologne 1957. Cf. Trier, E., Kunstchronik 12, 1959, 20ff.

25 Yamada, Chisaburō, Dialogue in Art. Japan and the West, Tokyo 1976, 149, 324.

26 See bibliography, p. 417. Yamada, who is one of the leading authorities in this field, organized the unforgettable exhibition 'Mutual influences between Japanese and Western arts', Tokyo 1968.

27 Adhémar, Jean, Toulouse-Lautrec: his complete lithographs and drypoints, New York 1965. Berger, Klaus, 'The reconversion of Odilon Redon', Art Quarterly, XXI, 1958, 151ff. De la Faille, J. B., L'Oeuvre de Vincent van Gogh. Catalogue raisonné, 4 vols, Paris, Brussels 1928; new ed. Paris, London, New York 1939. Cooper, Douglas, Drawings and Watercolours by Vincent van Gogh, New York 1955. Jannot, Paul, 'Degas', Gazette des Beaux-Arts, 1924 (probably the best analysis of the artist's style). Valéry, Paul, Degas. Danse. Dessins, Paris 1936 (also contains astute analysis). Chassé, Charles, Gauguin et le groupe de Pont-Aven, Paris 1921. Rewald, John, Gauguin, Paris, London, New York 1938. Malingue, Maurice, Gauguin, le peintre et son oeuvre, 2nd ed., Paris 1948. Goldwater, Robert, Gauguin, New York, London 1957. Leymarie, Jean, Paul Gauguin. Aquarelles, pastels et dessins en couleurs, Basle 1960. Sandberg, John, 'Japonism and Whistler', Burlington Magazine, CVI, 1964, 500ff. Sutton, Denys, The Nocturne. The Art of James McNeill Whistler, London 1963. Dorra, Henri and Sheila Adkin, 'Seurat's Japonisme', Gazette des Beaux-Arts, LXXIII, February 1969, 81ff. Kloner, Jay Martin, 'The influence of Japanese prints on Edouard Manet and Paul Gauguin', diss., Columbia University, New York 1968. Hanson, Anne Coffin, [review of] De Leiris, Alain, The Drawings of Edouard Manet, Art Bulletin, LIII, December 1971, 542ff. Reff, Theodore, 'Manet's portrait of Zola', Burlington Magazine, CXVII, January 1975, 34ff.

28 Current, William, Greene and Greene, Architects in the Residential Style, Fort Worth, Texas 1974.

29 Boyd, Robin, New Directions in Japanese Architecture, London 1968. A review of innovations in Japanese architecture linking the present and the future with the immediate past. A discussion of the work of many important contemporary architects and also a chapter on East-West exchange.

30 Conder, Josiah, Landscape Gardening in Japan, London 1893.

31 Miller, Roy Andrew, Japanese Ceramics, Vermont, Tokyo 1960, 55ff. Jakobsen, K. Japanische Teekeramik, Berlin 1958. Bergen, H., 'The pottery of the tea ceremony', Old Furniture, V, 1928.

32 Rose, Muriel, *Artist Potters in England*, 2nd edn, London 1970. d'Albis, Jean, 'La Céramique impressioniste à l'atelier de Paris-Auteuil', *Cahiers de la céramique*, XLI, 1968, 32ff. Leach, Bernard, *Hamada, Potter*, New York, London 1976.

33 These include, for instance, work on the Japanese use of vertical 'grilles' as a system of articulating planes and suggesting depth (Tokyo 1981); the adoption of Japanese floral motifs in Western art (Osaka, in preparation); and the 'picture within a picture'.

34 Kopplin, Monika, 'Das europäische Fächerblatt von Manet bis Kokoschka', diss., Cologne 1979.

35 Weighman, Christine, 'Ikonographische Details im *Manga* von Hokusai', diss., Karlsruhe 1976.

36 Canz (n.9).

37 Perucchi-Petri, Ursula, *Die Nabis und Japan. Das Frühwerk von Bonnard, Vuillard und Denis*, Munich 1976. With reference to n.13 (p. 407) to the introduction of this book, I must state that I was unacquainted with Frau Perucchi-Petri's manuscript, and that my contribution to the cat. 'Weltkulturen und moderne Kunst' was written in 1971. Frau Perucchi-Petri presented her dissertation, on which her book is based, at the University of Heidelberg at a time when the Munich exhibition was already in its closing phase. It confirms my conclusions on certain points.

38 Berger, Klaus, *Japonismus in der westlichen Malerei 1860–1920*, Munich 1980.

A case-study: the kimono (pages 16–21)

Incorporates material from cat. 'Weltkulturen und moderne Kunst', Munich 1972, 194–97.

1 Emil Orlik made several journeys to the Far East. Together with Carl Thiemann, he is recognized as having contributed most to the practical assimilation of the techniques of the Japanese colour woodcut in Germany. The individual stages were known in theory, but from *c.* 1900 Orlik used them in the development of a personal artistic statement. See cat. 'Emil Orlik', Munich 1932, 21ff.

2 Kurth, Julius, *Der japanische Holzschnitt*, Munich 1922, 28. Weber, V.F., *Ko-Ji Hō-Ten*, (Dictionnaire à l'usage des amateurs et collectionneurs d'objets d'art japonais et chinois). Paris 1923, I–II, 214–15, 240–41, 377.

3 Kurth (n.2).

4 Kurth (n.2), 28ff.

5 Novotny, Fritz and Johannes Dobai, *Gustav Klimt*, New York, London 1967, 78.

6 Bonicatti, Maurizio, 'Der Mythos des fernen Ostens', cat. 'Japanischer Farbenholzschnitt', Vienna 1973, 9ff.

7 Annette Kolb (German poet, 1875–1967), *Das Exemplar*, 1913, *Daphne, Herbst*, 1928, *Die Schaukel*, 1934, etc.

8 Lessing, Julius, *Bericht von der Pariser Weltausstellung 1878*, Berlin 18/8, 10. Schulze-Naumburg, Paul, *Die Kultur des weiblichen Körpers als Grundlage der Frauenkleidung*, Jena 1910. Klein, Ruth, *Lexikon der Mode*, Baden-Baden 1950, 225.

9 *Das grosse Bilderlexikon der Mode*, Prague 1966, 23.

10 Joseph Wackerle modelled his *Lady of fashion* (53) on Josefine Schallerer, a fashionable Munich corsetiere.

11 There is an incisive description of conventions of posture in Kurth (n.2), 28.

12 Lessing (n.8), 261.

13 Lessing (n.8), 235.

14 Nebehay, Christian M., *Gustav Klimt. Dokumentation*. Vienna 1969, 201ff.

Manet (pages 23–25)

1 Utamaro was popular with French artists generally, but Manet's liking for him was stronger than any, followed by Jules Chéret, who took Utamaro as the model for his posters as early as 1866. Chéret was held in high esteem by the first generation of French Impressionists, especially by Manet and Monet. His murals depicting the 'joys of life' in the main salon of the Hôtel de Ville in Paris already show his debt to Utamaro.

The print *Urie Jutaro with an umbrella* was shown in the exhibition 'Le Japon à l'Ecole des Beaux-Arts', 16 May 1890, and reproduced in *La Vie artistique*, 1st series, 1892, 112ff. See also Goncourt, Edmond de, *Outamaro, le Peintre des Maisons Verts*, Paris 1891, 257. Natanson, Thadée, 'Estampes de Outamaro et de Hiroshige exposées dans les Galeries Durand-Ruel', *La Revue blanche*, 16, February 1893. Kloner, J.M., 'The influence of Japanese prints on Manet and Gauguin', diss., Columbia University, New York 1967. Guérin, Marcel, *L'Oeuvre gravé de Manet*, Paris 1944, nos 84, 86, 89, 90, 91. Leiris, Alain de, *The Drawings of Edouard Manet*, Berkeley, Calif. 1969. Rouart, Denis and Daniel Wildenstein, *Manet*, Lausanne, Paris 1975, no. 268.

2 Schmidt, Steffi, *Katalog der chinesischen und japanischen Holzschnitte im Museum für ostasiatische Kunst Berlin*, Berlin 1971.

3 Emile Zola said of the Japanese influence on the Impressionists: 'All this is the work of the Impressionist painters: a closer investigation of the sources and effects of light, which has influenced drawing and colouring in an equal degree. It has been said, and rightly, that they have taken Japanese prints, which are so widely disseminated today, as their example.' (*Salons*, Paris 1959.)

4 Helmholtz, Hermann von, *Handbuch der physiologischen Optik*, Leipzig 1885, 38ff., 67ff., 108ff.

5 Zola, Emile, *Salons*, Paris 1959. Reff, Theodore, 'Manet's portrait of Zola', *Burlington Magazine*, CXVII, January 1975, 34ff.

6 Zola (n.5).

Degas (pages 26–39)

Incorporates material from cat. 'Weltkulturen', Munich 1972, 202–05.

1 Bandages were worn to prevent a longer stride. The width of the *obi* affects the shape of the body when walking. Weber, V.F., *Ko-Ji Hō-Ten*, Paris 1923, I, 240–41.

2 Kurth, Julius, *Der japanische Holzschnitt*, Munich 1922, 28. Weber (n.1), 214–15.

3 See cat. 'Emil Orlik', Munich 1972, no. 133.

4 See the different treatments of these subjects in numerous colour woodcuts by Utamaro, Kiyonaga, Shunshō, Koyūsai, Harunobu and others.

5 Van Gogh, Vincent, *The Complete Letters*, 3 vols, New York, London 1958, letter 500.

6 Masayoshi, Kiato, *Models for Quick Sketches*, Yeddo 1813. Weber (n.1), 104, 142, 347, 482.

7 Weber (n.1).

8 Wichmann, S., *Die Gruppe als Gruppenerfolg in der Bildnismalerei des Franz von Lenbach und seiner Zeitgenossen*, Munich 1975.

9 Wichmann, S., *Franz von Lenbach und seine Zeit*, Cologne 1973.

10 Wichmann (n.8).

11 Wichmann (n.8).

12 Wichmann, S., *Bemerkungen zur Neuausgabe Manga von Hokusai*, Tokyo, Munich 1974. Weber (n.1), 509.

13 Cabanne, Pierre, 'La "Mangua" de Hokusai', *Le Japon artistique*, 8, 1888.

14 Holmes, C.J., *Hokusai*, London 1898. Goncourt, Edmond de, *Hokusai*, Paris 1896. Fukumoto, Kazno, *Hokusai and Impressionism*, Tokyo 1947. Kobayashi, Tai'ichiro, 'Hokusai et Degas sur la peinture Franco-Japonaise en France et au Japon', Japanese National Commission for Unesco, *Collection of the papers presented at the international symposium . . . Tokyo 1959*, 69ff.

15 Quoted in Cabanne, Pierre, *Edgar Degas*, Paris 1957.

16 The expression of physical posture that Degas created under the stimulus of Hokusai remained influential for more than a generation. Cachin, Françoise, 'Le portrait de Fénéon par Signac. Une source inédite', *Revue de l'art*, 6, 1969, 90f.

17 The basic poses adopted by the Expressionists, inspired by African art, are still influential today.

Van Gogh (pages 40–44)

1 Van Gogh, Vincent, *The Complete Letters*, 3 vols, New York, London 1958, letter W3 (to his sister Wilhelmina).

2 For example: 'My great longing is to learn to make those very incorrectnesses, those deviations, remodelings, changes in reality, so that they may become, yes, lies if you like – but truer than the literal truth.' (letter 418, to Theo.) In this Van Gogh was at odds with the Impressionists, whose ambition was to create as realistic a copy as possible of the media of light, air, steam, water in material consistency with the aid of colour perspective.

3 Van Gogh (n.1), letter W7. J.B. de la Faille, 'een merkwaardig Zelfportret van Vincent van Gogh', *Phoenix*, IX, 3, 215.

4 This portrait is of a type common in the fourteenth century, with the almost frontal view of the shaven head, to which the body serves as the basic of a sculpted bust.

5 Van Gogh (n.1), letter W7.

6 Van Gogh (n.1), letter 542.

7 Van Gogh (n.1), letter 487, to Theo.

8 Van Gogh (n.1), letter 500, to Theo.

9 Van Gogh probably saw signs from the 'green houses' in the Yoshiwara quarter of Edo in Samuel Bing's gallery, and made a note of them so as to be able to use them in the borders he gave his copy of Hiroshige, without knowing what the characters meant. His purpose was to intensify the value of the local colours by placing the bright red border round them – a sign of his belief in the importance of colour values, and in the primary role colour played as a signal. See Novotny, Fritz, 'Die Bilder van Goghs nach fremden Vorbildern', *Festschrift Kurt Badt*, Berlin 1961, 213ff.

10 Goepper, Roger, *Im Schatten des Wu-Tung-Baumes*, Munich 1959, 35.

11 Van Gogh (n.1), letter B2.

12 Van Gogh (n.1), letter 500.

13 To his sister he wrote: 'But by intensifying *all* the colors, one arrives once again at quietude and harmony.' (Letter W3.)

14 Tralbaut, M.E., *Vincent van Gogh und Charles de Groux*, Antwerp 1953, 135ff. Jaffé, Hans, 'Vincent van Goghs Suche nach dem heiteren Leben', cat. 'Weltkulturen', Munich 1972, 169ff.

15 Cooper, Douglas, 'Two Japanese prints from Vincent van Gogh's collection', *Burlington Magazine*, XCIX, 1957, 204ff. Basil, Stewart, *Japanese Colour Prints*, London 1920, 36f.

16 Kurth, Julius, *Geschichte des japanischen Holzschnitts*, 3 vols, Leipzig 1925–29, III, 86ff.

17 The breakdown of colour in Impressionism was not something that Van Gogh was interested in taking up and pursuing further. He wanted to unite line and colour values, while preserving the integrity of the picture plane. The Japanese print strengthened him in this determination. See Jaffé (n.14).

18 He wrote to his sister-in-law: 'Might it not be a fact that when you are fond of something, you see it better and more truly than when you are not fond of it?' (Letter 591).

Gauguin and the white-line technique (pages 45–51)

1 Rewald, John, *Post-Impressionism*, new rev. ed., London 1980, 457ff. Goldwater, Robert, *Paul Gauguin*, London 1957.

2 Wildenstein, G., *Gauguin: catalogue*, Paris 1964, I. Guérin, M., *L'Oeuvre gravé de Gauguin*, Paris 1927.

3 Fukumoto, Kazno, *Hokusai and Modern Painting*, Tokyo 1968, 38ff.

4 This was why Gauguin was able to keep going back to a small number of typical forms of pose and gesture, unlike Degas, who represented movements differently every time.

5 Schmidt, Steffi, *Katalog der chinesischen und japanischen Holzschnitte im Museum für ostasiatische Kunst*, Berlin, Berlin n.d., pl. 82.

6 Rewald (n.1), 488.

7 Cabanne, Pierre, *Edgar Degas*, Paris 1957.

8 Weber, V.F., *Ko-Ji Hō-Ten*, Paris 1923, I–II, 509.

9 Hokusai followed tradition. The foreshortened view which he selected in his animal studies has predecessors in early Chinese art.

10 Segalen, V., *Lettres à Emile Bernard*, Paris 1950.

11 Gauguin's prints have a meditative depth he was unable to achieve in his paintings. Printing his woodcuts on layers of translucent paper created a diaphanous effect which corresponded to the dark, nocturnal atmosphere he described under the heading 'The night was dark', *Noa-Noa* (1893–94; facsimile ed., Paris 1954).

12 Hempel, Rose, in cat. 'Ukiyo-e, Sammlung Scheiwe', Essen 1972, 26. Kurth, Julius, *Der japanische Holzschnitt*, Munich 1922, 50.

13 See n.12.

14 In particular, the technique of the white-line print from a black block dominated much of the book illustration of the period.

15 Hempel (n.12).

16 In this connection, Chinese stone-rubbings are of great interest, showing affinities with the frottage techniques of Max Ernst, and vice versa. (See cat. 'Max Ernst, Frottagen, Collagen, Zeichnungen, Graphik, Bücher', Zürich, Frankfurt, Munich 1978.) Gauguin's finely articulated drawing in the technique makes the final effect similar in character to a monotype.

17 Guérin (n.2).

18 The colours were printed from the same block, and the grain of the wood creates an extraordinary *mouvementé* effect through the layers of transparent paper; the combination of the layers creates a *chiaroscuro*, giving an illusion of spatial depth.

19 Dube, W.D., *Ernst Ludwig Kirchner, das graphische Werk*, Munich 1967, 18, 19, 39, et al.

Line and dot in Van Gogh's drawings (pages 52–61)

Incorporates material from cat. 'Weltkulturen', Munich 1972, 171ff.

1 Van Gogh, Vincent, *The Complete Letters*, 3 vols, New York, London 1958, letter 510.

2 Yamamoto, *Painters' manuals, drawings and their explanation*, transl. from Old Japanese into Middle Japanese (Japanese compilation from Chinese sources); modern ed., Tokyo and Kyoto 1930, enlarged ed., 1968. See ills 99 and 102.

3 Goepper, Roger, *Vom Wesen chinesischer Malerei*, Munich 1962, 39ff.

4 Contag, Victoria, 'Tung Ch'i-ch'ang's Hua-ch'an-shih sui-pi und Hua-shuo des Mo Shih-Lung', *Ostasiatische Zeitschrift* 1933, 18ff.

5 Goepper, Roger, *Im Schatten des Wu-T'ung Baumes*, Munich 1959, 33.

6 From the preface to his *Hundred Views of Mount Fuji*, Edo 1834, 3 vols, Tokyo, National Library.

7 Van Gogh (n.1), letter 542.
8 Berlin, Museum für ostasiatische Kunst (Jap. 23 Kl. Bd. 1–3, OS, 16, 37).
9 Berlin, Museum für ostasiatische Kunst (Jap. 213 Kl. OS, 14, 148).
10 Berlin, Museum für ostasiatische Kunst (Jap. 245 Kl. OS, 19, 369).
11 Berlin, Museum für ostasiatische Kunst (Jap. 285 Kl.)
12 Berlin, Museum für ostasiatische Kunst (Jap. 375, OS, 04, 401).
13 Van Gogh (n.1), letter 511.
14 Van Gogh (n.1), letter 511.
15 Van Gogh (n.1), letter 511.
16 Van Gogh (n.1), letter 474.
17 Reidemeister, Leopold, cat. 'Der Japonismus', Berlin 1965, 24.
18 Van Gogh (n.1), letter 533, to Theo.

Gesture and grimace in Lautrec (pages 62–69)

1 Lemoisne, P. A., *Degas et son oeuvre*, 4 vols, Paris 1946–49. Delteil, Loys, *Edgar Degas. Le Peintre-graveur illustré*, Paris 1919.
2 Shinoda, Yūjirō, 'Der Einzug des Japanischen in die französische Malerei', diss., Cologne 1957. Fukumoto, Kazno, *Hokusai and Impressionism*, Tokyo 1947. Hahn, Ethel, 'The influence of the art of the Far East on nineteenth-century French painters', diss., Chicago 1928. 'Degas and Japonisme', *Scritti di storia dell'arte in onore di Lionello Venturi*, Rome 1956, II, 125ff.
3 Adriani, Götz, *Toulouse-Lautrec: das gesamte graphische Werk*, Cologne 1976, 10.
4 Especially in posters: e.g. *Le Divan japonais* and *L'Artisan moderne*.
5 The Place Pigalle was a favourite gathering-place for tourists in the 1890s. See Jurdent, E., *Offizielle Führer durch die Stadt Paris*, Leipzig 1893, 18.
6 Winzinger, Franz, *Shunga. Meisterwerke der erotischen Kunst Japans*, Nuremberg 1975 (introduction).
7 Unbridled, primary movement was irreconcilable with establishment art, which moved increasingly towards the ceremonial and the stereotyped.
8 The assertiveness of gesture is sacrificed to the throw-away effect; the class-conscious provocation of the potentate's stance is converted into an ornamental, burlesque movement. See Wichmann, S., *Die Gruppe als Gruppenerfolg in der Bildnismalerei um 1900*, Munich 1975.
9 *Sumō* wrestling was governed by ritual.
10 In his lithographs Toulouse-Lautrec developed a thin, sensitive line, which could assume a rhythmic grace; by this means the artist intended to stimulate specific extra-aesthetic reactions to the subject.
11 Hempel, Rose, cat. 'Ukiyo-e: Die Kunst der heiteren vergänglichen Welt', Essen 1972, no. 193.
12 'Keeping up appearances' was a matter of displaying behaviour considered appropriate to the social standing of the individual, and calculated to arouse specific expectations in the beholder.
13 Exaggerated gesture and convoluted posture went even further in the work of the Expressionists.
14 G. Needham contributed a comparison of the painting and the kimono pattern to cat. 'Japonisme', Cleveland 1975, 128.

Vallotton's woodcuts and the Orient (pages 70–73)

1 Koella, R., Cat. 'Félix Vallotton. Bilder, Zeichnungen, Graphik', Winterthur 1978, 31.
2 In 1855, 1867, 1878 and 1900. See the official catalogue of the 1878 exhibition, xi, 247.
3 Koella (n.1) suggests Gauguin's zincographs as a possible model. Certainly Gauguin's knowledge of *ishizuri-e* and Chinese monochrome prints was to lead to a transformation of the woodcut in Europe, but the high 'density' of the silhouetted forms in Vallotton's prints indicates that he knew Chinese monochrome prints at first hand. On the Far Eastern technique, see Seckel, Dietrich, *Buddhistische Kunst Ostasiens*, Stuttgart 1957, 139.
4 Hillier, J., *The Japanese Print, a New Approach*, London 1960, 2/1975.
5 Cat. 'Taiso Yoshitoshi 1839–92', Cologne 1971, 21ff.
6 Cat. 'Yoshitoshi' (n.5), ills 3, 4, 8, 14.

Living creatures in art (pages 74–75)

1 Bousquet, Georges, 'L'Art japonais', *Revue des deux mondes*, May 1877, 288ff.
2 'Les Insectes et leur interprétation décorative', *L'Art décoratif*, XXVIII.
3 Van Gogh, Vincent, *The Complete Letters*, 3 vols, New York, London 1958, letter 542.
4 Cat. 'China und Europa', Berlin 1973.

5 Eggeling, Tilo, 'Die Chinoiserie in der Vorlageornamentik des 17. und 18. Jahrhunderts', cat. 'China und Europa' (n.4).
6 Beutler, Christian, *Weltausstellungen im 19. Jahrhundert*, Munich 1973.
7 At that date a large number of children's book illustrators were active in England, such as R. Anning Bell, Francis D. Bedford, Randolph Caldecott, Franz Cizek, Walter Crane, Edmund Dulac, Joseph M. Gleeson, Kate Greenaway, J. A. Shepherd, Winifred Smith and Hugh Thomson. These artists studied the work and techniques of Japanese artists.
8 Information supplied by the Zeitungswissenschaftliches Institut der Universität München.
9 *Japanische Dichtungen*, Leipzig and Tokyo, 1895. The Japanese illustrators represented were Mishima Yūnosuke, Suzuki Sōtarō (Kwason), Arai Shūjirō (Yoshimune), Kajita Teitarō (Hanko) and Yeda Masajirō (Sadahiko). The names in brackets are the professional pseudonyms some of them used.
10 Feddersen, Martin, *Chinesisches Kunstgewerbe*, Brunswick 1958, 250, and *Japanisches Kunstgewerbe*, Brunswick 1960, 269.
11 Feddersen (n.10). Goepper, Roger, *Blumen aus dem Senfkorngarten*, Munich 1960, 56ff.
12 Rokuroku, Kinzin, *Collection of Field and Garden Bindweeds*, Osaka 1816–17.
13 Terrasse, Claude, *Petites scènes familières pour piano*, Paris 1893 [with 19 lithographs by Bonnard], and *Petit solfège illustré*, Paris n. d. [30 pp., each with a border in Japanese style by Bonnard].
14 *Gerlachs Jugendbücherei*, 34 parts in 32 vols, Vienna, Leipzig 1900–20.
15 Ed. A. Cronbach and H. H. Ewers, Berlin 1905.

Trees (pages 76–83)

1 Goepper, Roger, *Im Schatten des Wu-T'ung Baumes*, Munich 1959, 7. In France in the second half of the nineteenth century, the Barbizon School and the Impressionists turned to models from the Far East in the depiction of tree forms. Later painters and graphic artists of the Art Nouveau picked out tree structures of a type they had found in Hokusai and Hiroshige. See below *The Grille* . . . (pp. 228–41).
2 The tree became an ornamental element in pictures. By the 1880s book illustration in Europe was following the example of the Far East in allowing the tree a decorative role, with trunks and branches providing a border to the page. Grautoff, Otto, *Die Entwicklung der modernen Buchkunst in Deutschland*, Leipzig 1901, 9, 15, 39, 74, 118, 140 etc. Hofstatter, Hans H., *Jugendstil Druckkunst*, Baden-Baden 1968, 33, 53, 55, 67, 70, 74, 76ff. Nebehay, Christian M., *Ver Sacrum*, New York 1977, 57, 63, 65, 69, 117, 156, 161, 165, 167, 201, 213 etc.
3 Goepper (n.1), 14.
4 Goepper (n.1), 15.
5 Seckel, Dietrich, *Buddhistische Kunst Ostasiens*, Stuttgart 1957, 24ff., 230f.
6 Goepper (n.1), 35.
7 Goepper (n.1), 35.
8 Tralbaut, M. E., 'Van Goghs Japonisme', *Mededelingen van den dienst voor schone Kunsten der Gemeente s'Gravenhage*, IX (1954), 6ff.
9 Goepper (n.1), 34.
10 Goepper (n.1), 35.

Bamboo (pages 84–85)

1 Reproduced in cat. 'Japonisme', Cleveland 1975, 88, no. 110.
2 Yang En-Lin, ed., *Der Senfkorngarten. Lehrbuch des chinesischen Malerei*, Leipzig 1966. *The Mustardseed Garden (Chieh-tzu-yüan hua-chuan)* is a Chinese painter's manual, by the painter Wang Kai, in 4 volumes, edited in Chinese by Shên Hsiu-yu, with a preface by Li Yü, originally published in Nanking 1701. It is dedicated to the 'four noble plants' (*szuchün-tzu*), orchid (or iris), bamboo, plum blossom and chrysanthemum. In Book II it is said of the bamboo (*chu*): 'Every single brush stroke must be sustained by a vital idea, and you shall naturally encounter immediacy in each single aspect.' Netto, C., *Japanischer Humor*, Leipzig 1901, 63, 146, 233.
3 Goepper, Roger, *Im Schatten des Wu-T'ung Baumes*, Munich 1959, 14. Goepper, Roger, *Blumen aus dem Senfkorngarten*, Munich 1960, 17. Weber, V. F., *Ko-Ji Hō-Ten*, Paris 1923, I, 49.

The Art Nouveau iris (pages 86–89)

1 The Kelmscott Press, for example, founded by William Morris in 1890.
2 Hilschenz, Helga, *Das Glas des Jugendstils*, Düsseldorf 1973, 72, 198, 285, 287, 353.
3 Gyssling-Billeter, Erika, *Objekte des Jugendstils*, Berne 1975, nos 88, 315, 372, 463. Cat. 'Kunsthandwerk um 1900. Jugendstil', Darmstadt 1973, no. 315.

4 Preface to Eckmann, Otto, *Neue Formen, dekorative Entwürfe für die Praxis*, Berlin 1897.
5 Cat. 'Le groupe des XX et son temps', Otterlo 1962. Cat. 'Präraffaeliten', Städelsches Kunstinstitut, Frankfurt a. Main 1974.
6 Wichmann, S., *Jugendstil*, Herrsching 1977, 4ff.
7 Wichmann (n.6).
8 Wichmann (n.6).
9 Grautoff, Otto, *Die Entwicklung der modernen Buchkunst in Deutschland*, Leipzig 1901, ills on pp. 74–76, 84, 118 etc.
10 Feddersen, Martin, *Japanisches Kunstgewerbe*, Brunswick 1960, 42, 66, 157, 273. Weber, V. F., *Ko-Ji Hō-Ten*, Paris 1923, I, 315f.
11 Yang En-Lin, ed., *Der Senfkorngarten*, Leipzig 1966 (*The Mustardseed Garden*, see n.2, p. 84).
12 Yang En-Lin (n.11), 24.
13 Yang En-Lin (n.11), 19.
14 Berlin, Museum für ostasiatische Kunst.
15 Yang En-Lin (n.11), 18.
16 There is a volume of Hokusai copies of the Edo period in the Collection Franz Winzinger in Regensburg.
17 The central division of the picture by the fold of the book results in a certain asymmetry when one looks only at the right or left-hand side on its own. In each case the fold in the centre creates effects of fragmentation and underlines the sense of the picture's being a detail. See Seckel, Dietrich, *Einführung in die Kunst Ostasiens*, Munich 1960, 218.

Gourds and autumn leaves (pages 90–91)

1 *Tsuba* by Lucien Falize in the form of an ornamental gourd (wrongly described as 'bean'), ill. in Hase, Ulrike von, *Schmuck in Deutschland und Österreich*, Munich 1977, after a *satsuma tsuba* by Oda Naoka in the form of a truss of gourds in openwork relief, d.7.5 cm. (3 in.). See Feddersen, Martin, *Japanisches Kunstgewerbe*, Brunswick 1960, 133, ill. no. 115. Weber, V. F., *Ko-Ji Hō-Ten*, Paris 1923, II, 259.
2 Weber (n.1), I, 42 (aubergine). Feddersen, Martin, *Chinesisches Kunstgewerbe*, Brunswick 1958, 248, 253. Li Tieh-Kuai, the legendary disciple of Lao-tse, used to carry a bottle-gourd, from which strange shapes rose up to the clouds. By this magic means he remained in close touch with Lao-tse, for he could send his own soul up to heaven.
3 Feddersen (n.2).
4 Hokusai, *Manga*, IX, 27. Cf. the Taoist magician Chō-Kwa-Ro. Weber (n.1), I, 111.

Butterfly and peony (pages 92–93)

1 Wilhelm, R., *Chinesische Volksmärchen*, Jena 1914. Weber, V. F., *Ko-Ji Ho-Ten*, Paris 1923, II, 160f.
2 Mensching, G., *Buddhistische Symbolik*, Gotha 1929. Weber (n.1).

The tiger (pages 94–97)

1 Feddersen, Martin, *Chinesisches Kunstgewerbe*, Brunswick 1958, 250. Weber, V. F., *Ko-ji Hō-ten*, Paris 1923, I–II, 391f. Netto, C., *Japanisches Humor*, Leipzig 1901, 44. Feddersen, Martin, *Japanisches Kunstgewerbe*, Brunswick 1960, 269. Wilhelm, R., *Chinesische Volksmärchen*, Jena 1914, 62.
2 Weber (n.1), II, 287. Waterburg, F., *Early Chinese symbols and literature*, New York 1942, 92.
3 Joly, Henri L., *Legend in Japanese art*, Tokyo 1968.
4 Netto (n.1), 88. Weber (n.1), II, 391f.
5 Feddersen, (n.1). Weber (n.1). Netto (n.1).

The cat (pages 98–105)

1 Bruhs, Leo, *Geschichte der Kunst*, Hamburg 1954, I, 44ff. Wilhelm, R., *Chinesische Volksmärchen*, Jena 1914, 32.
2 Weber, V. F., *Ko-Ji Hō-Ten*, Paris 1923, I, 96. Joly, Henri L., *Legend in Japanese art*, Tokyo 1968.
3 Weber (n.2).
4 Weber (n.2).
5 Lane, John, *Cats' legends*, London 1907. Netto, C., *Japanischer Humor*, Leipzig 1901, 26, 44, 138, 174.
6 Other designers at the Royal Copenhagen Porcelain Factory worked on animal forms, notably C. Thomsen, E. Nielsen and T. Madsen. See cat. 'Stilkunst um 1900 in Deutschland', Staatliche Museen, Berlin 1972, 87ff.
7 Kloner, J. M., 'The influence of Japanese prints on Edouard Manet and Paul Gauguin', diss. Columbia University, New York 1968. Guérin, Marcel, *L'Oeuvre gravé de Manet*, Paris 1944, nos 52, 53, 74. Leiris, Alain de, *The Drawings of Edouard Manet*, Berkeley, Calif., 1969, nos 226, 229, 475. Rouart, Denis and Daniel Wildenstein, *Edouard Manet. Catalogue raisonné*, Lausanne, Paris 1975. Hanson, Anne Coffin, [review of] De Leiris, Alain, *The Drawings of Edouard Manet*, *Art Bulletin*, LIII, December 1971, 542ff. Harris, Jean C., *Edouard Manet. Graphic works*, New York

1970. Weisberg, Gabriel P., 'Early sources and French printmakers 1854–82', cat. 'Japonisme', Cleveland 1975, 40f.

Waterfowl (pages 106–07)
1 Mandarin ducks and similar waterfowl occur already as symbols of conjugal harmony as early as in the first poem of the Shi-ching, celebrating a prince's wedding. The first strophe runs,
> Two ducks call to each other,
> They have built on a river-island.
> Quiet and chaste is the pure maiden
> Bride of the noble prince.
See Feddersen, Martin, *Chinesisches Kunstgewerbe*, Brunswick 1958, 251; also Netto, C., *Japanischer Humor*, Leipzig 1901, 168, 250.
2 Collection of Far Eastern copy books, Private Collection, southern Germany.
3 In woodcuts too we find extremely bold downward-looking views onto stretches of water with pairs of ducks. See the *tanzaku* (tall, narrow format, 38 × 13 [15 × 5⅛]) by Andō Hiroshige. In cat. 'Ukiyo-e, Sammlung Scheiwe', Essen 1972, 270, no. 486.
4 Mandarin ducks were also carved in jade. See Nott, St. Ch. 1, *Chinese Jade*, Rutland, Vt, Tokyo 1962, Pl. LXXIV.
5 Collection of Japanese copy books between 1820–76, Private Collection, Southern Germany.

Birds of Prey (pages 107–08)
1 In Japanese ghost stories icy-cold fog is symbolized by a giant white-headed hawk. This fog hawk was painted by Takehara Shunsen. See Netto, C., *Japanischer Humor*, Leipzig 1901, 80, 81; also Feddersen, Martin, *Japanisches Kunstgewerbe*, Brunswick 1960, 270.
2 Katsushika Hokusai, facsimile ed., Tokyo 1974, Vol. 9.
3 Magaud d'Aubusson, *La Fauconnière*, Paris 1879, 17.
4 Bruhns, Leo, *Antike und Frühes Mittelalter (Die alten Völker)*, Vol. 1, 30ff.

Cranes and herons (pages 110–13)
1 Weber, V.F., *Ko-Ji Hō-Ten*, Paris 1923, II, 426; also Brauns, D., *Japanische Märchen und Sagen*, Leipzig 1885.
2 Feddersen, Martin, *Japanisches Kunstgewerbe*, Brunswick 1960, 270.
3 Weber, V.F. (n.1). Waterbury, Fl. *Early Chinese Symbols and Literature*, New York 1942. Wilhelm, R., *Chinesische Volksmärchen*, Jena 1914, 16.
4 Weber, V.F. (n.1). Wilhelm, R. (n.3), 48ff.

Cock and hen (pages 114–16)
1 Weber, V.F., *Ko-Ji Hō-Ten*. Wilhelm, R., *Chinesische Volksmärchen*, Jena 1914, 51. 'Mythologie Asiatique', Paris 1928, Vol. 4, section 8.
2 Mori Shunkei, active around 1818–30. *Cock and hens under a plum tree*. Year of the cock, 8th year Bunsei (1825). See cat. 'Ukiyo-e, Sammlung Scheiwe', Essen 1972, no. 525.
3 Waterbury, Fl., *Early Chinese Symbols and Literature*, New York 1942, 87. Weber (n.1), Vol. 1, 126.
5 Mensching, G., *Buddhistische Symbolik*, Gotha 1929. Maspéro, H., 'Légendes mythologiques dans le Chou-King', *Journal Asiatique*, CCIV, 1924.
6 Weber (n.1), Vol. I, 126.

The raven (pages 117–19)
1 Waterbury, Fl., *Early Chinese Symbols and Literature*, New York 1942. Weber, V.F., *Ko-Ji Hō-Ten*, Paris 1923, I, 126.
2 Guérin, Marcel, *L'Oeuvre gravé de Manet*, Paris 1944, No. 86. Leiris, Alain de, *The Drawings of Edouard Manet*, Berkeley, Calif. 1969, Nos 431, 440, 441. Kloner, Jay Martin, 'The Influence of Japanese Prints on Edouard Manet and Paul Gauguin', diss., Columbia University, New York 1947. Hanson, Anne Coffin, [review of] Leiris, Alain de, *The Drawings of Edouard Manet*, *Art Bulletin*, LIII, December 1971, 542–47. Harris, Jean C., 'Edouard Manet – Graphic Works. A Definitive Catalogue Raisonné', New York 1970.
3 Williams, C.A.S., *Outlines of Chinese Symbolism and Art Motives*, 1932. Weber, V.F. (n.1), I, 126, II, 186ff.
4 Weber, V.F. (n.1), I, 126.
5 As n.4.
6 Wilhelm, R., *Chinesische Volksmärchen*, Jena 1914.
7 Weber, V.F. (n.1), 126.
8 As n.7. Mensching, G., *Buddhistische Symbolik*, Gotha 1929.

The wild carp (pages 120–23)
1 This fabulous creature was drawn by Hokusai and reproduced in his *Hundred Views of Mount Fuji* in 1834/5. The roof peaks of the imperial castles at Tokyo and Nagoya were adorned with the same type of fish. See Feddersen, Martin, *Japanisches Kunstgewerbe*, Brunswick 1960, 268.

2 Feddersen, Martin, *Chinesisches Kunstgewerbe*, Brunswick 1958, 251.
3 Joli, Henri L., *Legend in Japanese Art*, Tokyo 1968. Weber, V.F., *Ko-Ji Hō-Ten*, Paris 1923, I, 421 (*Kin-toki*).
4 Weber (n.3), 81, 175.
5 Weber (n.3), 53.

Insects (pages 124–25)
1 Goepper, Roger, *Blumen aus dem Senfkorngarten*, Munich 1960, 17.
2 Schmidt, Steffi, 'Katalog der chinesischen und japanischen Holzschnitte im Museum für Ostasiatische Kunst in Berlin', Berlin, 160 (introduction).
3 Shunkei, Mori, *Selected scratchings seen from close up*, Edo 1820. 1st ed., Berlin, Staatliche Museen, Museum für Ostasiatische Kunst, Jap. 378 Kl. Bi 99, 249.
4 Schmidt, Steffi (n.2), 160 (introduction).
5 Guérin, Marcel, *L'Oeuvre gravé de Manet*, Paris 1944, No. 63a. Leiris, Alain de, *The Drawings of Edouard Manet*, Berkeley, Calif. 1969. Rouart, Denis and Daniel Wildenstein, *Manet*, Lausanne, Paris 1975.
6 Collection of Japanese zoological and botanical manuals, 1820–80. Private Collection, southern Germany.

The wave (pages 126–27)
1 Colta Feller Ives, *The Great Wave*, 'The Influence of Japanese Woodcuts on French Prints', The Metropolitan Museum of Art, New York Graphic Society, 1974. Scheyer, Ernst, 'Far Eastern Art and French Impressionism', *Art Quarterly*, VI, Spring 1943, 116–43, Weber, V.F., *Ko-Ji Hō-Ten*, Paris 1923, I & II, 419.
2 Michalski, E., *Die entwicklungsgeschichtliche Bedeutung des Jugendstils*, Rep Kw Vol. 46, 1925. Schmalenbach, F., *Jugendstil*, Würzburg 1935, 23ff.
3 Audsley, George A., *Ornamental Arts of Japan*, London 1884.
4 As n.3.
5 Muromachi period (1336–1573) – dominance of the art-loving Ashikaga shōguns.
6 Grautoff, Otto, *Die Entwicklung der Modernen Buchkunst in Deutschland*, Leipzig 1901, 146 et al. Cat. 'Symbolismus in Europa', Baden-Baden 1976, 106 (Kupka), 115 (Maillol), 125 (Martini). Also Klinger, Max, *Die Welle*, Munich Bayer. Staatsgemälde-Sammlungen. Cat. 'L'Ecole de Pont-Aven', Nantes 1978, nos 45, 59, 105.
7 Goepper, Roger, *Kunst und Kunsthandwerk Ostasiens*, Munich 1968, 247.
8 Michener, James A., *The Hokusai Sketch-Books*, Tokyo 1958. Facsimile ed., Tokyo 1974 (with introduction by S. Wichmann). Reman, Ernest, 'Hokusai's *Manga*', *Le Japon artistique*, 9, 1889, 99ff.
9 Cat. 'L'Ecole de Pont-Aven', Nantes 1978, Nos 45–50.
10 As n.9, colour plate no. 45.
11 Weber (n.1), Paris 1923, I & II, 452.
12 Michalski (n.2), Vol. 46.
13 De la Faille, J.B., *Vincent van Gogh*, Paris 1939, 418, 454, 455.
14 Schmalenbach (n.2), 23ff.
15 Yang En-Lin, ed., *Der Senfkorngarten*, Leipzig 1966, 15.
16 Yukio, Yashiro, *Japanische Kunst*, Munich, Zurich 1958, Pl.152.
17 As n.16.
18 As n.16, Pls 155/6.
19 Hokusai, Katsushika, *Comb Designs*, Tokyo, National Library, H.1867 II.
20 As n.19.
21 Audsley, George A. (n.3), 28ff. Cutler, Thomas W., *A Grammar of Japanese Ornament and Design*, London 1879.
22 Cremona Italo, *Il tempo dell'Art nouveau*, Florence 1964, No. 262. Hofstätter, Hans H., *Jugendstil-Druckkunst*, Baden-Baden 1973, 99, 158, 185, 202, 256, 270. Nebehay, Christian M., *Ver Sacrum*, New York 1977, 52, 59, 134, 179.

The bridge (pages 138–45)
Incorporates material from cat. 'Weltkulturen', Munich 1972, 208–09.
1 As cartographic draughtsman in the Washington marine department Whistler had some training in technical construction and construction drawings. He also painted bridge pictures on screens and produced numerous etchings of bridges. See *Old Hungerford Bridge* (C.76, III), *London Bridge* (C.153, V), *Old Battersea Bridge* (C.177, IV), *Old Putney Bridge* (C.178, IV), *Amsterdam Bridge* (C.409, III). Naylor, Maria, *Selected Etchings of James A. McN. Whistler*, New York 1975. Whistler's bridge etchings, lithographs, and drawings display not only a fine mastery of draughtsmanship, but also his close understanding of bridge construction. See Laver, James, *Whistler*, London 1930, 86ff., 90/98.

2 The extreme close-up view compressed within tight picture borders was also an essential compositional technique of Chinese painting. Goepper, Roger, *Vom Wesen chinesischer Malerei*, Munich 1962, 39ff.
3 Japanese painting presented a combination of analytic bridge construction and bright colour. This makes the naturalistic landscape backgrounds somewhat abstract.
4 Siegfried Berndt handled his print blocks in a manner similar to his Japanese models, rendering colours more intensely towards the top and bottom of the print.
5 Edvard Munch uses the bridge theme in his lithograph *The Scream*, 1895. See Ehmke, H., *Pressa* poster, Cologne 1928, et al.
6 At Giverny Monet laid out a garden in Chinese and Japanese style, creating ponds by damming the Epte, and planting water-lilies and willows. A Chinese-type hump-backed bridge, with wisteria straggling over it, spanned the river. Monet continued to paint this bridge into old age, producing over forty versions of the subject. Wildenstein, Daniel, 'Claude Monet', Lausanne, Paris 1974, Vol. I, nos 195, 314, 318, 319, 364.
7 Goepper, Roger, *Im Schatten des Wu-T'ung Baumes*, Munich 1959, 44.
8 Yukio, Yashiro, *Japanische Kunst*, Munich 1958.
9 Yukio (n.8), Ill. Toun-Shisetsu, *Frost clouds send fresh snow*, Pl. 169.
10 Goepper (n.7), 44. Hishino, Kunio, *Gestaltung von Brücken*, Stuttgart 1972.
11 Bonatz, P. and Leonhardt, F., *Brücken*, Königstein 1965. Hishino, K., *Monocoque and Hump-Backed Bridges*, diss. Tokyo 1968. Kato, S., *The Aesthetics of Bridges*, Tokyo 1936.
12 Bridges were of great strategic importance in Japan. At the same time they were also 'famous places', as they always constituted a point of convergence of different roads. Hokusai's bridge cycle *Wonderful views of famous bridges in the provinces (Shokoku meikyo Kiran)* dates from 1827.

Rocks in the sea (pages 146–53)
Incorporates material from cat. 'Weltkulturen', Munich 1972, 212–13.
1 Wildenstein, Daniel, 'Claude Monet', Lausanne, Paris 1974, Vol. I, no. 259, Vol. II, nos 816–22, 828–33.
2 Monet attempted to portray the plunging 'movement' of rocks in surf in one series of paintings. Wildenstein, Daniel (n.1), Vol. I, nos 907, 908, 1017–19, 1032–53, Vol. III, nos 1084–89, and 1100–19.
3 Gustave Moreau, at the very beginnings of Symbolism, saw rocks as figurative beings. See also Maurice Chabs, Raoul du Gardier, Georges Lacombe, Alexandre Séon in cat. 'French Symbolist Painters', London 1972. Weber, V.F., *Ko-Ji Hō-Ten*, Paris 1923, I & II, 138, 198ff., and 419.
4 Already in Chinese painting rocks were imbued with significance, and were depicted differently according to schools. Goepper, Roger, *Vom Wesen chinesischer Malerei*, Munich 1962, 104ff.
5 Weber, V.F. (n.3), I, 138, II, 419.
6 See M.L. Maufra (No. 59), H. Moret (No. 69), R. O'Conor (No. 74), P. Sérusier (No. 88) in cat. 'L'école de Pont-Aven', Nantes 1978.
7 Armand Séguin, *L'Occident*, Paris 1903, 97–99.
8 Weber, V.F., (n.3), I & II, 198, 452.
9 Goepper, Roger, *Kunst und Kunsthandwerk Ostasiens*, Munich 1968, 124.
10 Yang En-Lin, ed., *Der Senfkorngarten*, Leipzig 1966.
11 Berger, Klaus, documentation of 'Weltkulturen' exhibition, Munich 1972, 97.

The folding screen (pages 154–56)
Incorporates material from cat. 'Weltkulturen', Munich 1972, 246ff.
1 Edmond and Jules de Goncourt, *Mémoires de la vie littéraire*, Paris 1959, Vol. II, 1234–35.
2 Unpublished letter from Franz von Lenbach to Frau von Wertheimstein, of 6.4.1880, Cologne, Private Collection.
3 Two large screens by Kōrin appeared in Louis Gonse's exhibition in the rue de Sèze in 1883. Screens were also illustrated in the magazine *Le Japon artistique*, Paris 1888–91.
4 The paintings *Caprice in purple and gold, No. 2, The Golden Screen*, and *Rose and silver: the princess from the land of porcelain* are influenced by the screen.
5 Goepper, Roger, *Im Schatten des Wu-T'ung Baumes*, Munich 1959, 35, Ill. 16.
6 Yukio, Yashiro, *Japanische Kunst*, Munich 1958, Pl. 153.
7 In second-generation Impressionism the illusion of depth is no longer achieved by colour perspective, rather the picture surface is ordered into a decorative progression of colour fields. See Terrasse, Antoine, *Pierre Bonnard*, Paris 1967, 10ff.

8 Terrasse, Antoine (n.7), 12ff.

9 Goncourt, Edmond and Jules de (n.1), 1234–35.

10 Seckel, Dietrich, *Emaki: die Kunst der klassischen Bilderrolle*, Zürich 1959, 58ff. Badt, Kurt, *Raumphantasien und Raumillusionen*, *Wesen der Plastik*, Cologne 1963.

11 Odilon Redon saw in screen painting a chance to create an abstract pictural continuum independent of the individual picture surface. Glaser, Curt, *Die Kunst Ostasiens*, Leipzig 1913, 55–57.

12 In all of Chagall's work we find a tendency towards arbitrary partitioning of space according to the angles of the supportive planes of the various objects. The continuous hovering of the figures is ideal for the spatial rhythms of screen art.

13 Seckel, Dietrich, *Buddhistische Kunst*, Stuttgart 1957, 136, 227ff.

14 As n.13.

15 As n.13.

16 Tōyō Sesshū, born, it is thought, in Akahama/Okayama, went to Kyōto and became the pupil of Shunrin Shūtō in the Shōkuku-ji. As a priest he was called Tōyō. In 1462 he took the name Esshū.

17 Hasegawa Tōhako (1539–1630), known as Bunshiro, and later as Kyūroku. Court painter to the regent Hideyoshi and the Shōgun Iyeyasu. Yukio, Yashiro, *Japanische Kunst*, Munich 1958, Pl. 123/4, 125.

18 Ogata Kōrin had a great influence on European art, his subtle yet vigorous, rhythmic wave technique being translated into the universally identifiable Art Nouveau line. See Weber, V.F., *Ko-Ji Hō-Ten*, Paris 1923, I, 452ff. Louis Gonse displayed works by Kōrin in Paris as early as 1883 (see exhib. rue de Sèze). In the auction of the bequest by Burty on 19.3.1891 works by Kōrin featured alongside many others. (See Geffroy, G., *La Vie artistique*, 1892, 135.)

19 Kōrin's influence was considerable throughout the Far East, especially in Japan. His style was in a constant state of flux, adapting to each new occasion.

20 Goepper, Roger (n.5), 40.

21 Seckel, Dietrich (n.13), 70, 127ff, and 136. See also Seckel, Dietrich, *Einführung in die Kunst Ostasiens*, Munich 1960, 225.

The fan (pages 162–69)

Incorporates material from cat. 'Weltkulturen', Munich 1972, 311–13.

1 Painted fans were produced by, among others: E. Bernard, S. Berndt, Boudin, G. H. Breitner, R. Bresdin, M. Cassat, W. Crane, Ch. Daubigny, Th. Deck, E. Degas, J. L. Forain, P. Gauguin, G. Henry, O. Kokoschka, H. Makart, E. Manet, A. Monticelli, B. Morisot, G. de Nittis, E. Orlik, C. Pissarro, O. Redon, H. Rivière, A. Stevens, C. Thiemann, and H. Toulouse-Lautrec. 241ff. of the 'Weltkulturen' cat. (Munich 1972) are reproduced here.

2 Fan painting produced new visual approaches which influenced European landscape painting. Striking close-ups or portrayals of distance were integrated into a striking format. See Kopplin, Monika, 'Das europäische Fächerblatt von Manet bis Kokoschka', diss. Cologne 1979.

3 Pissarro, always open to new inspiration, realized that the disposition of compositional weight could be especially effective in the fan. He made bold designs, as he himself recognized, and was eager to learn more about Japan. He awaited impatiently the return of Duret and Cernuschi from their visit to Japan in 1873. 'I do hope you will tell us a bit about Japan when you get back. It is such a remarkable country to view, and is so exceptionally and wonderfully artistic, that I will be most interested in it … I hope, when you come, to be able to show you some bold studies, which you will – perhaps! – like: after all you will just have returned from Japan, which is so daring and revolutionary a country in any artistic matter.' Pissarro writing from Pontoise to Duret.

4 Together with the Barbizon painters, in Munich in the late 1840s up to the 1860s the following artists produced painted fans: Eduard Schleich the Elder, Adolf Grützner, Dietrich Langkow, Adolf Lier, Christian Morgenstern, and others.

5 The Impressionists offset spatial emptiness by intensity of colour or form. This technique was of major importance in modern art. Rouart, D. and D. Wildenstein, 'Edouard Manet', cat. raisonné, Lausanne, Paris, 1975, nos 385, 386. See also Kopplin, Monika, 'Shi fu jo – a fan cycle by Keisen and Claudel', *Pantheon*, Vol. II, 1979.

6 Lemoisne, P. A., *Degas et son oeuvre*, 3 vols, Paris 1946.

7 Tawaraya Sōtatsu (c.1570–c.1640) was influenced by Kōetsu. His painting is highly inventive, and makes frequent use of broad brush-strokes. See Tanaka, Ichimatsu, *Tawaraya Sōtatsu*, Tokyo, 1956. Yujiro Shinoda, 'Degas, der Einzug des Japanischen in die französische Malerei', diss. Cologne 1957.

8 Presentation fans in the Far East still use india ink decoration. The following observations relate to cat. 'Weltkulturen', Munich 1972, 243ff.

9 *Manual for fan painting*, 6 block books, Kyōto 1827. It is not known who edited these little books, which derive in part from *The Mustardseed Garden*, Nanking 1701, the Chinese painting manual. The fan flower paintings of De Nittis also owe much to *The Mustardseed Garden*. *Manual for fan painting*, Tokyo 1878.

10 See *Manual* 1827 (n.9). One block book is devoted exclusively to combinations of bamboo and chrysanthemums. See Stroh, G., *Blumen und Blüten in der japanischen Heraldik*, 1908, 26ff.

11 Fans of various types also appear in paintings by Manet, Monet, Gauguin, Breitner, Toulouse-Lautrec, and others.

12 Gauguin's fans. Georges Wildenstein, 'Gauguin', I cat., Paris 1964. See Kopplin, Monika, (n.2).

13 The fans Kokoschka painted for Alma Mahler in Vienna in 1914 mark a high point in European fan painting. Numbering five altogether, their decoration follows the vertical lines of the folds. In this respect they differ from Far Eastern fans, on which the decoration is conceived regardless of the folds.

14 Far Eastern calligraphy and india ink paintings exploit all the rich subtleties of texture which the genre affords. The india ink is usually rendered thicker or thinner on the edge or sloping side of the water bowl. This bowl is thus important for achieving exactly the desired tonal consistency for any one brush-stroke.

15 India ink has of necessity to be applied swiftly, in single brush-strokes, given the absorbent nature of the paper.

16 Fan painting was included in the programme of the Wiener Werkstätte. Hoffmann and Kolo Moser most notably proved extremely adept at the technique.

17 See cat. 'Weltkulturen', Munich 1972, 241ff.

18 Buss, Georg. *Der Fächer*, Leipzig 1904.

19 Feddersen, Martin, *Jap. Kunstgewerbe*, Brunswick 1960.

20 Buss (n.18), 30.

21 Buss (n.18).

Pillar pictures and vertical formats (pages 170–77)

Incorporates material from cat. 'Weltkulturen', Munich 1972, 253–56.

1 The emphatic cutting-off which is a characteristic feature of the tall narrow format prompted the Nabis to develop piled-up compositional structures. See Russell, John, *Edouard Vuillard*, London 1971, 36–39, 43, 48. Vaillant, Annette, *Pierre Bonnard*, Munich 1966, 28, 29, 91.

2 Goepper, Roger, *Vom Wesen chinesischer Malerei*, Munich 1962, 32 ('Bildform in China und im Abendland'). Weber, V.F., *Ko-Ji Hō-Ten*, Paris 1923, I and II, 170ff.

3 These formats were first used in interior decoration as wall panels. Later, in the Art Nouveau interior, they became free-standing. See Wildenstein, Daniel, *Claude Monet*, Lausanne, Paris 1974, nos 813, 814, 919, 920, 925, 926, 931, 932, 937, 938, 943, 944, 949, 950.

4 See Yukio, Yashiro, *Japanische Kunst*, Munich 1958, Pl. 87.

5 Rewald, John, *A History of Impressionism*, rev. ed., London 1980.

6 Seckel, Dietrich, *Buddhistische Kunst Ostasiens*, Stuttgart 1957, 146ff.

7 Audsley, George A., *Ornamental Arts of Japan*, London 1884. Brüning, Adolf, *Der Einfluss Chinas und Japans auf die europäische Kunst*, Brunswick 1900–01, 281–96.

8 The vertical format provides as it were a focus on transitoriness.

9 Kurth, Julius, *Der japanische Holzschnitt*, Munich 1922, 37.

10 Throughout Klimt's oeuvre we can trace his analysis of the Japanese *naga-e* or 'country picture', and his development of it to his own form of open, universal vision.

The sword guard (pages 178–87)

1 Brinkmann, Justus, *Kunst und Kunsthandwerk in Japan*, Berlin 1889, 141. Weber, V.F., *Ko-Ji Hō-Ten*, Paris 1923, 201–07, 245. Yumoto, John M., *The Samurai Sword*, Tokyo 1958, 19ff.

2 Brinkman, Justus, 'Die Sammlung japanischer Schwertzierathen im Museum für Kunst und Gewerbe zu Hamburg', Hamburg 1893. See also Goepper, Roger, *Kunst und Kunsthandwerk Ostasiens*, Munich 1968, 413.

3 Emile Baeuerle, Karl Beyerlein, Theodor Fahrner, Martha Gahmberg, Ferdinand Hauser, Josef Hoffmann, Paul Merk, Kolo Moser, Emanuel Novák, Alfred N. Oppenheim, Erhard Topf, Otto Tragy, Anna Wagner.

4 Feddersen, Martin, *Japanisches Kunstgewerbe*, Brunswick 1960, 120ff.

5 Yumoto, John M. (n.1). Goepper, Roger (n.2), 419.

6 Joly, Henri L., *Legend in Japanese Art*, Tokyo 1968.

7 Weber, V.F. (n.1), 201–07.

8 Lalique, Vever, Fouquet, and Cranach use combinations of metals similar to that in *tsuba* work. Alexis Falize and his son Lucien made analyses of Japanese metal and enamel techniques. See 'L'Art japonais. A propos de l'exposition organisée par M.

Gonse', *RADS* III, 1882–83, 334, (Josse).

9 Feddersen, Martin (n.4), 232.

10 See Haase, Ulrike von, *Schmuck in Deutschland und Österreich*, Munich 1977, 385, Ill. 44.

11 Feddersen, Martin (n.4), 272.

12 Weber, V.F. (n.1), II, 270. Hara, Sh., *Die Meister der japanischen Schwertzierate*, Hamburg 1932. (Paul Vever 1851–1915, Henri Vever 1854–1942).

13 One comb from Henri Vever's workshop, in its original box (1898), bears a Japanese master's device next to the inscription 'Maison Vever'. Munich, Private Collection.

14 *Journal* No. 9, Paris, 1892–95, 85ff. (ed. Flammarion and Fasquelle).

15 Sale cat. 'Collection of the Comte de Tressan', London 1973. Sale cat. 'Collection Henry Vever: Part I'. Sotheby and Co., London, March 26, 1974. Wada, *Hompō Kinkō Rayakushi*, Tokyo 1913, privately printed. Text and plates. Summary of text by the Marquis de Tressan. 'Ostasiatische Zeitschrift' III, 260 and 'Bulletin de la Société Franco-Japonaise' XXIII, 43.

16 Art Nouveau artists were fond of arabesque linearity, as it is to be found especially in pierced Heianjō *tsuba*. Goepper, Roger (n.2), 427.

17 Theodor Fahrner liked to use ovals and circles for pendants, brooches, and buckles. The decorative motif is generally closely bound to the side, becoming more open in the middle. The pierced metal technique also shows traces of possible influence by the heraldic *mon* motif. See Amstutz, Walter, *Japanese Emblems and Designs*, Zürich 1970.

18 Weber (n.1), 226ff., 349. Yumoto, John M. (n.1). Winkworth, W. W., 'The Davies Sale of Japanese Sword-Fittings', *Oriental Art*, Vol. II, No. 4, 1950.

19 Feddersen, Martin, 'Über die Benutzung graphischer Vorbilder für die figürliche Darstellung auf japanischen Schwertzierten', *Jahrbuch der Asiatischen Kunst*, 1925.

20 Feddersen (n.4), 120ff.

21 Audsley, Georges A., *Ornamental Arts of Japan*, London 1884, 29ff.

22 Henry van de Velde's sketches especially reflect awareness of Japanese crests – he must have seen the little books of these that exist in Japan. See cat. 'Henry van de Velde', Brussels 1963, 53 (*Ecce Homo*).

23 Block book, Kyōto, 1856, *Japanese Crests*, Furukawa, T., *Zōken Kinkōzuzo*, Ill. Japanese sword-fittings in the editor's collection, Tokyo, 1913.

24 Dyers' stencils (*katagami*) also influenced goldsmiths and appear in this genre crests within circles. The Österreichisches Museum für angewandte Kunst has the largest collection of stencils in Europe. See Haase, Ulrike von (n.10), 303, 361. Barten, Sigrid, *René Lalique*, Munich 1977, 225, 229, 230, 234, 451, 452, 575, 576.

25 See *mon* book, Tokyo 1886, block book, 77–80.

26 Japanese sword cutlers must have been familiar with the technical botanical books produced by their fellow countrymen.

27 Frequently large and robustly fashioned, sword blades often have an archaic beauty. Victoria and Albert Museum, *A Picture Book of Japanese Sword Guards*, London 1927. Weber, V.F. (n.1), 67.

28 Goepper (n.2), 413ff.

Decorative combs and hairpins (pages 188–95)

Incorporates material from cat. 'Weltkulturen', Munich 1972, 311–13.

1 The tall coiffures fashionable at the turn of the century were ideal for decorative combs. In general the arbiter of all taste was the 'modèle à la japonaise'. Se Marcel Prevost's novel *Les Demivierges*, Paris 1894, 3. Japanese fashion 'imports' were not merely aesthetic, however, they were also functional. Thus for instance greater use was found for screens, certain forms of brush were introduced for painting, and india paper began to be used. The kimono also had an important influence on the more 'sensible' clothes adopted around 1900. Europeans imagined the kimono to be a loose hanging garment, whereas in reality the hips have to be tightly bound around.

2 A prominent element of fashionable dress around 1900 was the frilled flounce, a vestige of the 'cul de Paris'. An important influence on and pattern for this was the *obi* (worn high up) and Japanese body posture. See Kybalova, Ludmila, *Das grosse Bilderlexikon der Mode*, Prague 1966, 293, 573, Ill. 967. Weber, V.F., *Ko-Ji Hō-Ten*, Paris 1923, I, 189, 377, Pl. XL and text. Brinkmann, Justus, *Kunst und Handwerk in Japan*, Berlin 1889, 117ff.

3 This body posture became kinked as a result of tight corsets, which dug into the wearer. The *obi* achieved a similar effect through outer layers and pronounced 'structures' under the main garment, emphasizing the upper thighs. This accentuation of certain parts of the body is interesting from an ethnological point

of view, as indications of different behaviour patterns. Weber, V. F. (n.2), 214/5.

4 James McNeill Whistler (1834–1903). Laver, *Whistler*, London 1930, 108. Whistler, *The Gentle Art of Making Enemies*, London 1890. Denys Sutton, *Nocturne. The Art of James McNeill Whistler*, London 1963. See Loti, Pierre, *Madame Chrysanthème*, Paris 1887. Van Gogh read this novel in Arles with great interest.

5 Both the decorative comb and the hairpin (*kanzashi*) were influenced by kimono peony motifs.

6 These costly hair ornaments – principal comb, two secondary combs, and smaller *kushi, kanzhi,* and *kōgai* – were kept in equally magnificent caskets.

7 Lucien Gaillard in Paris also made hair ornaments in sumptuous cases in Paris around 1900.

8 The curved edge can in certain cases form almost a half-circle. It was on this section of the comb that jewellers lavished skill and imagination. At the same time it made a good surface for compositional experimentation, like the fan.

9 Feddersen, Martin, *Japanisches Kunstgewerbe*, Brunswick 1960, 251. Weber (n.2), Pl. XL.

10 Particularly beautiful hair ornaments were made by Eishōsai Chōki, Kigugawa Eizan, Ikeda Eisen, Tōshūsai Sharaku and Yashia Gakutei (*surimono*).

11 Ethnologists have found that decorative combs are symbols of status among all peoples. See 'Häuptlingskämme in der Sammlung Carlotta Czeschka', Hamburg.

12 Barten, Sigrid, *René Lalique*, Munich 1977, 97–99, 181–215.

13 As n.12.

14 This example shows how Art Nouveau styles combined form and ornament – along Japanese lines in both respects.

15 Hair ornament in original case, Munich, Private Collection.

16 See cat. 'Zierkämme', Pforzheim 1978.

17 Barten, Sigrid (n.12).

18 As n.17.

19 See Harunobu to Kuniyoshi etc. Cat. of exhib. in Idemitsu Museum, Tokyo 1970.

20 Hokusai, Katsushika, *Sketch-Books for Decorative Combs*, Tokyo, National Library, H.1867, II. Duret, Théodore, 'Les peignes', *Le Japon artistique*, I, 1888–89, 57.

21 The floral designs on decorative combs corresponded to the set plants for each month: February – peach, March – peony, April – cherry, May – magnolia, June – pomegranate, July – lotus, August – pear, September – mallow, January – prunus. See Feddersen, Martin, *Chinesisches Kunstgewerbe*, 248.

22 Japanese woodcuts often portray everyday scenes. Women arranging combs and hairpins, *kōgai* and *kanzashi*, is a much-loved subject. See esp. Utamaro's series *Time in the Life of Today's Beauties*, 1797–98. See also Eishi, Hosoda, *Beautiful Women Vying with Each Other*, c.1796, etc.

23 Examples of *kanzashi*, worn both symmetrically or asymmetrically, can be seen in Idemitsu Museum, Tokyo 1970.

24 'Hairstyles over the Centuries', cat. Idemitsu Museum, Tokyo 1970.

25 Cat. 'Decorative Combs and Hair Ornaments from Japan', Pforzheim, Schmuckmuseum 1978.

26 In Japan the long-toothed comb became fashionable only in the late nineteenth century when, under European influence, hair was no longer oiled.

27 In the latter part of the nineteenth century and during the Art Nouveau period the decorative comb replaced the classical diadem. It became a significant article of jewellery. See Haase, Ulrike von, *Schmuck in Deutschland und Österreich*, Munich 1977. Barten, Sigrid (n.13), 97–99, 181–215.

The dyer's stencil (pages 196–203)

1 For the spiral pattern on the clothing in his *Fulfilment* (Stoclet frieze, Brussels) Klimt sought inspiration in the approx. 6,000 *katagami* then in the K. K. Osterreichischen Museums für Kunst und Industrie in Vienna.

2 Josef Hoffmann copied dyers' stencils from the above-mentioned collection.

3 See cat. 'Weltkulturen', Munich 1972, 275. Audsley, George A. *Ornamental Arts of Japan*, London 1884, 86ff.

4 As n.3.

5 See Wichmann, Siegfried, *Jugendstil*, Munich 1977, 4–10.

6 As n.5.

7 There are numerous examples. In Germany *Pan, Jugend,* and *Insel* all carried vignettes and decorative borders derived from dyers' stencil motifs.

8 Human hair was preferred, as it was more flexible and offered more resistance to the chemical effects of the starch.

9 Ferdinand Staeger also used this technique in his graphic illustrations around 1900.

10 Margarete von Brauchitsch embroidered for H. Obrist at the Debschitz school in Munich around the turn of the century. Obrist

was familiar with Japanese dyers' stencils. See Vorbilder-Sammlung Nachlass. Wichmann, Siegfried, 'Hermann Obrist, Wegbereiter der Moderne', cat., Munich 1968.

11 Broken strip motifs of this kind were very popular in the Wiener Werkstätte. See Cutler, Thomas W., *A Grammar of Japanese Ornament and Design*, London 1879, 28ff. Weber, V.F., *Ko-Ji Hō-Ten*, Paris 1923, I and II, 182, 183, 232–34.

12 Animals and flowers on clothes were always significant and were frequently commissioned: for example, cranes and pine trees stand for long and successful life, the carp for endurance and courage, the iris for victory. Cutler, Thomas W. (n.11), 19ff. Seckel, Dietrich, *Buddhistische Kunst Ostasiens*, Stuttgart 1957, 178ff.

13 The reticulated ground is the negative form of a dotted surface usually signifying moss or lichen.

14 European graphic artists acquired greater assurance of composition through the balance of light and dark areas, as all the harmony and beauty of *katagami* derive from the composition of progressive yet at the same time self-sufficient motifs. Moser, D. H., *Book of Japanese Ornamentation*, London 1880, 32ff.

15 The huge *katagami* collection in the Osterreichisches Museum für angewandte Kunst contains some superb pieces, which were exhibited at the international exhibitions and of which some were for sale. Hector Guimard probably saw examples at the Paris international exhibitions of 1878, 1889 and 1900.

16 Franz von Zülow, who lived in Vienna, must have been familiar with the collection in the Osterreichisches Museum für angewandte Kunst.

17 William H. Bradley commercialized the technique, creating stereotyped motifs that are modish rather than universal as are true *katagami*.

Ornamental patterns (pages 204–17)
Incorporates material from cat. 'Weltkulturen', Munich 1972, 177–183.

1 Crane, Walter, *Line and Form*, London 1900.

2 Münsterberg, O., 'Bayern und Asien im XVI, XVII, und XVIII Jahrhundert. (Ostasiatisches Kunstbewerbe in seinen Beziehungen zu Europa)'. With 2 photogravure and 28 text ills., Leipzig 1895. 'In highly compact form, and with exquisite illustrations and easily digestible style, the author here seeks to present the origins and conditioning factors of the extreme individual art that is Japan's.' Lohnek, Fr., *Anleitung zur Holzmalerei*, Leipzig 1903. Frisch, A., *Japan-Vorlagen für Kunstgewerbe und häusliche Kunstarbeit*, 1902. Frisch, A., *Humor in der Tierwelt, Japanische Vorlagen*, Leipzig 1902.

3 Ayrton, M. Chaplin, *Child-Life in Japan and Japanese Child-Stories. With many Illustrations including seven Full-Page Pictures drawn and engraved by Japanese Artists*, London 1888. Griffith, Farrah, Okeden, and Welsh published Japanese-style children's books in London and Sydney.

4 *Gartenlaube* was a family magazine, founded by Ernst Keil. First issue January 1853, 6,000 copies. It ran for 91 years, until 1944. *Pan, Die Insel, The Yellow Book, The Studio, Ver Sacrum,* etc.

5 Pecht, Friedrich, *Kunst und Kunstindustrie auf der Wiener Weltausstellung*, 1873, Stuttgart 1873, 298.

6 Lessing, Julius, 'Bericht von der Pariser Weltausstellung 1878', 244, 245.

7 Diner, Helen, *Seide*, Riga 1944, 122ff.

8 Kurth, Julius, *Der japanische Holzschnitt*, Munich 1922, 64, 88ff.

9 See Sherman, E. Lee, *Japanese Decorative Style*, Cleveland Museum of Art, 1961. Cutler, Thomas W., *A Grammar of Japanese Ornament and Design*, London 1879 and 1880, 19ff. Weber, V.F., *Ko-Ji Hō-Ten*, Paris 1923, 232, 234.

10 The Wiener Werkstätte also produced stylistically rather better quality 'sensible' women's clothes – always a loose hanging style, similar to the kimono. The 'sensible' approach did not pay much regard to the human form either. Schultze-Naumburg, *Die Kultur des weiblichen Körpers als Grundlage der Frauenkleidung*, Jena 1910, 116ff. Brinkmann, Justus, *Kunsthandwerk in Japan*, Berlin 1889, 117–34.

11 The author has been able to see important textile collections, especially kimonos etc., in Japan. The selection for the 'Weltkulturen' exhib. in 1972 in this sphere was made actually in Japan. See cat. 'Weltkulturen'. Wichmann, S., 'Beitrag Japans zur Ausstellung', 320ff.

12 These books of heraldic devices are often to be found in second-hand bookshops. Even later editions are good quality. They were naturally on display and for sale at all international exhibitions. They reveal extraordinary variety in the realm of kimono ornamentation.

13 This description reveals that Europeans were now interested in the artistic techniques as well as the themes of Far Eastern art –

an interest that led to wide adoption and thorough understanding of the creative principles behind it. Cutler (n.9).

14 The aesthetic principle of the *mon* became recognized around 1900. The result of this was the Western 'vignette'. Collection of 18th and 19th-century Japanese heraldic books, Private Collection, Southern Germany.

15 Lessing, Julius (n.6), 272.

16 Supplement to the 1873 Vienna international exhibition, 'Textiles', 86.

17 Cat. 'Weltkulturen', 180ff.

18 See chapter 'Die europäische Schwarzweissgraphik und die japanische Färberschablone' in Wichmann, S., *Jugendstil*, Munich 1977, 114ff. Bing, S., 'Exposition de la gravure japonaise à l'Ecole Nationale des Beaux-Arts, Paris, 1890'.

19 Kurth, Julius (n.8), 66, 88.

20 As n.19, 64. Seidlitz, W. v., *Geschichte des japanischen Farbenholzschnitts*, Dresden 1910, 28, 36, 72.

21 Kurth, Julius (n.8), 64. See Azechi, Umetaro, *Japanese Woodblock Prints. Their Technique and Appreciation*, Tokyo 1963.

22 Kurth, Julius (n.8).

23 Cat. 'Weltkulturen', 177ff.

24 Cat. 'Maurice Denis', Paris 1970, 87, 115ff. Cat. 'Die Nabis', Mannheim 1964.

25 Hahnloser-Bühler, Hedy, *Félix Vallotton et ses amis*, Paris 1936.

26 See *The yellow bedspread*, Paris, Private Collection. This shows a kimono draped over a bed.

27 Segard, Achille, *Mary Cassatt, un peintre des enfants et des mères*, Paris 1913, 29ff.

28 Camille Pissarro, *Letters to his son Lucien*, London, New York 1944.

29 As n.28.

Diagonal composition (page 218–23)

1 This section includes parts of 'Die Diagonale als extremer Sichtverlauf …' from cat. 'Weltkulturen', Munich 1972, 222–23, into which new findings have been incorporated. In the *Manual for Edo Lacquer Painters*, 1842, long diagonal strokes and decorative systems on objects (writing cases and large boxes with lids) are thoroughly explored. Diagonals are always used to divide up space, creating a succession of interrelated surface areas, some empty, some filled with designs.

2 Antithetical line systems setting off movement within a picture were used above all in the supremely beautiful art of horizontal scroll painting (*emaki*). See Seckel, Dietrich and Akihisa, Hasé, *Die Kunst der klassischen japanischen Bilderrollen*, Zürich 1959.

3 The surrounds of the picture itself were at the same time a kind of spatial boundary while conventional academic art required static, explicitly calculated pictorial composition.

4 Even European paintings of battles were static in construction. They portrayed a sort of miniature cosmos within which elemental events unfolded.

5 It was above all the illusion of depth in landscape that was renounced in favour of the downward-looking angle of Far Eastern 'surface space'. The hovering of objects against an area of space stirred new creative impulses in European art. See Crane, Walter, *Line and Form*, London 1900.

6 Individual forms in Japanese painting varied immensely with the use of the spatial diagonal principle in individual formats or on three-dimensional objects. Seckel, Dietrich, *Einführung in die Kunst Ostasiens*, Munich 1960.

7 The view from above and below were already important features of spatial composition in Chinese painting. In Far Eastern art a downward angle of vision and high piling of elements both indicate space. See Goepper, Roger, *Vom Wesen chinesischer Malerei*, Munich 1962, 39ff.

8 Thiemann active in Munich around 1900 worked above all for the magazine *Jugend*, to which he contributed woodcuts. He, much more than Orlik, was responsible for the flowering of the colour woodcut in German arts and crafts.

9 According to various sources, Manet had by the end of the 1860s explored the whole gamut of Japanese woodcut techniques. Of particular importance were the silhouette style and asymmetry. See Hopp, Gisela, *Edouard Manet, Farbe und Bildgestalt*, Berlin 1968.

10 The use of objects to represent pictorial depth was of course current in Europe. What is new is the perfect graphic independence of individual objects, which are no longer integrated into a common bed of colour perspective.

11 The following observations are culled from cat. 'Weltkulturen', 223. Time and space are brought into remarkable unity in *emaki* art, as the viewer becomes caught up in the 'undefined space' which he himself can at any one time determine. See Seckel and Akihisa (n.2).

12 Screen painters made great use of the diagonal street scene: e.g. the 17th/18th-century large two-leaf screen in the Tokyo Idemitsu Museum (*Folk life in Edo* [*Edo Fuzokuzu*]. See cat. 'Weltkulturen', Munich 1972.)
13 In the chinoiserie of the mid to late 18th century we find partially misunderstood decoration on (most popularly) chests and boxes and wall panels. The diagonal technique was often abandoned in favour of piled spatial planes. See cat. 'China und Europa', Berlin 1973, 76ff., 83ff.

Composite formats (pages 224–27)
Incorporates material from cat. 'Weltkulturen', Munich 1972, 231–34.
1 Hempel, Rose, cat. 'Ukiyo-e, Sammlung Scheiwe', Cologne 1969, no. 172.
2 Weber, V.F., *Ko-Ji Hō-Ten*, Paris 1923, 170ff. Collection of manuals for lacquer painters, Kyōto 1848, (block book). Private Collection, Southern Germany.
3 See cat. 'Taiso Yoshitoshi 1839–1892', Cologne 1971. Ill. 10, cat. no. 37.

Trellis and grille (pages 228–41)
Incorporates material from cat. 'Weltkulturen', Munich 1972.
1 Unpublished letter from Emil Orlik to Julius Kurth c.1912, Berlin, Private Collection, Dr Walter Jakoby.
2 Armand Séguin in *L'Occident*, Paris 1903, 16–18.
3 Cut-off objects bring a new kind of movement to painting, as they mean a picture is then no longer viewed as a 'sprung' progression of individual elements. This pictorial approach leads in the end to an assertion of the value of pure surface in a picture – thus a break away from the tradition of 'boxed space'. The vertical section effect of, for instance, parallel posts and tree trunks in a landscape also creates a certain picture-surface tension, which can then be developed into an ornamental structure. See Yamada, Ch. F., *Dialogue in Art, Japan and the West*, Tokyo 1976, ills 16, 17, and cover. See also Wildenstein, Daniel, *Claude Monet*, Lausanne, Paris 1974, Vol. III, nos 1291–313.

Truncated objects and oblique angles (pages 242–50)
Incorporates material from cat. 'Weltkulturen', Munich 1972, 231–34.
1 Goepper, Roger, *Kunst und Kunsthandwerk Ostasiens*, Munich 1968, 184ff.
2 Manet had by this time already recognized the essential characteristics of the Japanese woodcut. See Rouart, D. and D. Wildenstein, *Edouard Manet*. Catalogue raisonné, Lausanne, Paris 1975, nos 64, 150, 192, etc.
3 Wildenstein, Daniel, *Claude Monet*, Lausanne, Paris 1974, Vol. I, nos 647, 648, 649; Vol. III, 1152, 1153, 1250.
4 In Hiroshige's large-scale landscape series one sheet in particular is striking. It is the *aizuri*, (blue print), *Gathering shells at low tide in Shibaura*. This sheet could have directly influenced Manet's watercolour *Ships at sunset*. Repr. in cat. 'Ukiyo-e, Sammlung Scheiwe', Essen, ed. Rose Hempel, Essen 1972, no. 408a.
5 Perucchi-Petri, Ursula, *Die Nabis und Japan*, Munich 1976, 55ff., 137ff.
6 Goepper, Roger, *Vom Wesen chinesischer Malerei*, Munich 1962, 148ff.
7 Crane, Walter, *Line and Form*, London 1900.
8 The transitory and the fragmentary element, the open form provide a heightened transition into the real world which the observer must take mentally into account. This tendency corresponded to European Symbolism, yet in another way also to a Buddhist way of looking at things.
9 Klimt, Gustav, borders for *Ver Sacrum*. See Nebehay, Christian M., *Ver Sacrum*, New York 1977, 113, 114.
10 Wildenstein (n.3), Vol. I, nos 718–24.
11 Beenken, Hermann, *Das neunzehnte Jahrhundert in der deutschen Kunst*, Munich 1944, 331ff.
12 Beenken (n.11).
13 Letter, Cologne, unpublished papers, Private Collection.
14 All-over lighting, however, was only used by the second generation of Impressionists as a glow in the midst of layers of objects on parallel planes. The objects were truncated at will.
15 Hess, Walter, *Dokumente zum Verständnis der modernen Malerei*, Hamburg 1956, 7ff.
16 It was on view at the 1883 exhibition in the rue de Sèze organized by Louis Gonse (see cat.).
17 The horizontal picture scrolls (*emaki*) which were exhibited at the international exhibitions also played an essential part. See *Kasuga Gongen Kenki Emaki*, early 14th-century, and others.
18 Redon, Odilon, *A soi-même* (journal) 1867–1915, Paris 1922.

Posts as spatial dividers (pages 251–57)
1 Brinkmann, Justus, *Kunst und Handwerk im Japan*, Berlin 1889, 41.
2 Paine, Robert T., Alexander Soper, *The Art and Architecture of Japan. The Pelican History of Art*, Harmondsworth 1955/56. Lancaster Clay, 'Oriental Forms in American Architecture 1800–70', *Art Bulletin*, Vol. XXIX, 1947, 183–93.
3 Schmidt, Steffi, cat. 'Chinesische und japanische Holzschnitte im Museum für Ostasiatische Kunst Berlin', Berlin 1971.
4 See *La Peinture au Musée du Louvre, École Française XIX. Siècle*, Paris 1960, 533. Venturi, Lionello, *Les Archives de l'Impressionisme*, 2 vols, Paris, New York 1939.
5 Lurker, Manfred, *Symbol, Mythos und Legende in der Kunst*, Strasbourg 1958, 18. Vincent van Gogh, *The Complete Letters*, 3 vols, New York 1958.
6 Hempel, Rose, *Holzschnittkunst Japans. Landschaft, Mimen, Kurtisanen*, Stuttgart 1963.
7 Shinoda, Yūjirō, *Degas. Der Einzug des Japanischen in die französische Malerei*, diss., Cologne 1957.
8 The scene viewed from above and divided by posts occurs frequently in early Expressionism and Fauvism. A good example is the etching by Ernst Kirchner, *An der Alster* 1910. However, Maurice de Vlaminck and André Derain are still initially influenced by this type of pictorial structuring and composition.

The silhouette (pages 258–67)
Incorporates material from cat. 'Weltkulturen', Munich 1972, 266–70.
1 Brinkmann, Justus, *Kunst und Handwerk in Japan*, Berlin 1889, 37f.
2 Séguin, Armand, *L'Occident*, Paris 1903, 16–18.
3 Séguin, strongly influenced by the proclamations of the Pont-Aven School, combines a linear style with solid internal colour in the manner of *cloisonné*. The autonomy of the colour surfaces is heightened by brown-black outlines.
4 Paintings by Velazquez and Frans Hals had encouraged Manet to re-examine 'colourful black' and Manet's so-called Black Period around 1870 is again activated by the Japanese silhouette technique. See Hopp, Gisela, *Edouard Manet. Farbe und Bildgestalt*, Berlin 1968.
5 Manet, therefore, already begins in the late 1860s to reduce the spatial depth in his pictures in favour of a flat wide stage. Busch, Günter, *Edouard Manet. Un bar aux Folies-Bergères*, Stuttgart 1916. Duret, Théodore, *Histoire d'Edouard Manet et de son oeuvre*, Paris 1902.
6 The black silhouette in *L'Arlésienne* (after a drawing by Gauguin), 1890, plays a central role in Van Gogh's *oeuvre*. See De La Faille, J.B., *Vincent van Gogh*, Paris 1939, nos 710–13.
7 Decisive for portraiture is the background of the head seen as a still life. The background is usually kept very neutral and monochrome in the silhouette portrait. Cf. Cuno Amiet, Léon N. Bakst, Aubrey Beardsley, Emile Bernard, Eugene Grasset, Gustav Klimt, Félix Vallotton and others. Duret, Théodore, *Histoire des peintres impressionistes*, Paris 1906, 3rd ed.
8 On Utamaro's technique see Kurth, Julius, *Der japanische Holzschnitt*, Munich 1922, 42.
9 This technical process is supposed to emphasize the tactile qualities of materials to a certain extent, though on parallel planes. A new artistic compositional possibility is provided by the contrasts between the tactile structure (thick, firm hair-do) and abstract surface.
10 The static structure sharpened understanding of the events depicted. Fosca, François, *Degas. Biographische kritische Studie*, Geneva 1954.
11 The greatest collection of dyers' stencils, c.6,000 examples, is to be found in Vienna, in the Österreichisches Museum für angewandte Kunst.
12 Vincent van Gogh, *The Complete Letters*, 3 vols, New York, London 1958, letter 510.
13 The 1888 exhibition in the Café Tambourin, organized by Vincent van Gogh, influenced Emile Bernard and his friends towards *cloisonnisme*. The coloured areas are outlined as in *cloisonné* enamel and their effect is therefore heightened.
14 The aim of *cloisonnisme* is to emphasise areas of solid colour and to reduce or remove its representational qualities. Hofstätter, Hans H., *Die Entstehung des 'Neuen Stils' in der französischen Malerei um 1890*, diss. Freiburg 1954.
15 *Lettres de Paul Gauguin à Emile Bernard*, 1888–91, Geneva 1954, no. 63.
16 See n.15.
17 Goncourt, Edmond and Jules de, *Journal. Mémoires de la Vie Littéraire 1851–1896*, Paris 1956–59, Vol. III, 480–81.
18 Monnier, Jacques, *Félix Vallotton*, Paris, Geneva 1970. Cat. 'Félix Vallotton', Winterthur 1978.
19 Aquatint etching and drypoint, 30.2 × 12.5 (11 × 4), 1879–80,

New York Public Library, Prints Division, Astor, Lenox and Tilden Foundations.
20 The style is particularly strongly developed in the poster. See the posters *Le Divan japonais* and *Aristide Bruant dans son cabaret*, both 1893.
21 The way was paved for the silhouette by the Chinese shadow play and by early nineteenth-century cut paperwork. In Grandville's and Carl Spitzweg's *oeuvre* it is already highly developed. What remains important for Japonisme is its applicability to the coloured silhouette, and the patterning and thus enriching of the black area. See Hofstätter, Hans H., *Jugendstil-Druckkunst*, Baden-Baden 1973, 27, 55, 89.
22 The solid coloured silhouette of the Vienna Secession is particularly strongly developed in *Ver Sacrum*. See Nebehay, Christian M., *Ver Sacrum*, New York 1977, 54, 57, 63, 72, 130, 143, 188, 202, etc.
23 See n.14.
24 The black silhouette becomes part of a combined technique by placing coloured solids behind it. Effects are thus achieved which can transform the landscape into an abstract in the Symbolist manner. See Nebehay (n.22), 57.
25 The radical way the silhouette is used leads to a stained-glass effect which is also employed later by Christiansen in large, decorative window designs. Hofstätter (n.21), 94, 160, 179.
26 Hevesi, Ludwig, *Acht Jahre Secession*, Vienna 1906, 108.
27 Hevesi (n.26), 232ff.

The spirit world (pages 268–75)
Incorporates material from cat. 'Weltkulturen', Munich 1972, 291–96.
1 Edouard Dujardin was the first to see connections between European Symbolism and the Buddhist cult of ghosts in his essay 'Aux XX. et aux Indépendants; Le cloisonnisme ...', *La Revue indépendante*, March 1888, 489ff. Denis, Maurice, *Théories* (1890–1910). 4th ed, Paris 1920. and *Journal* (1884–1943). 3 vols, Paris 1957–59. Denis notes further: 'Remember that a picture – before being a war horse, a naked woman or some anecdote – is essentially a flat surface covered with paints assembled in a certain order' (*Théories*, 1). Weber, V.F., *Ko-Ji Hō-Ten*, Paris 1923, 38, 39, 47, 66.
2 Redon, Odilon, *A soi-même* (journal) 1867–1915, Paris 1922.
3 Berger, Klaus, 'The reconversion of O. Redon', *Art Quarterly*, XXI, 1958.
4 Cat. 'Alfred Kubin', Munich 1964, 30
5 Cat. 'Alfred Kubin' (n.4). 30ff.
6 Klinger, Max, *Der Alptraum, ein Gheist über dem Bett*, Leipzig Museum der bildenden Künste. Already in existence in March 1883 and therefore available to Kubin through publications.
7 Redon (n.2).
8 Redon (n.2).
9 Cat. 'Alfred Kubin' (n.4), 41.
10 Cat. 'Alfred Kubin' (n.4), 47.
11 Cat. 'Alfred Kubin' (n.4), 14.
12 Cat. 'Alfred Kubin' (n.4), 27.
13 Here connections with Hokusai's *Manga* need to be emphasized particularly.
14 Cat. 'Alfred Kubin' (n.4), 29. Duthuit, Georges, *Chinese Mysticism and Modern Painting*, Paris, London 1956. On the figures' elongated limbs see Weber (n.1), 38, 39, 166, 167, 214, 402, 435.

Stylization and abstractions (pages 276–93)
Incorporates material from cat. 'Weltkulturen', Munich 1972, 302–05.
1 These types of landscape are still popular today. See cat. 'Japanese Art Treasures from the Imperial Collection', Tokyo 1971, 14.
2 The view of spectacular nature and the simultaneous treatment of the insignificant detail present a new concept of nature, both representative and intimate.
3 Bucher, B., *Über ornamentale Kunst auf der Wiener Weltausstellung*, Berlin 1874. The abstract viewpoint is heightened in lacquer, porcelain and textile decoration. Particularly impressive abstractions are achieved in gold lacquerware. See Feddersen, Martin, *Japanisches Kunstgewerbe*, Brunswick 1960, 150ff.
4 Hokusai too in his *Manga*, Vols 3, 6, 8 and 12 provides impressive examples. See also Shunkei, Mori, *Ausgewähltes Gekrabbel aus der Nähe gesehen*, Edo 1820. Berlin, Staatliche Museen Preussischer Kulturbesitz, Museum für Ostasiatische Kunst. Jap. 378 Kl., Bi 99, 249.
5 The so-called 'high viewpoint' creates an abstract effect when there is a convincing overview into the farthest distance. The depiction of flat space is preserved without giving the illusion of depth. See Seckel, Dietrich and Akihisa Hase, *Emaki. Die Kunst der klassischen japanischen Bilderrolle*, Zürich 1959.

6 This system was also highly suitable as a border in weaving, screen-making and book design and was so used into the 1930s. Blum, Stella, *Designs by Erté*, New York 1976, 19, 20.

7 In the art of illustration, especially in children's books and collections of fairy-tales, elements of space and time are presented in a manner influenced by Japanese depictions of natural events.

8 Around 1900 in Europe, Mount Fuji becomes a symbol which is used repeatedly in posters and coins.

9 Goncourt, Edmond et Jules de, *Journal. Mémoires de la Vie Littéraire*, Paris 1892, Pl. II/16.

10 Seckel, Dietrich, *Buddhistische Kunst Ostasiens*, Stuttgart 1957. Eckhardt, André, 'Wesen und Wirken der japanischen Malerei', *Universitas* 14, 1959.

11 Vincent van Gogh, *The Complete Letters*, 3 vols, New York, London 1958, letter 469.

12 Among them, above all Hokusai's cycle *Trip to the Waterfalls in the Provinces*, 1828/29 and Hiroshige's *53 Stations on the East Sea Road*, 1832–34.

13 Hodler not only took Mount Fuji as his theme, his coloured skies and clouds are also influenced by Japanese woodcuts. See cat. 'Die Alpen in der Schweizer Malerei', Chur 1977, nos 89, 209. It is interesting that the Japanese painter Ryuzaburo Umehara paints Mount Fuji around 1920 in the manner of Hodler. See Theile, Albert, *Die Kunst des Fernen Ostens*, Hamburg 1955, Fig. 113.

14 Schmithals, Hans, Unpublished Papers, Wiesbaden, Private Collection.

15 Seckel, Dietrich, *Emaki. Die Kunst der klassischen Bilderrolle*, Munich 1959, 180.

16 Yukio, Yashiro, *Japanische Kunst*, Munich, Zürich 1958, Pl. 87.

18 The close relationship of the Japanese to his natural surroundings caused him to create so-called 'natural cult pictures'.

19 Yang En-Lin, ed., *Der Senfkorngarten*, Leipzig 1966, 15.

Signs and emblems (pages 294–301)

1 See Rosenberg, Alfons, *Die christliche Bildmeditation*, Munich 1955, 16. Jung, Carl Gustav, *The Collected Works*, Vol. 9, Part I, *The Archetypes and the Collective Unconscious*, London, Princeton 1959.

2 Zimmer, Heinrich, *Mythen und Symbole in indischer Kunst und Kultur*, Zürich 1951, 60ff, 102. Seckel, Dietrich, *Buddhistische Kunst Ostasiens*, Stuttgart 1957, 178ff.

3 Elida, Mirce, 'Kosmogonische Mythen und magische Heilungen', *Paideuma*, Vol. VI, 1956, 197.

4 Burckhardt, Titus, *Vom Wesen heiliger Kunst in den Weltreligionen*, Zürich 1955, 5.

5 Kühn, Herbert, *Tat und Versenkung. Europa und Asien*, Mainz 1948, 50.

6 Bucher, B., *Über ornamentale Kunst auf der Wiener Weltausstellung*, Berlin 1874. Weber, V.F., *Ko-Ji Hō-Ten*, Paris 1923, I & II, 182–83, 503. Lee, Sherman E., *Japanese Decorative Style*. The Cleveland Museum of Art 1961. Cutler, Thomas W., *A Grammar of Japanese Ornament and Design*, London 1879, 1880, 19ff. Duthuit, Georges, *Chinese Mysticism and Modern Painting*, Paris, London 1936. Moser, D.H., *Book of Japanese Ornamentation*, London 1880, 26ff.

Semi-precious stones and glassware (pages 302–13)

1 Jade is a general term for the minerals nephrite and jadeite. Mineralogically nephrite belongs to the hornblende or amphibole group. The material was easy to work, for with a degree of hardness of about 6, it is related to felspar. The colour variations are great, from brown-black via yellow, green, grey to white. The places where it occurs on Lake Baikal and in East Turkestan had an almost sacred, mythical significance. Jadeite was also seen as a cult material. Mineralogically it belongs to the augite or pyroxene group, it is harder, comparable to quartz, measuring roughly 7 on the scale. It is found in East Asia, though more in South Asia, in Upper Burma, in the Mekong and in the S.W. Chinese Province of Yuman. The places where it occurs are very widespread, almost in every part of the world. In prehistoric times it was valued as a precious stone. In China both minerals are grouped together under the term *yü*. The soft shine of jade was compared to illuminated humanity, its hardness to justice, its musical note when struck to wisdom, its toughness to bravery and its purity to virtue. Feddersen, Martin, *Chinesisches Kunstgewerbe*, Brunswick 1958, 167ff. Gure, Desmond, 'Notes on the Identification of Jade', *Oriental Art*, Vol. III, 1951, no. 3. Michel, H., 'Astronomical Jade', *Oriental Art*, Vol. II, 1950, no. 4.

2 See Baudelaire, Charles, *Les Fleurs du Mal*, 'Les Bijoux' and 'Le Flacon'. Numerous examples can be found in French Symbolist poetry.

3 The elusive quality of Art Nouveau glass had reached its public through the specialist galleries in European capitals and through the international exhibitions. At Samuel Bing's gallery in Paris up

to 4,000 gold marks were paid by museums for these glass pieces. Judged by the cost of living of the time, these were fantastic sums. See also Hevesi, Ludwig, *Acht Jahre Secession*, Vienna 1906, 232ff.

4 A notable vessel of this period is to be found in the Österreichisches Museum für angewandte Kunst in Vienna.

5 *Pâte de verre*: The glass powder is mixed with the juice of quince kernels which does not stain and leaves no deposit behind. The paste, coloured in the molten state, is pressed into the ready-prepared mould, is built up from the inside, sometimes with reliefs and irregularities on the inner walls to correspond to the Chinese *objets trouvés*. After this it is fired at a low temperature and dried out finally fairly slowly. If the temperature is too high and the firing period too short streaks and cracks develop, though sometimes this is intentional. *Verre de jade*: dyes are added directly to the molten glass. Thus, the colour is created by the addition of chromium oxide mixed with cadmium sulphide or brown stone and iron oxide, according to the shade required. It is then polished and engraved.

Vessels on stands (pages 314–24)

1 Major gold and silversmiths also designed excellent stands for vases around 1900. See cat. 'Art Nouveau Belgium/France', Houston, Texas 1976, 202, 216, 219, 315, 316, 320.

2 Wichmann, S., *Jugendstil*, Munich 1977, 11.

3 Cat. 'Art Nouveau Belgium/France' (n.1), 316.

4 Seckel, Dietrich, *Buddhistische Kunst Ostasiens*, Stuttgart 1957, 166. Weber, V.F., *Ko-Ji Hō-Ten*, Paris 1923, 42, 181, 413, 421.

5 Inv. no. 130–1885.

6 Goepper, Roger, *Kunst und Kunsthandwerk Ostasiens*, Munich 1968, 114, 124, 138, 141.

7 Feddersen, Martin, *Japanisches Kunstgewerbe*, Brunswick 1960, 271; Joly, Henry L., *Legend in Japanese Art*, Tokyo 1967; Weber (n.4), 317.

8 Willetts, William, *Das Buch der chinesischen Kunst*, Düsseldorf, Vienna 1968, 92ff.

9 Nott, Stanley C., *Chinese Jade*, Vermont, Tokyo 1962.

10 Weber., *Ko-Ji Hō-Ten* (n.4), 148–51.

11 See the example in the Österreichisches Museum für angewandte Kunst, Vienna. The piece is based on Chinese models.

12 Edgar Paul Durand often designed stands for Gallé but rarely signed them. The chronology of his life is not yet known. There is a private Gallé collection in Ascona.

13 The models here are of jadeite and nephrite. The basketwork decoration around the body of the vessel is striking. The mounts of Bohemian glass of c.1900 are modelled on such pieces. See Wichmann (n.2), 26, Fig. 53. vase.

14 Wichmann, S., cat. 'Internationales Jugendstilglas', Munich 1969, nos 76, 101, etc.

15 Inv. nos. c.1242/1917 and c.380 or 599–1966. resp.

16 London, Victoria and Albert Museum, Salting Col, inv. nos 818–1910 and 803–1910.

17 See cat. of international exhibition, Paris 1900, 412ff. Ferd, W., 'Glas und Keramik auf der Pariser Weltausstellung', *Kunst und Kunsthandwerk*, suppl. 3, 1900, 421.

18 Arnold, D.L., 'Art Glass of Gallé', *Western Collection*, V, no. 6, June 1967.

19 Joudain, Franz, 'En vue de l'exposition de 1900', *Revue des Arts Décoratifs*, Vol. 19, 1899, 118.

20 In 1851 the Crystal Palace in London had already added a new dimension to the lighting of indoor exhibitions. The international exhibitions of 1855, 1867, 1878, 1889 and 1900 in Paris increased the daylight in the exhibition halls. See Beutler, Christian, *Weltausstellungen im 19. Jahrhundert*, Munich 1973.

21 Hevesi, Ludwig, *Acht Jahre Secession*, Vienna 1906, 112.

22 Hennivaux, J., *La Verrière à l'Exposition Universelle de 1900*, Paris 1902, 66.

The bottle-gourd form (pages 324–25)

Incorporates material from cat. 'Weltkulturen', Munich 1972, 352/53.

1 Feddersen, Martin, *Chinesisches Kunstgewerbe*, Brunswick 1958, 248.

2 Feddersen (n.1), 248.

3 Joly, Henry L., *Legend in Japanese Art*, Tokyo 1967.

4 London, Victoria and Albert Museum, Netsuke Collection, N 12.9.241. See Rayerson, E., *The Netsuke of Japan illustrating Legends, History, Folklore and Customs*, London 1958. See Rigozzi, E., 'Das Netsuke', *Asiastische Studien* 1, 2, 1947.

5 Camard, Jean-Pierre, 'Die Bedeutung des Fernen Ostens für die Renaissance der französischen Keramik Ende des 19. Jahrhunderts', cat. 'Weltkulturen', Munich 1972, 337.

6 Wichmann, S., *Jugendstil*, Munich 1977, 51.

The black and white effect (pages 326–35)

1 Quoted in Brinkmann, Justus, *Kunst and Handwerk in Japan*, Berlin 1889, 180.

2 Collection of Botanical Handbooks, Kyōto 1827–40.

3 Seckel, Dietrich, *Buddhistische Kunst Ostasiens*, Stuttgart 1957, 178.

4 Seckel, Dietrich, *Einführung in die Kunst Ostasiens*, Munich 1960, 236ff.

5 One could have traced nearly all vase decoration around 1900 back to these models, if only it had not been watered down by ignorant imitation.

6 The models from the years after 1871 were paralysed by unsurpassable verism. Jedding, Hermann, 'Historismus', cat. Hamburg 1977, 255, 274f.

7 For examples of overloading of decoration and deep grinding, see Jedding (n.6), 185.

8 See Bing, S., Foreword to exhibition catalogue, 'Estampes d'Outamaro et de Hiroshige exposées dans les Galeries Durand-Ruel', Paris 1893.

9 The cutting and grinding techniques are kept very shallow, and the decoration also includes insertions and incrustations. See Wichmann, S., *Internationales Jugendstilglas*, *Vorformen moderner Kunst*, Munich 1969 (Technology).

10 The demand for Japanese décor was enormous at the international exhibitions. European pattern books grew in number after every exhibition and reflect the fact that public interest was becoming a 'trend'.

11 We can assume that he drew according to the old Japanese botanical texts and himself passed on the stylistic details on which Nishi-gawa had based his work.

12 Clearly visible in the needle etchings, which show the sprouting leaves and stems with the same sharpness as the original. The engraved interior drawings around 1898 also follow the decorative stimulus of Japan.

13 Japanese sample books were all derived from botanical text-books.

14 The collection appeared in various editions, later as well. It is doubtful that the 1846 edition was the first.

15 Brinkmann, Justus, *Kunst und Handwerk in Japan*, Berlin 1889, 7ff. (*Die Pflanzen Welt*).

16 Joly, Henri L., *Legend in Japanese Art*, Tokyo 1968.

17 New 'cut-off' compositional form, related to Ikebana. Growth out of nothing is comparable with the way (a flower) rises from the foot of a vase.

The dragon motif (pages 336–39)

1 Feddersen, Martin, *Japanisches Kunstgewerbe*, Brunswick 1960, 267. Feddersen, Martin, *Chinesisches Kunstgewerbe*, Brunswick 1958, 249.

2 Weber, V.F., *Ko-Ji Hō-Ten*, Paris 1923, I, 148–52. Feddersen (n.1 1960) 20, 81, 104, 117, 267ff. Feddersen (n.1 1958) 202, 208–13, 249–51.

3 Streaming hair, often in the form of a dragon with the sacred burning pearl, also occurs in connection with representations of the phoenix in the Kang-hsi period.

4 Weber (n.2) 148–52.

5 Chinese ceramic techniques were investigated by means of all kinds of glazes. See Heuser, Maria and Hans-Jörg, cat. 'Französische Keramik zwischen 1850 und 1910', Munich 1974.

6 The so-called 'whiplash line' was well adapted to the dragon motif. In the Königlicher Porzellanmanufaktur in Berlin dragon decorations were placed on ox-blood glazes designed by Hermann Segers himself.

7 Heuser (n.5) 68ff.

8 Heuser (n.5) 92.

Chinese ceramic forms (pages 340–43)

1 Lessing, Julius, *Bericht von der Pariser Weltausstellung*, Berlin 1878.

2 Franke, O., *Geschichte des Chinesischen Reiches*, Berlin 1930–37. Stange, H.O.H., 'Geschichte Chinas vom Urbeginn bis auf die Gegenwart', *Geschichte Asiens* by E. Waldschmitt and others, Munich 1950.

3 Feddersen, Martin, *Chinesisches Kunstgewerbe*, Brunswick 1958, 13ff.

4 It was Théodore Deck above all who made it his business to investigate Chinese techniques. See Heuser, Maria and Hans-Jörg, cat. 'Französische Keramik', 68.

Celadon and white porcelain (pages 344–57)

1 Survey of the equipment of Cha-no-yu: Weber, V.F., *Kō-Ji Hō-Ten*, Paris 1923, I, 90. The larger water pots of Seto-yaki ware have noticeable production marks on them covered by flecked flow glazes. Even more important are the angular water pots of red-grey stoneware from the early Edo period. They can be 35–40 cm high

and up to 30 cm in diameter. There are pots of this kind with descriptive inscriptions on the base, such as *Iwao* (rock). A pot like this is in the Berlin Museum für Ostasiatische Kunst, no. 1190.

2 Weber (n.1).
3 Munsterberg, Hugo, *Zen-Kunst*, Cologne 1978, 87ff. Berliner, Anna, *Der Teekult in Japan*, Leipzig 1930. Okakura Kakuzo, *Das Buch vom Tee*, Leipzig (Inselbücherei 274). See also Seckel, Dietrich, *Einführung in die Kunst Ostasiens*, Munich 1960, 286ff.
4 Munsterberg (n.3) 88ff.
5 Munsterberg (n.3) 94. Miller, Andrew, *Japanese Ceramics*, Tokyo 1960, 63.
7 Miller (n.6) 51.
8 Miller (n.6) 55ff.

The influence of the Japanese House (pages 358–67)

1 Yoshida, Tetsuro, *Japanische Architektur*, Tübingen 1952, 13ff. Balzer, F., *Das japanische Haus*, Berlin 1903, 28ff.
2 Brinkmann, Justus, *Kunst und Kunsthandwerk in Japan*, Berlin 1889, 33ff. Sekino, T., *Nihon-no-Kenchiku-to-Geijutsu* (Architecture and Art of Japan), Tokyo 1940. Taut, Bruno, *House and People of Japan*, Tokyo 1937. Morse, E.S., *Japanese Houses and their Surroundings*, Boston 1886, 37ff. Lancaster, Clay, 'Oriental Forms in American Architecture 1800–1870', *Art Bulletin*, XXIX, New York 1947, 183–93.
3 Yoshida (n.1) 15.
4 Le Corbusier, *The Modulor*, London 1954. Lancaster, Clay, 'Japanese Buildings in the United States before 1900', *Art Bulletin*, XXXV, 3, 1953, 217–25.
5 Yoshida, Tetsuro, *Das japanische Wohnhaus*, Berlin 1935. (Kiwari-ho method).
6 Yoshida (n.5).
7 Yoshida (n.1) 12ff. ·
8 Yoshida (n.1).
9 Harmonious design of ground-plan and elevation is evident in the early buildings in the USA and Europe to be influenced by Japanese architecture, with their clear delineation of surface units outside and inside.

Gradually the trend begins of having the entire building relate to one binding unit of measure, determined by the length and breadth of the *tatami*, 6:3 ft. One concern of all avant-garde architects is to dispense with ornamentation in favour of architecturally determined structural parts, clearly emphasized both externally and internally. Frank Lloyd Wright uses open ground-plans and opens the house to nature, i.e., to the garden. See *Wright: An organic architecture* (the Sir George Watson Lectures of the Sulgrave Manor Board for 1939), London 1939, 2–4. See also Lancaster, C., *The Japanese Influence in America*, New York, Tokyo 1963. For a further survey see Buchanan, *History of the Panama Pacific International Exposition*, San Francisco 1915, 193. The West's encounter with Japanese architecture was discussed in American professional literature immediately after the first exhibition pavilions were erected. See *American Architect and Building News*, 12 Feb. and 2 Apr. 1876. Dresser, C., *Japan, its Architecture, Art and Art Manufactures*, London 1882.
10 Front of Theodore Irwin House, Pasadena, completed 1907 by the architects the brothers Greene. Ill. in Lancaster (n.9) 108, (83). Gamble House, Pasadena, Calif., built by the brothers Greene in 1908. Ill. in Lancaster (n.9) (87, 88 and 6). Pratt Bungalow, Ojaiain, Calif., built by the brothers Greene in 1909–11. Ill. in Lancaster (n.9) (93, 94). Photographs of the interior of the Pratt house and the Gamble House (Atrium) also in Zevi, B., *Storia dell'architettura moderna*, Turin 1950, 55. J. A. Freeman House, Pasadena. Built by Arthur S. Heinemann in 1913. Ill. in *The Western Architect*, August 1914. Japanese-style bungalow in Buckingham Rd., Brooklyn, designed by John J. Petit and James C. Greene, built in 1903. Japanese-style bungalow in Cedar Manor, Long Island, N.Y. Architect Henry Wilson 1909. Ill. in Lancaster (n.9) 130 (108).
11 Taut, Bruno, *Fundamentals of Japanese Architecture*, Tokyo 1937.
12 Open ground-plan is a feature of the following Japanese buildings in America: Tea house in a Japanese garden in New England, ill. in *Country Life in America*, March 1905, 495–98. Japanese house in Japanese garden, Silver Strand, Coronado, Calif. Built 1904. Designed by George Turner Marsh. Lancaster (n.9) 209 (176). Holiday house on Steilacoom Lake, Washington. Architect Jay Knapp. See *The Architect*, November 1915, 245. Sho-fu-den, country home of Dr Jokichi Takamine, Merrieworld Park, near Monticello, N.Y. Ill. in Lancaster (n.9) (125–30). Three pavilions of the Louisiana Purchase Exposition are integrated into the building complex. Tea house with garden in Georgian Court, Lakewood, N.J. Designed by Takeo Shiota. See *House and Garden*, December 1916 (14). Japanese garden with architectonic layout. Clemson Pk., Middletown, N.Y., 1913. Architect F. J. Lindsey; gardener: Ikeda. See Lancaster (n.9) 203 (174). Harwell

Hamilton House, Fellowship Park, Los Angeles. Built by the owner, the architect Harwell Hamilton Harris 1935. See Lancaster (n.9) 182 (155). Kiyoshi Hirasaki House in Gilroy, San José, Calif. Built 1940. See Lancaster (n.9) 181 (153). Summer house in Holland, Mich. Architects Obryon and Knapp. Built 1956. See Lancaster (n.9) 173 (145).
13 Yoshida (n.1) 168ff.
14 Yoshida (n.1).
15 Yoshida (n.1) 14, 15.
16 Horiguchi, S., *Sôtei* (Grass Garden, collection of essays on tea room and tea garden), Tokyo 1948, 16ff.
17 Brinkmann, Justus, *Kunst und Handwerk in Japan*, Berlin 1889, 7 (*Die Pflanzen Welt*).
18 A list of the dwelling houses follows with brief references to the literature. The peculiarities of all of them – openness to nature, to the garden, ground-plan, windows, roof structures, etc. – can be understood only by reference to Japanese architecture. Mansion for Chauncey L. Williams, Edgewood Place, River Forest, Ill., built 1895. House for B. Harley Bradley, Kankakee, built 1900. See Lancaster (n.9) 61 (66). House for Warren Hickox, built 1900. See Lancaster (n.9) (3). Martin House, Oakpark, Buffalo, N.Y., 1906. See Cassou, Langue, Pevsner, *The Sources of Modern Art*, London 1962. Penwern Mansion, built for Fred B. Jones on Lake Delavan, Wisc. Taliesin, built by the architect as his own dwelling, 1911. See Lancaster (n.9) 92 (67–68). Nothome House, built 1912 for François W. Little, Jr. at Lake Minnetonka, Wayzata, Minn. See Lancaster (n.9) (4) 93 (69). Falling Water Residence, Pennsylvania 1936–37. See Hitchcock, H.R., *Architecture of 19th and 20th Centuries*, (145(A)). Winkler-Goetsch House, built in Michigan 1939. See *Handbuch Moderner Architektur*, 1957, 254, 255.
19 See Lancaster (n.9) (6, 87, 88). Gamble House, Pasadena, Calif., built 1908 by the brothers Greene.
20 Johnson, Philip, *Mies van der Rohe*, New York 1947, 36ff. Hilbersheimer, Ludwig, *Mies van der Rohe*, Chicago 1960. Drexler, Arthur, *Mies van der Rohe*, New York 1960.
21 Taut (n.11) 26ff.
22 Choay, Françoise, *Le Corbusier*, New York 1958.
23 Choay (n.22).
24 MacCoy, Esther, *Richard Neutra*, London 1961.
25 Yoshida (n.1) 157ff. (Hanging shelf).
26 Balzer, F., *Die Architektur der Kultbauten Japans*, Berlin 1907. Fujishima, G. in *Nihon-Kenchiku-shi* (History of Japanese Architecture), Tokyo 1930, 16ff, 93f.
27 MacCoy (n.24), illustrations.
28 Johnson, Philip, *Johnson House*, New Canaan, Conn., 1949, 12ff.
29 Brinkmann (n.17) 43.
30 Cat. 'The Floating World', London 1973, II, 15 (Kiyohiro).

The gardens (pages 370–75)

1 Adachi, K. in *Nihon-Kenchiku-Shi* (History of Japanese Architecture) Tokyo 1930, 12ff.
2 Japan received Buddhist doctrine from China via Korea. The doctrine adhered to by the then Prince Regent Shotoku Taishi spread rapidly through the country in the Asuka period (552 645).
3 Brinkmann, Justus, *Kunst und Kunsthandwerk in Japan*, Berlin 1889, 81ff.
4 Brinkmann (n.3). Paine, Robert T. Soper, Alexander, *The Art and Architecture of Japan*, Pelican History of Art, Harmondsworth 1955.
5 The Gold Pavilion Kinkaju-ji was re-built in 1955 as a replica of the original of 1394. The gardens are also continually renewed.
6 In the presence of the author, 1972.
7 Garden of the Four Seasons in Kyōto in the Daioji Temple district. Sickmann, Laurence/Soper, Alexander, *The Art and Architecture of China*, Pelican History of Art, Harmondsworth 1956.
8 Brinkmann (n.3).
9 Brinkmann (n.3).
10 Yasuoka, K., *Chashitsu-to-Chatei* (Tea room and tea garden) Tokyo 1924.
11 Yasuoka (n.10).
12 Yasuoka (n.10).
13 Yasuoka (n.10).

Interiors and modules (pages 376–79)

1 Far Eastern influences are strongly expressed in the following buildings of Charles Rennie Mackintosh: Entrance hall to Windyhill, built 1899–1901. See Tschudi Madsen, Tschudi, *Sources of Art Nouveau*, Oslo 1956, 287 (159). Entrance hall to Hill House, built 1902–03. See Robert Schmutzler, *Art Nouveau*, New York 1964. Tea rooms in Ingram St, Glasgow, built 1901–12. See Pevsner, Nikolaus, *Pioneers of The Modern Movement from William Morris to Walter Gropius*, Harmondsworth 1960. Eating room and tea room in 'The Willow', built 1904. See Schmutzler

above. Library of the Glasgow School of Art, Built 1907–08. See Pevsner above, 100 (83).
2 The firm of R. Wagner in Berlin SW, Dessauerstr 2, offered complete Japanese rooms and salons. In their advertisements they asserted 'We don't import mass production items geared to the European market.'
3 The same firm recommends: 'Porcelains, faiences, particularly faiences decorated by artists, lamps and hangings from temples, screens by great masters, papers from the Imperial workshops and other items.'
4 1876/77. See Bénedite, Léonce, 'Whistler', *Gazette des Beaux-Arts*, 34, 1905, 142–58. Sandberg, John, 'Japonisme and Whistler', *Burlington Magazine*, 106, November 1964, 500–07.
5 Brinkmann, Justus, *Kunst und Handwerk in Japan*, Berlin 1889, 40.
6 Cat. 'Weltausstellung' Vienna 1873. Cat. 'Kaiserlich japanischen Ausstellung' Vienna 1873. Falke, I v, *Die Kunstindustrie auf der Wiener Weltausstellung 1873*, Vienna 1873.
7 Falke (n.6).
8 See official cat. 1867, London, cat. 1900, Paris.
9 Yoshida, Tetsuro, *Japanische Architektur*, Tübingen 1952, 202. Brinkmann (n.5) 48.
10 The expression Japonisme was probably first formulated by Philippe Burty in 1872. Burty wrote a series of articles under the title 'Japonisme' in *La Renaissance Littéraire et Artistique* from May 1872 to February 1873.
11 See Immos, Thomas and Halpern, Erwin, *Japan*, Cologne 1974, Foreword.
12 Howarth, Thomas, *Charles Rennie Mackintosh*, London 1952, (30).
13 Joseph Hoffmann, Hall in Haus Moser, built 1902. See Madsen (n.1) 405 (241). Exhibition of the Wiener Werkstätte in Hohenzollern-Kunstgewerbehaus. See Giulia Veronesi, *Josef Hoffmann*, 75. Villa Heuneberg/Hohe Warte, built 1905. Design of the Library. See Veronesi above (87). Palais Stoclet, Brussels, built 1905–11. See Schmutzler (n.1) 253 (257). Adolf Loos, Villa Karma, Lake Geneva, cloakroom, built 1904–06. See Münz, L. and G. Künstler, *Der Architekt A. Loos* (1964), (55). Adolf Loos, Kärntner Bar, Vienna, interior, built 1907. See Schmutzler (n.1) (264). Adolf Loos, Landhaus Khuner bei Paerbach, Lower Austria, built 1930. Interior view of the hall seen on the big glass wall. See Münz and Künstler above (44). Josef Olbrich, Living room in the crafts exhibition, Dresden 1906. See Platz, G.A., *Wohnräume der Gegenwart*, Berlin 1933, 211. Margold, E., Design for a bedroom and a dining room (1907). See *Deutsche Kunst und Dekoration*, 1908–09, 144, 145. Fürst, Walter, Design for a bedroom in a private house. See Lancaster, Clay, 'Oriental contributions to Art Nouveau', *Art Bulletin*, XXXIV, 1952, 297–310.
14 Lancaster (n.13).
15 Lancaster (n.13).
16 Wichmann, Hans, *Aufbruch zum neuen Wohnen*, Stuttgart 1978, (179, 195, 196, 221, and others).
17 The architect Josef Hoffmann worked in Vienna; he and his students established the new building methods. Square – circle – point and chequered ornamentation are features of the new design. Their own stylistic desires were confirmed by the stimulus they received from Far Eastern art. Japanese ideas reached Vienna through English periodicals such as *The Yellow Book*, *The Studio*, and exhibitions visiting Vienna. See Hevesi, Ludwig, *Acht Jahre Secession*, Vienna 1906.
18 The reports of the international exhibition all agreed in emphasizing these criteria.
19 The technical means were the determining factor for many designers, and Hermann Obrist handled his early furniture in the same way.
20 With this furniture the modular system began to be effective in Europe for the first time.
21 Yoshida (n.9) 142.
22 Yasuoke, K., *Tea room and tea garden*, Tokyo 1924. Wichmann, S., *Secession, Europäische Kunst um die Jahrhundertwende*, Munich 1964, 87ff.

From Zen to Tachism (pages 380–406)

1 The horizontal or hand scroll (*emakimono*) is an exceedingly broad format with a particular function. Whereas the tall, narrow format occurs with many different measurements. This unique format derives from South East Asian 'banner paintings', a cult format apparently known in early Buddhist times in India. In China it appears more strongly in the second half of the T'ang Dynasty (after the 8th century), but still generally in the form of cult pictures. In the period of the Five Dynasties (907–60) the hanging scroll with animal and plant motifs increases in importance, and so does landscape painting.

In the Sung period (960–1279) the hanging scroll is treated with

equal importance as the horizontal scroll. The Southern Sung Dynasty in particular (1127–1279), with its meditative outlook of Ch'an or Zen Buddhism, tended towards a more differentiated outlook on life, formed by aesthetic and religious conceptions.

In Japan, extreme formats were developed for woodcuts. These are the strip or pillar pictures, *hashira-e* (*c.*70 × 12 cm) and others.

The Japanese woodcut masters used the tall, narrow formats as compositional exercises in which figures are 'daringly brought into the picture'.

2 European patternbooks take up these formats in detail. See Munsterberg, O., *Japanische Vorlagen*, Leipzig 1895. Dolmetsch, H., *Japanische Vorbilder*, Stuttgart 1886.

3 Champfleury, 'La Mode Des Japonaiseries', *La Vie parisienne*, November 21, 1868, 862/3. Chesneau, Ernest, 'Le Japon à Paris', *Gazette des Beaux-Arts*, 18, 1878, 385–97, 841ff. Fukumoto, Kazno, *Hokusai and Impressionism*, Tokyo 1947.

4 Hahn, Ethel, 'The Influence of the Art of the Far East on 19th Century French Painters', diss., University of Chicago 1928. Hermann, Fritz, 'Die "Revue Blanche" und die "Nabis"', diss.

Zürich, Munich 1959, 224–32. In this important work it is mainly Japanese woodcuts that are compared with the Nabis; less attention paid to the ink paintings, though their effect is acknowledged.

5 Hermann (n.4) 227–30.
6 *La Revue Blanche* 1891, *The Studio* 1893, *The Yellow Book* 1894, *Pan* 1895, *Ver Sacrum*, *Jugend* 1896, *Simplizissimus* 1896, *The Savoy* 1896, *Deutsche Kunst und Dekoration* 1897, *Dekorative Kunst* 1898, *Die Woche* 1899, *Die Insel* 1899.
7 Bing, Samuel, *Le Japon artistique*, Paris, Aug., Nov., 1889.
8 Gauzi, François, *Lautrec et son temps*, Paris 1954. Duret, T., *Toulouse-Lautrec*, Paris 1920.
9 Goepper, Roger, *Kunst und Kunsthandwerk Ostasiens*, Munich 1968, 178.
10 Goepper (n.9).
11 Goepper (n.9).
12 Goepper (n.9).
13 Goepper, Roger, *Im Schatten des Wu-Tung Baumes*, Munich 1959, 32.

14 Mark Tobey, 'Aus Briefen und Gesprächen', Cat. Düsseldorfer Kunsthalle, 1966.
15 Lambert, Jean-Clarence, *Die abstrakte Malerei*, Lausanne, Paris 1967, 91.
16 Masson, A., 'Über die neuen Beziehungen zwischen Malerei und Betrachter' (lecture given on 25 February 1958 in the Collège Philosophique in Paris). From Masson, A., *Eine Kunst des Wesentlichen*, Essays, Paris 1961.
17 See Cat. 'Weltkulturen', Munich 1972, 398, (1596).
18 Lambert (n.15), 92.
19 Lambert (n.15), 95.
20 See Cat. 'Weltkulturen', Munich 1972, 405.
21 Lambert (n.15), 95.
22 Cat. 'Weltkulturen', Munich 1972, 403.
23 Lambert (n.15), 96.
24 Munsterberg, Hugo, *Zen-Kunst*, Cologne 1978, 131.
25 Munsterberg (n.24).

Photographic acknowledgments
Numbers refer to the illustrations

Agraci, Paris 24, 357; Albright-Knox Art Gallery, Buffalo 344; Art Institute of Chicago 77, 84, 86, 233, 709; Art Museum, Seattle 16; Atami-Museum, Shiznoka-Ken/Japan 330; Badisches Landesmuseum, Karlsruhe 181, 214, 240, 426; Baur Collection, Genf 831; Bayerische Staatsgemäldesammlung, Munich 27, 752, 1080; Berner Kunstmuseum 367; Bernheim-Jeune 411, 643; Bethnal Green Museum, London 175; Biblioteca Ismeo, Rome 1077; Bibliothèque Nationale, Paris 19, 269a, 377, 566, 630, 646, 660, 698, 713, 724, 726, 729; administrators of R. R. Blacker's Residence, Pasadena 1015; Werner Blaser 1009; Boller Collection, Zürich 376; Bridgestone Museum of Art, Tokyo 368; British Museum, London 174; Hans Brockstedt Collection, Hamburg 470; Emile Bührle Collection, Zürich 146, 669; Eisei Bunko, Tokyo 1056; Cleveland Museum of Art 209, 324, 325; Fachschule Turnau/Nordböhmen 484; Fratelli Fabbri Editori 12, 28, 29, 35, 63, 68, 71, 75, 157, 159, 161, 178, 182, 207, 265, 387, 392, 409, 413, 422, 423, 424, 447, 571, 599, 600, 761, 860, 863, 988, 990, 995, 998, 1001, 1002, 1003, 1009, 1014, 1019, 1037, 1040, 1049, 1051, 1053, 1055, 1074, 1075, 1087, 1102; R. W. Finlayson, Toronto 166; Folkwang Museum, Essen 741, 747; Foto Marburg 922; Galerie Beurdeley, Paris 1097; Galerie Beyeler, Basle 1096, 1101; Galerie Jeanne Bucher, Paris 1104; Galerie Durand-Ruel & Cie, Paris 450; Galerie de France, Paris 1078; Galerie Louise Leiris, Paris 1089, 1099; Galerie van de Loo, Munich 1095; Galerie de Nittis, Barletta 417; Galerie Jeanette Ostier, Paris 1054; Galerie Vallotton, Lausanne 607; administrators of David Gamble's House, Pasadena 983, 1005; Glass Museum, Corning (NY) 842; S. R. Gnamm, Munich 53, 190, 197, 213, 243, 261, 280, 284, 285, 309, 488, 499–522, 827, 828, 840, 841, 843, 844, 848, 850–52, 858, 864, 867, 871–73, 879, 880, 914, 920, 929, 935, 936, 941, 949, 950, 953, 954, 956–62, 966, 971–73, 975, 977, 978, 980, 1039, 1088, 1100; Mrs Frank Jay Gould, USA 443; Graphische Sammlung Albertina, Vienna 721; Gutenberg-Museum, Mainz 366; Claus Hansmann, Munich 5, 6, 7, 22, 26, 47, 49, 70, 270, 395, 401, 403, 406–08, 418, 420, 432, 435, 438, 445, 526, 527, 530, 531, 534, 536, 537, 539, 540, 543, 544, 555, 572, 580, 581, 592, 594, 623, 626, 772, 814–17, 838, 839, 854–56, 859, 878a, 881, 912, 915–18, 923–27, 930–34, 942–48, 951, 952, 964, 965, 967, 968, 1090, 1093; Harvard University, Moritz Wertheim Foundation 62; Harwell H. Harris 994; Haussmann Reprotechnik 172, 272; Hessisches Landesmuseum, Darmstadt 195, 331; Hill Stead

Museum, Farmington (CT) 34; Historisches Museum der Stadt Wien 448; Idemitsu Museum, Tokyo 1076, 1085, 1094; Institute of Technology, Chicago 991; Jingo-ji, Kyōto 705; M. Samuel Josefswitz Collection, Lausanne 586; Karlsberg Glyptothek, Copenhagen 124; Kestner-Museum, Hanover 896; Klipstein & Kornfeld, Berne 414; Kodansha International Ltd, Tokyo 939, 1058, 1059, 1061, 1063, 1064; Kunstgewerbemuseum, Cologne 589; Kunstgewerbemuseum, Zürich 764; Kunsthalle, Bremen 585, 696; Kunsthaus, Zürich 774; Kunstindustrimuseet, Copenhagen 313, 473; Kunstmuseum, Düsseldorf 294, 833, 846, 847, 905, 919; Kunstmuseum Winterthur 149; Kunstsammlung Basel 753; Kunstsammlung Nordrhein-Westfalen, Düsseldorf 1091; Mora Lacombe, Paris 379; Landesmuseum Karlsruhe 13; Landesmuseum Schleswig 639; Fritz Lüdtke 1011–13, 1017, 1020–22, 1024, 1027; Otto Maier Verlag, Ravensburg 985, 986, 993, 996, 997, 999, 1008, 1010; Maison Coilliot, Lille 875; Marlborough-Gerson Gallery Inc., New York 1082; Hans Mayr, Vienna 306, 308, 390, 523, 548, 554, 588, 629, 644, 645, 664, 683, 732, 742, 750, 751, 770, 829; Metropolitan Museum of Art, New York 36, 81, 385, 613, 657, 677; Moderne Galerie, Dresden 615; Musée d'Art Moderne, Brussels 106; Musée de l'Orangerie, Paris 680; Musée de Rennes 321; Musée des Arts Décoratifs, Paris 479, 819; Musée des Beaux-Arts, Lyons 383, 673; Musée du Louvre, Paris 145, 229, 365, 429, 590, 622, 662, 675, 676; Musée Léon Alègre, Bagnols-sur-Cèze 685; Musée Municipal de Brest 375; Musée National d'Art Moderne, Paris 431, 695; Musée National Gustave Moreau, Paris 740, 743; Musée Toulouse-Lautrec, Albi 14, 116, 121, 133, 137, 471; Museu de Arte, São Paulo 655; Museum für dt. Keramik, Deidesheim 976; Museum für Kunst und Gewerbe, Hamburg 2, 183, 421, 425, 591; Museum für Ostasiatische Kunst, Cologne, 290, 343, 579, 659, 661, 722; Museum of Art, Philadelphia 318; Museum of Decorative Arts, Prague 487; Museum of Fine Arts, Boston 671; Museum of Modern Art, New York 105; Nasjonalgalleriet, Oslo 92; National Gallery of Art, Chester Dale Collection, Washington, DC 658; Nationalmuseum, Cracow 327; National Museum of Western Art, Tokyo 652, 656; Nezu Art Museum, Tokyo 745; Niedersächsische Landesgalerie, Hanover 775; Ostasiastika Museet, Stockholm 549; Osterreichische Galerie, Vienna 563; Osterreichisches Museum für angewandte Kunst, Vienna 200, 264, 332, 334, 474, 494, 890–92, 894; Ostdeutsche Galerie, Regensburg 634; Marlen Perez, Hochfelden (Switz.) 210, 288, 410, 907; Public Library, New York 780; Rijksmuseum Kröller-Müller, Otterlo 114, 314, 583, 650, 716; Rijksmuseum Vincent van Gogh,

Amsterdam 95, 97, 101, 109, 160, 754; Rijksmuseum voor Volkenkunde, Leiden 219; Routhier, Paris 30, 355, 582; Royal Porcelain Manufactory, Copenhagen 311; Rutgers University Fine Arts Collection, New Brunswick 177; Dr Georg Schäfer Collection, Obbach 184, 339, 575; Schleswig Holsteinisches Landesmuseum, Schloss Gottorf 326; Schmuckmuseum, Pforzheim 462, 475; Shuppan Co., Tokyo 937, 938, 940, 963, 970, 979; Paul Signac Collection 147; Staatliche Graphische Sammlung, Munich 220, 302, 333, 335, 341; Staatliche Museen Preussischer Kulturbesitz, Museum für Ostasiatische Kunst, Berlin 52, 189, 205, 222, 276, 356, 415, 498, 559, 576, 593, 627, 674, 728, 744, 746, 789, 790; Stadtmuseum, Munich 878b; Städtisches Museum, Flensburg 757; Stadt. Galerie im Lenbachhaus, Munich 748; Stadtbibliothek, Munich 17; State Pushkin Museum of Fine Arts, Moscow 389; Stedelijk Museum, Van Gogh Collection, Amsterdam 162, 163, 167, 168, 298; Tate Gallery, London 345, 771; Alfred R. Stern Collection, New York 1067; Tokyo National Museum 193, 304, 663, 749, 1050; Charles E. Tuttle Co., Rutland, Tokyo 861, 862; Victoria and Albert Museum, London 85, 89, 90, 156, 329, 369, 398, 452, 735, 821, 832, 874; Völkerkundemuseum, Munich 370; David Weill Collection, Paris 42; Welz, Salzburg 1036; Wildenstein, Paris/New York 18, 20, 21, 419; Winzinger Collection, Regensburg 199; L. Wittamer-de-Camps, Brussels 328; Wolf, Karlsruhe 455, 1086; Württembergisches Landesmuseum, Stuttgart 493.

The author and Schuler Verlagsgesellschaft would like to express their thanks to Frau Prof. Dr. Ottilie Thiemann-Stoedtner for making available lithographs after works by Carl Thiemann, and to Dr. Herbert Fux for preparing the captions to the objects from the Museum für angewandte Kunst in Vienna. To Herr Prof. Dr. Franz Winzinger they owe their thanks for giving permission to reproduce the woodcuts from his collection, and indeed to all the collectors and galleries who have given permission to reproduce objects from their collections, and who have been so helpful. They are grateful too to the Galerie Tsura-Ya in Munich for providing the jacket subject.

Select bibliography

Other references to be found in the Notes

Adachi, Barbara, *The Living Treasures of Japan*, illustrated by Michael Foreman and photographed by Peccinotti, Tokyo 1973.
Alcock, Rutherford, *The Capital of the Tycoon: Narrative of a Three Years' Residence in Japan*, New York 1863, repr. New York 1969.
——, *Catalogue of Works of Industry and Art Sent from Japan. International Exhibition*, London 1862.
——, *Art and Art Industries in Japan*, London 1878.
Alexandre, Arsène, 'George Auriol', *Art et Décoration*, 5, June 1899, 161–70.
Allemand, Geneviève, 'Le rôle du Japon dans l'évolution de l'habitation et de son décor en France dans la seconde moitié du XIXè siècle et au début du XXè siècle', diss. Ecole du Louvre 1964. 'L'Art de la poterie en France de Rodin à Dufy', Sèvres, Musée Nationale de Céramique, 1971.
Anderson, William, *A History of Japanese Art*. Transactions of the Asiatic Society. First series, 1874–1922, Tokyo 1879.
——, *Japanese Wood Engravings*, London 1892.
——, *The Pictorial Art of Japan*, London 1886.
André, Edouard, *Alexandre Lunois*, Paris 1914.
Aslin, Elizabeth, 'E. W. Godwin and the Japanese Taste', *Apollo*, Dec. 1962.
Astruc, Zacharie, 'Beaux-Arts: L'Empire du Soleil Levant', *L'Etendard*, Feb. 27 and March 23, 1867.
——, 'Le Japon chez nous', *L'Etendard*, May 26, 1868.
Aubert, Louis, *Les maîtres de l'estampe japonaise*, Paris 1914.
Audsley, George A., *The Ornamental Art of Japan*, London 1882–83.
—— and James L. Bowes, *Ceramic Art of Japan*, London 1875.
Aymer-Bression, Pierre, *Histoire générale de l'Exposition universelle de 1867*, Paris 1868.
Azechi, Utemaro, *Japanese Woodblock Prints, Their Technique and Appreciation*, Tokyo 1963.
Bandmann, Gunter, 'Das Exotische in der europäischen Kunst', *Festschrift Lützeler*, Düsseldorf 1962, 337–54.
Bellecour, P. Duchesne de, 'La Chine et le Japon à l'Exposition universelle', *Revue des deux mondes*, 37, July 1867, 710–32.
Bénédite, Léonce, 'Félix Bracquemond l'Animalier', *Art et Décoration*, 17, Feb. 1905, 35–47.
Béraldi, Henri, *Les Graveurs du dix-neuvième siècle*, Paris 1885–92.
——, *La reliure du XIXe siècle*. 4 vols, Paris 1896.
Bing, S. 'La Gravure japonaise', *L'Estampe et l'Affiche*, 1, April 1897, 38–44.
——, 'L'Art japonais et l'industrie', *Revue des Arts décoratifs*, 8, 1887/8, 851–52.
Blakemore, Frances, *Who's Who in Modern Japanese Prints*, Tokyo 1975.
Bodelsen, Merete, *Gauguin's Ceramics*, London 1964.
——, 'The Missing Link in Gauguin's Cloisonisme', *Gazette des Beaux-Arts*, 53, May–June 1959, 329–44.
Boller, Willy, *Masterpieces of the Japanese Colour Woodcut*, London 1957.
Borrmann, M., *Moderne Keramik*, Leipzig 1901.
Borrmann, Richard, *Moderne Keramik*, Leipzig 1902.
Bouillon, Jean-Paul, 'La Correspondance de Félix Bracquemond, une source inédite pour l'histoire de l'art français dans la seconde moitié du XIXè siècle', *Gazette des Beaux-Arts*, 82, Dec. 1973, 351–86.
Bowes, James, *Japanese Pottery*, Liverpool 1890.
Bowie, Henry P., *On the Laws of Japanese Painting*, San Francisco 1911, repr., New York 1952.
Boyd, Robin, *New Directions in Japanese Architecture*, London 1968.
Breeskin, Adelyn, *The Graphic Work of Mary Cassatt*, New York 1948.
Buhot, Felix, *Japonisme*, Paris 1883.
Burty, Philippe, *Les Emaux cloisonnés anciens et modernes*, Paris 1868.
——, 'Le Musée oriental à l'Union centrale', *Le Rappel*, Oct. 25 and Nov. 2, 1869.
——, 'Exposition Universelle de 1878. Le Japon ancien et le Japon moderne', *L'Art*, 15, 1878, 241 ff.
——, Series in *La Renaissance littéraire et artistique*, 1, Japonisme I, May 1878, 25–26; Japonisme II, June 1872, 59–60; Japonisme III, July 1872, 83–84; Japonisme IV, July 1872, 106–07; Japonisme V, Aug. 1872; 122–23; Japonisme VI, Feb. 1873, 2–5.

——, *Grave Imprudence*, Paris 1882.
——, 'Félix Buhot, Painter and Etcher', *Harper's New Monthly Magazine*, 76, Feb. 1888, 329–36.
——, *Le Japon artiste*, Paris 1887.
——, 'Trois conférences sur la poterie et le porcelaine au Japon', *Revue des Arts Décoratifs*, Jan. 1885.
Cachin, Françoise, 'Le Portrait de Fénéon par Signac: une source inédite', *Revue de l'Art*, No. 6, 1969, 90–91.
Caso, Jacques de, '1861: Hokusai rue Jacob', *The Burlington Magazine*, 111, Sept. 1969, 562–65.
Champfleury, 'Le Mode des Japoniseries', *Le Vie Parisienne*, Nov. 21, 1868, 862–63.
——, *Les Chats*, Paris 1869.
——, *Le Réalisme (Textes choisis et présentés par Geneviève et Jean Lacambre)*, Paris 1973.
Charlevoix, Père de, *Histoire et description générale du Japon*, Paris 1736.
Chassiron, Ch. Gustave de, *Notes sur le Japon, la Chine et l'Inde, 1858–1859–1860*, Paris 1861.
Chesneau, Ernest, *L'Art japonais*, Paris 1869.
——, 'Beaux-Arts: l'Art japonais', *Le Constitutionnel*, Jan. 14, Jan. 22 and Feb. 11, 1868.
——, *Les Nations rivales dans l'art*, Paris 1867.
Chisolm, Lawrence W. and E. Fenollosa, *The Far East and American Culture*, New Haven, London 1963.
Clavery, E., 'Art japonais art européen', *Bulletin de la Société Franco-Japonaise*, 17 Dec. 1909.
Cluzot, Ernest and Ch. Follot, *Histoire du papier peint en France*, Paris 1935.
Cooper, Michael, S. J., ed., *The Southern Barbarians: The First Europeans in Japan*, Tokyo, New York 1971.
Crauzat, E. de, *L'Oeuvre gravé et lithographié de Steinlen*, Paris 1913.
Dalloz, Paul, 'Le Tour du monde au Champ de Mars: au Japon', *Moniteur Universel*, Aug. 5, 1878.
Denis, Maurice, *Théories, 1890 1910*, Paris 1912.
Dorra, Henri and Sheila C. Adkin, 'Seurat's Japonisme', *Gazette des Beaux-Arts*, 73, Feb. 1969, 81–94.
Duranty, Edmond, 'L'Extreme Orient à l'Exposition universelle', *Gazette des Beaux-Arts*, Series 2, 18 Dec. 1878, 1011–48.
——, 'Japonisme', *La Vie Moderne* (June 26, 1879), 178–80.
Duret, Théodore, *Voyage en Asie: le Japon, la Chine, la Mongolie, Java, Ceylan, l'Inde*, Paris 1874.
——, 'L'Art japonais – les livre illustrés, les albums imprimés, Hokusai', *Gazette des Beaux-Arts*, Aug. 1882.
——, *La Critique d'avant garde*, Paris, 1885.
——, *Whistler*, Paris 1911.
——, 'L'Art japonais', *Gazette des Beaux-Arts*. Series 2, 36, Aug. 1882, 113–33.
Elisseeff, V., 'Tokyo Symposium on Fine Arts', *Artasia*, 2, Spring 1966, 43–47
Faillié, J. B. de la, 'Een merkwaardig zelfportret van Vincent van Gogh', *Phoenix* 3, 1948, 215.
Fenollosa, Ernest, *Epochs of Chinese and Japanese Art: An Outline History of East Asiatic Design*. Ed. McNeil Fenollosa, 1911. Rev. ed., New York 1913; paperback, New York 1963.
——, *Hiroshige: The Artist of Mist, Snow and Rain*, New York 1901
——, *The Masters of Ukiyo-e*, New York 1896.
Fischel, Lilli, 'Von der Bildform der französischen Impressionisten', *Jahrbuch der Berliner Museen, Jahrbuch der Preussischen Kunstsammlungen*, Neue Folge, 15, Berlin 1973.
Focillon, Henri, 'L'estampe japonaise et la peinture en Occident dans la 2ème moitié du XIXè siècle', *Actes du Congrès international d'Histoire de l'Art*, Paris 1921; Paris 1923, I, 367 ff.
French, Calvin L., *Shiba Kokan – Artist, Innovator and Pioneer in the Westernization of Japan*, Tokyo 1974.
Frigerio, Simone, 'L'influence japonaise dans la peinture occidentale', *Aujourd'hui, Art et Architecture*, Jan. 1964.
Goncourt, Edmond and Jules de, *Manette Salomon*, Paris 1867.
Goncourt, Edmond de, *Hokusai*, Paris 1896.
——, *La Maison d'un artiste*, Paris 1881.
Graff, C., 'Der anglo-japanische Stil des 19. Jahrhunderts', *Österreichische Monatsschrift für den Orient*, XI, 1885, 39, 41.
Graul, Richard, *Die Krisis im Kunstgewerbe*, Leipzig 1901.
Guerrand, Robert H., *L'Art Nouveau en Europe*, Paris 1965.
Guimet, Emile, *Promenade japonaise*, Paris 1878.

——, *Rapport au Ministre de l'Instruction Publique et des Beaux-Arts sur la Mission Scientifique de M. Emile Guimet dans l'Extrême Orient*, Lyons 1877.
Hacker, Inge, 'Die künstlerischen Beziehungen zwischen Japan und der westlichen Welt seit der Mitte des 19. Jahrhunderts', *Saeculum*, 16, 1965, 283–95.
Haga, Toru, *Taikum no shisetsu* (Ambassadors of the tycoon), Tokyo 1968.
Harada, Minoru, *Meiji Western Painting*, trans. Akiko Murata, Arts of Japan Series, Vol. 6. Adapted from the Japanese-language series, *Nihon no Bijutsu*, Tokyo, New York 1928.
Harbron, D., *The Conscious Stone. The Life of Edward William Godwin*, London 1949.
Hayashi, Tadamasa, 'Le Japon', *Paris Illustré*, 1 May 1886.
Hillier, J., *The Uninhibited Brush. Japanese Art in the Shijo Style*, London, 1974.
Houelaque, E., 'Les Arts à l'Exposition Universelle de 1900: L'Exposition rétrospective du Japon', *Gazette des Beaux-Arts*, June 1900, Jan. 1901.
Humbert, Aimé, *Le Japon illustré*, Paris 1870.
Ikegami, Chuiji, *Paul Gauguin to Nihon kaiga* (Paul Gauguin and Japanese pictorial art; Gauguin and the popularity of things Japanese in France). *Bijutsushi*, 17, 1967, 1–17.
——, 'Ukiyo-e and Impressionism', *Fuzoku-ga to Ukiyo-e-shi* (Genre paintings and masters of ukiyo-e), ed. Yuzo Yamane, Tokyo 1971, 206–13.
——, 'Le Japonisme de Félix Bracquemond en 1866', *Kenkyu*, 1969, 30–62.
Jacquemart, Albert, 'Les Laques: le Japon va-t-il nous être ouvert?', *Gazette des Beaux-Arts*, Nov./Dec. 1859.
Jacques, Bertha E., 'An Artist's Home in Japan: How Helen Hyde has modified an Eastern Environment to meet Western needs in its own way', *The Craftsman*, 4, Nov. 1908, 186–91.
Japan, *A Guide to Japanese Architecture*. Rev. ed. Tokyo 1975.
Japanese National Commission for UNESCO (ed.), *Collection of the Papers Presented at the International Symposium on the History of Eastern and Western Cultural Contact, 1957*, Tokyo 1959.
——, *International Round Table on the Relations between Japanese and Western Arts, Sept. 1968 in Tokyo and Kyōto*, Tokyo 1969.
Joosten, E., 'Het rijke begrip invloed', *Museumsjournaal*, 5, 1959–60, 73–76.
Kanda, Takao, 'Nihon shumi no tansho to kore ni taisuru Nihon no hanno' (The start of Japonisme and the reaction to it in Japan), *Hikaku bunka kenkyu*, 3, Tokyo 1962.
Karsham, Donald H., and Donna M. Stein, *L'Estampe Originale. A Catalogue Raisonné*, New York 1970.
Kawakita, Michiaki, *Modern Currents in Japanese Art*. Trans. and adapt. Charles Terry. *The Heibonsha Survey of Japanese Art Series*, 24, Tokyo 1974.
Kobayashi, Hideo and Pierre Alechinsky, 'Japanese Calligraphy and Abstraction', *Graphis*, 2, Nov. 1956, 542 ff.
Kobayashi, Tai'ichiro, 'Nihon-Bijutsu oyobi Inshogaha to Théodore Duret' (Japanese Art, Impressionism and Théodore Duret), *Kokuka*, Nr. 571, 572, Osaka 1946.
——, 'China and France', *Bijutsu-Kogei*, Osaka 1947.
——, *Chosakushu* (Selected Writings), Kyōto 1973–74.
Koch, Robert, 'Art Nouveau Bing', *Gazette des Beaux-Arts*, 53, March 1959, 179–90.
Kodansha International (pub.), *Masterworks of Ukiyo-e*, Tokyo, New York 1968–76.
Koschlin, Raymond, 'Tadamsa Hayashi' (obituary), *Bulletin de la Société Franco-Japonaise*, Dec. 1906.
Kurt, Julius, *Sharaku*, Munich 1910.
——, *Utamaro*, Leipzig 1909.
Lambert, Théodore, *Motifs décoratifs tirés des pochoirs japonais*, Paris, n.d.
Lancaster, Clay, 'Oriental Contributions to Art Nouveau', *Art Bulletin*, XXXIV, 1952, 297–310.
——, *Japanese Buildings in the United States before 1900*', *Art Bulletin*, XXXV, 3, 1953.
——, 'Synthesis. The Artistic Theory of Fenollosa and Dow', *Art Journal*, 28, 1969.
Le Japon à l'Exposition Universelle de 1878, Paris 1878.
Lee, Sherman E., *A History of Far Eastern Art*, London 1964.

—, *Japanese Decorative Style*, Cleveland 1961.

Ledoux, Louis *Kokusai Bunka Shinkokei* (Japanese Prints in the Occident), Tokyo 1941.

Leipnik, F. L., *A History of French Etching*, New York 1924.

Lemoisne, R. A., 'Yeishi, Choko, Hokusai', *Gazette des Beaux-Arts*, 1913.

Lessing, Julius, 'Japan und China im europäischen Kunstleben', *Westermanns Monatshefts*, 49, 1881, 383–408.

Loevgren, Sven, *The Genesis of Modernism: Seurat, Gauguin, Van Gogh and French Symbolism in the 1880s*, Bloomington, Ind. 1971.

Lowry, John, 'The Japanese Influence on Victorian Design', 1952 (unpubl.), Victoria and Albert Museum, London.

Marchiori, Giuseppe, 'L'Opera grafica di Toulouse-Lautrec (Degas, Japonisme)', *Scritti Storia Arte, Festschrift L. Venturi*, 2, Rome 1956, 125–30.

Madsen, S. Tschudi, *Sources of Art Nouveau*, Oslo 1956.

—, *Art Nouveau*, London 1967.

Mantz, Paul, 'Exposition retrospective de l'art Japonais', *Gazette des Beaux-Arts*, Series 2, 27 May 1883, 400–10.

Martino, Pierre, *L'Orient dans la littérature française*, Paris 1906.

Marx, Roger, *Les Décorations et l'art industriel à l'exposition universelle de 1889*, Paris 1890.

—, 'Sur le rôle et l'influence des arts de l'Extrême Orient et du Japon', *Le Japon artistique*, 3, 1891, 141–48.

Matsugata, Masuyoshi and Masana Maeda, *Porcelaines et faïences japonaises histoire et fabrication*, Paris 1878.

Merx, Klaus, 'Carl Thiemann, Meister des farbholzschnittes', *Beitrag zur dekorativen Kunst des Jugendstils*, 1976.

Michalski, Ernst, 'Die entwicklungsgeschichtliche Bedeutung des Jugendstils', *Repertorium für Kunstwissenschaft*, 16, 1925, 133–49.

Michener, James A., *The Hokusai Sketch-Books: Selections from the Manga*, Tokyo, Rutland, Vt. 1958.

Migeon, Gaston, *Chefs-d'oeuvre d'art japonais*, Paris 1905.

—, 'La Peinture japonaise au Musée du Louvre', *Revue de l'art ancien et moderne*, March 1898.

Miner, Earl *The Japanese Tradition in British and American Literature*, Princeton 1958.

Montgomery Hyde, H., 'Oscar Wilde and his Architect', *The Architectural Review*, CIX, 1950, 175–76.

Mourey, Gabriel, 'French Wood Engraver: Auguste Lepère', *The Studio*, 12, 1898, 143–55.

Munsterberg, Hugo, 'East and West in Contemporary Japanese Art', *Art Journal*, 18, 1958/59.

Muther, Richard, 'Die japanische Ausstellung der Secession', *Studien und Kritiken*, I, 1900.

—, *The History of Modern Painting*, Vols 2 and 3, London 1896.

Nakamura, Tanio, *Contemporary Japanese-Style Painting*, transl. and adapt. by Mikio Ito, Tokyo 1969.

Natanson, Thadée, 'Estampes de Outamaro et de Hiroshige exposées dans les Galeries Durand-Ruel', *La Revue blanche*, 16 Feb. 1893.

Noguchi, Isamu, *A Sculptor's World* (autobiography), New York 1968.

Nouët, Noël, *Edmond de Goncourt et les arts japonais*, Tokyo 1959.

Novotny, Fritz, 'Die Bilder van Gogh's nach fremden Vorbildern', *Festschrift Kurt Badt*, Berlin 1961, 213–30.

Okakura, Kakuzo, *The Book of Tea*, New York 1906, repr. 1964.

—, *The Ideals of the East, with Special Reference to the Art of Japan*, London 1903. New edition with an introduction and notes by Hiroshi Muraoka, Tokyo 1940, repr. Tokyo, Rutland, Vt. 1970.

Oliphant, Lawrence, *Narrative of the Earl of Elgin's Mission to China and Japan in the Years 1857–1858–1859*, Edinburgh and London 1859, repr. Hong Kong 1970.

Peterson, Susan, *Shoji Hamada. A Potter's Way and Work*, Tokyo, New York 1974.

Preetorius, Emil, 'Japan und die europäische Kunst des 19. Jahrhunderts', *Universitas*, 2, 1947, 927–31.

Price, C. M., 'Japanese Idealism in Interior Decoration', *Art and Decoration*, 4, April 1914, 216–19.

Ragon, Michel, 'Cent ans d'influence japonaise sur l'art occidental', *Jardin des Arts*, October 1961.

Rappard-Boon, Charlotte van, 'Japonism, the First Years, 1856–1876', *Liber Amicorum, Karel G. Boon*, Amsterdam, 1974, 110–17.

Renan, Ernest, 'La "Mangua de Hokusai"', *La Japon artistique*, 9, 1889, 99ff.

Renan, Ary, 'La "Mangua de Hokusai"', *La Japon artistique*, 8, 1888 and 9, 1889.

Revon, Michel, *Etude sur Hokusai*, Paris 1896.

Roger-Marx, Claude, *Bonnard Lithographie*, Monte Carlo 1952.

—, *Graphic Art: the Nineteenth Century*, New York 1962.

—, *L'Oeuvre gravé de Vuillard*, Monte Carlo 1948.

Rookmaaker, H. R., *Gauguin and Nineteenth Century Art*

Theory, Atlantic Highlands, N.J. 1972.

Roskill, Mark, *Van Gogh, Gauguin, and the Impressionist Circle*, London, Greenwich, Conn. 1970.

Rosny, Léon de, 'L'Empire japonais et les archives de M. de Siebold', *Journal asiatique*, 11.

Russell, John, *Edouard Vuillard, 1868–1940*, London, Greenwich, Conn. 1971.

Sadler, A. L., *A Short History of Japanese Architecture*, Sydney 1941, repr. Tokyo, Rutland, Vt. 1963.

Sandberg, John, 'The discovery of Japanese Prints in the nineteenth century before 1867', *Gazette des Beaux-Arts*, 71, June 1968, 295–302.

Sandblad, Nils Gosta, *Manet, Three Studies in Artistic Conception*, Lund 1954.

Sansom, George, *The Western World and Japan*, New York 1950.

Satow, Sir Ernest, *A Diplomat in Japan*, London 1921, repr. Tokyo, Oxford, in *Asia Historical Reprints*, 1968.

Saunier, Charles, *A. Lepère, 1849–1918*, Paris 1931.

Schapiro, Meyer, *Van Gogh*, New York 1950.

Scheyer, Ernst, 'Far Eastern Art and French Impressionism', *Art Quarterly*, VI, 1943, 116–43.

Schmutzler, Robert, *Art Nouveau*, New York 1964.

Schneider, Pierre, *The World of Manet*, New York 1968.

Schwartz, William Leonard, 'The Priority of the Goncourts' Discovery of Japanese Art', *Publications of the Modern Language Association of America*, 42. Sept. 1927, 798–806.

—, *The Imaginative Interpretation of the Far East in Modern French Literature*, Paris 1927.

Seidelitz, W., *A History of Japanese Colour-Prints*, London 1910.

Seitz, William C., *Claude Monet*, New York 1960.

Shapiro, Barbara S., *Camille Pissarro. The Impressionist Printmaker*, Boston 1973.

—, *Edgar Degas – The Reluctant Impressionist*, Boston 1974.

Shaw, Wilfried B., 'The Relation of Modern American Art to That of China and Japan: Demonstrated at the Recent Exhibition at Ann Arbor', *The Craftsman*, 18, Aug. 1910, 522–30.

Shibusawa, Ei'ichi, *Shibusawa Ei'ichi taifutsu nikki* (Shibusawa's diary – the shogunal mission to France from 1867 to 1868), Tokyo 1928.

Shinoda, Yūjirō, 'Degas. Der Einzug des Japanischen in die französische Malerei', diss. Cologne 1957.

Spiteris, T., 'Influence of Japanese Prints on French Painting', *Artasia*, Spring 1967, II, 1, 19–22.

Statler, Oliver, *Modern Japanese Prints. An Art Reborn*, Tokyo, Rutland, Vt 1956.

Steinlen, Théophile Alexandre, *Des Chats, dessin sans paroles*, Paris, n.d.

Stern, Harold P., *Master Prints of Japan*, New York 1969.

Stevens, Alfred, *Impressions on Painting*, New York 1891.

Strange, Edward F., *History of Wood-Engravings*, London 1897.

—, *Japanese Colour Prints*, London 1904.

—, 'Influences in European Art', *The Colour-Print of Japan*, New York 1906, 72–79.

—, *The Colour-Prints of Hiroshige*, London 1925.

Sullivan, Michael, *The Meeting of Eastern and Western Art from the Sixteenth Century to the Present Day*, Greenwich, Conn, London 1963.

Sutton, Denys, 'Cathay, Nirvana and Zen', *Apollo*, Aug. 1966.

Takahashi, Kunitaro, 'Shonen shisetsu akitake o megurite' (Special envoy of the Tokugawa shogunate to the International Exhibition of Paris in 1867), *Kikusai bunka*, 143–55 (except No. 147), 1966.

—, 'Takashima Hokkai to Art Nouveau', *Hoshum*, 239, Jan. 1975, 12–16.

Takahashi, Seiichiro, *Traditional Woodblock Prints of Japan*, New York 1972.

Thirion, Yvonne, 'L'influence de l'estampe japonaise dans l'oeuvre de Gauguin', *Gazette des Beaux-Arts*, 47, Jan.–April 1956, 95–114.

—, 'Le Japonisme en France dans la seconde moitié du 19è siècle, ...', *Cahiers de l'Association Internationale des Etudes Françaises*, XII, 1960, 117–30.

Tinchant, Albert, *Sérénités*, illus. by George Auriol. Fau, Poitevin, Henri Rivière, Henry Somm, Steinlen, Paris 1885.

Toudouze, Georges, *Henri Rivière*, Paris 1907.

Uyeno, Naoteru, ed., *Japanese Art and Crafts in the Meiji Era*. English adaption by Richard Lane, *Japanese Culture in the Meiji Era Series*, Vol. 7, prepared under the auspices of the Centenary Culture Council, Tokyo 1958.

Vallotton, Maxime and Charles, Georg, *Félix Vallotton, catalogue raisonné*, Geneva 1972.

Vever, Henri, *La bijouterie française au XIXè siècle*, Paris 1908.

—, 'L'influence de l'art japonais sur l'art decoratif moderne', *Bulletin de la société franco-japonaise de Paris*, 22, June 1911, 109–19.

Weisberg, Gabriel P., 'Félix Bracquemond and Japanese Influence

in Ceramic Decoration', *Art Bulletin*, LI, Sept. 1969, 277–80.

—, 'Samuel Bing: Patron of Art Nouveau', 'Part I: The Appreciation of Japanese Art', *The Connoisseur*, 172, Oct. 1969, 119–25; 'Part II; The Salons of Art Nouveau', 172, Dec. 1969, 294–99, 'Part III: The House of Art Nouveau Bing', 173, Jan. 1970, 61–68.

—, *The Etching Renaissance in France, 1850–1880*, Salt Lake City, Utah 1971.

—, 'Japonisme in French Ceramic Decoration'. 'Part I: The Pieces for E. Rousseau, Paris', *The Connoisseur*, 183, July 1973, 210–13; 'Part II: The Pieces by Camille Moreau and Albert Dammouse', *The Connoisseur*, 184, Oct. 1973, 125–31, 210–13.

—, 'Aspects of Japonisme', *The Bulletin of The Cleveland Museum of Arts*, 42, April 1975, 120–30.

—, 'Les Albums Ukiyo-e de Camille Moreau; Sources nouvelles pour le "Japonisme"', *Nouvelles de l'estampe*, Paris 1975.

Wichmann, Siegfried, 'Edouard Vuillard ein Überwinder des Impressionismus', *Die Kunst* June 1962.

—, 'Malerei des Jugendstils in München', *Die Kunst*, Aug. 1962.

—, 'Die Entwicklung des französischen Glasformers Emile Gallé', *Weltkunst*, Oct. 1963.

—, 'Ferdinand Khnopff: I lock my door upon myself', *Kunstwerke der Welt*, 1964.

—, 'Begegnungen osasiatischer und europäischer Kunsttraditionen in der Malerei und Graphik des 19. Jahrhunderts', *Alte und Moderne Kunst*, Jan. 1974, 51–59.

—, 'Ostasiatische Gefasse aus Halbedelstein und ihre Sockelung als analoger Prozess in der Glaskunst um 1900', *Extrait des Annales du 6è Congrès de L'Association Internationale pour L'Histoire du Verre*, Liège 1975.

Wiegand, Charmion von, 'The Oriental Tradition and Abstract Art', *The World of Abstract Art*, ed. American Abstract Artists, New York 1957, 55–67.

Wiese, E.P., 'Source Problems in Manet's Early Paintings', diss. Harvard 1959.

Wildenstein, G., et al., 'Textes concernant Gauguin', *Gazette des Beaux-Arts*, 98, 6, 47, 1956, 1–211.

Yamada, Chisaburō, 'The Western Challenge and Eastern Response', *Artasia*, II, Spring 1967.

—, *Ukiyo-e to Insho-ha* (Ukiyo-e prints and the Impressionists), Tokyo 1973.

Yanagi, Soetsu, *The Unknown Craftsman. A Japanese Insight into Beauty*, adapt. Bernard Leach, Tokyo, New York 1972.

Exhibitions and catalogues
Listed in chronological order

'Catalogue of Works of Industry and Art Sent from Japan, International Exhibition' by Rutherford Alcock, London 1862.

'Descriptive and Historical Catalogue of a Collection of Japanese and Chinese Paintings in the British Museum' by William Anderson, London, 1866.

'Catalogue de l'exposition universelle de 1867', E. Dentue, Paris, n.d.

'Descriptive Catalogue of Art Works in Japanese Lacquer, Forming the Third Division of the Japanese Collection in the Possession of James L. Bowes' by George A. Audsley, London, 1875.

'Catalogue de l'exposition universelle de 1878', E. Leroux, Paris, 1878.

'Catalogue de l'exposition rétrospective de l'art japonais', Paris, 1883.

'Exposition de la gravure japonaise a l'Ecole Nationale des Beaux-Arts'. Catalogue by Samuel Bing, Paris, 1890.

'Collection Philippe Burty: catalogue de peintures et d'estampes japonaises, de miniatures indo-persanes et de livres relatifs à l'Orient et au Japon', E. Leroux, Paris, 1891.

'Estampes d'Outamaro et de Hiroshige exposées dans les Galeries Durand-Ruel'. Introduction by Samuel Bing, Paris, 1893.

'Collection des Goncourt: arts de l'Extrême-Orient, objets d'art japonais et chinois', Hôtel Drouot, Paris, 1897.

'Catalogue of the Morse Collection of Japanese Pottery', Cambridge, 1901.

'Collection Tadamasa Hayashi' (3 vols), Hôtel Drouot, Paris, 1902–03.

'Collection Charles Gillot: estampes japonaises et livres illustrés' (2 vols), Durand-Ruel, Paris, 1904.

'Collection Pierre Barboutau' (2 vols), Paris, 1904.

'Collection Samuel Bing' (6 vols), Durand-Ruel, Paris, 1906.

'An Illustrated Catalogue of Japanese Old Fine Arts Displayed at the Japan-British Exhibition'. Catalogue edited by the Office of the Imperial Japanese Government Commission to the Japan-British Exhibition, London, Tokyo, 1910.

'Estampes japonaises tirées de collections de MM. Bing, Bonasse, etc. et exposées au Musée des Arts Décoratifs en janvier 1911'. Catalogue by Inada and Vignier, Paris, 1911.

'Catalogue des estampes anciennes et modernes composant la collection Edgar Degas', Paris, 1918.

'Aufbruch zur modernen Kunst', Haus der Kunst, Munich, 1958. With an Art Nouveau section containing Japanese-type objects. Conceived and organized by Siegfried Wichmann.

'Orient-Occident: rencontres et influences durant cinquante siècles d'art', Musée Cernuschi, Paris, Nov. 1958 – Feb. 1959. (Contains a section by Yvonne Thirion on 'La Révélation japonaise en France dans la seconde moitié du XIXème siècle et son influence sur l'art', pp. 92–97.)

'L'Estampe japonaise et les peintres d'Occident', Musée des Augustins, Toulouse, 1960.

'Les Sources du XXe siècle – les arts en Europe de 1884 à 1914', Musée National d'Art Moderne, Paris, Nov. 1960 – Jan. 1961. German section organized by Siegfried Wichmann.

'Secession. Europäische Kunst um die Jahrhundertwende', Haus der Kunst, Munich, 1964. Conceived and organized by Siegfried Wichmann.

'L'Avanguardia: Hans Schmithals', Milan, Rome, 1965. Catalogue by Siegfried Wichmann.

'Der Japonismus in der Malerei und Graphik des 19. Jahrhunderts', Berlin Sept.–Oct. 1965. Organized by Leopold Reidemeister. Catalogue by Leopold Reidemeister.

'Jugendstilsammlung', Staatliche Kunstsammlungen, Kassel, 1968.

'Mutual Influences Between Japanese and Western Arts', National Museum of Modern Art, Tokyo, Sept.–Oct. 1968.

'Internationales Jugendstilglas. Vorformen moderner Kunst', Stuck-Villa, Munich, 1969. Conceived and organized by Siegfried Wichmann. Catalogue by Siegfried Wichmann.

'Internationale Jugendstilobjekte. Glas, Keramik, Porzellan, Metall', Stuck-Villa, Munich, 1969. Catalogue by Siegfried Wichmann.

'Hermann Obrist, Wegbereiter der Moderne', Stuck-Villa, Munich, 1969. Catalogue by Siegfried Wichmann.

'James McNeill Whistler', Nationalgalerie, Berlin, Oct.–Nov. 1969.

'Rencontres franco-japonaises: catalogue de la collection historique réunie sur les rapports de la France et du Japon du XVIIe au XXe siècle', Paris, Osaka, 1970.

'Rimpa – Masterworks of the Japanese Decorative School', The Japan Society, New York, 1971. Catalogue by Harold P. Stern.

'Weltkulturen und moderne Kunst. Die Begegnung der europäischen Kunst und Musik im 19. und 20. Jahrhundert mit Asien, Afrika, Ozeanien, Afro- und Indo-Amerika', Haus der Kunst, Munich, 1972. Catalogue by Siegfried Wichmann.

'Félix et Maria Bracquemond', travelling exhibition': Mortagne, Chartres, May 1968 – Sept. 1972. Catalogue by Jean-Paul Bouillon.

'Art Nouveau – Jugendstil – Nieuwe Kunst', Rijksmuseum, Amsterdam, April–July 1972.

'Art Nouveau – Affiches belges, 1892–1914', Muzeum Plakatu, Warsaw, June 1972.

'Japanischer Farbholzschnitt und Wiener Sezession', Österreichisches Museum für angewandte Kunst, Vienna, 1973.

'Nanban Art: Exhibition from Japanese Collections', Japan House Gallery, New York, 1973.

'Symbolismus', Munich 1973. Catalogue by Siegfried Wichmann.

'Collection Henri Vever: Part I', sale catalogue, Sotheby, Parke, Bernet & Co., London, 26 Mar. 1974.

'Hommage à Félix Bracquemond', Bibliothèque Nationale, Paris, 1974. Catalogue by Jean-Paul Bouillon.

'Félix Bracquemond and the Etching Process: An Exhibition of Prints and Drawings from the John Taylor Arms Collection', John Carroll University, Cleveland, 1974. Organized by Robert H. Getscher.

'The Great Wave: The Influence of Japanese Woodcuts on French Prints', The Metropolitan Museum of Art, New York, 1974. Catalogue by Colta Feller Ives.

'Céramique impressioniste', Ancien Hôtel des Archevêques de Sens, Paris, Dec. 1974 – Feb. 1975.

'Japonisme: Japanese Influence on French Art 1854–1910', travelling exhibition: Cleveland Museum of Art, July–Aug. 1975; Rutgers University Art Gallery, New Brunswick, Oct.–Nov. 1975; Walters Art Gallery, Baltimore, Dec. 1975 – Jan. 1976.

'Konstruktiver Jugendstil', Munich 1977. Catalogue by Siegfried Wichmann.

A note on block books and painters' manuals

Japanese and Chinese publications in block book form (single prints bound up together) are a substantial and indispensable source of material for the study of Far Eastern art. The seventeenth- and eighteenth-century books tend to be considered the most valuable and interesting, but on close examination those of the nineteenth century also turn out to be a treasure-house of art and culture. The nineteenth-century painters' manuals are as valuable as they are little known, and Western scholars have had little access to the later examples (after about 1870). The books are wide-ranging anthologies of art, often augmented with examples of the work of the great masters. They include many otherwise unknown sketches, designs and calligraphic symbols, often organized into themes, as in the present volume. They incorporate, for instance, a comprehensive survey of Japanese heraldic art.

The choice in each block book is wide; they include the newly imported media of copper engraving and etching as well as the woodcut. In about 1900, a Japanese version of 'Art Nouveau' appeared, and the ancient tradition of the woodcut returned to pre-eminence. The resulting books, and those that continued to be produced up to the 1930s, were themselves undervalued in Japan at the time, but their importance was quickly recognized by Europeans, and they became prized collectors' items. Over and over again, one is astounded by the consistent high quality of Japanese colour prints on all themes, which caused much excitement among European painters, draughtsmen and craftsmen.

The following Western artists and art historians are among those known to have been acquainted with Japanese painters' manuals and related publications, and to have used them as models or written about them: Josef Maria Auchentaller, Aubrey Beardsley, Emile Bernard, Siegfried Berndt, William Bradley, Carl Otto Czeschka, Daum brothers, Edgar Degas, Maurice Denis, Georges Fouquet, Eugène Gaillard, Emile Gallé, Vincent van Gogh, Thomas Theodor Heine, Ferdinand Hodler, Josef Hoffmann, Christian Hondard, Walter Klemm, Gustav Klimt, Arnold Krog, Maximilian Kurzweil, René Lalique, Walter Leistikow, Kolo Moser, Alfons Mucha, William Nicholson, Manuel Orazi, Bruno Paul, Odilon Redon, Hans Schmithals, Ferdinand Staeger, Henri Vever, Edouard Vuillard, Franz Wacik, James A. McN. Whistler, Franz von Zülow.

Japonisme and 'Weltkulturen und moderne Kunst'

These numbers indicate parallels between illustrations in this book, and those in the exhibition catalogue 'Weltkulturen und moderne Kunst' (Munich, 1972). A list of contributors will be found in the catalogue after the organizer's introduction.

Numbers refer to the illustrations in this book; those in **bold** type refer to the exhibition catalogue.

5–**J6, p. 324**, 9, 10–**637**, 11–**630**, 6–**644**, 7–**906**, 15–**646**, 22–**648**, 27–**671**, 28–**674**, 32/33–**pp. 202/3**, 44–**663**, 36–**742**, 38–**743**, 64–**652**, 65–**651**, 66–**654**, 67–**653**, 70–**650**, 84–**1759**, 108–**p. 174**, 116–**976**, 183–**720**, 184–**723**, 185–**724**, 186–**729**, 208–**731**, 209–**730**, 308–**866**, 310–**857**, 311–**858**, 312–**869**, 313–**861**, 315–**p. 258**, 321–**854**, 331–**871**, 343–**684**, 344–**686**, 345–**685**, 350–**691**, 353–**693**, 366–**694**, 370–**714**, 371–**p. 212**, 373–**696**, 367–**710**, 368–**697**, 369–**698**, 379–**1013**, 391–**700**, 397–**p. 252**, 395–**829**, 401–**834**, 403–**J3 p. 322**, 404–**J1 p. 320**, 406–**835**, 414–**821**, 415–**822**, 425–**826/28**, 438–**844**, 450–**836**, 508–**1080**, 509–**1089**, 549–**p. 181**, 548–**917**, 547–**p. 167**, 555–**J6 321**, 570–**904**, 566–**902**, 574–**734**, 575–**735**, 572–**733**, 573–**732**, 576–**754**, 577–**753**, 578–**746**, 593–**776**, 594–**773**, 608–**758**, 611–**762**, 612–**761**, 629–**755**, 630–**756**, 650–**807**, 646–**744**, 661–**808**, 659–**809**, 660–**947**, 679–**760**, 709–**892**, 711–**885**, 714–**979**, 715–**983**, 716–**983**, 723–**994**, 724–**992**, 718–**1010**, 721–**1008**, 727–**1004**, 734–**1033**, 738–**1032**, 736–**1034**, 742–**1019**, 743–**1018**, 748–**1023**, 746–**1029**, 747–**1028**, 751–**856**, 752–**855**, 775–**748**, 827–**1199**, 828–**1197**, 829–**1196**, 839–**1191**, 840–**1210**, 841–**1209**, 854–**1421**, 855–**1420**, 878a–**1246**, 878b–**1247**, 917–**1166**, 918–**1166a**, 914–**1177**, 915–**1176**, 923–**1506**, 924–**1505**, 925–**1343**, 926–**1512**, 927–**1511**, 951/2–**p. 361**, 980–**1313**, 1041–**947**, 1042–**p. 325**, 1056–**p. 326**, 1091–**1612**, 1092–**1620**, 1093–**1671** (Oto Bihalji-Merin-Schneckenburger), 1094–**1667**, 1095–**1646** (Prof. M. Schneckenburger), 1099–**1596**, 1082–**1637**, 1101–**1589**, 1103–**1630**, 1078–**1635**.

Artists' biographies

This alphabetical list also includes a number of manufacturing firms.

Adrion, Lucien Strasbourg 1889 – 1953
Landscape painter. Resident in Paris. Member of 'Mai' group. Influenced by Utrillo and Le Douanier Rousseau.

Akaba, Untei Genjiro Tokyo 1912 – Tokyo 1975
From the early age of fifteen Akaba devoted himself to calligraphy. Received awards 1948, 1951, 1952. Member of Nitten Society for the Furtherance of Calligraphy; became President 1959. Received the Great Japanese National Award 1961. Important retrospective at Takashiaya's 1968. Works shown at exhibition 'Weltkulturen und moderne Kunst', Munich 1972.

Alechinsky, Pierre Brussels 1927
Painter. Resident in Paris. Student at Ecole Nationale Supérieure d'Architecture et d'Arts Décoratifs, Brussels, then under Stanley Hayter, Paris. Member of 'Cobra' group 1948. Visited Japan 1955. Studied Japanese calligraphy, and made a film about it.

Andri, Ferdinand Waidhofen an der Ybbs 1871 – Vienna 1956
Painter and graphic artist. Student at Akademie, Vienna, then under Kaspar Ritter and Claus Meyer in Karlsruhe. Member of Vienna Secession 1899–1909; President 1905. Professor at Akademie, Vienna, from 1919. During World War I at the front as war artist. Received Waldmüller prize 1944.

Anker, Albert Ins-Anet (Berne canton) 1831 – Ins 1910
Painter. Student of Protestant theology in Berne and Halle, then of painting under Charles Gleyre, Paris, and later at Ecole des Beaux-Arts. Worked for a while at the factory of Théodore Deck. Later a landscape genre painter, an accurate portrayer of milieu and one of the most important representatives of Swiss painting from the mid 19th century to the early 20th century.

Anker, Hans Berlin 1873 – Hanover 1950
Painter and graphic artist. Student at Unterrichtsanstalt des Kunstgewerbemuseums and at Akademie, Berlin, then under J. P. Laurens at Académie Julien, Paris. Also worked as illustrator and commercial artist. Pursued decorative style influenced by Bernard's *cloisonnisme*, after 1900.

Appel, Karel Amsterdam 1921
Painter. Student in Amsterdam 1940–43. First exhibition, 1946. Co-founder of 'Reflex' group, Holland, 1948, and of 'Cobra'. Resident in Paris after 1950. Appel's point of departure is graphic Expressionism: powerful brush marks are intensified by the symbolic content. Flowing ridges of paint are combined calligraphically with figurative forms.

Arsale (Arsal)
This trade mark, of the glassworks of St Louis (Münzthal bei Lamberg, Alsace-Lorraine), was used repeatedly between 1894 and 1907. Crystal and flashed glass of the Nancy type was produced here. Products were mass-produced from early on. After 1900, its ware sometimes bore the monogram SL, or was signed 'd'Argental', often with the Cross of Lorraine.

Atmer de Reig, Christine Hamburg 1935
Potter. Experimented in glazes after the Chinese chien-yao. Produced lavender-blue copper glazes characteristic of Sung pottery. Later she used monochrome glazes favoured by Ch'ing artists, and ox-blood glazes. Pupil of Jan Boutjes van Beek. Own workshop, Hubbelrath (near Düsseldorf).

Auchentaller, Josef Maria Vienna 1865 – Grado 1949
Austrian painter and designer. Student at Akademie, Vienna. Produced a variety of outstanding designs for arts and crafts and was responsible for decorative details of the Vienna Secession exhibitions. Illustrations influenced by Japanese colour prints and dyers' paper stencils.

Bandell, Eugénie L. Frankfurt a.M. 1863 – Frankfurt a.M. 1918
Landscape painter and graphic artist. Pupil of G. Cornicelius, B. Mannfeld and W. Trübner. Exhibited in Munich and with Berlin Secession. Simplified flat areas in illustrations derive from Japanese block books. She was familiar with Far Eastern silhouette techniques.

Beardsley, Aubrey Brighton 1872 – Menton 1898
Self-taught and influenced by Pre-Raphaelites and Japanese prints. Pursued own individual black and white style which greatly influenced book illustration and Art Nouveau movement. Illustrations for Wilde's *Salome*, for *Volpone* and *Lysistrata*.

Beckerath, Willy von Krefeld 1868 – Irschenhausen im Isartal 1938
Painter and designer. Student at Akademie, Düsseldorf. Active in Düsseldorf, in Munich at the Deutsche Werkstätten für Handwerkkunst and in Hamburg at the Kunstgewerbliche Lehranstalt (Gewerbemuseum) after 1907. Graphic art shows involvement with ornamental areas and configuration of objects. Influenced by Japanese block books and colour prints.

Beek, Jan Boutjes van Vejle, Jutland 1899 – Berlin 1969
Potter. Apprenticed to Valentin Frank, Undenheim, Rhine, 1919.

Studio in Fischerhude 1922–32. Studied at Professor H. Seger's Chemisches Laboratorium für Tonindustrie, Berlin, 1923. Own workshop, Berlin-Charlottenburg, 1932. Director of Hochschule für angewandte Kunst, Berlin-Weissensee, 1946–50; Director of Werkkunstschule, Berlin-Charlottenburg, 1953–60; Professor at Hochschule für Bildende Künste, Hamburg 1960–66. Member of Kunstakademie, Hamburg, Berlin and Geneva. Resident in Berlin again after 1965.

Behrens, Peter Hamburg 1868 – Berlin 1940
Architect, versatile designer, painter, graphic artist and writer of theoretical works. Resident in Munich after 1890. Co-founder of Munich Secession 1893. Called to Darmstadt and appointed Professor there 1903. His creative field changed constantly: from painting, through decorative arts to architecture.

Berlin Königliche Porzellanmanufaktur
Brought under royal control by Friedrich II in 1783. Artistic director in 2nd half 19c. the painter Alexander Kips. Schmuz-Baudiss joined staff 1902, Director 1908–26, introduced *pâte-sur-pâte* technique. Experimental chemical laboratory founded 1878. Discoveries under direction of Hermann Seger, Seger porcelain, china red and Celadon glazes, under Albert Heinecke, 1888–1914, crystalline glaze.

Bernard, Emile Lille 1868 – Paris 1941
Pupil of Cormon 1885. Met Van Gogh and Gauguin 1886; worked with them in Pont-Aven. Editor of periodical *La Rénovation esthétique*. Visited Italy, Spain and the East. Developed *cloisonnisme*, a method of dividing up pictures with contour lines separating the colour patches, reminiscent of medieval *cloisonné* enamel.

Berndt, Siegfried Gorlitz 1880 – Dresden 1946
Landscape painter and graphic artist in Dresden. Pupil of Eugen Bracht. Visited Scotland, Italy, USA and Far East, including Japan. Continued his studies in Paris. Inspired by Japanese prints, c.1900, and worked from Japanese pattern books.

Bernischke, Max Schönberg 1879
Goldsmith. Pupil of J. Hoffmann at Kunstgewerbeschule, Vienna 1899–1900. Active in Breslau 1923. Received commissions from Trebnitz and Leubus monasteries. Made chalices for Kreuzkirche in Breslau.

Beyerlein, Karl 1869–1928
Goldsmith. Worked in Eduard Schöpflich's Munich workshop for modern jewellery, decorative and functional objects. Wedding chalices for Prince Rupert of Bavaria. Influenced by Japanese pattern books.

Bigot, Alexandre Mer (Loire-et-Cher) 1862 – Paris 1927
Pupil of minerologist Friedel. Professor of Physics and Chemistry, Paris. Turned to the successful production of flambé and crystalline glazes for stoneware. Glazed stoneware shown in Salon of Société Nationale des Beaux-Arts. Later he produced innovatory crystallization effects (Heuser); decorated sculpture. Acquainted with dealer S. Bing, Paris.

Bing & Grøndahl
Porcelain factory. Founded 1853, for private use of the potters Frederik Grøndahl and brothers, M. Ludwig and J. Harald Bing. J. F. Willumsen, painter, Artistic Director 1897 – 1904.

Bissier, Julius Freiburg im Breisgau 1893 – Ascona 1965
Painter and graphic artist. Student at Kunstakademie, Karlsruhe, 1914. Self-taught after war service 1914–18. Friendship with Ernst Grosse (Orientalist) 1927, and introduced to Far Eastern art. Taught at Freiburg university 1929–33. Went over to abstract painting 1929. Early works destroyed in university fire 1934. Worked almost exclusively in wash 1932–47, monotypes and woodcuts 1947–51; egg and oil tempera 1955–65. Resident at Hagnau, Lake Constance 1939; Ascona from 1961. Member of Akademie der Künste, Berlin, and Honorary Member of Akademie der Künste, Nuremberg.

Bonnard, Pierre Fontenay-aux-Roses 1867 – Le Cannet, Cannes 1947
Student at Académie Julien, Paris, with Vuillard and Roussel. Familiar with works by Manet, Cézanne and Degas. Belonged to Nabis group, and was nicknamed 'Nabis très japonard'. Joined Indépendants 1895. Strongly influenced by Japanese colour prints.

Bourke-White, Margaret USA 1904 – 1971
Artist and photographer. Large spatial projects. Influenced by Christo. Her action art, 'The Great Rake of God', is a super-dimensional configuration of objects which has some geometric abstractions drawn into it. With this she fills a particular role within land art.

Boutet de Monvel, Charles Paris 1855
Painter and jeweller. Student at Ecole des Beaux-Arts, Paris

1893–96. Made cast and hammered silver jewellery decorated with motifs from plant life; frequent use of animals as part of total decoration. Found inspiration in Japanese sword guards and dyers' paper stencils.

Bouvier, Laurent Vinay 1840 – Saint-Geoire 1901
Painter and potter. In Paris from 1861, resident later at Saint-Marcellin. Contributed regularly to Paris Salon 1866–76. Went over almost exclusively to pottery 1877; produced vessels from own designs and was influenced by Japanese and Persian models.

Bradley, William H. Boston, Mass. 1868 – Lamesa, Texas 1962
American illustrator and poster maker. Contributed to periodical *Pan*, Berlin 1895–97. Artistic Director of *Collier's Magazine* 1907–09. Influenced by Beardsley. Took as his model Japanese black silhouette techniques and was familiar with dyers' paper stencils, which he adapted for poster illustration.

Brauchitsch, Margarete von d. 1957
Pupil of Hermann Obrist, Debschitz Schule, Munich. Graphic artist and embroiderer. Worked in Munich. Founder member of Vereinigte Werkstätten für Kunst in Handwerk, Munich. Colleague of Obrist and Henry van de Velde.

Brown-Westhead, Moore & Co.
Ceramics factory, Cauldon Place, Hanley, Staffs. Founded 1862. Produced pottery and porcelain. First international exhibition, Vienna, 1873; later exhibited in Paris, 1878, and Chicago, 1893. Porcelain decorated in a modern style in gold, silver or one colour. The company closed in 1904. A successor firm existed in Stoke-on-Trent under the name Cauldon Potteries Ltd, from 1920. Production ceased in 1962.

Buhot, Félix Valognes 1847 – Paris 1898
Painter and graphic artist. Contributed etchings and watercolours to Salons. Went over later to print-making; numerous maritime etchings and illustrated books. Owned innumerable Japanese pattern books.

Bunchô, Mori, see Ippitsusai Bunchô

Burns, Robert Edinburgh 1869 – London 1928
Scottish figure and portrait painter. Student in Paris 1890–92. After his return to Edinburgh exhibited in Royal Scottish Academy from 1892; became member 1902. Contributed to international exhibition, Venice, 1901, and to Glaspalast exhibition, Munich, 1908. While tending towards archaism, he showed talent for ornamental arrangement.

Burns, Robert Clayton b.1916
American painter and designer.

Busz, Ralf b. 1939
Potter. Taught in Ankara. Active at Staatliche Werk-Akademie, Kassel (now Hochschule für Bildende Künste). Important for his oil-spot glazes. Influenced by Chinese chien-yao techniques.

Carder, Frederick Brockmoor 1864 – Corning, New York 1963
Glass technician and designer. Co-founder with Thomas G. Hawkes of Steuben Glass Works, Corning, N.Y., 1903. Like Tiffany, he mastered various iridescent processes; influenced by objects of antiquity. Experimented with Chinese glass-making techniques and adopted some forms of Far Eastern jade works.

Carriès, Jean-Joseph Lyons 1855 – Paris 1894
Pupil of sculptor, A. Dumont, Ecole des Beaux-Arts, Paris 1874, then self-taught. First acquainted with Japanese stoneware, international exhibition, Paris. Founded large pottery in Saint-Amand-en-Puisaye and purchased the Château de Monriveau, Nièvre, as a second studio. Exhibited successfully at international exhibition, Paris 1889; sensational reception at Salon of Société Nationale des Beaux-Arts 1892. Pottery bequeathed to his friend, Georges Hoentschel.

Cassatt, Mary Pittsburg, Pa., 1845 – Le Mesnil-Theribus 1927
Painter and graphic artist. Student at academy, Philadelphia, then in Europe. Settled in Paris 1875. Pupil of Degas. Worked in oil and pastel; dry-point and colour etching. Very familiar with Japanese printing techniques and used them in her printing.

Chagall, Marc Vitebsk 1887
Russian painter, sculptor and potter. Resident in Russia until 1910. Residence in Paris 1910–14. Short Cubist period under influence of Léger, turned to mystical Symbolism. Resident at Vitebsk 1914–18; in Paris again after 1918, and in USA after 1941.

Chang, Hung 1577 – after 1668
Chinese landscape painter. Style at first 'unrestrained'. Went over to finely balanced compositions with contrasts of light and dark, and later to graduated ink tones with large blank spaces.

Chaplet, Ernst Paris 1835 – Choisy-le-Roi 1909
Porcelain painter. Trained at Sèvres; worked at Laurin factory, Bourg-la-Reine 1856. Invented Barbotine process, 1871–72. Entered Haviland's studio, Paris-Auteuil 1874. First success with

re-creation of Chinese ox-blood glazes, 1883–84. Haviland made over studio in rue Blomet to Chaplet 1885. Worked with Gauguin. Studio and Chaplet's formulae (except that for ox-blood glaze) sold to A. Delaherche 1886. Afterwards regularly attended Salon of Société Nationale des Beaux-Arts, Paris. Went blind 1905.

Chen, Huan Sutachou c.1600
Chinese painter who maintained tradition of early Ming Wu School.

Chéret, Jules Paris 1836 – Nice 1932
Painter and lithographer. After great success with poster designs, founded own printing works 1866, where he was the first to produce three-colour posters in yellow, red and blue. Later designed lithographs for posters. Important works include poster designs for *Pan, Le Petit Faust*, Moulin Rouge, and the dancer Loïe Fuller. Also produced decorative paintings and designs for tapestries. Favoured methods of Japanese wood engravers.

Chillida, Eduardo San Sebastián 1924
Sculptor. Resident at Hernani, Spanish Basque country. Studied architecture, Madrid 1943–47; turned to sculpture 1947. Resident in Paris for three years, then returned to Hernani. Worked mainly in iron and stone. First sculpture prize, Biennale, Venice 1958. Fusion of geometric and expressive elements of construction.

Christiansen, Hans Flensburg 1866 – Wiesbaden 1945
Painter, graphic artist and designer. Apprenticed in Hamburg and student at Kunstgewerbeschule, Munich and at Académie Julian, Paris, after 1895. Invited to artists' colony in Darmstadt 1899. Resident in Paris again after 1902. Worked mainly as painter and graphic artist. Published *Neue Flachornamente*. Craft objects date from time spent in Darmstadt. Choice of themes and methods influenced by Japanese colour prints.

Chudant, Jean Adolphe Besançon 1860 – Paris 1932
Painter. Studied with Paul J. Blanc, Paris. Visited Italy, Spain, N. Africa, Germany, Russia and Far East. His style a combination of Neo-Impressionistic dots of colour and homogeneous areas of colour after Bernard.

Clarke, Harry Dublin 1889 – Switzerland 1931
Apprenticed to an architect, then entered and successfully ran father's stained glass workshop; won several gold medals. Illustrated Poe, Andersen and Perrault; designed textiles.

Combaz, Ghisbert Antwerp 1869
Painter, graphic artist and designer. First active as an amateur while practising as a barrister. Showed landscapes in Société des Hydrophiles and at exhibitions of La Libre Esthétique. Later devoted himself exclusively to designs for tiles, embroidery, interior decoration and posters. Used Japanese painters' manuals and experimented in Japanese colour prints.

Copenhagen Kongelike Danske Porselaine Fabrik
Under state control from 1799; privately owned from 1849 but kept name 'Royal'. Merged with Amuminia pottery 1882; bought by Philip Schou 1884. Arnold Krog appointed director 1885. F. Dalgas director after 1902. First typically Danish piece with underglaze painting of Japanese motifs 1886.

Le Corbusier (Charles Edouard Jeanneret) La Chaux-de-Fonds 1887 – Roquebrune-Cap Martin, 1965
Architect and painter. Resident in Paris from 1917. Pupil of Josef Hoffmann, Vienna and Peter Behrens, Berlin. With his cousin, Pierre, created a new kind of house. Designs for pilgrimage church, Notre-Dame-du-Haut, near Ronchamps 1952–55; important for modern church-building. Influenced by screen systems in Japanese architecture.

Czeschka, Carl Otto Vienna 1878 – Hamburg 1960
Designer, graphic artist and painter. Pupil of Christian Griepenkerl at Akademie, Vienna. Professor at Kunstgewerbeschule, Vienna 1902–08. Member of Klimt group and co-founder of Wiener Werkstätte. Professor at Kunstgewerbeschule, Hamburg after 1908. Collected non-European art; besides sword guards and dyers' paper stencils, had a large collection of prints. Collection of African art has been preserved in part.

Dalpayrat, Adrien Pierre Limoges 1844 – Paris 1910
Potter. Worked with Alphonse Voisin-Delacroix and with Adèle Lesbros after 1893, with whom he shared a studio in Bourg-la-Reine (Dalpayrat & Lesbros). Well known for stoneware vessels with *flambé* and coloured *art-de-feu* glazes. Executed vessels from designs with sculptor Maurice Dufrène. Exhibited successfully in Berlin, Budapest and at international exhibition, Paris 1900; contact with other Parisian sculptors was assured. Samuel Bing dealt in his work. Separation from Adèle Lesbros between 1902 and 1905. Last exhibition at Salon d'Automne, 1910.

Dammouse, Albert Louis Paris 1848 – Sèvres 1926
Sculptor and potter. Pupil of Jouffroy; later active in studio of Solon Miles. Used *art-de-feu* glaze. Began to decorate porcelain 1870; produced mostly stoneware after 1882. In late years *pâte-de-verre* glass.

Daum Frères
French glassworks in Nancy. Founded c.1875 by Jean Daum

(1825–85). Brothers Jean-Louis Auguste (1853–1909) and Antonin (1864–1930) inherited the factory and changed production to Art Nouveau glass c.1890. Their studios, La Verrerie de Nancy, founded 1891. Exhibited in Chicago 1893, and at international exhibition, Paris 1900. Distinctiveness lies in small-lot production. Etched glass has innumerable variations; remarkable forms have been achieved by chemical means and by hand. Noteworthy is the technique of re-melting powdered glass (*pâte-de-verre*).

Deck, Théodore Guebwiller 1823 – Sèvres 1891
Served apprenticeship at stove factory, Hugelin, Strasbourg. Travelled through Germany to Vienna; later visited Hungary, Prague, Berlin, Hamburg and Düsseldorf. Settled in Paris as stove manufacturer 1847. The 'Exposition des Arts Industials' 1861, and the exhibition of 1878, both in Paris, established his reputation as a potter. Director of Sèvres manufactory 1887. Reintroduced Celadon ware at international exhibition 1889. Own productions. Imitated Turkish and later Chinese and Japanese wares.

Decoeur, Emile Paris 1876 – Fontenay-aux-Roses 1953
Porcelain and faience artist. Received bronze medal at international exhibition 1900. Robustly fashioned vessel bodies, with floral decorations in relief. Moved to Fontenay-aux-Roses. Took part in almost every stage of the process. Bowls, plates, jugs, vases, etc. reveal fine, colourful decoration, partly in faience and partly flashed with metallic lustres. Exhibited frequently at Salons. Late work decorated in abstract styles; enamelled surfaces and structured glazes were his hallmark. Invented new ceramic substance 1927. Active at Sèvres manufactory 1939.

Degas, Edgar Paris 1834 – Paris 1917
Pupil of Lamothe at Ecole des Beaux-Arts. Admired Ingres and old masters; painted history pictures. Met Manet and other Impressionists 1865; paintings of ballet, theatre and racing after 1872. Absorbed graphic qualities and composition of Japanese prints. As draughtsman influenced by Impressionists.

Delaherche, Auguste Beauvais 1875 – Paris 1940
Potter. Student at Ecole des Arts Décoratifs, Paris, 1877–82. Pursued pottery after 1883. Took over E. Chaplet's studio, rue Blomet, Paris 1886. Gold medal for stoneware, international exhibition, Paris 1889. Moved to Armentières, near Beauvais 1894. Grand Prix, international exhibition, Paris 1900. Also produced architectural decorations and tiles. First experiments with porcelain-like substance as *pâte rapportée* on stoneware as early as 1895. True porcelain only after 1900.

De Morgan, William London 1832 – 1917
Student at Royal Academy. Painter. Founder and owner of pottery studio connected with Morris group. Sought inspiration from Damascene techniques; revived Persian lustre techniques of Persians (Kashan, Ragy, Gurgan) and was influenced by Hispano-Moorish art. Noteworthy are decorative tiles combining floralism, Victorian and Islamic styles.

Denis, Maurice Granville 1870 – Saint-Germain-en-Laye 1943
Student at Académie Julien, Paris 1888; joined Bonnard, Vuillard, Sérusier in Symbolist group. Shared studio with Bonnard and Vuillard. First visit to Italy 1895; with Gide in Rome 1897. Influenced by Gauguin early 1890s. Commissions from the Church after 1894. Interest in Buddhism and Japanese art.

Despret, Georges 1862–1952
Director of Jeumont glassworks from 1884. Development of *pâte-de-verre* for hollow glass after 1890, which was first shown at international exhibition, Paris 1900. Worked with many glass artists. Extension of glassworks; but entire works destroyed in World War I; rebuilt in 1920s and closed 1937.

Dibbets, Jan (Gerardus Johannes Maria) Weert 1941
Studied at Academy, Tilburg, 1959–63 and at St Martin's School of Art, London, 1967. Founded international institute for re-education of artists, Amsterdam 1967. Contribution to Venice Biennale 1972.

Doat, Taxile Albi 1851 – after 1914
Joined Sèvres manufactory, 1877, after study at Ecole des Arts Décoratifs, Limoges, and (like Carriès) with sculptor, A. Dumont at Ecole des Beaux-Arts, Paris. Own studio, Paris, without giving up work at state-run Sèvres manufactory. Moved his studio to Sèvres 1898. Resigned from Sèvres to work on his own 1905. Took up post at University City, St Louis, Mo., 1909. With Solon and Dammouse, was an important exponent of *pâte-sur-pâte* decoration used almost exclusively on porcelain with fire-proof colours or coloured glazes.

Dongen, Kees van Delfshaven 1877 – Paris 1968
Painter. Moved to Paris 1897. Met up with Neo-Impressionists. Exibited at Salon d'Automne and at Salon des Indépendants. Active in Berlin Secession after 1908.

Dotremont, Henri Tervuren 1922
Student at Académie, Louvain 1937. In Paris 1941–42 where he met Paul Eluard, Picasso, Jean Cocteau, Giacometti and Henri Goetz. Met Ai-Li 1943; became acquainted with Chinese art. In Brussels 1949–51 with Alechinsky, Appel, Attau and others. Visited

Scandanavia. Publication of lyrics.

Duchamp, Marcel Blainville 1887 – Neuilly 1968
Portrait and figure painter. Dadaist. In New York with Francis Picabia 1912–17. Founded periodical *The Blind* in USA. After return to Paris no longer worked as artist.

Dülmen, Gerd van Cloppenburg 1939
Painter. Student at Hochschule für Bildende Künste, Berlin 1959–60. Visited Latin America Student at Hochschule für Bildende Künste, Treves, under Hann Trier 1971. Kunstpreis, Berlin 1971. Taught at Staatliche Akademie der Bildenden Künste, Karlsruhe 1971–73. Took up post at Akademie, Karlsruhe 1974. Appointed Professor 1975; lives in Karlsruhe.

Eckmann, Otto Hamburg 1865 – Badenweiler 1902
Painter, graphic artist and designer. Student at Kunstgewerbeschule, Hamburg, and at Akademie, Munich. Exhibited at Munich exhibitions after 1890. Contributor to *Pan*, Berlin, and *Jugend*, Munich, after 1895. Taught decorative painting at Kunstgewerbeschule, Berlin 1897. Designs for carpets, linen weaving, tapestries, ceramic tiles, metalwork, furniture and furnishings.

Eishi, Hosoda 1756 – 1829
Eldest son of Shōgun court official. In his youth Chamberlain for Painting Materials with Shōgun Jeharu. Studied classical Chinese painting under the Kanō painter Eisenin II Sukenobu. Retired from office between 1780 and 1785 to devote attention to full-length figures of women, prints and paintings.

Eishō, Chōkōsai active 1794 – 1800
Pupil of Hosoda Eishi. Like his teacher, depicted mainly women. His large heads of courtesans and the portraits of Eisui and Eiri are among the masterpieces of the Hosoda School.

Endell, August Berlin 1871 – Berlin 1925
Architect and designer. Student first of philosophy, Munich, then, influenced by Hermann Obrist, changed to architecture and the applied arts. Supervised building of studio, Elvira, Munich, 1896, and of sanatorium on Föhr 1898. Showed jewellery designs at exhibition of Munich Secession 1899; designs for Buntes Theater, Berlin 1901; for race course, Berlin 1910–11; designs for various town houses and villas in Berlin and Potsdam. Director of Akademie für Kunst und Kunstgewerbe, Breslau.

Endell, Fritz Stettin 1873 – Bayrischzell 1955
Graphic artist; brother of August. Pupil of Hermann Obrist at Kunstgewerbeschule, Munich. Resident in Paris 1898–1902, then a pupil of L. von Kalckreuth and A. Hölzel at Akademie, Stuttgart. Spent sometime in New York; drawing master at Duncan School.

Ensor, James Ostend 1860 – Ostend 1949
Painter, etcher, writer and composer. Student at Académie, Brussels, mainly self-taught and encouraged by Félicien Rops, 1877–88. Co-founder of 'Club des Vingt' group. Made a baron by King Albert of Belgium 1929. One of the most important and controversial painters of his time. Well known for his exotic and macabre mask paintings. Painted interiors and landscapes; etchings.

Ericot
Collective mark of various glasswares. Used above all on etched glass influenced by Daum brothers.

Fachschule, Gablonz (Technical School)
Founded by the Austrian Kultusministerium in Gablonz, Isar-gebirge, called K.K. Kunstgewerbliche Fachschule für Gürtler, Graveure, Bronzearbeiter, etc. Became later largest production centre for fashion jewellery.

Fahrner, Theodor 1868 – 1929
Jewellery manufacturer in Pforzheim. Son of founder of the firm of same name. Worked from designs by Bernischke, v. Berlepsch, Böres, Bürch, Dressler, Gradl, Habich, Hildenbrandt, Huber, Kleemann, Kleinhempel, from the Kunstgewerbeschule, Pforzheim, and by Morawe, Müller-Salem, Schmid and Wolber.

Falize, Lucien (Josse) Paris 1838 – Paris 1897
Goldsmith and jeweller of a famous family of goldsmiths and jewellers. Known for experiments undertaken with his father, Alexis (1811–98) and the enameller, Taad, to revive the Japanese *cloisonné* technique for use by contemporary artists.

Feure, Georges de Paris 1868 – Paris 1928
Painter, stage designer, graphic artist, designer and glass artist. Professor of Decorative Arts at Ecole Nationale des Beaux Arts, Paris. First exhibited in Germany in the Secession; encouraged by Samuel Bing.

Fidus (H. Hoppener) Lübeck 1868 – Schönblick bei Woltersdorf 1948
Painter and graphic artist. Student at Gewerbeschule, Munich, and at Akademie, Munich. Pupil of Diefenback, at Hollriefelskreuth im Isartal, until 1889, who gave him name Fidus. Returned to Akademie, Munich 1889–92. Moved to Berlin. Put forward mystical and theosophical notions.

Figini, Luigi Milan 1903
Architect. Diploma, Milan, 1926. Founder member of 'gruppo 7'.

Worked with Gino Pollini. Exponent of clear line 'screen' architecture; later, functional wall areas as decoration. His modular systems based on ground plans establish a parallel with Japanese architecture.

Fouquet, Georges 1862 – 1957
Goldsmith in Paris. Worked from designs by Alfons Mucha. Silver medal, international exhibition, Paris 1900. Stylized decorative forms influenced by Japanese models. Familiar with Japanese painters' manuals.

Gaillard, Eugène Paris 1862 – Paris 1933
Architect and furniture designer. Work may be seen in Musée des Arts Décoratifs, Paris. Influenced by Japanese art.

Gaillard, Lucien 1861
Goldsmith. Known for work inspired by Japanese designs. Employed Japanese jewellers, tortoise-shell and ivory cutters in his Paris workshop. Often confused with his brother, Eugène (see above).

Gallé, Emile Nancy 1846 – Nancy 1904
Apprenticed at Meisenthal glassworks 1862. Worked at faience factory, Saint-Clément, 1870. Studied glass, enamel and gem artistry, in 1870s. Established own factory, Nancy 1874. Own pavilion at international exhibition, Paris 1889. Developed 'Gallé glass', made from melting together a number of coloured layers. Inspired by Chinese woodcutting techniques. Collaboration with Japanese botanist and painter, Tokouso Takacyma, who stayed in Nancy between 1885 and 1888. Mass-production began 1890. Development of *marquéterie de verre*. Top award, international exhibition, Paris 1900. Some 300 people involved in the production of Gallé glass.

Gallén-Kallela, Akeseli Björneborg 1865 – Björneborg 1931
Painter and graphic artist: etchings, wood and lino cuts, posters and book-plates. Began in naturalist vein, went over to moderate realism and then to romantically tinged Symbolism c.1900, arriving finally at elaborate decorative forms. Mausoleum fresco, Pori.

Gassner, G. 1851 – 1916
Worked at first for various firms in Frankfurt am Main as gold- and silversmith, specializing in jewellery. Became interested in the work of French Art Nouveau goldsmiths, c.1900.

Geiami Kyōto 1431 – Kyōto 1485
Painter and graphic artist. Like his father, Nakao Nōami (1397–1494), artist advisor to the Ashikaga-Shōguns.

Godwin, Edward William Bristol 1833 – London 1886
Architect. Resident in London after 1862. Received architectural and restoration commissions. Knew Whistler. Designed furniture for Watts & Co. 1877.

Gogh, Vincent van Groot-Zundert 1853 – Auvers 1890
Employed at first as art dealer in Brussels, London and Paris. Began to draw and paint c.1880. Received private lessons in Brussels 1880–81. Began to paint in oils 1882–83. Student at Academie, Antwerp 1885. Studied in Cormon's studio 1886. Knew Toulouse-Lautrec, Seurat, Signac and Gauguin. Friendship with Bernard 1887. Visited Arles 1888. Intense preoccupation with Japanese prints after 1888. Intermittent breakdowns 1888–89. Admitted to mental asylum. Admitted to clinic of Dr Gachet, Auvers 1890. Detailed study of abbreviations and techniques of Far Eastern painters and draughtsmen.

Goncharova, Natalia Moscow 1881 – Paris 1962
Painter, graphic artist, sculptress and costume designer. Student at art school, Moscow. Moved to Paris 1914. Exhibited with Indépendants at Salon d'Automne 1903, and at Salon des Tuileries 1923. Painted some very large works, composing them piece by piece like a mosaic; figurative, still-life, flower paintings, designs for ballet, etc. Influenced by Oriental art.

Gorguet, Auguste François Paris 1862 – Paris 1927
Painter, graphic artist and sculptor. Pupil of Gérôme, Boulanger and Bonnat. Contributed works to Salon des Arts Français after 1883. Visited Spain, Algeria and Tunisia on state scholarship. Painter of large decorative works and frescos; tapestry designs.

Grasset, Eugène Lucerne 1841 – Sceaux 1917
Sculptor, architect, graphic artist and designer. Student of architecture. Visited Egypt. Moved to Paris 1871. Adopted French citizenship 1891. Appreciated in his time. Exhibited frequently in 1890s. In graphic work, favoured a mixture of techniques including lithography and the woodcut.

Groux, Henry de Brussels 1867 – Marseilles 1930
Painter, graphic artist and sculptor. Pupil of Navez, Portaels, X. Mellery and Alfred Stevens. Debut in Brussels with very large painting, *The Mocking of Christ*.

Guan, Hsio 832 – 912
Painter. Resident for long period in Chengtu, Szechwan.

Guillox, Charles 1874 – Paris 1932
Landscape painter in romantic Symbolist vein. Worked in Paris where he exhibited, after 1892. Works shown in Salon of Société Nationale des Beaux-Arts, 1905, and in Salon des Indépendants,

1911–14. Early works in Brittany, later views of Paris and the environs.

Guimard, Hector Paris 1867 – New York 1942
Architect, sculptor, designer. Professor at Ecole des Beaux-Arts, Paris. Major works: Castel Béranger, Paris, 1894–98, and entrance to Paris Métro, c.1900. A champion of floral direction in Art Nouveau. Resident in USA after 1938.

Haagsche Plateelbakkerij Rozenburg, The Hague
Founded by W. von Gudenberg, 1883. New ceramic style under T.A.C. Colenbrander, 1884–89; J. Juriaan Kok, director, 1894–1913. Temporary production of porcelain, 1899–1900. Use of faience techniques, after 1900, and 'eggshell' porcelain invented by M. N. Engelen, chief technician.

Hablik, Wenzel Brüx 1881
Painter, graphic artist, designer. Student at Kunstgewerbeschule, Vienna, and under F. Thiele, Prague. Moved to Itzehoe, Schleswig-Holstein. Also made etchings and designs for hand-weaving.

Haida Böhmisches Glasmacherzentrum
Preference for floral designs, 1890s–1900s. Changed to constructive and geometric cuts in spirit of Vienna Secession. The following firms comprised the Haida centre: Mühlhaus & Co., Gebrüder Rachmann, Tschernich & Co., Josef Gerner, Karl Pold. The Fachschule für Glasindustrie founded in Haida, 1870, contributed to Wiener Werkstätten, c.1900. Notable teachers: F. Opitz, A. Hanel, and J. Oertl who worked to designs by J. Hoffmann.

Hakuin, Ekaku Tokyo 1685 – Tokyo 1768
Joined the Shoin-ji in Hara (now the Shizuoka) at age of 15. Pupil of Tanrei. Adopted name Ekaku. Became abbot of Myōshin-ji, Kyōto, 1717. Founded own temple in Izu, 1758. Produced numerous books and disseminated teachings of Zen amongst ordinary people. Composer of folksongs; painter, calligrapher. Important for reviving Zen Buddhism in Edo period.

Harpignies, Henri Joseph Valenciennes 1819 – Saint-Privé 1916
Landscape painter and graphic artist. Apprenticed to Jean Achard, 1846. Student at Académie de France, Rome, 1850. Spent 6 months in Capri. Returned to Paris, 1852. Painted on Loire, after 1859. Returned to Italy, 1863. Many watercolours influenced by Corot. Active in France, late 1870s.

Harrachov Gräflich Harrach'sche Glasfabrik, Novy Svet (Neuwelt), Bohemia
Founded 1630. Johann Graf von Harrach, resident at Rohrau, named as owner, 1891. Addition of decorating, cutting, engraving and etching shops, by 1895. Famous for decorated vessels and richly engraved luxury glass, after 1900. Flashed and iridescent effects. Contributed to international exhibitions, after 1900.

Harris, Harwell Hamilton 1903
Modern American architect. Made his name with residential and country homes distinguished for their simplicity and suitability to the character of the surrounding countryside. His designs took into account also social, economic and climatic considerations.

Hartung, Hans Heinrich Ernst Leipzig 1904
French painter and graphic artist. Student in Leipzig, Munich and Dresden. Visited Spain 1932–34. Moved to Paris 1935. French citizen since 1945. Developed improvised pictorial language through abstract statements. Spontaneous calligraphic-effect techniques and freely applied rapid strokes. A major representative of School of Paris, an *art informel* counterpart to American Abstract Expressionism.

Harunobu, Suzuki H., pseud., Hozume Jihei, Go Choeiken Tokyo (?) 1724 – Tokyo 1770
Pupil of Nishimura Shiyenaga. Drew portraits of actors and women of demi-monde. Early woodcuts printed at most in four colours. Contributed much to technique of 4-colour printing. Imitated by a great number of pupils.

Heine, Thomas Theodor Leipzig 1867 – Stockholm 1948
Painter and graphic artist. Student at Düsseldorf. Resident in Munich as illustrator for *Fliegende Blätter* and *Jugend*, after 1889. Important contributor to *Simplizissimus* – founded by Herbert Langen 1896 – together with O. Gulbransson and E. Thöny. Collective exhibition, Munich 1909. Illustrations for Thomas Mann's *Wälsungenblut*, Munich 1921. Moved to Prague, 1933. In Stockholm from 1942.

Hiroshige I. Andō Tokyo 1797 – Tokyo 1858
Son of fire-brigade official. His real name was Tokutarō, later Tokubei, his nicknames Yeumon and Yubei, the family name Andō. First a pupil of Kanō painter, Okajima Rinsai. Studied under Toyohiro who gave him name Hiroshige. Other pseudonyms: Ichiyusai, Ichiryusai (1832) and Ryusai (c.1841). Subject matter: actors, heroes and courtesans; produced illustrations for novels and comic poems as well as views of famous places in the Eastern capital. As *ukiyo-e* painter, he also worked on silk and paper. Famous as landscape painter.

Hodler, Ferdinand Berne 1853 – Geneva 1918
Painter. Pupil of landscape painter, F. Sommer, Thun, 1867.

Visited Spain, 1878–79. Contributed to a panorama painting in Lyons, 1885. A friend of Symbolist poet, Louis Duchosal sympathetic to art of Baudelaire, R. Wagner and Hodler. Joined Société Nationale des Artistes Français, Paris, 1891. Exhibited with G. Klimt, M. Klinger and L. von Hoffmann in Berlin Secession, 1905. Painter of bird's eye view landscape inspired by Japanese colour prints. Views built up in areas; accentuation of colour values and ornamentalized direction of light. Moved into apartment in Geneva decorated by J. Hoffmann, 1914.

Hoentschel, Georges Paris 1855 – Paris 1915
Architect and wealthy art dealer whose collection catalogues bear witness to connoisseurship. Friend and executor of J. Carriès, after whose death Hoentschel bought the two potteries at Amand-en-Paisaye and Montriveau to ensure continuation of production. He and Emile Grittel, Nils de Barck and Paul Jeanneney were Carriès' closest pupils. Carved woodpanelled pavilion and rarely seen ceramic works made his name at international exhibition, Paris, 1900. Parts of pavilion now in Museum für Kunst und Gewerbe, Hamburg. Influenced by Japanese stoneware.

Hoffmann, Josef Pirnitz bei Iglau, Moravia 1870 – Vienna 1956
Student of architecture at Akademie, Vienna, under O. Wagner. Visited Italy as winner of the Rome prize. Co-founder of Vienna Secession, 1898. Professor of architecture, Kunstgewerbeschule, Vienna, after 1899. Co-founder with K. Moser and H. O. Czeschka of Wiener Werkstätte. Left Secession with Klimt group and organized the Kunstschau, 1905. President of Vienna Secession, 1912. Founder and director of Österreichischer Werkbund, leaving it in 1920 to take on directorship of Gruppe Wien of the German Werkbund. Contributed to furnishing and planning of international exhibitions. Designs for buildings, interior decoration (Palais Stoclet, Brussels, 1905–11), furniture, tapestries, tableware, glass, lighting, jewellery and small art objects.

Hoffmann, Ludwig von Darmstadt 1861 – Pillnitz 1945
Painter, graphic artist and designer for arts and crafts. Student at academies in Dresden, Karlsruhe and Munich, 1883–86. Student at Académie Julian, Paris, 1889, where he copied murals by A. Besnard. In Berlin joined Elf group which included M. Klinger, Leistikow and M. Liebermann. Went to Kunstschule, Weimar, 1903. Called to Akademie, Dresden, 1916. Designed stage-settings for the intimate theatre of Deutsches Theater, Berlin, Woodcuts for *Hohes Lied* (Song of Solomon), G. Hauptmann's *Hirtenlied*, Berlin, 1922. Designs for textiles, posters and book-binding.

Hokkei, Totoya 1780 – 1850
Real name: Iwakubo Shogorō. Because he was a fishmonger used signature 'Totoya' (fishmonger). Learned to paint and write Kyōka poetry with Kanō Yōsenin (*surimono*, landscape panoramas). Became pupil of Hokusai (*surimono*, landscape panoramas).

Hokuja, Shōtei 1763 – 1824
Painter; pupil of Hokusai. Real name: Kazumasa (Issei), pseud.: Shōtei. Student of European copper engraving. Landscapes from beginning 1800s are remarkable for central perspective, cast shadow and cloud flourishes. Besides landscape prints – almost exclusively views of Edo – some book illustrations.

Hokusai, Katsushika Tokyo 1760 – Tokyo 1849
The most frequently used name. Began to paint at six. First apprenticed to woodblock engraver then to *ukiyo-e* master, Shunshō, 1777. First illustrated book 1780. Studied European painting under Kokan, and Chinese painting. Received commissions to illustrate books after 1789.

Hondard, Christian active in France c.1900
Draughtsman and lithographer. Worked in Paris on magazines and as poster-designer. Influenced by international exhibitions and Japanese prints.

Ippitsusai Buncho, Mori shi. (Mori Bunchō) 1727 – 1796
Poet and woodcut designer. Work comprises c.800 one-page prints of actors and fashionable scenes, dated 1770–78. Own illustrated books in collaboration with Harunobu, Shunshō and Koryusai.

Johnson, Philip Cleveland, Ohio 1906
Architect. Student of classical philology at Harvard. Influenced by Henry Russell Hitchcock's article on modern architectural movement. First director of the architectural department at The Museum of Modern Art, New York, 1930s. Studied architecture at Harvard, early 1940s. Early work a reminder that he was a pupil of Mies van der Rohe, whom he met in Europe in 1930. Modified glass-buildings after introduction by Hofer to connection between landscape and architecture, 1950–55. His pavilions reveal that same relationship between volume of building, colonnades and landscape and suggest influence of Japanese architecture.

Jorn, Asger (A. Jørgensen) Vejrum near Struer 1914 – Aarhus 1973
Danish painter, graphic artist and potter. Student in Paris under F. Léger, 1936–37 and Copenhagen, 1939–40. Visited Holland and Germany, 1936–37; in Lapland and N. Africa, 1947–48. Abstract artist. Member of Cobra group and of 'International Movement for a Bauhaus Imaginist' (*sic*). Resident in Paris, after 1954.

Kauffer, Edward McKnight USA 1891 – New York 1954
Commercial artist, poster designer and illustrator. Student in Chicago, Munich and Paris. Lived in London from 1914. Official British war artist 1940–45. Designed posters for Continental Oil Co. and London Transport (Underground).

Kirchner, Eugen Halle a.S. 1865 – Munich 1938
Painter, draughtsman and etcher. Resident in Munich. Attended Akademie, Berlin, 1883; Munich, 1888, pupil of Uhde. Collective exhibitions, 1904 and 1913/14 in Secession. Owned collection of Japanese prints by Hiroshige.

Kiyomitsu, Torii 1735 – 1785
Son of Kiyomasu II. Versatile artist, endows fantasy scenes with dreamlike charm.

Kleemann, Georg Oberwurmbach, Mid-Franconia 1863
Designer for applied arts and goldwork. Student at Kunstgewerbeschule, Munich. Designs for ceramics, wallpaper, bookbindings, etc. Professor at Staatliche Fachschule für Edelmetall, Pforzheim, after 1887.

Klemm, Walter Karlsbad 1883 – Weimar 1957
Painter and graphic artist. Student at Akademie and Kunstgewerbeschule, Vienna. Introduced to Japanese prints by Orlik. First wood engravings as contribution to exhibition of Vienna Secession, 1905. Shared studio with K. Thiemann in Libotz, near Prague, 1906. Moved to Dachau, 1908. Teacher at Hochschule für Bildende Kunst, Weimar, after 1913.

Klimt, Gustav Vienna 1862 – Vienna 1918
Student at Kunstgewerbeschule, Vienna, 1876–83. With brother Ernst and F. von Matsch decorated ceilings in theatres at Reichenberg, 1882, Fiume, 1883, Karlsbad, 1886, in Burgtheater, Vienna, 1886–90, and in Kunsthistorisches Museum, Vienna, 1890–91. President of Vienna Secession. Until his resignation in 1905, he, C. Moll and J. Hoffmann directed the exhibitions of the Secession. Honorary member of international art committee, London, 1898. Influenced by Puvis de Chavannes, J. Toorop, F. Khnopff and Japanese art, found own style towards 1899. Murals for Vienna University, *Philosophy*, *Medicine* and *Jurisprudence*, 1900–03, caused such a scandal that attempts were made to prevent their being mounted. Left Secession, 1905. Wall mosaic for Palais Stoclet, Brussels, designed by J. Hoffmann, 1910. Honorary member of Vienna and Munich academies of fine art.

Kline, Franz Wilkes-Barre, Pa., 1910 – New York 1962
Painter. Student at University of Boston, 1931–35 and at Heartherly's Art School, London, 1937–38. Went to New York, 1939. Cubist and Expressionist painter; developed own style Action Painting under influence of DeKooning. Calligraphic, improvised brush-writing of girder-like strokes on light surfaces. First one-man show, 1950. Major exponent of Action Painting.

Klinger, Julius Vienna 1876
Graphic artist. Student at Technologisches Gewerbemuseum, Vienna and illustrated comic papers in Munich and Berlin. First poster originated in Berlin, 1897. Contributed to poster exhibition of Vienna Secession, 1914, and opened studio for poster art, Vienna, 1919. Turned to typography after 1898, developed the typefaces Klinger-Antiqua, Berlin, 1912, and Klinger, Dresden, 1926. Published book with plates, *Die Grotesklinie und ihre Spiegelvariation im modernen Ornament und in der Dekorationsmalerei*. Invented so-called 'Betterway-Grotesken'. Gave lecture at the Vienna concert house called 'Das Chaos der Künste' ('Chaos in the arts'), 1924, which later appeared in print.

Klinger, Max Leipzig 1857 – Grossjena bei Naumberg 1920
Graphic artist, sculptor and painter. Pupil of G. Gussow, Karlsruhe and Berlin 1874–77. Student in Brussels and Munich. In Paris 1883–86, in Rome 1888–93. Worked in Leipzig after 1893. First large etching series, *Skizzen*, 1878. Beethoven monument, Leipzig, made from various materials, completed 1902.

Kok, Juriaan Rotterdam 1861 – The Hague 1919
Architect and designer. Director of faience factory, Rozenburg, The Hague, 1894–1913. Under Kok's direction, temporary porcelain production, 1899–1900. Then development of 'eggshell' porcelain after 1900. Influenced by Javanese batik designs.

Kōrin, Ogata Kyōto 1658 – Kyōto 1716
Studied style of Kanō-School. Made a Hokkyō (Buddhist honorary title, equivalent to fifth court rank). Produced fan paintings, ink drawings, designs for textiles and decoration for lacquered work. Kōrin considered greatest Japanese decorative artist. Painted in glazes and body colour on gold paper. His wave patterns influenced Art Nouveau decoration.

Krog, Arnold Emil Fredriksvoerk 1856 – Tisvilde 1931
Student at academy, Copenhagen, 1874–80, graduated in architecture. Visited Italy, 1881–82. Appointed director of Kongelike Danske Porselaine Fabrik, Copenhagen, 1885. Reintroduced underglaze painting at international exhibition, 1889 and 1900, Paris. Influenced by Japanese prints.

Kung, Hsien Kiangsu 1620 – Nanking 1689
Poet, calligrapher and painter. Beach and mountain landscapes

done in dry ink with dense layers of pointillistic brush marks, reminiscent of those made with reed pens, divided by strong light and dark contrasts.

Kuniteru Utagawa 1830 – 1874
Pupil of Kunisada; used name Sadashige before 1844.

Kurzweil, Maximilian Bisenz, Moravia 1867 – Vienna 1916
Painter and woodblock engraver. Student at Vienna Akademie, 1886–92, and at Académie Julian, Paris, 1892–94. First exhibited in Salon of Société Nationale des Artistes Français. Painted in Condarneau, Brittany. Returned to Vienna, 1894. Became member of Genossenschaft der bildenden Künstler, Vienna, 1896; member of Vienna Secession, 1897–1905. Contributed to Secession's periodical *Ver Sacrum*, 1898–1903. Taught at Akademie, Vienna, 1911–15. Collected Japanese colour prints.

Laage, Wilhelm Hamburg-Stellingen 1868 – Reutlingen 1930
Painter and graphic artist. Graphic work shows understanding of monochrome colour harmonies. Studied technicalities of colour in order to imitate Japanese flat decorative surfaces.

Lachenal, Edmond Paris 1855 – active after 1930
Pottery apprenticeship. Joined Théodore Deck's studio, 1870. Exhibited at international exhibition, Vienna, 1873. Opened own studio, Paris, 1880. Studied Japanese ceramics and prints. Enjoyed great success at international exhibition, Paris, 1889. Invented glaze called *émail mat velouté*. Worked in stoneware, 1896. Produced glazed faiences 'Ligno-ceramiques', 1900; 'Metallo-céramiques', 1901.

Lacombe, Ethel Versailles c.1888
Painter and illustrator in Jacques Lacombe's circle. One of Bernard's group. Inspired by pre-1900 English illustrators and turned later to children's books.

Lacombe, Georges Versailles 1868 – Alençon 1916
Painter and sculptor in wood. Greatly influenced by Sérusier. Produced numerous oil and pastel portraits, symbolic decorative wood sculpture and busts. As sculptor influenced by Gauguin.

Lalique, René Ay (Marne) 1860 – Paris 1945
Gold and silversmith; worked in enamel, glass and precious stones. Student at École des Arts Décoratifs, Paris. First successful exhibition in Salon du Champ de Mars, 1895. Designs for jewellery and useful objects are graceful. Used plant and animal motifs. Own pavilion at Exposition des Arts Décoratifs, Paris, 1926. Closed factory in Combs-la-Ville, before 1937. Influenced by Japanese sword guards and dyers' paper stencils.

Latenay, Gaston de Toulouse 1860 – Paris 1928
Landscape painter and graphic artist. Resident in Paris. Contributed to Salon des Artistes Français, 1886–93 and Salon de la Société Nationale, 1894–1914. Influenced as illustrator by Japanese colour prints.

Lee, Sydney Manchester 1866 – London 1932
Landscape and architectural painter, graphic artist. In illustration favoured ornamentation inspired by Japanese painters' manuals.

Legras & Co
Glassworks and decorating-shop for luxury and household glass, Saint-Denis, Seine. Founded by glass-maker, Auguste J. F. Legras, 1864. Became important for production of goblets and flasks. Manufacture from Lalique's designs until 1908. Production ceased 1914. After World War I production resumed under name Verreries et Cristalleries de Saint-Denis et de Pantin Réunies.

Leistikow, Walter Bromberg 1865 – Berlin 1908
Painter and graphic artist. Student at Akademie, Berlin. Taught at Kunstschule, Berlin, 1890–93. Co-founder of 'Die Elf', 1892, from which came the Berlin Secession, 1898. Designs for tapestries, wall-coverings and furniture.

Lenormand, Pierre Louis Paris 1864
Architect. Pupil of Raulin. Designed castle and monastery, Saint-Leonard; Hôtel Buffet, Nancy, and chapel of Saint-Jean, Paris.

Léveillé, Baptiste Ernest France, active c.1890
French glass-maker. Influenced by Rousseau, c.1885, but created more austere forms and stronger colour effects. At international exhibition, 1889, he exhibited for first time glasses decorated with crackling and coloured oxide decoration formed partly with tongs.

Lévy-Dhurmer, Lucien Algiers 1865
Painter and designer for arts and crafts. Resident in Paris. Began as lithographer. Artistic director of ceramic factory of C. Massier, Golf Juan, Alpes Maritimes, for eight years. Self-taught painter: ornamental, allegorical work in pastel.

Lindberg, Stig 1916 – Stockholm 1943
Swedish potter, enamel painter and graphic artist. Enhanced body of vessels with decoration sometimes using underglaze paint in strong colours.

Long, Richard Bristol 1945
English artist, important exponent of Land Art. Student at St Martin's School of Art, London, 1966–68. Exhibited for first time at Biennale, Venice, 1976. His *Walking a Straight Line for 10 Miles* is a photographic record; uses stones in landscapes to create a sense of place, as in Japanese stone gardens.

Lötz & Co. Glassmanufaktur, Johann Lötz-Witwe, Klostermühle, S. Bohemia
Tradition of glass production from 1890s. Firm came into ownership of Max Ritter von Spaun, 1879. Artistic peak c.1900. Imitation iridescent glass of type created by Louis Comfort Tiffany. Mainly Viennese designers after 1902. Factory ran into financial difficulties, c.1910.

Lübbert, Ernst Warin 1879 – near Grodno 1915
Painter and graphic artist. Student with Kallmorgan at Kunsthochschule, Charlottenburg. Contributed to *Berliner Illustrierte Zeitung* and *Illustrierte Zeitung*, Dresden.

Lum, Bertha Iowa 1869 – San Francisco 1934 (?)
American painter and woodblock engraver. Pupil of F. Holme and Anna Weston. Influenced by Japanese prints. Member of Asiatic Society of Japan. Landscapes, figurative work.

Mackintosh, Charles Rennie Glasgow 1868 – London 1928
Architect, designer and graphic artist. Student at Glasgow School of Art, 1884, then with architect, John Hutchinson. Designs for new building of Glasgow School of Art, 1897, and for Scottish Pavilion at international exhibition, Turin, 1902. Designed furniture, bookbindings, posters and patterns for printed textiles, after 1913. Retired to Port Vendres, France, 1920, and painted landscapes in watercolour.

Mackmurdo, Arthur Heygate London 1851 – Wickham 1942
Draughtsman, architect and craftsman. Student at Ruskin School, Oxford. Visited Italy with Ruskin. Opened architect's office, London. Active member of Arts and Crafts movement. Founded Century Guild of Artists, 1882. Friendship with W. Morris. Founded periodical, *The Hobby Horse* 1884. Founder member of Society for the Protection of Ancient Buildings.

Maillol, Aristide Banyuls-sur-mer 1861 – Marly-le-Roy 1944
Sculptor, painter and graphic artist. Student at Ecole des Arts Décoratifs and at Ecole des Beaux-Arts under Cabanel. Met Gauguin and had links with Nabi group, 1892. Applied himself to sculpture, 1895 and exhibited three works in wood. Woodcut illustrations for Virgil's *Eclogues*; bronze statues, *Pomona*, *Flora*, *Spring* and *Summer*, 1910–12. The Cézanne monument commissioned for Aix-en-Provence, 1912, was, like the *Méditerranée*, later placed in the Tuileries, Paris. An abundance of figurative sculpture followed.

Majorelle, Louis Toul 1859 – Nancy 1926
Craftsman. Student at Académie des Beaux-Arts, Paris. Took over father's pottery and furniture workshop in Nancy, 1879. Designed furniture with rich intarsia floral decoration. Collaborated with Daum brothers for whose glassware he produced metal mounts. Exhibited in S. Bing's Art Nouveau shop and at international exhibition, Turin, 1902. With Gallé and Daum a leading representative of the School of Nancy.

Masanobu, Kitao 1761 – 1816
Painter and writer. Born into family of Samurai and merchants. Important for books. Illustrated cheap, black and white editions of *Kibyōshi* and *Sharebon* (joke-books), after 1778. Ran into trouble with government's strict censorship laws, c.1789 and from then on devoted himself to writing.

Massier, Clément Vallauris, 1845 – Golfe-Juan, Cannes 1917
Potter. Apprenticed in father's studio in Vallauris, opened own studio in Golfe-Juan, near Cannes, and supplied Riviera villas with vases. Massier successful at decorating pottery with coloured metal glazes: reddish, copper-oxide glazes which mixed with silver became colour of mother of pearl; ruby glazes. Massier softened iridescents by process of partial corrosion, allowing earth colours, mixed with the glaze, to flow one into the other. Exhibited at Paris spring exhibitions. Family relationships have yet to be researched: relative positions within family of Delphin and Jérôme Massier (son) and of Clément himself not clear.

Masson, André Balagny (Oise) 1896
Painter and graphic artist. Studied in Brussels and Paris. Fluctuated between Cubist and Surrealist tendencies; turned to abstract art. Stayed in Catalonia, 1934–36; returned to Paris, 1937; visited New York and Connecticut, 1941–45; returned to Paris, 1946. Resident in Aix-en-Provence, after 1947. Awarded French state prize for the arts, 1954.

Mathieu, Georges Boulogne-sur-Mer 1921
Painter. Major exponent of Tachism. Development of personal style, 1942: expressive, unconsciously improvised brushwork. Influenced by Wols and Far Eastern calligraphy. Active speed-writing in spirit of Action Painting. Contributed to exhibitions of 'Surindépendants' and in salon of 'Réalités Nouvelles'. Contributed to 'Tachistes' exhibition, Kunsthalle, Berlin, Jan.–March, 1955. Demonstrated his spontaneous method of painting in public.

Maufra, Maxime Nantes 1861 – Pouce (Sarthe) 1918
Painter and graphic artist. Post-Impressionist. First influenced by Monet, turned then to style between Pont-Aven school and Neo-Impressionism. Influenced by C. Le Roux and Gauguin. Published lithographic series, *Paysages de Guerre*.

Maurin, Charles Le Puy 1854 – Grasse 1914
Genre and portrait painter, woodblock engraver and graphic artist. Student at Académie Julian.

Mayer, Martin Mainz 1873 – Mainz 1935
Gold and silversmith. Owner of firm of same name with Mainz wheel its mark. Student at Goldschmiedschule, Frankfurt a.M., 1889–93. Awarded gold medal, international exhibition, Paris, 1900.

Meisenthal Lothringische Glasfabrik Gebrüder Christian und John Meisenthal
Lorraine glassworks; favoured strong colours, but decoration in general more sharply contoured than Gallé's. Vessel designs influenced by Venetian and Moorish works

Melchers, Franz M. Münster i.W. 1868 – Brussels 1928
Portrait and landscape painter. Student at Académie, Brussels. Worked in Belgium, Paris and Holland. Influenced by Belgian symbolists; linked to 'Les Vingt' group. Shared studio with Xavier Mellery.

Michel, Eugène Lunéville – before 1910
Glass-cutter in Rousseau's studio, later with Léveillé. Became an independent glass decorator. His flashed glass with coloured, woodcut-type decoration greatly influenced by 18c. and 19c. Chinese glass. Worked for while with Eugène Lelièvre who provided metal mounts for his cut and engraved crystal jugs and vases. Influenced by Japanese botanical books.

Minton & Co.
Pottery, Stoke-on-Trent, Staffs., England. Founded by Thomas Minton, 1796. Peak period in 19c. when pottery was producing 'Palissy' and 'Della Robbia' hard-paste porcelain, followed by *pâte-sur-pâte* wares. The most important manufacturers of architectural ceramics.

Mohrbutter, Alfred Celle 1867 – Neubabelsberg, near Potsdam 1916
Painter, graphic artist, designer for arts and crafts. Student at Kunstschule, Weimar, under L. von Kalckreuth, 1887–90. Student at Académie Julian, Paris, 1893–94. Taught at Kunstgewerbeschule, Charlottenburg, Berlin, 1904–10. Designs for pictorial carpets and textiles.

Mokuan, Shōtō 1611 – Edo 1684
Chinese Zen priest. Arrived in Japan, 1654, became second abbot superior of Ōbaku School. One of the 'three calligraphers of the Ōbaku sect'. His work is remarkable as example of painting style of Zen man of letters.

Moret, Henri Cherbourg 1856 – Paris 1913
Marine painter. Student of Gérôme. Influenced by Gauguin during sojourn in Brittany, later by Monet. Used strong colours enhanced by violet tones. Interest in characteristic value of colour stemmed from studies of Japanese colour prints.

Moronobu, Hishikawa 1618 (1625?) – Edo 1694
First known master of *ukiyo-e* woodblock engraving in Edo. Depictions of plebeian world, no longer bound to religious subjects. Went to Edo, 1658; appearance of first signed book, 1672. Some 100 picture books attributed to Moronobu.

Morris, William Walthamstow, Essex 1834 – London 1896
Studied theology. Turned to architecture and worked in G.E. Street's office. For short while learned to paint with Rossetti till 1860. The Red House, designed for him by friend, Philip Webb, was the mainspring for foundation, 1861, of Morris, Marshall and Faulkner (later Morris & Co.) for manufacture of furniture, carpets, wall-coverings, typeface and jewellery.

Moser, Kolo (Koloman) Vienna 1868 – Vienna 1918
Painter, graphic artist and designer for arts and crafts. Student at Akademie and Kunstgewerbeschule, Vienna. Founder member of Vienna Secession, 1897. Teacher, 1899, then professor, 1900, at Kunstgewerbeschule, Vienna. He and J. Hoffmann were co-founders of the Wiener Werkstätte.

Mucha, Alfons Maria Eibenschütz (Ivancice), Moravia 1860 – Prague 1939
Painter, graphic artist and designer for arts and crafts. Student in Munich and Vienna and at Académie Julian, Paris, under J.P. Laurens 1890–94.

Muller Frères
Glassworks and decorating-shop for luxury glass at Croismare and Lunéville, France. Brothers, Henri and Désiré, pupils of Gallé. Henri set up on his own in Croismare, c.1900. Both worked at Cristalleries de Val Saint-Lamberg factory, 1906–7. Took over old works at Croismare, c.1910; design studios and decorating-shop in neighbouring Lunéville. Flashed glass and vases made from cloudy, multicoloured layers of powdered glass (*pâte-de-verre*), till 1933. Muller influenced by Daums' original forms and Gallé's corroding and cutting techniques. His personal style, however, was compactness and symmetrical ornamentation.

Munch, Edvard Loften 1863 – Ekely, Skoyen 1944
Painter. Studied at School of Arts and Crafts, Oslo, 1882–83. Visited Paris for three weeks, 1885. First important works

originated in Oslo while member of circle of Christiania *Bohème*, 1886. First visit to Assgaardstrand, 1888. Sojourn in Paris on state scholarship, 1889. Influenced by Pointillists. Exhibition in Berlin, 1892, led to a scandal which made Munch's name known. Influenced by Symbolists around Mallarmé and by Strindberg. Showed *Frieze of Life*, Salon des Indépendants, Paris, 1897. Visited Germany, France and Italy, 1898–1901; Berlin, Hamburg, Weimar, Elgersburg and Kösen, 1902–8. Designed theatre décor for Max Reinhardt, 1906.

Münzthal Verreries et Cristalleries de Saint-Louis, Münzthal (Argental), Alsace-Lorraine
Sheet and hollow glass, decorating-shop for luxury and household ware. Factory still survives under name: Compagnie des Cristalleries de Saint-Louis S.A.

Musashi (Miyamoto Niten) 1568 – 1615
Painter in ink, sword-cutler and fencing master.

Nantenbō 1839 – 1925
Zen Buddhist priest. Son of Samurai family from province of Hizen. Painter in ink.

New England Glass Company
Glasshouse and decorating-shop for luxury and household ware, E. Cambridge, Mass. Family concern founded in 1818, could not hold its own against competition, taken over by W.L. Libbey & Son, 1889.

Nicholson, Sir William Newark-on-Trent 1872 – London 1949
Painter, graphic artist, woodblock engraver. Studied briefly at Académie Julian, Paris, otherwise self-taught. First woodcut publication, after 1896. Under pseud. 'Brothers Beggarstaff', he and James Pryde designed modern woodcut posters, influenced to some extent by Continental printmaking, e.g. Emil Orlik. Influenced by Japanese black silhouette techniques and dyers' paper stencils.

Nittis, Giuseppe de Barletta 1846 – Saint-Germain 1884
Painter and graphic artist. Student in Naples under Marinetti and Smargiassi and in Paris under Brandon, Gérôme and Meissonier. Active in Paris area and London, painting street scenes. Painted fans in Japanese and Chinese tradition.

Novák, Emanuel 1866 – 1918
Designer in Prague. Developed own style, after 1900. Austere poster-like borders and decoration of total form. Influenced by E. Bernard and Pont-Aven School.

Okyo, Maruyama Kyōto 1733 – Kyōto 1795
Graphic artist. Worked in realistic vein which required study of nature. Depicted animals and plants.

Orazi, Manuel second half 19c.
Painter and graphic artist. Well known for numerous poster designs – Sarah Bernhardt, Loïe Fuller, etc. Influenced by Jules Chéret and Toulouse-Lautrec, later by Wiener Werkstätte.

Paul, Bruno Seifhennersdorf, Lusatia 1874 – Berlin, after 1968
Builder and designer for arts and crafts. Student at Kunstgewerbeschule, Dresden, 1886–94 and at Akademie, Munich, after 1894. Co-founder of Vereinigte Werkstätten für Kunst im Handwerk, 1897. Director of educational institute attached to Kunstgewerbemuseum, Berlin, after 1907; director of Vereinigte Staatsschule für freie und angewandte Kunst. Retired as director of master class, 1933. Exerted great influence on modern furniture design (designed prototypes).

Pollini, Gino Rovereto, Trento 1903
Architect. Graduated in Milan, 1927. Founder member of 'gruppo 7'. Worked with Luigi Figini. Designs for houses, factories (Olivetti, at Ivrea). Exhibition and interior architect. Designs for church, Madonna dei Poveri, Milan, 1952–56.

Preissig, Vojtech Svetec 1873 – Dachau 1944
Painter and graphic artist. Student at Kunstgewerbeschule, Prague and in Paris under E. Delaune and A. Schmid, after 1898. After return to Prague, 1903, occupied with typefounding. Taught at Columbia University, New York, after 1910. Made Czechoslovakian propaganda posters during World War I. At Wentworth Institute, Boston, 1916–24. Returned to Prague, 1930. Master of colour etching. Particularly well known in USA for linocuts. Illustrations, bookbindings.

Redon, Odilon Bordeaux 1840 – Paris 1916
Student under Gérôme, Paris, 1856. Friendship with Fantin-Latour 1870. Visited Holland. Contributed to first Salon des Indépendants 1884. Almost exclusively graphic work, 1883–89. Resident at Bièvres after 1909. Symbolic and surrealist work influenced by connection with Buddhism.

Reimers, Lotte Hamburg 1932
Contributed to touring exhibition 'Neue deutsche Töpferei' 1951–61. Self-taught. Participation in building up of Museum für moderne Keramik, Deidesheim, after 1961. Own pottery production, largely involved in glaze and colour experimentation, after 1965. Co-publication with Hinder of book *Moderne Keramik aus Deutschland*, 1971. Received Rhineland-Pfalz prize, Treves, 1976. Reopening of Museum für moderne Keramik, 1977.

Exhibition of work in German and foreign museums. Retrospective exhibition, Städtisches Museum Simeonstift, Treves.

Roller, Alfred Brno 1864 – Vienna 1935
Painter and graphic artist. Student at Akademie, Vienna. Taught at Kunstgewerbeschule, Vienna. Set and costume designer at Vienna theatres; designed for R. Strauss opera premières. Also worked for M. Reinhardt in Berlin.

Rops, Félicien Namur 1833 – Essonnes 1898
Painter, etcher and lithographer. Student of science and literature, Brussels. Discovery of artistic talent while drawing for student magazine, *Le Crocodile*, 1853–56. Began as lithographer, influenced by Gavarni and Daumier. Caricatures on society and political life for periodicals, *Uylenspiegel* and *Charivari belge*. Occupied exclusively with etching and its various techniques, 1858. Own studio, Paris, after 1876.

Rozet & Fischmeister
Jewellers in Vienna, c.1900. Fischmeister studied at Ecole des Arts Décoratifs, Paris, under Lalique and possibly Vernons. Worked from own and others' designs, including those of K. Moser and H. Ofner.

Ruskin, John London 1819 – Brantwood, Coniston 1900
Writer on art and social problems. Also painter and draughtsman. Student at Oxford. Pupil of painters, C. Fielding and J.D. Harding. Met J.M.W. Turner, 1842, to whom he dedicated the first volume of *Modern Painters*, 1843. Wrote on Pre-Raphaelitism, 1851. Famous Utopian essay, *Sesame and Lilies* published 1868. Slade Professor of Fine Art 1870–71, 1883–85. Founded art classes for artisans and a model co-operative for craft and industrial works, the Guild of St George.

Sadahige, Gountei (Gyokuransai) 1807 – 1873 (?)
Pupil of Utagawa Kunisada. Usual name, Hashimoto Kenjirō; pseud.: Gyokuransai and Gountei. Resident for many years in Yokohama where he depicted the lives and doings of foreigners after opening up of the country 1853. Exhibited examples of Japanese woodcut with Kuniyoshi pupil, Yoshiume, at international exhibition, 1866.

Scharvogel, Johann Julius Mainz 1854 – Munich 1938
Apprenticed at Villeroy and Boch factory, Mettlach. Own studio, Munich. First attempts at underglaze painting influenced by Japanese pottery. Worked as glaze technician. Directed the Grand Ducal pottery, Darmstadt, 1906–13. Returned to Munich.

Scheid, Ursula Freiburg im Breisgau 1932
Potter. She and Karl Schied of Hesse are amongst the most important of new German potters. Vases, bowls and pots now made only in stoneware and porcelain.

Schiele, Egon Tulln a.d. Donau 1890 – Vienna 1918
Painter and graphic artist. Student at Akademie, Vienna, 1905–9. Met G. Klimt, 1907. Co-founder with Paris v. Gütersloh of Neukunstgruppe, 1909. Worked at Krumau, 1911, and later in Neulengbach, Lower Austria. Contributed to 'Sonderbund' exhibition, Cologne, 1912. Contributed to periodical *Die Aktion*, ed. F. Pfemfert, Berlin. Exhibited at Folkwang Museum, Essen, and in Vienna Secession, 1918.

Schmithals, Hans Kreuznach 1878 – Munich 1969
Student at Obrist-Debschitz-Schule, Munich, 1902. Almost exclusively furniture designs, 1902–9. Resident in Paris, 1909–11. With W. von Wersin, co-founder of Ausstellungsverband für Raumkunst, Munich. 'Werkbund' exhibition, Cologne, 1941. Owned collection of Japanese colour prints.

Schmuz-Baudiss, Theo Herrnhut, Saxony 1859 – Garmisch 1942
Painter, draughtsman and potter. Learned pottery production at pottery in Diesen am Ammersee, 1896. Contributed illustrations to periodical *Die Jugend*. Founder member of Vereinigte Werkstätten für Kunst im Handwerk, Munich. Employed by Berlin Porcelain Factory, 1902, served as artistic director 1908–26. His tableware and pictorial plates influenced much of the ceramic production of Berlin factory.

Schumacher, Emil Hagen 1912
Painter and graphic artist. Student at Kunstgewerbeschule, Dortmund, 1932–35. Professor at Hochschule für Bildende Künste, Hamburg 1958–60; professor at Staatliche Akademie der Bildenden Künste, Karlsruhe, 1966. Numerous international awards and exhibitions. Awarded prize of Japanese Minister of Culture at 5th International Art Exhibition, Tokyo, 1959.

Séguin, Armand Brittany 1869 – Paris 1904
Painter and graphic artist. Writer. Friend and pupil of Gauguin. Member of Pont-Aven School. Admired Japanese black silhouette techniques and drew from Japanese painters' manuals.

Seiko
Japanese painter in ink. Active mid 19c. Painted naturalistic genre pictures in spirit of Meiji period. Fan painting very popular in Japan during this time.

Sengai, Gibon 1750 – Tokyo 1837
Born into farming family in inner Japan, Province Mino. Joined monastery c.1761. Pilgrimage 1769–70. Studied Zen under Gessen

Zenji in Nagata, Yokohama. After death of his teacher journeyed through mid and N. Japan. Became abbot of Shōfukuji temple. Retired in 1811 to devote next 20 years to painting. Other known signatures: Hyakudo, Kyohaku, Muhosai and Amaka Osho.

Seurat, Georges Paris 1859 – Paris 1891
Painter. Studied under Ingres pupil, H. Lehmann. Interest in theories of colour of Chevreul, Rood and H. de Superville. Link with Signac, after 1884, led to development of theories of Neo-Impressionism. First contribution to Salon 1883. Three recognizable phases of development in work: light and dark studies, especially in drawing 1880–83; nature studies, non-Pointillistic, 1883–84; large compositional works and landscapes, including harbours on north coast of France: geometric lines, colours still mixed but brush marks already blobbed 1884–91.

Sèvres Manufacture Nationale
Transfer of porcelain factory from Vincennes to Sèvres, 1756. Taken over by king 1759. Directed by Charles Lauth 1879–87. Improvements in industrial processes and in quality of paste. Production of a hard paste, 1884, enabled melting of colours and burning on of muffle colours onto finished glaze. School founded for rising generations of artists, 1879. Théodore Deck, director, 1887–91. George Vogt directed factory, after 1891, and Coutan, Chaplain and Sandier employed as artistic directors.

Shigenaga, Nishimura 1697 – 1756
Japanese painter, probably self-taught, but influenced in choice of materials and in style of drawing by Okumura Masanobu. With Kiyomasu II he produced series of fan pictures decorated with gold curves sprayed on with aid of stencils.

Shikimaro
Japanese graphic artist and woodblock engraver c.1800–50. Member of School of Utagawa Toyoharu and influenced first by Toyokuni. Painted actors and did book illustrations. Did not reach the excellence of Sharaku although he aspired to imitate his style.

Shikō, Momogawa active 1772 – 1800
Woodblock designer. His art is related to Toriyama Sekien's. Illustrated picture volumes and cheap picture books (kibyoshi), 1772–84.

Shimposai
Japanese painter and woodblock engraver c.1700. In engraving inspired by Moronobu, later by Sukenobu. Worked as book illustrator and depicted plebeian scenes.

Shōen, Uemara
Japanese portrait painter early 20c. Influenced by Kobayashi Kiyochika, he applied himself to sosakuhanga, a popular art amongst 20c. wood engravers.

Shūi-Mutō 1275 – 1351
Painter of late Kamakura period.

Shumman, Kubota 1757 – 1820
Horse doctor, poet, painter in S. Chinese and ukiyo-e traditions. Pupil of Inō Nahiko and Kitao Shigemasa. As a Kyōka poet he went over to book illustration and surimono after 1790. Master of the art of surimono.

Shunsen, Katsukawa 1762 – after 1830
Pupil of Tsutsumi Tōrin III, used name Shūrin before 1806; changed it to Shunsen 1806, while pupil of Shunei; called himself Shūnko II after 1820. Active as graphic artist until 1830, later painted pottery. Influenced by European art, he attempted shadow effects in landscape.

Shunshō, Katsukawa Tokyo 1726 – Tokyo 1793
Pupil of ukiyo-e painter Katsukawa Sunshi. Possible influence of Harunobu in early work. Attempted to detach himself from stylization of Torii School and portrayed individuality in faces of actors. Published with Bunchō the Ehon Butai Ogi, 1770; with Shigemasa, the Seiro Bejin awase suyata kagami. Favourite themes include wrestlers, warriors, courtesans. Illustrated many books. Pupils included Shunei, Shunrō (Hokusai), Shunzan.

Shunzan, Katsukawa active c.1782 – 1798
Pupil of Katsukawa Shunshō, painter and graphic artist.

Siedlecki, Franciszek Wincenty Cracow 1867 – Warsaw 1934
Painter, graphic artist and art writer. Student at Cracow University, in Munich and at Académie Colarossi, Paris. Visited Italy, and Holland. Resident in Warsaw, 1902–4. Director of stained-glass studio at Rudolf Steiner's Goetheanum, Dornbach, 1914–19. Resident in Warsaw, after 1919. Influenced by Symbolism and Art Nouveau.

Simmen, Henri Paris 1880 – Paris 1959
Employed briefly in Lachenal's studio where he was introduced to stoneware techniques, but also to faience glazing. Familiar with technique of lustre painting. Visited Far East to study stoneware processes and used Japanese art of glazing. Used ox-blood glazes. Experimented with Celadon earthenware.

Soulages, Pierre Rodez, Aveyron 1919
Painter, lithographer and engraver. Moved to France, 1946, and became a major representative of School of Paris. Exhibited with abstract painters at the Surindépendants. Influenced by Asiatic

calligraphy. Severe compositions, gestural and dynamic spanning of areas.

Spilliaert, Léon Ostend 1881 – Ostend 1946
Painter and graphic artist. Self-taught. Friendship with Émile Verhaeren after 1908. Mainly watercolour and pastel with Expressionist and Surrealist characteristics. Book illustrations for Maeterlinck and Hellens.

Staeger, Ferdinand Trebitsch, Moravia 1880
Painter, graphic artist and designer of tapestries and household textiles. Worked in Penzberg, Upper Bavaria. Exponent of realistic symbolism. Influenced in early years by Japanese dyers' paper stencils.

Steinschönau Fachschule für Glasindustrie, N. Bohemia
Glass industry training school; developed from school for draughtsmen founded by Prince Rudolf von Kinsky, 1839. The K. K. Fachschule für Glas- und Metallindustrie founded in 1880. Taken over by Ministry for Culture and Education 1882. Further development through technical innovation, also in engraving and etching. Contributions to international exhibitions in 1880s and 1890s. Extension of technical laboratory, 1890. Extension of school, 1905. Adoption of Japanese décor, 1907. Name changed to Deutsche Staatsfachschule für Glasindustrie, 1918. Addition of experimental and educational institute, 1936.

Stevens & Williams Brierley Hill Glassworks
Manufacturers of luxury and household ware at Brierley Hill, Stourbridge, Staffs. Founded in 1776 when known by name of its founders, William Stevens and Samuel Cox Williams. Under directorship of Frederick Carder, 1881–1902, production of Moss Agate glass with crackled linings and coloured oxide deposits. Satin glass, after 1886, with etched surface, sometimes decorated with sculptured glass threads. John Northwood enriched production with cameo glass cutting in Roman fashion. Production of cameo glass in relief engraving and intaglio deep-cut. The firm is still active under name Royal Brierley Crystal Glassworks.

Stöhr, Ernst St Pölten, Lower Austria 1865 – 1917
Painter and graphic artist. Co-founder of Vienna Secession, 1898. Works: historical portraits, landscapes and interiors.

Sukenobu, Nishikawa 1671 – Kyoto 1751
Painter and illustrator. Studied under Kanō Eino and Tosa Mitsusuke. Went over to book illustration c.1710. Some 300 books, after 1718, bear his name. Influenced Edo artists up to Harunobu.

Takagi, K. active 1840s
Painter and graphic artist. Published design catalogue for kimonos 1840. Depictions of mass scenes in tradition of the Kuniyoshi. Designer of theatrical costumes.

Thiemann, Carl Theodor Karlsbad 1881 – Dachau 1966
Student at academy, Prague, under F. Thiele. Visited Holland, Belgium, Italy and France. Resident in Prague, 1905–8. Revived modern original colour woodcut under Japanese influence.

Tien-Shêng 1693 – 1765
Zen Buddhist Chinese painter. Graphic form transformed into agitated technique, play with wash reveals masterly hand.

Tiffany, Louis Comfort New York 1848 – New York 1933
Student in New York under Inness and Coleman and in Paris under Bailly. Visited France, Spain, Italy and N. Africa. In painting favoured Oriental scenes. Developed special process for production of iridescent decorative glass – Favrile glass. The Tiffany Studio in New York still manufactures in period style using metal, horn, enamel and other materials.

Tobey, Mark Centerville, Wis. 1890 – Basle 1976
Self-taught after period as commercial artist in Chicago. Taught in Seattle after 1935. Visited Far East where he studied calligraphy. Lived in Japanese Zen monastery. Influenced by spontaneous calligraphy, he created his 'white writings', rhythmic and sensitive calligraphic squiggles whose point of departure is cityscape. They are to be understood as abstractions suggesting visions of space.

Toorop, Jan Poerowoedjo, Java 1858 – The Hague 1928
Painter and graphic artist. Son of Dutch government official stationed in Java. Resident in Holland after 1861. Student for one year at Polytechnic, Delft and then at Academy, Amsterdam, 1880–81 and Brussels 1882–83. Member of Les Vingt, after 1866. Acquainted with J. Ensor. Repeated visits to London 1885–89. First Pointillistic work influenced by Seurat and Ensor 1889. Return to Holland, 1889. Resident in Katwijk till 1891, afterwards in The Hague. Member of art circle, The Hague. Went over to Symbolism 1890–91; influence of poetry of Maeterlinck and Verhaeren. Second sojourn in Katwijk 1899–1902. Resident in Amsterdam 1900–9. Contributed to St Lucas exhibition, Amsterdam, 1908. Founded exhibition hall in Doburg 1910. Returned to The Hague, 1916, then occupied almost exclusively with religious art.

Toulouse-Lautrec, Henri de Albi 1864 – Malrombe 1901
Crippled by an accident 1878. Moved to Paris 1881, studied under Bonnat and Cormon. Met Bernard and Van Gogh. Influenced by Degas. Exhibited at Salon des Indépendants 1889. Contributions to

Revue blanche 1893; met Van de Velde. Visited London 1895; met Wilde and Beardsley. Breakdown 1899.

Toyokuni I, Utagawa Edo 1769 – Edo 1825
Born into family of puppet-makers called Kurahashi. Real name Kumakichi; pseud. Ichiyōsai. Apprenticed to Toroharu. Book illustrations in 1780s. Influenced by Kiyonaya, Shigemasa, Utamaro and Eishi. Favoured actors as subjects. Pupils include Toyohiro, Kunimasa, Kunisada and Kuniyoshi.

Toyokuni II, Utagawa Edo 1802 – 1835 (?)
Pupil of Toyokuni; real name Genzō Toyoshige; pseud. Ichiryūsai and Kōsotei. Adopted by Toyokuni. Depicted actors, girls and landscapes.

Turnau near Gablonz, N. Bohemia
Technical school for stone-setting and fashioning. Founded 1884. Important for production of garnet jewellery.

Utamaro, Kitagawa active 1780s
Pupil of Toriyama Sekien. Real name: Yūsuke; pseud.: Toyoaki. Called himself Utamaro 1782, but used many other pseudonyms. Taken into house of the publisher Tsuta-Ya Jūsaburō. Active as book illustrator 1780s, using refined printing techniques; impression of powdered metals – gold and silver, relief and blinding. Depicted mainly girls and women. Very few good pictures after 1804. Pupils include Utamaro II, Kikumaro and Banki.

Vallotton, Félix Lausanne 1865 – Paris 1925
Painter and graphic artist. Student at Académie Julian, Paris, 1882–85. Exhibited in Salon of Société des Artistes Français, 1885. Visited Austria and Italy 1889. Went over to graphic art, book and periodical illustration in woodcut. French citizen after 1900. Exhibited with Bonnard, Vuillard, Denis and Maillol at his brother-in-law's gallery, Bernheim-Jeune, Paris, 1902. Familiar with Japanese prints and interested in techniques of Chinese stone rubbing.

Val Saint-Lambert S.A. des Cristalleries de Val Saint-Lambert, Seraing-sur-Meuse, Liège
Glassworks founded 1825. Around 1900: workforce numbered approx. 4,500; annual turnover about 8 million francs; Managing director Baron F. de Macar; general director Georges Despret. Manufacturers of crystal glass of all kinds, especially diamond-cut, and art glass. Camille Renard-Steinbach designed Art Nouveau glass 1888–95. Later artistic production was influenced by Muller brothers of Nancy, pupils of E. Gallé, after 1900. Principally engaged in marquéterie de verre or fluogravure technique.

Velde, Henry Clemens van de Antwerp 1863 – Zürich 1957
Painter, architect and designer. Studied painting in Antwerp, Paris and Brussels. Went over to architecture and crafts under influence of W. Morris, 1890. Designed own house in Uccle, near Brussels, including furniture and interior decoration, 1895. Designed interior of Folkwangmuseum, Hagen, 1898–1902. Ideas formulated in Kunstgewerbliche Laienpredigte, Leipzig, 1902, and in Vom neuen Stil, Leipzig, 1907. Artistic advisor to Grand Duke Wilhelm Ernst in Weimar after 1902; established and directed art schools there 1906–14. Building of theatre of 'Deutsche Werkbund-Ausstellung', Cologne, 1914. Belgian State commission to establish Institut Supérieur d'Architecture et des Arts Décoratifs, 1925, later elevated to École Nationale. Designed Belgian pavilions for international exhibitions, 1937 and 1939–40. Commemorative exhibition at Kunstgewerbemuseum, Zürich, 1958.

Vever, Henri Metz 1854 – Paris 1942
Goldsmith. Pupil of A. Millet at Ecole des Beaux-Arts, Paris. Familiar with combination techniques of Japanese sword-cutlers and manufacture of Far Eastern ornament patterns.

Vlaminck, Maurice Paris 1876 – Rueil-la-Gadelière 1938
Self-taught. Met Derain, shared studio with him in Chaton, 1901. Knew Matisse 1901. Met Picasso 1905. Contributed to Fauves exhibition.

Vogeler, Heinrich Bremen 1872 – Kazakhstan 1942
Painter, graphic artist, interior decorator and designer for arts and crafts. Student at Akademie, Düsseldorf. Joined F. Mackensen and O. Modersohn in Worpswede, after 1889, where he later founded Worpsweder Werkstätte für Landhausmöbel and designed silverware, including the Bremen civic silver. Organized socialist educational courses for workers and turned his country house, Barkenhof, into a socialist commune. Publication of his creed Expressionismus der Liebe, 1918; publication of series of drawings, Reise durch Russland. Die Geburt des neuen Menschen, 1925. Resident in USSR, after 1931. Exhibition in Moscow, 1941.

Vuillard, Edouard Cuiseaux 1868 – Baule 1940
Moved to Paris 1877. Student at Académie Julian 1888, met Bonnard. Joined Nabis group 1889. Shared studio with Bonnard and Denis 1891. Taught at Académie Ranson 1908. Visited England and Holland with Bonnard 1913. Visited Spain, 1930. Interest in Japanese prints 1890s.

Wacik, Franz Vienna 1883 – Vienna 1938
Painter, graphic artist, illustrator and stage-designer. Student at art

school in Strehblow and at Kunstgewerbeschule, Vienna. Member of Vienna Secession, 1911. Painted frescos and designed stained-glass windows.

Walther, Ernst Hermann Landsberg a.d.W. 1858 – Dresden 1945
Painter and interior designer. Student at Akademie, Berlin, 1877–82. Designed furniture, etc., executed by Dresden Werkstätten für Handwerkkunst.

Webb & Sons Stourbridge, Staffordshire
Glassworks and decorating-shops for household and luxury glass. Founded by Thomas Webb, 1837. Under his sons who inherited the firm in 1869, it became one of the most successful producers of decorative glass which it continues to manufacture today.

Weiss, Emil Rudolf Lahr 1875 – Meersburg, Lake Constance 1942
Painter, graphic artist and craftsman. Contributed with H. Vogeler to art periodical *Insel*. Drawings in a decorative, emphatic style that he matched ornamentally to picture area. Strongly contoured silhouette technique suggests familiarity with Japanese prints.

Whistler, James Abbott McNeill Lowell, Mass., 1834 – London 1903
American-English painter, graphic artist and writer. Worked as Navy cartographer in Washington. Went to Paris 1855; apprenticed in Gleyre's studio. Met Bracquemond, Degas, Legros and Ribot. Studied in Louvre. First 13 etchings done in Paris. Rejected by the Salon 1859; exhibited in Bouvin's studio. Moved to London where he stayed with breaks till 1884. Visited Venice 1878–80. Exhibited portrait of Lady Archibald Campbell at '3.

Internationale Kunstausstellung', Munich, 1883. Resident in Paris after 1844. Opened a school. In London again from 1896 till his death. President of Royal Society of British Artists; president of International Society, London, 1898. Influenced by Courbet and Manet. Developed own style after 1865 – *Old Battersea Bridge*. Other influences: Rossetti, Millais, A. Moore, Velázquez and Japanese art.

Witkiewiez, Stanislaus Poszawsz 1851 – Lovrana 1915
Polish painter, architect and art writer. Student at academies, St Petersburg and Munich, 1880–82, under Anschütz. Worked in Warsaw. Resident in Zakopane after 1890. Painted landscapes and genre scenes. Designed many country homes around Zakopane.

Wolfers, Philippe Brussels 1858 – Brussels 1929
Sculptor and goldsmith, medallist and interior designer for arts and crafts. Designed flashed glass for Cristalleries de Val Saint-Lambert 1897–1903. Then became pupil of his father, J. de Rudders, and later active in workshop in Brussels.

Wright, Frank Lloyd Richland Centre, Wis. 1868 – Phoenix, Ariz. 1959
Pupil of L. H. Sullivan. Leading architect of modern America. Influenced to some extent by Japanese and Maya architecture. International style of design. Bold supporting structures suggest he well understood reinforced concrete. Did without ornamentation; subtle use of large number of different materials, old and new. Preference for open plan; emphasized relationship between building and nature. Construction and inner organization in spirit

of Japanese modular systems. 'Organic architecture' a belief central to his creative life.

Wu Chen Chia-hsing, Province Chekian 1280 – Chia-hsing 1354
One of the four great masters of the Yüan period. Bamboo and landscape painter. Lived as Taoist hermit.

Yoshitoshi, Tsukioka (Taiso) 1839 – 1892
Pupil of Utagawa Kuniyoshi. Real name: Yonijirō; used pseud. Ikkaisai, Taiso, Gyokuōrō, Kaisai and Sokatai. Studied old Japanese masters and Western art. Often chose historical themes for woodcuts. Active as illustrator for newspapers. Used Western techniques after 1860.

Zahn, Otto Gaggenau 1868
Taught gem-setting at Kunstgewerbeschule, Pforzheim. Designs influenced by Far Eastern models.

Zsolnay, Vilmos Pécs (Fünfkirchen) 1828 – Pécs 1900
Hungarian potter. Founder of the famous Pécs factory. Exhibited his Ivoire faiences at international exhibition, Paris, 1878. Vases and figures with metallic Eosin lustre, *c.*1890. Invented weather-proof pyrogranite with fine enamel, used in building.

Zülow, Franz von Vienna 1883
Landscape painter, graphic artist, modeller and designer for arts and crafts. Student at Graphische Lehr- und Versuchsanstalt of Akademie, Vienna, 1904–6. Visited Germany, England and France, 1912. Member of the Klimt group, 1908, and later of the Vienna Secession, the Secession of Upper Austria and the Märzbund. Visited Italy and Tunisia 1929.

Index